THE
ARTIST'S
HANDBOOK

THE
ARTIST'S
HANDBOOK

RAY SMITH

Alfred A. Knopf • New York 1987

PROJECT EDITOR
Caroline Ollard

ART EDITOR
Mark Richards

ASSISTANT EDITOR
Tim Hammond

DESIGNER
Joanna Martin

EDITORIAL DIRECTOR
Alan Buckingham

PHOTOGRAPHY
Peter Chadwick

SCIENTIFIC ADVISER
Alun Foster

THIS IS A BORZOI BOOK
PUBLISHED BY ALFRED A. KNOPF, INC.

First American Edition

Copyright © 1987 by Dorling Kindersley
Limited, London
Text and illustrations copyright © 1987
by Ray Smith
All rights reserved under International
and Pan-American Copyright Conventions.
Published in the United States by Alfred
A. Knopf, Inc., New York, and
simultaneously in Canada by Random House
of Canada Limited, Toronto. Distributed
by Random House, Inc., New York.
Published in Great Britain by Dorling
Kindersley Limited.

Library of Congress
Cataloging-in-Publication Data

Smith, Ray, 1949—
 The artist's handbook.
 Includes index.
 1. Art—Technique. 2. Artists'
materials.
I. Title.
N7430.S54 1987 760'.028 86-2985
ISBN 0-394-55585-6

Manufactured in Hong Kong.

•CONTENTS•

INTRODUCTION

The preparation of a new handbook for artists in which the nature and use of most art materials is accurately or even sensibly discussed is not an entirely straightforward undertaking. For unlike almost any other discipline with such a lengthy and unbroken history, the technical story of painting has never been systematically told.

It is not possible just from looking at a painting to make a scientifically accurate judgment about the nature of the medium or pigments used. Nor is it reliable to trust much of the early literature on the specific materials and techniques employed by artists, since the information has invariably come at best second-hand, and at worst, through a distorting chain of intermediaries.

Occasional experiments have re-created recipes from the literature on painting materials, but as far as I am aware, there has been no long-term and sustained scientific enquiry into the value and permanence of the many mediums and methods described in manuscripts such as those researched by Mrs Mary Merrifield and Sir Charles Eastlake, for example. There is now greater evidence, however, that many of the ingredients described in these works may have a damaging effect on the permanence of a paint film.

Modern scientific analysis

The only sound way of establishing an accurate study of painting materials and methods is by the scientific analysis of samples of the paintings themselves. The identification of pigments and mediums which is now possible through gas chromatography and mass spectrometry is generally limited to fragments obtained from paintings which have been selected by galleries for restoration. So the technical information thus obtained is a by-product of the main job of restoration.

This type of information is further constrained by the fact that few museums or galleries can afford the expensive equipment required to obtain it. Those that can generally concentrate on periods of painting in which the museum is particularly strong, so that certain periods, in which particular painting methods were employed, are left out altogether. The situation is further complicated by the fact that in the course of time, many of the ingredients of the painting media undergo chemical changes that can make them very difficult to detect, even with the most sensitive equipment. So until mass spectrometry began to be used, it was largely impossible to detect the presence of natural resins in a painting with any degree of certainty. It is relatively simple to identify the type of drying oil used, but it is considerably more difficult when there is a mixture of drying oils. With a fragment of a painting that has been built up in layers, each of which may contain a slightly different medium, it can be a complex task to identify each component. This means that, at the time of writing, it is not possible to complete a scientifically accurate history of painting materials and methods, although the information for such a work is beginning to emerge.

The need for a simple approach to materials
There is, of course, a certain

amount of accurate information in some areas. We know, for instance, considerably more about early painting methods (between the early fourteenth and late sixteenth centuries) than we do about those used in later paintings (made between the seventeenth and nineteenth centuries). Very little is known about the latter from a technical point of view. This is because these works often present multi-layer structures involving complicated groups of materials and these create problems of analysis. Many artists of that time tended to incorporate various different materials in their paintings – often with appalling effects on the structure of the paint film. The analytical data on the early paintings, on the other hand, shows them to be considerably more straightforward in their structure, relying on a simple drying oil such as walnut or linseed and only incorporating resinous material where necessary as in the (now obsolete) copper resinate green.

These considerations are both an obstacle and an advantage, especially in relation to the practice of oil painting. On the one hand they impose certain limitations on what can justifiably be taken to be accurate information and, on the other, they suggest a way forward which bypasses much of what can only be termed the "mythology of practice". This mythology sustains itself by being repeated in a barely modified form from one handbook to the next. It is a self-perpetuating form which only survives because there is a lack of accurate scientific information with which to dispel it. Not all of it, of course, is mere mythology. Some of the sound practices advocated by Cennino Cennini, for instance, remain as valid now as they were in the fifteenth century and have been confirmed by analysis; these are incorporated in this book. There are others, too, and what characterizes them

is a straightforward grasp of the nature of the materials which usually arises out of their authors' first-hand experience as artists.

The way forward, which bypasses the over-complex alchemy of pages of elaborate and infinitely variable recipes, is to rely on proven materials and to demonstrate that even work of apparent complexity can be achieved by simple means. As I have indicated, for example, recent studies by the National Gallery Scientific Department in London have confirmed that many of the masters of the fifteenth and sixteenth centuries who, it had previously been claimed, used highly complex painting mediums, in fact invariably relied for the whole work on a simple drying oil.

Modern and traditional tools and materials The first section of the book deals with the ingredients of the painting and drawing media. The materials that are detailed and discussed constitute the main components of the various painting systems explored in the chapters that follow. Which of the ingredients is used and in what proportions for particular media, is discussed in the relevant section – oil paints, acrylics, encaustic, and so on. In outlining the various pigments, oils, resins and other components used in the manufacture of artists' materials, I have attempted to include the modern synthetic materials that have become increasingly important in the last few decades and which are not explored in detail in other handbooks. In particular the synthetic resins and many synthetic organic pigments have been developed and improved dramatically, so that they now represent a significant proportion of the materials market. They have mostly been developed by large companies to service the needs of particular industries,

as in the development of bright, lightfast pigments for the automotive industry. These industrial developments provide spin-off benefits for artists. In many cases, the resulting products represent a considerable improvement on traditional materials. Accelerated testing methods show them to be reliably consistent and with few of the uncertain characteristics associated with some traditional materials.

The traditional materials are also fully discussed where they continue to be an important part of the artist's repertoire. For example, the natural drying and semi-drying oils will, no doubt, continue to be used for a considerable time and artists will continue to paint on linen, however attractive polyester fabric seems by comparison. Synthetic soft-hair brushes have improved beyond recognition, but there is still a special feel to a fine red sable brush with its bounce and resilience, its paint-holding and shape-retaining capacity, that makes it unmatched by its synthetic rivals.

In addition to its coverage of some of the newer materials, this book differs from earlier handbooks by its concentration, in the area of practice, on image as much as on text. Wherever possible, particular techniques have been illustrated, so that descriptions of the use of materials, especially in the sections on painting and drawing, are directly related to images accompanying the text. Where pictures from the history of art are used, it is because they tell a particular technical story – and they are so described.

The need for recognized standards
In the course of my research for this handbook, it has become clear that there is an urgent need for manufacturers to observe designated standards of permanence for products used in permanent painting or drawing. As it is, most artists'

materials manufacturers have an individual system of designating, for instance, lightfastness, and some claim lightfastness for significantly inferior products. The more reputable manufacturers are beginning to use uniform standards for permanence and to give Color Index references to their pigments. But without published specifications according to these established standards, the artist has no way of finding out if his colors are going to fade or his paper to degrade.

New developments and experimentation The handbook also looks at some of the newer areas of technical practice. The use of photography as an art medium, for example, has developed dramatically in recent years, and computer technology has created exciting innovations in visual art practice. The use of laminates for mural artwork is described here for the first time, and the technical possibilities of newer media such as acrylic paints are explored in ways that relate as much to their unique physical properties as to their ability to imitate the effect of more traditional media. I have also looked at some of the ways in which natural materials have been "re-discovered" and incorporated in works by contemporary artists.

Discovering alternative methods and materials Working on the handbook, often in conjunction with art students to whom I have introduced new materials and techniques, has shown me that the exploration of areas which painters are aware of, but have never really investigated, can be extraordinarily exciting, especially when one comes to them with some experience and facility in the more mainstream painting and drawing media. Silverpoint drawing, for instance, does not seem to be commonly practised

but it involves very little preparation and gives a unique and exquisite quality to drawing. Similarly, very few painters work in encaustic or egg tempera. These media are not only simple to prepare and use, but they also offer a wide variety of techniques and a permanence that rivals any of the more well-known painting media. Where such materials are less well known, I hope that the enthusiasm I have felt in exploring them may come across and generate a wider interest.

My approach has been predominantly that of the painter, whose techniques are invariably paralleled in the technical possibilities of the less well-known media. It is, for instance, possible to create s'graffito effects with oil pastel, oil or acrylic paints on conventional painting and drawing supports, but it is equally possible to create them on ceramic tiles, in stained glass, on vitreous enamel panels or in concrete. Indeed, research for this handbook has convinced me of the arbitrariness of the barriers which seem to be set up between the various disciplines and I have tried to show how straightforward and exciting it is to move freely between them. This applies just as much to printmaking, an area of practice from which the skills of drawing and painting have been inseparable, and I hope that the wide range of techniques discussed has given an accurate and helpful indication of the possibilities offered by the four main branches of the discipline.

The new spirit

The climate in which the painter is now operating has changed significantly in the last few decades. Many more artists are now active in the market-place, relying on their own initiatives to create work rather than on openings in the gallery circuit. This means that a great deal more public art is created in a wide variety of applied media. It is this new spirit that gives particular relevance to chapters which discuss the media for public art – including mural painting techniques, laminate painting, stained glass, vitreous enameling and ceramic tiles.

In preparing and collating the material for a handbook that covers such a wide area, I have been assisted by numerous artists and experts in various fields. I am most grateful to them for their time and patience and also, in many cases, for allowing their own images or researches to be incorporated in the following pages.

Ray Smith

·MATERIALS·

PIGMENTS

Painting is the art of distributing pigment over the surface of a support and, as such, the particles of pigment are the single most important component in any consideration of the painting process.

The appearance of the pigment can be modified by the nature of the binding medium in which the particles are suspended and which attaches them to the support, by the nature of the support itself or of the ground to which it adheres, and by the variable action of the light.

Until comparatively recently, the majority of pigments were derived from natural substances. Then, as knowledge of chemistry increased in the eighteenth and nineteenth centuries, new elements were isolated and a number of new pigments appeared, including those based on chromium, cadmium and zinc. In the twentieth century, a whole new range of synthetic pigments has been created as a direct result of further technical and scientific advances which have been made in the chemical industry.

In this book, I have concentrated on the permanent new pigments that have emerged – and been tried and tested – since the 1930s. The older and more established pigments have been well documented elsewhere; of these, only those that are currently available and in use are included. Details of specific pigments are given on pp.18–31.

·Pigment characteristics·

A pigment is solid material in the form of small separate particles. In their dry state, these particles exist in two main structural forms: as aggregates – in which primary particles or crystals are joined at the crystal faces; and as agglomerates – which are looser structures of aggregates.

PARTICLE SIZE AND SHAPE

The size and shape of the pigment particles affect the appearance of the paint – large particles tend to produce a matt, grainy texture – as well as properties such as lightfastness, opacity, consistency, flow, and brushability. In addition, particle size can affect stability; the smaller the particles, the slower the rate of settling for a given specific gravity in a liquid paint. In practice, this precludes certain coarse pigments from being used in acrylic emulsions, for instance (see p.209).

Particle size can be finely adjusted for optimum effects by modern industrial methods. The synthetic organic pigments, for example, are available in particle sizes ranging from 0.05 to 0.5 microns (1 micron = one-thousandth of a millimeter).

Different pigments have quite different particle characteristics (depending on their chemical group), so that natural Vermilion from the mineral cinnabar displays crystal fragments, while the artificial variety shows hexagonal grains and prisms. Lamp Black shows minute rounded particles while Bone (Ivory) Black exhibits irregular coarse grains.

WETTING AND DISPERSION

Before the pigment can be applied or manipulated, it must be dispersed in a binding medium. A paint should consist of a complete and continuous suspension of pigment in the vehicle or binding medium. A perfectly dispersed pigment is one in which each particle is separately and closely wetted with a completely enveloping film of medium.

Pigment particles are insoluble in the medium in which they are employed. The process of dispersion involves breaking down the agglomerates, but does not normally break down the aggregates; it is the size of these that determines whether the color is coarse or fine. For proper dispersion, the color and the medium must be ground together. When artists prepared their own color, this was done by hand using a muller and slab (see *Appendix*, p.334). Colors prepared in this way were generally unstable and separated rapidly in storage, requiring redispersion before being used again. The process of dispersion has now largely been taken over

by the artists' colormen who can ensure uniform and complete dispersion, and control precisely the medium content to a far greater degree than the artist at home. However, there is still a place for the craft of preparing one's own colors, especially for media such as egg tempera (see *Appendix*, p.335).

OIL ABSORPTION

The oil absorption of a pigment is the minimum amount of linseed oil which can be worked into a given weight of pigment (100gms) so as just to form a coherent paste. This varies considerably from pigment to pigment and depends on the way the oil penetrates the pigment mass – the gaps between particles and irregularities in the individual particles – to form a complete coating. Such a paste is putty-like in appearance and the amount of oil or medium used to bring it to this state bears no resemblance to the amount necessary to make it workable for the artist. A number of factors determine the oil absorption, including particle shape, the specific gravity of the pigment, and the fact that variations in the volume of 100gms can be considerable for different pigments. Thus, although the oil absorption of a pigment can be a useful guide if you are making your own colors, it should be treated cautiously as a guide to structuring a painting for optimum durability (see also p.182).

COLOR

The color of a pigment depends on its absorption of light (see *Color*, p.291). For example, yellow pigment absorbs most of the blue-violet light and reflects green and red light. This combination of green and red light rays produces the yellow color effect. The groups of

THE COLOR INDEX
The number of new organic pigments is increasing rapidly (see p.14) and common descriptions such as "azo" are meaningless in judging the durability of a pigment; even "arylide" or "B.O.N. arylide" do not give sufficient information. The only designation which as near as possible defines the composition of a pigment is its Color Index name; for example, Phthalocyanine Blue is Pigment Blue 15. The Color Index is compiled by the Society of Dyers and Colorists and is an internationally recognized designation.

atoms responsible for the color of the pigment are known as chromophores; secondary groups, which intensify color, are known as auxochromes.

OPACITY

Light rays passing from one transparent medium to another are bent or refracted at varying angles. This property is quoted as the refractive index relative to air. The opacity of a color will be greater the higher the refractive index, i.e., the greater the difference between the indices of the pigment and the medium. Conversely, the transparency of a color is increased the smaller the difference between the refractive indices. An example is chalk, which has a refractive index of 1.57. Chalk in oil gives a whitish gray transparent coating because the oil has a refractive index of 1.48. Water has a much lower refractive index at 1.33 and, since the difference between the refractive indices is that much greater than for oil, chalk in a glue solution is considerably more opaque, with good hiding power – as used in gesso, for instance (see p.65).

LIGHTFASTNESS

The lightfastness, or permanence, of a pigment is its resistance to change on exposure to light (especially ultra-violet light). This depends on the chemical nature of the pigment, its concentration, and the medium in which it is employed. In watercolor, for instance, the concentration of pigment is less than in oil, so the paint film is generally thinner. In addition, the water-based medium itself offers less protection to the pigment than an oil medium. Pigments in watercolor are therefore less permanent than in oil, so it is more important to protect a watercolor from exposure to direct light.

Many pigments which are extremely lightfast in full strength lose lightfastness when they are reduced in tints with white.

Lightfastness standards
Artists' color manufacturers usually give an arbitrary rating to their colors, but there may be little relationship between the ratings of different manufacturers. Sometimes the classification may be related to a standard such as British Standard 1006, also known as the Blue Wool scale, in which eight numbered patterns of dyed cloth fade in an approximately geometric order. Each standard takes twice as long to fade as the one below it, so a pigment classified as 8 would be 128 times as fast as one rated 1. This remains, for the moment, the most commonly used standard and usually refers to pigments bound in an air-drying alkyd medium (see p.36).

Recently an ASTM D4302 (American Standard Test Method) has been established for the accelerated testing of artists' colors relating to twenty years of gallery exposure. This test represents the most absolute classification in use for artists' materials.

·Inorganic pigments·

Inorganic pigments are made up of chemical elements other than carbon, although simple carbon compounds – such as carbonates – are often regarded as inorganic. There are three types of inorganic pigment: earth, mineral and synthetic.

EARTH PIGMENTS

These include the natural products of the weathering of iron and manganese ores and feldspartic rock (which contains aluminum and silicon).

Ochres

These are aluminum silicate clays tinted with ferric hydroxides. French ochres are cleaner in tone and less transparent than the Italian "siennas". Heating turns the ferric hydroxide into iron oxides, giving red to reddish brown pigments. Red ochres such as Caput Mortuum and Venetian Red can also be formed by natural dehydration.

Umbers

These are also aluminum silicate clays, containing 45–55 per cent iron oxide and 8–16 per cent manganese oxide. The best quality comes from Cyprus and is a warm reddish brown color. North Italian and German umbers are lighter in tone. Roasting turns the raw earth a reddish brown to give Burnt Umber.

Other earth colors

Terre Verte comprises plate-like silicates containing iron oxide. The burnt variety is a red brown color. Vandyke Brown is a brown earth of variable composition, so is not reliably stable. It is partly organic.

MINERAL PIGMENTS

Several pigments important to early painters occurred naturally as minerals.

Cinnabar (vermilion)

This bright orange-red, was known in China in prehistoric times and is now synthesized from mercury and sulfur.

Lapis lazuli (ultramarine)

This natural blue was first used as a pigment in the sixth century. Artificial ultramarine was first prepared in France in the early nineteenth century.

White minerals

China clay, chalk, gypsum and barytes are transparent in oils but they are important pigments in grounds and for gesso.

SYNTHETIC INORGANIC PIGMENTS

These inorganic pigments do not occur naturally, but are manufactured.

Whites

White Lead (basic lead carbonate) was first manufactured in the fourth century B.C. Zinc White (zinc oxide) was introduced in 1834 and Titanium White (titanium dioxide) first became available in 1918.

Yellows and reds

Naples Yellow (lead antimoniate) came into vogue in the eighteenth century and has now largely been replaced. Specially treated grades of lead chromates (and molybdates) are now available which offer a relatively inexpensive opaque yellow; their main drawback is toxicity. Cadmium sulfide and selenide pigments have been available since 1910 and offer an alternative range of opaque yellow to red pigments which are relatively safe in normal use.

Blues

Prussian Blue, discovered accidentally in 1704, has now largely been replaced by the synthetic organic Phthalocyanine Blue. Other popular synthetic mineral pigments first introduced in the nineteenth century are Cobalt Blue and Cerulean Blue.

Greens

Cobalt Green is an oxide of cobalt mixed with zinc. Anhydrous chromium oxide and its hydrated form Viridian became available in 1850.

·Natural organic pigments·

Organic pigments are those made up of compounds of carbon. Those derived from natural sources may be either animal or vegetable in origin. Many occur as dyes, which are soluble, and these must be rendered insoluble for use as pigments. This is achieved in a process known as "laking", whereby the dye is precipitated on to an inert pigment or substrate.

A red pigment of vegetable origin which is still used today is Madder Lake, made from alizarin and purpurin dyes that are extracted from the root of the madder plant. Carmine, familiar in Europe since the mid sixteenth century is obtained from the cochineal insect. Gamboge, the gum resin from the *Garcinia* tree is still used as a watercolor pigment though it has poor lightfastness.

Obsolete natural organic pigments include the following:
■ Indian Yellow — manufactured from the urine of cows fed on mango leaves
■ Sepia — derived from the ink sac of the cuttlefish or squid
■ Dragon's Blood — a red resin from the fruit of the rattan palm
■ Mummy — a bituminous pigment once prepared from the bodily remains of Egyptian mummies, embalmed with asphaltum.

·Synthetic organic pigments·

This important group of pigments are complex compounds of carbon which do not occur naturally, but are manufactured in the laboratory.

Permanent synthetic organic pigments have been available since 1935 with the invention of Phthalocyanine Blue and Green. These are comparatively cheap to produce and both are very lightfast and extremely strong. More recent pigments of similar fastness are the Quinacridones, Isoindolinones, Dioxazine and many of the azo-type pigments.

With the exception of Alizarin and Indigo, these synthetic pigments are unrelated to the natural dyes. Early synthetic pigments produced from coal-tar had poor lightfastness, but these have been replaced by pigments from petroleum chemicals and many are extremely lightfast.

CHARACTERISTICS OF SYNTHETIC ORGANIC PIGMENTS

Organic pigments are of three types:
■ insoluble dyestuffs
■ lakes — pigments made by precipitating or fixing a soluble dye upon an inert pigment or substrate.
■ toners — metal salts of organic dyestuffs.

These are synthetically produced by various chemical reactions involving substances known as "intermediates" which react to form a colored dyestuff. Four types of reaction occur:
1 Intermediate A + Intermediate B = Insoluble dyestuff
2 Intermediate A + Intermediate B = Soluble dyestuff
3 Soluble dyestuff + precipitant + base = Lake
4 Soluble dyestuff + precipitant = Toner.

Most modern synthetic organic pigments are brighter, stronger and more flexible than traditional pigments. However, there are many commercially available products which, although similar in appearance and chemical structure, have very different performance characteristics. Pigments Yellow 12 and Yellow 13 for example, look almost identical; they are both diarylide pigments but, whereas the former has very poor lightfastness, the latter has medium-to-good lightfastness. If you rely on color manufacturers for your paints, you must insist on an exact chemical type of pigment, the lightfastness of which is marked on the product in accordance with a recognized standard.

Manufacturers buy their synthetic organic pigments from chemical companies whose main customers are industrial paint, plastics and printing ink manu-facturers. The pigment products are designed to satisfy their requirements and not those of the artists' colormen — who represent a tiny percentage of the market. Printing-ink manufacturers want brighter colors but are not concerned with lightfastness. The automotive industry, on the other hand, demands durable, lightfast pigments and they subject them to extremely vigorous testing procedures. Pigments which withstand such tests must be extremely weather- and lightfast and it is from this range that artists should select their pigments.

Permanence
Although chemists can be reasonably sure of the permanence of any synthetic organic pigment, only time can really confirm this. They have not, like the natural earth colors, existed for millions of years.

Wetting and dispersion

It is possible to make your own painting media using synthetic organic pigments, but this can prove difficult as the pigments in powder form are light and fluffy compared to the older, denser pigments. The fine powder creates a dust that literally "gets into everything", so an enclosed working area with a ventilation system is advisable. The pigments are chemicals and, although most are not toxic, care should be taken not to inhale pigment dust and to avoid contact with skin and eyes.

Grinding modern synthetic pigments with a binding medium in the traditional way is not an efficient way of dispersing them. Some manufacturers supply pigments in paste form as aqueous dispersions, or dispersed in vinyl or acrylic resins. These pre-dispersed forms can provide a more convenient basis for making certain painting media, since the binding mediums, extenders and reducing components only need to be stirred in. However, most pigment manufacturers will only sell small amounts of pigment at a high premium, so the process is not economic.

Color

Color strength depends to a large extent on the size of the pigment particles. Among the synthetic pigments, the individual particle size is generally between 0.05 and 0.5 microns although, sold as pigment powder in aggregated form, the size of the aggregate might be between 50 and 100 microns. Where opacity is required, a little color strength is sacrificed for a larger particle and, where transparency is required, a very small particle size is obtained.

If the color strength peaked at the same particle size as for lightfastness, it would be relatively simple to make a permanently bright pigment, but this is generally not the case and manufacturers have to establish a compromise between color strength and lightfastness. High-value lightfast pigments which are ground too small can have their lightfast properties destroyed completely.

Pigment purity

Manufacturers use a number of techniques to control particle size apart from simple grinding and milling operations. For instance, they sometimes add dyestuff to stop crystals growing or they heat the pigments in order to sharpen and strengthen the crystals and to enhance light-reflecting qualities.

The high-quality pigments are generally sold as pure pigments but others are sold with resins, dyestuffs or other additives adhering to them, and you may not know precisely what you are getting, especially if you buy a lower-grade product.

TESTING COLOR

The "purity" of color of a pigment can be established by a spectrophotometer which measures the amount of light absorbed by the pigment from within the visible spectrum and records the results on a graph called a chromaticity chart. This can be done by transmitting white light through a thin layer of the pigment and measuring what comes through the other side – i.e., white light minus the color absorbed. Alternatively, the light reflected off the surface of a sample of the pigment can be measured.

A very "pure" color has an absorption band that is very sharp or narrow at a particular wavelength. The higher the peak, the brighter the color will be. If the curve is broad, it means that the pigment is absorbing wavelengths from either side, and that the color is "dirtied" or at least less pure.

TYPES OF SYNTHETIC ORGANIC PIGMENT

There are, broadly speaking, two main classes of synthetic organic pigment – classical and non-classical. The pigments used in artists' colors come from both classes.

Classical pigments

Classical pigments are those for which the basic chemical structures have been known for many years, are produced in bulk relatively cheaply and used in areas which do not demand great light- and weatherfastness (e.g. printing inks, decorative paints). Examples are the simple mono- and dis-azo pigments and the copper phthalocyanines, though the latter are also used in much more demanding applications.

The azos

The common characteristic of the classical azo pigments is that they all contain at least one "azo" group, in which two nitrogen atoms are linked ($-N{=}N-$) to join two separate chemical entities – an aromatic amine and a coupling component. Mono-azo pigment molecules contain one azo group and dis-azos contain two.

The chemical reactions which occur in the manufacturing process tend to produce amorphous pigments which need some form of "after-treatment" to make them crystalline, so they reflect and refract light more efficiently, appearing brighter and stronger. This after-treatment usually only involves heating the aqueous pigment slurry, but additives may also be incorporated at this stage (see pp. 44–5). Common use is made of resin additives, particularly those resins derived from pine rosin. This helps the pigment to disperse in the ink or paint system and enhances optical effects such as gloss, transparency and hue.

Azo pigments are usually forms of yellow, orange or red.

The actual color obtained depends on:
◼ the structure of the aromatic amine
◼ the structure of the coupling component
◼ the type of crystal obtained
Common mono-azo pigments are Pigment Yellow 1, Pigment Orange 5 (see pp.18–31) and Pigment Red 2.

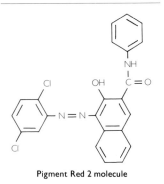

Pigment Red 2 molecule

The major use of Pigment Red 2 is for the magenta shade in three-color printing (see p.292). Here, a metal (calcium) is added to fix, or "lake" the acidic groups in the amine and coupling component, producing an insoluble pigment. Without the addition of the metal, the product would be a soluble dyestuff and would "bleed" in the ink or paint.
Increased color strength in yellows can be obtained from dis-azos, in which the molecular weight of a mono-azo yellow pigment is effectively doubled. Commonly used examples are Pigment Yellows 12, 13 and 14. These are produced in large tonnages for the printing ink industry.

The phthalocyanines
Blue and green pigments have been dominated by copper phthalocyanines since their accidental discovery in Scotland in 1928. Copper phthalocyanine is a "classical" pigment in that it is produced from cheap, readily available raw materials, but its properties are such that it could

also be classified with the expensive "non-classical" pigments. Thus, not only can it be used in cheap printing inks and paints, but also in areas demanding high heat stability and high light- and weatherfastness. These excellent properties are due to the very stable nature of the phthalocyanine crystal, in which the individual molecules are packed together closely.
The chemical structure of synthetic copper phthalocyanine is based on a ring system (called a porphin) which has parallels in nature – for example, chlorophyll, the light-absorbing green pigment in plants (which contains magnesium rather than copper), and haemoglobin, the red chromoprotein of blood (in which the metal is iron).

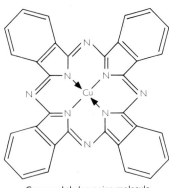

Copper phthalocyanine molecule

Various forms of copper phthalocyanine exist, the commonest being the reddish blue α and the greenish blue β forms, used extensively by artists as a very strong Prussian Blue. These can be interchanged or mixed to give the desired color shade by a variety of chemical techniques such as solvent treatment, grinding with added salts or dissolving in strong acid and reprecipitating ("acid pasting"). Although of the same chemical constitution, the α form is less stable than the β form (to which it tends to revert in organic solvents) but can be stabilized by incorporating

special additives.
Green pigments are obtained from copper phthalocyanine by reacting with chlorine and/or bromine. The brightest green (PG7) is obtained when virtually all the outer ring hydrogen atoms of copper phthalocyanine have been replaced by chlorine. This green is more intense and clearer coloristically than the traditional Viridian. The yellowest green (PG 36) is produced when a mixture of chlorine and bromine is used.

Non-classical pigments
Non-classical pigments are those whose chemical structures, whilst known, are more varying, complex, and difficult to obtain, are manufactured in small quantities and are used in areas demanding a high performance level of, for example, thermal stability (e.g. in plastics) and light/weather-fastness (e.g. in automotive paints).
Since the 1950s, considerable research and development has gone into producing new chromophores as pigment. Some have been developed from an already known chemical structure, while others have emanated from entirely new chemical entities. All are characterized by their very good applicational properties and their relative expense to manufacture compared to the classical pigments. All of them need "conditioning" before use (e.g. grinding, solvent treatment or heating under pressure). The non-classical pigments are divided into groups according to their chemical structure.

New azo pigments
The properties of the azo pigments (see above) have been improved in two ways:
◼ by doubling the molecular weight to give the "azo condensation pigments" (e.g. Pigment Red 166), which have improved bleed properties and lightfastness.
◼ by incorporating suitable

amide groups (—CO—NH—), allowing increased hydrogen bonding, to give the benzimidazolone pigments (e.g. Pigment Yellow 156) which have greater stability and insolubility.

Azomethine metal complexes

These highly durable pigments, used mainly in metallic car paints, are based on the azomethine group (—CH=N—) rather than the azo (—N=N—) group (see above).

Quinacridones

These red to violet pigments (e.g. Pigment Violet 19) are commonly used in artists' paints and have outstanding lightfastness. Their structure is polycyclic, each molecule consisting of a number of six-membered rings joined in a straight line. As with the phthalocyanines, the quinacridones exist in several different forms; the properties of commercial products depending on the form of after-treatment given to the crude product.

Anthraquinones

The main use of anthraquinones is in vat dyestuffs for the coloration of textile fibers, but several are used as pigments for high-grade paint and plastic applications. The anthraquinone molecule is usually doubled up to increase the molecular weight and reduce solubility. Examples include Pigment Red 177 and Pigment Yellow 23. Various other ways of connecting two anthraquinone molecules give indanthrones (blue), flavanthrones (yellow), pyranthrones (orange) and anthanthrones (red). All are expensive, difficult to manufacture and only used where the particular shade obtained cannot be produced by other means.

Thioindigo

Indigo has been used as a deep blue coloring agent for fabrics for thousands of years. Substitution of the nitrogen atoms in the indigo molecule with sulfur gives red to violet thioindigo pigments. The use of these in high-grade paints is decreasing, due to environmental problems associated with sulfur during manufacture. Pigment Red 88 is a thioindigo.

Perylenes

These are high-grade polycyclic red pigments which offer high weatherfastness and are used in automotive paints. The pigments are based on the structure shown here, where X may be oxygen, as in Pigment Red 224, or nitrogen, as in Pigment Red 179 and Pigment Red 190.

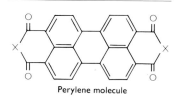

Perylene molecule

Isoindolines

Many new pigments, generally yellow, have recently been introduced based on the isoindoline system.

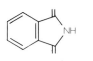

Isoindoline molecule

Examples include the tetrachloroisoindolinones, such as Pigment Yellow 110. These have outstanding light- and heatfastness properties, making them suitable for use in high-temperature plastic formulations (e.g. for colored window frames) and fibers, as well as paints.

Dioxazines

This is another polycyclic class of pigments, useful in most applicational areas including artists' paints where durability is necessary. The major commercial product is Pigment Violet 23.

Dioxopyrrolopyrroles

New high-quality pigments based on a novel chemical structure occur only rarely nowadays. One such recently discovered group is the red pigments based on a surprisingly simple structure, 1,4-dioxopyrrolo (3,4-pyrrole) (D.P.P.).

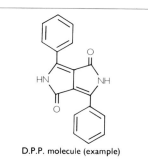

D.P.P. molecule (example)

These pigments offer fantastic heat stability, high coloring strength and hiding power and excellent light- and weatherfastness. They promise to dominate the high-quality red pigments in the same way that the copper phthalocyanines have dominated the blues.

Conclusion

In recent years, the range of bright, permanent colors has been greatly enhanced.

For stable, lightfast blue and green pigments, copper phthalocyanine and its derivatives are unsurpassed and, due to the size of manufacturing operations, their cheapness is unlikely to be matched by any other pigment. In the yellow to red pigment area, no such monopoly exists and research constantly uncovers new structures which offer slight improvements over existing ones. The simple azo pigments have been supplemented with more durable azo condensation pigments (from Ciba-Geigy) and benzimidazolone azo pigments (from Hoechst). The variety of polycyclic, high-quality pigments (from Ciba-Geigy) offering new horizons in gloss, brightness, strength, thermal stability and lightfastness.

·Pigment charts·

The following pages contain details of reliable pigments that are generally available to the artist in various forms. I have excluded pigments that are very highly poisonous or that show very poor lightfastness, as well as any of historical interest which are now not generally used. Instead, I have listed many synthetic organic pigments, since

the pigment industry is now producing more permanent and reliable colors which the artists' colormen can use with confidence. As most dependable artists' paint manufacturers now put the Color Index name and number on their products, I have included these in the pigment information, with a description of each color.

PERMANENCE

Some less lightfast synthetic organic pigments are found in students' color ranges and similar areas where permanence may not be important. These may have other qualities which may make them worth using but, if you are concerned about permanence you should

YELLOWS

PIGMENT	ALTERNATIVE NAMES	CHEMICAL TYPE	CHEMICAL COMPOSITION/ FORMULA	COLOR INDEX NAME	COLOR DESCRIPTION
Arylide Yellow G	Hansa Yellow	Azo	H_3C—⬡—$N=N-C.CO.HN$—⬡ with NO_2, CH_3, $C-OH$	Pigment Yellow 1	Middle shade bright yellow
Arylide Yellow 10G	Hansa Yellow	Azo	H_3C—⬡—$N=N-C-CO.NH$—⬡ with NO_2, CH_3, $C-OH$	Pigment Yellow 3	Bright greenish yellow
Barium Chromate	Lemon Yellow, Barium Yellow	Inorganic	Barium chromate $BaCrO_4$	Pigment Yellow 31	Pale dull greenish yellow
Chrome Yellow, Chrome Lemon	Lead Chrome	Inorganic	Lead chromate $PbCrO_4$ Lead sulfochromate $PbCrO_4.xPbSO_4$	Pigment Yellow 34	Greenish yellow to orange
Zinc Yellow	Zinc chromate	Inorganic	Zinc chromate $4ZnO.K_2O.4CrO_3.3H_2O$	Pigment Yellow 36	Bright greenish yellow

YELLOWS

avoid using the following:
Arylide Yellow G (PY 1)
(borderline)
Benzidine Yellow (PY 13)
Dinitraniline Orange (PO 5)
Tartrazine Yellow (PY 100)
Benzidene Orange (PO 13)
Lithol Red (PR 49)
Lithol Rubine (PR 57)
Magenta Lake (PV 1)
Basic Violet I (PV 3)
Basic Violet II (PV 2)
Basic Violet IV (PV 4)
Pigment Green B (PG 8)

TOXICITY RATINGS

The classifications used in the charts are based on those intended for the guidance of artists' color manufacturers, where large quantities of toxic chemicals may often be involved. The risk for an artist using small amounts of color is therefore comparatively small.

Class A
Non hazardous.

Class B
Relatively harmless – casual contact represents a negligible hazard.

Class C
Very low toxic hazard – some precaution necessary when handling.

Class D
Defined physiological hazard – appropriate precautions necessary.

PERMANENCE	OIL ABSORPTION	OPACITY	TINTING STRENGTH	TOXICITY	APPLICATIONS	ORIGIN/ COMMENT
BSS1006 7 ASTM II	40	Semi-transparent	Good	B	Oil color, watercolor, acrylic May bleed in plastics used in solvents, lacquers; stable to 150°C	1909: one of the first azo pigments to be accepted as an artists' pigment. PY 1 is gradually being replaced by PY 73, which is similar in hue but of better lightfastness. PY 1:1 is of a redder shade and also found in artists' colors.
BSS1006 7 ASTM II	32	Semi-transparent	Good	B	Oil color, watercolor. acrylic May bleed in plastic, lacquer solvents; stable to 150°C.	1911: one of the first azo pigments to be accepted as an artist's pigment.
BSS1006 8	10	Opaque	Very weak	D*	Oil color, watercolor	1809: precipitated from barium chloride and potassium chromate. Fairly unique color, Titanium Yellow now becoming a substitute although many manufacturers call PY 10 Lemon Yellow. These colors do not resemble PY31 in hue or opacity. *Soluble chromate, ingestion and skin contact cause barium poisoning.
BSS1006 6–8	15–20	Opaque	Good	D*	Oil color, watercolor Chromes are the only cheap opaque yellows available to the artist.	Precipitated from solutions of sodium or potassium dichromate and lead salts. The color depends on the lead salts used. Although of reasonable lightfastness, lead chromes tend to darken on exposure to industrial atmospheres. Modern pigments are often treated to reduce reaction with sulfur dioxide. Not as popular as in the past. *Chromates can cause lead poisoning and skin cancer, although lead chromates are not as soluble as other chromate pigments. Pigments are available with low soluble lead content in the deeper shades.
BSS1006 8	20	Semi-transparent	Weak	D*	Oil colors, sometimes in combination with blues to form Permanent Greens (so-called).	1809 (not commercially produced until 1847): precipitated from zinc sulfate solution by potassium dichromate. Of dubious color stability. Used commercially for anti-corrosive primers. *Soluble chromate, may cause skin cancer.

YELLOWS

PIGMENT	ALTERNATIVE NAMES	CHEMICAL TYPE	CHEMICAL COMPOSITION/ FORMULA	COLOR INDEX NAME	COLOR DESCRIPTION
Cadmium Yellow		Inorganic	Cadmium sulfide CdS	Pigment Yellow 37	Greenshade yellow to redshade yellow
Aureolin	Cobalt Yellow	Inorganic	Potassium cobaltinitrate $2K_3(Co(NO_2)_6).3H_2O$	Pigment Yellow 40	Middleshade yellow
Naples Yellow	Lead Antimoniate, Antimony Yellow	Inorganic	Lead antimoniate $Pb_3(SbO_4)_2$ $Pb(SbO_3)_2$	Pigment Yellow 41	Greenish yellow to reddish yellow
Nickel Titanate	Titanium Yellow	Inorganic	Mixed oxide of antimony, nickel and titanium	Pigment Yellow 53	Greenish yellow
Arylide Yellow GX	Hansa Yellow GX	Azo		Pigment Yellow 73	Midshade yellow
Diarylide Yellow		Disazo		Pigment Yellow 83	Reddish yellow
Isoindolinone Yellow	Tetrachloro-isoindolinone			Pigment Yellow 109/110	Greenish yellow, reddish yellow
Flavanthrone Yellow	Anthraquinone			Pigment Yellow 112 or PY 24	Reddish yellow
(no common name)	Chromophytal Yellow 8GN (Ciba-Geigy)	Azo conden-sation	(not available)	Pigment Yellow 128	Bright transparent yellow

YELLOWS

PERMANENCE	OIL ABSORPTION	OPACITY	TINTING STRENGTH	TOXICITY	APPLICATIONS	ORIGIN/COMMENT
BSS1006 7 ASTM I	17–21	Opaque	Good	B/C*	Oil color, watercolor, acrylic Under damp conditions, chemical fading can occur due to oxidation of sulfate. Acid soluble; stable in most organic solvents.	Made by roasting cadmium oxide or carbonate with sulfur, or by precipitation from solutions of cadmium salts. Greenish yellow shades may be cadmium zinc sulfide PY 35. Often used coprecipitated with barium sulfate as Cadmium Lithopone PY 37:1. *Soluble cadmium levels controlled to below 1000 ppm, not considered toxic under normal usage but may be restricted in certain areas, e.g. toys.
BSS1006 6 ASTM II		Transparent	Weak	C*	Oil color, watercolor Not heat stable, decomposed by acid and alkali.	1848: made by reacting acidified cobaltous nitrate with potassium nitrate. *Soluble cobalt may have chronic toxic effects.
BSS1006 7–8 ASTM I	10–15	Opaque	Weak	D*	Oil color, fresco, ceramics, glass Stable in organic solvents; decomposed by acids.	High temperature calcination of oxides of lead and antimony or reactions of metal salts. Similar pigment containing also zinc and bismuth oxides used in Babylon c.600B.C. Naples Yellow is often a mixture of pigments based on White Lead or titanium dioxide. *Lead and antimony poisoning.
BSS1006 8 ASTM I	15	Opaque	Weak	B	Oil color, acrylic Stable to 950°C.	Made by calcining antimony, nickel and titanium oxides at high temperatures. Substitute for the less reliable Barium Chromate (Lemon Yellow).
BSS1006 7 ASTM I	35–50	Semi-transparent	Good	B	Oil color, watercolor, acrylic Not suitable in lacquer solvents, xylene.	Recently introduced as a more lightfast pigment with similar hue to Arylide Yellow G, it is only just being introduced into artists' ranges.
BS1006 7 ASTM I	57	Transparent	Good	B	Oil color, watercolor Stable to 200°C; stable to most solvents.	
BSS1006 7–8 ASTM I	31–42	Semi-transparent	Good	B	Oil color, alkyd	A permanent color, but not very often used because of its high cost and rather chalky appearance. *PY109 R= PY110 R=
BSS1006 6* ASTM I	35	Transparent	Good	B	Oil color, plastics Heat stable to 260°C; insoluble in most organic solvents.	1901: originally known as Vat Yellow 1. Although one of the earliest of the vat dyestuffs offering greater lightfastness in an organic yellow, it has not become a popular artists' pigment. *Darkens in full strength; 7–8 in very pale tints.
BSS1006 7–8	41	Transparent	Average	A*	Oil color, acrylic (no known current availability) Stable to 180°C; good solvent resistance.	Possible permanent alternative to Aureolin, Indian Yellow. *No known toxic effects.

ORANGES

PIGMENT	ALTERNATIVE NAMES	CHEMICAL TYPE	CHEMICAL COMPOSITION/ FORMULA	COLOR INDEX NAME	COLOR DESCRIPTION
Perinone Orange	Anthraquinonoid Orange	Organic		Pigment Orange 43	Orange
(no common name)	Irgazin Orange 3GL (Ciba-Geigy)	Isoindolinone	(not available)	Pigment Orange 66	Reddish orange
Quinacridone Red	Permanent Rose	Organic		Pigment Violet 19 (γ-form)	Bluish Red
Toluidine Red	Scarlet Lake (bluer shades), Bright Red	Organic		Pigment Red 3	Midshade red
Permanent Crimson	Naphthol AS-TR*, Naphthol Crimson, Red F4RH	Organic		Pigment Red 7	Blue-red
Rose Madder (genuine)	Madder Lake*, Pink Madder	Natural Lake		Natural Red 9	Pale pink-crimson
Alizarin Crimson	Madder Lake	Organic Lake	Metal complex of alizarin; color depends on metal salts present: aluminum = red calcium = bluish red iron = maroon See Rose Madder (above) for molecular composition.	Pigment Red 83	Blue-red
Vermilion	Cinnabar	Inorganic	Mercuric sulfide HgS	Pigment Red 106	Orange red – blue red

REDS

PERMANENCE	OIL ABSORPTION	OPACITY	TINTING STRENGTH	TOXICITY	APPLICATIONS	ORIGIN/ COMMENT
BSS1006 7–8 ASTM I	48	Semi-opaque	Good	B	Stable to 200°C; stable to most solvents.	1924: Originally known as Vat Orange 7. Relatively new pigment in the artists' field, more often found in acrylic colors than traditional ranges.
BSS1006 7–8	37	Opaque	Average	A*	Oil color, acrylic (no known current user) stable to 200°C.	Possibly useful as a permanent mid orange, otherwise obtainable only by mixtures or use of cadmiums. * No known toxic effects.
BSS1006 7–8 ASTM I	60–80	Transparent	Good*	B	Oil color, watercolor, acrylic Very useful for mixing, giving bright oranges with yellows and violets with blues.	β-form known as Quinacridone Violet, often found in artists' colors as Permanent Magenta. * usually considerably reduced in commercial colors due to its high cost.
BSS1006 7–8*	40–45	Opaque	Good	B	Not suitable in solvent based colors Stable to 150°C (30 minutes).	Widely used in students' and school colors. In full strength, it is suitable for use in artists' color, but should not be used in weak tints. * Half-strength: 6.
BSS1006 7–8 ASTM I	40	Semi-transparent	Good	B	Poor solvent resistance One of the more stable of the azo pigments, commonly found in Acrylics as Permanent Crimson.	1921: * Napthol AS-TR description commonly used in USA only describes one of the coupling components. Check C.I. number of pigment; Napthol descriptions can be misleading as several different pigments of considerably varying lightfastness may be found under the same description (this applies to all Napthol designations).
BSS1006 6 ASTM II	80	Transparent	Weak	B	Oil color, watercolor	Alizarin lake prepared by extraction of dye from madder root with alum, followed by precipitation with alkali on to an aluminum hydroxide base. Alizarin Crimson is a similar lake based on synthetic dyestuff. Although much stronger, this has been shown to be less lightfast than the natural product at similar tint. * This term also found for synthetic alizarin.
BSS1006 7* ASTM II	76	Transparent	Fairly good**	B	Oil color glazes, watercolor Should not be used reduced with white.	1826: Alizarin extracted from Madder. 1888/9: Synthetic dyestuff (Perkin). Formerly considered as a standard for artists' colors, it is now considered insufficiently lightfast (ASTM test is in reduced form). * Half strength: 5. ** Usually not used in tint because of poor lightfastness.
BS1006 7–8* ASTM I	10–16	Opaque	Good	C**	Mainly oil color Has a tendency to blacken in watercolor.	Natural cinnabar known since prehistoric times. Manufactured from mercury and sulfur or by reaction of sulfides and mercury or its salts. * In pure form. ** Pure mercuric sulfide is insoluble and therefore not toxic, but soluble mercury compounds which are toxic are likely to be present, so handle appropriately.

PIGMENT	ALTERNATIVE NAMES	CHEMICAL TYPE	CHEMICAL COMPOSITION/ FORMULA	COLOR INDEX NAME	COLOR DESCRIPTION
Cadmium Red		Inorganic	Cadmium sulfoselenide CdS.xCdSe	Pigment Red 108	Orange red to deep red (becomes redder the more selenide is present).
Permanent Red FGR	Naphthol AS-D	Organic		Pigment Red 112	Bright red
(no common name)	Chromophthal Red BRN (Ciba-Geigy)	Azo condensation		Pigment Red 144	Midshade red
(no common name)	Chromophthal Scarlet R	Azo condensation	Su = substituent	Pigment Red 166	Yellowish red
Brominated Anthranthrone				Pigment Red 168	Bright yellowish red
Naphthol Carbamide	Naphthol Crimson	Organic		Pigment Red 160	Blue-red
Anthraquinonone Red	Anthraquinonoid			Pigment Red 177	Blue shade/red
Naphthol Red	Naphthol Red AS, ·B. O. N. Arylide	Organic		Pigment Red 188	Yellowish red
Perylene Red	Perylene			Pigment Red 190	
Quinacridone Red	Permanent Rose	Organic		Pigment Red 207/209	Yellower red than PV 19

PERMANENCE	OIL ABSORPTION	OPACITY	TINTING STRENGTH	TOXICITY	APPLICATIONS	ORIGIN/ COMMENT
BSS1006 7 ASTM I	17–21	Opaque	Good	B/C*	Oil color, acrylic, watercolor Acid soluble; stable to most organic solvents.	*Soluble Cadmium levels are usually controlled to below 1000ppm. This is not considered toxic under normal usage. Its use may be restricted.
BSS1006 7–8	54	Semi-transparent	Good	B	Oil color, acrylic	
BSS1006 7–8	55	Semi-transparent	Average	A*	Oil color, acrylic (no known current user) stable to 180°C.	*No known toxic effects.
BSS1006 7–8 ASTM I	85	Opaque	Average	A*	Acrylic Good chemical resistance; slightly soluble in alcohol, acetates, ketones, xylene, cellusolve.	*No known toxic effects.
BSS1066 7–7 ASTM II (oil), I (acrylic)	74	Semi-transparent	Good	B	Oil color, acrylic Soluble in very strong organic solvents and xylene; insoluble in acetone, alcohol and toluene; good heat resistance to 400°C.	1913: as Vat Orange 3. Prepared by bromination of anthranthone, or ring closure in sulfuric acid of [1,1'-binapthalene]-8,8'-dicarboxylic acid. More useful in acrylics than oils, due to its greater fastness.
BSS1006 6–7 ASTM II (oil), I (acrylic)	65	Semi-transparent	Good	B	Oil color, acrylic	Used commercially in printing inks, where lightfastness is not so critical.
BSS1006 7–8 ASTM	55	Transparent	Good	B	Oil color	Possible replacement for Alizarin Crimson.
BSS1006 7 ASTM I	70	Reasonably opaque	Good	B	Oil color, watercolor, acrylic	Useful in oils as it does not bleed through white and is resistant to fading with Flake White.
BSS1006 7–8 ASTM I	32	Transparent	Very good	B	Oil color, acrylic Stable to 450°C.	Other similar pigments:— PR 224: bluer shade but yellow undertone. PR 179: dull yellowish red (Perylene Vermilion).
BSS1006 8 ASTM I	60	Transparent	Average	B	Mainly found in acrylic, as it is a recent introduction.	Very recently introduced Quinacridone pigments, yet to become established in traditional media.

VIOLETS

PIGMENT	ALTERNATIVE NAMES	CHEMICAL TYPE	CHEMICAL COMPOSITION/ FORMULA	COLOR INDEX NAME	COLOR DESCRIPTION
Cobalt Violet		Inorganic	$CO_3(PO_4)_2.8H_2O$ pink $CO_3(PO_4)_2.4H_2O$ deep violet $CO_3(PO_4)_2$ violet	Pigment Violet 14	Red to blue violet
Ultramarine Violet	Ultramarine Pink	Inorganic	Polysulfide of sodium alumino-silicate (complex structure)	Pigment Violet 15	Pink or violet
Manganese Violet	Permanent Mauve	Inorganic	$Mn''' NH_4P_2O_7$ Manganese ammonium pyrophosphate	Pigment Violet 16	Violet
Quinacridone Magenta	Quinacridone Violet, Permanent Magenta	Organic		Pigment Violet 19 (β-form).	Transparent red-violet
Dioxazine Violet	Dioxazine Purple, Carbazole Violet	Organic		Pigment Violet 23	Blue-violet
Phthalocyanine Blue	(often marketed under manu- facturer's brand name)	Organic		Pigment Blue 15	Bright greenish blue – reddish blue
Prussian Blue	Iron Blue, Milori Blue, Bronze Blue	Inorganic	$MFe''' [Fe'''(CN)_6] \times .H_2O.$ M = K, Na or NH_4 Alkali ferri ferrocyanide	Pigment Blue 27	Blue
Cobalt Blue	Kings Blue	Inorganic	$CoO.Al_2O_3.$ Blue $4CoO.3Al_2O_3.$ Green Cobaltous aluminate	Pigment Blue 28	Green blue – blue
Ultramarine Blue		Inorganic	Complex polysulfide of sodium alumino-silicate	Pigment Blue 29	Green blue – reddish blue
Manganese Blue		Inorganic	Mixed crystal: 11 per cent barium manganate $BaMnO_4$ 89 per cent barium sulfate $BaSO_4$	Pigment Blue 33	Bright greenish blue
Cerulean Blue		Inorganic	$CoO.SnO$ cobaltous stannate Commercial product usually 18 per cent CoO, 50 per cent SnO_2, 32 per cent $CaSO_4$	Pigment Blue 35	Greenish blue
Indanthrone Blue	Indanthrene Blue	Anthra- quinonoid		Pigment Blue 60	Violet blue

BLUES

PERMANENCE	OIL ABSORPTION	OPACITY	TINTING STRENGTH	TOXICITY	APPLICATIONS	ORIGIN/ COMMENT
BSS1006 7–8 ASTM I	10	Semi-opaque	Good	C*	Oil color, watercolor acrylic, ceramics	*Cobalt can have chronic toxic effects if swallowed.
BSS1006 7–8	35	Semi-transparent	Relatively weak	B	Oil color, watercolor, acrylic Bleached by acidic mediums.	Prepared from Ultramarine Blue by heating with ammonium chloride or chlorine and hydrochloric acid.
ASTM I	25	Semi-transparent	Weak	C*	Oil color, watercolor Heat sensitive.	Often used as a substitute for Cobalt Violet in students' grades. *Manganese can have chronic toxic effects.
BSS1006 7–8 ASTM I	68	Transparent		B	Oil color, watercolor, acrylic Used as a tinting color for violets or for glazing.	(See Quinacridone Red.)
BSS1006 7–8 ASTM I	40–60	Transparent	Very good	B	Oil color, watercolor, acrylic	Condensation of 3-amino-9-ethylcarbazole with chloranil in trichlorobenzene. Due to its cost, it is mainly found in highest quality artists' colors but, due to its high fastness, rapidly becoming a standard violet pigment, replacing the less fast lake pigments.
BSS1006 7–8 ASTM I	40–50	Transparent	Very good	B	Oil color, acrylic Good resistance to solvents and chemicals in certain forms; stable to 150°C.	Tends to flocculate unless treated; most modern forms are resistant to flocculation.
BSS1006 7 ASTM I	35	Transparent	Good	C	Oil color, watercolor	Although still popular as a "traditional" color, it is largely being replaced by Phthalocyanine Blue.
BSS1006 7–8 ASTM I	20–30	Semi-transparent	Relatively weak	C	Oil color, watercolor, acrylic, ceramics	Various, e.g. High temperature calcination of mixture of oxides of cobalt and aluminum
BSS1006 8 ASTM I	25–40	Semi-transparent	Good	B	Oil color, watercolor, acrylic Stable to 300°C.	1822: Synthetic equivalent of lapis lazuli. Fusion of kaolin, soda ash, Glauber's salt, sulfur, carbon and kieselguhr.
BS1006 7 ASTM I	30	Transparent	Weak	C*	Oil color, watercolor, acrylic	Unique hue, but not widely used. *Ingestion may result in barium poisoning.
BSS1006 7 ASTM I	15–25	Semi-transparent	Weak	B	Oil color, watercolor, acrylic, ceramics	Often substituted, particularly in students' grades, by a mixture of Phthalocyanine Blue and Green with Titanium White.
BSS1006 7–8 ASTM I	37	Transparent	Very good	B	Oil color, acrylic	Possible substitute for Indigo (usually mixtures have replaced the natural color).

GREENS

PIGMENT	ALTERNATIVE NAMES	CHEMICAL TYPE	CHEMICAL COMPOSITION/ FORMULA	COLOR INDEX NAME	COLOR DESCRIPTION
Phthalocyanine Green		Organic	Chlorinated copper phthalocyanine	Pigment Green 7	Bright blue green
Oxide of Chromium	Chromium Oxide Green	Inorganic	Cr_2O_3 Chromium sesquioxide	Pigment Green 17	Dullish yellow green – green
Viridian	Hydrated Chromium Oxide, Guignets Green	Inorganic	$Cr_2O(OH)_4$ or mixture $Cr_4O_3(OH)_6$ and $Cr_4O(OH)_{10}$ with 0.5–10 per cent boric acid	Pigment Green 18	Green – bluish green
Cobalt Green		Inorganic	Oxides of cobalt and zinc $CoO.ZnO$	Pigment Green 19	Pale to dark yellowish green
Terre Verte	Green Earth	Inorganic (natural)	Alkali-aluminum-magnesium-ferrous silicate of varying composition	Pigment Green 23	Bluish grey green to olive
Nickel Azo Yellow	Green Gold	Organic nickel complex	[chemical structure: Cl—⬡—N=N—, HO, HO N]	Pigment Green 10	Greenish yellow
Light Green Oxide	Cobalt Titanate Green	Inorganic	Oxides of cobalt, titanium and other metals, e.g. nickel Co_2TiO_4	Pigment Green 50	Bright green
Raw Sienna, Burnt Sienna		Inorganic	$FeO(OH)$ containing alumino-silicates and magnesium dioxide (0.6–1.5 per cent).	Pigment Brown 7	Bright yellowish brown (Raw) Bright reddish brown (Burnt)
Yellow Ochre	Natural Hydrated Iron Oxide	Inorganic	$FeO(OH)nH_2O$	Pigment Yellow 43	Yellow – orange yellow
Light Red (yellower), Indian Red (bluer), Venetian Red	Red Iron Oxide, Red Ochre	Inorganic	Ferric oxide Fe_2O_3	Pigment Red 102	Yellow red – deep bluish red
Raw Umber, Burnt Umber		Inorganic	$FeO(OH)$ containing manganese dioxide	Pigment Brown 7	Greenish brown – reddish brown

EARTHS

PERMANENCE	OIL ABSORPTION	OPACITY	TINTING STRENGTH	TOXICITY	APPLICATIONS	ORIGIN/COMMENT
BSS1006 7–8 ASTM 1	35	Transparent	Very good	B	Oil color, watercolor, acrylic Special grades are often required for optimum color development in watercolor; stable to 150°C; stable to most chemicals.	1935: Prepared by chlorination of copper phthalocyanine under catalytic conditions. A yellow shade, PG 36, is obtained by replacing some of the chlorine with bromine.
BSS1006 8 ASTM 1	15	Opaque	Weak	B	Oil color, watercolor Stable to 900°C; insoluble in most solvents.	Prepared by reduction of potassium dichromate at high temperatures.
BSS1006 7 ASTM 1	90	Transparent	Relatively weak	B	Oil color, watercolor, "traditional" glazing color	Often used in mixtures with Cadmium Yellow to get Cadmium Green or Zinc Yellow to get Permanent Green. Phthalocyanine Green is often used as a substitute. Being much stronger, it is often found reduced as Viridian Hue in students' grades.
BSS1006 7–8 ASTM 1	20	Semi-transparent	Weak	C	Oil color, watercolor, acrylic	Difficult to match by mixing. A recently introduced variety found in acrylic colors also contains chromium oxide.
BSS1006 7–8 ASTM 1	20–30	Transparent	Very weak	B	Oil color, watercolor	Used as artists' color since Roman times. Becomes red on heating, making Burnt Green Earth.
BSS1006 7–8 ASTM 1	47	Semi-transparent	Very good	C	Oil color, acrylic Bleeds in organic solvents.	1905: Not a very popular color. Unique shade but of little artistic value.
BSS1006 8 ASTM 1	20	Opaque	Reasonable	B	Ceramics Stable above 1000°C; insoluble in most solvents.	Produced by high temperature calcination of a mixture of metal oxides. Recently introduced pigment, more common in acrylics than traditional ranges.
BSS1006 8 ASTM 1	60–80	Transparent	Variable	B	All media	Occurs in Northen Italy; similar but less transparent Siennas in USA. Burnt Sienna usually calcined Raw Sienna. More transparent varieties of Raw Sienna are often classed as PY 43.
BSS1006 8 ASTM 1	30–35*	Opaque	Good	B	All media Reddens above 100°C; soluble in acid.	Synthetic substitute PY 42 found in some colors, particularly acrylics. Synthetic pigment tends to be brighter, stronger and more opaque. * Naturals may be higher.
BSS1006 8 ASTM 1	15–30	Variable	Good	B	All media	Synthetic iron oxides (PR 101) are gradually replacing naturally occurring ones due to greater tinting strength and cleanness. When mixed with white, Light Red forms salmon pinks and Indian Red forms rose pinks.
BSS1006 8 ASTM 1	40–50	Transparent	Good	B	All media	Occurs in Italy, Cyprus. Redder shades produced by roasting in open hearth furnace.

BLACKS

PIGMENT	ALTERNATIVE NAMES	CHEMICAL TYPE	CHEMICAL COMPOSITION/ FORMULA	COLOR INDEX NAME	COLOR DESCRIPTION
Mars Black	Black Iron Oxide	Inorganic	$FeO.Fe_2O_3$	Pigment Black 11	Bluish gray – black
Ivory Black	Bone Black	Inorganic	10 per cent carbon, 78 per cent calcium phosphate, 8 per cent calcium carbonate	Pigment Black 9	Black with brownish undertone
Lamp Black	Vegetable Black Carbon Black	Inorganic	Almost pure carbon	Pigment Black 6, 7	Black with bluish under-tone (P BK 6), brownish undertone (P BK 7).
Zinc White		Inorganic	Zinc Oxide ZnO	Pigment White 4	Bluish white
Titanium White		Inorganic	Titanium Dioxide TiO 2 crystalline forms: Rutile and Anatese (bluer, tends to chalk due to UV absorption)	Pigment White 6	Bluish white
Flake White	Cremnitz White	Inorganic	Basic lead carbonate $PbCO_3.Pb(OH)_2$	Pigment White 1	Slightly yellowish white
Aluminum Hydrate	Alumina White	Inorganic	$3Al_2O_2.SO_3.9H_2O$ Aluminum hydroxide with varying amounts of basic aluminum sulfate (8–10 per cent sulfate).	Pigment White 24	White
Blanc Fixe	Barium sulfate, precipitated	Inorganic	$BaSO_4$	Pigment White 21	
China Clay	Kaolin	Inorganic	Natural hydrate aluminum silicate $AL_2O_3.2SiO_2$ containing impurity metals such as calcium, magnesium, iron.	Pigment White 19	White – off white
Calcium Carbonate	Chalk, Whiting, Paris White	Inorganic (natural and synthetic).	$CaCO_3$	Pigment White 18	White or off white
Lithopone		Inorganic	Coprecipitate of barium sulfate and zinc sulfate $ZnS.BaSO_4$	Pigment White 5	

EXTENDERS • WHITES

PERMANENCE	OIL ABSORPTION	OPACITY	TINTING STRENGTH	TOXICITY	APPLICATIONS	ORIGIN/COMMENT
BSS1006 8 ASTM 1	15	Semi-opaque	Relatively weak	B	Oil color (not popular), acrylic Insoluble in organic solvents; stable to 150°C.	Oxidation of ferrous hydroxide followed by calcination. Common black for acrylics, the fine particle size of other blacks causing stability problems.
BSS1006 8 ASTM 1	50	Transparent*	Relatively weak	B	Oil color, watercolor	Carbonizing animal bones (originally ivory, hence the name). * Optically, all blacks are opaque by definition.
BSS1006 8 ASTM 1	80–100	Opaque	Good	B	All media Tends to retard drying in oil colors; insoluble in organic solvents.	Lamp Black is more commonly found than the purer and more intense Carbon Black (P BL 7). The latter tends to give glossy watercolor but is often used in extended products where its greater intensity does not produce a grey.
BSS1006 8 ASTM 1	20	Semi-opaque	Reasonable	B	Oil color, watercolor Unsuitable in acidic media.	1751 (commercially produced in 1850). Burning zinc at 300°C.
BSS1006 8 ASTM 1	18–22	Opaque	Highest tint resistant white	B	All media	Gradually replacing Flake White. Early pigment did have problems with film strength and was always used with zinc oxide. Modern pigments have been produced with greater film stability.
BSS1006 7 ASTM 1	10–15	Opaque	Good tint resistance	D*	Oil color Stable to 230°C.	Despite its toxicity, it is still the most popular oil color white due more to its reputation than its chemical properties. Modern Flake White does not react in the same way as the old stack process white. * Lead poisoning (accumulative).
	70	Transparent in oils	Weak	B	Commonly precipitated for lakes. Extender for oil colors, gives good flow characteristics.	Add soda ash or caustic alkali to aluminum sulfate or potassium, sodium or ammonium alum. Not to be confused with aluminum oxide which is more opaque.
	12–20	Transparent in oil		*	Commonly used extender for strong organic pigments. Often used in gouache to give opacity.	Sometimes used in primers to give tooth, being coarser than PW 21. * Soluble barium is usually low in precipitated product and is suitable for most applications except toys.
	26–30	Transparent in oil		B	Extender in oil color and watercolor to control consistency.	Occurs in Cornwall, Devon, France. Other forms, such as Bentonite, occur in USA and form gels with water-based media and find use as thickeners and stabilizers.
	Variable	Variable	Variable		Used as extender in water-based paints. Gessos and grounds.	Not usually found in artist's quality color. Magnesium carbonate and magnesium calcium carbonate also listed as PW 18. These are often used as extenders in oil colors, as they are less reactive than calcium carbonate.
	10–25	Opaque in watercolour	Weak		Watercolor, process whites	Often found as an extender in watercolors.

OILS

The natural oils used in oil painting are obtained from the seeds and nuts of certain plants. They are referred to as vegetable oils and classified as drying, semi-drying or non-drying oils, according to their ability to dry under normal conditions when applied in a thin film. Of these, only the first two are commonly used in painting.

The characteristic odors of plants are due in nearly every case to essential oils. These differ from fatty (vegetable) oils by evaporating rapidly without leaving any residue. For the artist, the most important of the essential oils is turpentine, which is extensively used in a number of ways and in particular as a diluent (see p.41) to reduce the consistency of oil paint and to facilitate its manipulation on the canvas.

·Vegetable oils·

These are the oils used for grinding paints and in painting mediums. The main ones are linseed oil, which is a drying oil; safflower, sunflower and poppy seed oils, which are all semi-drying. The latter are normally paler and have less tendency to yellow. Linseed oil is extracted from the ripe seeds of the flax plant *Linum usitatissimum*. Safflower oil comes from the safflower plant *Carthamus tinctorius* which is an annual herb native to the Himalayan foothills. Sunflower oil is extracted from the sunflower *Nechanthus annus* while poppy oil comes from the opium poppy *Papaver sonniferum*. Walnut or Nut oil, from the maturing kernels of the walnut tree *Juglans regia* was used extensively in the past, being particularly favored for its drying and non-yellowing properties. Light colors were nearly always ground in it. Nowadays, it has gone out of favor because, unless it is used fresh, it quickly goes rancid with a strong disagreeable smell.

The oils do not dry by evaporation, but form dry, solid films by absorbing oxygen from the air. The complex reactions which occur during the drying process change the chemical and physical properties of the oil and, once it has dried, the oil film cannot be returned to its original liquid state.

The drying oils serve four purposes. Firstly, they protect the pigment particles by binding them in an enveloping film; secondly, they comprise the medium in which oil colors can be applied; thirdly, they act as an adhesive, in that they attach the pigment to the ground and, fourthly, they contribute to the visual effect of the painting by bringing out the depth and tone of the color.

COMPOSITION OF VEGETABLE OILS

Vegetable oils have the same chemical characteristics as fats and belong to the chemical compounds known as esters. They are composed of triglycerides of fatty acids together with small percentages of natural impurities which are largely removed by refining.

Some acids commonly found in vegetable oils are:
- stearic acid
- oleic acid
- linoleic acid (the main component in semi-drying oils)
- linolenic acid

It is linolenic acid that imparts the greater drying properties of linseed oil but also the after-yellowing.

All these fatty acids contain 18 carbon atoms and are known as $C18$ fatty acids, but they differ in the way the carbons are bonded together. The drying properties of the oil depend on the number of carbon-carbon double bonds ($C = C$). Stearic acid contains no double bonds and is termed saturated; it is non-drying. Linolenic acid, on the other hand, contains three double bonds which accounts for the superior drying properties of linseed oil.

ACID VALUE (acid number)

As well as triglycerides, oils contain free fatty acids; the amount of these determines the acid value of the oil and is an important factor in making oil colour. The free fatty acid acts as a wetting agent and helps pigment dispersion, so oil of a high acid value is generally used for grinding paint (see *Appendix*, p.334), while that of a low acid value is used in painting mediums. An oil-refining process which uses alkalis reduces the acid value, so is detrimental to pigment dispersion. Alkali-refined oils require the addition of a wetting agent.

PROCESSING OF VEGETABLE OILS

Oil is extracted from the seed by pressure. Modern oils are usually hot-pressed with the aid of steam, but cold-pressed oils are also available and some claim these are superior.

The oil is then further processed to remove impurities. This can be done naturally by allowing impurities to settle, by washing, or by chemical means such as acid or alkali refining. Acid-refined oils are not normally used, however, as they tend to react with pigments such as Flake White and Zinc White.

The properties of oils can be modified by treating them in various other ways.
Raw linseed oil, for example:
▨ + alkali and Fuller's earth = alkali-refined linseed oil
▨ + acid and Fuller's earth = acid-refined linseed oil (both of these can be polymerized to give stand linseed oil)
▨ oxidized = blown linseed oil; + solvent = reduced linseed oil
▨ oxidized with a drier = boiled linseed oil; + diluent = reduced linseed oil.

TYPES OF VEGETABLE OIL

The classification of vegetable oils depends on the method of processing they undergo. There are three main types:

Polymerized oil (stand oil)
The viscosity of an oil can be increased by heating to a predetermined temperature, in the absence of air, until the required viscosity is reached. The oil undergoes a molecular change which polymerizes it. Such an oil is known as stand oil. Stand linseed oil is a particularly useful oil in painting mediums. When thinned with turpentine or mineral spirit, it imparts excellent flow and leveling properties to oil paint. These qualities cannot be achieved with a raw oil. Stand oil is slow-drying because polymerization has taken place without oxidation but, when dry, it yellows less and is more flexible than raw oil. Metallic soaps may be added to increase the drying rate of the oil; lead, manganese and cobalt are commonly used. Such driers accelerate the autoxidation process, but their addition must be carefully controlled as too much can produce wrinkling and cracking of the oil film.

Sun-bleached and sun-thickened oils
These oils have undergone polymerization with oxidation, so they dry faster than stand oils. Sun-bleached and sun-thickened oils have been used by artists for centuries. The method of producing them is to shake up the oil with an equal amount of water and to expose it to the sunlight in loosely covered flat trays. The oil and water are mixed thoroughly every day for a week and then left for some weeks until the required viscosity is. reached. The oil is then filtered and separated from the water when it is ready for use. The bleaching action of the sun is said to have only a temporary effect, the color of the oil deepening when it dries and hardens later. The sun merely bleaches out the fugitive plant coloring material and does not affect the yellowing which occurs with age.

Boiled oils and blown oils
The use of boiled oils has led to a considerable deterioration of the paintings executed in them and they should be avoided by artists. They are sometimes still found as drying oils but, nowadays, liquid driers are often added to the oil without heating.

Blown oils have air blown through them during heating. This oxidizes the oil to give a heavy product similar in appearance to stand oil but inferior in quality, tending to be considerably less flexible.

THE DRYING PROCESS OF THE OIL FILM

The drying process determines the best way to apply the oil color to enhance durability.

Once applied, the paint absorbs oxygen from the air and changes from the liquid state to a solid film. In this complex process, known as "autoxidative polymerization", molecules of oil become linked together to form a polymeric structure.

As well as absorbing oxygen, and hence increasing weight, the oil film releases volatile by-products which must be allowed to escape if the film is to dry properly. Thus, to ensure a sound structure to the painting, the artist must apply the "fat-over-lean" principle in which each superimposed layer of paint has slightly more oil (fat) in it than the layer beneath. Each layer must be allowed to dry before more paint is applied, and the painting must not be varnished too soon. This is discussed in detail in *Oil Paints* (see p.205).

The main drying stages in a film of linseed oil are:
▨ A small change in consistency.
▨ A marked change, from a liquid to a firm gel.
▨ A further small change in consistency as the gel hardens.

Other changes occur with aging, and these depend on the type of light to which the film is subjected:
▨ diffuse light – slow hardening, relatively little decomposition and some yellowing.
▨ ultraviolet light – rapid hardening and embrittlement, followed by severe deterioration.
▨ Sunshine – fairly rapid hardening with embrittlement and severe decomposition.
▨ darkness – slow softening and considerable yellowing.

When it has dried hard, the film is a cross-linked three-dimensional structure. If aged under normal conditions, the film continues to harden and becomes less flexible.

·Essential oils·

Many essential oils are mixtures containing volatile consituents with non-volatile matter carried over by distillation. They are colorless or yellow liquids when freshly prepared but often darken on exposure to air and light, producing resinous materials. It is for this reason that turpentine, for instance, should be kept in a dark or sleeved bottle and that, as it is used, the level in the bottle should be maintained by filling it with clean glass beads or something similar. This keeps the air content in the bottle to a minimum.

The essential oils are mainly used as diluents but some can be used to retard the drying of oil paints; as preservatives, to deter mould; and as odorants, to mask unpleasant smells in paint formulations.

COMPOSITION

The composition of essential oils is complex, their principal characteristics being mainly due to the presence of various hydrocarbons and alcohols. The precise composition of an oil can vary considerably according to source. For example, English lavender oil may contain 10 per cent esters, while the same plant in France may yield 35 per cent.

Essential oils are extracted in various ways, including simple expression and fermentation. Most of the commonly used oils are distilled by water or steam.

TYPES OF ESSENTIAL OIL

There are six main essential oils of interest to artists.

Turpentine oil
Turpentine oil is distilled from the oleoresinous exudation of various pine trees. The oleoresin is known as crude turpentine and the non-volatile residue is rosin or colophony (see page 37).

Common sources of turpentine oil are the yellow pine (*Pinus palustris*) in the USA, the Maritime Pine (*Pinus pinaster*) from France and Portugal and the Scotch Pine (*Pinus sylvestris*) from Russia. The best turpentine is obtained by aqueous distillation. The inferior steam-distilled product made from roots, logs or stumps is known as Wood Turpentine and has a pungent smell. The toxicity of turpentine varies with its constituents and hence its source; the main constituent is pinene. Redistillation, or "rectification" is often employed to remove any lingering resinous components.

Turpentine oil can be bought as "pure gum spirits of turpentine", "oil of turpentine", "rectified turpentine" or merely "distilled turpentine". It is used to thin oil color and as a solvent to make resin varnishes like dammar varnish. It is also used as an ingredient in a number of painting mediums and in many other ways in painting and in conservation.

Spike-lavender oil
Distilled from a particular variety of lavender, *lavandula spica*, spike-lavender oil is a complex mixture of linalol, cineole, d-pinene, d-camphene and camphor. It was used extensively in the past as a diluent (see p.41), though it is a less volatile solvent than turpentine and can take several days to evaporate. In the seventeenth century, it was recommended that a little spike-lavender oil, added to white and blue pigments ground in poppy oil, would prevent the colors fading. It has also been used in soft resin varnishes, as a solvent for wax and as an alternative diluent for artists who dislike the smell of turpentine or who get headaches from it.

A wax/oil-of-spike medium can be used with oil paints where a matt appearance is desirable. Some tempera recipes recommend the use of spike oil, as in the egg-yolk and linseed oil tempera medium described in the *Appendix* on p.335.

Clove oil
Distilled from the buds and stems of *Eugenia carophyllata*, clove oil has antiseptic properties and may be found as a preservative and odorant in water-based paints. It has also been used as a retardant to the drying of oil paints, enabling work to be carried over to the next day. However, some claim it can be harmful if used in this way, having a strong solvent effect on existing paint layers and causing blackening.

Lemon oil
Lemon oil is simply expressed from the fresh peel by squeezing. It is one of the most complex of the essential oils, containing, amongst other things, α-pinene, β-pinene, camphene and β-phellandrene. It is sometimes added as a reodorant in solvents as is orange oil.

Pine oil
Pine oil is a volatile oil obtained from the needles and young shoots of many coniferous plants. It contains several terpenes, d-pinere, dipentene and Sylvestrene.

It is used to delay the drying of oils and can be added to casein paints or gum tempera emulsions as a preservative and/or odorant.

Thyme oil
Obtained from the common thyme plant, *Thymus vulgaris*, thyme oil contains 20 per cent thymol which is used as a preservative in some water-colors and a disinfectant on backing card in framed drawings, to inhibit the growth of mould.

RESINS

Resins are obtained naturally from the secretions of certain living or, in the case of fossil resins, dead trees. They are used in the preparation of varnishes for finished paintings, and in oil painting mediums, although they tend to darken more than oil and are generally less durable. Synthetically produced resins are now also widely used.

Resins are hard, glassy, non-crystalline solids with an amorphous structure. They soften when heated, melting to a sticky fluid and burning with a smoky flame. They are insoluble in water but partially or completely soluble in organic solvents (see pp.41–2). In this respect, they should not be confused with the substances known as "gums" which are also exudations from plants but which are soluble in water (see p.40).

·Natural resins·

With the exception of shellac, natural resins are obtained by exposure to the atmosphere, by evaporation, oxidation or by the polymerization of oleoresins (see p.37). There are two main types of natural resins:

SOFT RESINS

Soft, or "recent", resins are obtained from living, rather than fossilized trees. These are also known as spirit-varnish resins since they are soluble in alcohol and hydrocarbons.

Damar

Damar is regarded as the best of the soft resins to use as a varnish, for which it is usually dissolved in turpentine (see *Terpene solvents*, p.42). However, it can discolor if impure, resulting in the "gallery tone" (golden, "antique" look) in paintings. Damar also becomes less soluble with age so strong solvents may be needed for its removal. See p.186 for details of how to make damar varnish.

Damar can also be used in oil painting mediums, where it accelerates the drying time of the paint, though not if dissolved in mineral spirit.

Mastic

Mastic resin is soluble in turpentine, alcohol and aromatic hydrocarbons, has good brushing properties and has been used as a varnish for finished paintings. However, it yellows strongly and darkens with aging.

Mastic is no longer used in oil painting mediums. The "megilp" substance, used with disastrous consequences by nineteenth-century artists in particular, was a mixture of linseed oil and mastic varnish.

Sandarac

Sandarac resin has similar properties to mastic but is harder. It has been used, dissolved in alcohol, as a retouching varnish but it is extremely brittle and becomes dark and red with age.

Shellac

Shellac is a resinous material secreted by a stick insect on to certain trees. The dried resin is often highly colored and may be bleached for some purposes.

Shellac is normally dissolved in alcohol and used for French polishing, metal lacquers, etc. It is not soluble in turpentine, a fact that has made it useful in the past as a sizing medium on walls.

It has also been used to reduce the absorbency of gesso panels, as a pastel fixative and an isolating layer in tempera painting. It may be rendered soluble in water by treating it with alkali and has been used in this way as a binder in drawing inks.

HARD RESINS

The hard, or "fossil", resins are often known as "copals" (though this can be misleading as soft copals, such as manilla, are found in spirit varnishes). They are the fossilized exudations of decomposed trees dug up from the ground. Such resins are almost insoluble in oils and organic solvents, and can only be rendered oil-soluble by heating or "running", when they combine with hot drying oils to form oil varnishes. These "run" copals became the basis for most general-purpose varnishes outside the art materials industry, but were unsuitable for artists' purposes because of their tendency to darken and crack with age. They are now very difficult to obtain, and have been replaced by alkyd resins which can also be used, to some extent, in the art materials industry.

·Synthetic resins·

Many of the natural resins are being replaced by synthetically produced alternatives.

Oil-soluble phenolic resins

These are usually based on a mixture of linseed and tung oil. Varnishes containing phenolics are rather yellow but useful where a heat-resistant finish is needed or for exterior use.

Oil-modified alkyd resins

Alkyd resins are insoluble in hydrocarbon solvents. As such, they are unsuitable as film formers and require the addition of an oil to convert them to oleoresinous media for surface coatings, hence the term "oil-modified alkyds". The oils used in the manufacturing process may be linseed or a semi-drying oil such as safflower or soya (see p.32). The latter form paler resins and are used for artists'

mediums. Those most likely to be encountered by the artist require the addition of driers (see p.44) and then form air-drying finishes.

Epoxy resins

Epoxy resins are very stable and generally used with other resins as surface coatings. They may also be found as components of stoving finishes, in collapsible tube enamels, cold enameling colors or adhesives.

Polyamide resins

The polyamides have extremely good adhesion and are used in collapsible tube coatings and as curing agents for epoxy resins. They are also incorporated into decorative finishes to give "non-drip" properties.

Unsaturated polyester resins

These were originally developed

for laminating applications and have only recently found use as surface-coating resins. Very thick films can be used for making three-dimensional "paintings".

Polyurethanes

More correctly called polyisocya-nates, these coatings are used in wood and metal finishes, rubber lacquer, and fabric proofing. The so-called polyurethane decorative paints are in fact urethane oils or urethane alkyds.

Nitrocellulose

Cellulose ethers are used as thickeners in water-based paints. Cellulose nitrate (nitrocellulose) is used as a binder and its properties are controlled by plasticizers and solvents.

Nitrocellulose can be explosive when dry and has to be moistened with water, denatured alcohol or butanol.

THERMOPLASTIC RESINS

Thermoplastic (linear polymer) resins are those that soften under heat and dissolve, and these include the acrylic polymers which provide the binding medium for artists' acrylic colors (see p.209).

Very soft resins may soften under the heat of handling and pick up dirt or, if the resins are too hard, they may create a brittle paint film. The resins are made from chemicals known as monomers – normally mobile liquids which are subjected to a chemical change known as polymerization. The hardness of the resin is controlled by the choice of chemical ingredients that are polymerized.

During polymerization, the properties of the substance are changed. Its softening tempera-ture is increased, it becomes less brittle and its tensile strength increases. Different polymeriz-ation techniques produce resins

with different properties.

Polyvinyl chloride (PVC)

This has poor heat/light stability and is brittle so it has to be plasticized. It is of little use to artists except as the main constituent of hot melt com-pounds such as "vinamold" which are used for mould-making.

Polyvinyl acetate (PVA)

This is the commonly used vehicle for PVA paints which represent the cheaper end of the polymer paint market (see p.209). The resin has far greater light stability than PVC, for instance, and is more flexible, though it generally requires the addition of plasticizers, which often have limited stability. The PVA film consequently has a tendency to embrittle with time and to be less permanent than the acrylic resins. PVA is commonly used as an adhesive medium in schools and colleges,

where it is also often mixed with powder paint to give a durable paint film.

Acrylic polymers

Acrylic esters can be produced with differing degrees of flexibility, e.g. polyethyl acrylate is very flexible, polymethyl methacrylate is harder. By producing mixed polymers known as copolymers, the properties can be adjusted without need for addition of plasticizers. They are therefore more stable than PVA.

Acrylic copolymers are the most useful to the artist and are used in both solution and dispersion form. It is in the dispersion form that polymer resins are most commonly encountered, when they are known as "polymer emulsions".

Solution polymers are often used by restorers and may also be found in varnishes as mineral spirit solutions of poly isobutyl methacrylate.

Polymer emulsions

These are particles of polymer suspended in water and they dry by evaporation. Acrylic emulsions tend to be alkaline, so they cannot be used with alkali-sensitive pigments. They have a low viscosity which is not dependent on molecular weight, as with solution polymers.

Polymer emulsions are probably the most stable of all artists' mediums because, once they are dry on the finished painting, no further chemical change takes place.

THE COMPLEXITY OF POLYMER EMULSION COLORS

Whereas it is relatively straight-forward to disperse pigment into an oil medium (see p.184), the complex composition of polymer emulsion colors has to be finely balanced to prevent the emulsion from breaking. Even the pigment particle size can have a destabilizing effect, and a number of other factors must also be considered:
■ Each polymer has a minimum film-formation temperature.
■ The equilibrium of dispersed particles must be maintained by using coalescing solvents; any disruption can cause the emulsion to "break" and its film-forming properties to be destroyed.
■ Freezing and thawing is a common problem, so an "anti-freeze" is added. It is also essential to add water-softening agents, preservatives and anti-foaming agents. In addition, polyacrylate or cellulose thickeners are necessary if a tube consistency color is required.

·Oleoresins·

Oleoresins – or "balsams", as they may also be known – are the thick liquid exudations from coniferous trees. They are a mixture of essential oils (see p. 34) and resin and are used either in their natural state in painting mediums or to obtain essential oils like turpentine. The resinous by-product of the distillation of turpentine is rosin or colophony, which has been used extensively in industrial surface coatings, but has not been recommended for use by artists in permanent painting materials as it turns dark and cracks in time. Recent advances in refining and in chemical or physical modification processes, however, have produced modified rosins and related resins which give far greater resistance to embrittlement and discoloration.

USES OF OLEORESINS

Oleoresins are said to impart lustrous flowing properties to oil paint. Venice and Strasbourg turpentine have in particular been used extensively in the past in oil painting mediums and egg tempera emulsions.

In my opinion, the addition of any natural resinous material to an oil paint film will undermine its structure and resilience and, if more than very small quantities are added to the painting medium, the resulting paint film will be soluble in the solvent used when varnishing – with possibly disastrous results. It is, however, safe to use alkyd resin-based mediums.

TYPES OF OLEORESINS

Oleoresins should not be confused with the term "oleo-resinous" which is used to describe varnishes and mediums made from cooked mixtures of hard resins and vegetable oils (i.e. a manufactured combination of oil and resin). There are four main types of oleoresin:

Venice turpentine

Obtained from the larch *Larix Europea* or *Larix decidua*, this is a viscous yellow liquid from which resin acids cannot be crystallized and in this respect it differs from common turpentine. It is soluble in alcohol, ether, acetone and turpentine but only partly soluble in petroleum hydro-carbons. When purified, it no longer shows its natural tendency to darken a painting and produce cracks, but is very cohesive mixed with a fixed oil or an oil of petroleum.

Strasbourg turpentine

From the white fir *Abies pectinata*, this is paler than Venice turpentine and very difficult to obtain. It is said to have protective qualities, locking up pigments, such as Verdigris, that are prone to decomposition. However, such qualities are not generally required with modern pigments.

Canada balsam

Said to resemble Strasbourg turpentine, Canada balsam is relatively pure and valuable for its transparency and its high refractive index (see p.12).

Copaiba balsam

Of variable composition and viscosity, copaiba balsam consists largely of free acid resins and so has a high acid value (see p.32). At one time, picture restorers used it for regenerating turbid or blanching oil paintings. Since it was found to be impossible to remove all traces of the copaiba (which displays excessive darkening and shrinkage) it now tends to be avoided, though it is still sometimes used with aqueous ammonia as a picture cleaner.

GLUES, STARCHES AND GUMS

In addition to the drying oils discussed on pp.32–3, there are various natural binding materials which are soluble in water. These fall into two groups: those of animal origin, such as glue, gelatine and casein (which are proteins) and those of vegetable origin, such as starch, dextrin and gums (which are carbohydrates).

The chemistry of all these materials is related to their colloidal behaviour. The term "colloid" is derived from a Greek word meaning glue and it is used to describe a dispersion of particles, of a size between those of a suspension and a solution, which is kept in equilibrium by electrical charges absorbed on to the surface. Without these electrical forces, the particles would settle like a normal suspension. These particles and their absorbed charges are known as "micelles". A colloidal suspension is known as a "sol"; and the jelly formed from solution is known as a "gel".

The water-soluble natural binding materials are widely used in the preparation of sizes, as vehicles for watercolor paints and in adhesives.

·Proteins·

This complex group of compounds make up an important part of animal matter. Proteins are polymers consisting of chains of amino acids. The main types that may be encountered by the artist are:

■ albumens, such as the egg albumin present in egg yolk, and globulins, which occur in egg white; both these form part of the egg tempera medium.

■ collagen – the bone or hide protein from which gelatine is extracted, and which is used for sizing painting supports.

■ isinglass, which is extracted from the swim bladders of fish and which has been used as a vehicle for watercolors.

■ mucoids and bovomucoid – more complex proteins found in egg white and used in egg tempera mediums.

■ phosphoroteins, such as those found in casein which is most commonly used as a binder in water-proof poster colors.

GLUE AND GELATINE

Glue is an organic colloidal substance of varying composition obtained by drying solutions made from boiling prepared animal matter, such as skin and bone, in water. Gelatine is a purer form of glue made from selected and cleaned animal matter.

There is no hard and fast line separating glue from gelatine. Glue is simply impure gelatine and any good-grade glue of a suitable strength and appearance could be classed as a gelatine. For most artists' purposes, a high gel strength of between 130 and 160 according to the Bloom strength test is required. This is the standard measurement of gel strength in which a cylinder of given dimensions is lowered on to a gel of given concentration and a measurement taken of the force required to penetrate a certain distance.

Gelatine is most commonly used in the preparation of glue size with which artists' supports are primed.

Preparing glue size

Glue size should be prepared using clean utensils as glues are susceptible to bacteria (see also p.64). The ratio of dry size to water may vary from around 35 gms per liter ($1\frac{1}{4}$oz per quart), giving a thin sizing for canvas, to 75 gms per liter ($2\frac{1}{2}$oz per quart) which makes a strong sizing for a panel.

The dry size is soaked until sufficiently softened. Ground glues absorb water more quickly than thick sheets of solid glue, which must be soaked overnight. When a fine jelly has formed, the glue is heated in a double boiler at a temperature not exceeding $65°C$. Only the quantity required should be made, as repeated heatings reduce the strength of the glue.

Adding alum increases the viscosity of the size. Some recipes recommend the addition of up to 10 per cent of alum to the dry weight of the size, but this is likely to make the size layer considerably more acidic.

The addition of formaldehyde (which may be used to harden the size) decreases the gel strength, particularly in lower concentrations and weaker glues.

Water-solubility
Glue and gelatine swell in water to form a complex colloidal gel or "sol". During the first stage of preparing a glue size, the dry gelatine is soaked in cold water overnight and absorbs water to give a "water dissolved in gelatine" system. It is, in effect, a solution of water in gelatine since the gelatine itself does not dissolve until it is heated, when it becomes a "gelatine dissolved in water" solution.

Application and cooling
While it is still fairly hot, the glue size can be simply brushed on to the support. Then, as the temperature drops, a solid film is formed. The cooling process causes the size to contract and the solvent (in this case water) separates from the gel, thereby increasing its strength.

CASEIN

Casein is not a single protein, but a complex mixture of several. It is manufactured from the natural curd of soured skim milk, its exact composition depending on the method used to isolate it. The untreated curd from skim or whole milk has been used for centuries in adhesive and binding materials, and its effectiveness is proven.

However, the modern commercial product is preferable nowadays as it is free of impurities and of known concentration.

The most common means of precipitating the micelles which yield casein is by the addition of hydrochloric or sulfuric acid to fresh skim milk. Casein is sold as a granular powder and can be used as an alternative to glue size, but is more commonly found as a binding material for waterproof poster colors.

Solubility
Dry casein is essentially a granulated jelly; it absorbs water and swells considerably but does not dissolve until alkalis are added to form a colloidal solution. The usual way of making casein miscible with water is to soak it overnight in a solution of ammonia.

Casein is insoluble in most organic solvents but soluble in alcohol containing hydrochloric acid or sodium hydroxide and in alcohol/water mixtures.

Casein adhesives
Solutions of casein in alkalis containing enough protein to give a suitable viscosity can be used as adhesives. By varying the proportion of casein to water or changing the ratio of alkali to casein, the viscosity can be varied. Casein "glues" of this type have very good strength but are not water-resistant. The alkali used may be sodium or ammonium hydroxide. See *Appendix*, p.336 for casein glue recipes and method.

Dry glues, in which a powder is mixed with water, can also be made. See *Appendix*, p.337 for dry casein glue recipes.

Casein binders
Pigments bound in casein have been used extensively as waterproof poster colors and in mural painting, but casein has now been largely replaced by synthetic resin binders.

"Modern" casein paints developed in different ways on each side of the Atlantic. Whereas in the U.S.A., the paints were generally casein-bound, in Europe, casein tended to be used as the emulsifying agent in oil-in-water emulsions. In casein paint systems, the pH of the solutions of casein has to be around 8 or 9 to form a stable liquid paint. Pigments for casein paints must obviously be alkali-resistant.

Drying oils are readily emulsified in casein paints. These emulsions give low porosity and have good exterior durability but show an unfortunate tendency to yellow rapidly. Resin varnishes or waxes have been suggested as an alternative to oils in casein emulsions.

Casein gesso
Casein can be used as the glue component in size and gesso ground (see pp.63-6). It can be applied cold and is more resistant to water than conventional glue size. However, it is said to be a less satisfactory surface to paint on and is more brittle than conventional gesso grounds.

·Carbohydrates·

The carbohydrates, or saccharides — a major component in all forms of plant life — are the other type of water-based natural binding materials. The main types of carbohydrates which may be encountered by the artist in paint formulations are:
▨ sugar (sucrose) – sometimes used as a plasticizer in watercolors.
▨ sorbitol – used as a plasticizer in some water-

colors; it is cheap alternative to glycerine, but does not have the same moisture-absorbing properties.
▨ sodium alginate – may be used as a thickener in some watercolors.
▨ starch – used to make adhesive pastes and as a binding material for watercolors.
▨ gums – used as thickeners, binders and stabilizers in watercolors, and as binders for soft pastels.

STARCH

Starch and dextrin, obtained by heating dry starch, are used by artists as pastes for adhesive purposes. In more soluble forms, they are used as binding materials for gouache paints and watercolors, where their low solubility in cold water makes them suited to the application of washes.

Starch is found in all plant cells, being synthesized from carbon dioxide and water during photosynthesis. It swells but is insoluble in cold water. If a starch suspension in cold water is heated, it forms a viscous solution which converts to a gel on cooling.

Pastes or gels made from starches which have been modified by oxidation are used for sizing paper and textiles.

The chemistry of a starch solution is complex (as with other colloidal material) and the method of preparation can affect its behavior in a paint. See *Appendix*, p.337 for how to prepare starch paste.

On aging, aqueous solutions of starch undergo a process called retrogradation, in which the starch becomes less soluble. The effect in a paint film is to reduce gloss and transparency and impart a chalky appearance. This can be reduced or prevented by dextrinization.

Dextrinization

This process involves heating the dry starch to 160–190°C, so it loses moisture, turns brown and becomes soluble in water. Acidification of the starch before heating enables the process to take place at a lower temperature and a better color is obtained. Nowadays a pure white product can be made.

Maize, potato and tapioca are most commonly used in the manufacture of dextrin. Tapioca starch has slightly greater strength than potato starch. The properties of dextrins depend on the source of the starch and the type of processing, so that only experimentation can give the desired properties for paint formulations. Two properties which are important to color manufacturers are:

▨ flow – dextrin shows approximately normal liquid flow characteristics, or "Newtonian flow", whereas less modified starch exhibits non-Newtonian flow characteristics, being altogether more viscous.

▨ solubility – dextrin disperses in water to a more or less transparent colloidal solution. The higher the solubility at room temperature, the more liquid the solution. Low-solution "white" dextrins give thin, transparent solutions at higher temperatures, but thicken as the temperature falls. A completely cold-water-soluble dextrin has good stability.

Additives may sometimes be used to control the behavior of the product. Borax is often added to increase the viscosity of a solution. Formaldehyde or formaldehyde donors may be added to give increased water resistance (though toxicological legislation is likely to restrict this application). Glycerol or sorbitol may be used as plasticizers.

Dextrin is a cheap alternative to gum arabic and, for those pigments which react adversely with the latter, it is the only viable binding medium. Dextrin may also be used in conjunction with gum arabic to control the properties of a color.

HISTORICAL USE OF STARCH

Starch was used by the ancient Egyptians in the manufacture of paper and papyrus, and traces of starch adhesives have been found on documents dating back to 3500 B.C., but it was not used as a size for textiles until the fourteenth century. "British Gum", a form of dextrin, appears to have been discovered by accident after a fire in a Dublin textile mill in 1831. Dextrin was first produced commercially in Germany during the mid-nineteenth century.

GUMS

Gums are amorphous substances obtained from trees or solvent extraction. They are used as the binding medium for both pastels and watercolors (see also pp.80 and 140).

Gum arabic

Gum arabic exudes from the stems of certain acacia trees. Being a natural product, there is invariably some variation in quality and only the best, pale gum should be used. This will dissolve almost completely in cold water.

Gum is a seasonal product and its properties vary according to when it is harvested. The early crop, harvested between December and February, is hard and difficult to break down. It must be stored for up to three months before it will be soluble. Late, or "soft" gum, harvested from March onwards, dissolves more easily and imparts better flow.

For watercolors, a 30–40 per cent solution is usually made. This should give good flow when mixed with pigment. With some pigments you may need to add a thickening agent or a gelled gum such as gum tragacanth.

Gum tragacanth

As well as a thickener/stabilizer in watercolors, gum tragacanth has traditionally been used to bind the enamel colors used in vitreous enameling and glass painting and as a binder for soft pastels. The gum is "dissolved" in distilled water to which precipitated chalk and pigment are added in varying proportions to form a mouldable paste (see *Appendix*, p.334).

SOLVENTS

A solvent is any liquid in which a solid can be dispersed to form a solution. Solubility depends on electrical properties and molecular size, small molecules being more readily soluble than large ones. Molecules are electrically neutral, because their positive and negative charges are balanced. If the arrangement of charges is symmetrical, the molecule is called "non-polar", if it is not symmetrical, it is "polar". In general, non-polar materials are soluble in non polar solvents and polar materials are soluble in polar solvents. Glucose, for example, is soluble in water; cellulose, which is made up of glucose units, is insoluble in water. However, if cellulose is made more polar by conversion to carboxymethyl cellulose, it becomes water-soluble.

For artists, solvents are important for their ability to render a solid substance, such as glue or resin, into a stable solution that enables the solid to be freely spread and manipulated on the surface of the support while the solvent subsequently evaporates without leaving a residue. More important, perhaps, is the use of solvents as thinners. These are used to decrease the viscosity of a paint or varnish and enable it to be spread thinly. A resin may be dissolved in one solvent and thinned with another.

In a paint formulation, it may be necessary to add more than one solvent to obtain the required properties of the paint. The correct combination is known as "solvent balance". This has to be determined by experimentation. In a solvent mixture, a solvent need not be compatible with the solute (or substance being dissolved) at all concentrations.

SOLVENT PROPERTIES

The usefulness of a solvent is determined by these six major properties:

Solvent power
This is the ability of the solvent to disperse the solute. Solvent power can be measured in various ways:
- The Kauri-Butanol value (or KB) – this is the amount of a kauri resin-in-butanol solution needed to turn a given quantity of the solvent being tested cloudy, or turbid.
- The Aniline-point – this is the temperature at which turbidity occurs in a mixture of the solvent and aniline, a colorless oily liquid.

Boiling point
This is the temperature at which the solvent evaporates. A pure liquid of single chemical composition has a characteristic boiling point. A mixture, such as mineral spirit, has a boiling range, as different constituents evaporate at different temperatures. This is normally known as the "distillation range" (which is stated as the initial boiling point, the distillation of given percentages, the dry point and the final end point).

DILUENTS
In order to adjust such things as flow or rate of evaporation, solutions of resins are often diluted with a liquid that is not a solvent for the resin. The liquid is then termed a diluent and its addition must be carefully controlled or the resin could be precipitated from solution.

Alternatively, thinners may be added to a resin solution to give it a required consistency. Such additions are normally solvents for the resin and will not cause it to be precipitated from solution.

Evaporation rate
Of particular interest to artists, this is a measure of the rate at which a volatile solvent leaves the paint or varnish film. It is especially important for a film that dries solely by solvent evaporation. Evaporation rates are comparative; butyl acetate is usually taken as a standard and given a figure of 100, so that xylene at 68 is slower evaporating and ethyl alcohol at 203 considerably faster.

Flash point/flammability
This is the temperature at which the vapor given off by the liquid will ignite if a source of ignition is present. This is mainly important for the safe handling of the solvent.

Toxicity
Volatile materials may readily enter the body by inhalation. They may also have toxic effects if in contact with the skin. Toxicity varies, but many

solvents have narcotic effects and should only be used with adequate ventilation. If necessary, organic solvent vapor respirators should be worn, particularly if spraying (see p.136). Barrier creams should be used also.

Using solvents safely
1 Open windows to ensure free movement of air.
2 Use an extractor fan to remove harmful fumes.
3 Apply barrier creams to protect your hands.
4 Wear a respirator to prevent the inhalation of toxic gases.

Odor
This may be characteristic of the solvent itself or it may be due to impurities. The odor of mineral spirit, for example, is due to the presence of aromatic hydro-carbons. So-called odorless solvents have these removed, but the solvent power is thereby reduced and they may not be as tolerant of resin addition.

WATER AS A SOLVENT
High levels of soluble salts present in untreated water can have very damaging effects on watercolors, inks and acrylics, so distilled water is used in their manufacture. This is not necessary when diluting water-colors or acrylics, however, although manufacturers do recommend it for diluting inks. Distilled water should be used in tempera emulsions.

TYPES OF SOLVENT

The non-aqueous solvents used by artists may be divided into seven groups:

Terpene solvents
These are the oldest solvents in use in the paint industry. They have already been discussed under oleoresins and essential oils (see pp.34 and 37) and they include turpentine, dipentene and pine oil. Turpentine is used to make resin varnishes such as dammar varnish. Dipentene and pine oil are used to retard skinning, the latter can also be used as an antifoam agent and has some anti-bacterial action.

Hydrocarbon (non-polar) solvents
These have largely replaced the terpenes as the most common solvents used in surface coatings. The commercial hydrocarbon solvents, obtained by the distillation of petroleum, are usually mixtures of closely related compounds. Hydrocarbon solvents fall into three classes:
■ Aliphatic: These are straight, open-chain hydrocarbons, commonly known as paraffins (but not to be confused with paraffin burning oil which is a mixture of petroleum hydro-carbons). They include petrol, paraffin, vaseline and wax. Mineral spirit is a mixture of aliphatic and aromatic hydrocarbons.
■ Naphthenic: These are cyclic hydrocarbons – compounds that contain closed rings rather than open chain molecules. Odorless solvents may contain high proportions of naphthenes if aromatics have been converted by hydrogenation.
■ Aromatic: These are cyclic hydrocarbons that contain a benzene ring. Examples are toluene and xylene.

Oxygenated (polar) solvents
These are better solvents for the polar film-forming materials such as shellac, cellulose esters, urea/formaldehyde (U/F) and melamine/formaldehyde (M/F) resins and the vinyl resins.

Alcohols
Examples of alcohols are methanol (CH_3OH), ethanol (C_2H_5OH), isopropanol ($CH_3CH_2(OH)CH_3$) and butanol ($CH_3CH_2CH_2OH$).
These may be encountered by the artist as solvents for shellac, mastic and for dewaxing damar resins (see p.35). Denatured alcohol is ethanol containing up to 4 per cent methanol and may be used as a solvent for polyvinyl acetate in charcoal fixatives.

Esters
These have characteristic odors. Perhaps the best known is amyl acetate – the "pear drop" smell in adhesives and nail lacquer. Of particular interest to the artist are ethyl acetate and butyl acetate, which are found in aerosol fixatives and cellulose lacquers. They are highly flammable and narcotic.

Ketones
Ketones such as acetone are often used by restorers for removing varnishes which are no longer soluble in hydrocarbons. Mineral spirit is usually used as a diluent in this case.
Acetone has a wide range of uses. As well as being the principal constituent in most commercial paint-removers, it mixes well in all proportions with water, oils and many other solvents. This makes it a particularly useful ingredient in solvent mixtures.

Glycol ethers
This group of solvents, which includes 1-ethoxyethanol (cellosolve), may be found in specialist lacquers based in natural resins, nitrocellulose and synthetic resins. They should be avoided if possible unless conditions can be carefully controlled as they are readily absorbed through the skin, producing irreversible toxicolog-ical effects.

WAXES

Waxes are chemically complex, but are mainly esters of higher fatty acids and fatty alcohols, often containing free acids, alcohols and hydrocarbons. They are all inert, permanent and durable, provided they are protected from mechanical damage and excessive heat. Wax is very resistant to permeation by moisture and has been used for centuries as a protective coating for wood, stone, plaster and fabric. All waxes melt at a lower temperature than the boiling point of water.

The most common uses of waxes are as protective coatings, as matting agents in certain varnishes, as the binding material for wax crayons and oil pastels (these also contain animal fats), as components in pencil and crayon manufacture and in wax resist painting methods. They are used as stabilizers in oil paint, and adhesives in wax-resin compounds used in conservation, as components in wax emulsions for tempera painting, in modeling materials and as the binding medium for encaustic painting. These uses are detailed in the relevant sections of the handbook.

TYPES OF WAX

The main waxes used by artists are beeswax, carnauba wax and a number of types of kerosene wax. In addition, candelilla wax is sometimes used as a slightly softer alternative to carnauba wax.

Beeswax
Beeswax is the most important wax for artists' use. It is naturally yellow, though wax from newly built honeycombs is said to be white. Pure refined yellow beeswax, which is subsequently bleached by exposure to the sun in flat shallow trays, is claimed to be superior to that which has been factory-bleached, as this may change the chemical composition of the wax and make it soft and greasy. All commentators warn not to overheat beeswax much over its natural melting point of around 63°C, otherwise it will darken. Beeswax gives a soft film and it is for this reason that it is used in conjunction with resins, in varnishes, and in blends with carnauba wax – for example, in encaustic painting (see page 228) – to give a harder film.

Beeswax may sometimes also be used in casein tempera recipes (see *Appendix*, p.336).

Carnauba wax
Carnauba wax occurs as a coating on the leaves of a Brazilian palm, *Copernicia cerifera*. It is a hard, brittle wax with a melting point of around 85°C, more resistant to marking than beeswax and consequently more durable. Its main use is in coatings, where it is generally found in mixtures with beeswax.

Kerosene waxes
The kerosene, or hydrocarbon, waxes are particularly stable. Their hardness can be controlled depending on the molecular weight and a wide range of melting points can be obtained. This enables manufacturers to have a great deal of control over the particular type of wax to suit a particular product. For modeling materials, waxes are required that soften on touch, so relatively low melting point waxes are used here. For wax crayons, a wax that softened on touch would be inappropriate, so a harder wax is used, but not one so hard that it requires a very high temperature to melt it during the manufacturing process. Wax crayons and oil pastels are generally made from hydrocarbon waxes, though the latter incorporate a non-drying oil like tallow which renders them less durable than, for instance, linseed oil-based pigment, but gives them better adhesion to the support than pure wax crayons. Provided the pigmentation levels are adequate, the wax components, being inert, are acceptably permanent.

Candelilla wax
Candelilla wax is the exudation from the Mexican plant *Pedilanthus pevonis*. It is comprised mainly of paraffinic hydrocarbons and has a melting point of between 56 and 70°C, somewhat lower than that of carnauba wax for which it is a rather inferior substitute.

Other waxes
The relatively hard polyethylene waxes are not used extensively in art materials. They are not as inert as the paraffin waxes, but are sometimes used as matting agents for varnishes.

Chinese insect wax is hard and yellowish; it is produced by insects and used in the Far East as a substitute for beeswax. Spermaceti – a brittle white substance obtained from the sperm whale – is a wax no longer widely used in art.

ADDITIVES

A number of ingredients are involved in the preparation of paints, varnishes, painting mediums and other artists' materials that are not discussed in the preceding pages. These include preservatives, plasticizers, driers, surfactants, extenders and thickeners. Driers tend only to be used in oil paints and oil painting mediums and varnishes. These additives are also discussed elsewhere, in the appropriate sections of the book.

PRESERVATIVES

Preservatives are added to watercolor and acrylic paints and mediums to prevent the surface effect of mould growth and the spread of bacteria within the paint itself. Certain bacteria can affect the stability of the paint, especially in watercolor where the gum content can be attacked, causing a thinning of the paint.

Traditionally, camphor, thymol, eugenol, phenol and formaldehyde have been used as antiseptics and disinfectants. Phenol and formaldehyde are still used extensively in watercolor paints. They are extremely toxic in high concentrations and restrictions on the levels allowed are severe, especially in the U.S.A. Gluteraldehyde is sometimes used as a "safer" alternative to formaldehyde.

With the increased awareness of the health risks involved in the use of preservatives, manufacturers are trying to find alternatives which are as effective as traditional ones, but at much lower concentrations.

Among these are the phenol derivatives PCMC and PCMX – which are used in educational products, and the formaldehyde donors – such as "Dowicil" – which are commonly used in artists' materials and especially in acrylic paints. Modern iso-thiazolone derivatives include "proxel" from ICI and "Kathon" from Rohm and Haas; both are used in watercolors and acrylics. "Tektamer" is another preservative in common use for watercolors.

Pigments vary in the amount of preservative required. Blacks, for example, need high concentrations of preservative, possibly because their absorption of heat helps to incubate bacteria. Some mediums – gum tragacanth, for example – are more prone to mould than others, so colors that incorporate it as a thickener will require more preservative.

Another consideration is the reactivity of certain pigments to preservatives. Quinacridones, for example, and some aluminum-based lakes, cannot be used with phenol for this reason, so formaldehyde tends to be used instead.

All preservatives are classified as dangerous substances under EEC legislation and may be toxic, harmful or irritant.

PLASTICIZERS

Plasticizers are added to binding materials to impart flexibility to a paint film. In watercolor, glycerine or glycerol is the most common plasticizer, with sorbitol being used in the cheaper grades. A tube water-color requires more glycerine than a pan color (see p.140).

Glycerine is also used in poster or gouache colors, where the thicker paint film requires more flexibility. There is up to 10 per cent glycerine in gouache colors and below 5 per cent in watercolors.

Chemical plasticizers, such as dibutyl phthalate are used in alkyds, celluloses and certain synthetic resins such as PVA. The acrylics are generally internally plasticized by the incorporation of softer polymers. This makes for a more permanently flexible paint film.

DRIERS

Driers, or siccatives, are incorporated into certain oil colors, oil painting mediums and some varnishes. They are generally metallic salts from lead, cobalt or manganese. They can be characterized as surface driers (cobalt) or through driers (lead). The former dry at the surface first, leaving a soft film underneath; the latter dry through the film from the inside. In the manufacture of oil colors, a single drier can be used, but in the manufacture of varnish or mediums, a balance of surface and through driers is generally incorporated for even drying.

Manufacturers consider that a brushed-out oil film should be touch-dry within 2–14 days. Particularly slow-drying pigments are modified with driers to come within this accepted drying range.

Driers are usually only used in painting mediums when working with thin paint, as in a glaze for example. A combination of lead, cobalt and calcium is generally used, the latter not being a drier in itself but preventing bloom in transparent films. Nowadays the

toxic lead, with its darkening effect, tends to be replaced by cerium and zirconium.

The use of driers in varnishes is dying out, as the modern ketone or acrylic-based varnishes dry by evaporation and not by oxidation.

SURFACTANTS

Surfactants, or surface active agents, are added to lower the surface tension at an interface between two surfaces (such as that between the pigment and the binding medium or the liquid paint and the paint support). The action of a surfactant causes changes in properties such as wetting, emulsification, detergency and foaming. Wetting agents are used in watercolor, oil and acrylic paints as an aid to pigment dispersion and in watercolor especially to give good flowing-out characteristics.

Some pigments are difficult to wet and more than one wetting agent is needed. But even those that are easy to wet will have a wetting agent added, to alter the surface tension so as to improve flow and control the wash. Wetting agents such as oxgall are also used to create certain marbling effects.

The surfactants used as wetting agents for oil colors serve a second purpose, replacing the acidity of the alkali-refined oil used in pigment grinding. This improves the wetting out characteristics reduced during the refining process.

The surfactants most commonly used in artists' paints are:
■ alkylaryl sulphonates, such as sodium dodecyl benzene sulphonate, used in emulsion polymerization (see p.37) and as a wetting and dispersing agent in watercolors.
■ ether sulfates, including sodium lauryl ether sulfate, also used for emulsion polymerization.
■ sulpho succinates, such as sodium di-octyl sulphosuccinate,

used as a wetting and dispersing agent in watercolors and acrylics.
■ alkylphenol ethoxylates, such as nonyl phenol ethoxylate, used as a wetting agent and an emulsifier.
■ alcohol ethoxylates, such as fatty acid ethoxylate, used as a dispersing agent in oil colors and a wetting agent in acrylics.
■ polyethylene glycol stearate – used as a wetting agent to help disperse the pigment in wax crayons.

Other substances which may be encountered include the polycarboxylates, which are used as pigment dispersants and in emulsions. Mineral oil-based surfactants are used as antifoams in emulsions, and the condensation products of formaldehyde and naphthalene sulphonates are commonly used in cheaper water-based color. In powder form, they are also used in powder color and color blocks.

Apart from those mentioned above, the main wetting agent in artists' watercolor is oxgall. That sold to artists is only about 0.4 per cent oxgall in solution but even one drop of this added to the color, to the water or to the mixed wash is enough to improve flow.

EXTENDERS

Extenders are used to control the pigment strength and consistency of those colors that are naturally too strong to be used as they are. Phthalocyanine Blue, for instance, has up to 50 per cent extender added before use. Commonly used extenders include precipitated chalks, magnesium carbonate, alumina hydrate (for transparent colors), blanc fixe and china clay (see pp.30–1). They are used in acrylic and oil paints, and also in opaque watercolors – but only if they are absolutely essential, since they produce a white coloration and do not give such a bright transparent wash.

THICKENERS

These are used in oil, acrylic and watercolor to "body" the paint, to give it more stability in the tube and to produce a tube-consistency color. Some pigments give a thin solution when mixed in watercolor, for instance with gum, so they need to be thickened. The coarser natural earths would separate in the tube if thickeners were not added. Aluminum stearates are used in artists' quality oil paints in proportions of up to 2 per cent, but are only effective with certain pigments. The modern alternatives are hydrogenated castor oil derivatives which are predominantly used in second quality tube colors. Other modern silicates or swelling clays modified for oil dispersion are used in limited quantities. Waxes are sometimes used, but these are softened by the later application of solvents. In acrylic paints, polyacrylate or cellulosic products are used as thickeners.

Watercolor paints that need to be transparent cannot be bodied in the same way as oil paints. For watercolor, gum tragacanth is used and also starch or dextrin. In addition, swelling clays like bentone are used. Thickeners are not generally used in pan colors.

OTHER ADDITIVES

In addition to the above, acrylic paints may also contain:
■ anti-freeze, added to protect consignments of paint during transit. This does not affect the paint properties. The most common is propylene glycol.
■ coalescing solvents, which lower the minimum film-forming temperature of acrylic emulsions. Aromatic glycols, such as phenoxy ethanol, are used.
■ anti-foam agents – these prevent the foaming that acrylic emulsions sometimes exhibit. They are mineral oil-based substances.

SUPPORTS

The support is the structure to which the paint and ground layers of a painting adhere. It can be either rigid, such as wood or aluminum, or flexible, like paper or canvas. If the paint film is to remain intact, the support must have good dimensional stability and durability.

The main advantage of using a truly rigid or inflexible support is that it induces no strain at all into the paint layers. Therefore, you need only concern yourself with the movement of the paint film itself, rather than with the movement of both paint film and support. This reduces the risk of cracking and allows for more freedom in the handling of paint and a greater lassitude as far as the rules of painting are concerned. It also enables you to use painting media like egg tempera or casein, which are often considered too brittle to use on flexible supports.

·Natural wood·

The advantage of a rigid support as described above is a somewhat relative one where wood is concerned, as the main defect of natural wood is its tendency to shrink, expand and distort as it loses and absorbs moisture in the atmosphere. "Green" wood contains a great deal of water — one cubic foot of oak, for example, can hold as much as 100 liters (22 gallons). When cut and seasoned, the wood loses much of its water content but remains "hygroscopic", or liable to absorb moisture.

THE SEASONING PROCESS

The danger of shrinkage and distortion is lessened by seasoning, a process whereby the moisture content of the wood is reduced to the same level as the atmosphere surrounding it. There are two methods:
▤ air-drying, in which the planks are stacked horizontally with thin sticks between them to allow the natural and free movement of air around the whole piece.
▤ kiln-drying, where the wood is subjected to steam heating which removes the moisture more rapidly but is said to be less effective in the long term than air-drying.

Wood has an extremely variable structure, and the moisture absorbence can vary within a single plank of wood, due to differences between early wood and late wood, sapwood and heartwood, and the direction of the grain.

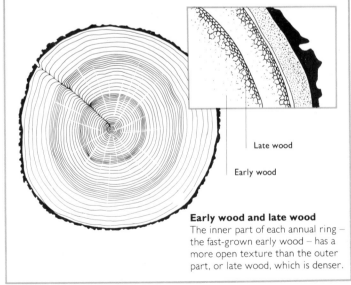

ANNUAL GROWTH RINGS
The cross-section of a log has annual rings which are caused by seasonal growth. The number of rings therefore corresponds to the age of the tree. The rings become narrower as the girth increases, producing denser timber, which is less prone to moisture. A board cut with very different ring widths in it may tend to move differently across the width — particularly if the rings are not perpendicular to the board.

Late wood

Early wood

Early wood and late wood
The inner part of each annual ring — the fast-grown early wood — has a more open texture than the outer part, or late wood, which is denser.

How trees grow

During the early part of the year's growth, thin-walled cells are produced which carry water and minerals from the roots to the rest of the tree. Cells with thicker walls are then formed to give strength to the new growth – this wood is darker than the early wood (see box, opposite).

Sapwood and heartwood

Sapwood is the pale outer area of a log, through which the sap travels and in which the food materials are stored. It comprises living cells, in contrast to the heartwood, or inner part of the log, which has dead cells that contain air rather than sap.

Grain

The grain or orientation of the fibers in the trunk indicates the direction of the tree's growth. The slope of the grain in relation to the cut of the timber directly affects the strength of the wood.

Texture

The texture of a timber is determined by the size and configuration of the cell pores. Trees with large pores, such as oak and balsa, have a coarse texture and are more resistant to atmospheric moisture.

CUTTING TIMBER

Most timber is plain sawn – that is, the planks are cut "through and through" the log. However, logs sawn in this way show a marked tendency to distort. Radially sawn planks, on the other hand, are the most stable.

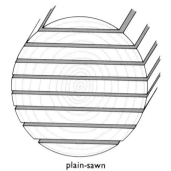

plain-sawn

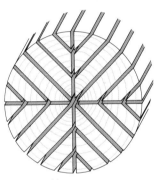

old quarter-sawn

The old method of radial or "quarter sawing" – produced the best planks but a great deal of waste. Nowadays, the quarter-sawn log represents the most commercially viable compromise. Quarter-sawn planks should always be used in the construction of panels for painting.

modern quarter-sawn

The effect of the grain in the plank With plain-sawn timber (top), the end grain is comparatively oblique to the surface of the plank. This makes the possibility of movement much greater than with quarter-sawn timber (above).

USING SECOND-HAND WOOD

Since the natural process of seasoning can take years, some painters prefer to make panels from old, second-hand timber, provided it is worm- and rot-free. However, even well-seasoned timber will move and, although movement along the grain is virtually negligible, movement across it can be quite dramatic. Radial checks or cracks can develop and are one of the most common problems with old panels. The effect of all this can be very destructive if the movement of the wood causes cracking of the brittle paint film (see *Conservation and Framing*,

pp.310–13). However, the paint film will probably not be entirely inflexible and the wood may be considerably more mellow and less vigorous than new, unseasoned wood, especially if kept at a reasonably constant temperature and humidity.

Bowing and cupping
The surface of a plank may bow along the grain (above) and cup across it (top), causing distortion in the shape of the panel.

TYPES OF WOOD

There are two main types of wood:
▧ softwoods – mainly conifers in the gymnosperm group. These have comparatively long cells, they often contain a great deal of resin and they can deteriorate rapidly.
▧ hardwoods – the broad-leaved trees. They can be deciduous or evergreen, and they belong to the angiosperm group. They have shorter fibers than softwoods but are more durable and resistant to wet rot. Timber for artists' panels generally comes from the temperate or tropical hardwoods, though some softwoods are occasionally used.

History of painting on wood

A wide variety of timbers was used in the past. Egyptian paintings on cedar panels are well preserved, and panels were almost universal in Italy until the fourteenth century. Cennini recommended poplar, which was widely used, together with linden and willow. Other woods used included lime, beech, chestnut and walnut. In Holland and other areas of northern Europe, oak was particularly favored for its strength and resistance to the damp climate. A survey of 1100 early Renaissance paintings from Europe has shown that 560 Flemish and 80 German panel paintings used oak panels as supports. An oak well coated on the back with gesso glue and tow and covered with black varnish, has been found to be immune from wood-worm and perfectly preserved.

Among other woods that were less available to Renaissance artists, is mahogany, which can be recommended in every respect. It is extremely durable, has medium to good working qualities, small moisture content, and is of medium price. Another good all-round wood is cedar and, in particular, the Western red cedar.

MAKING PANELS

There are various ways of joining planks of wood together to make panels. Tongue-and-groove or zig-zag joints can be cut, or wooden dowels and butterfly keys used to join one panel to another. The planks can be clamped after glueing with a proprietary wood adhesive; perhaps the most durable is a urea-formaldhyde type. In the past, a glue made from cheese and lime was used, and examples of planks bonded in this way remain strong to this day. Cennini recommended planing the panel to degrease it, covering knot holes with sawdust and glue and covering nails (in old panels) with tin foil before preparing the panel for painting.

Well-seasoned quarter-sawn planks are best but, if you have to use plain sawn planks (see p.47), the direction of the curve of the grain should be alternated to prevent large sections of the panel from cupping.

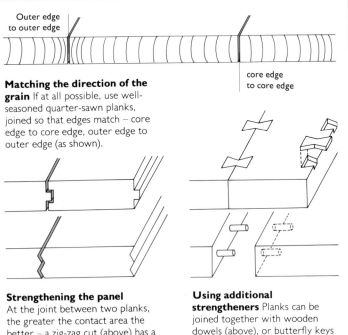

Matching the direction of the grain If at all possible, use well-seasoned quarter-sawn planks, joined so that edges match – core edge to core edge, outer edge to outer edge (as shown).

Strengthening the panel
At the joint between two planks, the greater the contact area the better – a zig-zag cut (above) has a larger surface area than a tongue-and-groove joint (top).

Using additional strengtheners Planks can be joined together with wooden dowels (above), or butterfly keys (top) which are inserted at the rear of the panel.

SUPPORTING THE BACK OF THE PANEL

If the panel is small enough, or if its planks are stiff enough to be self-supporting within the frame, it does not need additional support from behind. This allows it maximum freedom to adjust to slight changes in temperature and humidity.

It used to be thought that a panel could be kept rigid by "cradling", a process in which hardwood battens or slats were glued to the back of the panel in the direction of the grain, with holes cut in them through which runners could freely move. However, this approach was entirely insensitive to the natural movement of the wood. The cradle tended to be stronger than the panel so that, if the painted panel was trying to take up its natural curve, the fixed bars would restrain it, causing it to crack and break. If there was any movement at all, the runners would jam and create more trouble.

Nowadays, restorers of old panel paintings use a "pavement" of light balsa blocks secured with a wax-resin adhesive in place of cradling, but only if support is absolutely necessary.

Cradling
Museum conservation experts now remove cradling and, where necessary, they employ other methods of reinforcement.

·Man-made wooden supports·

PLYWOOD

Plywood panels consist of a central wooden core sandwiched between a number of thin layers of wood which are glued together. The number of plywood laminations ranges from three to thirteen or more in an 18mm ($\frac{3}{4}$in) panel. "Multi" laminations, or plys, add to a panel's strength but not necessarily its stability, since there is more in-built tension in a panel with many layers. Fewer laminations are said to make the panel more susceptible to moisture and insect attack.

Of the various timbers used to make plywood, poplar and birch are among the most common. The best plywood is W.B.P. (Weather and Boil Proof), in which the glue used is based on phenolic resin. An upgraded W.B.P. plywood for marine or outdoor use is known as marine ply. Such panels are often made purely of mahogany and are thus extremely durable. A birch ply gives a good, fine-grain structure which takes a priming well. All sizing and priming should be done on both sides of the panel and on the edges so as to keep the whole sheet stable.

Plywood can be obtained in sheets up to 3 × 1.5m (10 × 5ft). Large panels must be glued to a rigid framework to prevent twisting. This is unnecessary with smaller panels.

The advantage of plywood is that its construction makes it reasonably stable, rigid and unlikely to split. In the manufacturing process, a sharp blade peels a thin veneer from a rotating log which has been softened by steaming or being immersed in boiling water. The continuous rotary-peeled veneer is cut into standard lengths which are overlaid and glued, so the direction of the grain of each layer is at right angles to the one beneath. The boards are then pressed, trimmed and sanded. This alternating method of construction gives stability to a panel containing slices of wood that would otherwise have a tendency to roll back to their original shape.

BLOCKBOARD

Blockboard is made of narrow parallel softwood or, less commonly, hardwood strips glued edge to edge and faced, like ply, with a thin veneer. In "three-ply" construction, the inner core is only covered by one outer layer on each side. In "five-ply", there are two skins on each side of the blockboard core. Such panels are the most suitable for artists' purposes as they are more durable and extremely rigid. Unfortunately, the quality of blockboard is very variable.

CHIPBOARD

Chipboard is a dense material made of chips of wood compressed into rigid panels with synthetic resin glues. It is commonly used as a substrate for laminates in furniture making and, in high-density forms, as a flooring material. The standard compressed density is 600, while the flooring grades are 720 and above. The latter make the best artists' supports since they have a more uniform consistency and are very stable. Chipboard is heavy and large boards may be difficult to maneuver.

COMPOSITE PANELS

These are among the most attractive and stable of the rigid supports available to artists. They are made from wood which is reduced to a pulp and then reconstituted with various synthetic resin-type adhesives.

Hardboard
The homogenous structure of hardboard is said to be more stable than solid wood, plywood or blockboard. It is made by hot

Types of man-made board
1 Plywood
2 Blockboard
3 Chipboard
4 Hardboard (smooth)
5 Hardboard (rough)

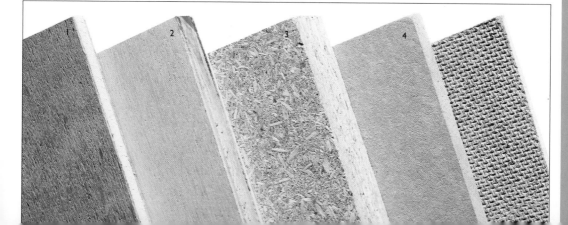

pressing steam-exploded wood fibers with some resin, and relies mainly on the lignin that is naturally present in the wood to cement the particles together. It is commonly available in 3mm and 6mm ($\frac{1}{8}$ and $\frac{1}{4}$in) thicknesses. Large hardboard panels must be glued to a rigid framework, but smaller sizes can be used with no additional reinforcement.

Hardboard panels have one smooth and one mesh-like surface; both can be used to paint on. The smooth side should be degreased but not sanded, as this may cause irregular swelling of the surface when size or water-based primer is applied.

Medium-density boards

A number of medium-density fiberboards, such as "Ranger", are now available. Their process of manufacture is similar to that of hardboard, but they use amine resins as binders. Pulped wood fibers are steam-forced into a narrow gap between rotating rollers and sprayed with urea-formaldehyde resin, which disperses into the wet fibers as they begin to dry. The boards are available in fifteen standard thicknesses, from 6–30mm ($\frac{1}{4}$–$1\frac{1}{4}$ins), and in sheets of up to 1525 × 2745mm (5 × 9ft), making them particularly useful for false wall mural work. They have smooth front and back finishes and are among the most stable boards available.

The urea-formaldehyde resins used in their manufacture are also used in proprietary sealers. These may be used by the artist prior to priming in the usual way or the boards can be prepared as for a normal wooden panel. Although fiberboard panels have excellent moisture resistance, their edges are very much more absorbent than their surfaces, so these should be well sealed.

The medium hardboards are rigid and light and have been extensively used by artists. They are available in widths of 7–12mm ($\frac{1}{4}$–$\frac{1}{2}$in) and the standard sheet size is 2440 × 1220mm (8 × 4ft). The grade "A", which has some resistance to water absorption, is the board recommended for artists' use. These boards are acceptably permanent and have a less hard and glossy face side than standard dense hardboard. This surface, combined with some degree of porosity, gives a size or primer an acceptable key.

·Other rigid supports·

HONEYCOMB ALUMINUM PANELS

These are considerably lighter than plywood, yet strong and dimensionally stable. They provide a practical support for painting which needs no additional strengtheners or supports. If a fabric texture is required, they can be covered with a lightweight, loosely-woven cloth, bonded on with any of the proprietary adhesives recommended by the manu-facturers, and subsequently primed. Honeycomb aluminum panels are also used extensively in the conservation departments of many museums as backing boards for old panel paintings.

The boards are supplied in a ready-to-paint form. They measure 2440 × 1220mm (8 × 4ft), with thicknesses varying from 13.9 to 52.3mm ($\frac{1}{2}$–2in). Strictly speaking, they should be prepared according to the standard method for aluminum and glass fiber-reinforced plastic (G.R.P.) surfaces (see below) but experi-ments show that, if the boards are degreased and sanded, they will accept conventional artists' primers. The titanium-pigmented, oil-modified alkyd resin primer mentioned above is a durable primer for both the aluminum- and G.R.P.-faced panels. Alternatively, the aluminum-faced board can be directly coated with two coats of acrylic primer, allowing each to dry thoroughly for at least 24 hours before recoating. The primer should be completely hard and dry before painting.

SHEET ALUMINUM

Although the honeycomb panels described above offer the best aluminum surface for painting, some painters may wish to work on sheet aluminum. This needs to be properly prepared.

The first stage is to degrease it using mineral spirit, denatured alcohol or a proprietary oil-removing fluid. This is washed off and the panel left to dry. Avoid using alkali cleaners, such as ammonia-based ones, which can damage aluminum.

The degreased panel should then be given an acid wash with dilute phosphoric acid, or rubbed down well with emery paper, to give it a good key. A very thin coat of self-etching primer is then applied. This gives an excellent bond between metal and subsequent coatings. A red oxide primer is satisfactory for internal use; the more durable zinc tetroxychromate etch primer is recommended for external use. Two coats of oil painting primer should then give a satisfactory painting surface.

An alternative method is to use a two-part polyurethane undercoating within 24 hours of applying the soft etch coat. The "A" component of polyurethane coatings consists of saturated polyester resins. The "B" component consists of isocyanate

resins, either aromatic or alphatic. (The latter should be used in white pigments as they are less yellowing.) The first coat should be thinned with 15 per cent thinners and a full-strength coat applied between six and 24 hours later. Rub down the dried polyurethane with wet and dry abrasive paper to give a good key.

GLASS FIBER

Glass fiber in flat board film is not a common support for panel painting; artists generally use it to mould low-relief constructions.

The advent of the honeycomb aluminum boards with glass fiber reinforced plastic faces (see opposite) has provided a new light, rigid support which can be satisfactorily primed for artists' purposes. The surface should first be degreased and sanded with wet and dry abrasive paper, then coated with a proprietary glass fiber primer. This evaporates rapidly and slightly softens the surface so that it can receive the primer. A conventional oil/resin-based artists' white primer will take satisfactorily to the surface. Alternatively, use the polyure-thane coating described in the above section. Such coatings contain curing agents which react with hydroxyl groups in the fiberglass gel coat and this makes for a very durable bond. Fiberglass is known to degrade in UV light so must be protected from sunlight.

STEEL

Steel should be grit-blasted to remove all traces of rust, after which an epoxy resin coating should be applied. Such coatings are very tough, being water-, chemical- and solvent-resistant.

There are two component coatings: the "A" component, produced by condensing epichlorhydrin and diphenylo-propane in a caustic environ-ment, and the "B" component – an organic diamine or polyamide. Two more coats of this should be applied, each being allowed to dry thoroughly. Then a white polyurethane undercoat as described above should be applied and, subsequently, the artists' proprietary white primer.

Prepare galvanized and zinc-sprayed steel as for sheet aluminum (see opposite).

COPPER

Copper is soft, so it dents and bends easily. It has a high coefficient of expansion and this can give problems for paint adhesion, although it is very stable when kept indoors. Copper is prepared for priming by thoroughly abrading with 180–200 emery paper, after which the White Lead in oil, or titanium in oil-modified alkyd, can be applied directly. It has been suggested that a stippling technique is used to apply the first thin coat of primer. Each subsequent coat should be

allowed to dry thoroughly until completely hard before the next is applied. Dull the primer surface slightly by abrasion before painting.

Types of rigid supports
1 Honeycomb aluminum coated with glass fiber-reinforced plastic
2 Honeycomb aluminum
3 Copper
4 Sheet aluminum
5 Steel

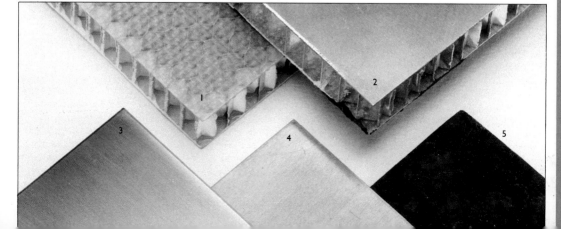

·Paper·

RAW MATERIALS

The basic raw material in paper is cellulose fiber, which comes from a wide variety of plant sources. The plant fibers are reduced to a pulp and certain potentially harmful substances removed before they are felted together in sheet form as paper.

Different plant fibers have quite different characteristics which affect the quality and appearance of the paper. In the West, the best artists' papers have traditionally been made from linen rags. The linen fiber is said to be stronger than cotton or any of the alternative plant fibers but, nowadays, pure linen paper with its characteristic natural flax color is very rarely found. Cotton is now used by most paper manufacturers. Whereas, in the past, cotton was used in such forms as shirt cuttings or other offcuts from clothing manufacturers, or even old "debuttoned" cotton clothing, the introduction of man-made fibers such as nylon and rayon into cotton fabric has made the use of rag impracticable, since these artificial fibers produce unacceptable clear specks in a sheet of paper.

Nowadays, cotton linters are used. These are the fibers left on the seed after the longer 2–6cm ($1-2\frac{1}{2}$in) fibers used for making yarns have been taken off. They can vary in length from approximately 2–6mm ($\frac{1}{12}-\frac{1}{4}$in) depending on whether they come as first cut (longest) to fourth cut (shortest). The longer the fiber, the stronger the paper. The best linters come from the southern United States or from Egypt and are usually bought in by paper manufacturers in bleached sheet form (as is wood pulp). The bleach has been thoroughly washed out by this time but, to check for impurities, some manufacturers subject sheets from each new batch to fading tests using xenon lamps.

The other common raw material is wood pulp. This has not been recommended in the past as a suitable material for artists' paper since it contains harmful yellowing materials such as lignin. But, with the advent of photographic paper production, wood pulps needed to be developed that were considerably more pure than before and, nowadays, the so-called wood-free papers made from chemical wood pulp are not far behind cotton papers in permanence, with some respectable high-purity wood-pulp watercolor papers (such as "Bockingford") on the market. For some watercolor papers, a mixture of cotton linters with the clean, longer-fibered spinning waste from cotton mills is used. There are also some manufacturers of handmade papers who used flax/cotton mixtures in their pulps.

For Oriental papers, a wide range of plant fibers are used, ranging from the short-fibered "Gampi" (*Wickstroemia shikokiana*), which gives a thin, transparent paper with a fine, smooth finish, to the longer-fibered, stronger "mitsumata" (*Edgeworthia papyrifera*) paper. The Oriental papers are sized using vegetable sizes made from pulp vegetables and stored in pots underground.

THE MANUFACTURING PROCESS

Water plays a large part in the manufacture of paper and it is for this reason that many established paper mills are situated by a natural water supply. River water from limestone hills is very pure and requires only mechanical filtration before use.

The pulping process

The sheets of cotton linters or wood pulp are put into hydro-pulpers with water and blended for ten minutes to produce a slurry of fiber and water. This is pumped into storage towers and then through refiners – conical-shaped machines that have a fixed outer cone with metal bars on its inside surface. An inner cone rotates and can move in and out so that the distance between the rotating bars on its outside surface and the fixed bars inside the outer cone can be carefully controlled. The fiber-and-water slurry passes between the bars and is treated lightly or heavily according to the type of end product required. The refining process controls the length of the fiber and the extent to which each fiber is split into individual fibrils. These tiny strands which are teased off each main fiber join with those on other fibers to impart strength to the paper.

For handmade papers, the pulping and refining stages are combined and "Hollander" beaters are used to beat the pulp and to modify the fibers. The refining process can be more closely controlled in this way.

Internal sizing

From the refining machine, the pulp goes to storage chests and, from there, via a large pump and continuous internal sizing, to the paper-making machine. At the large pump stage there is 99 per cent water and 1 per cent pulp. For the internal sizing which is mixed in with the pulp, manufacturers have, in the past, used rosin fixed with alum, both of which are harmful to permanence – the first because it darkens and becomes brittle, the second because it is acidic. The better manufacturers now use a synthetic size with a neutral pH. The new size is alkyl ketene dimer, which avoids the harmful effects of the old rosin/alum sizings. This is known as alkaline sizing or neutral sizing, because it is carried out in the absence of

alum. The sizing, which is based on a fatty material derived from tallow, relies for its effect on a chemical reaction with the cellulose in the fiber.

The alkyl ketene dimer molecule has two main components – one end attracts water and the other attracts oil. The watery end attaches to the cellulose by hydrogen bonding – the cellulose being naturally hydrophylic – while the fatty end leaves a spot on the cellulose that is water-repellent. The degree of water repellence can be varied according to the intended use. Whereas a conventional size puts a waterproof layer down on to the support, the alkyl ketene dimer size gives a sizing effect without blocking the pores or the porosity of the fibers.

The internal sizing controls and absorbency of the sheet and gives a controlled pick-up of gelatine when the paper is tub-sized after being formed. On a mould-made paper with only internal sizing, a watercolor wash will generally be absorbed and fixed into the paper and will not be readily adjustable as with a surface-sized sheet.

On handmade papers, most of which are internally sized, the internal sizing is far stronger than that on the machine- and mould-made papers where further surface sizing is required.

Commercial machine-made papers

On the large commercial "Fourdrinier" paper-making machines, the fiber and water is projected on to a continuous, moving wire-mesh screen. Water drains through the mesh and the paper now formed is passed through presses and steam-heated drying cylinders. At the wet "mesh" stage, the screen is vibrated from side to side, but the fibers still tend to align themselves along the length of the roll, i.e. in one direction. This makes machine-made papers unstable for watercolor purposes, causing cockling or distortion.

Mould-made papers

Artists' mould-made watercolor and drawing papers are made on a slower-moving cylinder mould machine. Here, the fiber and water are pumped into a vat in which a large cylinder mould revolves. The sleeve or mould cover is made of thin wire mesh which, through a gravitational suction effect, draws up the pulp from the vat. Here, the fibers arrange themselves in a more random order on the mesh, which gives the sheet great strength and even stretching properties in each direction. The mould-made paper is thus far more dimensionally stable than the machine-made sheet. Handmade paper in which the fibers show no direction at all is the best in this respect.

The deckled edge to the paper is formed naturally on each edge of the roll, but artificially at right angles by the use of a terylene tape which indents the paper to provide a tearing bar when the roll is made into sheets. The paper is carried away through a press section on a woollen felt or blanket which gives the paper its characteristic grain. For rough paper, a coarse base weave is used for the felt, with a lot of texture and very little nap. For NOT paper, a more spongy, teased-up felt is used with more nap. The paper and felt go through a press section which mechanically squeezes water out. Subsequently, the paper – still with a 65 per cent water content – goes round steam-heated drying cylinders on an open mesh which holds the paper in contact with the cylinders and the rest of the water is removed.

Tub sizing

In the next stage, the sheet is totally immersed in a warm solution of gelatine. This is the surface-sizing process which enables watercolor paper to stand up to a number of washes and manipulations.

The paper picks up its own weight in gelatine before going through squeeze rollers to remove excess liquid and, subsequently, through steam-heated drying cylinders. The surface-sizing pick-up on the cylinder mould machine, with its total immersion process, is far greater than that which can be had on the large commercial machine, but it does not compare with the true tub sizing which handmade papers were given in the past. Unsized papers were immersed in gelatine which was allowed to soak thoroughly into each sheet of paper before the paper was squeezed, left to stand for twelve hours and air-dried for a week. The front of the sheet could be identified by holding it up to the light and reading the watermark. Nowadays, both sides of all kinds of paper can generally be used.

Hot-pressed paper

For mould-made paper, the H.P. surface is obtained by passing the paper through calender rollers which control the thickness and finish of the paper. For handmade papers, a system known as plate glazing has been in use for the last hundred years. Individual sheets of paper are interleaved between sheets of zinc and passed between heavy rollers. A combination of pressure and slippage produces the characteristic smooth surface.

THE CHARACTERISTICS OF PAPER

The three standard descriptions for Western drawing and watercolor paper have been identified as:
- Rough
- NOT (cold-pressed)
- H.P. (hot-pressed or smooth paper)

Within these categories there is a wide range of surface textures provided by different manufacturers who use different types of felt and different

finishing treatments. There are HP papers of a glassy smoothness and those that come close to a NOT surface. Some rough papers are characterized by such a uniformity of texture that they look like sections of an endlessly repeating textured wallpaper. Others have a much more varied and random-looking texture.

Absorbency

The nature of the paper is not just determined by its texture, but by its degree of absorbency. "Waterleaf" paper has no sizing and is held together merely by the fibers themselves. Such papers are commonly used in relief printing. Other papers have very little size and are known as "soft" papers. These are also particularly important in printmaking. The internally or neutrally sized papers have been mentioned, as has the process of gelatine tub or surface-sizing. Many handmade papers for watercolor and drawing are now only internally sized using the new neutral sizing mentioned above. This is adequate for most watercolor manipulations except for the use of masking fluid which tends to pull off the surface of the paper when it is rubbed off. If masking fluid is to be used extensively in a painting, a paper with a gelatine surface sizing is more appropriate. The watercolor artist generally requires such a paper. Some artists, like Emil Nolde and Jackson Pollock, on the other hand, found the very absorbent

Japanese mulberry papers particularly suited to direct, expressive one-stroke painting methods.

Weight

The grammage or weight of the paper is now universally measured in grams per square meter (gsm or gm²) and can range from 12, for a Japanese mulberry paper, to 640 for a heavy watercolor board. On the cylinder mould-made paper, the weight is controlled by the ratio of fiber to water at the wet end of the machine and, in addition, by the speed at which the machine is run.

pH neutrality

Artists' quality pure "rag" or chemical wood-pulp papers should have a neutral pH reading of around 7. Reputable paper makers are careful to ensure the purity of the cellulose fiber. It is what is added to the fiber that can cause impermanence, and the rosin/alum internal sizings are now generally avoided in favour of the newer neutral sizings. For surface sizing, however, an acidic medium like alum is needed to fix the gelatine on to the fiber and to harden the gelatine film. The amount of gelatine in a surface sizing is relatively small, so any acidity may not register in a pH extract but can still be present on the surface. For this reason, paper makers are beginning to use new, neutral sizing mediums in place of the old acidic ones.

Laid/Wove

"Laid" refers to the horizontal and vertical pattern of lines created by the wire mesh of the mould on which the pulp is lifted. The chain lines are those that are furthest apart (often vertical) and the laid lines at right angles are the fine lines that are close together. A woven mesh, looking more like canvas, was created to provide a more uniform overall texture. This is known as "wove".

PIGMENTED PAPER

High-quality, pigmented, acid-free, all-rag paper which is colored by adding lightfast pigments at the pulp stage is difficult to obtain.

Barcham Green in England make a "Camber Sand" light tan paper, a "De Wint' brown, which is a more neutral straw-colored paper, and "Turner Grey", a blue-gray paper, in their watercolor paper range; these are good supports for charcoal, chalk, crayon and pastel drawing.

Types of paper

1 Arches paper (rough)
2 Arches paper (NOT)
3 Arches paper (H.P.)
4 Handmade printing paper
5 Waterleaf paper
6 Mulberry paper
7 Watercolor board
8 Laid paper
9 Wove paper
10 Barcham Green "Turner Grey" pigmented paper

Among their conservation papers which are, of course, acid-free, and also quite suitable for drawing and painting, is an "India Office" brown which is deeper in tone than the De Wint and with more blue in it, though even this is barely a mid-tone paper. In the printmaking range is a NOT wove Duck Egg Blue paper (Boxley) with a slightly green cast. This can also be used for drawing and painting.

A greater range of reliable papers of mid-to-light tone would provide excellent supports for pastel painting, and work in chalk, charcoal and gouache. Unfortunately, many of the commonly available colored drawing papers are of only reasonable quality, being colored with dyes which quickly fade.

Methods of tinting paper

Fortunately, it is not too difficult to tint a sheet of white paper, though the effect is somewhat different from an internally pigmented sheet. It is generally advisable to stretch paper (see below) before wet toning. There are a number of wet methods of tinting. The first is done by laying a uniform watercolor wash over the whole sheet (see p.144–5).

This is to be recommended where dry work is to be superimposed as, depending on the absorbency of the paper,

DRY TINTING PAPER

Dry tinting can be done by rubbing pigment powder into the fibers of the paper with cotton. H.P. paper takes such a treatment better than NOT or rough, where only the raised ridges of the paper pick up the color. This method is generally

1 Tip a little pigment on to a clean scrap of paper and rub the cotton quite vigorously in it, so that pigment lodges in the fibers.

2 Gently rub the pigment into the surface of the paper, gradually increasing the pressure to obtain a reasonably even tone.

used for dry work such as pastel or charcoal drawing, but I have found that it is also possible to use paints without disturbing the pigment in the paper. When painting on such a ground with watercolor, it will be noted that the surface has a characteristic gritty feel.

there is likely to be a pick-up of the background color with painting. This is not so likely to happen if a weak size solution – partially pigmented with color – is applied, for if gelatine is used which is only soluble in warm water, it will not be dissolved when cold water is applied with the paints on top. A warm size solution of 20:1000, applied in large, parallel strokes with a flat brush, has been suggested. Such a solution can be used simply to gelatine-size a soft paper. It should be pointed out that it is not easy to incorporate

pigment into size and, strictly speaking, it should be mullered in. Perhaps the simplest insoluble method is to apply a uniform tint by glazing with a weak solution of acrylic paint of "watercolor wash" consistency.

This will effectively only be a stain and will not affect the permanence of the paint film. Handbooks have, in the past, recommended a four per cent solution of formalin to render a ground waterproof, but this is not recommended here, as very small amounts of formaldehyde are known to be highly toxic.

HOW TO STRETCH PAPER

Paper should generally be stretched on a slightly absorbent surface like an unprimed wooden drawing board. This absorbs some of the moisture from the damp paper during the drying process. In fact, almost anything with a flat surface will do, from a sheet of laminate to a piece of thick glass. It needs to be larger all round than the sheet of paper.

1 Cut four strips of thick gummed tape. Thoroughly dampen the paper on both sides by dipping it into cold water, allowing the excess to drain off.

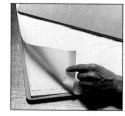

2 Leave the damp paper for a while between layers of clean newsprint, sandwiched between two drawing boards. This ensures a uniformly damp paper and keeps it flat.

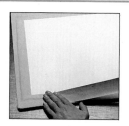

3 Remove the paper, lay it on a board and push out from the center towards the edges, so that it lies flat. Stick the tape firmly along all four edges. Leave the paper to dry in a warm room.

·Canvas·

The term "canvas" applies to all types of stretched fabric traditionally used for artists' supports, including linen, cotton and man-made materials such as polyester. Silk, hemp and jute have also been used in the past. Canvas has been a popular support since the fifteenth century and remains so today, despite the fact that it needs more careful and time-consuming preparation than most other materials.

LINEN

Linen is made from the fibers of the flax plant (*Linum usitatissimum*). The variety used for its fibers has a long, relatively unbranched stem compared to that used for linseed oil, which is shorter, with a branched stem and larger seeds. Textile flax is grown all over the world, with Russia the major producer. The best flax in the Western world is said to come from a 200 kilometer wide band of country stretching from lower Normandy through Picardy to Flanders and up into Holland, where there is a great flax-growing tradition.

The growing period is around 100 days, with the flax being sown from the end of March and harvested from July to August. The flax is pulled, rather than cut, so as to take full advantage of the long fibers which run into the roots of the plant. The plant ripens from green through yellow to dark green or brown, and the best fibers are obtained from the plant when it is yellow.

The manufacturing process

Once the seeds have been removed – a process known as "rippling" – the flax is "retted", i.e., allowed to decompose so that the pectins that bind the fibers together are broken down. In ground or "dew" retting, the flax is left in the fields to decompose naturally by the action of the dew and the warm sun – which takes between three and six weeks. In water retting, the flax is soaked in tanks of warm water at 37°C for three to five days. After drying for between eight and 14 days in "stooks", the flax is "scutched", which is a process of separating the fiber from the waste woody matter known as "shiv" or "shive". In scutching, the straw is passed through wooden breaker rollers and then rubbed and beaten by steel turbine blades. This produces long fibers of flax known as "line flax", with fibers of between 60 and 90cm (24–36ins) in length, and short fibers or "tow", which are between 10 and 15cm (4–6ins) in length. The flax is then combed or "hackled" to separate the line from the tow flax and ensure that the long fibers are parallel to each other. It also eliminates any further waste matter. The linen fiber is then drafted or pulled several times until a rove is formed that is wound on to bobbins – the rove is a very fine sliver of flax fiber with a slight twist in it. It is the rove that is spun into yarn.

Textural variations

There are two spinning methods: wet spinning and dry spinning, and these affect greatly the nature of the woven linen surfaces. Both line flax and tow flax can be either wet spun or dry spun. The wet spinning process, in which the rove is soaked in warm water (60–70°C) during spinning, softens the pectins that are found between the shorter (6–60mm) ultimate fibers (fibrils) within the fiber itself. These ultimates slide and twist with the pulling and twisting action of the spinning process to produce a strong, sleek and lustrous yarn. The dry spinning process produces a rougher yarn. Dry-spun line flax is less fuzzy than dry-spun tow.

A great many permutations can be obtained during weaving by using different yarns for the warp – the yarns stretched along the length of the linen – and for the weft – the yarns that are laid across the fabric. For artist's linen, which relies on the stability of the product, the warp and the weft should be made from the same yarn. The strongest and most durable linen is that which employs wet-spun line for both warp and weft. This has a smooth "hard" surface with no fuzz, the texture being dictated by the thickness or weight of the yarn.

During weaving, the warp thread is held at considerable tension. The interlaced weft thread is not so taut. When the warp is relaxed, it "crimps", which makes it considerably more distendible than the weft if the canvas is stretched in its loomstate form. In order to get rid of the crimp and to straighten out the yarn, linen should be put through a "de-crimping" stage. It should be stretched, wetted and allowed to dry. It should then be taken off the stretchers and subsequently restretched prior to the application of size and/or priming. This is well worth the trouble as it provides a much more dimensionally stable cloth which, on its second stretching, will have a more even tension all round. It also counteracts somewhat the "stress-relaxation" factor which applies to linen. This effect is one in which the stretched linen will naturally relax its tension unless there is something to counteract it. The phenomenon is not so apparent with oil painting, in which the contracting oil film counteracts the slackening of the linen, but it is quite noticeable when painting with acrylic on linen.

COTTON

The use of cotton as a textile support in painting has only been widespread since the 1930s. Although it is not as popular as the traditional linen, a good-quality cotton canvas provides a perfectly acceptable surface on which to paint. Cotton comes in the main from two species of cotton plant – *Gossypium hirsutum* and *Gossypium barbadense*. The plants are cultivated annually on a 175–225 day cycle and reach a height of between 25cm (10ins) and 2m (6ft). The cotton fibers are seed hair fibers which are revealed as soft downy hairs when the boll or seed pod splits open. Unlike the long ("bast") fibers of the flax plant, which are connected together by pectins in the stalk, the cotton fibers have merely to be mechanically separated from the seeds by "ginning" and then compressed into bales before spinning and weaving.

The best cotton is Sea Island cotton from the United States which has the longest fibers or "staples" of between 40 and 55mm ($1\frac{1}{2}$–2ins). An average medium staple such as that produced in the USA would be between 25 and 30mm ($1-1\frac{1}{8}$ins).

The manufacturing process

The best cotton canvas is "loomstate" canvas, which is untreated by any of the finishes to which most fabrics for domestic and industrial purposes are subjected. Such treatments are known as resin finishing (though the products used are not exclusively resins) and impart the crease- and shrink-resistant qualities to natural fibers that enable them to complete with synthetic fibers. The two main methods of treating natural fibers are, firstly, to deposit chemicals by poly-condensation on the fiber and, secondly, to use a chemical that actually reacts with the cellulose of the fiber. A gain in crease recovery and dimensional stability is coupled with an increase in the brittleness of the fiber and a loss of tensile strength and abrasion resistance. Though these deteriorations are counter-acted by the further use of chemicals, they still suggest both physical and chemical reasons for avoiding painting on treated fabrics.

Grades of cotton

The weight of the canvas is important and this is measured in terms of grams per square meter or ounces per square yard. The most common good-quality cotton for artists' use is cotton duck at 410gsm (12oz) or 510g (15oz), though it is possible to go down to 340gsm (10oz) and get a reasonable weave. Below this, the canvas is of scenic quality, i.e., it is used for making "flats" for theater sets, and it has a much looser weave. To stiffen it and add weight, manufacturers often use sized yarn coated with starch or some proprietary paste which is difficult to identify and, for this reason, it should be avoided. The 410gsm is usually a plain weave of 2 × no.12 threads folded or twisted once for the warp and 2 × no.12 threads for the weft. The 510gsm variety comprises 3 × 12 by 3 × 12 threads – the additional yarns giving the increased weight. Yarns for such heavy duty canvases are carded rather than combed. Combed cotton yarns, in which the fibers have been combed in parallel and any impurities eliminated, are not generally used in artists' canvas, though there would appear to be sound reasons for using them.

REMOVING BULGES IN COTTON CANVAS

Cotton does not exhibit very good elastic recovery, which can make it difficult to remove bumps and bulges in a canvas. In the studio, however, the artist will risk dealing with minor bulges by very slightly dampening the back of the canvas with water, so that the bump is pulled out.

Types of linen and cotton
1 Fine grade linen
2 Coarse grade linen
3 410gsm (12oz) cotton
4 510gsm (15oz) cotton

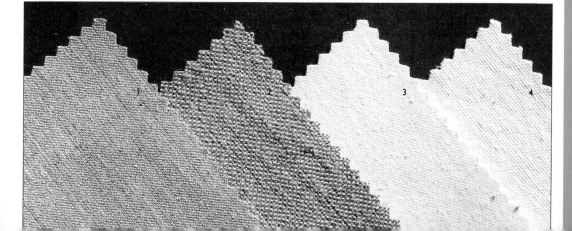

COTTON VERSUS LINEN

It has been claimed that cotton is vastly inferior to linen and that any artist who values performance should avoid the use of cotton canvas. There is, in fact, very little evidence to support this. It is certainly the case that the flax fiber used to make linen is longer and stronger than the cotton fiber, that linen exhibits more dimensional stability and less deformability per unit force than cotton, and that an artist having to choose between the two might opt for best quality loomstate linen as his first choice. But the fact is that a good quality 12–15oz loomstate cotton duck canvas is a perfectly acceptable support for permanent painting. It is unfortunate that manufacturers of prepared canvases have used greatly inferior cotton fabric in their second-grade products. This has had the effect of widening the apparent gap in quality between linen and cotton, presenting an unfavorable impression of the latter which is undeserved and discouraging many artists from trying it for themselves.

Chemical and physical comparisons The similarities between cotton and linen are marked. The simplest fundamental unit of each material is identical. Chemically, they are both composed of cellulose:

cellulose molecule

Cotton and linen have similar wet and dry strength and rapid moisture absorption. Where the fibers differ most is in the orientation of the cellulose crystallites. The higher orientation in the flax fiber makes it much stronger and smoother, but these advantages are offset by its greater sensitivity to abrasion. This sensitivity is even greater when the linen is wet.

Texture and strength
In the plain-weave fabric used by artists, linen and cotton show quite different surface textures; the linen texture is very characteristic and more varied

than the cotton one, depending on the weight and tightness of the weave and the length of fibers used for the yarn. Cotton provides a more uniform texture which, in the artists' quality grades, is more tightly woven because it is heavier.

A lightweight cotton canvas is not so strong as a lightweight linen one. However, linen is generally used in much lighter weight than cotton, so that a heavyweight cotton duck of 12–15oz, for example, is probably as durable as linen. Indeed, it has been shown that thicker yarns, such as are found in cotton, degrade more slowly than thinner ones.

Degradation
The degradation rates on exposure to light of cotton are in fact slower than those of linen, though, in a painting in which the textile is covered with opaque pigment and with its back to a wall, most of the degradation is thermal and the reactions that occur are in relation to the ambient conditions in the room (see *Conservation*, p.311).

—·Other flexible supports·—

POLYESTER FABRIC

A number of synthetic fabrics have been used in the manufacture of artists' canvases, including polypropylene, nylon and polyester. Of these, polyester has proved the most suitable, having superior paint adhesion qualities. It comes in a wide range of weights from 20gsm to 540gsm and, although normal widths are only 90cm (1 yard), 2m (6ft) widths can be obtained from sailcloth manufacturers. Polyester sail-cloth, which is all plain weave, is woven extremely densely and this produces a very stiff material. After weaving, the cloth is heat-set, which makes

each yarn shrink irreversibly, producing a tighter and more dimensionally stable cloth. Such fabrics are resin-coated when used as sails but, for artists' supports, they should be used untreated.

Characteristics of polyester
Polyester fabric has qualities that are lacking in either linen or cotton. Firstly, it has far greater durability than linen or cotton, with a strong resistance to acid attack. Secondly, it absorbs very little moisture, with 0.4 per cent water at 65 per cent relative humidity compared to 12 per cent for linen. Thirdly, polyester has exceptionally good dimen-

sional stability. And, fourthly, it has good elastic recovery.

A highly inextensible flexible support (that is, one which will not stretch out of shape) is best for painting and, in this respect, polyester is greatly superior to traditional supports. It is stretch-resistant but remains flexible. This is a desirable characteristic, since there is less strain involved for a stiff material like polyester than there is on a less stiff one like linen or cotton in arriving at the level of tautness required for a painting support. The effect of this is to induce a smaller strain into the paint layers and for less stress to build up within the glue size or oil layers when the

relative humidity falls.

The only factor which has deterred artists' materials manufacturers from using polyester fabrics for flexible supports is that the texture of polyester weave is unlike that of more traditional supports. Some fabrics have a surface "fuzz" which could prove helpful in adhesion for thickly worked, impasted painting but which can be sanded down between primings for a smoother finish.

Stretching polyester
Polyester can be stretched in the same way as linen and cotton canvas, though it is suggested that the staples are attached closer together and that the fabric is pulled two ways before being stapled (see p.61).

LEATHER

Originally, leather was vegetable-tanned using the natural tannin from the barks and leaves of trees. Nowadays, animal skins are, for the most part, chrome-tanned in a process that imparts flexibility, chemical stability and significant per-manence to the product, making it suitable for painting on. The raw animal skins are saturated in alkali which softens the hairs and allows them (and other adherent waste products) to be easily removed by helical blades after being passed through rollers. The skins are washed and tanned with chromium sulfate, in large revolving wooden drums. The chromium sulfate effectively removes the biochemical mix surrounding the animal fiber. This is then replaced with a fat liquor which prevents the skins from drying out and imparts suppleness. The fat liquor is generally introduced at the dyeing stage. The leather is stretched and given a surface treatment dependent on end use. Surface treatments include the use of polyurethane and acrylic resins and nitrocellulose. Artists may question the effectiveness of coating a support containing a non-drying oil, but the per-centage of the oil does not seem to be great enough to create "cissing" or non-adherence, and a pigmented acrylic polymer primer forms an acceptable bond with the surface of the leather. A measure of porosity in the leather and in the acrylic paint enables the binder to be absorbed sufficiently for adhesion and the passage of moisture to take place. The pH of leather is around 3.5 to 4, so this acidity is somewhat counteracted by the alkalinity of acrylic paint with a pH of between 9 and 10.

The orientation of the hairs on an animal skin and, therefore, of the fibers, makes for a stable support. However, soft leather is very extensible and, if leather is to be used as a support, it should preferably be glued with an acrylic, PVA or EVA adhesive to a rigid support. A non-dyed, non-surface-coated leather should be used. After chrome tanning, this will be a pale duck-egg blue.

Leather has a smooth, or "hair", side with a characteristic grain and a suede or "flesh" side which gives a slightly rougher surface with more key. Either side can be used to paint on.

PARCHMENT AND VELLUM

Parchment and vellum (which is, strictly speaking, calf skin) are made from the skins of calves, sheep or goats. The skins are not tanned but merely de-haired, stretched and scraped before being used as supports. The stages in manufacture are as follows.

The skin of a freshly slaugh-tered animal is washed and then soaked in lime for a few days. This enables the hair or wool to be removed and any adhering flesh to be scraped off. The skin is then washed again, stretched and allowed to dry before scraping on both sides to give a uniform thickness. Chalking and rubbing with a fine abrasive such as pumice produces the charac-teristic smoothness of parch-ment. Both sides may be used as painting supports and give slightly different results, the skin side being smoother and the flesh side having more tooth to hold the color.

Types of flexible support
1 Leather (rough)
2 Leather (smooth)
3 Polyester fabric
4 Vellum

·Preparing flexible supports·

STRETCHING CANVAS

The aim of stretching canvas is to produce a taut support with even tension in which the warp and weft yarns remain parallel with the bars of the stretcher frame. The rigidity of the frame is an important factor in the mechanical structure of a painting made on a flexible support. Modern stretcher frames are generally machine-made. They have mitered corners with slot and tenon joints that can be expanded by the use of wedges known as "keys". Stretchers are generally made of softwood in varying widths and thicknesses, depending on the size of the painting. The face side of a stretcher piece is beveled to prevent the inner edge of the frame creating "ridge" lines in the painting.

Conservation departments in museums tend to use much stouter stretcher pieces than artists. Large frames are mortised in the middle to take cross bars. These reduce the possibility of bowing or warping when the frame is under tension.

PROBLEMS WITH STRETCHER FRAMES

Stress

The main disadvantage of conventional stretcher frames is the strain they impose on the canvas. Although the edge of the frame is generally planed down somewhat, the yarn is still distorted and the canvas subjected to concentrated stress as it is turned around the angles of the stretcher edge.

Prolonged stress leads to the splitting of the canvas along the edge, the tacking margin becomes separated from the painting and the whole thing has to be relined. The conservation departments of museums are full of paintings which have become damaged in this way.

The tacks or staples which secure the canvas aggravate the condition by imposing further focal points of stress. Thick staples are better than tacks in this respect and these should be attached very close together along the stretcher frame. Redesigning the stretcher frame in the way shown here would greatly increase the life of the canvas, although the picture frame would need to have a modified and deeper rebate in order to accommodate the new style of stretcher.

Distributing stress evenly
The problem of stress can be solved by giving the stretcher piece a completely rounded profile. This eliminates the maximum distortion of the yarn around a right angle, instead distributing the stress evenly around the curve.

Cracking

Conventional stretchers encourage the imposition of forces in the corners that run at 45 degrees to the stretcher bars. If the canvas is stretched too tightly, these forces result in the ultimate cracking of the paint film. This can be seen in many old paintings, where the crack pattern runs at 45 degrees to the right angles of the stretchers, becoming less severe towards the center of the painting. The problem is reduced by stretching the corners less tightly.

Contraction

When a painting with a heavy layer of glue size is subjected to a very dry environment, it tends to shrink. The rigid design of the stretcher does not allow for contraction, so the painting may develop tensions and subsequently crack. This problem can be lessened by using very little or no glue size.

Assembling a stretcher frame

1 Loosely assemble all four sides of the frame, including cross bars, then carefully ease them together by tapping with a rubber hammer or a metal hammer and wooden block.

2 Gradually work round the frame, tightening up all the joints in stages. Use a set square to ensure the frame is square, or check the diagonal measurements are the same.

3 After stretching the canvas, drill holes in the keys, pass nylon loops through, and attach them to the stretcher pieces with tiny brass screws to prevent them falling out.

How to stretch canvas

1 Attach the canvas with three non-rusting staples along the middle of one of the longest sides. Pull the canvas taut and secure it with three more staples on the opposite side.

2 Make sure the line of the yarn is straight by pulling the canvas towards the third side of the frame. Then attach it to the middle of the third side.

3 Pull the canvas firmly towards the fourth side and attach it with three more staples. You should now have established a cross of tension through the middle of the frame.

4 Pull the fabric towards one corner and attach it with a temporary staple. Do the same at the diagonally opposed corner and then at each of the other corners.

5 Extend the row of staples along the first side towards one corner, stopping slightly short of it. Do the same on the opposite side, towards the diagonally opposite corner.

6 Staple from the center of the third side right up to the corner, and do the same to the diagonally opposite corner. Each row of staples should point towards a different corner.

7 Repeat steps 5 and 6, working towards, or right up to, the remaining corners in the same order. The spaces left on the longest sides enable a neat finish to be made.

8 Make two folds in the canvas at each corner, pull one fold over the other and staple the canvas to the frame. This maintains even tension right up to the corners.

9 Stick down the edges of the canvas with masking tape and tap in the stretcher frame keys, ensuring the angle of the grain is not parallel to the stretcher piece.

DE-ACIDIFYING A CANVAS

It has already been suggested that a linen canvas should be "de-crimped" by stretching and wetting, allowing it to dry then restretching before priming (see p.56). Another useful process, which recent research at the Courtauld Institute has shown to at least double the life of the fabric, is to de-acidify it.

There are proprietary de-acidifying products, but these are expensive on large canvases.

A simple alternative is to brush, spray or soak the canvas with solutions of calcium hydroxide or magnesium bicarbonate. These are non-toxic, readily available and easy to prepare.

Using calcium hydroxide

Shake up 2gms of fresh calcium hydroxide in a liter of distilled water and allow it to settle. Then decant or filter the clear solution. It will last for about a week in a tightly stoppered glass or polythene container.

Using magnesium carbonate

Mix 9gms of magnesium hydroxide – or (not so good) 15gms of light magnesium carbonate (laboratory grade) – with part of one liter of distilled water, and pour it into a soda syphon. Add the rest of the water and shake the syphon. Discharge two bulbs of carbon dioxide into the mixture, and shake vigorously every five minutes for about an hour. Transfer the solution to a glass bottle and filter it before use.

PRIMING A CANVAS

After a canvas has been stretched, it must be primed. It is important that the canvas is prepared in this order as, if it were primed before being stretched, the priming layer would introduce an additional strain that would increase in dry conditions. By priming an already stretched canvas, on the other hand, the priming itself will not be affected and the strain in a typical painting will be limited to around 0.2 per cent. The priming process for oil painting supports can be divided into two stages: glue sizing and the application of the ground (see opposite).

GLUE SIZING

Glue sizing a canvas is said to protect it from the harmful oxidizing effects of the oils in the priming or paint layers. However, the oil content of an oil ground is only about 12 per cent so it should not be a major problem. In any event, linen degrades by oxidation in light or dark conditions and there is no evidence to suggest that glue sizing retards this degradation significantly. It has been claimed that glue sizing prevents the ground from coming through to the back of the linen, as if that were a bad thing. In fact, it may well be a useful method of enabling the ground to adhere well to the support.

The temperature of the size
During the nineteenth century, when artists' colormen took over the preparation of linen supports from the artists themselves, they applied sizing as a cold gel which created an effective surface sealer and enabled the Lead White and chalk primers to be very thin. However, if the painting became damp, the priming – with the painting on top – just popped off the glue size layer.

Commentators have maintained that sizing should be applied cold or just warm, rather than hot, so as to ensure that it does not penetrate the fibers of the canvas. Again there is insufficient data to establish that the application of hot size is damaging. Indeed, there are times where the behavior of the size can be seen to compensate for changes undergone by the canvas as the humidity varies. As humidity increases, the size relaxes and swells so that, when the canvas shrinks at a RH of about 85 per cent, glue size within the fibers begins to counteract this tension.

Contraction
The major problem with size in a painting, however, is in dry conditions (which are more common than wet ones). If there is a lot of size on the canvas, so that it is able to operate as a distinct layer, it becomes by far the most powerful factor in the system. In such conditions the canvas is relaxed, the size layer extremely tense, and the paint layer only slightly tense. The result is that the contracting size layer pulls at the canvas and the paint, forcing cracks and the peeling of the paint layer. Such problems are clearly noticeable in a large number of nineteenth-century paintings. (See also p.64, where a possible alternative to glue size is also discussed.)

The answer is to use as little size as possible and to apply it hot. Polyester fabrics require no size at all with an oil priming since such fabrics are stable to acids and alkalis.

PROTECTING CANVASES FROM THE BACK

Anything that prevents the back of the canvas coming into contact with ambient dirt will considerably reduce its rate of degradation. A double layer of canvas from the nineteenth century in which the lower layer has a priming facing outwards, has shown the protected linen to be far less degraded than contemporary conventional supports. A tight-weave polyester cloth can be stretched first on the frame and linen canvas stretched over it.

A backboard helps prevent accidental knocks. It should not have any holes in it as they help transmit irregularly any changes in humidity – the mystique about "letting the painting breathe" is a nonsense.

Enclosing the canvas completely would provide the best protection but, since glazing interferes with appreciation, a coat of varnish is used to protect the face of the canvas from dirt.

Using a backboard
A backboard made from hardboard, or even cardboard, will protect the back of the canvas by helping to stabilize the environment around a painting. Fix it on with tacks.

TENSION AND FLEXIBILITY
The different materials used to prime canvas may react differently to aging and to the support itself, causing problems of tension and flexibility.
■ Oil grounds become very brittle but they do not develop the same kinds of tension as glue size (see above).

■ Soft acrylic grounds on fabric are not in themselves too flexible to use for oil painting but they leave the structure itself too flexible for the oil film. They may be a more suitable ground for oil painting on a more rigid sailcloth-type polyester fabric. See pp.66–7 for details of grounds suitable for flexible supports.

GROUNDS

Traditionally, the ground is the layer of glue size (see opposite), together with the pigmented primer, that is laid over the support to provide a suitable surface for painting. This layer can range from a thin coat of pigmented acrylic emulsion to a thick coat of white gesso. Different techniques and different painting media require different kinds of ground. These are outlined in the following section and detailed in the various painting media sections.

The functions of a ground
The ground performs three main functions: Firstly, it isolates the support from potentially damaging ingredients in the paint. This is particularly important in oil painting, where an excess of oil seeping from the paint into the fibers of the canvas is said to oxidize and embrittle the cellulose in them and cause their disintegration. The seriousness of this problem has, however, been largely overestimated in the past.

Secondly, the ground provides a surface that will accept the paint and allow it adequate adhesion. The surface must have a degree of tooth that will enable it to accept the paint, and a certain degree of absorbency. For oil painting, a ground that is too absorbent soaks up most of the oil from the paint, leaving a brittle film of paint that is liable to crumble to dust. If the ground is completely non-absorbent, however, the paint film will probably peel off.

Finally, in transparent and semi-transparent painting techniques, the ground enhances the colors of the painting by providing a white reflective background. This illustrates the need to use permanent materials in the pigmented ground. For example, an artist who used a cheap household emulsion as a primer, and then made a painting using transparent glazes that relied on the white of the ground, would soon be faced with a dull, yellowing painting as the ground would discolor within ten years.

·Size and gesso ground·

This type of ground consists of a layer of glue size and a layer of "gesso", the name given to the white powder which is mixed with glue size to form the actual surface on which a painting is made. There are various methods of mixing and applying the ground, but I have chosen to describe only the standard modern method and one of the traditional techniques.

Size and gesso ground is commonly used for rigid supports, but is not recommended for flexible supports. See pp.66–7 for alternative grounds.

Making glue size
Dry granules of rabbit skin glue are mixed with water and heated gently in a double boiler.

THE GLUE SIZE

Glue size is made by mixing dry glue with water. Glues made from rabbit-skin or other animal skin, or hide, are generally recommended for size and gesso ground. Rabbit-skin glue is flexible and dries out with relatively little tension. The more refined gelatine can also be used but is thought to be less effective and more brittle.

The ratio of dry glue to water is a crucial factor in determining the strength of the size. Too strong a size will produce great tension and cracking; too dilute a size will produce a weak, soft film. A more porous support will require a stronger solution than a less porous one. The ratios of size to water vary considerably. A 6:100 solution is recommended by Wehlte as the standard solution for most of his gesso

recipes. Mayer advises around 90gms (3oz) of glue to 1 liter (1 quart) of water for rigid panels. If used as an isolating layer on canvas, a weaker solution of 35–45gms per liter is used.

The glue is allowed to swell in cold water overnight. The mixture is then gently heated in a double boiler until it is hot (it should not be boiled, as this impairs the strength of the size).

Mixing alum with the glue size Many commentators have recommended the addition of alum at up to 10 per cent by weight of the dry glue. This has the effect of hardening the gesso and making it slightly less resoluble. It does not affect the absorbency of the ground. Since most glues are only resoluble with warm or hot water, this would not seem to be a particular problem. In addition, size on a rigid support would need no hardening. Perfectly good results are obtained without this additional acidic element, so it is a matter of individual choice rather than necessity.

Applying the glue size
Apply the size to the back and edges of the support as well as the front. The first coat should be slightly thinned down and subsequent layers applied at full strength. Use a bristle brush and allow each coat to dry thoroughly before applying the gesso (see opposite).

Coating the panel
Two coats of glue size, applied at right angles to each other, are usually used.

Glue size on flexible supports
Although size and gesso ground should not be used on flexible supports, glue size can be used as an isolating layer on cotton or linen canvas, and does not need to be as strong as for rigid supports (see also p.62). Glue size has been shown to be responsible for a great deal of the mechanical damage (cracking) which oil paintings on flexible supports often display. This is due to the changes in stiffness that the glue layer undergoes in relation to changes in relative humidity. Glue size remains, however, the most common method of isolating the oils in paint and in the ground from the canvas. It should be diluted in a thin solution of 35–45gms per liter and applied reasonably hot as recent research has shown that it may do less damage to the paint film if it is to some extent absorbed within the fibers of the canvas.

SODIUM CARBOXY-METHYLCELLULOSE AS AN ALTERNATIVE TO GLUE SIZE
For some reason, many artists are wary of modern materials, although they are often more suitable than traditional ones. A possible alternative to using the traditional glue size on flexible supports is carboxymethyl-cellulose (CMC), which has been used for some time in the textile industry as a warp size.

CMC is a cellulose ether, produced by reacting alkali cellulose with sodium mono-chloroacetate. It is available as a whitish powder or granulate which dissolves in water to form a clear viscous solution. It can be obtained in a wide range of viscosities but, for textile sizing, a relatively low viscosity type is generally used.

Refined CMC forms a flexible film that is resistant to oils and organic solvents. It is also physiologically inert.

Applying a chemically com-patible sizing to the cellulose fibers of the cotton or linen canvas alleviates the problems associated with traditional glue sizing. Any expansion which occurs with changes in relative humidity will take place at a similar rate between the cellulose size and the canvas, so avoiding cracking.

Although, like glue size, the coating will stiffen the canvas, this is not at the expense of flexibility – the cellulose does not shed or crack as glue size might do in certain dry conditions.

Around an eight per cent solution is generally used for sizing, the powder being dissolved in cold or hot water in much the same way as a wall-paper paste, which it closely resembles. It should be stirred and left to swell, after which it can be stirred again before being applied with a stiff brush. It basically forms an outer coating on the fibers, though there is some diffusion through the pores and some seepage into the fiber itself, depending on the viscosity of the grade. Two coats may be applied. As with glue size, no priming should be applied until the cellulose size is completely dry.

THE GESSO

The gesso layer provides the background color and texture on which the painting is made. Gesso is simply made by pouring hot glue size gradually into dry whiting or precipitated chalk and stirring vigorously until the mixture has a light creamy consistency. It is left for a few minutes, to allow trapped air to surface, before being applied.

Pigments and other additives in the gesso The huge number of varying recipes for gesso all basically consist of inert white pigments bound in aqueous glue solution, but a wide range of other ingredients has been suggested. The two main factors which should determine your choice are whiteness and texture.
■ You must first decide how important it is for the board to be a brilliant white. For thin, transparent coatings which rely

for their effect on the whiteness of the ground, this is an important factor, so a certain amount of white pigment can be added. Titanium White is to be recommended for its opacity. I combine 1 part with 9 parts dry whiting or precipitated chalk, which bulk out the gesso and give it other working qualities.

■ The second consideration is the hardness, smoothness or roughness of the ground. If a very smooth ground is required, the traditional red or white bole or clay can be mixed with the chalk. China clay or kaolin is an almost identical clay which can be used for the same effect. If a rough ground with a great deal of tooth is required, powdered pumice, sand, marble grit or limestone dust are all acceptable ingredients.

You can very easily experiment with various mixtures and create grounds that are most suited to your own requirements. Since these additives are inert, they have no chemical effect on the subsequent paint film and, provided they are well bound in the gesso and to the rigid support, will remain reliably permanent. (They can of course be added to acrylic emulsion primers.)

Other ingredients

When attempting to use size and gesso on flexible supports – a practice which should be discouraged – artists have incorporated ingredients like honey or glycerine to impart flexibility to the primer. The use of such moisture-sensitive ingredients is not sound practice.

APPLYING THE GESSO

The number of coats of gesso that are applied is a question of personal preference, but it should create a smooth, even surface of brilliant whiteness. Artists generally apply between three and seven layers. The absorbency of the ground is increased with the thickness of the gesso layer as is the tension created by the size. It has been suggested that the upper layers of the gesso be bound more weakly than the lower ones in order to avoid the worst effects of the inherent tension in the film.

Strictly speaking, to minimize the risk of warping, the ground should be applied to both sides of a panel and also to the edges (not so much care needs to be taken with the back).

Sealing the gesso ground

The gesso described above is absorbent and, for some techniques, it will need sealing in some degree to lessen its absorbency. A completely absorbent ground will soak up all the oil from an oil color, leaving the pigment dusty, dry and far too weakly bound to be permanent. Among the sealers that are safe if used thinly and on rigid supports are diluted synthetic resin dispersions, glue size and shellac diluted in alcohol.

The sealer should not be resoluble in the solvent which is used to thin superimposed layers of oil paint.

How to apply gesso

I Work the first coat into the surface of the panel, using a bristle brush, a nail brush or a linen rag. Trapped air bubbles can be released by smoothing the gesso with the fingers.

2 As soon as the first coat is dry enough, apply a second coat with a flat bristle brush. Apply subsequent coatings of gesso at right angles to each other.

3 Allow the gesso to dry thoroughly and abrade it to a smooth level surface using wet and dry paper or an orbital sander, which will do the job much more quickly.

4 A still smoother, lustrous finish is achieved if you rub the gessoed panel with a damp cloth. When it has dried, it will be ready to paint on.

Using glue size as a sealer
A weak solution of gelatine or glue size is a perfectly adequate sealer.

TRADITIONAL SIZE AND GESSO GROUND

This variation on the ground already described is that recommended by Cennino Cennini in the fifteenth century. This traditional method of coating a panel in gesso provides as permanent and white a ground for rigid supports as many a modern preparation (see *Tempera*, p.172). Nowadays, chalk (as natural calcium carbonate or precipitated chalk – an artificial whiting) is used more commonly than the gypsum that Cennini recommended. It is generally mixed in varying proportions with opaque pigments such as Titanium White or Zinc White. Pigment/whiting ratios of between 1:10 and 1:1 have been suggested. Cennini's method uses two types of gesso:

■ *Gesso grosso* This is made by grinding plaster of Paris in glue size. A single coat is applied with a spatula.

■ *Gesso sottile* Here the plaster of Paris is soaked in water for a month – the mix being stirred every day before being ground, squeezed of water and added to hot, but not boiling, size. A number of coats are applied at right angles to each other.

Using cloth

Cennini recommends covering the sized panel with thin strips of linen. These should be soaked in size, then laid and smoothed over the panel. This would generally be done over the joins between individual planks to minimize the risk of cracking. Covering the whole panel with small pieces of cloth was said to avoid the stress that a continuous piece might put on the panel by contraction. In practice, if a lightweight, loosely woven linen is used, there is little danger of this. With a gesso priming, the cloth is not visible in the finished panel. With a panel more thinly primed with a modern acrylic or oil-modified alkyd resin primer, the texture of the cloth will be an integral part of the look of the panel, so a continuous piece of fabric must be used. If the backing panel is a rigid piece of composite board such as hardboard or fiberboard, there is of course, no danger of cracking. See p.51 for the modern way of gluing fabric to rigid supports.

Some commentators have argued that cloth adds an additional and largely un-necessary element to a panel, with risks of defects such as blistering. But, provided the cloth is lightweight enough, there is very little risk of such changes. However, it is true to say that a panel can be perfectly well prepared without fabric – especially nowadays, with the wide range of modern man-made wooden supports that are available (see pp.48–9).

·Other types of ground·

TRADITIONAL EMULSION GROUND

A proportion of linseed oil (at least 25 per cent by weight), added drop by drop to a hot gesso mix and stirred vigorously, produces an emulsified mixture. The resulting ground is far less absorbent than the aqueous gesso described above, and also more flexible. It shows a tendency to yellow and may become more brittle in time. But it is a perfectly acceptable ground, especially for rigid supports and opaque painting methods (which conceal it).

TRADITIONAL OIL GROUND

This is a traditional method of preparing a rigid support with a non-absorbent oil ground on a rigid panel. The panel is coated with linseed oil and allowed to dry. Then it is coated in White Lead ground in linseed oil and, when this has dried – which may take a number of days – the ground is abraded. The process is repeated with long gaps for drying each time. The resulting coating is hard and thin and suited to the "enamel-like application of paint with subtly fused color gradations" (Wehlte).

White Lead in oil is still favoured by some painters but, nowadays, it is usually applied over a coat of glue size. Two coats are usually satisfactory and each should be allowed to dry thoroughly before overpainting. The panels are usually left for six months before painting. The reason is that applying fresh, wet oil paint on a half-dry oil ground causes serious problems of cracking and non-adhesion.

MODERN "OIL" GROUNDS

The White Lead in oil primer can be acceptably replaced by the primer produced by a number of artists' materials manufacturers, which is made from titanium dioxide in oil-modified alkyd resin. The synthetic resin medium is extremely durable and non-yellowing. It should be allowed to dry thoroughly between coats but does so in a much shorter time than the linseed-oil-based equivalent. As with other primers, the edges and back of the panel should be painted to prevent moisture absorption and warping. Unlike the White Lead in oil primers, they can be applied directly (provided the panel is clean and free from grease), but textile supports are generally given one or two coats of thin glue size first.

OTHER SYNTHETIC RESIN-BASED GROUNDS

The so-called "acrylic gesso primers" are not gesso at all. They are merely pigmented acrylic resin dispersions. As such, they are non-yellowing and non-cracking and give good adhesion to most surfaces without the need for a preliminary coat of glue size. They are extremely flexible and are appropriate on canvas for use with acrylic paints. They can be used as primers for oil painting on rigid supports but they are too flexible to use as primings on canvas for oil painting – the film of oil paint would be less flexible than the ground and would therefore be extremely vulnerable. There are more rigid self cross-linking acrylic resins which provide suitable dispersions in primers for oil painting on canvas, but these are difficult to obtain. The proprietary acrylic primers can be given additional tooth by small additions of inert fillers like powdered pumice or marble dust. Such modifications are acceptable as long as the resin can still form a coherent film which does not powder or crack.

The acrylic dispersions (called emulsions) which bind the white pigment powder are available in non-pigmented form as acrylic mediums. These have the characteristic milky appearance of resin dispersions and dry transparent. They can be used directly as primers for flexible or rigid supports when the artist wishes to use the color of the linen or wood as part of the painting scheme.

PVA painting mediums are often used in this way (see p.210). The problem with these resins is that, although they are acceptable on rigid supports, they are not so reliable on canvas. The reason is that their flexibility is, in many cases, a result of the addition of plasticizers which may lose their effectiveness after a time, leaving a brittle film. PVA resins are said to exhibit more yellowing characteristics than acrylic ones, though they are constantly being improved in this respect and some are also now internally plasticized, which makes them more durable. If the unpigmented emulsions of PVA mediums are used by artists as sizing, sealing or adhesive coatings, preferably on rigid supports; those that dry without being resoluble are best. There are a number of such mediums on the market that are resoluble – these usually contain large amounts of dextrin.

HOUSEHOLD PAINTS AS PRIMERS

Most water-based emulsion paints for house decoration are based on vinyl resins and these have been used as primers by artists needing a fairly absorbent ground. In addition, there are now acrylic-based, semi-gloss paints that are said to be considerably more durable than the alkyd-based ones and which some artists have used (after abrading the dry surfaces to give it key) for semi- or non-absorbent grounds. Artists have also used commercial oil-based white matt undercoats as priming coats over glue size for oil painting. Although the manufacturers of all these paints may well be using the same basic oils or resins that are used by the manufacturers of artists' materials, they are working to a specification which requires a maximum life of only ten years. Certainly, in the recent past, a great deal of colophony or rosin was added to house paints and commercial coatings. If used by artists, these would eventually lead to serious discoloration and embrittlement of the paint film. Such coatings are safer on rigid supports, and when an opaque painting technique is employed where the colors do not ultimately rely on the whiteness of the ground.

OTHER COMMERCIAL COATINGS

The widespread use of materials developed by modern industrial processes was discussed in the introduction to the book see (pp.6–9). As the technology of coatings becomes more refined and scientifically complex and the products more reliable, it seems likely that the artist will come to rely on them a great deal more for priming purposes.

As with the commercial development of extremely lightfast pigments for the automobile industry, or the development of stable wooden boards or honeycomb aluminum for various construction industries, the artist can capitalize on high-performance industrial products and exploit new materials that are demonstrably better than those that have traditionally been used for artistic purposes in the past.

Some of the newer resins outlined on pp.35–7 provide tough, durable coatings that can be used on wooden or metal supports. These include the two-part polyurethane and epoxy resin systems, which are particularly durable and resistant to chemical attack. Many are suitable for exterior use. If used as priming coats on glass fiber, aluminum or wooden panels, they should be rubbed with wet and dry abrasive before over-painting. These systems are outlined in the discussion of the rigid supports on which they can be used (see pp.49–51).

A number of exterior texture paints have appeared on the market in recent years. Such paints are normally based on flexible resin binders and incorporate high-grade pigments and inert mineral fillers. They are often applied over an open-weave polyester membrane that is stuck to the wall or substrate being coated. This technique has been used on rigid supports to obtain a particularly rough and abrasive ground.

·DRAWING·

PENCIL

The so-called "lead" pencil is, in fact, made from graphite. This material used to be called "black lead", thus "black lead pencil", which became shortened to "lead pencil". Graphite is a form of natural carbon, created, like coal, by the pressure of the earth on the decaying forests of pre-history. Coal is formed by pressure alone, but a combination of pressure and heat re-crystallizes the amorphous carbon into plate-like crystals of graphite. These are weakly bound between layers, which gives graphite its smoothness.

The most common form of naturally occurring graphite is the amorphous, or shale type which is crystalline but crumbly, and so not suitable for direct use as a drawing medium. Solid graphite was discovered in Borrowdale, Cumbria, England, around 1500 and subsequently mined for three centuries. Its main use was in the armaments industry, in making moulds for cannon balls.

·Pencil drawing equipment·

THE HISTORY OF THE GRAPHITE PENCIL

The Cumberland mine where graphite was initially discovered, was unique, and the material became very expensive. A thriving black market developed which smuggled large quantities abroad. Solid graphite was found to have excellent mark-making characteristics and pieces of graphite wrapped in sheepskin were used as a drawing medium.

The first wood-encased pencils Between 1600 and the late seventeenth century, pencil manufacture developed very little. Pencils were made from graphite sawn into thin sheets. A sheet was wedged into a channeled groove in a piece of timber. The graphite was scored along the top edge of the groove, and broken off. Another piece of timber was glued on to it. This "square" pencil was then rounded with a hand-plane.

Napoleon urged his scientists to come up with an alternative to solid graphite, and in 1795, Conté discovered a method of mixing amorphous graphite with clay and firing the mixture at high temperature to form a "solid" graphite. This is the basis for the manufacture of leads today.

Solid graphite
This material was first used for making cannon ball moulds. Being volcanic, it remained unaffected by the heat of the molten metal.

Nineteenth-century pencils
A bundle of American Thoreau pencils. These are early examples of the more modern method of pencil manufacture.

HOW MODERN PENCILS ARE MADE

The purest and best graphite is that with the highest carbon content. Very pure forms with 98–99 per cent carbon come from Sri Lanka but sources are worldwide, ranging from Mexico to Korea. Graphite is micronized to a very fine powder before being supplied to pencil manufacturers. The degree of hardness or softness of the pencil lead depends on the proportion of clay to graphite. The more clay, the harder the pencil. The clay has two functions: to hold the mix together before it is fired and once fired, to act as a rigid matrix, or carrier, to hold the graphite in place.

The lead manufacturing process The clays in pencil leads are ball clays from various deposits. These are essentially silicates, colloidal in particle size and nature. The clay is mixed with water to make a slurry and charged into a ball mill which grinds down the particle size of the graphite and provides an intimate mixture (thoroughly mixed compound). The water is

removed by filtration, resulting in graphite clay solids called "cake". The cake is ground into a fine powder. A known amount of water is added and the solid mass hammered into a bullet or cylinder about 37.5cm (15in) long and 15–17.5cm (6–7in) in diameter. A vacuum pressure system sucks the remaining air out and a ram-head drives the mass in an extrusion press from which the material gets squeezed out like spaghetti through a die-head. This material is chopped into pencil-lead lengths and dried to remove water. The structure now has a number of holes previously occupied by the water. The leads are then fired at about 1800°F, allowing the clay to soften, lose its chemically combined water, and fuse with the rest of the clay to form a structure. It is a matter of skill to fire to just the right point.

At this stage, the leads would be too scratchy to write with, so they are impregnated with molten wax – soft or hard depending on whether the degree of hardness or softness of the pencil needs adjusting. As the leads are immersed in a wax bath, bubbles of air show the wax displacing the space which the water had occupied during the extrusion process. Finally, excess wax is spun off.

The wooden casing of the pencil

The first tailor-made timber for pencils was cedar from Florida, taken from old railroad sleepers, well seasoned with oil and steam from the trains. This was used in the 1930s. Subsequently, Kenyan cedar was used, shipped in planks, sawn into slats and placed in pressure chambers for impregnation with an oil emulsion. This provided lubrication, enabling the timber to give a neat cut when the pencil was sharpened.

How pencils are assembled

1 Nowadays, slats for pencil-making come ready cut, seasoned and impregnated with wax and stain, from Californian companies which supply the world market. The wood comes from the incense cedar, *Libocedrus decurrens* – not a true cedar, but a relation of the Californian redwood, or sequoia.
2 Channels are drilled in the slats.
3 The pencil leads are glued into each slat with PVA adhesive.
4 A second slat is glued on top.
5 The pencils are shaped, separated and coated with cellulose paints.

PENCIL SIZES AND SHAPES

Although most pencils come in a standard 17.5cm (7in) length, the shape and diameter of the lead and of the outer casing vary. Apart from the flat, rectangular carpenter's type, pencils are usually hexagonal or round. A pencil with a thin casing can be used for odd pieces of work, but working with it for any length of time tends to fatigue the hand.

The hexagonal pencil

This sits firmly cradled in the hand with the index finger on one face and the thumb and middle finger on two others. This gives a firm grip suitable for writing or close line work.

The round pencil

For flexibility on the point or side of the core, a round pencil is more suitable as it can be rolled fractionally to any position rather than only through 60 degrees as with hexagonal types.

The widest (4mm) cores are mostly used in colored pencils or in very soft graphite ones, where the edge of the lead is as important as the point. In a standard graphite pencil, kept sharp and used for writing or drawing, probably only five to ten per cent of the core is actually used, so a thinner core is preferable.

Obtaining an even effect

When shading large areas of even tone, use the flat area which develops on the side of the pencil's core. Keeping your hand pressure constant, you can produce an even shade. But rolling the pencil so that an edge of the flat (with far less surface area) is in contact with the paper, even if your hand weight stays constant, will result in a streak. In practice, you are unlikely to roll the pencil in your fingers during constant shading, but this is why it is possible to have problems with continuous pencil tones.

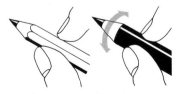

Holding round and hexagonal pencils A hexagonal pencil tends to rest in the same position in your hand; a round pencil can be rolled slightly so as to use every part of the side of the lead.

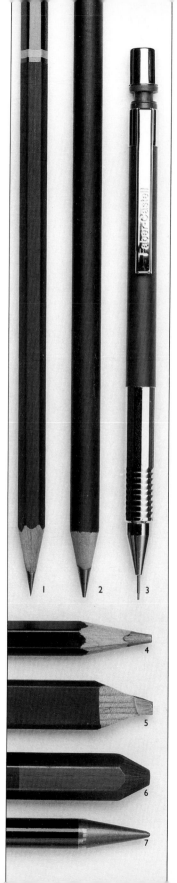

TYPES OF GRAPHITE PENCIL

The most commonly available pencils are the standard hexagonal 17.5cm (7in) type with a 2mm-diameter round graphite strip or lead encased in wood. Round versions are slightly less common. Some manufacturers offer a range of thicker lead, wood-encased drawing pencils, up to 4mm or 5.7mm. Others make a range of round or hexagonal "pure" graphite crayons, 7mm, 8mm or 12mm in diameter. Mechanical clutch pencils are also sold; these carry leads in a range from 0.3mm to 2mm.

The graphite strip which does the drawing is basically the same product in each case. A "thin to fat" range of 0.3mm to 12mm and degrees of hardness to softness of 7H to 8B means you can carry out a wide range of manipulations and techniques.

Pencils for drawing (left)
1 Standard hexagonal pencil
2 Round drawing pencil
3 Mechanical clutch pencil
4 Large hexagonal pencil
5 Rectangular lead sketching pencil
6 Thick hexagonal graphite stick
7 Round graphite stick

SHARPENING PENCILS

Pencils are best sharpened with a sharp blade (craft knife or modeling knife). Although pencil sharpeners are extremely efficient at first, the blade becomes blunt fairly rapidly and artists tend not to replace or sharpen it. The action is no longer smooth; invariably the pencil lead breaks or the wood is not shaved away smoothly.

SUPPORTS FOR PENCIL DRAWING

White or cream paper is the most common support for most types of pure pencil drawing, though other light-toned colored papers may also be used. Some artists make under-drawings in pencil for paintings on board or canvas. Matt polyester drafting film is a relatively new support, with a surface that is particularly receptive to graphite.

For permanent drawings on white paper, choose an acid-free pure rag paper; even high-quality cartridge paper will yellow with age. If not accidentally erased, graphite marks are, in themselves, totally permanent.

ERASERS

One of the aspects of pencil drawing which accounts for its popularity with artists, is the fact that marks can easily be erased and re-drawn. There are a number of proprietary erasers on the market, including the conventional rubber variety, the soft putty or kneadable eraser, the artgum eraser and probably the most useful of all, the relatively new plastic or vinyl erasers. White ones are used for pencil work and are highly efficient. They are firm-textured but do not remove the paper surface. They can easily be cut into sections for precise work.

Types of erasers
1 Kneadable putty rubber
2 Standard rubber eraser
3 Artgum eraser
4 Plastic eraser

·Pencil line techniques·

Pencil is permanent, and yet adjustable in a way that other drawing materials are not. The artist has enormous control over the pencil line since it can be worked, erased and reworked. It can have a soft, velvety quality or a crisp sharpness. It is capable, on the one hand, of great subtlety and delicacy and of great boldness and vigor on the other. Pencil is an economical, efficient and tidy medium.

THE QUALITY OF THE PENCIL LINE

These simple wavy lines made with three types of graphite lead on two different white paper surfaces (smooth and rough), show how much the nature of the surface affects the nature of the line. The two left-hand sets of lines were drawn with an even pressure, the two right-hand sets with the pressure varied along the length of the line.

How pressure alters line quality The pencil lead gives you considerable control over the tone of each line. With Indian ink, felt-tip or biro, it is impossible to get the subtlety and variation along the length of a line that can be had by altering the pressure with a pencil. In pure line drawings, artists can make great use of this tonal gradation within a line by deepening the line where two contrasting tones abut and lightening it where the tones are similar.

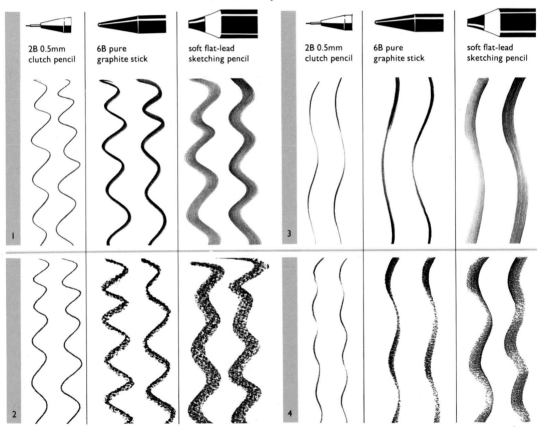

2B 0.5mm clutch pencil

6B pure graphite stick

soft flat-lead sketching pencil

2B 0.5mm clutch pencil

6B pure graphite stick

soft flat-lead sketching pencil

I Smooth paper, even pressure The smooth paper encourages fluency of line and even distribution of tone along the length of the lines, which have a clarity of edge lacking on the rough paper.

2 Rough paper, even pressure This paper gives a much greater depth of tone; the surface traps and holds more graphite. However, the paper texture also makes the lines rougher and less crisply defined.

3 Smooth paper, varied pressure Hand pressure on the lead has been adjusted from firm to light along the length of each line. These lines are more "ribbon-like", existing in a more three-dimensional space than sets I and 2.

4 Rough paper, varied pressure Altering the hand pressure is equally effective here, especially with the graphite stick and sketching pencil. The grain of the paper emphasizes tonal gradation.

THE SENSITIVITY OF THE PENCIL LINE

This portrait drawing shows great composure, without being over-precious. An extraordinary control, and, one imagines, a great deal of preliminary sketching-out, are evidenced in the careful fluency of the line with which every curve is treated. The delicacy of the features and of the curve of the chin is equally present in the folds of the material, which is positioned with careful poise over the left shoulder.

Sketch for the Portrait of Mme Devauçay (1807), by Auguste-Dominique Ingres.

Controlling the quality of the line Your choice of pencil plays an important part in determining the quality of the line. For instance, in quick, small-scale, sketchbook drawings where you wish to work in a direct and immediate way, a sharpened hard to medium pencil (H, HB or B) is very suitable. By contrast, a pencil in the soft range (3B to 7B) produces a deep, thicker, velvety line.

Whichever pencil is used, the graphite line can vary considerably in tone along its length and has a quality of warmth and engagement which is hard to find in other media.

Using a crisp line
In this two-minute drawing, a sharp HB pencil has been used to sketch in the basic outline of the figure. The sketch was made as a direct response to the model, with no prior measuring or careful following of contours.

Line work with a 2H pencil
Artists who are unfamiliar with hard pencils are apt to dismiss them in favour of the "B" range – a 2B is probably the most common drawing lead. In fact, the "H" range is just as expressive. This study of a young girl was drawn with a sharpened 2H pencil on middle-weight cartridge paper. The pencil was held at the end farthest from the point so that it could be moved lightly and quickly over the paper, giving a light-toned, random feel. The scattered marks gradually resolved themselves into the girl's features.

Working with a hard pencil
The ultra-fine, feathery lines were made with a lightness of touch not possible with softer pencils. They give a kind of mobility to the face.

Using a tonally varied line
A sketchbook drawing made with a 4B pencil. The same drawing made in uniform-tone pen and ink would be flatter and less complex in feel.

·Pencil tone techniques·

There are several methods of building up the appearance of tone in pencil drawing. The techniques rely for their particular quality on the nature of the support. Three of the most popular and effective methods – cross-hatching, shading, and shading and rubbing – are shown in these examples. Other linear methods include closely following the contours of an image with closely-drawn parallel lines.

Cross-hatching
Types of cross-hatching involve using intact pencil lines running in two or more different directions. The samples show that the rougher the surface, the more the regularity of the cross-hatching is broken up. Only on the smooth paper is the crisp mark of each line retained; the pencil marks appear to lie on the surface. Cross-hatching is rendered less mechanical by the rough surface, which seems to incorporate the marks satisfyingly into the surface.

Shading
The simplest method of building tone, this can be done using the natural movement of the arm or wrist, the elbow acting as the pivot on the drawing board. The samples show patches of close one-way shading in each lead on each paper. These show a similar effect. On the rough paper, the grain of the paper turns them into uniform areas of half-tone where the graphite adheres to the ridges of the paper, but the indented areas are left white. The flat-lead pencil on the smooth paper quickly and effectively creates a uniform area of tone without the marks of the tip of the lead shown by the graphite stick and the clutch pencil.

Shading and rubbing
Within the close, one-way shading, lines can be formed or softened using the fingers, a paper stump or an eraser. The white indented areas on the rough paper become filled with a soft, pale gray tone. In general, it can be seen that the thinner the lead used, the finer the tone will be; note especially the differences between the graphite stick and the clutch pencil.

Creating tones in pencil
For these tone samples, three different kinds of graphite lead were used on two different surfaces – smooth and rough papers.

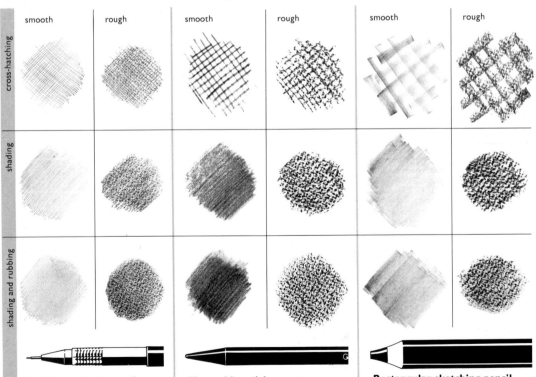

2B 0.5mm clutch pencil
The fine lead inserted in the clutch pencil is capable of producing a range of delicate tones.

6B graphite stick
This yields the deepest tones but can be sharpened to make finer lines than the sketching pencil in cross-hatching.

Rectangular sketching pencil
The soft, flat lead in this pencil is very chunky and builds tone quickly.

TONAL DRAWING WITH LINES

These two tree studies on pure rag paper illustrate some fairly unconventional shading techniques. For the first tree, a series of long or short vigorous upward strokes was made with two flat-lead drawing pencils – a soft 4B and a hard H. As the marks were gradually built up and superimposed, a fully rounded form emerged. The flat edges of these pencils make broad, tapering, axe-like marks. Turned around 90 degrees, they provide sharp, thin marks for the impression of detail.

In a freer and bolder version of the same drawing (bottom), a very soft, dark 6B graphite stick was used in a series of vigorous, wavy down-strokes to indicate not only the form, but also the tones. Although it is still essentially a line drawing, a plastic eraser was pulled down it in a series of strong strokes. Strangely, this emphasized the upward growth of the foliage.

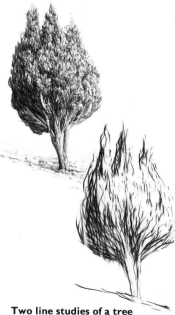

Two line studies of a tree
The direction in which the pencil strokes are made alters the character of the drawing – top, upward strokes; bottom, downward strokes.

HIGHLY RESOLVED PENCIL DRAWINGS

Pencil drawings can be taken to a high standard of finish because a graphite pencil can effortlessly cover the whole tonal range. Restricting a drawing to a single grade of pencil can give the work an overall unity, especially where an image speaks for itself as a convincing representation by the subtle modification of tone and form over the whole paper surface, rather than in any overly expressive marks which bring forward the personality of the artist.

PENCIL DRAWING WITH COLORED WASH

A pencil drawing can be used as a kind of *grisaille* or mono-chromatic underpainting, over which transparent watercolor or acrylic paints are laid to provide color. Working in this way is like color-tinting a black and white photograph, and produces something of a period feel. In *grisaille* underpainting, the tones are generally lighter than they appear in the finished work (in order to give dark, transparent pigments real depth in shadows). But in this example, the picture was made as a fully-worked drawing with a complete range of tones before color was applied.

The difficulty in creating a work of this kind over many hours is in retaining its immediacy and freshness. Also, reworking parts of the drawing without smudging finished areas can be tricky. One solution is to fix the work in stages, or simply to lay a clean sheet of paper over completed parts and to rest your drawing hand or arm on this (taking care not to shift it sideways).

Pencil study for a painting
The drawing in B pencil on H.P. paper is a highly resolved piece of work. The loose handling of shading on the diagonal helps keep it alive.

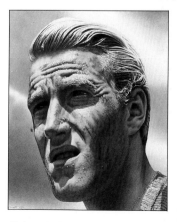

Colored portrait
This was originally drawn for a record cover and colored by spraying with transparent acrylic colors through masking film stencils with airbrush. Some hand-painting was also done with sable brushes.

DRAWING WITH AN ERASER

Working with an eraser is of course generally combined with conventional pencil drawing.

Erasers can also be used as drawing instruments themselves, as a means of working on line or tone quality in a drawing or even, by working into an area of continuous tone laid down on the paper, as the sole means of creating an image (see example, below). This technique is a satisfying method of working with tone in broad, bold shapes.

Once the uniform tone is laid down, the overall shape is picked out with the eraser and any large areas of light tone erased with bold strokes. Highlights are picked out and other light areas suggested by partial erasure. Stroking the eraser gently across the tone will smudge it slightly; careful use of this effect can suggest the mid to dark tones.

Nude study with an eraser
This drawing was made entirely with a vinyl eraser out of a uniform gray tone laid over white cartridge paper with the side of a 6B graphite stick.

DRAWING WITH A RANGE OF GRAPHITE LEADS

Many artists seem to stick to a favourite pencil, such as a 2B or a 4B, without exploiting the possibilities of using a range of degrees in one drawing. The thin, sharp, light mark of a 2H, next to the dense, black mark of a 6B, is an exciting contrast.

Landscape with several pencils
This small drawing uses a range of pencils from 4H to 6B, with smudging, erasing and indenting into the paper.

PENCIL DRAWING WITH OTHER MEDIA

This portrait shows the successful integration of two very different drawing media in one work. The eyes, nose, mouth, ear and basic shape of the head have been drawn with an HB or B pencil. The marks for eyebrows, nostril and line of the mouth have all been pushed more firmly into the paper. Other lines are lighter, but each has an assurance that comes of knowing precisely what the pencil is doing at each stage. Thick black and pale gray oil pastels have also been used. The juxtaposition of pencil and pastel creates a fully resolved work in which one complements the other.

Ray Smith (1980), by David Nash.

ALL-PURPOSE PENCIL

The all-purpose wax pencil (known under various trade names) was originally designed for marking plastic, china, metal or glass surfaces that could not be marked with a normal pencil. It is also well known for marking photographic contact sheets or strips of color transparencies in plastic wallets. But the all-purpose pencil is also an original and effective drawing instrument and can be used to good effect on paper.

The pencil, which varies slightly from one manufacturer to another, is rich in wax with a small amount of filler and high pigmentation. The wax gives it a soft, almost sticky touch on the paper and it can be used to make pale, soft tones or deep, velvety ones. The effect is similar to that of oil pastel and can be used for the overlaid and scraped-off effects characteristic of that medium (see p.90). All-purpose pencil is a more precise medium, coming as it does in pencil form and being easily sharpened.

LINE WORK IN ALL-PURPOSE PENCIL

Strong, chunky line work is a feature of the all-purpose pencil medium; once made, marks are permanent and cannot be erased, so drawings have to be made directly and with no adjustments. For this reason, it is a useful medium for direct observation drawing practice.

As well as deeply pigmented black lines, softer-toned lines can be made. The pencil can feel its way around a form in a more tentative, exploratory way, making more fragmented lines.

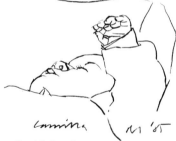

Rapid sketch
All-purpose pencil is a speedy medium, ideal for drawing quickly and directly. Subjects like children may require you to work speedily. Here the essential features of the baby's face were recorded rapidly in just a few moments.

Soft-toned sketchbook line drawing This larger work, 21 × 27cm (8½ × 10¾in), was made directly, with no alterations, beginning with the model's right eye and working outwards from the features.

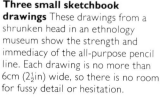

Three small sketchbook drawings These drawings from a shrunken head in an ethnology museum show the strength and immediacy of the all-purpose pencil line. Each drawing is no more than 6cm (2½in) wide, so there is no room for fussy detail or hesitation.

TONE WORK IN ALL-PURPOSE PENCIL

Softly blended tonal effects can be obtained by progressively heavier shading. It is possible to soften tones by rubbing with your finger as in graphite pencil work, but note that you have to rub hard and the drawing may smear. Most artists find it easier to rely on the grain of the paper for half-tone effects.

Fine shading, using a very sensitive touch on the paper surface, creates an effective range of tones. Just "grazing" the paper with the pencil leaves a mark. With this technique, pushing up with the middle finger (to prevent too deep a tone emerging too quickly) is just as important as pushing down with the index finger. As the pencil is sharpened and gradually used up, and your fingers get closer to the tip, the wax becomes warmer, stickier, heavier and slightly less controllable in the light tones.

Working on mid-toned paper Using both black and white all-purpose pencils on a mid-toned ground further increases the tonal range of the medium; the white providing highlights and the black the dark tones. Half-tone effects can be achieved by setting black and white lines against the middle tone of the paper.

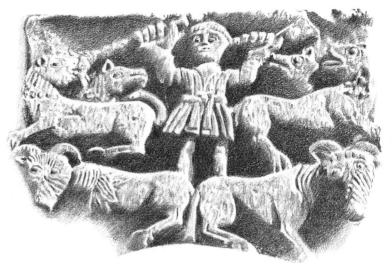

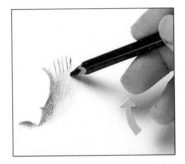

Using the pencil purely tonally Very few lines are used in this drawing. Different densities of the all-purpose pencil produce the tones.

Controlling the all-purpose pencil Handling the all-purpose pencil correctly helps you render tones by more or less pressure. Let your middle finger act as a counter-pressure to the index finger, which exerts a downward force.

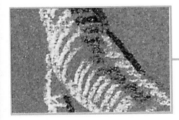

Tree study in black and white pencils Black and white all-purpose pencils were used on a mid-tone (green) paper for this drawing. Linear modeling was used to suggest the shapes of the trunks and branches by indicating their cylindrical forms with parallel lines (see detail, above).

COLORED PENCIL

In the past, artists have been justifiably wary of manufactured colored pencils which have sometimes failed to come up to the high lightfastness standards they require. Manufacturers are beginning to show a greater awareness of the problem and starting to make more consistently lightfast pencils. The most reputable ones are now prepared to identify the pigments used, with their lightfastness in full strength and in reduction (most colored pencils are reduced with white). You can, therefore, if you wish, choose to work with just those colors that come within the 7–8 category on the Blue Wool Scale (see p.13). The choice of available products is expanding greatly now that both water-soluble and turpentine-soluble colored pencils have been introduced. The range of possible manipulations and techniques is increasing accordingly. The medium is so rich and versatile in itself that it is regrettable that some manufacturers still sacrifice permanence for brightness in certain parts of the color spectrum.

——·The character of colored pencil·——

HOW COLORED PENCILS ARE MADE

Colored pencils are manufactured in the same way as graphite ones (see pp.69–70), except that the leads are not fired in a kiln since this would destroy the pigments. Instead, the mixture comprises pigment, a filler (chalk, talcum or Kaolin) and a binding material (usually a cellulose gum like hydroxy-propyl methylcellulose).

As with graphite pencils, the pigment sticks are immersed in molten wax to give them their drawing properties. Very stringent rules apply in the manufacturing of pencils that are liable to be chewed or sucked by children, and this means that pigments containing traces of soluble heavy metals cannot be used. This discounts the chromes and cadmiums and even naturally occurring earth pigments which could contain toxic heavy metals.

In general, the lightfast iron oxides are used for the earth colours, and for the greens and blues, newer permanent synthetic organic pigments like Phthalocyanine Blue and Green. Manufacturers have chosen less lightfast red/purples which look bright in the box but which are somewhat fugitive, especially in tints. I recommend using crayons at full pigment strength. Be wary of the red/purples unless you are sure of the pigment.

COLORED PENCIL EFFECTS

Many different effects can be obtained with colored pencils. When used without a solvent, they are characterized, however deep the tones, by a certain softness arising from the effect of the grain of the paper on the medium. Even on H.P. papers, the pencils leave a network of tiny white indentations which the pigment has failed to fill. This acts as a kind of overall "softener", especially on mid- to light-toned areas.

Using a solvent
The skilful use of water or turpentine (depending on the type of pencil) can fill the white areas left in the paper with the characteristic "watercolor" look, while retaining the shading.

Optical color mixing
The most outstanding feature of the medium is its use in subtle optical color mixing. Colors are not, of course, mixed before being applied to the support, but combine optically on the support itself, when shaded diagonally next to each other or overlaid

with various cross-hatching techniques. Because the tip can be sharpened to a fine point, transitions between colors or tones can be subtly controlled.

Choosing the support
Colored pencils are particularly sensitive to the nature of the surface of the support and marks on cold-pressed (NOT) paper look quite different to those on smooth H.P. paper. For permanence, a well-sized white, pure rag drawing paper is best, and an H.P. surface allows the most subtle manipulations.

·Colored pencil techniques·

Colored pencils can produce a broad range of effects from soft, light-toned sketching to highly resolved drawings with a full range of tones. There are several different ways of using them to apply color to paper.

USING WATER-SOLUBLE COLORED PENCILS

The effect of a "drawn and painted" image is very satisfying. With water-soluble pencils, this is quick to achieve. The effect of water-soluble pencils used dry is slightly softer than that of regular colored pencils – they deposit their pigment a little more easily on the paper.

To obtain the "watercolor" look, paint over the pencil work using clean water and either a damp, or a very wet sable brush, depending on the effect you want (see opposite). The best technique is to paint over the marks quickly and confidently. This way, the colors do not become too mixed and muddy and the original pencil marks are retained. Of course, the characteristic "dry" colored pencil appearance is totally changed, but it is replaced with something equally interesting, especially on textured paper. If the brush is too wet, the color can disappear completely. And if you over-work the surface, the optical effect will be destroyed.

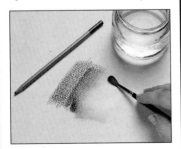

Working over water-soluble pencil Paint over the pencil marks quickly with a wet brush, but take care not to over-work the color.

SHADING AND COMBINING COLORS

For the series of exercises shown opposite, designed to demonstrate the properties of dry and water-soluble colored pencils, a simple "house" shape was used, with three faces showing – to represent light, middle and dark tones. For shading up to the sharp edges, a ruler acted as a "stop". Two kinds of Arches paper were used – a smooth H.P. and a fine-grain NOT paper.

Building up color mixtures
All the examples were worked in the same color stages: blue, blue/red and blue/red/green. When the second color, red, was added to the blue house, the colors blended optically but retained their separate identities. This effect is unique to colored pencil and would be difficult to achieve in any other medium, except possibly tempera, particularly on this small scale. When a third color (green) was added, the darkest side of the house showed just how deep a tone can be obtained.

Simple one-way shading on different papers
On the houses drawn with dry pencil shading on smooth paper, the shading lines can be seen, but on the NOT paper, the strong, granulated texture of the surface dominates the lines. Though drawn in the same way, the houses look rougher and are very expressive.

When red was added, the characteristic optical mixture was produced. The green pencil was shaded over the red and blue. In the darkest areas of the one and two-color houses, flecks of white paper were still visible, but these were obliterated by the third layer of heavy shading. Where the green filled the white gaps, it remained a "pure" color.

Shading with water-soluble pencils
The same shapes were also drawn with water-soluble pencils. Before any water was applied, the marks looked almost the same as the regular ones but, if anything, denser.

The houses were painted over with clean water, using a round sable brush, dipped in water, then dabbed on an absorbent tissue to stop it being too wet. The result was particularly effective on the NOT paper, where the "wash" covered the white indentations in the paper, but the darker tones of the pigment stayed on the ridges.

Hatching with water-soluble pencils Different effects can be obtained by using more water with water-soluble pencils or by using them to draw into wet colored pencil pigment. On both papers the plain blue house was painted over with a very wet sable brush, so that the pigment moved freely in the wet area.

Next a blue house was wetted more carefully and a red water-soluble pencil used on the damp surface. On the light and mid-toned facets, just a touch of red deposited a rich mark. But on the dark side, the red crayon was pulled down in vigorous strokes, pushing aside the wet blue pigment and leaving its mark on the white paper beneath. A similar effect occurred when green was introduced.

Cross-hatching with water-soluble pencils The houses were re-drawn using the water-soluble pencils, with cross-hatching. Superimposed colors were drawn at different angles, so that even the third color in the darkest tone might still cross a white area of paper and leave touches of pure color. The three-color effect was richly variegated and more interesting than the other versions.

EXAMPLES OF SHADING AND COMBINING COLORS

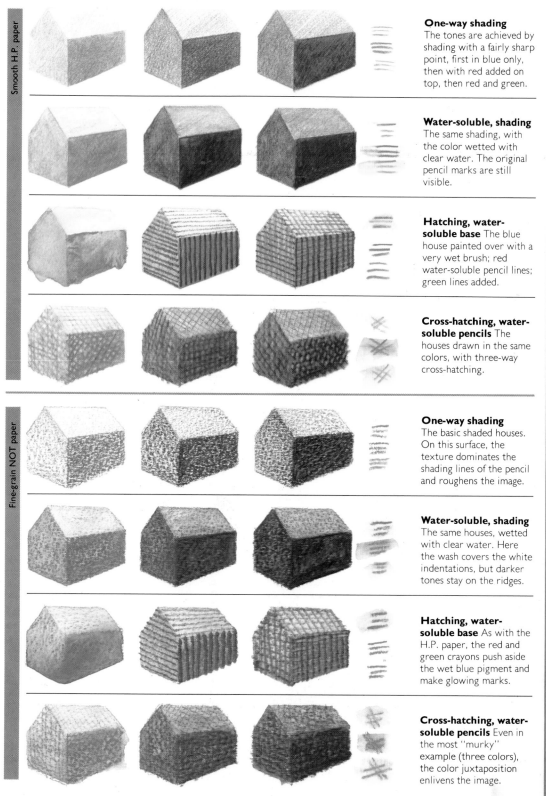

Smooth H.P. paper

One-way shading
The tones are achieved by shading with a fairly sharp point, first in blue only, then with red added on top, then red and green.

Water-soluble, shading
The same shading, with the color wetted with clear water. The original pencil marks are still visible.

Hatching, water-soluble base The blue house painted over with a very wet brush; red water-soluble pencil lines; green lines added.

Cross-hatching, water-soluble pencils The houses drawn in the same colors, with three-way cross-hatching.

Fine-grain NOT paper

One-way shading
The basic shaded houses. On this surface, the texture dominates the shading lines of the pencil and roughens the image.

Water-soluble, shading
The same houses, wetted with clear water. Here the wash covers the white indentations, but darker tones stay on the ridges.

Hatching, water-soluble base As with the H.P. paper, the red and green crayons push aside the wet blue pigment and make glowing marks.

Cross-hatching, water-soluble pencils Even in the most "murky" example (three colors), the color juxtaposition enlivens the image.

OVERALL SMOOTH TONES IN COLORED PENCIL

Working and reworking areas of even tone can be a long process since the technique involves very gradually depositing more color on the paper.

In this example worked up from a photograph, parallel diagonal shading was used in two colors – a blue and a green/blue – to build up a smooth, continuous graded tone. A tone like this will probably need to be worked over at least twice. It is important not to press too hard on the pencil but to deepen the shading by degrees. Using the natural backwards-and-forwards motion of the arm, you can work speedily, fractionally rotating the shaft of the pencil in your fingers all the time, to find the best shading edge and make the tip flatter or sharper as required.

Shading with two colors

Working with two colors in this way gives a drawing qualities that it would not have if it were monochromatic. There is an added depth and richness of texture in which subtle shifts in color modulate the uniformity of the surface and enliven it. This effect can be seen in the water behind the "splash" itself. Its depth of tone and color takes the drawing far beyond the pastel tones often associated with colored pencil work. Despite this, it still retains the softness that characterizes the medium.

Retaining white areas

For part of the watersplash and the many tiny drips to remain white, the paper had to be kept free of pencil marks in those areas. An equivalent to masking fluid for colored pencil has yet to be invented, and it is almost impossible to remove unwanted marks with an eraser. However, it is remarkable how hand and eye begin to coordinate as if on "automatic pilot" when shading quickly, the crayon stopping each time at the very edge of the area to be left white. And where the eye perceives gaps or inconsistencies in the uniformity of the tone, the pencil moves almost automatically to fill them.

"Splash!" drawing with graded tone background Derived from a photograph, the outline of the splash was traced on to NOT paper and the drawing built up by shading from the top left to the bottom right.

"Glazing" over a monochromatic "underdrawing"

This is an effective technique for colored pencils. Draw an image using just one color in a full range of tones, then work over the top using a different color. In the fish drawing (below), just one color was used – yellow – over a blue underdrawing, which has produced a range of greens. You can superimpose as many different colors as you wish, provided the underdrawing is not so densely drawn in the shadows that it will not take any more superimposed color.

Yellow "glaze" over blue "underdrawing" (detail) The fish glimpsed through sunlit water were first drawn in a range of tones of the same blue, then worked over with a yellow pencil.

HIGHLY WORKED DRAWING

Colored pencil drawing often calls to mind a soft, sketchy style of work and there are many excellent examples of this approach to the medium. However, it can also be used to make highly worked representations with a full range of tones. Even elements such as hard metal objects can be rendered very successfully. For precise, sharp details and edges, use techniques like shading up to the edge of a ruler. For other straight or slightly curved edges, use a thin sheet of flexible aluminum as an edge stop and remember to keep all your pencils well sharpened. A drawing like this may take several days to complete.

Insect tank drawing
Based on a photograph taken with a flash, this highly resolved still life contains some hard-edge, dark shadows and bright white highlights — plus a full range of tones in between.

SOFT-TONED PORTRAIT

Among contemporary artists who have worked with colored pencils is David Hockney, whose drawings recognize and celebrate the immediacy of the medium, with its soft clarity of color and its potential for the juxtaposition and super-imposition of tones and colors. This portrait is an excellent example of the kind of sympathetic portrait which Hockney can create so well. Here there are no complementary color juxtapositions as in much of his work, but rather the offsetting of related colors within a given range of browns and reds in the fleshtones, with dark brown for the hair and a single cool blue in the undershirt. There is an obvious delight in the drawing of the hair.

The delicacy of this kind of work, combined with its soft tones and colors, gives the medium its unique quality.

Don Crib (1973) by David Hockney.

SOFT PASTELS

Although weakly bound pigment had been used to color drawings as early as the fifteenth and sixteenth centuries, it was not until the eighteenth century that the art of pastel painting came into its own. The portraits and drawings of the Venetian artist Rosalba Carriera were extremely successful, and soon, artists like Maurice-Quentin de la Tour and Jean-Baptiste Chardin were exploiting the possibilities of the medium.

The most celebrated pastel painter remains Edgar Degas who, in addition to making works with the pure, dry pigment sticks, experimented successfully with mixed media effects.

A pastel painting has the most vulnerable of all painted or drawn surfaces. Although its "dusty" look is what gives pastel work its particular character, it must be protected almost as soon as it is completed if it is to remain permanent (see below).

·Pastel drawing materials·

COMMERCIALLY MADE PASTELS

Soft pastels are dry crayons made from powdered pigment, weakly bound in a solution of gum tragacanth or methyl cellulose. They usually contain a preservative, and sometimes a fungicide. A wide range is supplied, in different grades – hard, medium or soft (the most traditional) – and different shapes (thin or fat, square or cylindrical). Pastels can be bought separately, or in boxed sets of selected colors. The wood-encased pastel pencils are slightly harder than the conventional sticks. You can also make your own pastels at home; see *Appendix* p.334.

Color ranges and pigments

As much of the art of pastel painting lies in laying down the precise tones of the colors required, the greater the number of shades in the pastel box, the better. One French manufacturer offers 552 shades in the hand-made artists' range but, for most purposes, 50–100 shades suffice.

The most reputable artists' colormen supply colors of specified pigments so, if you buy "Viridian" for instance, you

know you are using a permanent pigment. Others merely supply crayons with romantically descriptive names which give no indication of the nature or permanence of the pigment. Pastels can also vary in softness within what should be a consistent range as different pigments require different strengths of binding solution, from very weak (Raw Umber) to strong (Alizarin Red). Although this can vary between pigment batches, some manufacturers do not take enough account of it.

Different forms of soft pastels
1 Round sticks
2 Square stick
3 Wood-encased pastel pencil

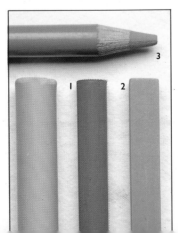

PASTEL FIXATIVES

With a lightly drawn piece of work, just blowing on it is enough to remove much of the color, so fixatives can be extremely useful. Modern proprietary fixatives are solutions of polyvinyl acetate resin (PVA) in denatured alcohol. They are as effective as any of the older shellac-based fixatives. Although casein/ammonia/alcohol types are said not to increase the saturation of pastel colors, in fact, any fixative changes the appearance of a painting. With a PVA fixative, the resin coats the surface or is absorbed by the pigment, changing its refractive index and giving a darker, more transparent look; some pigments are more liable than others to change in this way.

However, if a pastel work is properly mounted, framed behind glass and sealed into its frame, there is no reason why it should be any less permanent if it is left unfixed. Clean the glass of a framed work with a damp cloth; a dry one can cause static electricity to build up, attracting pigment particles to the underside of the glass.

SUPPORTS AND GROUNDS

Pastel works well on sized 100 per cent rag, neutral pH water-color or drawing paper. It takes easily to NOT or rough surfaces, can also be used on H.P. paper, but does not adhere to shiny surfaces like coated papers. As long as there is some tooth to which the pigment can cling, it will lodge fairly permanently, provided it is not scuffed.

Pastels can be used on almost any other surface which has a slight roughness and the ability to pick up the pigment. Such surfaces include hardboard or cardboard coated or overlaid with butter muslin, then primed.

Toned grounds

While natural rag papers for watercolor are generally white, a wash of color − watercolor, size or cellulose paste paint, tempera, thin acrylic, or even lightfast inks − provides the toned ground that pastellists prefer. There are also colored papers made especially for pastel painting. They come in a wide range of soft colors, especially in cream through dull ochre to brown, blue and green/grays, and a group ranging from pale gray through to black. Between the opaque marks made by the pastels, a colored ground provides a network of warm or cool tones.

Sizing for pastel papers

The amount and type of sizing used in rag papers varies considerably between brands. Some are well sized, which gives the surface an underlying hard-ness to which pastels readily re-spond. Others are less well sized and more absorbent; their fibers begin to loosen when pastel is worked into the paper and the paper may "rub up" annoyingly during drawing. However, this does not happen with commer-cial colored pastel paper and is easily overcome with pure rag watercolor paper by giving an extra coat of glue size.

Flocked papers

Velour, or flocked, papers are sheets of thin paper with a coating of powdered cloth, giving a velvety appearance. They come in a wide range of colors. Although its color lightfastness and structural permanence is difficult to establish, this is a unique surface for pastel. It enables you to make smooth, velvety lines or soft, uniform tones. With most papers, the pastel has to be laid on and rubbed in to make an overall tone, but here, the paper seems almost to do its own rubbing in when the pastel is laid on.

CARING FOR PASTEL DRAWINGS

Pastels should always be kept in dry conditions to prevent them being attacked by mould. Various precautions have been proposed, including framing them with an absorbent cardboard backing sheet, impregnated with a 25 per cent disinfecting solution of thymol, and placing a waxed sheet between that and the backing board. Pastels bound with cellulose are not so prone to mould as those made with natural gums.

Papers for soft pastel work
1 Ingres paper
2 Canson paper
3 Canson paper
4 100 per cent rag drawing paper
5 Fine sandpaper
6 Velour (flocked) paper

ADDING TEXTURE TO A PAPER

If you are re-sizing or coloring a paper, you can give it additional tooth by sifting an inert pigment such as pumice powder or marble dust over the wet surface. The result is like a fine sandpaper which holds the pigment well, producing rich, vibrant colors. Alternatively, you can obtain large sheets of very fine sandpaper from glass paper manufacturers. These have an overall uniformity of texture and can be overpainted with gouache or thin acrylic color before you draw on them, to provide an alternative to the natural pale yellow/gray.

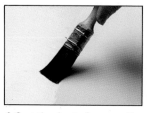

1 Coat the sheet of paper with warm size, cellulose paste or acrylic medium.

2 Immediately scatter the pumice powder or marble dust evenly over the surface, using a fine sieve. Shake off excess.

·Soft pastel working methods·

Pastel work has a particular soft, matt quality. When you draw a pastel stick over a paper or other support with a degree of "tooth", the pigment crumbles, lodging in the fibers of the paper or in the surface coating. A certain amount of pigment dust in the atmosphere, on the floor and on your hands and clothes, is inevitable, so choose non-toxic pigments for pastels (see *Pigments Charts* pp. 18–31).

LINE AND TONE EFFECTS

Pastel painting involves the soft fusion of tones and colors by blending on the support with fingers, stumps or brushes. Crisp, overlaid strokes provide highlights or juxtapose colors. By varying pressure on the stick, you can either force the pigment into the surface of the paper or make it lie delicately on top.

COLOR EFFECTS

Gently shading one color over another, and rubbing with a paper stump produces a mixture of the two colors. This is a common pastel technique and particularly useful where, for example, a pure color need to be dulled or reduced in key. To make a transition between two different colors or tones on the paper, try a linear shading effect with the strokes of the two colors interlacing so that one appears to blend into the other.

Color effects can be created by cross-hatching over rubbed grounds – a pure use of color with no further blending other than that created by the eye.

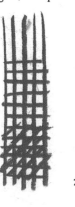
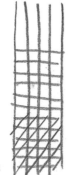

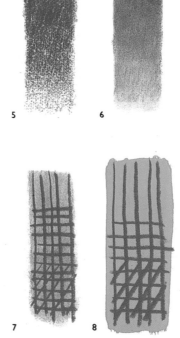

Using line and tone
1 Line grid applied with firm strokes, using a soft pastel.
2 The same grid applied with a pastel pencil. The result is harder and more scratchy.
3 The grid from 1 rubbed over with the index finger, using tight, circular movements. This produces a smooth, dense, overall tone. The grid is still just visible.
4 The grid from 2 rubbed over with the index finger. The harder pastel is less malleable, and a thinner, more smudged tone emerges. Here, the grid still predominates.

5 A graded tone in soft pastel, applied directly with no rubbing or shading. Using a lighter touch as the crayon moves down the paper creates the half-tone effect.
6 The same as 5, rubbed from the lighter towards the darker tone with the side of a paper stump, used with gentle circular movements.
7 A uniform tone gently laid over the area, then rubbed with the side of the tip of the stump. This creates an overall undertone over which the line grid was drawn as for 1.
8 The pastel grid is applied over a thick, dried coat of gouache.

Using color
1 Six colors in the pale yellow to red range, in overlapping bands.
2 The same colors, further blended with the tip of a paper stump.
3 Linear shading in the same six colors, showing an alternative method of color blending.

4

DEGAS' USE OF PASTEL

Degas was a master of the art of vigorous strokes of the pastel over rubbed pastel grounds. His drawings of women performing acts of washing or drying themselves contain all the characteristic techniques of juxtaposed and superimposed colors with a great deal of vigorous rubbing out and bold overlaid squiggles. The bottom right-hand side of this work shows bright Viridian squiggles over orange/purple and the flesh is a soft greeny pink with bold pink and white strokes overlaid. The rubbed purple shadow areas have lighter-toned pink scribbled over them.

Woman Drying Herself (1880), by Edgar Degas.

Colors overlaid and blended with stump
4 Red and yellow makes orange; blue and red makes violet; green and brown makes a dull green.

5

6

7

8

Cross-hatching effects
5 Orange/red hatching over a near-complementary green ground.
6 More complex four-color hatching on an orange/red ground.

7 Four-color hatching, with no blending.
8 The same, blended with the index finger. The result is an overall color, but it still contains the marks of the grid.

Adding a binding or fixing medium
9 Red over orange hatching, with cellulose paste or PVA emulsion brushed over each layer. The color blends like 8.

9

10

11

Overlaying colors
If you draw into pastel pigment with a new color, the purity of the overlaid color is retained, but there is a limit to the amount of pigment the support will take.
10 The technique on a rubbed pastel ground.
11 The technique on a non-rubbed pastel ground.

·Conventional pastel techniques·

TONAL PORTRAIT TECHNIQUES

Pastel lends itself particularly well to portraits, and can give them a softness and immediacy which other media lack. In the conventional portrait drawing below, the ground is a flecked blue/green paper which contrasts effectively with the warm pinks of the pastel fleshtones. This contrast is emphasized by the use of blue/green pastels in the blankets indicated around the figure and hands.

Building up the pastel portrait The technique is straightforward. First, the basic position of the features was faintly indicated with pencil or pastel. Then, using the background paper color as a guide to the middle to dark tonal range, highlights were drawn on the forehead with a white pastel. Subsequently the lightest pink and yellow tints were touched in around the highlights and the whole area of the forehead modeled in this way. Then a clean paper stump was used to blend adjacent tones and to work the pastel into the paper, producing the smoothly modulated surface.

Using pastels in this way is an excellent method of practising tonal gradation, and although pastels, by their nature, generally work best in the middle to light range of tones, an impression of the full tonal range can be effectively demonstrated.

The drawing was worked downwards from the forehead, using the same method of laying in adjacent tones and subsequently blending them with the stump for the eyes, nose and mouth. Working from top to bottom helped prevent the drawing from being smudged.

Once the whole image was defined, it was reworked by adjusting colors and tones, re-blending, adding the darkest touches, and finally re-adding the highlights. A putty eraser was used for minor adjustments and corrections and to erase smudges on the surrounding paper.

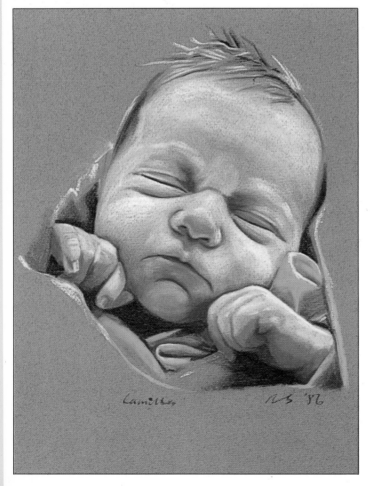

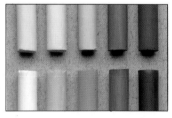

The pastel palette
Just ten pastels ranging from pink to dark brown were used to produce a full range of tones.

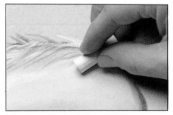

Touching in the lightest tints.

Blending adjacent tones
Beginning in the centre of each highlight, the stump was used with gentle, circular rubbing movements.

LANDSCAPE TECHNIQUES

The warm orange paper used for this landscape contrasts with the blue/greens of the drawing. The image was worked from the top downwards to avoid smudging. To help suggest aerial perspective, the drawing was carried out in horizontal tonal bands, becoming progressively darker down the paper. It is much easier to control a range of tones by working across one band at a time, at least initially, than to build up the image randomly.

For the distant hills, blue shading was overlaid with pink, then rubbed with the fingers. For the trees, touches of color were applied in soft, circular movements which were repeated with a paper stump, working from the outside of the tree inwards. Blue was used with green for the distant trees while, for the nearer ones, the second color was brown. The sunlit fields were drawn with white, pink or yellow/green pastels. The darker tones were added and worked in with the paper stump.

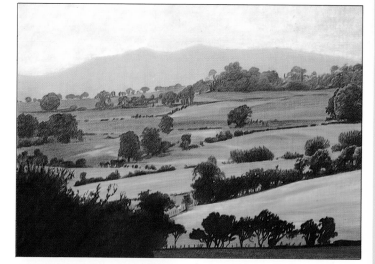

Rendering the sky
The sky combines white pastel, applied using the side of the stick, with the color of the paper.

Softening the texture
The sky's textural roughness was modified by rubbing all over with the fingers, using a circular motion.

DIRECT DRAWING METHODS

Another approach to soft pastels is to use them directly, with no rubbing or blending techniques.

Drawing on sandpaper
This drawing was built up from a series of direct stabs of short pastel lines which exploit the deep, rich colors that sandpaper or similar supports give to pastels. The lit area incorporates a range of yellow and orange pigments with touches of mauve, brown and blue, while the areas in shadow include deep blue, violet, purple, mauve and brown. An object which is essentially a block of white stone is transformed into a mass of color which relies for its effect on the complementary yellow and violet. The monochromatic background brings the object forward.

High-key color on sandpaper
The texture of sandpaper means it holds pastel pigment well, creating rich tones and deep colors.

Rapid linear technique
A bold linear approach was used for the drawing below. The shape of the cap and loincloth, body and plinth were shaded in and rubbed with a paper stump in uniform tones of red, blue/green and blue respectively. Then an indication of outline, form and highlight was given with bold strokes of black, white and red.

Rapid, direct drawing
Pastel drawings made in this rapid and direct way can have a strong, positive presence.

OIL PASTELS

Oil pastels are made from mixtures of pigment, hydrocarbon waxes and animal fat. In a sense, they are more similar to wax crayons than to soft pastels. The better brands contain more pigment and are more flexible than wax crayons, which also have a certain hardness. However, their malleability changes with the temperature and anyone working with the remains of a stick of oil pastel in hot hands will know about its tendency to "putty". It becomes harder to control and more color is deposited on the drawing surface than when the stick is cool.

Being largely wax-based, oil pastels do not undergo any of the changes during the drying process that occur with a medium like oil paint. The material's appearance remains unaltered unless it is rubbed with mineral spirit, which dissolves it, or subjected to severe heat, which melts it.

·Using oil pastels·

The oil pastel surface can be manipulated in various different ways, such as in textural and scraped effects, where different colors are superimposed on each other and scraped back to reveal colored images. Interesting color combinations can be created with gentle shading; burnishing the color (rubbing with a finger nail) gives it a more saturated look. Combining it with watercolor or acrylic paint exploits the "wax resist" technique (see also p.164). And turpentine can be used as a solvent for softer effects.

OPTICAL COLOR MIXTURES

Gentle shading with superimposed colors can produce optical mixtures in which colors are blended by the eye of the viewer.

BASIC COLOR MANIPULATIONS

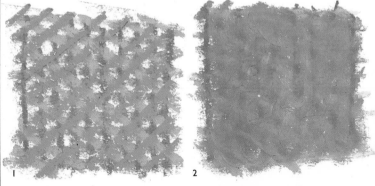

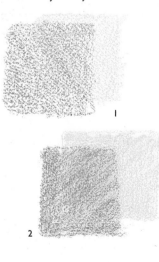

1 Four oil pastel colors – orange, pink, red and yellow – superimposed by cross-hatching.
2 The same four colors, rubbed with a fingernail to mix them.
3 The same, scraped with a blade or fingernail. Notice that orange, the first color to be laid down, shows the most prominently.

1 Red and yellow optical mixture.
2 As 1, burnished with a fingernail.

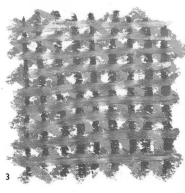

USING MINERAL SPIRIT OR TURPENTINE

Although oil pastels are thick and viscous, they are soluble in mineral spirit or turpentine. This means they can be thinned to create wash-like effects, best worked on the heavier papers.

The turpentine technique is especially useful for expressing aerial perspective or distance. If you draw the sky at the horizon and the furthest areas of land with a thin wash-like effect, rendering the land mass near the foreground more thickly with the pastel, the illusion of distance is easy to maintain — a technique used in oil painting.

Take care not to over-work oil pastels with mineral spirit — they can easily become too thin and muddy. Use deft, one-stroke wipes of the cloth or tissue.

White spirit for portraying distance Touches of pink, white, blue, lilac and green in the sky and horizon were blended using mineral spirit. But in the foreground, the pastel was used directly.

WAYS OF USING MINERAL SPIRIT

▨ Soak the paper first in mineral spirit, then draw on the damp surface with oil pastels.
▨ Draw on dry paper with oil pastels, then soften and thin them by rubbing over with a clean cotton rag or paper tissue dampened with mineral spirit.
▨ Dip a cotton bud into mineral spirit and squeeze it out on absorbent paper. Use the bud to work on small areas of color, as shown below.

"SCRAPERBOARD" TECHNIQUES

This technique, which works well on a smooth paper surface, involves laying a uniform, bright, light-toned color (burnished with a fingernail) over the whole picture area, applying black over the top, then scratching through the black to reveal the color beneath using a scraperboard cutter or any metal object like a screwdriver or the tip of a blade.

You can achieve a range of effects, from delicate tracery with fine line work to the removal of large areas of tone with wide-edged scrapers. The surface is very "pliant" and easy to work.

Scraping out a bold image

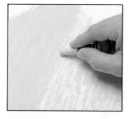

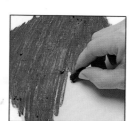

1 Cover the paper surface with a light-toned oil pastel.

2 Now cover this completely with a layer of black oil pastel.

Multi-colored background In this "sunset" drawing, the colored background was blocked in before the black was applied.

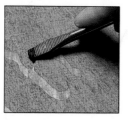

3 Scrape out the image using a chunky tool such as a wide screwdriver.

4 The result is a bold image. For finer effects, use a blunt needle.

Silhouette effects These trees etched against the sky look almost like a woodcut. The residual traces of black give a mottled look to the sky.

INCORPORATING A LINE DRAWING

The basic technique of super-imposing a dark over a lighter colour and scraping off, can be adapted by making a black line drawing first. Shade the lighter oil pastel on top, then super-impose the black. When the whole surface is scraped off, the black line drawing is again revealed, incorporated into the overall color of the background.

Drawing with two superimposed layers A drawing like this (above) has a quite different feel to one with the black line merely superimposed over the background color.

Portrait drawing with partial scraping In a modification of the technique (left), the base drawing, made on smooth paper, has had yellow, orange and blue pastel superimposed. These have only been partly scraped back to give the background texture.

SCRAPING BACK ON ROUGH PAPER

On textured paper, super-imposed layers of oil pastel conceal the colors beneath by only "taking" on the ridges of the paper surface (to which the previous coats have also at-tached). As more coats are built up, the troughs between the ridges gradually fill with color. When you scrape the surface with a blade, the superimposed layers of color are pushed into the troughs surrounding the ridges, while the ridges them-selves are taken back to the first color layer, creating lively variegated color and texture.

This technique can be used to good effect in combination with watercolor or acrylic paint, where the "wax resist" effect means that the paint only takes to the areas of paper not covered by the oil pastel (see p.164).

Sample strips Superimposed colors from pale yellow, through orange to brown. When half the area was scraped back, the ridges on the paper reverted to pale yellow and the troughs around them were filled with the other colors.

Rhinoceros The black outline was filled in with blue/gray. The background was filled with yellow, then the whole picture covered, with warm brown, then black. The whole area was scraped with a blade held at a shallow angle.

COMBINING OIL PASTEL AND WATERCOLOR

Using the wax resist principle (see p.164), oil pastel can be used in conjunction with watercolor to provide an underlying texture for an area of tone or color, usually on rough-grain paper. The watercolor only takes to the paper on the areas not covered by the pastel. Acrylic paint may also be used (see p.94). The color of the oil pastel can provide a total contrast to that of the watercolor, or it can show a lighter or darker tone of a similar color. It can also provide the basis for the tonal modeling of forms.

For this exercise, combining the two media in different ways produced different effects on five different trees. The exercises explore the effects of complementary color textures and of using similar hues of differing tone. All the oil pastels were applied before the paint. Just two watercolor pigments were used – a green in several tones, and a blue for the river. When the watercolor was dry, the oil pastel areas were scraped to give them emphasis. For the white areas in the water, strokes of white oil pastel were applied before the blue watercolor.

Trees exercise
I Red pastel was applied heavily, so what emerges is a "red" tree with green shadows.
2 Similar to the first, with yellow pastel instead of red.
3 A green pastel, similar in hue but lighter in tone to that of the watercolor was applied heavily over most of the tree.
4 The same green pastel was used on one side of the tree to provide extra contrast with the watercolor.
5 More tonal modeling was used in this tree, where the yellow oil pastel was applied heavily on one side. Here there was no paper for the watercolor to adhere to, and the area reads as sunlit foliage.

MAKING A BACKGROUND
Using the wax resist principle (see p.164), experiment with different combinations of the two media on rough paper. Use the effect to create an overall mottled ground for a line drawing.

I Cover a sheet of rough paper with oil pastel.

2 Apply watercolor to "take" on the white area.

3 Once this is dry, draw over the top if you wish.

COMBINING OIL PASTEL AND ACRYLIC PAINT

A single coat of acrylic can be used to advantage with oil pastels. For instance, you can shade over a rough ground with a light-colored oil pastel and then give a coat of dark acrylic color (with a thick cream consistency). You can then scrape out an image from the wet acrylic.

An acrylic surface laid over a continuous film of oil pastel would be unstable and impermanent. But, if you use rough paper, the acrylic forms a satisfactory bond in the indented network where the oil pastel has not picked up. Handle finished drawings with care.

Wax-resist technique with acrylic For a more sophisticated approach to wax resist with oil pastels, try making a more finished oil pastel drawing, paying particular attention to the middle and light tones, including the highlights. Paint over the whole image with a deep-toned acrylic color. Scrape this back,

working down the drawing in vertical strokes. Each scraping stroke should overlap the last one. The oil pastel image is revealed as a fully resolved drawing, with the acrylic color acting as the dark-toned ground. This is a versatile technique with many variations, and a quick way to create a fully-toned drawing.

Acrylic "scraperboard" drawing
Yellow oil pastel was laid down on rough paper and blue watercolor painted over the top. This was dried, and dark blue acrylic was painted on top. A small screwdriver was used to scrape out the image, revealing the blue and yellow under-layer.

Sculptor preparing his clay
The sunlit figure against the dark hedge was well suited to this treatment. The figure, bowl, bench and foliage highlights were drawn, then the rest of the paper shaded with black oil pastel. A thin, green watercolor wash was applied. When it was dry, thick, creamy Phthalocyanine Blue acrylic was painted over the whole image and scraped off while wet, leaving the atmospheric mottled ground.

Scraping back the acrylic layer
Work down the drawing with a razor blade or a piece of thin flexible plastic like a credit card.

CHALK AND CONTÉ CRAYON

There is a long tradition of working with black and white chalks or pastels on mid-toned paper in gray or other colors. It is an economical way of working. You can express mid-to-light tones with a white crayon and mid-to-dark tones with a black crayon, leaving the ground for the middle tones. In many respects, it parallels monochromatic methods of painting.

The black and white technique appears throughout the history of art. Tintoretto uses it in figure studies characterized by their massive fluency and where the white chalk is used only for the highlights. Van Dyck makes more refined figure drawings where the contours have a limpid fluency and the shadows define the form with a gentle touch. Red and brown crayons are equally traditional and have been used extensively for landscape, portrait and figure work.

Tonal modeling in black and white
Prud'hon uses black and white chalk to establish a complete range of tones in his fully rounded figures. *The Fountainhead* (c.1801), by Pierre Paul Prud'hon.

·Traditional colors·

The red ochres, or iron oxide reds, have always been freely available as permanent, natural coloring matter. The "sinopie", or underdrawings for frescos, came to be known by that name after the red oxide pigment known as sinopia, which was used for this purpose, see *Buon fresco*, p.235. When used for drawing, this rich, warm color has a very pleasing quality; red chalk or conté crayons have been widely used. The term "sanguine" simply designates the particular red/brown terracotta color. (For an example of a drawing made in sanguine crayon, see p.96.)

Other colored crayons of a similar type are sepia (warm brown) and bistre (cool brown). These take their name from brown pigments obtained from the ink sac of the squid or cuttlefish (sepia), or from the soot of burnt beechwood (bistre). In fact, more lightfast pigments are now used in the manufacture of crayons with these names.

Selection of conté crayons
1 Black
2 White
3 Sanguine
4 Bistre
5 Sepia

DRAWING "À TROIS COULEURS"

This technique uses three chalk or conté crayon colors — sanguine, black and white — to create a drawing which goes quite some way towards being a full-color image. The most regular use of the technique is in portrait drawing. Broadly speaking, the sanguine defines the face and features, the white is used for highlights on forehead, nose, cheeks, chin and neck, and the black is often used for the hair and possibly for special detailing round the eyes and eyebrows. Artists like Bernini or François Le Moine used the crayons in this way, but others, like Watteau and Greuze, made more use of the black crayon for shading and definition on the face itself. Although there are, of course, no hard and fast rules, the color combination seems a successful and enduring one. This technique can be used to some effect in landscape drawing as well as portraits.

Low-key portrait on gray paper In this portrait of a black girl drawn on mid-gray paper, the sanguine was used for the face itself, with the rest of the head being drawn in black. A paper stump was used to blend tones and, to some extent, to blend the actual pigments. The dark tones around the eyes and below the nose and lips are mixtures of sanguine and black. The only pure white touches are the reflections in the pupils.

Achieving a low-key effect
The dark effect, with lighter tones only on the forehead, bridge of the nose and cheeks, gives a sense of intimacy and immediacy.

THE QUALITIES OF SANGUINE

Sanguine has been particularly popular as a result of the softness and warmth it imparts to a drawing. Many artists have found its soft, voluptuous qualities especially appropriate to nude drawing. It is often used on a slightly warm-toned, off-white paper.

This drawing is given a softness by the color and texture of the sanguine crayon. The low viewpoint and high vanishing point, together with the solid triangular composition, leads the eye up the diagonal from bottom right towards top left, to the lighted window which frames the young woman. The drawing is very much a study, so that the dark tonal shading round the window, for instance, is not extended and completed to the right. And yet the faces of the young woman and the old man are drawn with great simplicity and sympathy.

Roman Charity (1699), by Mattia Preti.

·Black and white techniques·

The experience of working with black and white conté crayons on a mid- or mid-to-dark-toned ground shows how direct and economical a method of working it is. Black and white crayons can be used not only to make large, bold drawings which have great immediacy but also for carefully composed works with more fully resolved detail. The white crayon produces highlights of great luminosity on a colored paper.

DRAWING LOOSELY IN BLACK AND WHITE

The medium is very effective for drawing portraits, particularly when both black and white crayons are used. The dramatic contrast between black and white heightens *chiaroscuro* effects. The crayons may be used directly, to "punch out" facial features, especially where strong lighting creates deep shadows on a face.

Black and white self-portrait
This drawing was made with no pre-drawing, starting with the right eye and working outwards. The artificial light source leaves deep shadows under the brows, nose, lips and chin.

WORKING ON MID-GRAY PAPER

Using a mid-gray paper allows you to work economically; tones and forms can be established very quickly.

In the example below, a paper stump was used for occasional softening of the pigment where the tones blend into the gray paper and out to the black. This can be seen at most of the tonal "junctions" in the drawing and in particular on both sides of the nose and at each side of the face. The hair was left as an almost uniform gray tone made with broad strokes of the flat side of the crayons; a few diagonal lines made with a sharp edge indicate the way the hair falls on to the forehead. The subject is looking directly at the artist/spectator. The straight look is emphasized by the use of the white crayon only on the face itself, giving a particular form to its features, and also by the fact that the eyes have been drawn with slightly more detail than the rest, especially the iris and the pupil with its bright highlight. This gives a sense of direct engagement with the subject.

Portrait on a mid-gray paper
Although the portrait has quite a finished appearance, it is in fact rather loosely drawn, demonstrating the economy of the technique.

WORKING ON MID-TO-DARK-TONED PAPER

A mid-to-dark paper acts as the mid-toned base for a black and white drawing with no rubbing or blending. This drawing of a boy beside an estuary was made on blue/gray paper. An image like this relies on a strong black and white content for its effect, but the intermediate effect of the blue paper modulating the contrast and performing positive mid-tone functions is a very important component of the scheme. Plenty of white was used to show the effect of bright sun reflecting off the wet mudflats. The areas of black shading – linked by the line of the stream – act as stepping stones towards the distant shore. They stretch from the silhouette of the boy to that of the fishing boat, and beyond that to thin horizontal edges of shadow before the line of the river itself.

In the distance and middle ground, the flat side of the conté crayon (broken off to size) was used extensively. In the foreground, the square shape of the crayon provided a number of sharp edges that enabled the finer detail to be drawn.

Using the flat side of the crayon
Break off a section from the conté crayon to the correct length for the width of stroke you wish to make.

Using the square tip of the crayon The corners and edges of the end of the stick provide sharp lines and details to offset broader tones.

THE ECONOMY OF BLACK AND WHITE CHALK

This sketch perfectly shows the economy and richness of black and white chalk used on a mid-toned paper. The low evening light is broadly defined with sweeps of white which outline the head of the cow against the sky. Touches of white suggest the back of the cow in the water, reflections in the water and highlights in the bark of the tree. Fluent strokes of the black chalk reinforce all the dark-toned areas. For all its sketchiness, the whole image has a sense of completeness and an air of repose.

Landscape with Cattle at a Watering Place, by Thomas Gainsborough.

DRAWING WITH A PAPER STUMP

Black conté crayon on white paper was used for this striking interior. The whole drawing was worked with a paper stump using various types of manipulation. The dense, rich, black pigment that characterizes the conté crayon produces soft, smoky effects when it is manipulated with the stump. Used in this way, the chalk can provide particularly effective *chiaroscuro* effects. Here the very strong light through the window makes a deep, dark silhouette of the chair and turns the lamps and tables beside the curtain into shadowy forms.

How to use the stump

1 A long, downward stroke using the broad edge of the tip horizontally, as in the walls.

2 A long, downward stroke using the broad edge of the tip vertically, as in parts of the drapes.

3 Fine adjustments made with the tip, as in parts of the window frame. It can also soften outlines.

4 Circular movements of the broad edge of the tip, as in the floor.

CHARCOAL

Charcoal is one of the oldest drawing materials, produced by firing willow, vine or other twigs at high temperatures in air-tight containers. This carbonizes the wood, but leaves each stick whole and ready for use as a drawing medium. Cennino Cennini described the technique in the fifteenth century: slips of willow were tied in bundles, sealed in earthenware pots, placed in the local baker's oven, and left overnight until they were quite black. He pointed out the importance of timing; overfiring produces a crayon that splits into pieces with use. Two centuries later, Volpato described how pieces of wood were crammed into an iron tube which was sealed with hot ashes, made red-hot, then plunged into water to cool off.

Early writings suggest that charcoal was essentially used as a means of drawing out images for panel painting or fresco. Nowadays, although it is still considered a suitable medium for drawing out an image prior to painting, charcoal is used very much as an expressive medium in its own right.

The Renaissance painters found charcoal useful because they could easily modify an image during the drawing stage by erasing parts of it with feathers. Once the drawing was satisfactory, it was worked over with brush, pen or silver stile, and any remaining charcoal brushed away. Charcoal was handled with surprising precision. Sharpened to a point, each piece was attached to a stick "about the length of your face" (Cennini).

·Manufacture and equipment·

HOW CHARCOAL IS MADE

Nowadays, willow for artist's charcoal is grown in organized plantations and harvested annually during the winter months. The most common species, *Salex Trianda*, provides the standard sticks of charcoal for drawing. The seven-foot Trianda willow rod tapers naturally to produce thick, medium and thin sticks. Another species, the osier willow (*S.*

Viminalis), is harvested every two years and provides a thicker stick for large-scale work (scene-painter's charcoal, see p.102).

Once the cut willow rods have been sorted, they are bundled into wads and boiled in water for nine hours to soften the bark. This is then stripped off in a revolving machine and the willow dried in the open air. The sticks are tied into bundles, sawn into standard lengths, and packed tightly into iron firing boxes.

The boxes are filled with sand on a vibrating table, to prevent air getting to them while in the kiln. The sticks shrink considerably during firing and the sand takes up the space. After pre-heating to dry them out, the sticks are fired in a kiln for several hours at a high temperature. Twenty-four hours later they are cool enough to be packed. (If the charcoal is removed from the sand too early, it may spontaneously combust.)

A crop of willow rods in storage prior to being sorted and bundled.

Boiled, stripped and dried willow rods in the bundling machine.

Sawn willow sticks packed in an iron firing box, after firing in the kiln.

Compressed charcoal

This is made from Lamp Black pigment, mixed with a binder and compressed into square or round sticks. It also comes in pencil form. Compared to willow charcoal, it is dense and heavy and produces deep, rich, velvety blacks. It is not suitable as a preliminary drawing medium for oil painting as it cannot be brushed off so easily and would blacken the colors of the underpainting. But as a drawing medium in its own right, it is unequalled for rich, black lines and soft, dark tones. Like willow charcoal, it can be manipulated on the paper with fingers or a paper stump.

Different forms of charcoal
1 Thin willow charcoal
2 Medium willow charcoal
3 Thick willow charcoal
4 Scene-painter's charcoal
5 Charcoal pencil
6 Compressed charcoal sticks
7 Vine charcoal

OIL CHARCOAL
You can make this by soaking charcoal sticks in a vegetable oil such as alkali refined linseed oil. Fill a sealable cylindrical container with upright charcoal sticks. Cover with linseed oil and seal the container. As the oil is absorbed by the charcoal, top up the container. Within 24 hours, the sticks will have soaked up all the oil they require. Take them out, wipe them and wrap individually in tinfoil or household plastic film, twisted at each end to exclude air and prevent rapid drying out. Do not keep oil charcoal too long before use; it dries out eventually.

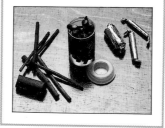

FIXATIVES FOR CHARCOAL

In the past, charcoal fixatives were dilute solutions of shellac, mastic or colophony in alcohol.

Modern proprietary fixatives Sold in pressurized cans, modern fixatives are poly-vinyl acetate solutions in a quickly evaporating acetate solvent. They work well on small drawings, but for large-scale work such as murals, the cans are expensive and the product does not provide so much protection as might be desired.

Acrylic emulsion
As an alternative, two or three coats of an acrylic emulsion, applied with a spray gun, provide a permanent sealed surface. This holds the charcoal in its original state and is not affected by accidental scuffing. Allow the acrylic to dry between each spraying. Dilute the emulsion with around ten per cent water before spraying. A PVA emulsion can also be used but this may tend to yellow in time.

Applying acrylic emulsion
Set the spray gun at fairly low pressure so as to avoid blowing charcoal dust over the drawing.

SUPPORTS FOR CHARCOAL DRAWING

Most good-quality papers make suitable supports for charcoal drawings, but the softer, rough-grain papers are the best, since they hold the charcoal more effectively. For permanence, choose an acid-free pure rag paper. The coated papers used for illustration work are too smooth for charcoal.

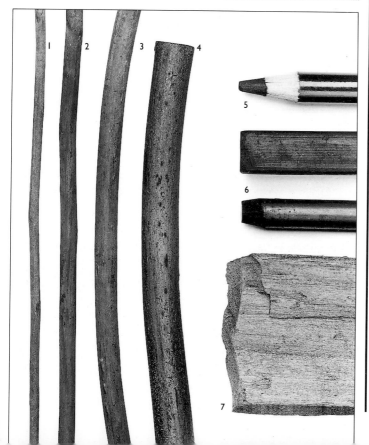

·Charcoal line techniques·

Charcoal is a fast, direct and responsive drawing medium. It is also one of the least inhibiting, since by nature, it encourages a broad and unfussy approach. Charcoal gives a soft or strong quality of line that is unsurpassed for its flexibility and expressiveness, and reflects more than any other the confidence and fluency, the care and hesitation, the forcefulness or timidity of the artist's intention.

DRAWING WITH WILLOW CHARCOAL

The quality and feel of a charcoal line is determined by the method of application. Holding the charcoal between thumb and forefinger and pulling the stick down the paper gives a fluid, controlled line, but the charcoal is prone to snap or crumble under pressure. Pushing a mark up the paper, on the other hand, produces a deeper, stronger line which can give a solid effect to a drawing.

Varying the direction of the line Pulling the stick down the paper produces a free, fluid line that echoes the movement of the dancers (above). The solid, chunky nature of the sculpture (left) is reflected in the weight and density of the line made by pushing the stick up the paper.

USING SCENE-PAINTER'S CHARCOAL

These extra-thick charcoal sticks are designed for heavy "industrial" use in the theater where large-scale work has to be drawn out. But they can equally well be used for fine-art work in very large drawings or where a thick, bold line is required.

Charcoal's expressive qualities translate well to large-scale work, especially now that fixing presents less of a problem (see p.101). The image shown below is just one "panel" from a large work, drawn up in separate sections that then combine to form a stronger and more intensely worked version of a much smaller original. The process aims to give each panel an abstract intensity that adds tension and strength to the reassembled image.

Detail of large-scale work
In each section of this drawing, the marks have been made rapidly, being "crushed" or "punched" into the primed canvas with fluent sweeps of the arm. Much of it was drawn with the side of the stick.

HOLDING THE CHARCOAL STICK FLAT

Using the charcoal stick horizontally on the paper is another way of creating lines of a slightly different quality. Pulling the stick along lengthways produces a narrow line; using it widthways creates a broad, chunky stroke which readily reflects the texture of the paper. Break the charcoal stick to the right length for the required width of line. When working on a large area, it is possible to "burn" the fingernails on the support. Adhesive tape on the fingertips protects them.

"GHOST" LINES

Charcoal lines can be partially erased with the fingers during the drawing process. This leaves "ghost" images that record on the paper how the final image came to be made. The result is that a few simple, expressive black lines, drawn with economy and assurance, arise out of what is actually an intensive process of drawing and re-drawing. Nowhere is this more evident and successful than in the charcoal drawings of Henri Matisse – where all the preliminary observation work, in various densities of soft gray, gives an authority to the clarity of line which finally emerges. In the nude shown here, the plump tension of the figure, outlined with confident assurance, is given softness and buoyancy by the grays beneath.

Reclining Nude with Arm Behind Head (1937), by Henri Matisse.

USING CHARCOAL ATTACHED TO A CANE

Using charcoal in the way favoured by Renaissance painters (see p.100) gives a new perspective on drawing. The piece of charcoal – secured to the end of a length of cane – seems so far away that the drawing almost seems to develop on its own.

The technique involves holding the cane in one hand, with your thumb and forefinger extended along the shaft, the other fingers pushing the cane against your forearm to balance and control it. The marks produced have a soft, tentative quality, and, although fluffy and insubstantial in themselves, they can combine to create an image with a strong sense of form, like the foliage study detail. The method can be used for drawing on walls and ceilings, or on paper or canvas laid on the floor.

Securing the charcoal
1 Split the end of the cane with two cuts at right angles
2 Open out the end and insert the charcoal
3 Secure with tape wound round the cane.

Manipulating the charcoal
For extra control, steady the end of the cane with the thumb of your other (non-drawing) hand.

·Charcoal tone techniques·

Subtle and well-developed tonal effects can be created with charcoal in a variety of ways. Charcoal lends itself beautifully to the use of the grain of the paper for building tone – the charcoal stick often being used on its side to cover an area quickly. In the same way, it can be used on thin paper laid over grainy wood or sandpaper (frottage method) for other textured effects. Smooth tonal gradations can be achieved when charcoal lines or tones are softened and lightened by rubbing and smudging with a finger or a paper stump. And highlights can be picked out of charcoal with an eraser – putty or vinyl. The deep-toned softness of compressed charcoal is ideal for rendering tones; a paper stump can actually be used as a drawing instrument when loaded with powdered compressed charcoal (see *Drawing with a paper stump*, p.105).

USING THE PAPER'S TEXTURE

Thin sticks of willow charcoal applied in small, circular movements on a rough-grain paper create a continuous half-tone effect. You can vary the lightness and darkness according to how much pressure you apply to the stick. It is an efficient way of covering a fairly large area with tone – much faster, for instance, than doing a similarly precise work with either paint or pencil. If you are right-handed, work from left to right to avoid smudging, and make any final adjustments by resting your hand against a mahlstick or brush handle to keep it off the drawing.

Tonal drawing on textured paper (detail) This drawing is entirely tonal, with no linear work. The grain of the paper and hand pressure provide all the tones.

TONAL EFFECTS FROM RUBBING IN

Comparatively smooth papers may be used for rubbing in tones, but make sure the paper has just enough tooth to retain the charcoal powder in its interstices; if the surface is too smooth, the charcoal simply slips

off it. Highlights can be picked out with an eraser which can also be used to generally "tidy up" the drawing.

As a contrast to using the grain of the paper for tone, perfectly smooth gradations can be made after drawing or shading with the charcoal by rubbing it into the paper with the fingers.

Smooth tones on H.P. paper (detail) A drawing like this could be used as a solid, monochromatic "underpainting" for transparent color washes which would build the image into a full-color painting.

THE QUALITIES OF OIL CHARCOAL

This interesting medium (see p.101 for how to make it) produces a unique quality of line and tone. The marks are permanent and penetrate the support. They can only be erased by swabbing with linseed oil or turpentine. The paper can be given a thin coat of glue size to protect the cellulose in the fibres from the potentially damaging effect of the oil.

Oil charcoal tone
Left, regular drawing; right, the same, rubbed.

Standard charcoal tone
Left, regular drawing; right, the same, rubbed.

WORKING AND REWORKING AN IMAGE

Repeated working and erasing on a tonal drawing enables you to progress beyond a mere "surface" treatment to a point where the interaction between the paper surface and the charcoal becomes more intensive. Such a drawing can be seen as the sum of many superimposed erasings, each of which leaves its mark on the paper and adds a softness and richness to the succeeding layer, while the final marks merely underline the essential features of the drawing. With such work, the image is often lost and rediscovered several times during the drawing process. Overworking may cause loss of freshness.

Highly worked portrait study
A continual process of rubbing (with fingers and paper stump), re-drawing, erasing (with a PVC rubber) and reworking can be used to build a fully developed drawing.

DRAWING WITH COMPRESSED CHARCOAL

This versatile form of charcoal is available in stick or pencil form (see p.101). It is not as liable to break or splinter as standard willow charcoal, and produces deep, soft blacks which can be partially erased for the lighter tones, and rubbed or smudged like ordinary charcoal.

Landscape in compressed charcoal The dark silhouette of the lock gate against the bright water is given solid weight by the thick, matt black of the charcoal.

USING A PAPER STUMP

A paper stump or smaller tortillon can be made of rolled paper, felt or leather. Stumps are used for spreading charcoal on the paper to create blended or graded tones. They can also act as drawing instruments. Rub the end of the stump along a stick of compressed charcoal so that it picks up some black pigment, then rub this over the paper. Light or dark tones are produced according to how much charcoal you pick up and how hard you press. For the very lightest tones, use a barely discolored stump.

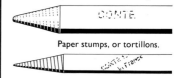

Paper stumps, or tortillons.

Drawing with a paper stump

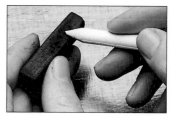

1 Rub the paper stump along the stick of compressed charcoal.

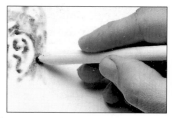

2 Use the stump with more or less pressure for the desired tone.

Drawing made with a paper stump This approach has a pleasing softness and a lack of hard edges.

SILVERPOINT

Silverpoint is the art of drawing with a silver wire, held in a clutch pencil or other holder, on coated paper or board. There is a soft and delicate clarity about this medium which is entirely unique among the drawing media. Silverpoint is readily available and requires little preparation.

A new silverpoint drawing is a gray/blue color. In time, the silver darkens and turns brown. This tarnishing effect gives silver-point drawings their characteristic appearance. The line remains permanent (it needs no fixing) and otherwise unaffected by light.

Furthermore, there is a velvety, but resistant, feel to the action of drawing in this medium which differentiates it from graphite pencil drawings (to which it looks most similar). Silverpoint feels more like a form of painting; each line cannot be erased and adds to the cumulative effect of the whole.

·Materials and equipment·

SUPPORTS FOR SILVERPOINT

Paper with a special surface for silverpoint is available, but tends not to be permanent. Making your own surface by coating paper with white gouache is far more satisfactory (see right). Subtly colored tinted grounds may be made by tinting the gouache. These may provide a particular background to a drawing, or give a surface which will take painted white highlights.

Other coatings may be used, including bone dust, gypsum and chalk, usually mixed with glue size. All give a slight tooth which holds the silver. Silverpoint can be used for underdrawing on glue-sized, gesso-primed panels.

Silver wire and holder
0.5, 0.7 and 0.9mm gauge wires are popular for drawing. The metal holder grips the wire securely.

PREPARING THE PAPER
Stretch some smooth, acid-free watercolor or drawing paper, then coat it with Zinc White gouache or watercolor. Silverpoint deposits its fine line clearly on this surface. One or two thin coats of gouache are usually enough – if too thick, it may crack. Above all, the coating should be even.

1 Thin gouache to the consistency of single cream and apply it to the paper with parallel strokes of a wide, flat brush.

2 When the first coat is dry, you can, if you wish, brush on a second, with the strokes going at right-angles to the first.

HOW TO USE SILVERPOINT

Before starting work, round off the end of the silver wire (see below). A wire cut with pliers and used directly is too sharp – it may cut through and break up the surface. Continuous drawing creates a flat on the rounded end of the wire, producing relatively broad strokes. Use the edge of the flat for thinner marks.

Silverpoint is probably at its best in fairly small-scale, finely crafted works with delicate cross-hatching, slowly worked up to the required depth of tone. Increasing hand pressure deepens the tone somewhat – although the deepest silverpoint tone is more like a mid-tone in most other drawing media.

Abrading the point of the wire
Round off the end of the silver wire on fine emery paper. This helps to achieve smooth marks.

·Silverpoint techniques·

FINE-LINE DRAWING

Silverpoint can be used to draw a network of tiny lines which may be built up into fully rounded images where the light and shade are transcribed reasonably accurately. Each line remains visibly part of the whole network.

In a drawing like the portrait below, the tiny cross-hatched lines follow the contours of the face. Many of the lines do not follow the natural movement of the hand on the pivot of the elbow or wrist, so it is important to try and sustain a natural fluency or lightness of line all over. This can be done with practice by changing the drawing position of the hand, or by turning the drawing on its side or upside down.

Silverpoint portrait
The drawing was built up using a 0.5mm wire in a clutch pencil holder. A 0.8mm wire was used to reinforce the shading in the darker areas.

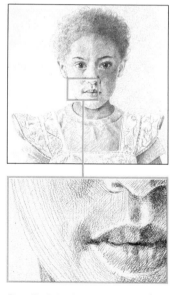

Detail of the face
On close inspection of the face, the overall effect is of great vitality and movement in the lines themselves, even through the girl's expression is quiet and composed.

LOOSER DRAWING

In contrast to the accurate style of the portrait, a much more loosely worked approach can be adopted. A 0.8mm wire was used for the example, where an interlocking network of small patches of cross-hatching, combine to represent a quiet scene.

In addition to the shading of small areas, there is shading on a larger scale, which follows particular patterns of movement through the drawing. Behind the temple, for example, along the first hedge-like backdrop of trees, the shading describes an overall area from the left, dropping down behind the temple along and up to the right in a "swathe". The lawn in front of the temple and the lake were finished with a horizontal shading which gives a solid base to the movement of the drawing.

Rotating the point of the wire
By moving the "pencil" around so that the edge of the flat was in contrast with the paper, thinner, sharper lines were made to counterpoint and offset the texture of the broad ones.

SCRAPERBOARD

The scraperboard (or scratchboard) technique is a form of *s'graffito*. Sharp tools are used to scratch away the smooth, black surface of a specially coated board, revealing a layer of white clay or chalk. Dramatic black and white images are created.

Scraperboard enjoyed a vogue among graphic artists during the first half of this century as it enabled half-tone effects to be created with line. These reproduced very well in newspapers and newsprint magazines where the quality of reproduction was generally mediocre. Among the works created for advertising were some which displayed virtuoso techniques in the skilful manipulation of line thickness, having an almost photographic realism. Scraperboard remains a unique and expressive medium in its own right and can be used to make drawings which are not necessarily designed for reproduction.

·Materials and tools·

THE SCRAPERBOARD SUPPORT

Images are created by scraping lines and tones out of black scraperboard, or out of black areas applied to white scraperboard. The board is manufactured industrially. It has a smooth, chalk-based surface, providing whites of great clarity. The black surface has a semi-matt sheen which picks up any grease marks from the fingers. Parts not being worked on should be protected from fingermarks by a clean sheet of paper. The board must be dry before you start work (important if you have applied Indian ink to the white board); damp board will crumble when cut and will not produce crisp lines. Always keep scraperboard flat – it readily cracks if bent. For how to make your own scraperboard ground, see *Appendix*, p.337.

Simple lines are easy to produce. As far as tone is concerned, whether you are starting with a white or a black board, the standard approach is first to establish the large white or black areas, then to fill in the middle tones by various cross-hatching, shading or stippling

techniques. Fine detail can be achieved in this way.

On the other hand, scraperboard responds equally well to a vigorous, more "expressionist" approach, where the work can have the look of a rough-hewn woodcut or linocut.

Working on white board
Although a board with a black surface is widely thought to be the normal starting point for scraperboard work, many devotees prefer to work on a white board, coating it with black Indian ink only where there are shapes to be scraped out. Thus a combination of scratching and ink drawing can be used. The white surface is an excellent support for pen or brush work; it has just the right amount of hardness and absorbency for crisp, fluent strokes.

To apply black ink to a white board, use a flat soft-hair brush for a thin, even coating. Do not brush the ink too much or the ground will soften. Use a small sable brush for outlines. When the ink is dry, pick out the details and highlights with cutters. Any mistakes can be scratched away or painted over, left to dry, then redrawn.

SCRAPERBOARD TOOLS

There are three basic kinds of conventional cutter (see below) which fit into pen-nib holders. Use an oilstone to keep your tools sharp; if the precision of the scraped mark is lost, work progresses much more slowly.

Less conventional tools – from pins and needles to staples and scalpels – can create different effects. Whatever you choose, it must be sharp. You can also use engravers' tools, including the multiples – chisel-edged tools with a row of teeth which create cross-hatched areas of tone very rapidly. Sections of hacksaw or fretsaw blade can also be used.

Conventional scraperboard tools
1 Lozenge-shaped tool with flat or curved edges.
2 Knife-blade type, like a scalpel with a curved cutting edge.
3 Gouge (scoop-shaped cutter).

·Scraperboard techniques·

LOZENGE-SHAPED CUTTERS

You can make fine lines with the points of the flat and curved lozenge-shaped tools. If you hold the tool like a spade and use it with a rapid digging action, you can create stipple effects. Pull the side of the flat across the board for thick, straight, wedge-shaped cuts, or down it for thinner, slightly curved ones. The curved cutter makes similar, but less angular cuts.

Stipple effect
Grasp the tool firmly so the handle is beneath your palm and use it at a relatively steep angle to the board.

KNIFE-BLADE CUTTER

You can use the point of the scalpel-type cutter to draw very fine lines, making carefully controlled manipulations and extremely detailed effects possible. As you work round the cutting edge, you can also make progressively broader lines. The skilful craftsman can vary the width of a line in a single stroke by gradually lessening the angle of the blade to the scraperboard (see below).

Producing a thickening line
If you reduce the angle of the cutter to the board while making the cut, a gradually thickening line is formed.

GOUGE

Held and used like a trowel, this tool makes tapering, scoop-like marks of varying size depending on the pressure you apply. If you hold it vertically and pull it down the board, it will create long, firm rectangular cuts. Or it is possible to make similar cuts at a diagonal using sideways movements of the gouge. If you use the tool too vigorously, however, it may push too deeply into the board.

Making "scoop-shaped" marks
Hold the gouge like a garden trowel and use it with a shovelling action to make marks for texture effects.

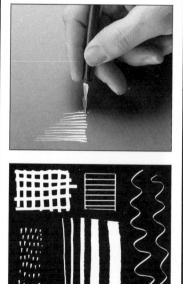

Marks made with lozenge-shaped tool.

Marks made with knife-blade tool.

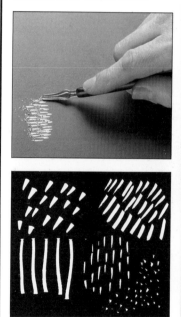

Marks made with gouge.

MULTIPLE LINE CUTTERS
A strip of staple-gun staples makes an unusual cutter. Pull it across the board several times for an effect which would be very difficult to achieve with single lines. This is a rapid way of building up an all-over texture.

Overlapping wavy line texture.

Complex straight line texture.

PURE LINE WORK

One of the simplest, most satisfying, most effective, and yet most difficult techniques is to draw directly from a model on to scraperboard. With this type of line work, no second attempts are possible. In the example, the starting point was the girl's right eye. From here, the simple outline drawing developed to the rest of the features, the outline of the head itself, then the arms and body.

Simple, direct portrait
A thin, white line taken out of dense, matt black has an illuminated quality that is unique to scraperboard.

LINEAR TECHNIQUE WITH BLADE CUTTER

In the past, a popular technique for creating tone and illusion was to use a series of parallel lines to define an image, varying the width of each line. Where the lines became thick, less black was visible between them, so at that point, the eye read a light tone. Conversely, thin lines meant a dark tone was read.

The ballroom dancers example is loosely based on this idea. Converging perspective lines were used to indicate a viewpoint looking down on some ballroom dancers. The ellipses of the spotlights and the girls' dresses are the lightest tones in the composition – where the white lines are thickest. The cast shadows and the mens' dark suits are the darkest with, in some areas, no white lines at all.

Ballroom dancing
This drawing was made with a blade cutter – the best tool to use with a ruler, having one straight, blunt edge that you can align with the ruler.

Using a ruler and blade cutter
When drawing straight lines with a blade cutter and a ruler, ensure that the cutting edge is angled away from the flat edge of the ruler.

Gymnast
Here the blade cutter was also used to create the image out of thicker or thinner parallel lines which were drawn freehand.

LINES AND CROSS-HATCHING

In a more loosely worked version of the ballroom theme, a flat-edged, lozenge-shaped cutter was used with freehand lines and irregular cross-hatching to create a similar effect of light and shade. Thin downstrokes, used in places over the horizontal/diagonal hatching on the dance floor, indicate the reflections of figures. Long, thicker, diagonal strokes were used to show the reflection of the spotlight on the floor.

Lights and reflections
The diagonal strokes used for the spotlight reflections trail off along the same line as the spotlight itself.

USING A BOLDER STYLE

In a third ballroom scene, thick, chunky strokes of the blade cutter follow the circular outline of the spotlight within its reflection. A picture like this has to be cut decisively; any alterations reduce its immediacy and so the "failure rate" is higher than for a precise and highly ordered work.

A dramatic version of the ballroom scene Here the effect is more like that of a woodcut or linocut and the chunky style gives a more "primitive" feel.

INCORPORATING OVERALL TEXTURES

The medium of scraperboard lends itself to exploring textures such as those of a landscape.

The example was made on black scraperboard using a lozenge-shaped, curved-edge cutter. It was built up in a series of small downstrokes of varying width, depending on the tones of the buildings. The buildings present rectangular planes whose cumulative effect is that of a patchwork fabric dotted with the dark recesses of the windows. The houses are diagonally cross-hatched to give a vague indic-ation of the forms, but not so much as to make any one element stand out too much.

Cityscape with downstrokes
This landscape aims to give a sense of the overall texture of the urban hillside. The pale sky was cut out of the black board with a wide blade; the cut marks are just visible.

SILHOUETTE EFFECT ON WHITE BOARD

The combination of ink and white board used in this drawing means that there are no cut-marks in the white areas. The shape of the coast was traced on to white board and drawn in with a round sable brush and black ink. When this was dry, it was worked with a knife-blade cutter. Cutting into the edges of the black defined the line of the breakwater, boats and people and helped to sustain the appearance of the whole image being cut back from black.

Evening seascape
The effect of the setting sun means the image is almost a silhouette, so few marks were needed to indicate the shoreline forms.

WORKING QUICKLY ON A WHITE BOARD

For a shape defined against white, like the parrot and branch, it is easier to paint the shape in black ink, then draw in the details with a cutter. For the distant landscape, pen and ink was worked over with a cutter for a half-tone effect; brush and ink was used for the foreground.

Parrot drawing on white board
This relatively simple drawing would have taken considerably longer to make on black board.

PEN AND INK

Despite the huge range of ink drawing materials now available to artists, the basic aspects of pen and ink work remain the same as they have always been. The mark of the pen is a direct, unequivocal statement in line which, once set down, is fixed and permanent. Although there are erasers for ink, a pen line is not generally modified and adjusted in the way that a pencil line can be. It is a once-and-for-all technique and directly reflects the artist's approach to his subject, be it tentative or confident, nervous or fluent.
So it is interesting to note that Cennini's advice to would-be artists in the Renaissance was only to begin working in pen and ink after at least one year spent drawing in charcoal and metal point. He describes a less direct working method, when a charcoal drawing is partially erased with feathers, then carefully inked in to provide the under-drawing for a panel painting. There are many examples of highly finished pen and ink drawings made over preparatory work in pencil. Such methods may be less direct than drawing from life, but even here, there is still only one chance to make the pen line come alive.

·Materials and equipment·

The range of pens for drawing has increased in the last few years. The nature of the mark made by a pen is determined by the nib type and its ink supply.

PENS

As well as traditional quill or reed pens and a wide range of steel nibs, there are now new types of drawing pens, including various sophisticated technical pens with tubular nibs which make lines of established width. These are primarily designed for technical drawing but provide the artist with a useful new drawing tool. Among the new technical pens are also those which feed ink at a constant rate to more traditional nibs.

The range of roller-tip or ball-point pens is constantly being expanded and upgraded in relation to line width and ink flow. There is, in addition, an increasing range of self-inking pens with various kinds of nylon, acrylic, wool or polyester fiber tip – the so-called felt-tip pens. These are made with water- or spirit-based inks and although the latter are claimed to be more permanent, the dyes which provide the colors are generally extremely fugitive, so it is probably best to avoid them – at least in the brighter color ranges – if you want to make a permanent work.

Different nibs and their marks The nature of the mark made by a pen is determined by the type of nib and the supply of ink. Some nibs, especially steel ones, are very flexible and enable you to make a line of varying width. A nib with a broad point uses more ink than one with a fine point, so the length of line you can produce with one dip in the ink is an important consideration. Those in the technical pen range make lines of uniform width. They have to be held at a much steeper angle to the paper than traditional steel drawing pens.

Reed pens provide a soft, chunky line; mapping pens produce a sharp, scratchy line.

Pens for drawing
1 Quill pen
2 Reed pen
3 Mapping pen
4 Steel drawing pen
5 Script pen, pointed nib
6 Script pen, flat nib
7 Script pen, round nib
8 Technical pen
9 Roller-tip pen
10 Fiber-tip pen

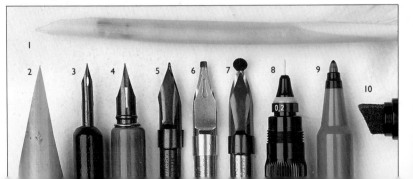

The extraordinary lightness of a quill pen makes the artist particularly aware of the point of contact between nib and paper. Among the fiber-tip pens, the "chisel" tip provides a sharper, more angular italic-style line, while the "bullet" tip gives a rounder, more uniform line. These pens can be used with the drawing board held vertically; other pens cannot.

INKS

Apart from black and white drawing inks which are pigmented rather than based on soluble dyes, some of the brighter colors may be fugitive. Manufacturers have now introduced ranges of pigmented colored inks. They claim high levels of lightfastness for most of the colors, with excellent permanence in red, blue and green and only slightly less in the yellows.

These inks are transparent and very pure in color, so you can mix particular colors with great accuracy, or control them by glazing with overlaid color. The introduction of these inks may well result in artists producing more work in full color in this medium rather than in the traditional black or sepia.

SUPPORTS

The traditional support for pen and ink drawing is sized paper. Paper which is too absorbent will make the edges of a pen line bleed, losing its crispness. H.P. rag paper provides a permanent support which can be used for most pen and ink manipulations, especially if it is stretched. Other smooth papers with coated surfaces are prepared by manufacturers with pen and ink work in mind. These are often mounted on board to avoid the need for stretching. They make fine surfaces for the work, but can be of doubtful permanence.

THE QUALITY OF THE INK LINE

The tonal variations possible within a single line and the particular expressiveness of the diluted ink line (see box, right) are aspects of pen and ink work which are often overlooked.

The chart below shows the great variety of line quality produced by different nibs on both dry and damp paper. The NOT surface, although sized, is still fairly absorbent, and there is some bleeding along the edges of the lines, though the characteristic look of each nib clearly emerges. Next to these marks, others were drawn on the same paper, dampened. This produced a wet-into-wet bleeding effect.

The three script pens included in the chart offer exciting alternatives to the more standard artists' drawing nibs. The round nib comes in several different widths and is excellent for making thick, strong lines. The square version gives lines a particular ribbon-like quality, with fluid variations within the thickness of a particular line.

USING DILUTED INK

There is a significant alteration in the nature and appearance of marks made with diluted ink, compared to similar ones made with undiluted ink.

Here the ink was progressively diluted in four stages and wavy lines similar to those in the chart below were drawn. The marks were made with a reed pen (top) and a natural goose quill (bottom).

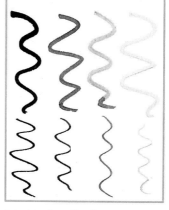

Ink drawing nibs chart
Wavy lines drawn with eight different pens in turn on stretched NOT rag paper dry (left) and dampened (right).

	DRY PAPER	DAMPENED PAPER
Mapping pen	~~~	~~~
Gillot drawing	~~~	~~~
Script pointed	~~~	~~~
Script flat	~~~	~~~
Script round	~~~	~~~
Technical pen	~~~	~~~
Natural reed	~~~	~~~
Natural goose quill	~~~	~~~

·Pen and ink techniques·

LINE TECHNIQUES

One of the most positive aspects of pen and ink is its immediacy when used to draw directly from life. This is demonstrated in a series of small-scale nude drawings (below). The drawings were made in one session with the model and drawn with a Gillot steel nib and black Indian ink on stiff cream cartridge paper.

Although the drawings are similar in some respects, they show various approaches. The style ranges from the tentative, almost whimsical approach of the first drawing, to the bolder third and fourth studies where the lines are drawn with more assurance and where increased pressure on the nib produces some generally thicker lines. The fifth study explores the thicker line further and includes lines worked over and redrawn.

Series of small nude studies
1 A tentative, rather nervous approach gives a delicate, tenuous line.
2 A slightly bolder approach with varying line quality.
3 Here the drawing is made with a more "single outline" approach.
4 Further exploration of a thicker, but more scratchy line.
5 Another view, but a similarly immediate response to the model.

1

2

3

4

5

Fine line on a damp support
On damp paper, a similar technique to that used for the nudes gives a feathery edge to delicate lines. Here the ground, a well sized NOT rag paper, was dampened with a pale wash of dilute ink before the drawing was made.

Working on dampened paper
The effect of using a damp support in this drawing is to incorporate the line into the ground so that there is more of a sense of the medieval wall-painting that inspired the drawing.

Using a very wet support

Try thoroughly wetting the paper before beginning the drawing, rather than merely dampening it. This gives you somewhat less control over the finished appearance. Chance plays some part in determining the success of the technique, since you can never be sure exactly how and where the ink will run. On the other hand, it is just this freedom of the ink that gives work of this kind its appeal.

Drawing on very wet paper
The ink lines were drawn into very wet paper and allowed to dry. The background and the shadow in the hood were filled in with a brush.

Line and brush

A bold, direct use of pen, brush and undiluted ink is an economical way of creating dramatic effects of light and shade. Areas of solid black counterpoint the lines of the pen.

Juxtaposing lines with an area of black The fluent pen line which defines the figures and details their expressions is offset by a solid background, which pushes the figures forward as if into a spotlight.

CHOOSING NIBS FOR DIFFERENT EFFECTS

Combining a fine line with a more chunky one in the same drawing is often the solution to a problem of expression, perhaps when you need to "separate" the subject and background.

A technical pen yields a fine line of uniform width. However, if you pull the pen quite rapidly across the paper, it deposits the ink in a series of tiny dots and

CUTTING A QUILL PEN
1 With a scalpel, cut off the tip of the quill using an oblique cut.
2 Take out a flat scoop along the underside of the quill.
3 Make a central slit in the nib.
4 Shape the nib on either side of the slit.
5 Insert a small, S-shaped strip of metal, cut from a ring-pull, to act as the ink reservoir.

dashes. These lighter, broken lines can be used to modulate areas of tone. The example below shows the combination of a 0.3mm technical pen and a conventional drawing pen with a round script nib.

Technical pen with round script nib Ruled technical pen lines were used to frame this image based on one made by a child. The people were drawn with a round script nib. For the shadows, very dilute ink was used.

Using a home-made quill pen A series of long or short lines in a range of three or four tones of black ink can follow the contours of a face, and gradually build up an image with form and volume. The eye travels from line to line around the head, giving a lively effect.

Portrait drawn with a goose quill cut with a wide, flat end.

Using a reed pen

The nature of the contact between pen and paper is quite different between the hard, flexible steel nib, the horny, flexible quill and the less flexible but less scratchy, straightforward touch of the reed pen. The reed pen has a broadness of feel and a solidity that makes its contact with the paper a natural and satisfactory one. In some ways, it is similar in feel to a felt-tip pen, though the latter is more uniform and less resilient.

The reed pen makes a mark that reflects its natural, chunky appearance. It does not lend itself to over-sophisticated techniques; the most successful drawings are those that rely on its plain, short strokes – there is a strict limit to the amount of ink the reed pen can hold. Vincent Van Gogh was perhaps the most outstanding exponent of reed pen drawing, and his works in the medium have a clarity and intensity which is unparalleled.

Reed pen nude drawing

Diluted ink seems particularly well suited to the reed pen. In this study, the contact between the model and the mattress is an important aspect of the drawing, so the pen marks are similar on body and background.

Script pen with point

Just by varying the thickness of the line in a pure line drawing, you can indicate tone and perspective. The movement from thin to thick along one fluid stroke can also give a drawing a sense of fluency. This very pure form of drawing is quite hard to accomplish. The pointed script nibs with more than one slit are ideal; the steel pens usually have a reservoir attachment, enabling you to make fairly long strokes.

Line drawing: hounds

A pointed script nib with two slits was used for this rapid drawing.

Combining a script pen and a drawing pen These drawings were made with a Gillot drawing pen nib (left) and a steel script pen with a pointed nib (right). The first drawing employs traditional cross-hatching techniques to build up a strong tonal effect. The second is much looser and shows again the flexibility of the script pen nib with two slits.

Tonal work with a pointed script nib
Cross-hatching gains an extra dimension when carried out with a script pen and pointed nib. Varying the thickness of the line within the same drawing and making the cross-hatching more loose and random gives a drawing a sketchy quality but a rich depth of tone. Working in this way with pen and ink, you may feel that you have lost the image by over-drawing. But if you work into the drawing even more extensively, a richer, more resolved image often emerges.

Loose cross-hatching

The pointed script nib enables fine and thick lines to be used together.

Using the script pen to control line width A steel nib with more than one slit will spring apart to produce a thick line without releasing all its ink. As pressure is reduced, it closes again to make a fine line.

"SHADING MACHINE" FOR PEN AND INK

Any artist who does a lot of tonal work with pen and ink will know how long it takes to cover a relatively small area of paper, especially when using a fine nib. It was with this problem in mind that I developed a method of speeding up the process by adding a single aluminum arm to the vibrating end of an electric toothbrush mechanism. On the aluminum arm is a hole in which to fix a technical pen with a tubular nib.

To make a drawing, the handle of the electric toothbrush is held like a normal pen, and the pen travels rapidly to and fro at the end of the aluminum arm in a series of parallel arcs. The distance of the pen from the center determines the width of the area across which it travels. The speed of movement of the hand across the paper determines the tightness or looseness of the resulting tone. By turning the paper or moving position, cross-hatching at various angles to the original marks can be made.

Controlling tone (left) Moving the hand slowly makes the parallel arcs closer.

Vapor trail drawing (right) The artist retains control over the outcome of the process.

WORKING IN BLACK AND WHITE INKS

Black and white ink on mid-toned paper has an extensive history as a drawing medium. White is often reserved for the highlights, but cross-hatching in black and white provides a range of medium tones from dark to light, with the paper providing an underlying middle tone.

In the drawing below, the background behind the sculptured figure was painted with solid Indian ink. Stonework details were picked out with white, then parallel diagonal lines were drawn across the whole dark area. When these were dry, they were overlaid with parallel black lines, drawn at a shallower angle. These "broke up" the white lines, bringing them forward to create an effect of dispersed light.

Hatched and cross-hatched drawing The image was drawn with a Gillot drawing nib on gray paper.

BRUSH AND INK

It is impossible to think of brush drawing without calling to mind the Chinese and Japanese traditions in the medium. Oriental brush drawing, whether purely calligraphic or more representational, is a traditional art, rooted in centuries of discipline and practice. In the finest examples, a combination of technical virtuosity and a deep understanding of the nature of the subject matter is found.

Over the centuries, handbooks in China and Japan have charted practically every stroke that it is possible to make, with every position of the brush. Oriental brush drawing has at its core an overriding preoccupation with the nature of the line itself. It is an art of great immediacy. In the West, where representation has taken a different course, there is no such "academic" tradition of precise brush handling, speed and pressure of stroke; the brush has tended to have a more workmanlike role in "filling in", adjusting and manipulating, rather than as the highly tuned instrument which only has one chance to make its mark.

·Oriental and Western techniques·

Brush drawing is the hand-writing of the artist and reflects – perhaps more than any other medium – the artist's character and decision. The reason for this lies in the responsiveness of the charged brush to pressure and movement from its manipulator. In the West, wherever a brush has been used directly, and by a great artist, its marks can have just as much life and appropriateness as in Oriental works. Over the last hundred years or so, artists from the West have been increasingly aware of Oriental brushwork and have incorporated many of the traditional techniques in their own work. It is beyond the scope of this handbook to deal in depth with such a complex discipline, but some of its main aspects and techniques, especially those concerning the handling of the brush, are incorporated in this section.

THE CALLIGRAPHIC TRADITION

An extraordinary fluency and control characterizes the best examples of Oriental calligraphy. The complexity of some of the "one-stroke" characters makes their perfection remarkable to anyone who practises brushwork.

Comparing details from two pieces based on ancient Chinese calligraphy (right), the different personalities of the artists can immediately be seen. The calligraphy on the left is refined, elegant and consistent, that on the right is bolder and more vigorous, but also volatile.

Examples of ancient calligraphy
These two pieces of calligraphy, although fluent and controlled, are remarkably different in character.

HOLDING THE BRUSH

The huge variety of brushes at the artist's disposal (see pp.131–3) is largely responsible for the versatility of brush drawing as an art medium. Brushes range from fine-pointed sables to coarse, hemp-like bamboo brushes, and the nature of the brush dictates to a large extent the nature of the mark. The way in which the brush is held also gives the mark a special character. Artists have developed their own methods of holding the brush for particular manipulations and some have devised whole schemes inspired by Oriental methods. Through the various holds, pressures and movements, a whole language of brush drawing is created which is articulated by the whole body.

The Western way

In the West, there is an automatic tendency to hold the brush like a pen, at an angle, and with the handle resting beside, or just below, the knuckle of the first finger. With this grip, the fingers are usually clamped together and move in unison, encouraging a one-directional stroke.

The Eastern way

In Oriental brushwork, the brush is held vertically and the support is horizontal. The thumb and middle finger provide a firm central grip which can be moved multi-directionally by the action of all the fingers. The brush is held away from the palm and the tips of the fingers do most of the holding and moving, giving a firm but sensitive control. The main considerations which determine the look of the stroke are:

- tightness of grip
- position of the fingers
- position of the wrist and arm
- pressure on the hairs
- speed of the stroke.

A tight hold gives stronger, firmer strokes; a looser hold gives more suppleness. There are three basic positions of the fingers on the handle – low, middle and high. The brush moves more freely and sensitively in the high position than in the low one, where the movement is more restrained. The distance of the hand from the support provides another set of variables, with four main positions outlined by the Chinese calligrapher Chiang Yee (see below). The width of the stroke is determined by pressure on the tip of the hairs. The three main pressures produce fine, middle and heavy-width strokes.

Whereas in the West, artists often use the whole of the brush up to the ferrule for certain manipulations, this is rare in the East – at least in calligraphy, where up to half the length of the hairs may be used, but where the very tip is the most important part, the rest of the hairs acting as the ink reservoir.

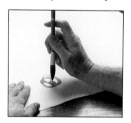

Level wrist
The wrist rests on the paper. While the right hand is drawing, the left rests flat on the table.

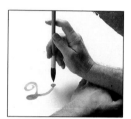

Pillowed wrist
A slightly raised wrist position, in which the wrist rests on the back of the flat left hand.

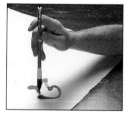

Raised wrist
Here the elbow rests on the table and the forearm is raised.

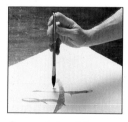

Suspended wrist
Wrist and elbow are held above the table. This is used when standing, for large-scale work.

·Inks, supports and brushes·

BRUSH DRAWING MEDIA

Although Oriental stick ink and Indian ink are the most popular and traditional media for brush drawing, any painting medium can be used, including watercolor, acrylic and even oils, depending on the support.

Oriental stick ink

In the East, the traditional brush drawing medium is Chinese or Indian ink in stick form. This has been made for over 2,000 years. It consists of Lamp Black pigment (derived from the imperfect combustion of pinewood or oil in small earthenware lamps), mixed with glue and scented with musk, camphor or rose-water. The sifted, ground soot is mixed into a warm size made from a mixture of fish glue and parchment size. This forms paste balls which are heated and shaped into sticks. These are hammered, perfume incorporated and the material pressed into wooden moulds then dried, cleaned and polished. The favored colour is a blue or violet-black. Pure black, brown and yellowish black are also seen.

How stick ink is used
The stick is ground on an inkstone with water. If it is too thick, it will not flow well; if too wet it will blot and expand.

Indian and other inks

Nowadays, Indian inks are generally carbon pigment suspensions in shellac or in a synthetic resin-based binding material, though some proprietary liquid Indian inks are made from Chinese sticks. Various other inks can be used for brush drawing. Sepia, prepared from the ink sac of the squid or cuttlefish, enjoyed a vogue in European brush drawing from the end of the eighteenth century.

SUPPORTS FOR BRUSH DRAWING

Paper or silk is the traditional support, but other canvas or panel supports may also be used.

The virtues of Oriental papers

Japanese and Chinese papers (see p.45) come into their own for brush drawing. They are generally thinner and more absorbent than Western papers, so there is a close relationship between brush, ink and paper. Brushmarks are absorbed and become an integral part of the fabric of the paper rather than "sitting" on its surface, as with heavier-sized Western papers.

Oriental papers give each stroke a remarkable form and clarity. They seem to retain the action of the stroke in a way that Western papers do not, particularly in direct drawing. Where a drawing is built up in washes of different tones, the more solid Western rag papers are better.

Using a silk support

Silk as a painting or writing support is first mentioned in China in the fourth to fifth century B.C.. The use of silk as a painting support has generally been confined to the Far East. It is naturally highly absorbent and in order to paint on it, you must first size it and then degrease it by dusting with French chalk. The appearance of the brushwork depends to a great extent on the types of weave – tight or loose.

USING DIFFERENT PAPERS

A fat, pointed Chinese brush in a plastic enlarging holder, attached to a bamboo handle was used for a series of brushstrokes on several different Oriental papers. The responsiveness of the papers to nuances of pressure and speed of line was noticeable. A momentary hesitation deposited more ink, leaving a denser tone. When the brush was slightly under-charged with ink, the edge of the line broke up, giving an expressive "drybrush" look. With diluted ink and an over-charged brush, flooding and bleeding occurred at the edges. The "palm tree" symbol drawn with a less wet brush, for example, gave a drier, grainier and more expressive image than some of the shapes made with a fully-charged brush.

Absorbing excess water

Diluted ink gives a softer, gray effect. But if the brush is too wet, the edge of the stroke will bleed. With the thinner papers, a sheet of absorbent paper placed below the sheet being painted on absorbs the excess fluid. Artists like Jackson Pollock have taken the image which appears beneath and turned it into a work in its own right (see p.124).

Using a smooth coated paper

Similar strokes made with the same brush on smooth cartridge paper showed a different character to those on the thinner, absorbent, Oriental papers. The crisper edges are somehow more separate from the action of the ink within the lines. A tonal effect produced by holding the brush at the end of the handle and swinging it in circular movements, is similarly "separate" from the paper.

Examples on smooth paper

Marks are more crisp-edged (top) than on Oriental papers. Marks made with a Chinese brush using a pendulum-like action (below) reflect the speed of the motion.

Simple marks on Oriental papers

1 Shoji off-white laid
2 Kozo shi toned laid
3 Gifu shoji white laid
4 Kawasaki off-white laid
5 Hosho sized white laid
6 Sekishu shi white laid
7 Hosho waterleaf white laid

BRUSHES FOR LINEWORK

Loaded with ink, a brush makes a dense, black line. With diluted ink, the line looks paler but just as even. As the brush discharges its ink, it becomes progressively drier and the nature of the stroke changes. This makes a variety of expressive effects possible and these can be exploited, together with effects created by the differences between the various soft-hair and bristle brushes and types of support.

To explore the qualities of different ink lines (below), three different flat brushes – a 12mm (½in) ox-hair brush, a 2.5cm (1in) nylon one-stroke brush and a No. 8 bristle brush – were used on smooth paper to demonstrate the effects of a loaded and a dry brush and of using diluted ink. The texture of the line revealed in the "drier" strokes is different in each case.

Sable brush set in a quill
This chisel-ended brush, used by sign-writers, is of equal interest to artists and provides an even line.

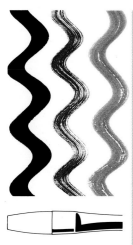

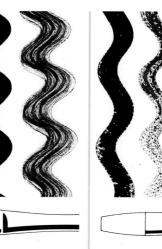

Ox-hair brush
This was tried with diluted and undiluted ink. The smooth paper gave a stringy effect. Stroking the dry brush across the paper surface can create areas of half-tone.

Nylon one-stroke brush This provided a fluent, ribbon-like effect. The close parallel lines of individual hairs or groups of hairs are plainly visible and spread uniformly over the width of the stroke.

Bristle brush
The No. 8 bristle bright produced a more ragged line, with a rougher, less even texture than that produced by the one-stroke brush.

Different paper surfaces The ox-hair brush was also tried out on a paper with a fine-grain surface. This gave a granular effect, contrasting with the stringy line produced on smooth paper.

Varying the angle and grip

A fine, soft-hair, pointed rigger was used for these lines (right) made on smooth cartridge paper, using different hand positions and brush angles.

■ With the brush held vertically in a firm grip and the hand resting on the paper, a fluent, wavy line of fairly uniform thickness was produced.

■ With the brush held at an angle of about 40 degrees, the side of the palm of the hand resting firmly on the paper and with a constant pressure on the tip of the brush, a line of even width resulted.

■ With the brush held in a similar way, but with both hand and arm off the paper, it was easier to modulate the thickness of the line by varying pressure.

■ Holding the brush at the ferrule gave yet another type of line, while holding it at the far end of the handle produced a looser, bolder, more fluent line.

Different angles and grips
1 Brush vertical, hand resting on paper.
2 Brush angled, hand resting on paper.
3 Brush vertical, hand and arm off table.
4 Brush held at ferrule.
5 Brush held at end of handle.

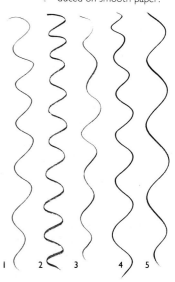

1 2 3 4 5

·Brush drawing techniques·

The expressive character of the single outline brush drawing has been recognized and exploited by artists for centuries. The Egyptian drawings (right) were made on limestone flakes with red or red and black ink, probably using brushes made from reeds. The cat has an alertness and poise which is partly due to the skilful use of line. The heavier reworked line behind its ears and down its back is the solid, arching key to the poise of the drawing. The less lyrical, but more amusing drawing of the unshaven stone mason is a credible and witty characterization. There is some red ink underdrawing with suitably bold, black ink lines drawn on top.

Ancient Egyptian ink drawings
These two small ink on limestone drawings were made in Egypt between 1310 B.C. and 1080 B.C.

WORKING ON SMOOTH AND TEXTURED PAPERS

The character of a brush line drawing is directed by the nature of the brush and of the support. The two drawings below were made with the same brush – a round pointed sable – on two different surfaces, a smooth paper and a grainy paper. The drawings were made rapidly with simple, bold strokes – a style with a high failure rate. In the second example, the hardness of line of the first is broken up and softened by the effect of the grain of the paper. To get this effect, the brush should be dipped in the ink then partially wiped off with an absorbent tissue before drawing.

Direct line drawing on smooth paper.

Direct line drawing on grainy paper.

USING A VARIETY OF BRUSHWORK

About three thousand years after the Egyptian works above, Rembrandt – arguably one of the greatest exponents of direct drawing with the brush – was producing masterly studies such as this one in brush and brown ink.

For all its apparent simplicity, such a drawing contains a rich variety of brushwork, from the thin, dark, fluent lines around the sitter's left arm to the thicker strokes of the foreground. It is fluent and light, but has a solid presence.

A Girl Sleeping (c.1655–6) by Rembrandt.

Direct drawing on Japanese paper These two examples of line drawing directly from the model were made on absorbent Japanese paper. The soft texture of the paper and its creamy translucency add to the expressiveness.

Using a fairly dry brush
This drawing, made with a small, pointed sable brush on Shoji off-white laid paper, shows the responsiveness of Japanese paper to the brush.

Using a wetter brush
A wetter Chinese goat-hair brush on Kozu shi toned laid paper provided the rapid sketch of the same model.

Fine brush line on smooth paper
Drawing fairly rapidly using a firm, vertical grip and a fine line gives an effect that could almost be mistaken for pen drawing.

RAPID BRUSHWORK

The brush is more readily maneuverable than the pen. It can be moved extremely rapidly and fluently. Varying the pressure on the tip during the rapid movements of the brush produces lines which vary considerably in width within one stroke – a unique effect of brush and ink. Fluid brushwork of this kind is difficult to control and needs practice.

Using a long-haired brush
A long-haired lettering brush, or rigger, can be used to good effect in brush drawings. If you move the brush rapidly within your fingers, the hairs begin to set up their own movement, producing a "scribble" effect. This creates a sense of urgency and movement within a drawing.

Rapid, fluid brushwork
Here a large Chinese brush was held vertically, its tip just touching the paper. Altering pressure on the tip varies the thickness of a single line.

Landscape drawn with rigger and striper brushes Here, a perspective effect was achieved by using small brushes at the top, and large ones in the foreground.

JACKSON POLLOCK'S CREATIVE TECHNIQUES

Jackson Pollock's technique of letting ink from one drawing soak through to the paper beneath to form the basis for a second drawing has already been mentioned. To make the original marks, Pollock employed a variety of dripping, pouring and spattering effects. Some of the ink may have been poured from a pot so, strictly speaking, this may not classify as brush drawing. However, he certainly made wide use of the brush in techniques where the hairs never touched the surface of the paper. The brush might be held loosely over the drawing, allowing the ink to drip or trickle on to it at leisure.

Alternatively, Pollock swung the brush violently above the surface, or held it upright and flicked paint from the hairs.

Untitled (1951), by Jackson Pollock.

TOWARDS TONAL BRUSH DRAWING

Apart from the pure use of line, there is a more tonal aspect of brush drawing. In the portrait sketch (below), for instance, the shadows were blocked in with a fat brush and the details picked out with a thinner one. This is just a sketch, but the technique can be extended to fully resolved works, with various dilutions of ink providing the half-tones.

The thin brush can take the place of a pen in providing the outlines of the brushed tonal modeling. Poussin, for instance, was a superb draughtsman who made many drawings in which simple, bold, dark washes over outline pen drawings flood the drawings with light and give them solidity and dimension.

Portrait sketch
A No. 18 round nylon brush was used to block in the solid black areas of this portrait. The details and finer lines were drawn with a No. 5 round pointed sable.

Line and tone sketch
In many ways, this sketch is similar to the one on the left but, here, drybrush was used for the halftones.

PURELY TONAL BRUSH DRAWING

Some ink drawings are handled in a very economical way with the brush, yet give an impression of a full tonal range. In the contemporary drawing based on a television image, a range of tones is shown by the use of diluted ink. This is a purely tonal drawing with no line work at all. It was begun by masking out the white highlight areas — the dancer's dress and reflection and the singers and their reflections — using rubber masking fluid. When this was dry, the drawing was washed over with a light grey tone which was then worked into with deeper tones — both wet and dry. The darkest tones were added last.

Tonal drawing with diluted ink

Several different tones of ink were used in this drawing and masking fluid kept the highlights white.

USING A SINGLE TONE OF INK

Nicholas Poussin (1594–1665) made some ink drawings where he used tone entirely. This pure brush landscape drawing contains no penwork at all and was drawn using a single tone of ink. Poussin describes a complete landscape with the ink and brush and makes use of drybrush techniques to provide the half-tone impressions.

View of the Tiber Valley (1640s), by Nicholas Poussin.

OTHER DRAWING TECHNIQUES

The sophisticated drawing products of the artists' materials manufacturers, with all their aspects of design, packaging and promotion, may obscure for some artists the fact that their raw materials comprise, to a very large extent, natural materials such as graphite, clay, charred twigs or earth pigments. There are a number of artists whose art arises out of a direct involvement with the natural world and for whom the natural materials that are found on site rather than the manufactured product, provide the basis for work made either immediately or later in the studio or gallery. Mud, sand, twigs, leaves, water, berry juices and lumps of chalk have all been used to make work which ranges from conventional "drawing" on paper to less conventional, but nonetheless "traditional", mark-making or "drawing" on the land itself. In addition, the actions of the sun, wind and rain have all been called upon as a means of modifying, or even creating work.

·Large-scale drawing·

One kind of large-scale work is that illustrated, for instance, by the wall drawing of Sol le Witt. In this type of work, the concept is critical, since the drawing itself can be made by others to the artist's plan. Sol le Witt says: "The artist conceives and plans the wall drawing. It is realized by draftsmen. (The artist can act as his own draftsman). The plan (written, spoken or a drawing) is interpreted by the draftsman". Such a scheme allows for the draftsman's own decisions, interpretations, contributions and errors, but the work itself remains that of the artist. "The wall drawing is the artist's art, as long as the plan is not violated".

THE QUALITIES OF WALL DRAWING

Large wall drawings like the one shown (right) have geometry and order and utilize the whole of the available space. Sol le Witt's large-scale drawings in white chalk on matt black grounds are remarkable for their ability to transform the space they inhabit, making it both exciting and new, but also tenuous. The dusty fragility of the chalk line is somehow emphasized by the parallel geometry of the lines – horizontal, vertical or diagonal. There is a matter-of-factness about this work, particularly in a description or illustration, which seems to leave little room for speculation or debate. So it is ironic, in a way, that the experience of the work itself should remain so startling and memorable for the spectator.

On four black walls, white vertical parallel lines, and in the centre of the walls, eight geometric figures (square, circle, rectangle, triangle, trapezoid, parallelogram, cross, and X) within which are white horizontal parallel lines. The vertical lines do not enter the figures (detail), by Sol le Witt.

Scaled-up wall drawing

Some drawings are enlarged to a massive scale. The Gilbert and George charcoal on paper sculpture (right) is an example. It was scaled up from an original drawing using the grid method, with the artists working on each of the large sheets freehand, referring to the relevant section of the grid on the original. In order to fix such a huge work, fixative was supplied in large drums and applied with a spray gun and compressor.

Using the landscape in large-scale work

A number of artists have incorporated the actions of the elements in their work. The rain has often made its mark upon a work quite by chance, but there are also artists like Julian Schnabel, for instance, who have made whole suites of drawings based on the action of the rain on watercolor or charcoal. Other artists have used the sun's rays to make drawings. Roger Ackling uses a powerful magnifying glass to concentrate light from the sun, burning images into pieces of driftwood. For him, the slow, careful method of working that this entails is perfectly suited to his temperament.

There are artists who make drawings in the landscape itself and whose work is documented

The Shrubberies No 1 and No 2 (1971), by Gilbert and George (Charcoal on paper sculpture). Each sheet was "aged" by being wetted and sprinkled with permanganate of potash.

Seagull by Roger Ackling There is a sense of appropriateness about the seagull image burned slowly into timber worn and bleached by exposure to sea and air.

in various ways before being washed away by the rain or tide, or blown away in the wind. Joseph Beuys, for instance, made a series of drawings in smooth sand with a stick. On a larger scale, Walter de Maria has made drawings by leaving motorcycle tracks in the desert sands.

·Using natural materials·

Many different approaches are adopted by artists who actually use natural materials as their drawing medium. The materials may be taken directly from the subjects they represent or used entirely separately.

WORKS IN MUD OR WATER

Some artists use mud or water to make works. Such works are discussed here as drawings, for

although they are not drawings in the conventional sense, they nevertheless have the immediacy and indeed, for all their scale, the intimacy of the direct and personal form of mark-making that is traditionally associated with drawing.

The mud and water works of Richard Long (see p.128) are of a different order to works like the "natural media" drawings of David Nash (see p.129). Representation is more focused on the action of making than on the

recreation of external appearances. The mud drawings are worked by hand within the matrix of a circle, or confined to the effect created by a single splash or bucket-load thrown against a gallery wall. Long creates works which are not representational, but are startlingly real in themselves. Their presence in the gallery is of a quite different order to that of a work in acrylic paint, for example. The dusty mattness of

the mud speaks directly of itself and of the landscape from which it is taken. The works have that clarity which comes of the natural material being taken out of its natural context and placed within the geometric order of the white gallery space. But this is no mere juxtaposition. The works transform the space, evoking a world quite separate from that of the gallery and its urban context. There is nothing placid or laid-back about them, however; these are strong and active works.

In the *River Avon Mud Circle*, the active nature of the drawing/daubing process is evidenced by the splashes of mud around and within the perimeter of the work. Within the mud circle, the interwoven marks of the fingers create a dense and urgent lattice-work. The texture of the fingermarks gives an impression of depth from a distance, though from close-to, their effect is to reinforce the flatness of the wall, a notion which is further emphasized by the overall uniformity of the tone of the work.

Whereas the mud circle is a busy, energetic, "spinning" work, the *Muddy Water Falls* piece is altogether "grander" and less "active". The shapes loom from the gallery floor which, as with all the mud pieces, is quite cleaned of the mud and water which is deposited while the work is made. Herein lies an answer to the presence of these works, for while our general associations with mud might be with wetness and muddy boots, these works, for all their immediacy and for all that they reflect the activity of their making, are cleaned up. They are highly sophisticated works whose immediacy is contained within the rectangle of gallery space.

River Avon Mud Circle (1985), by Richard Long The trajectories of the mud splashes round the edges of the circle directly reflect the movement of mud from container to wall and combine to give a sense of motion to the whole work.

Muddy Water Falls (detail, 1984), by Richard Long Works like this do not set out to be anything other than what they are – muddy water falls – but this very matter-of-factness means that they prompt many varied associations in the viewer, however little these may be intended.

USING MATERIALS RELATED TO THE SUBJECT

Certain artists work on a smaller scale, on paper, incorporating natural materials found on site and related in a direct way to what is being drawn. Among them is the sculptor David Nash. The "sheep spaces" drawing (right) uses conventional drawing materials – graphite stick, gray pastel and chalk – for the rocks, while the "sheep spaces" – where the sheep rub themselves in the ground in the shelter of the rocks – are rubbed into the drawing with material from the ground itself. Grass has also been rubbed into the drawing. This goes brown very quickly on exposure to light and can be seen to have done so here. The action of the sheep in rubbing the ground – itself a primitive act of mark-making – is paralleled in the deep brown smudges which form the main substance of the drawing.

In a drawing based on his own sculpture *Tongue and Groove Stoves*, (right) Nash incorporates ash, charcoal and the underside of rotting bark from the work itself and earth from its base as the main drawing materials. Using materials in this way gives a sense of physically re-creating rather than just imitating the appearance of the sculpture.

***Blackberry and Elderberry* by David Nash** Here the small drawings of blackberries and elderberries have been made using the actual berry juices. The juices – smeared across the base of the two charcoal drawings – would soon fade if the drawings were not designed to be kept in a book, out of the light.

***Sheep Spaces* (1980) by David Nash** This drawing depicts places by the rocks where the sheep rub themselves and seek shelter. Although there are no sheep in the drawing, their presence is strongly implied by the marks made by the natural materials, taken from the gray-brown landscape.

***Tongue and Groove Stoves* by David Nash** This artist's drawings from his sculptures are not merely a form of two-dimensional document-ation. They are exciting recreations in a new medium incorporating materials provided by the work itself.

·PAINTING·

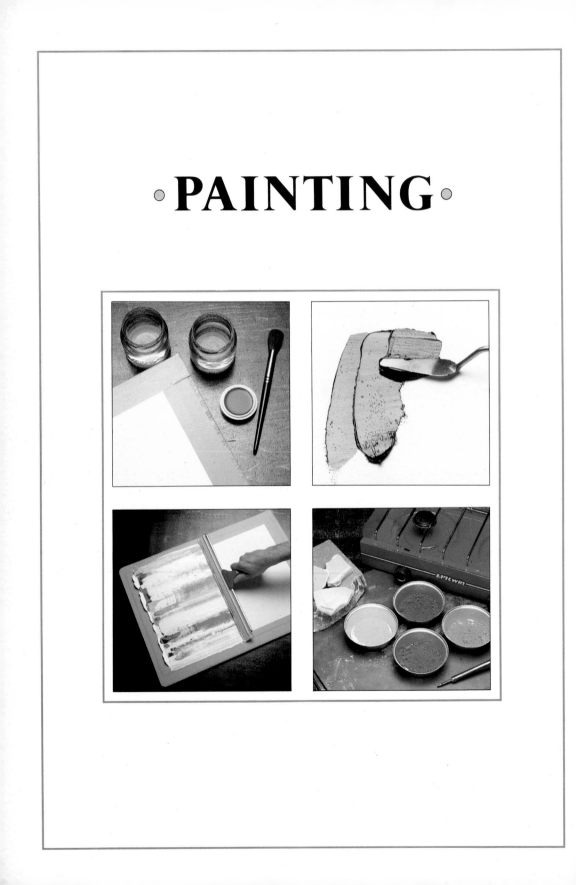

PAINTING EQUIPMENT

Brushes for painting fall into two main categories: soft-hair brushes like the red sables, squirrel hair, ox-hair or synthetic soft-hair types, and the harder bristle brushes which are made from hog-hair or synthetic fibers, and which are stiff and resilient. In addition to these brushes which apply the paint, there are others, such as blenders, which are used to manipulate it once it has been applied to the support.

SOFT-HAIR BRUSHES

Their precise handling of thin washes of color means that soft-hair brushes are the ones used almost exclusively in watercolor painting. They can be used in the same way with acrylics and oil colors, especially for glazing, and for very precise painting. Other uses include hatching techniques in tempera and fresco, decorative work in ceramics, painting on glass, and many other areas calling for subtlety and control.

These brushes can hold a good deal of thin paint while retaining their shape. Apart from their use in creating large, spontaneous wash effects in watercolor, they are also used for precise work.

BRISTLE BRUSHES

These are used extensively in oil painting and with acrylics. They are particularly suited to rich, impasted brushwork and large-scale work. They are rarely used in watercolor except when dampened with water for scrubbing or washing off, or with color to impart special textured effects. Bristle brushes are rougher than soft-hair brushes; they have coarse hairs which hold plenty of thick paint and yet retain their shape.

Bristle brushes are useful for covering large areas with a uniform tone, for blending or graduating thick oil or acrylic colour, and for frottage or stenciling effects.

HOW BRUSHES WERE MADE IN THE PAST

Since primitive times, brushes have typically been made from animal bristle hairs bound to a stick, or soft hairs set in a quill. However, in ancient Egypt, reed brushes were made by crushing one end of a reed, separating the individual fibers and binding the reed tightly at the point of separation of the fibers. Other brushes were made by binding twigs of varying thickness.

Cennini, writing in the fifteenth century, gives detailed instructions for making brushes. For soft-hair brushes, bunches of hairs were selected from cooked minever tails to fit various quills ranging from those of a vulture to those of a dove. The hairs were tied, inserted into the quill, and pulled through to the required length for the tip. A smooth, tapered chestnut or maple stick, about 22.5cm (9in) long, was inserted into the quill to form the handle.

Bristle brushes were made by tying a pound of white hog bristles to a stick, which was then used to whitewash walls until the bristles were supple. This was then untied and bound into smaller bundles of the required sizes. The tip of a stick was inserted into each bundle and the brush bound down half the length of the bristles. This method, with various modifications, was practised until the nineteenth century, when metal ferrules became widespread. The metal ferrule meant that the shape of the brush, which had hitherto been round, could itself be modified to form flat brushes.

Egyptian scribes' reed brushes.

MODERN BRUSH MANUFACTURE

Modern brush-making methods are not so different from those used in the past. Artists' brushes are still made by hand, and special craft skills are involved.

Preparing hair for brushes

Nowadays, brush manufacturers buy hair that has been bundled and dressed by specialist suppliers. In the case of sable hair, this involves cutting the hair in strips close to the skin, removing the tip and the base of the hair and combing out the soft wool at the base, leaving only the strong guard-hairs. The hair is straightened by steaming under pressure, and dragged out according to the length required.

The manufacturing process

The brush-maker places bundles of hair in a cylindrical container called a cannon. Tapping the cannon settles the base of the hairs and blunt hairs – identified by their white tip – are removed with a penknife. Short hairs are combed out. The brush-maker lays a row of hair on the work surface and picks up just enough to fit snugly in the ferrule (metal band which secures the join between hairs and handle). The hair is placed in a smaller cannon and tapped down. Then it is gripped, removed, and twisted with the fingers. This twisting forms the shape of the round sable brush. Individual hairs taper towards the tip and the base.

With long bristle and nylon brushes, the shape of the tip is formed by tapping the hair into a cannon with a shaped base. The hair is snugly fitted into the ferrule without tying. Large sable brushes are tied off with thread using a clove-hitch knot before being inserted into the ferrule and pulled through. The length of the hair out of the ferrule is checked for consistency. Filbert brushes are made like round brushes and the ferrule flattened with pliers. Flat brushes (see p.133) are made on a flat-bottomed cannon and placed in a round ferrule which is also flattened with pliers. Prepared ferrules are placed in trays with the hairs pointing downwards and a blob of glue (usually epoxy resin) is squeezed on to each. The glue is softened, then the handles jammed into place.

Each ferrule is "knurled" on a machine whose three rotating wheels squeeze it, giving it a strong grip on the wooden handle. Any loose hairs are removed by scraping with a blunt penknife. The brush is dipped into a weak glue solution to hold its shape. Sable brushes are then sucked to form a point while hog brushes are tied with thread to hold their shape while the glue dries.

TYPES OF BRUSH

Within the two main kinds of brushes – soft-hair and bristle – there are two different shapes: round and flat. This characteristic is determined by the cross-section of the ferrule, the metal band surrounding the join between hairs and handle. Within these main groups are sub-divisions, identified by the length and shape of the hairs.

Round brushes

Among the round brushes are the standard pointed rounds. The soft-hair versions taper to a fine point and come in a number of different hair lengths. The shortest are used for miniature painting. In the more standard lengths, the shorter-haired, pure sable brushes cost less than the longer ones. They hold less paint and have slightly less fluent points.

The longer-haired pointed sables include writers and riggers, the latter being so named after their original use in painting the rigging on pictures of ships. Such brushes are used by signwriters, who also use striper brushes – round, long-haired brushes with a "chisel" end – for painting long lines of uniform thickness.

Other round soft-hair brushes include mops and wash brushes. These are usually made from squirrel or imitation squirrel hair and are used, as their names imply, to lay large areas of wash or soak up unwanted paint.

Round bristle brushes have smooth, curved ends. They are tough and hardwearing, with good paint-carrying capacity.

Filberts

Between the flats and the rounds are the filbert brushes. Strictly speaking, these are in the flat category, since they have flat ferrules. In fact they are made as round brushes which subsequently have the ferrules flattened. They have rounded points and combine some of the best features of round and flat

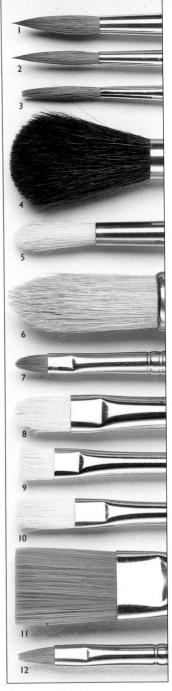

Common brush types
1 Pointed round
2 Writer (rigger)
3 Striper
4 Mop (wash brush)
5 Round bristle brush
6 Large round bristle brush
7 Sable filbert
8 Bristle filbert
9 Bristle bright
10 Long-haired bristle flat
11 One-stroke brush
12 Pointed flat

brushes. The curved tip allows you to control the brush well when painting up to an irregular edge, especially when you use the very end of it.

Flats

All square-edged brushes set in flattened ferrules are known as "flats". Those with the shortest hair are brights. Bristle brights were developed for *alla prima* oil painting and are used for applying short dabs of color.

Longer-haired flats made from soft hair are also known as one-stroke brushes. They carry enough color for the artist to make a single, clean-edged stroke across a support of medium dimensions. The thin edge can also be used to make sharp lines. The resilience of the hairs on a long-haired bristle flat gives a longer, smoother stroke than the bright, but retains the characteristic "rectangular" shape.

The pointed flat is a soft-hair brush that tapers to a point when wet and forms a chisel edge when loaded with color. It is useful both for applying color and for softening edges.

Brush sizes

Within each type, brushes come in various sizes from oo (the smallest) to around 16 (the largest). The width of the handle is directly proportional to the size, so that a No. 16 brush has a thick handle and a No. oo a thin one. The characteristic handle shape, with the wood thickening just below the ferrule, is designed to keep the wet hairs of separate brushes from touching when you are holding and working with several at once.

Brush length has become largely standardized. Brushes for watercolor are made 17–20cm (7–8in) long and those for oil, alkyd and acrylic 30–35cm (12–14in) long. Watercolor brushes are made shorter, since the scale of watercolor painting is usually more intimate than that of oils or acrylics. Of course, it is best to choose the length and size of handle that suits you. Artists often extend brushes by taping them to canes.

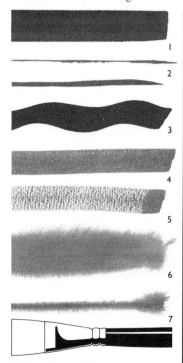

Using a 25mm (1in) one-stroke brush

These examples of strokes were made on dry and wet paper.
1 Brush used flat.
2 Strokes made with the edge of the end of the brush.
3 Wavy stroke with brush used flat.
4 Fast, flat stroke with dry brush.
5 The same stroke made even faster.
6 Brush used flat on wet paper.
7 Stroke made with the edge of the brush on wet paper.

BRUSHSTROKES MADE WITH BRISTLE BRUSHES

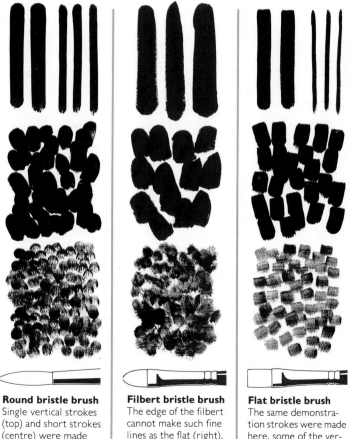

Round bristle brush
Single vertical strokes (top) and short strokes (centre) were made with a loaded brush. Stippling with a dry brush is also shown (bottom).

Filbert bristle brush
The edge of the filbert cannot make such fine lines as the flat (right). The short strokes and dry brushwork clearly show the shape of the end.

Flat bristle brush
The same demonstration strokes were made here, some of the vertical strokes being made with the flat of the brush, the thinner ones with the edge.

SYNTHETIC BRUSHES

Both soft and stiff-hair types of synthetic brushes have been considerably improved over the last few years, and make a useful and economical alternative to natural hair brushes. However, when used for oil and acrylic painting, no amount of cleaning seems to prevent them from gradually stiffening and accumulating paint in the "heel" above the ferrule. This causes the hairs to splay out and the brush to lose its point. In my experience, they do not last nearly as long as the natural hair brushes. For laying watercolor washes, however, synthetic one-stroke brushes are very effective and seem to be a match for natural hair alternatives.

SPECIAL-PURPOSE BRUSHES

Apart from the most common brushes, there are various others which perform auxiliary functions.

Quill sables

Soft-hair brushes made in the old way, by tying hairs and inserting them into quills, come in a range of sizes relating to the size of the bird from which the quill is taken. Generally available, in ascending order of size, are: Lark, Crow, Small Duck, Duck, Large Duck, Swan, Small Goose, Goose and Large Goose. Henry Peacham's advice on choosing brushes in "The Gentelman's Exercise" of 1612 remains sound, though today, retailers offer a pot of water to test the points: "Chuse your pencils by their fastness in the quils, and their sharpe points, after you have drawne and wetted them in your mouth. You shall buy them one after another for eight or tenne pence a dozen at the Apothecaries."

Quill brushes are round, long-haired sables with points (writers) or square ends (stripers).

Blender brushes

Fan blenders or dusters are flat, fan-shaped brushes, designed to modify paint already on the canvas. They are used dry to soften edges of applied color, to eliminate brushstrokes for a smoothly modeled appearance (on a portrait for instance), or to blend adjacent tones. They have other specialized uses such as adding highlights to hair.

The badger blender is a full, round, flat-ended brush, like a shaving brush (which in fact makes a good substitute), used mostly for manipulating transparent glazes on a painting. Hold it at right angles to the canvas, and use a series of stroking actions to spread, smooth and blend the paint. Dab it on a rag to remove excess paint after every few strokes.

Stenciling brushes

These are thick, stubby, round brushes with very stiff hairs and flat ends, used to apply paint through holes cut in a stencil.

Stipple brushes

These are made for decorators but are equally useful for artists. They come in a wide range of shapes from the "shaving brush" type to rectangular brushes used for stippling thick-textured paint.

Varnishing brushes

Flat, wide, long-haired bristle brushes for applying varnish to oil paintings in long strokes.

Oriental brushes

Apart from the hake brush – a flat brush used for applying washes or dusting off charcoal – most Oriental brushes are round. They are constructed round a central core of hairs (deer, goat, rabbit or wolf), to which more are added to establish the shape and size. Even in the largest sizes, most have a fine point, enabling very delicate manipulations to be made. The brush is held at right angles to the horizontal support.

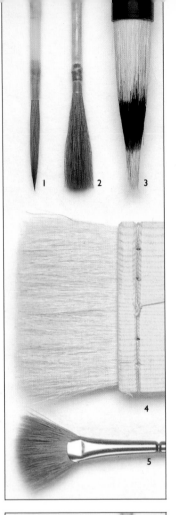

Special-purpose brushes
1 Pointed quill sable (writer)
2 Square quill sable (striper)
3 Round Oriental brush
4 Hake brush
5 Fan blender
6 Decorator's badger blender
7 Stipple brush
8 Stenciling brush
9 Varnishing brush

CLEANING BRUSHES

With quick-drying media like acrylic, brushes should be wiped and washed after each manipulation. With a slow-drying medium, you must clean them after each session. Never use hot water – it may expand the metal ferrule causing hairs to fall out, and it can harden acrylic paint on the brush.

Use water as a solvent for acrylics and watercolor, mineral spirit for oils. Have two jars of solvent. Wipe dirty brushes, then rinse them in one jar. Before using a new color, rinse them in the other.

Cleaning a brush correctly

1 Wipe the brush, rinse it in solvent, then rinse repeatedly in clean solvent. Hold the brush under a cold running tap.

2 Rub the brush gently over a block of household soap, then work up a lather in the palm of the hand (it will soon show the color of the last pigment).

3 Re-wash the brush in cold water and repeat the soaping until no trace of pigment appears in the lather. Rinse in cold water. Shake off the water, reshape with the fingers and place in jar, hairs uppermost.

OTHER MEANS OF MANIPULATING PAINT

Apart from the huge range of brushes available for painting, there are many alternative methods of applying paint.

Sponges and pads

Natural sponges come in different sizes and are useful in watercolor work for dampening paper, applying washes, removing color, or for textural effects. In addition, they can be used on a large scale with acrylics.

Synthetic painting pads were developed as an alternative to decorating brushes. The smaller sizes offer some interesting technical effects for artists, including their ability to sustain a band of color of uniform consistency and width over a longer span than a traditional one-stroke brush.

Spatulas and scrapers

The flexible metal spatulas used for mixing colours are not usually used as painting tools. But plastic spatulas or scrapers like the ones used to apply proprietary D.I.Y. fillers are used by artists in various ways. They can be used to apply priming or paint, covering large, flat areas and avoiding brushmarks, or create textured effects using several colors at once. Small pieces of thin, flexible plastic can be used – such as old credit cards, or the plastic-edged scrapers used to remove frost from car windows. A window

cleaner's squeegee with its rubber or plastic strip can also create effects that could not be made with traditional painting implements. Scrapers with modeled edges for texture paint effects may also be used.

Paint rollers

There are many types of paint rollers, from pure lambswool to the rubber or plastic types with molded textures that provide specialist finishes for texture paints. Various kinds can be used by artists for applying grounds, particularly when a smooth finish is not required. They are more suited for work on rigid supports than on canvas, unless the canvas is first stretched against a flat wall or board and subsequently re-stretched on a stretcher when the painting is finished. With thin, wet paint, a roller can quickly produce an overall texture effect similar to that created with a sponge. With thick paint, a roller creates a characteristic texture which can be used in a variety of ways for expressive purposes. When using a roller to cover a very large area rapidly, it is a good idea to attach it to a broom handle.

Alternative painting implements

1 Synthetic painting pad
2 Natural sponges
3 Windowcleaner's squeegee
4 Car windshield scraper
5 Credit card
6 Plastic D.I.Y. spatula
7 Comb-edge D.I.Y. scrapers
8 Lambswool paint roller
9 Texture paint roller

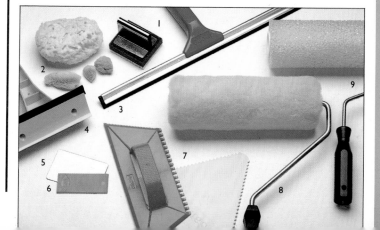

Airbrushes and spray guns

These instruments use compressed air to atomize paint and apply it to the support in a fine spray. An airbrush is a miniature, pen-like spray gun which enables you to control the work over a very small area.

With a standard spray gun, you can apply uniform or graded tones over large canvases. There are a number of different systems, including the pressure-feed and airless ones. However, the gravity-feed guns (paint container mounted above the gun to allow gravity to feed the nozzle) or the suction-feed system (paint container below the gun so paint is supplied by a syphoning method), are the systems usually employed by painters with a comparatively small amount of paint to deliver, and who use paints of low viscosity.

The paint should be mixed to a creamy consistency, free of any lumps which could clog the airbrush or gun. It is a good idea to pour it through a nylon mesh or sieve before use. With oil paint and acrylics, it is very important to clean the instrument directly after use. The standard cleaning method is to spray solvent through the system, usually by covering the nozzle of the airbrush or spray gun tightly with a rag and operating it. Accumulated paint deposits from the nozzle bubble back into the reservoir. Repeat until the solvent sprays clear.

It is extremely important to wear an appropriate respirator when spraying paints; atomized droplets of paint and solvent can hang in the air for some time after spraying.

AIR SUPPLY FOR AIRBRUSHES AND SPRAY GUNS

An air compressor is usually used to power spray guns and airbrushes – although for airbrushes it is possible (but expensive) to use proprietary cans of compressed air. A good compressor supplies air at constant and adjustable pressure for both airbrushes and spray guns. An air tank helps the compressor to maintain a constant pressure and an even spray.

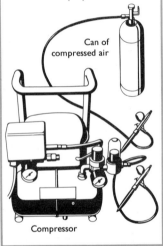

Can of compressed air

Compressor

Airbrushing equipment
1 Gravity-feed airbrush
2 Respirator
3 Gravity-feed spray gun

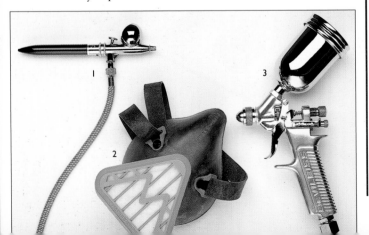

PAINTING ACCESSORIES

Palettes

Hand-held palettes have been used since the fifteenth century, though they have evolved in shape since then. Originally, they were rather small, square or paddle-shaped objects with a handle – sometimes with a thumbhole set into them. By the nineteenth century, large oval or kidney-shaped palettes with a thumbhole near the center were fashionable. These were soaked in linseed oil and allowed to dry hard before use, to prevent oil from the paint being absorbed into the wood and making the paint too lean. They are still made, usually from a hard wood like mahogany and also in an oblong shape. Nowadays, palettes are sealed with polyurethane varnishes or cellulose lacquer.

When large wooden palettes were popular, people often painted on a red/brown ground. A mahogany palette showed how the colours would look against this. In the same way, there is a strong argument in favour of using a white palette if you are painting on a white ground. These are made of melamine-faced laminates or other plastic, ceramic or enameled materials.

Non-absorbent, disposable paper palettes are sold in tear-off pads. Some artists mix their colors on a glass slab laid over white paper, resting on a small table beside the painting.

Plates and saucers are useful and old cups, jars and tins can be used for mixing. They can be covered with plastic film between sessions to stop paint drying.

White porcelain slant-and-well tiles and cabinet saucers are excellent for mixing watercolor and acrylic washes. They are heavy, so not liable to spill, and easy to clean – even dried acrylic paint peels off easily under a warm tap. Although expensive, they last indefinitely. Plastic mixing trays are suitable for watercolor, poster and powder paint.

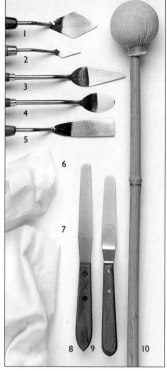

Mahlstick, painting knives and palette knives
1 Diamond-shape painting knife
2 Small diamond-shape painting knife
3 Trowel-shape painting knife
4 Pear-shape painting knife
5 Paddle-shape painting knife
6 Paper tissues
7 Cloths
8 Straight palette knife
9 Cranked-shank palette knife
10 Mahlstick

Palettes and dippers
1 White plastic palette
2 Wooden palette
3 Tear-off paper palettes
4 Double dipper
5 Single dipper with lid
6 Tinting saucer
7 Cabinet saucers
8 Divided slant tile

THE MAHLSTICK

This light bamboo or aluminum stick about 1.25m (4ft) long has a ball-shaped end, covered with soft leather. If you are right-handed, hold the stick with your left hand, the ball end touching the canvas or easel so that your right hand can rest on it while painting. This helps you to work with a steady hand in a particular area.

Dippers

These small containers clip on to the palette and are generally used in pairs – one for solvent or diluent, the other for drying oil or painting medium. Dippers are usually made of tin plate, nickel-plated brass or plastic, and are open, wide and shallow. This makes them easy to clean, but the solvent can evaporate quickly, especially outdoors in hot weather. So other versions are available with narrower tops and screw-on lids. Clean these carefully after use.

Palette knives

These are straight- or cranked-blade flexible steel tools used to move and mix paint on the surface of the palette and to scrape it off at the end of the painting session. They are also used to mix ingredients for painting media on a grinding slab before mullering and for scraping paint off the edges of the muller.

Painting knives

Not to be confused with palette knives, these are used for applying paint to canvas. A painting knife has a long, thin curved steel shank, with a blade at the end. The cranked shaft keeps the blade lower than the wooden handle so that your hand is kept away from the surface of the painting while working. The blades are flexible and springy and come in a wide variety of shapes, lengths and overall sizes. Common shapes are "diamond", "pear" and "trowel", and a number of effects can be achieved with them.

Cloths and tissues

A ready supply of clean cotton rag or absorbent tissues is an essential part of painting equipment. Wiping excess paint off brushes before cleaning them in solvent is most important. Unless you do this, jars of solvent quickly become dirty and need changing. Cloths are useful during the painting process to wipe paint off the canvas, or to impart particular textured effects. Paper tissues soak up excess water-color and may also be crumpled for "sponging out" (see p.152).

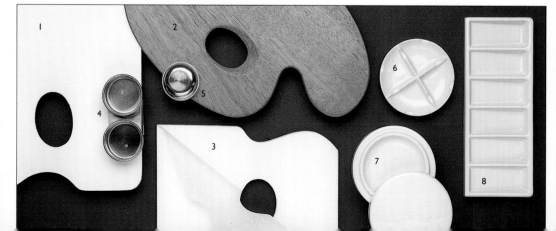

WATERCOLOR

Water-soluble binding materials of various kinds, added to ground pigments to act as vehicles in painting systems, have been used by painters for centuries. But the specific painting medium which is now known as watercolor, can be said to have developed and flowered in the English School of the latter half of the eighteenth and first half of the nineteenth centuries. During this relatively short period, a number of outstanding painters took up the watercolor medium. It had, until then, been largely topographical in approach and was used for the careful filling in with thin color washes of subjects that had previously been painstakingly drawn out in complete detail in pen and ink or pencil. These painters now turned watercolor into art, establishing a new tradition of painting that demonstrated the power and the subtlety of the medium and gave it a most striking immediacy.

The early watercolor painters

Among the pioneer artists who were able to recognize and exploit the possibilities of watercolor were Paul Sandby (1731–1809), whose highly resolved works incorporate both transparent and opaque painting methods, and J. R. Cozens (1752–1797), who used mainly transparent painting techniques and whose works have great scale and breadth combined with an extraordinary sense of atmosphere. In his short life, Thomas Girtin (1775–1802) demonstrated his knowledge and control of the medium and produced a series of works ranging from sensitive, loosely worked landscape studies to works of great precision and detail which still manage to retain a freshness of appearance. J. M. W. Turner (1775–1851), who was Girtin's exact contemporary, was the first to recognize what his fellow artist might have gone on to achieve if he had lived. As it was, it fell to Turner to push the possibilities of the medium still further with new experimental work with washes, wiping out, scratching

Watercolor wash over ink drawing The early use of watercolor tended to be confined to washing color thinly over pen and ink drawings.
The Punishment of the Avaricious (c.1585), by Federigo Zuccaro.

out, and the incorporation of body color. John Constable (1776–1837) produced watercolor studies directly from nature which retain the immediacy and spontaneity of the direct response, while John Sell Cotman (1782–1842) – one of the greatest artists of the period – demonstrated a control of the medium and a sense of design and order in his carefully constructed works which was completely unique to his time. David Cox (1783–1859), born a year later, produced – particularly in the later works – a series of paintings which are almost expressionist in the nervous, turbulent atmosphere which they evoke. The list could include many other artists of the time, such as Towne, the Varleys or de Wint, who are equally important and who made significant contributions to the development of watercolor painting.

The techniques of watercolor

The traditional "transparent" technique of watercolor painting involves the overlaying of thin, transparent color washes which rely on the white of the paper for their effect. The white of the paper provides the highlights, and as more washes or glazes are overlaid, so the tone and color deepen as more light is absorbed and less reflected from the support. Being water-soluble and, to a greater or lesser degree, resoluble when dry, the color can be modified in different ways by the addition or removal of water and by the use of brushes, sponges, cloths and tissues.

Watercolor is extremely versatile, and produces results as permanent as those of any other painting medium, provided permanent pigments and high-quality, acid-free papers are used. Opaque watercolor methods, in which gouache or body color is used, and which rely on white pigment to provide the highlights and pale tones, are discussed in the *Gouache* section at the end of the chapter (see pp.166–9). Mixed methods, in which both transparent and opaque techniques are incorporated in the same work, have been widely used. They usually work best when they are used in a balanced way.

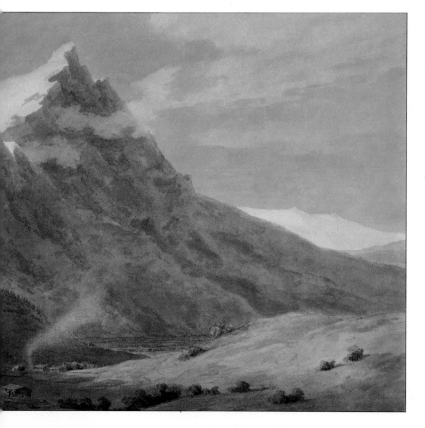

The subtlety of watercolor This work is painted with a great deal of subtlety, particularly in the use of color. The immediate impression is of a somewhat monochromatic work, but it becomes clear that the grays have been delicately modulated with crimsons and green/blues, giving the painting an altogether richer atmosphere. The painting is also a magnificent example of the artist's ability to give a monumental sense of scale to a relatively small-sized work. The tiny chalets at the foot of the mountain give a real sense of its massive presence. *In the Canton of Unterwalden* (1790) by John Robert Cozens.

·Watercolor paints·

Paints for watercolor are made by grinding powdered pigments into a water-soluble binding medium. This medium consists mainly of gum arabic but includes glycerine as a plasticizer, a wetting agent such as ox gall, and, where necessary, a thickener such as gum tragacanth. Other thickeners include starch, dextrin or a swelling clay such as Bentone. A preservative which acts as a fungicide and bacteriacide is usually also added. And, if absolutely necessary for controlling the property of a particular color, extenders (which may produce a white coloration) are sometimes added to the other ingredients.

Each pigment has slightly different requirements if it is to function consistently as a watercolor paint, so greater or lesser proportions of one or more of the ingredients need to be used. Watercolor mixing is therefore a skilled craft, based on trial and error and years of experience; home manufacture of watercolors is not recommended. For information on watercolor brushes, see p.131.

PAN AND TUBE COLORS

Manufactured watercolors come in pan or tube form.

Pan colors
These are useful for small-scale work or for outdoor sketching. However, producing mixes can dirty the colors in the box. Yellows, especially, may be sullied by touches of other colors and need to be constantly wiped clean with a sponge.

Tube colors
Containing more glycerine, these are in theory more soluble, although in practice it is not particularly noticeable. They are more suitable for large-scale work because it is easier to mix up larger amounts – of a wash, for instance. The colors are less likely to get soiled, since the required amount can be squeezed from the tube as it is needed.

Types of watercolor paints
Small pans in box, large pans, tubes.

CHOOSING PIGMENTS FOR WATERCOLOR

The properties of individual pigments have been described in the *Pigments Charts* on pp.18–31. Most of the permanent pigments approved for oil painters can be used for watercolor. In particular, it is worth noting the synthetic organic pigments, whose brilliance and intensity lend themselves to the watercolor medium.

Reds
Alizarin Crimson, Cadmium Red, Naphthol Red and Quinacridone (Rose and Magenta forms) are all recommended. Cadmium Red has largely replaced Vermilion, which is hard to find in its best grades and may unfortunately turn black.

For a limited palette, Cadmium Red and Quinacridone (Rose) are a good choice: the first a rich, semi-opaque yellow/red; the second a clean, transparent blue/red useful for mixing.

Yellows
Several synthetic organic yellow pigments are suitable. They include Arylide Yellow G, 10G and GX (very permanent), and Diarylide Yellow (acceptably permanent). A number of new or improved yellows have still to be taken up by manufacturers.

Indian Yellow, popular formerly for transparent washes, is not acceptably lightfast in its modern form. Aureolin (Cobalt Yellow), although only fairly permanent, is an alternative. Pigment Yellow 128, an Azo condensation color, is a much more lightfast and semi-transparent yellow. Lemon Yellow (Barium Yellow) is permanent, but so pale and weak that any impurities will readily discolor it. Cadmium Yellow is very useful, although paintings in which the cadmiums have been used should never get damp.

Blues
Five blues can be recommended unreservedly: Cerulean Blue,

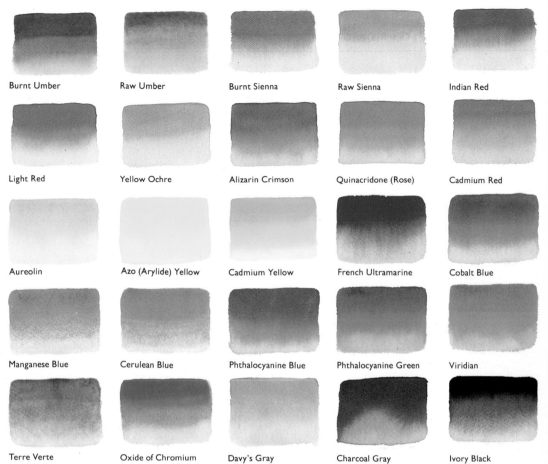

Burnt Umber	Raw Umber	Burnt Sienna	Raw Sienna	Indian Red
Light Red	Yellow Ochre	Alizarin Crimson	Quinacridone (Rose)	Cadmium Red
Aureolin	Azo (Arylide) Yellow	Cadmium Yellow	French Ultramarine	Cobalt Blue
Manganese Blue	Cerulean Blue	Phthalocyanine Blue	Phthalocyanine Green	Viridian
Terre Verte	Oxide of Chromium	Davy's Gray	Charcoal Gray	Ivory Black

Cobalt Blue (excellent in washes), Manganese Blue (a pure, transparent color with a tendency to granulate which is useful in creating texture under another color), Phthalocyanine Blue (a pure, transparent "primary" color, useful for mixing), and French Ultramarine (a unique bright blue with high tinting strength and a tendency to granulate).

Greens
There is also a good range of permanent greens. These include Phthalocynanine Green (a clean, transparent green which can be mixed with earth colors like Raw and Burnt Sienna or overlaid in washes to produce a wide range of "foliage" greens), Viridian (similar but not quite so intense) and Oxide of Chromium (a rich, opaque, dull green).

Earth pigments
All the earth pigments, including the Mars colors, are permanent. Terre Verte is a useful gray/green in thin washes. Raw Sienna and Yellow Ochre belong to the yellows, the former being slightly more transparent and less granular than the latter. Raw Umber is a transparent brown with a yellowish cast. Burnt Umber is considerably darker. Burnt Sienna is a useful transparent orange/red brown of particular beauty. The iron oxide colors – Indian Red, Light Red and Venetian Red – are thicker, more opaque colors. Light Red is the most orange, Venetian Red browner, Indian Red more crimson.

The synthetic Mars colors are all suitable although not extensively used by the manufacturers, due to their opacity compared with natural earths.

Recommended watercolor palette A personal choice of 25 good, permanent pigments for successful watercolor painting.

Blacks and grays
Ivory Black is a useful transparent color with a sooty appearance. Charcoal Gray is suitable when a uniform mid-tone is required and gives a quite different look in the same tone to that of Ivory Black. Another permanent gray is Davy's Gray – a pale color, with a greenish cast, made from a particular type of slate. Paynes Gray, a popular color, is a combination of pigments.

White
Chinese White (Zinc White) is the most commonly used white for watercolor, although Titanium White may be used.

WATERCOLOR PIGMENT CHARACTERISTICS

Apart from the obvious differences in color, watercolor pigments work in individual ways, with each one demonstrating its own characteristics. In oil painting, these differences are to some extent evened out by the drying oils, extenders and stabilizers contained in the paint. But in watercolor, the particle characteristics of the pigments can be seen much more clearly.

The series of different colored washes (below) helps to show some of these differences.

Granulation

Some pigments show a characteristic called granulation, where the way in which the pigment particles settle on the paper creates a mottled effect. The examples (below) show how two very similar colors can behave quite differently when brushed out on to paper, and so can be used for different effects.

Manganese Blue displays the best example of granulation. It shows up particularly well on rough paper, where the pigment particles (grains and stubby prisms) settle into the hollows of the paper, giving a mottled effect. Despite its different appearance, Cerulean Blue also shows a tendency to settle out

Granulation in two blues
The wash produced by Manganese Blue (left) is a striking example of granulation. Compare this with a wash of Cerulean Blue (right), which is of similar tone and also an artificial mineral pigment.

into the hollows of the paper, though this is not nearly as marked as that of Manganese Blue which shows the effect even in very pale washes. French Ultramarine is another blue pigment which exhibits granulation effects. Here the uniform, small, round grains produce a more finely divided pigment.

Flocculation

Sometimes, separate pigment particles are drawn together rather than dispersing evenly, giving the same mottled effect of grouping in the hollows of the support as granulation. The cause of flocculation is usually a series of reactions in the electrical charges in the pigment particles themselves, rather than simply the tendency of coarser pigments to settle faster.

Characteristics of modern synthetic pigments In general, these disperse well and evenly, producing a standard, even effect (see *Color Mixtures*, p.157). This means that the natural "textured" look created by pigments such as Manganese Blue, has to be obtained in other ways with these colors.

Also, some skill is required to produce an even tone in washes; the point where a brush is newly charged with paint to continue a wash tends to be obvious with these colors. Some Phthalocyanine pigments may show "flotation" effects where darker or lighter colors rise to the surface of the wash, resulting in streaks. Manufacturers usually avoid those pigments which produce this effect, or are able to counteract it in the preparation of the color.

Characteristics of earth pigments The natural earth colors are generally coarse and heavy pigments of irregular particle size. Their rough feel is a positive part of the watercolor medium and is reflected in the mid-toned washes shown below.

Pigment differences in washes
Five pigments brushed out in pale (top row), medium (centre row) and dark (bottom row) washes. The paler washes have more similarities.

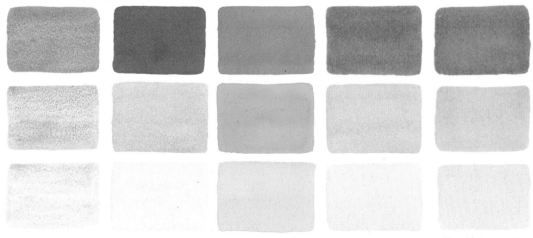

| Manganese Blue | French Ultramarine | Quinacridone (Rose) | Raw Umber | Terre Verte |

——·The effects of watercolor papers·——

Watercolor papers (see p.53) reveal different characteristics when paint is applied to them. Here, each sheet of paper was painted three times using three basic techniques:
▥ Wet-into-wet
▥ Brushstroke on dry paper
▥ Masking fluid

Top strip
A wash of clean water was applied. After a few minutes, a wet-into-wet brushstroke was made into the damp surface with a large soft-hair brush.

Center strip
A second brushstroke was made on to the dry center of the paper with the same brush.

Bottom strip
A stroke was made with masking fluid and allowed to dry. A uniform wash was laid over the area and left to dry. The masking fluid was carefully rubbed off.

HAND-MADE PAPERS

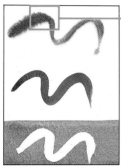

Barcham Green H.P.

MACHINE-MADE PAPERS

Arches H.P.

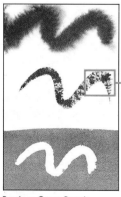

Barcham Green Rough

T.H. Saunders Rough

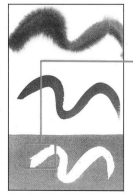

Barcham Green NOT

T.H. Saunders NOT

Wet-into-wet
The damp surface made the wet-into-wet brushstrokes spread. This was not so effective on the H.P. papers, (both machine and hand-made), as on the NOT and rough surfaces, where the flow of paint was more even and consistent. The tendency of Ultramarine to granulate can be seen where the paper was particularly wet.

Dry-brush work
The hand-made rough paper, with its almost "pneumatic" quality, showed a marked difference, with the paint picking up only on the raised areas of the paper's tooth. On the machine-made rough paper, the stroke showed more consistency of tone than on either of the H.P. surfaces. In general, NOT and rough surfaces have the effect of distributing the pigment more evenly.

Masking fluid
The masking fluid showed up the contrast between the internally sized hand-made paper and the surface-sized mold-made paper. It picked off the surface of both the hand-made papers, making further overpainting difficult. If you want to use a lot of masking fluid, choose a surface-sized paper or give hand-made (internally sized) paper a further protective coat of size before use.

·Wash techniques·

The art of watercolor painting lies to a great extent in the artist's ability to control the application of washes. A wash is a thin film of paint, well diluted with water, which can be applied to the paper in a number of ways.

A wash can provide a continuous, pale tone over the whole area of the paper, acting as a unifying background color for other, superimposed washes. Alternatively, it can be graded tonally from light to dark or from dark to light, to indicate, for instance, the lightening tone of the sky towards the horizon. Washes can be modified with the addition of clear water, by sponging and soaking up in various ways, or by being applied over masked-out areas. The appearance of a wash depends on several factors such as the type of pigment used, the amount of water added to the paint, the method of application, the nature of the paper surface, and whether the surface is wet or dry before the wash is applied. Watercolor washes can be laid one over the other in a variety of ways to create a range of different effects.

POINTS TO WATCH

▨ Mix enough paint. Very little can be done if the paint runs out before the area is covered.
▨ Keep control of the brush. Although speed is a prime factor in laying a wash, control is just as important. The movement should be quick, but not so quick that tiny air pockets form, leaving "pin-pricks" in the finished work.
▨ Consider the paper surface. The harder the coat of size on the paper, the greater the "pin-prick" problem is likely to be. To overcome it, add a drop of wetting agent such as ox gall to the paint, and give the paint enough time to cover the surface as the stroke is made.
▨ Don't push down too hard. If the heel of the brush touches the paper, this causes inconsistencies of tone. The touch of brush on paper must be deft and light but, because it is well charged with paint, full-bodied.

UNIFORM TONE WASHES

Washes of an overall uniform tone are generally applied using a series of strokes from either a large round wash brush such as a No. 16 squirrel, a flat one-stroke brush such as a 25mm (1 in) nylon, or a piece of natural sponge. The most important factors in the successful application of an even-toned wash are:
▨ speed
▨ control
▨ amount of paint in the brush or sponge
▨ correct angle to the horizontal of the support
This last factor is managed by sloping the support so that paint can gather along the base of each brushstroke and be picked up by the subsequent stroke, but not at such an angle that it runs all the way down the paper.

Uniform tone washes on dry paper In my opinion, a large, overall wash of uniform tone is somewhat more easily laid on dry paper than on paper which has been damped or wetted. Variations in wetness on the paper or slight cockling (buckling), even of stretched paper, can produce inconsistencies of tone in the finished wash. Of course, these effects may be part of the expressive nature of the work and can be positively exploited, but for uniformity of tone, they are undesirable.

Laying a wash is an aspect of watercolor painting that is perfected with experience. Whether you are using a soft round or a flat wash brush, the method is almost the same. Dilute the paint to the required consistency and mix more color than you think you will need to cover the area to be painted.

Remember that a watercolor wash dries considerably lighter than it looks while being applied. The depth of tone can be assessed before the wash itself is laid by trying out a small area on a piece of scrap paper and drying it quickly with a hair-drier.

PROBLEMS OF STREAKING

Stroking the brush repeatedly across the same area of the paper causes the paint to collect in ridges, giving an uneven tone (right). This can also happen if there is not enough paint in the brush. A similar problem can arise if the brush is overloaded with paint. This makes it difficult to control the wash and the pigment moves too freely (see far right).

Streaking due to repeated strokes.

Streaking due to overloaded brush.

Laying a uniform wash

1 With the board at a slight angle and the wash ready mixed, load the brush with paint. It should be well loaded, but not so much that paint drips off.

2 Make a series of horizontal strokes using the tip of the brush. Paint gathers along the bottom of each stroke and is picked up by the next.

3 The brush should be kept well loaded. As it starts losing its generous charge of paint, dip it into the mix and quickly continue making strokes.

4 With a round brush, strokes can run from left to right and back from right to left. With a flat brush, make them all from left to right.

Uniform wash made with No. 6 squirrel brush.

Uniform wash made with flat 25mm (1in) nylon brush.

Using a sponge

A piece of natural sponge, well filled with the wash mix, can also be used to make an even, continuous tone and is a quick and useful method of applying a wash over a large area. Grip the sponge between thumb and fingers and push it across and down the paper.

Using a sponge
Use the sponge as if cleaning a window. A sponge is also useful for dampening paper.

Uniform wash applied with sponge.

Uniform tone washes on wet/damp paper

If the paper is dampened before a wash is applied, the paint tends to spread naturally. Wet the paper as if laying a wash, using a wash brush or sponge. The paper may buckle slightly as you apply the water, making the paint run into troughs, which creates an uneven tone if it is left to dry on a horizontal surface. This can be avoided if the wash is applied in the way shown below.

Laying a uniform wash on damp paper

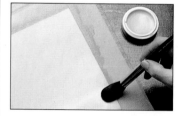 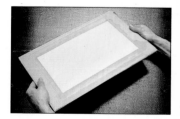

1 Apply the wash quickly. Note that paint does not collect at the bottom of the stroke on wet paper.

2 When the paper is covered, pick up the drawing board and tilt it so the paint evens out in all directions.

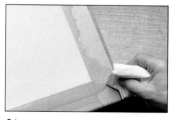

3 Let any excess paint run to one side and absorb it with tissues. The result is an acceptably uniform tone.

Uniform wash laid on damp paper It has a less "sparkly" look than a wash laid on dry paper.

GRADED WASHES

It is fairly difficult to lay a wash which moves completely smoothly and evenly from dark to middle and light tones. The simplest approach is to mix three separate tones of the same color – light, middle and dark – and set these up in separate saucers. Apply the tones in turn, as if for a uniform wash, over the whole of the paper.

Working from dark to light

With the board on a slight slope, start laying in the dark tone, work down a quarter of the area, switch to the middle tone and repeat with this, then with the light tone, then with clear water. This actually produces a "banded" look if the paint is applied relatively dry, as there is little opportunity for the tones to run into each other.

But if more "liquid" paint is applied, an effect is produced where, at the point of applying a lighter tone, there is a sudden lightening of tone in the wash which then darkens instead of lightening until it reaches the next tonal band where it lightens again. This is a result of the pigment being carried down with the slope of the board until it gets to the point at which more

water is applied in the lighter wash, which seems to act as a barrier, creating the lines which are clearly visible. To avoid this:
▓ Move the board around while the paint is still wet.
▓ Wet the paper first, lay in

Dry paint
The paint was applied dark to light, quite dry, giving an uneven banding effect.

Tilting the support
With the paint applied wet, the drawing board was moved to even out the wet wash.

strokes of pigment, move the board around, then if necessary, add a deeper line of tone at the top using a well-charged brush. These two methods produce lively and reasonably evenly graded tonal washes.

Wet paint
The paint was applied too wet, on a slope, giving an uneven lightening effect at the top of each stroke.

Adding extra pigment
The paper was wetted and pigment laid in with a flat brush. The board was moved around and deeper pigment added with a small brush.

Working from light to dark

The easiest and most reliable way to make graded tones is to work from light to dark, beginning with clear water and working down the slope to the dark

tones. The sequence below shows the use of a very wet No. 16 squirrel-hair brush, beginning with water and working through three tones of Burnt Umber.

Alternatively, use slightly less

wet paint, then gently work over the whole wash with a damp, clean, flat one-stroke brush. This has the effect of completing the blending and ensuring an even tonal gradation (far right).

Laying a light-to-dark graded wash

1 With the drawing board tilted, apply some clear water to the top of the paper.

2 Using the lightest color tone, lay in some strokes, letting the paint meet the wet area.

3 Repeat with the mid and dark tones, keeping the paint wet so that it merges with the previous tones.

4 Or, use the paint less wet, and stroke a damp, flat, one-stroke brush over the finished wash.

Bleeding a wash into wet paper A technique popular with watercolorists is that of applying a uniform tone wash and letting it meet an area of paper that has been wetted with clear water. The effect is partly random, but can still be quite strictly controlled in terms of where and how much the pigment spreads. You can superimpose as many colors as you wish, as long as the underlying color is completely dry. The amount of "interference" between layers can be kept to a minimum if the water and paint are applied rapidly, without repeating any strokes. If you repeat a stroke, the layer beneath will begin to break up and the edges of the stroke will be clearly visible through the diffusing wash.

Bleeding water into a graded wash Dropping water into a drying graded wash can produce some particularly striking effects, varying from three-dimensional effects to subtle cloud-like ones (below). More complex patterns can be made by dripping very wet, dark tones into the wash.

Superimposing colors

I Wet half the paper with clear water. Paint Manganese Blue over the dry half and let it run into the wet paper, then dry.

2 Re-wet the paper and repeat the procedure with Paynes Gray. Allow this to dry, then repeat with Rose Madder.

3 Take care not to repeat any brushstrokes or the color will be disturbed. For the fourth color, Paynes Gray was used a second time.

Adding water to a semi-dry wash Here, the wash was applied very wet over damp paper and left to dry partially before water was added along the top edge and allowed to creep into the color. Effects like these can be controlled by moving the board around.

Wash laid with a very wet round No. 16 squirrel hair brush This was was made by beginning with clear water and working through three tones of Burnt Umber.

The same technique, using slightly less wet paint A clean, damp one-stroke brush was used to gently work over the wash for an even tonal gradation.

Painting a uniform tone up to a complex outline

Sometimes an area of uniform wash may have an intricate edge or outline. The illustration shows the silhouette of a figure with a dog and other, seated figures by a boat. All these shapes are filled with the same uniform dark tone which is continued below the skyline. The particular method of achieving this without any unevenness or breaks in the tone, is to paint the silhouetted shapes with water, outlining them with a fine, soft brush and filling in with a larger squirrel brush.

Next, a fairly thick mix of the color to be used is dripped in large blobs into the wet areas. The color runs into all the shapes and flows over the whole area. The board may be tilted to help the paint fill the shapes.

1 Paint the outlines and shapes of the figures using clean water and a No. 5 round sable.

2 Take a larger squirrel brush and paint in the rest of the area with water.

3 Drip a fairly thick mix of Phthalocyanine Blue and Ivory Black into the wet areas.

4 Tilt the drawing board in different directions as necessary to help the paint flow.

·Wet-into-wet techniques·

Painting "wet-into-wet" simply means applying color to paper that you have previously wetted – either with water or with an earlier color that has not yet dried. The resulting effects cannot be reproduced in any other medium – with the possible exception of acrylics. Some of the effects have already been explored in *Wash Techniques*. To wet a sheet of paper, work as if laying a wash with water.

"SPONTANEOUS" EFFECTS WITH WET-INTO-WET

If the paper is well stretched and uniformly wetted, a blob of color from the tip of a well-loaded brush will run evenly outwards over the surface. It should feather out attractively, getting lighter in tone towards the edges as the color dilutes. If the paper is too light or not properly stretched, it will buckle when wet and the paint will run into troughs and create unwanted bands of deeper color.

1 Single-color effects
The paper was wetted thoroughly and evenly, then the brush loaded with blue/gray paint and lightly touched over the surface so that the color ran freely.

2 Dual-color effects
The same as the single-color, with pink blobs applied while the gray was still wet. The paper was left flat and the paint allowed to blend spontaneously.

3 Multi-color effects
Colors blended wet-into-wet tend to retain their intensity.

1

2

3

CONTROLLING PAINT FLOW

Although wet-into-wet painting produces spontaneous effects, a painting often succeeds according to the degree of control used. The flow and spread of the paint can be regulated in various ways.
■ Notice the absorbency of the paper. On heavily sized papers, paint travels further and faster.
■ Choose the right paper. The method of pressing used in the manufacture will affect its suitability for wet-into-wet.
■ Mix paint to the correct consistency. Thin paint flows more easily than thick.
■ Tilt and lift the paper to make the color move in any direction.
■ Try wetting only part of the paper to restrict "free" effects.
■ Use a hair-dryer to speed up the drying or blow the paint in the direction required.

DRAWING AN IMAGE WET-INTO-WET

It is possible to draw images and shapes directly on to damp paper with the fine point of a small, round sable, used very lightly and rapidly.

Wet-into-wet ink bottle study.

LAYING AND BLENDING COLOR WASHES

Wet-into-wet techniques are often used over large areas to create graded washes (see p.146). They also provide a natural blending method for producing smooth transitions between bands of color. There is no limit to the number of washes that can be superimposed, provided the surface of the paper has been allowed to dry thoroughly before it is re-wetted and re-painted. It is possible to obtain a great depth of tone in this way.

1 Blending two color areas Two areas of color can be fused by letting the damp paper do the blending. Here, blue and gray were painted at the top and bottom of the sheet. The paper was then rocked to and fro to let the paint merge.

2 Blending bands of color The same technique has been used here to merge horizontal bands, worked from the top of the paper downwards towards the bottom. Note how purple is created at the join between pink and blue.

3 Laying multiple washes Here several washes of horizontal color bands have been overlaid to create great depth of tone. Each coat must be allowed to dry before the next is applied.

WET-INTO-WET LANDSCAPE PAINTING

Emil Nolde (1867–1956) worked extensively with watercolors throughout his life, often painting out of doors in winter and allowing the snow and ice to create their own effects on the wet surface of his sketches. His fast and free method of painting gave great scope for wet-into-wet effects in which the colors seem to move and merge over the surface with their own life.

Lake (with Sailing Boat and Steamboat) (1946), by Emil Nolde.

·Washing off·

Several watercolor manipulations involve washing off dry pigment that has already been applied to the paper. This produces a variety of effects; results may vary according to the paper and pigment used and the temperature of the water. Most papers respond slightly differently to washing off, as do the various colors themselves. Particular pigments adhere to the paper surface with more or less tenacity.

DIFFERENT PAPERS

The examples show three crosses painted on two different types of paper – a rough Arches and a smooth Waterford. The crosses were painted using a uniformly pigmented watercolor wash: Burnt Sienna was used on the smooth paper, Ultramarine on the rough. The crosses were left to dry, then washed off (see bottom left), one set from each paper type held under a cold tap, the other under a hot one.

Hot water

Cold water

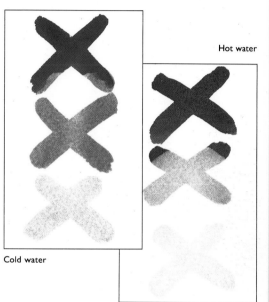

Hot water

Cold water

The smooth paper
The results were similar to the rough paper, with the pigment washing off slightly more easily. With hot water (which may dissolve the gelatine size on the surface more readily) the pigment again loosened slightly more easily. A granulated texture was seen on the center brown crosses, especially with cold water.

The rough paper
Although the pigment washed off, it still left a positive blue mark, even with the scrubbed-off crosses. Slightly more pigment washed off under the hot tap, especially from the scrubbed crosses. Both center crosses showed a marked mottling effect where the pigment had settled in the hollows of the paper.

Washing off test
Hold the paper under a hot or cold tap. Leaving the top cross intact, direct the water at the centre cross, while lightly scrubbing the bottom cross with a clean, flat bristle brush.

PIGMENT VARIATIONS
With the crosses painted in P.C. Lambertye Ultramarine on T.H. Saunders rough Waterford paper, the blue almost completely disappears after washing off with hot water. However, when Winsor and Newton Phthalocyanine Blue (right) – a tenacious pigment – is used on the same paper and also washed off with hot water, the pigment leaves its mark firmly fixed on the paper.

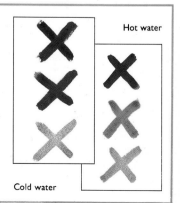

Hot water

Cold water

·Sponging out·

Several effects can be achieved by the technique of "sponging out", or "wiping out" – soaking up paint with a piece of sponge, absorbent cloth or paper tissue while a wash is at various stages of wetness. This is a popular and effective way of creating cloud effects (see below).

CREATING CLOUD SHAPES

In the cloud study (below), a uniform wash was laid over the whole area of the paper and allowed to sink in a little. The cloud shapes were drawn into the semi-wet work with a brush and clean water, then soaked up with a sponge. The work was dried with a hair-drier, then given a lighter wash. The cloud shapes were picked out with a damp sponge, giving a softer, "double-edge" look. If the sponge is too wet, dark patches form at the edges of the sponged areas (see *Problems*, right).

Sponging out clouds effectively

1 Draw cloud shapes in the semi-wet uniform wash with a No. 16 round squirrel brush and water.

2 Use a sponge to soak up water from the shapes. Stroke it across the lower third to lighten the tone.

3 Dry the work quickly with a hair-drier, then apply a lighter overall wash of the same color.

4 Pick out the cloud shapes again, using a damp sponge to soften the whole effect.

SPONGING OUT AND OVERLAYING WASHES

Interesting textural effects can be obtained by laying down a uniform wash and, while it is still wet, taking out areas with crumpled absorbent paper or paper tissues, drying it (try using a hair-drier for speed) and repeating the process over the first wash with a second color. In this example, three overlaid transparent washes were used: Raw Sienna, Quinacridone (Rose), and Cobalt Blue. The result has the look of a piece of textile design, but the technique has applications throughout the watercolor medium. (See also *Blotting Paper*, p.162.)

Sponging out with three washes

1 Dab some crumpled paper tissue or absorbent paper over the wet wash.

2 Dry the work thoroughly with a hair-drier.

3 Repeat with Quinacridone (Rose), then with Cobalt Blue.

Raw Sienna, Quinacridone (Rose) and Cobalt Blue sponged and overlaid.

SPONGING OUT PROBLEMS

There are a few problems to watch for when sponging out. Using too wet a sponge in a damp wash can cause the pigment to "reticulated" patches round the edge of the wet area.

Also, sponging out a shape with a damp sponge means that the lightened area is still damp, so it absorbs pigment from the surrounding areas. It is impossible to achieve a completely white area unless you use a hair-drier or dab the area with wads of paper tissue immediately after sponging.

SPONGING OUT WITH WASH TECHNIQUES

In this windmill study, the overall wash of the sky and the edges of the clouds were softened with clear water. The sky, once dry, was scrubbed with a bristle brush and water, then blotted. The landscape is formed from overlaid washes,

blotted and worked over when dry with a small bristle brush and water. The grasses were painted with quite thick lines, then partially scrubbed away and finer lines overpainted.

Combining watercolor techniques This painting has been built up using softening and blotting techniques with some reworking.

·Gum arabic·

Incorporating gum arabic in watercolor mixtures has two major effects. Firstly, it gives a varnish-like effect to the paint, imparting a depth and lustre that some might say goes against the spirit of matt watercolor painting.

Secondly, it greatly increases the solubility of the dried paint film. This makes it more difficult to paint over the film without disturbing it. It also means that

sponging or blotting effects tend to take the whole film with them, leaving the paper almost bare. This can be an advantage if a shape is to be taken out of a dried film. Simply paint the shape in clean water, leave it on for a minute or two (to dissolve the film) and blot off. Where it remains dry, the paint film will be intact, but the shape will appear as light as the original paper. So in a sense, it can

perform the same function as masking fluid (see p.163).

Greatly increasing the solubility of the paint film may also endanger the permanence of the color. Adding too much gum arabic may also make the paint film very brittle. Artists' materials manufacturers normally sell it in around a 30 per cent solution and used in moderation, it should not detract from the permanence of a painting.

Straight and gum arabic washes The straight wash (left) is matt, while the gum solution wash (right) shows fine granulation. The pigment seems suspended in the paint film.

Straight wash and gum arabic wash dried, then overpainted When lines are painted on in clear water then blotted, the resolubility of the gum film (right) shows up.

Water dripped into a wet straight wash and a wet gum wash Notice how the "bleeding" effect in the straight wash (left) is absent in the gum solution version (right).

·Scratching out·

In the past, before masking fluid was invented, the most common method of creating a completely white area or highlight in a "transparent" watercolor was to scratch away the painted surface with a sharp blade, revealing the white paper beneath.

An alternative method is to use opaque white, though this goes somewhat against the idea of the transparent method of painting. The use of masking fluid is actually limited to paintings where you know in advance precisely where the highlights will come, and also to paintings where you do not intend to do any vigorous scrubbing out which would remove the masking film. So the practice of scratching out is still fairly widespread.

TOOLS FOR SCRATCHING OUT

If the area to be taken off is very small, a scalpel blade is the best choice of tool. To take off a thin vertical line along the branch of a tree, for instance, gently scrape away along the line until the white paper appears. It is important to scratch gently at first and to reveal the white paper by degrees. Using a reasonably heavyweight paper makes the technique safer.

If the area to be scratched out is larger and it is necessary to remove areas of the paper "tooth" (textural ridges), it is best to use a rounded penknife blade or similar. Sandpaper may also be used for this type of scratching out.

Scalpel blade

Penknife blade

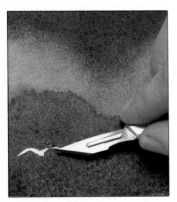

Using a scalpel to scratch out a fine detail.

SCRATCHING OUT LINEAR DETAILS

Paint has been scraped from the trunks of many of the trees where the light entering at the top left corner makes bright highlights. The individual fronds of ferns have been picked out in the foreground and in both waterfalls, giving a strong impression of water moving in the sunlight. The misty areas of foam are rendered with a combination of scrubbing and scratching out, while the finest lines from the tip of the knife blade define the ridge of water.

Weathercote Cave, near Ingleton (c.1816) by J.M.W. Turner.

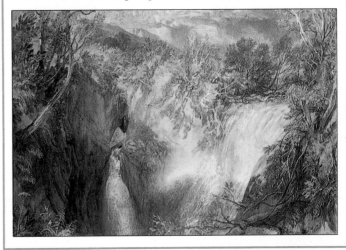

SCRATCHING OUT A CLEAR SHAPE

This involves cutting the outline with a scalpel – into, but not through, the paper – then scraping all the color away from inside the shape up to the edge of the line.

This detail of gulls flying above a lake, picked out against a dark mountain, is a good example of the scratching out technique.

Mountain Scene in Wales (detail, 1810) by John Sell Cotman.

·Softening edges·

A major problem for some watercolor artists is the "hard" line which forms round the edge of a painted shape when it dries. This happens most often when a shape is painted rather wet on to dry paper. If a hard edge is wanted, there is no problem. If, on the other hand, the artist wishes for a less abrupt transition from one part of an image to the next, there are various edge-softening techniques than can be employed, all involving the application of water in one way or another.

METHODS OF SOFTENING EDGES

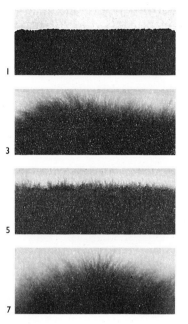

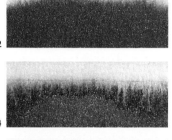

Examples
I With no softening, pigment has accumulated round the perimeter.
2 Soften the edge while the paint is still wet, using a soft brush dampened in clean water. The paper just beyond the paint is dampened by the brush, which then strokes the edge of the paint itself. This runs into the damp paper.
3 Using a slightly larger, wetter area of damp allows the paint to run more freely and extensively.
4 Painting a very wet, thin band of water outside the edge gives a totally different effect. Water runs into the pigment rather than the other way about. It is best to let the paint stand for a few minutes after application.
5 A long-hair bristle brush can soften the edges of a wet area of paint. Here, a dampened No. 4 filbert was stroked twice along the edge, in a fluent movement.
6 It is possible to soften the edges of a dried area, using a dampened stiff-hair brush. Some artists cut down an

old brush to produce a small, stubby brush (see below).
7 The paint was allowed to flood into a wide band of clear water applied outside the painted edge.
8 A thin, but very wet perimeter of clean water was painted around the edge of the color as it dried. The pigment particles collected into miniature "mud flats".

CUTTING DOWN AN OLD BRUSH
A worn-out bristle brush is useful for softening hard edges on dried watercolor. Cut down the bristles to make a short, stubby brush.

SOFTENING DRIED COLOR AREAS

As an alternative method of softening dried areas, try using blotting paper.

Using blotting paper

Area of dried color before softening.

I Paint over the whole area with clean water, then gently scrub at the edges with a bristle brush.

2 Lay a piece of blotting paper on top, run over it smoothly with the side of the palm, and peel it off.

The same area after softening
Notice the softness of the result. The hard clarity of edge has been lost, but not the shape itself.

·Mixing colors·

One of the chief aspects of watercolor paints which sets them apart from other painting media, is their ability to reflect the individual particle characteristics of the separate pigments. This has been discussed on p.142 and is one of the positive aspects of the medium that watercolorists like to exploit.

Modern synthetic pigments are finely ground and generally produce smooth, similar-looking washes. In this sense, they may be said to have less character than older, more traditional pigments. On the other hand, they are particularly pure pigments and it is possible, using only a limited selection of colors, to mix an altogether wider range of colors. In fact, using just three modern synthetic organic pigment primaries – a red, a yellow and a blue – it is possible to mix as wide a range of colors as you may ever need.

COLOR RANGE MIXED FROM THREE PRIMARIES

The colors in this range of 48 distinct hues, painted in a mid-tone, are all derived from combinations of Quinacridone (Rose), Arylide Yellow and Pythalocyanine Blue. All the colors are obtained by physically mixing the paint in a saucer before applying it to the paper. In principle, it should also be possible to arrive at them optically by superimposing pure yellow, red and blue transparent washes of the right tone.

Secondary colors
The two-color combinations of blue/greens to yellow/greens, of reds through yellow/orange and of blue/violet through mauve to pink, give a wide range of secondary colors.

Tertiary colors
Adding the third primary in each case gives a range of earth colors – gray/greens and blue/red grays that match very closely the color of many of the traditional pigments.

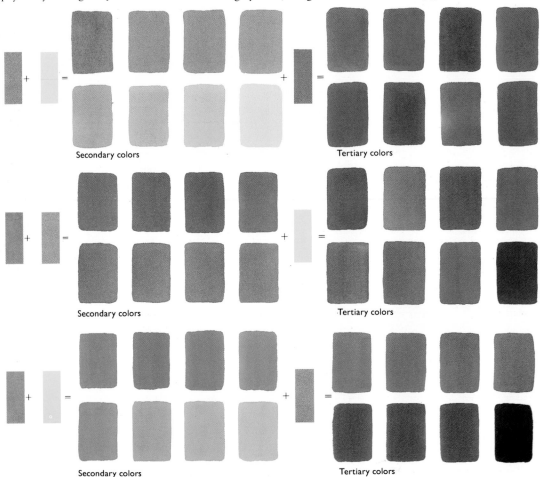

Secondary colors

Tertiary colors

Secondary colors

Tertiary colors

Secondary colors

Tertiary colors

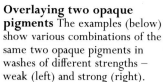

COLOR MIXING BY OVERLAYING WASHES

In watercolor, colors can be mixed optically by being overlaid in thin, transparent washes. To exploit this fact properly, artists should be aware of the degree of transparency of different pigments and of their resolubility.

Both transparent and opaque pigments are equally transparent in very pale washes, but the difference between them becomes marked in stronger mixes. Similarly, resolubility can be a problem when overlaying colors, and this is generally related to the paint thickness.

CHOICE OF PIGMENT IN COLOR MIXES

Pigment choice can affect the look of a painting. Compare a mixture of a traditional pigment – Raw Sienna – and a modern organic pigment – Manganese Blue (left) – with a similar color made by mixing the three modern organic pigments used on p.156, Quinacridone (Rose), Arylide Yellow and Phthalocyanine Blue (right). The first has a "textured" look with some pigment separation and a more rapid settling-out of the blue. The second is smooth.

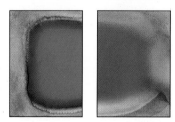

Settling out of certain pigments
Cadmium Red and Manganese Blue just after being mixed (left). A few seconds later (right), the blue has settled. Stir before application.

Overlaying transparent and opaque pigments

Examples 1–6 (below) show combinations either of two transparent colors, or of one transparent and one opaque, with one of the colors overlaid on to the other when the first is dry.

In 1 and 3, where one transparent pigment is laid on the other, the results are similar. In 5, the two transparent pigments are physically mixed before application. The result is much less intense.

In 2, where a wash of a more opaque color (Cadmium Red) is laid over a transparent one, the opaque color dominates. This does not happen to the same extent in 4, when the transparent color is laid over the opaque one, although the Cadmium Red still dominates more than it does in 6 – the physical mixture. In both the physically mixed squares, the settling out of the Manganese Blue is visible.

Overlaying two opaque pigments

The examples (below) show various combinations of the same two opaque pigments in washes of different strengths – weak (left) and strong (right).

The left-hand samples, where low-strength washes typical of watercolor have been used, show that transparent overpainting effects work just as well for opaque pigments. Whichever color is painted on top (7 and 9), there is little difference. The physical mixture, 11, is very similar.

The right-hand column shows the same opaque colours used at full-strength. This makes an overlaid wash an extremely difficult manipulation due to the almost immediate resolubility of the paint beneath. In 8, the Venetian Red almost obliterates the Cadmium Yellow; in 10, this happens in reverse. But the physical mixture, 12, provides a balanced combination.

Transparent and opaque pigments
1 Quinacridone (Rose) on Manganese Blue
2 Cadmium Red on Manganese Blue
3 Manganese Blue on Quinacridone (Rose)
4 Manganese Blue on Cadmium Red
5 Quinacridone (Rose) mixed with Manganese Blue
6 Cadmium Red mixed with Manganese Blue

Opaque pigments with other opaque pigments
7 Venetian Red on Cadmium Yellow (weak)
8 Venetian Red on Cadmium Yellow (strong)
9 Cadmium Yellow on Venetian Red (weak)
10 Cadmium Yellow on Venetian Red (strong)
11 Venetian Red mixed with Cadmium Yellow (weak)
12 Venetian Red mixed with Cadmium Yellow (strong).

SOLUBILITY AND OVERLAID WASHES

The problems of resolubility in thickly pigmented washes have been discussed on p.157. Although it is rare for watercolor to be used very thickly, except in gouache painting, resolubility can remain a problem even in thin washes. The proportions of ingredients used by manufacturers vary slightly. Some brands are so resoluble that they are almost impossible to paint over. The most experienced and reputable artist's colormen produce colors which are consistent in this respect and, provided the

artist does not "scrub" at a painting while laying on a wash, problems are rare.

For the whole range of watercolor effects to be exploited, the color must be able to be scrubbed, washed and sponged, but it must also be firm enough to accept overlaid color without dissolving. The correct balance is achieved through experience – another good reason why home-made water-colors are not recommended.

Although tube colors contain more glycerine and so might be expected to dissolve more easily the pan colors, there is very little difference between them in this respect.

TWO- AND THREE-COLOR SUPERIMPOSITIONS

TWO- AND THREE-COLOR SUPERIMPOSITIONS

The circles show the effects of two- and three-color superimpositions using permanent watercolor pigments. The same set of three colours is painted in a mid-to-light tone and a mid-to-dark tone. Notice how clear and "legible" the color juxtapositions remain in the former; those in the darker-toned version are more murky.

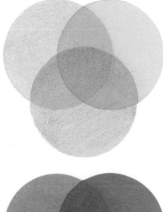

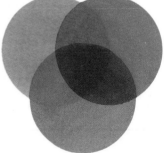

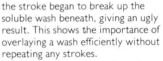

Resolubility
1 A Cobalt Blue wash was laid and left to dry undisturbed.
2 A single stroke was made with a one-stroke brush and clear water, then left to dry. The brushstroke has made almost no impression on the wash, so all overlaid manipulations should be made as quickly and smoothly as possible, using a loaded, but not dripping, brush.
3 The procedure was followed as for 2, then the stroke repeated. Here

the stroke began to break up the soluble wash beneath, giving an ugly result. This shows the importance of overlaying a wash efficiently without repeating any strokes.
4 A single stroke was made, and blotted after a minute or two. The blotted area shows the degree of resolubility of the pigment with no scrubbing. It is always a good idea to experiment first on scraps of paper to assess the solubility of new colors introduced in a painting.

Superimposed color samples
Both sets of circles were painted using Venetian Red, Terre Verte and Cerulean Blue. They show each color singly, and with one, then two colors superimposed.

THE VALUE OF OVERLAYING WASHES

A comparison between two deep tones of Cobalt Blue, the first (left) obtained with one wash of thickly mixed color, the second (center) built up from eight superimposed layers of a pale Cobalt Blue wash (right). The superimposed wash tone has a more pleasing texture and color.

Thickly mixed wash

Superimposed layers wash

Single pale wash

SUBTLE COLORS FROM OPTICAL MIXES

The subtle delicacy of colors mixed by the transparent method is one of the most positive and individual characteristics of the watercolor medium. The combination of pale, matt colors with the paper texture establishes an immediate and unique contact between pigment and ground. None of these colors, if mixed in a saucer and applied in one coat, would have the lively delicacy which they show in this form.

The color chart shows a set of subtle reds, browns, blues, greens and yellows, all mixed using the transparent overpainting method on rough Arches paper. With two exceptions where three colors were used, all the colors are formed from combinations of two other colors. In each case, the first color was allowed to dry thoroughly before the second color was superimposed.

The complementary or near-complementary superimpositions, such as those in which Light Red and Oxide of Chromium and Venetian Red and Terre Verte have been used, are especially interesting. Although the overall apppearance is of a warm or cool pale brown, a closer look reveals both red and green pigment particles creating a lively, vibrant surface. A similar effect occurs with the Viridian/Burnt Sienna and Raw Umber/Phthalocyanine Green combinations. The Cerulean Blue/Venetian Red combination produces a warm, overall pink/gray, although the separating out of the blue means that it retains its characteristic color.

Optical mixes

1 Cadmium Red/Alizarin Crimson
2 Burnt Umber/ Quinacridone (Rose)
3 Burnt Umber/Cadmium Red
4 Raw Sienna/Rose Madder
5 Light Red/Oxide of Chromium
6 Terre Verte/Venetian Red
7 Cerulean Blue/Venetian Red
8 Cobalt Blue/Rose Madder
9 Terre Verte/Cerulean Blue/Venetian Red
10 Phthalocyanine Blue/Ivory Black
11 Viridian/French Ultramarine
12 Terre Verte/Cerulean Blue
13 Phthalocyanine Blue/Arylide Yellow/Ivory Black
14 Viridian/Burnt Sienna
15 Raw Umber/ Phthalocyanine Green
16 Raw Sienna/Cobalt Blue
17 Terre Verte/Cadmium Yellow
18 Raw Umber/Aureolin (Cobalt Yellow)

TONAL DEPTH FROM OVERLAID WASHES

Some of the most subtle effects come from colors applied in thin, pure, overlaid washes. In this painting, the bridge is painted with a thin yellow wash – probably Raw Sienna. Where it is in shadow, a thin blue wash is superimposed. The even-toned wash provides a uniform background for the figure of the horse picked out against it. Similarly, through the arch of the bridge, the pink-brown washes of the land are repeated in their reflections in the water and subsequently overpainted with blue. The general movement from dark to light across the painting is achieved by superimposing color washes

in the shadows. The balance of the painting is retained by the large tree in shadow above the right-hand side of the bridge and the boulders in shadow symmetrically below it. Here again, tonal depth is achieved

not by mixing a deep tone for one wash, but by the repeated overpainting of thin, pale washes.

Greta Bridge (1810) by John Sell Cotman.

OPTICAL MIXING WITH HIGH KEY COLOR

Modern synthetic organic pigments provide a range of pure, bright "high-key" colors that can be exploited for their brilliance and clarity. Here, a traditional format landscape is painted using just four of these pigments: Phthalocyanine Blue, Phthalocyanine Green, Quinacridone (Rose) and Arylide Yellow.

The method of painting was inspired by the appearance of the

landscape on a video monitor – which, with its tiny blobs of pure color, inspires a style akin to a synthetic form of impressionism. Strokes or dabs of pure color are painted with no softening or blending. Tones are built up by superimposing strokes, and highlights preserved by the use of masking fluid. The final painting is rich in depth and texture, especially in the foreground.

The painting was made using dots and dashes of yellow, pink, blue and green with a pink/blue

mix – the only physical mixture to be used in the painting – providing a violet for the deep shadows and a basic color for the rocks beyond the shore. Highlit areas were protected with masking fluid.

Detail of the foreground

Close inspection shows the touches of pure color, laid side by side or overlapping. From a distance, the eye does not discern these colors individually; they become optically "mixed" into more solid areas of color.

·Texture effects·

The natural effects created by the granulation of certain pigments have already been demonstrated, but watercolor also lends itself to the creation of other textures. These are generally made by modifying the wet paint film as in blotted effects, or the dry paint film as in sanding effects, or by the introduction of a resist such as masking fluid or wax which prevents the paint from coating certain areas of the support.

SANDPAPER EFFECTS

Using sandpaper may sound alarming, but in fact it is a common method of achieving texture effects. The kind of result depends very much on the degree of coarseness of the sandpaper itself and also on the nature of the paper surface.

Fine sandpaper can be used on fine-grain paper to take soft, cloud-like shapes out of a dry wash. On rough watercolor paper, the pigment scraped off will reveal the white paper only on the ridges of the rough surface. So unless the rough surface is completely removed, the grain of the paper will be the most apparent feature.

Sandpaper texture samples
1 Paynes Gray pale wash, sanded heavily
2 Paynes Gray deep wash
3 The same, sanded lightly
4 Paynes Gray pale wash, sanded,

Alizarin Crimson pale wash on top, sanded heavily
5 Paynes Gray dark wash, sanded, Alizarin Crimson dark wash on top
6 Paynes Gray dark wash, sanded, Alizarin Crimson dark, sanded

Sandpaper effects in context
Sanding is normally combined with other techniques which enable it to be incorporated naturally within the painting as a whole. It is most often used with scrubbing out, sponging out and blotting techniques which are all associated in some way with the texture effects that sandpaper creates.

In this landscape study, the light in the sky and the "white" water and foam were created by sanding the surface off the paper in these areas. Sanding on such a rough-grain paper produces a particularly mottled or grainy texture. This would look odd in conjunction with normal, thin, uniform watercolor washes, so the effect was incorporated into a style of painting which, with the use of blotting and scrubbing out, retains an overall "texture".

Sanding straight edges
To make the sanding-out more precise, small pieces of sandpaper

were folded to provide straight edges or corners which, used with small circular movements, will take out quite accurate areas along irregular contours – as in the join of the furthest hills.

The foam and mist rising from the waterfall was sanded out at its base, but scrubbed in circular movements along the horizontal with a bristle brush and clear water, then blotted with an

Sanding up to straight edges (detail) Folded sandpaper provides a straight edge for the top of the waterfall.

absorbent tissue. In the sky above the sanded area, a uniform wash of pale Alizarin Crimson was blotted while still wet. It appears as a blue/pink mottled area which leads comfortably into the texture created by the sandpaper.

BLOTTING PAPER EFFECTS

"Sponging out" and "wiping out" with sponges or absorbent paper have been described as a means of obtaining particular effects like cloud forms (see p.152). For "overall" textures, particularly on rough-grain paper, sheets of blotting paper can be used.

The technique involves applying color and, while it is still wet, overlaying a sheet of blotting paper and smoothing it out over the painting with the side of your hand. When the blotting paper is raised, it can be seen that it has lifted color uniformly from the ridges of the paper, creating a mottled effect — an interesting background for subsequent washes.

Tearing the blotting paper

As a further development of this technique, shapes can be torn from blotting paper and laid into a wet wash. The roughly torn edges of the blotting paper create softly blurred contours.

Building a painting with blotted washes Successive overall washes may be laid on to create an atmospheric landscape, building from the sky and background of the picture to the foreground. Blot each wash and let it dry before applying the next. Tear the blotting paper irregularly to produce the shapes of treelines, hedges and land contours. Use a bristle brush and water to soften any unevenness of line or tone in previous washes.

Blotting paper landscape study
Here the blotting paper helped create the misty atmosphere of early morning and enhanced the aerial perspective. The receding lines of trees were given blurred outlines with torn blotting paper, the tones lightening into the distance.

"PRINTING" A TEXTURE

The standard method of achieving effects of broken color is to hold the brush at a shallow angle to a sheet of rough watercolor paper and drag it lightly over the surface so that paint is deposited only on the high ridges of the paper. When dry, it can be overpainted with another color to provide a two-color texture. This is a straightforward method for thicker paints like oil or acrylic, but it is much more difficult to control the evenness of dragged color with watercolor. Instead, try painting the required color on a separate piece of paper. Lay this over the area to be treated, and smooth it down with a roller or the side of your hand. When the paper is lifted off, a far more uniform result is obtained.

Try modifying the consistency and tone of the paint being applied. You can also use different colors on the printing sheet, or cut the sheet itself into shapes (use fairly strong paper or thin card).

"Printing" the color
Paint the color to be applied on a piece of scrap paper and lay it face down over the rough paper. Smooth with a roller or your hand.

Brushed-on and "printed" color
The brushed-on sample (left), shows an erratic texture. On the right, textural color was laid on far more evenly by "printing".

USING MASKING FLUID

Art masking fluid is a rubber latex solution which can be painted on paper to mask out an area which you do not wish the paint to cover. When the painting is complete, the fluid is removed, leaving white paper. One coat is usually enough, but two may be used for added protection.

Masking fluid can be used before any painting has been done, to ensure that any highlights are kept white throughout. Or it can be introduced at almost any other stage of the painting process. The fluid is generally available in a clear or slightly yellow-tinted form. The latter is useful when working on white paper, to remind you where it has been applied. But if it is used on too absorbent a paper it will leave a slight yellow stain.

The fluid can be used to paint out an intricate or well-defined shape. This can be drawn out in pencil before applying the masking fluid, using a fairly hard pencil, lightly, so that the outline is as faint as possible. Or, paint just over the edge of the pencil line with the masking fluid so that when it is rubbed off, the pencil line can also be erased.

Masking an intricate shape

1 Paint out the shape with masking fluid.

2 Apply the required washes over the paper. Blot for texture if desired.

3 Gently rub away the masking fluid with a clean fingertip or an eraser.

The finished shape If desired, apply an overall wash of another color.

Masking out negative shapes

Sometimes you may wish to mask out the background which lies around an intricate shape rather than the shape itself. This is useful for areas such as the sky in the study of pines below, where the painted-out areas are the shapes of the sky between the branches and foliage.

Other effects

Masking fluid can also be used for softer, textured effects. The brush needs to be used with sensitivity, lightly touching the paper to deposit the film on its ridges.

Pine trees with masked-out sky The picture was drawn out in pencil and painted conventionally before the masking fluid was applied.

Different movements of the brush Light, fast circular movements (left) and diagonal movements (right), both overlaid with a wash.

WAX RESIST

The fact that wax repels water is the basis of the wax resist technique. When strokes are made with clear wax then overpainted with color, the wash will only adhere to the paper where there is no wax. Colored wax crayons or white wax candles may both be used. Candles are usually made of inert hydrocarbon waxes which are permanent so long as they are not subjected to excessive heat (such as being laid in the sun).

In representational painting, wax resist reverses conventional procedures by obliging you to begin with the highlights and work back to the shadows. For textural purposes, it provides a range of grainy effects that rely on the nature of the paper surface.

Wax effects on textured paper

1 Wax rubbed over the paper with gentle, circular movements, then a wash of Quinacridone (Rose) applied and left to dry.
2 Same procedure as 1, then wax applied in the same way. A Phthalocyanine Blue wash was applied and left to dry.
3 Same procedure as 1 and 2, then wax reapplied. A wash of Phthalocyanine Green was applied and left to dry.
4, 5, and **6** The same process, this time drawing lines with the wax.
7, 8, and **9** The same process, but here the Quinacridone (Rose) wash was applied before any wax marks are made.

Modeling a shape with wax resist The method can be employed to paint in a representational and well-rounded way. The technique lends itself to subject such as this apple. It is important to work systematically from highlight to deep shadow. In fact, apart from the darkest shadow at the base of the apple and on the stalk, the whole apple has been painted using just overall washes, all the modeling being provided by the use of wax.

1 Wax the highlights. Paint an overall wash of Aureolin and allow to dry.

2 Wax the areas which will appear yellow. Wash with Light Red.

3 Wax areas to appear Light Red. Wash with Quinacridone (Rose).

4 Wax areas to appear Quinacridone (Rose). Add a purplish wash.

5 Allow the last overall wash to dry. Finally, paint the dark shadow on the stalk and that on the right-hand base of the apple, using Viridian.

·Mixing watercolor techniques·

The various watercolor techniques are rarely employed in isolation, but are more often used in conjunction with one another. The painting below involves a combination of methods discussed in this chapter; the figure itself is an example of monochromatic underpainting with superimposed washes.

MONOCHROMATIC UNDERPAINTING

Great depth and subtlety can be obtained by painting an image in tones of a single color, modeling as if for a finished work, incorporating techniques such as softened edges and graded washes, then adding the appropriate colors on top when the underpainting is dry.

Scarecrow study
Here, monochromatic underpainting was used for the figure. Among techniques used were:
■ Masking fluid (see p.163)
■ Graded washes (see pp.146–7)
■ Washing off (see p.151)
■ Softening edges (see p.155)
The image was drawn with a pencil and lightly fixed. Masking fluid was painted over the scarecrow to leave it white while the sky was painted.

A basic graded wash was laid for the sky with other washes added on top. Some washing off was done using a brush to soften the edges of the clouds. Blue pigment was floated in to deepen the sky and re-define the clouds.

Shadows on the crops were painted using tiny dabs of color; paler touches were used for the plants. A pale yellow/green wash was applied over the field; masking fluid was used to protect the highlights. When it was dry, a light to dark greener wash was laid from the horizon to below the foot of the scarecrow. When it was dry, the masking fluid was removed. The hedge was painted and its edges softened with a dampened soft brush.

The scarecrow itself was painted in a range of tones of Phthalocyanine Blue – in the medium to light range, so that the overlaid colors appropriate to the image could be used to give them their full depth.

1 Draw and fix the image. Paint the shape of the scarecrow with masking fluid.

2 Paint the sky. Wash off round clouds, deepen sky, add crop shadows and lighter tones for crops.

3 Add yellow-green wash on field and masking fluid for crop highlights. Lay graded wash.

4 Remove masking fluid and paint hedge. Underpaint figure, in tones of Phthalocyanine Blue.

5 When the underpainting is completely dry, add the final bright colors for the plastic sacks which form the scarecrow's body and paint its wooden support and the piece of string.

GOUACHE

Gouache colors are popular with many designers and illustrators who rely on them to provide flat, uniform areas of color. They are also useful for artists who work on a small scale in the tradition of Indian and Persian miniature painting, where particular areas may require "filling in" with flat, opaque color. Apart from these applications, gouache can also be used for highly resolved work on a large scale.

HOW GOUACHE PAINTS ARE MADE

Gouache, or body colors, are manufactured in the same way as transparent watercolors, using similar ingredients. The paint film needs to be thicker and more flexible than that of watercolor, which is used more thinly. So extra glycerine is used in gouache paints, making them more soluble than watercolors.

An essential aspect of body color is its opacity. The best manufacturers obtain this through a higher proportion of pigment. With naturally transparent pigments, an opaque extender like barium sulfate or blanc fixe is used. Precipitated chalk is used as a cheap extender for low-budget versions of gouache colors; the chalk is tinted with the pigment to provide the color. Fine grades of precipitated chalk may be used in this way for home manufacture of gouache colors (see *Appendix*, p.335).

Another important aspect of gouache is its ability to flow. If it does not brush out to a flat wash using a gum arabic solution as a medium, then dextrin is normally used. As the paints are often used in airbrushing, they are ground as, or more finely than watercolors.

GOUACHE PAINTING ON A LARGE SCALE

The "Perseus Series" of cartoons by Burne-Jones consists of very large works in gouache on stretched, toned paper. They show the medium being taken to a high level of finish. The matt quality of the paint surface gives the paintings an immediacy which is underlined by the vigor and expression of the brushstrokes. Illustrated is the ninth painting in the series, in which Andromeda watches the slaying of the sea monster by Perseus. The figure of Andromeda is painted with dry, light-toned brushwork over a darker flesh tone, producing a fully-rounded modeling of the form. This dry brushwork on the textured paper accentuates the highlights.

The Doom Fulfilled (1876–88), by Edward Burne-Jones.

USING GOUACHE COLORS

Despite their opacity, gouache colors can be used thinly, in transparent or semi-transparent washes. When used like this, they are usually considered less brilliant than regular watercolors, but among the products of the best materials manufacturers, and particularly with transparent pigments like Pythalocyanine Blue or Burnt Sienna, there is very little difference between them.

Transparent and opaque washes
I, 2 and **3** Light, middle and dark-toned washes, mixed with water.
4, 5 and **6** The same washes, mixed with white. The darker a tone, the more different it appears from the transparent version.
7 and **8** The difference between gouache used straight and gouache mixed with white is even more sharply defined in graded washes: **7**, transparent; **8**, opaque.

White paint dripped into gouache The smoky effects formed are modified by paint wetness and consistency and the nature, angle and movement of the support.

SOLUBILITY OF GOUACHE COLORS

Since they contain more glycerine, gouache colors are more readily soluble when overpainted than are straight watercolors. Softening and blending manipulations between layers are very easily achieved using a damp, clean brush.

Overlaying washes

If you apply a thin wash over another thin wash, the layer underneath will dissolve more slowly than a thicker one. You

Overlaying gouache washes
I Thin, semi-opaque wash over thin, semi-opaque wash.
2 Transparent wash over thin, semi-opaque wash.
3 Thin, semi-opaque wash over transparent wash.
4 Transparent wash over transparent wash.
5 Thick, opaque color over transparent wash.

can paint a fairly thick coat over a color of similar consistency without affecting it too much, provided you work quite quickly. You can vary the opacity of colours according to the dilution and the amount of white. Thus you can obtain a number of semi-opaque overlay effects that cannot be achieved in transparent watercolor painting.

Shown below are the effects of overlaying various consistencies:
▓ thin (with water only)
▓ semi-opaque (with a little white)
▓ opaque (with more white).

6 Thick, opaque color over thick, full-strength paint.
7 Thin, semi-opaque wash over thick, full-strength paint. Note how the brown has started to seep into the blue as the brush is taken across to the right.
8 Straight, relatively thick Arylide Yellow over thick, full-strength brown.

TRANSPARENT AND OPAQUE COLOR

Combining gouache with transparent watercolor allows a new set of techniques to come into play. In this painting, a transparent blue wash forms a background for the geometric bands of gouache designating the window frame. An opaque white outline surrounds the head of the figure. The transparent and opaque elements are emphasized and thrown into individual focus.

Figure Devant la Fenêtre, (1935), by Joan Miró.

USING TONED PAPER

As gouache is an opaque paint medium, it can be used to good effect on gray or colored papers of medium tone. Since the opacity varies with the consistency of the paint and the types of pigments used, the color of the paper affects the look of the paint either by being faintly visible through it, or by being juxtaposed with it.

Gouache used on white and toned paper These examples show the same gouache colors applied to white and to orange/brown paper. The two basic colors used are Yellow Ochre and Phthalocyanine Green. These are shown individually, then combined in a thick mix, and a thin mix, then mixed with white, again both thinly and thickly. This was done on both the white and colored papers. The difference in effect is quite dramatic. The opacity of the white has a marked effect on the colored paper, and it is hard to believe that both the No. 3 squares are from the same mix.

Gouache mixtures on white and toned papers
1 Yellow Ochre plus Phthalocyanine Green, thick mix.
2 Yellow Ochre plus Phthalocyanine Green, thin mix.
3 Yellow Ochre plus Phthalocyanine Green plus White, thick mix.
4 Yellow Ochre plus Phthalocyanine Green plus White, thin mix.
5, **6**, **7**, and **8** The same mixtures on toned paper.

Monochromatic gouache sketches on mid-toned paper

A convenient and often-used way of working with body color is to use a mid-toned paper for the support, with white gouache for the lights and highlights and brown, black or blue gouache for the mid-to-dark and dark tones.

This sketch is painted over a preliminary charcoal drawing. Its focus of interest is the lovely "double" façade of San Giorgio Maggiore in Venice. The whole area shines white in the sunlight against the dark shadows cast across the side of the building. Two tones of white gouache are used to suggest the architecture of the facade, with some shadowing in thin black gouache over charcoal. The blue paper functions positively as an overall tone for the sky and as a mid- to light tone for the buildings.

Black gouache is used freely in diluted, but still quite heavily pigmented form to provide some weight to the shadows of the building and to the tone of the water. The sketch demonstrates the economy of a technique that, for all its speed of execution, manages to produce an image that looks well resolved.

Monochromatic study
The opacity and economy of gouache can be seen in this study.

GOUACHE PAINTING ON A MID-TONED GROUND

In this large-scale gouache painting, the orange/brown mid-tone paper provides a unifying tone for the whole landscape. The sky, appearing through the branches of the trees is painted opaquely in a blue/white mix. The deeper tones of the branches are rendered in a fairly thin gray wash which allows the paper color to show through.

The leaves are represented by myriads of dots of body color, touched over washes of more transparent color.

An Ancient Beech Tree (1794) by Paul Sandby.

Apple tree study

This gouache painting shows a contemporary interpretation of the technique incorporated into *An Ancient Beech Tree* (see above).

The sky color is painted opaquely through the branches and the paper color acts as a unifying and underlying color throughout. The dark tones of the leaves and branches are thin blue/brown washes, while the areas in the light are semi-opaque and opaque yellow/green and yellow/white mixes.

1 Make a preliminary drawing in charcoal.

2 Dust off the charcoal to stop it interfering with the paint. It leaves a residual image.

3 Mix enough paint to paint the sky twice with a mixture of Titanium White and Phthalocyanine Blue.

4 Use Yellow Ochre and Pthalocyanine Green for the hedge. Add Burnt Umber for the dark tones.

5 Paint the darkest twigs and branches in a blue/brown mix. When this is dry, repaint the sky.

6 Paint the lighter tones on the branches in mixtures of yellow, green and white; add detail.

TEMPERA

In tempera painting, a natural emulsion such as egg yolk, or an artificial emulsion such as a gum or glue emulsion, provides the vehicle for the pigment. The essential feature of an emulsion is that it comprises a stable mixture or suspension of two liquids which do not normally mix — such as oil and water. The emulsions used in tempera painting are normally water-soluble or oil-in-water emulsions, where the oily ingredient is suspended in fine droplets in the aqueous (watery) liquid. However there are also water-in-oil emulsions, where fine droplets of water are suspended in the oily liquid.

The most common form of tempera painting is egg tempera, which is water-soluble. The egg yolk provides a natural emulsion which, when mixed with pigments and distilled or purified water, gives a fast-drying and highly characteristic painting medium. The medium has traditionally been used in works which are slowly and carefully constructed. It does not lend itself to direct styles of painting in which paint is worked thickly on the surface of the canvas. In egg tempera, the paint is used thinly and superimposed systematically. Its uniqueness is partly due to the fact that many more strokes of paint can be superimposed, without the painting losing any of its freshness, than can be done in almost any other medium. Indeed, the color and form of the very first layer of paint applied retain their effect on the subsequent layers.

Egg tempera was the standard medium of European panel painting up to the fifteenth century, and its characteristic tiny hatched strokes of color can be seen on close inspection of most paintings which precede the advent of the more manipulable oil color. Cennini's late fourteenth/early fifteenth-century *Il Libro dell'Arte* provides a full account of contemporary tempera methods.

THE DURABILITY OF EGG TEMPERA

This altarpiece showing St John the Baptist with St James and St John the Evangelist is attributed to Nardo di Cione and was probably painted towards the end of his life. Recent analysis of paint samples from the painting using gas chromatography have identified the painting medium as egg. The excellent condition of the paint surface demonstrates the reliability of egg tempera.

Analysis of the paint layers and of the construction of the work as a whole conforms accurately with Cennini's contemporary account of late-fourteenth century painting materials and techniques.

Altarpiece With Three Saints (c.1365), by Nardo di Cione.

·The character of egg tempera·

Preparing egg tempera paints is straightforward, and the clear and translucent effects that the medium provides are entirely unique. Colors are generally applied on a white gesso ground using round sable or nylon brushes in a series of hatching strokes. In the respect, the painting technique is similar to drawing and in one sense could be compared to colored pencils, which build up their tone and color effects by the use of superimposed strokes of color. In egg tempera painting, each stroke retains its autonomy as a shape, since it dries within a few seconds of application and so cannot be modified by physical blending with adjacent colors.

Egg tempera does, however, differ radically from colored pencil in the luminous clarity which each brushstroke retains. As the painting is slowly built up by cross-hatching, the optical effects of the superimposition of

semi-transparent colors provide the richness and subtlety that characterizes the best works in the medium. Egg tempera, when painted on rigid panels, is a particularly permanent medium. Although, when it first dries through water evaporation, the paint film is soft and easily damaged by scuffing or wetting, the oil content slowly begins to harden with time. Eventually the film becomes a tough, almost waterproof surface which can be buffed with a soft cloth to give it a sheen, or varnished.

EGG TEMPERA AS UNDERPAINTING

In the past, egg tempera was used to provide the underpainting for works which were then glazed in oil color. The underpainting was often monochromatic, the colors being supplied by the transparent oil glazes. The

advantages of this method were that the underpainting dried rapidly, permitting rapid overpainting, and the "skin" laid over the cross-hatched structure of the work by the oil glaze had an overall unifying effect. Such methods are technically sound though nowadays, oil painters are not just limited to using tempera for underpainting purposes.

The different combinations of egg tempera with oil paint have led several commentators to speculate on the precise painting methods and mediums of certain artists of the past. Some of their claims have later been discredited in the light of modern scientific analysis. However, some of these mixed techniques are sound and acceptable painting methods in themselves. In particular, introducing egg/oil tempera into wet oil glazes can be a useful and time-saving addition to the repertoire of painting techniques (see p.179).

─·The components of tempera painting·─

TEMPERA EMULSIONS

Since the medium relies heavily on home-made paints, it is not surprising that there should be more recipes for tempera emulsions than for any other paint vehicle. Purists maintain

that natural egg yolk provides the only true tempera emulsion. But many artists have introduced oil or oil and resin mixtures into the basic egg yolk and water mix, in order to facilitate particular manipulations, and to be able to paint in a more

impasted way. Mixtures that incorporate gum and oil or gum, oil and resin emulsions are slower-drying and so manipulable for longer. They are also more resoluble to overlaid color. Other emulsions use glues like casein, emulsified with a drying oil or, for a less yellowing emulsion, with a resin. Such emulsions are said to be useful for light work on paper. The dried paint film is insoluble.

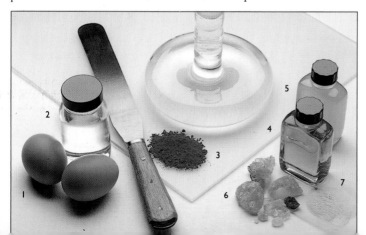

Selection of ingredients for tempera paints and emulsions
1 Egg yolk
2 Purified (distilled) water
3 Pigment powder
4 Stand linseed oil
5 Damar varnish
6 Gum arabic
7 Casein

SUPPORTS AND GROUNDS FOR TEMPERA

A traditional gesso ground is the ideal choice for tempera, but it can only be properly applied on a rigid support such as a wood panel or composite board (see pp.46–50). A dried tempera film may be too inflexible to withstand the movement of canvas.

A gesso ground has the right degree of absorbency to take up the tempera brushstroke sufficiently without absorbing all the binding material. (If necessary, the absorbency can be modified by applying a thin coat of diluted glue size.) Although an ultra-smooth surface is traditional, a textured version may be made by inscribing into the gesso when it is wet or by incorporating additional ingredients like sand. Although a modern acrylic-primed ground will accept the paint, it does not create the same close bond between paint and ground which characterizes the gesso surface.

Preparing the gesso ground

Gesso grounds are described generally on pp.63–6. For tempera painting, I use a rabbit-skin size prepared in a double-boiler at a strength of 75gm per liter (1½oz per 24fl.oz) of water. I give all surfaces of the panel a preliminary thin coat, followed when dry by a full strength coat. Whether you cover the panel with a thin, loose-weave linen or butter muslin cloth is a matter of personal preference. Once a panel is gessoed, it is just as smooth with or without the cloth, which really just provides a key for the gesso. Apply the cloth to the panel, then brush hot size on to the centre, over the cloth, working it out towards the edges and over the back.

When the size is completely dry, the gesso is applied. I use precipitated chalk with Titanium White pigment in proportions of about 9:1. This gives a particularly smooth, white surface. Traditionally, hot glue is stirred into the chalk and pigment until

it has a creamy consistency, and the mixture is strained before use. I use a kitchen blender, placing the dry chalk and pigment powder in the container, setting it on low speed, and pouring in hot glue size through the top. This may cause trapped air bubbles but these can be brushed out when applying the gesso.

Scrub the first coat well into the panel and rub it in with your fingers to eliminate any bubbles. Apply subsequent coats with a flat bristle brush held at right angles, building them up until you achieve a reasonable overall thickness. Allow the panel to dry thoroughly.

To smooth the gesso, the most efficient method is to use an electrical orbital sander with a fine-grade abrasive paper (alternatively, sand it by hand). Finally, smooth it again with light, circular movements, using a wad of slightly damp cotton sheeting. Work evenly, without going over the same area twice.

PREPARING PIGMENTS

In order to have a ready supply of usable pigments – at least for egg tempera painting – you should grind these in distilled (purified) water and keep them in tightly stoppered jars. Working on the relatively small scale normally associated with tempera, you use very little pigment. So you only need to grind enough of each color to fill a small 60ml (1–2½fl oz) jar.

This is enough for several paintings. To use a color, take a small amount of the paste from the jar and mix it with an equal amount of the tempera emulsion (if this is water-soluble). For oil tempera, grind pigments directly with the emulsion medium.

Making the pigment paste

For general information on grinding pigments, see *Appendix*, p.334. Prior to grinding, work the pigment into a paste with the

distilled water (see below). Grinding may be easy or hard depending on the pigment (see box, right). After a little experience, you will recognize the point when the pigment is well dispersed with the distilled water. The mixture looks and feels quite different to the granular paste obtained by simply mixing with the palette knife. Prepared pigment is stored under distilled water to keep it moist and avoid it having to be re-ground.

Preparing and storing pigments for tempera painting

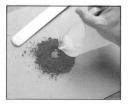

1 Place a small heap of pigment on the glass slab. Make a well in it. Pour in some purified water.

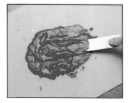

2 With the palette knife, turn the pigment into the water, pushing and scraping it until it is wet.

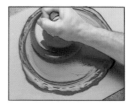

3 Now start grinding the pigment. For the correct way to use a muller, see *Appendix*, p.334.

4 When the pigment is ready, put it into a small jar. Top up with distilled water and replace the lid.

THE TEMPERA PALETTE

Among those pigments which wet easily and are permanent are many of the synthetic inorganic pigments such as:

■ Cobalt Blue (grinds well)
■ Manganese Blue (very gritty to grind)
■ Indian Red (gritty to grind)
■ Venetian Red (very gritty to grind)
■ The Mars colors (soak up water easily and grind well; they get sticky very quickly).

The natural and calcined earths generally grind well. Raw and Burnt Sienna tend not to be too gritty and grind silkily, as does Terre Verte. Yellow Ochre and Raw Umber are generally very gritty in the initial grinding, but are straightforward to mix and grind.

Other useful additions to the palette which present no great wetting or grinding problems are:

■ French Ultramarine
■ Viridian (gritty initially, but not too difficult to grind)
■ Titanium White (extremely straightforward to wet and grind)
■ Ivory Black

However, for a reasonably permanent red at the violet end of the range, either a Quinacridone pigment or Alizarin — both difficult to wet — has to be used.

Recommended pigments

1 Cadmium Red
2 Quinacridone (Red)
3 Alizarin Crimson
4 Mars Red
5 Indian Red
6 Venetian Red
7 Mars Orange
8 Cadmium Yellow
9 Yellow Ochre
10 Raw Sienna
11 Burnt Sienna
12 Raw Umber
13 Burnt Umber
14 Cobalt Blue
15 Ultramarine
16 Manganese Blue
17 Viridian
18 Terre Verte
19 Ivory Black
20 Titanium White

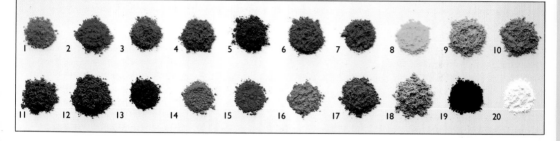

"DIFFICULT" PIGMENTS

Some pigments are very difficult to wet – notably the synthetic organic pigments such as Alizarin, the Phthalocyanine pigments and the Azo yellows, which are so light and fluffy that it takes a considerable time to persuade the water to adhere to them. These pigments also require a great deal of grinding – not to break down the particle size, but to ensure even wetting. Adding alcohol to the mix is said to encourage wetting.

It is also possible to obtain aqueous dispersions of modern synthetic organic pigments, prepared by pigment manufacturers to aid dispersion into vinyl emulsions by paint manufacturers. I have tried these with egg emulsions and they do seem to present a simpler alternative.

BRUSHES FOR TEMPERA

The most suitable brushes for the one-stroke hatching effects that characterize tempera painting are long-haired, round, pointed sables – or their synthetic equivalents. Since the hatching technique involves mixing up the tempera with water, loading the brush and then partially wiping off the paint so as to avoid unsightly blobs of color at the end of the stroke, choose a long-haired brush. The hairs retain more color and can be worked for longer than a short-haired equivalent. One characteristic of egg tempera is that a brush-load, even after the partial wiping off (see p.174), lasts for a surprising number of strokes.

Other suitable brushes are quill sables, pointed riggers, and the extra long-haired, round lettering brushes with either pointed or flat ends. These brushes can provide traditional effects, but, for creative techniques, many other types of brush may also be used.

Brushwork techniques

The important consideration is confining manipulations to one stroke of the brush, whether you are using a fine-pointed sable or a wide, flat bristle brush. If you immediately repeat a stroke, or scrub over it, the paint film will start to clog and disintegrate. Lower layers will probably be damaged and even the gesso ground might start to soften. Since the medium relies on the "quality" of a single stroke, it follows that whatever brush you use should be in good condition so that it deposits the paint evenly and with clean edges.

Long-haired pointed brush.

Long-haired flat-tipped brush.

·Egg tempera painting·

In my view, the traditional, pure egg-yolk emulsion is the most satisfactory medium for tempera painting. It is permanent, simple to prepare and gives painting a quite unique appearance. If you are interested in the careful construction and build-up to the finished appearance of a painting, the juxtaposition and super-imposition of colors for optical effects, and in a crisp, translucent look, egg tempera is ideal.

PREPARING EGG TEMPERA PAINTS

The preparing and storing of pigments for tempera painting has already been described on p.172. Generally, for egg tempera, the opaque pigments such as the cadmiums, and the artificial mineral pigments work particularly well. Since they are used thinly and within the egg emulsion, they do not work as completely opaque pigments in this medium but rather as semi-opaque or semi-transparent. This gives the painting body, while retaining its translucency.

Transparent colors may also be used for glazing, though this is still restricted to the single-stroke technique the medium requires (even if a stroke is made with a wide, flat brush).

Mixing the egg yolk and pigment Use a fresh egg. The colour of the yolk is not important, since it does not have a lasting effect on the pigment. One yolk is usually enough for a day's painting. Mix the yolk with the pigment paste and with a little more distilled water as described below. Use a plastic palette with indentations or, for larger amounts, use individual china or plastic saucers. Mix up all the colors you will need like this. Even when the pigment and yolk mixture has been well stirred, the pigment may settle, so stir each mix immediately before use.

As work progresses, the surface of the paint in the palette wells or china saucers may form a skin as it begins to dry. This is not a problem, though you should be careful not to paint any of the "skin" on to the panel.

1 Crack the egg and pass the yolk from one half of the shell to the other to remove most of the white, taking care not to puncture the yolk.

2 Place the yolk on a piece of kitchen paper in the palm of your hand and roll it around carefully. The remaining white will stick to the paper.

3 Hold the yolk sac at the edge of the paper and puncture it with a knife or sharp instrument. Pour the contents into a screw-top jar.

4 Take a little pigment paste from the jar. Add about the same amount of egg yolk and a little distilled water. Stir with an old, clean bristle brush.

EGG TEMPERA PAINTING METHODS

Mix some paint prepared as outlined above with more distilled water so that the mixture is not too glutinous. Load the paint brush and wipe it lightly on an absorbent cloth or paper tissues to remove excess paint. This avoids unsightly blobs at the end of each stroke.

If the paint is of the right consistency and the brush is not overloaded, each stroke is clear and uniform in tone. It dries quickly, allowing rapid overpainting. The brushstrokes should always be laid carefully and never "scrubbed" on to the surface.

Mixing colors
Physically blending colors on the surface is impracticable; tone and color graduation are achieved by juxtaposing tones and by cross-hatching. Any physical color mixing is done on the palette. Building up the tones and colors of an egg tempera painting is a slow business, and areas will need to be painted again and again. This process is particularly satisfying; the colors seem to retain their freshness and immediacy, even after constant overpainting.

Combining colors in egg tempera Cross-hatching is an effective way of combining two or more colors in a painting.

Other brushwork techniques

The emphasis I have placed on the "single-stroke" nature of egg tempera painting does not preclude other types of brushwork. You can, for instance, dilute the paint still further and apply thin washes of color with larger brushes over wide areas. It is not possible for the reasons already stated (see *Brushes for tempera* p.173) to make uniform washes or uniformly graded washes in the same way as for watercolor, for instance (unless you use a brush as wide as the painting and make the wash in one stroke). However, it is sometimes useful to underpaint a whole area in one thin color, providing an overall matrix beneath traditional hatched strokes. If the underpainted wash is rather streaky, this does not show when it is overpainted. And the luminous white of the gesso still shines through the superimposed colors.

Using egg tempera in a fluid way
Here a thick mix of color on each side was diluted with water, allowed to run over the support, then dried.

Tempera modeling
The brilliance of a color can be retained (even over a very different color) if you use enough strokes.

Study in cross-hatching and optical colour mixing

The small hayfield study painted on gesso over plywood, makes a visual connection between traditional egg tempera cross-hatching and the chopped strands of the baled hay and stubble. The painting was made principally with a small, round, pointed, soft-hair brush, with a larger flat bristle brush being used to apply the early washes. French Ultramarine, Viridian, Cadmium Red, Cadmium Yellow Deep, Burnt Umber and Titanium White were used, all prepared as described on p.172. A modern synthetic organic pigment, P.Y.109, already dispersed as an aqueous paste, was mixed with egg yolk, and used for the bright yellow.

Building up the study

1 Roughly sketch in the shapes and tones with a thin Burnt Umber mix. If the underpainting is too dark, it will cool down superimposed colors.

2 Paint a thin green wash over the field and hedges at the top, a deeper version of the same color over the first hedge and a thin yellow wash over the rest of the painting.

3 Work on the hedges and the far field at the top by overlaying thin strokes of various pale and dark greens, blues, pinks and reds. Add a fine network of Titanium White.

4 Paint the mid-ground and foreground with similar thin strokes, making them larger in the foreground to emphasize perspective. Make a series of red hatchings in the darkest areas. Paint white strokes in the lightest parts.

5 Gradually add more cross-hatched colors (orange, blue and pale and dark yellow/green). Work up the foreground stubble in similar colors, using vertical and near-vertical brushstrokes. Finally, rework the whole picture to ensure a uniform overall surface.

Hayfield foreground detail

The nearest hay-bale shows the complex and resonant optical mixtures possible with egg tempera.

TRADITIONAL EGG TEMPERA TECHNIQUES

Cennini's *Il Libro dell'Arte* explains in detail the method of egg tempera painting on panel practised in the early fifteenth century. It contains useful information for anyone working in the medium today.

An initial drawing should be made on the gesso panel using charcoal, most of which is then brushed off with a feather, leaving a faint image. This is reinforced with diluted (pigmented) ink and a small brush. Every trace of charcoal is removed and a blunt soft-hair brush is used to shade in some of the folds in the drapery and shadows in the face, with a similar pale wash of ink. Cennini recommends that draperies and background be painted before the faces, that the colors should always be tempered with an equal amount of egg yolk and that they should be "well worked up, like water".

Painting drapery

Cennini's systematic method of painting drapery is appropriate to the medium. First he prepares "dark", "middle" and "light" tones of a color.

The dark tones are painted in first, then the middle, then the light. Cennini emphasizes that the procedure must be repeated until the tones are perfectly blended. The next stage is to mix two yet lighter tones, followed by pure white, to build up the highlights, and similarly with the darkest tones, finally touching in the strongest darks.

Painting fleshtones

The technique is similar to that used for drapery, except that first, an overall wash of Terre Verte with some white is laid over part of the body to be painted. This differs slightly from the description of a similar process on wall paintings, where the face is drawn in first using a *verdaccio* mix of white, dark ochre, black and red, then shaded with Terre Verte before the warm colors are applied.

Now three values of flesh color are applied in a similar way to the tones of the drapery. Lastly, the lighter tones and highlights are applied before the final dark accents.

UNDERPAINTING AND OVERLAYING COLORS

Cennini recommends that the *verdaccio* (see left) used to shade a head should be mixed with some white for egg tempera panel painting. Since the medium confers a degree of translucency on even the most opaque pigments, any strong tone or color underlying subsequent layers of paint will have a strong effect on them. So a head underpainted monochromatically in, say, black, will have a "cool" look, even after the warm flesh colors are applied.

The principle can be exploited to advantage with, for instance, colors of mid-to-light tone overlaid by darker-toned complementaries. Using slightly darker tones over lighter ones allows the white ground to continue to contribute to the translucent quality of the painting. At this point, it should be said that the distinction between underpainting and overpainting can be quite arbitrary in tempera, especially where a fine cross-hatched technique is used, since no overall film of paint is being deposited over another. In fact, the technique allows for so many "overpaintings" that it would be difficult to decide where the underpainting stopped and the "top coat" began.

Monochromatic underpainting If the underpainting is broadly considered an interim stage in the progress of the work, it can still take many forms. It may be entirely monochromatic (painted in a number of tones of a single color). Different tones may be obtained by progressively diluting the paint with water to the point where the water is barely tinted with color. Or they may be had by progressively adding more white. This produces a richer, plumper underpainting. The color chosen has an important effect on

FIFTEENTH-CENTURY PANEL PAINTING

This small painting has not yet been subjected to the kind of analysis that can positively confirm the medium to have been (egg) tempera. However, it is conceived and executed with great care and clarity, and is a most exquisite example of the kind of work that is perfectly suited to tempera, with its characteristic fine linear tracery of brushwork.

St Nicholas Rebuking the Tempest (early 15th century), by Bicci di Lorenzo.

the individual colors used in the overpainting and provides a unifying effect to the finished picture. The range of tones in such a painting should remain in the mid-to-light area if the superimposed colors are to remain brilliant.

A highly resolved mono-chromatic underpainting is only worth applying if its qualities remain visible in the finished work. This will only be the case if transparent or semi-transparent colours are used in the over-painting – rather like tinting a black and white photograph. A less resolved underpainting, but with all the main shapes and shadows roughed in, allows for a highly resolved surface treatment in the overpainting. The underpainting need not be monochromatic, but each area of

shape or shadow may be painted in a color appropriate, by contrast or similarity, to the colors to be painted on top.

Underpainting for a highly resolved image The study of a child uses a cross-hatched "drawing" technique to produce a range of tones in the under-painting. The tone of individual lines is relatively consistent, but the paint has been further diluted to produce lighter grays in some areas. The image demonstrates that such a technique may be used in a relatively loose way as in the cross-hatching around the limbs, or tightened up to produce a more fully resolved image as in the area of the features, where there is also some stippling with the point of the brush.

TEMPERA UNDERPAINTING FOR OIL PAINTING

There is a long tradition of overpainting on tempera with oil paint (see p.171). Oil glazes are far more manipulable than tempera glazes, and it is con-siderably easier to make a smooth, uniform glaze in oil color than it is in tempera (see *Oil Paints* p.202). A tempera underpainting dries rapidly and there is no risk (as in oil painting wet-into-wet) of colors accidently mixing and muddying on the canvas. With egg tempera, you can establish the position and form of the image and start afresh immediately using oil color (you are not obliged to stick to glazing techniques in oils).

Adhesion of the two films
As regards the adhesion of the oil film to the emulsion film, there is no reason why this should be a problem, provided the oil paint is applied to the egg film while this is in a soft, partly absorbent state during the first few weeks after painting. Once the egg tempera is thoroughly dry, with a smooth, shiny and non-absorbent surface, there is a small possibility that adhesion problems could arise. One reason for incorporating egg/oil emulsions as tempera mediums (see p.178) is to allow better adhesion to an overpainted oil film. There could be some justification for this in terms of the overall structure of the paint film, but not enough for it to be the only reason for using such emulsions as tempera mediums. In fact, a particularly positive aspect of glazing over pure egg tempera is its imperviousness to all the glazing manipulations, whereas a tempera film which incorporates oil (which may not be dry) and/or resin (which may be resoluble in the glaze medium), makes the emulsion film more vulnerable – although this is only slightly noticeable in practice.

1 2 3

The three basic stages
1 The underpainting was carried out in Ivory Black egg tempera with a cross-hatched drawing technique, also including stippling.
2 An overall wash of Terre Verte was applied in single, adjacent vertical strokes with no repainting.
3 The image was over-painted in color. It remains rather too cool in tone due to the over-deep tones of the Ivory Black underpainting.

Detail of finished image The colored tracery of fine lines, which flow over and help to define the shape of the features, can be seen. When

painting the human figure in egg tempera, the use of curved, rather than straight, lines is more appropriate to the soft contours of the image.

·Other tempera emulsions·

In addition to pure egg-yolk emulsion, there are innumerable recipes – as many as there are tempera painters – which, for one reason or another, incorporate additional ingredients. These include oils, resins, gum arabic, glycerine and glues. Each recipe produces a paint film of a slightly different quality.

EGG/OIL/RESIN EMULSIONS

The main reasons for incorporating oils and resins in tempera are that they slow the drying time, thus rendering the paint manipulable for longer. They are also said to be useful in imparting impasto effects to the paint, presumably by adding flexibility and viscosity. Certainly a pure egg-yolk medium will crack if used too thickly. In addition, egg/oil emulsions are said to aid the adhesion of overpainted oil colour (see above). For several recipes for egg/oil/resin emulsions, see *Appendix*, p.335.

Still life study in egg/oil/resin tempera The still life study of clay figures was painted using an egg yolk/stand oil/damar varnish plus water emulsion. Thin color washes were used over the cross-hatched underpainting. The latter provided a unifying matrix for superimposed cross-hatching in color.

EGG/GUM ARABIC EMULSION

The use of egg yolk with gum arabic dates from medieval times when it was used as a medium for working on parchment. The early German "Strasburg manuscript" – a treatise on art materials – contains many references to the preparation of colors in a similar emulsion, generally also containing a little honey as a plasticizer, and vinegar as a preservative.

A recipe for egg/gum arabic emulsion is given in the *Appendix* (see p.336). Mix the medium with pigment as for egg tempera painting and use it in a similar way. The presence of the gum arabic makes it act more like watercolor. The dried paint is resoluble by overpainting, and this can be exploited for certain techniques. If, for instance, you overpaint an opaque yellow with a thin red wash, stroking the overpainting carefully and continuously with a damp brush for a short time, the colors will merge to form orange. If you did this in egg tempera, the stroking would result in the destruction of the first paint layer.

In washes, gum arabic makes the paint slightly "sparkly" and gives a somewhat granulated look. Combined with the slightly plastic mattness of the egg film in thicker layers, this makes for an interesting combination. Wet paint of different colors can be worked on the support for blended colors and graded tones. The paint may also be used in a loose and "juicy" manner, running freely into adjacent colors (but not so freely as in watercolor).

Egg yolk/gum emulsion on paper For blended color effects, this emulsion works best on paper, where it has the characteristic gum arabic (watercolor) look in washes.

GUM TEMPERA

The gum arabic solution used above may be emulsified with oil or oil and resin to produce a paint vehicle which bears no resemblance to egg tempera in appearance or performance. It works best on paper where it can be brushed out well. On gesso it has none of the milky smoothness of egg tempera. It produces a hard film which cannot be scratched with the fingernail when dry, but which is almost immediately resoluble to a damp brush. Emulsions of this kind, which incorporate oil and resin, are water-soluble given the right proportions, but the stickiness of the oil and resin are evident, however well emulsified, and can be felt in the palette and in the hairs of the brush. For loose, vigorous brushwork on paper using bristle brushes, it is a satisfying medium to work with. For a recipe for gum tempera, see *Appendix*, p.336.

GLUE TEMPERA

Various glues may be used to make tempera, including gelatine and size, but the most common is casein. This has the advantage of completing its chemical drying process in a matter of hours and also of being completely insoluble when dry. With the advent of vinyl and acrylic paints, casein emulsions are not so common now as they once were. Casein tempera is generally used in thin layers of broadly applied paint. The disadvantage of the medium is that it yellows when mixed with linseed oil. Alternative emulsions can be made with resin varnishes and waxes, see also p.336.

PAINTING INTO WET OIL FILMS WITH TEMPERA

Egg, or better, egg/oil tempera is often recommended for painting details like fine tracery patterns or small blobs of pigment, into wet oil films, particularly where you need a degree of body in the detail. The reason for using tempera rather than oil paint for this is that it is said to be difficult to keep oil paint separate from the wet oil film around it, whereas with tempera, the principle that oil and water do not mix enables crisp strokes to be made more easily. Also, the tempera dries quickly, enabling further oil manipulations to be made without delay. In practice, the technique is not quite so straightforward as it sounds. It is difficult, for instance, to paint small tempera details on an entirely freshly painted, thin, straight oil-color film. It is easier after half an hour or so, when the oil paint has become slightly tacky due to the evaporation of some of the solvent used to dilute it. Then the tempera can be applied using a long-haired sable brush, reasonably well loaded with paint. Even here, the strokes must be made confidently and with no re-working. The point of the brush may pick up a blob of the oil color at the end of a stroke. This must be touched off on a piece of tissue before the next stroke is made. Wait until the first layer of oil color is dry before overpainting in oil. This avoids the risk of damaging the strokes of dry tempera.

The problem of adhesion

If the tempera is applied as thick blobs on the oil paint, this can cause problems of adhesion when the second oil layer is added. In practice, this does not often arise but it is a good reason in itself for incorporating an egg/oil emulsion as a tempera medium for such manipulations, since the oil component can "lock in" to its counterpart in the oil paint.

White Lead tempera emulsion showing cracking Applying the emulsion in a wide band over wet oil color makes it prone to cracking. Titanium White is slightly less liable to crack as it is not such a fast drier.

An emulsion which I have found quite satisfactory as regards adhesion is: 1 part stand oil, 1 part turpentine, 2 parts skinless egg yolk, 2 parts water. The white pigment is ground into this emulsion. Titanium White works perfectly well for those who would rather avoid the very real problems of toxicity associated with handling White Lead in powdered pigment form, and its rather "cold" whiteness may easily be modified with a touch of a warmer color if necessary. The pigmented emulsion can be painted directly into a wet or "tacky" oil film, but the emulsion will crack if the oil paint is too wet or too thick, or if the emulsion is too liquid or contains too much egg yolk (see example above).

Incorporating resins

Artists who work in a mixed tempera and oil medium tend to incorporate natural resins into their painting process, from the application of soft resin varnishes over tempera underpaintings (before modeling in the white emulsion described above), to the use of oil/resin mediums for glazing over the modeling. The reason for using such materials is that drying times are speeded up considerably, enabling the white tempera to be painted in more easily, and for further oil/resin glazes to be applied and overpainted rapidly. They also make the paint more manipulable and glossy. The possible dangers of darkening, brittleness and resolubility associated with using natural resins in the paint film are explained on pp.185–6. Certainly the same effects can largely be recreated without using resins or balsams, if the artist is prepared to work for longer on each painting to allow for extended drying times.

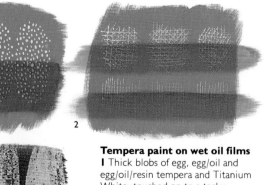

Tempera paint on wet oil films
1 Thick blobs of egg, egg/oil and egg/oil/resin tempera and Titanium White, touched on to a tacky Phthalocyanine Blue/Titanium White oil film, partly glazed with Quin-acridone (Rose) oil color.
2 Thin cross-hatchings of the same tempera on oil film, glazed as above.
3 Wide tempera strokes give broken color effects over a tacky oil film.

OIL PAINTS

Oil paints are made from pigments ground in a drying (or semi-drying) oil, such as linseed, nut, poppy or safflower oil. The use of oils like these as binding mediums gives oil paint its characteristic appearance and its qualities of easy handling. Pigments ground in oil have a distinctive depth and color resonance, and can be used in a wide range of techniques. These encompass transparent and opaque painting and include direct wet-into-wet painting methods, and those that work by building up a painting carefully, layer by layer, according to a prescribed system.

Oil paint can be applied in thin, transparent glazes or in thick, impasted strokes. It can be worked while wet on the surface of the support for far longer than other painting media, allowing scope for particular blending effects and for the safe introduction of fresh colors. In oil painting, the color laid down wet is effectively the same color when it dries, which makes some aspects of the medium much more straightforward than similar aspects of gouache or acrylic painting.

The history of oil painting

Oil painting dates back to well before the van Eycks, who have been popularly credited with the discovery of the technique. The middle German Strasburg Manuscript — an art treatise of the Middle Ages — gives detailed instructions for the preparation of a cooked and sun-bleached drying oil with which to grind and temper pigments, and also for a cooked oil and resin varnish, three drops of which are added to each color — presumably to aid manipulation. Cennini, who is

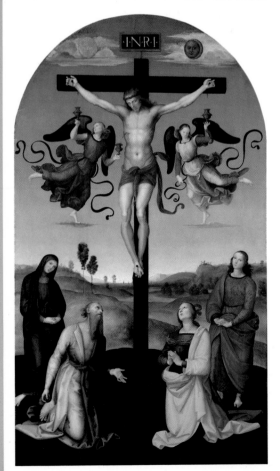

**The use of different oils
(left)** Analysis of paint samples from three areas of this early Raphael Crucifixion show the medium to have been linseed oil in the earth and green robe and nut oil in the sky. The pale nut oil was used for colors which might have been changed by the yellower linseed oil.
Altarpiece: The Crucified Christ with the Virgin Mary, Saints and Angels (probably 1502–3), by Raphael.

**The oil medium in landscape painting
(right)** The absorption of Narcissus with his own reflection in the pool described in Ovid's tale is reflected in the still, warm light which bathes the quiet landscape of this carefully composed work. *Narcissus* (1644?), by Claude.

more detailed on egg tempera techniques, also includes instructions for the preparation of a drying oil. The use of a drying oil as a painting medium was initially more popular in Northern Europe than in the South. The use of oil-ground color became increasingly popular in Venice during the fifteenth century, and by the early sixteenth century it was the accepted medium for easel painting throughout Italy and the rest of Europe.

The permanence of oil painting

Oil painting is no more permanent than other established painting media. In fact, if the oil painter fails to adopt sound working methods, a number of problems can arise. The oil film may crack due to the superimposition of lean (non-oily) paint layers over oily ones. Other problems are caused by overlaying colors of low oil absorption on those of high oil absorption, or by laying too strong a coat of glue size on canvas before priming. Over-bound pigment, with a surplus of oil, causes wrinkling and excessive yellowing, and under-bound pigment results in dry, crumbly paint which may flake off the canvas.

Methods and mediums, past and present

Oil painting need not be the complex undertaking that is suggested by the vast range of recipes for oil painting mediums and varnishes. Perfectly acceptable results can be achieved simply by using unadulterated pigments ground in oils, and diluted with turpentine or mineral spirit as necessary, and only painting over a layer of paint while it is still wet or after it has dried.

Some techniques and effects do require the modification of the straight oil color, but most can be reproduced using the simplest and soundest formulations. Some commentators claim to be able to identify the precise materials used by an artist simply by being able to copy an effect. However, at the time of writing, it often remains difficult to identify from small paint samples, the exact nature of the painting or glaze medium used. I have therefore decided to show how particular oil painting effects may be achieved, but not to claim that the same methods were used in the past. In many cases the method will be similar, although the painting or glaze medium used may not.

A sense of depth, color and scale
Howard Hodgkin's small painting combines subtle brushwork and blending (in the blues, whites and orange-pinks beyond the strong brown "proscenium arch") and broad, fluent strokes (in the foreground and on the shape of the arch). On the perimeter of the painting, dull crimson and blue-grays are vigorously over-painted in salmon pinks. *After Corot* (1979–82), by Howard Hodgkin.

·Oil colors·

Oil colors are made by mixing and subsequently grinding pigment powder with a drying oil. (Drying oils are discussed on pp.32–4 and also on p.184.) Linseed oil has been universally popular for many centuries. The less yellowing nut oil has just as long a tradition in painting, particularly for grinding white pigments. Poppy and safflower oils have also been used for this purpose. These are semi-drying oils – often used by manufacturers to slow down the naturally fast drying times of some pigments, or to produce a paint of better consistency for others. They may be used on their own or combined with drying oils. Mixing different oils in this way is perfectly acceptable, since they all contain the same triglycerides (see p.32).

With properly ground pigments, each particle is coated in oil and the paint mixture is sufficiently plastic to be manipulable, but sufficiently viscous to retain the mark of the brush or painting knife. When artists' colormen produce oil colors for the market, they aim to make colors of a similar consistency, which are compatible and which dry within, say, two to fourteen days. A number of factors are involved.

OIL ABSORPTION

Every pigment requires a different volume of oil to bring it to the desired consistency. The oil absorption of pigments varies considerably so that a pigment like Alizarin, for instance, requires almost twice as much oil by volume as White Lead. I stress this point because artists are often rightly advised not to paint in oil colors of low oil absorption over those of high oil absorption, since this results in a badly-structured paint film in which lower layers will be more flexible than those superimposed and may cause them to crack.

Extenders and thickeners

In the case of home-ground color, the oil absorption tip is good advice. With manufactured oil paints, the colormen modify the behavior of their colors, not only by the blending of drying and semi-drying oils and the addition of driers, but also by the addition of certain pigments (which are transparent in oils) as extenders. Aluminum hydrate, for example, gives good flow characteristics to certain colors. Blanc fixe is a commonly-used extender for strong organic pigments which are considered far too powerful without extenders to fit comfortably within the manufacturer's range of compatibility with other pigments. Kaolin (China clay) is also used to control the consistency of oil color. Such pigments have oil absorption figures of their own which affect the overall oil content of the tube color. The result is that an oil absorption figure allocated to a specific pigment may bear no relation to the oil content of that pigment in its tube-color form. Indeed, it would be difficult to find a manufacturer prepared to divulge the specific contents of each tube color in the range so that an accurate oil content figure could be computed. Other ingredients such as thickeners can also affect oil absorption.

The right approach to oil absorption Since manufactured colors are made to perform consistently within established limits, the result is that the effects of different oil absorptions are to a certain extent mitigated. You may be placing unnecessary restrictions on techniques if you strictly avoid painting in supposedly low-absorption pigments over high-absorption ones. In practice, it is still advisable to avoid fast-drying colors with high oil contents by volume (such as Umbers, Siennas and Cobalt Blues) in underpainting, as cracking may occur in overlaying layers if these do not contain relatively higher oil contents. Even these colors may be used in underpainting, however, if applied very thinly or in tints reduced with white, or in other admixtures with slower-drying pigments of lower oil absorption.

APPROXIMATE DRYING TIMES OF MANUFACTURED OIL COLORS

▦ Fast drying (around two days):
Aureolin, Manganese Violet, Cobalt Blues, Prussian Blue, Raw Sienna, Raw Umber, Burnt Umber, White Lead.

▦ Medium drying (around five days):
Phthalocyanines, Burnt Sienna (medium to fast).
Chromes, Cobalt Violet, Manganese Blue, Ultramarine, synthetic Iron Oxides (medium).
Cadmiums, Titanium White, Zinc White, Lamp Black, Ivory Black (medium to slow).

▦ Slow drying (more than five days):
Azos, Quinacridones, Alizarin.

APPROXIMATE OIL CONTENT OF MANUFACTURED OIL COLORS

It is impossible to provide more accurate figures (see left).

▦ High (more than 70 per cent): Burnt Umber, Raw and Burnt Sienna, Phthalocyanines, Alizarin, Cobalt, Quinacridones, Lamp Black.

▦ Medium (55–70 per cent): Cadmiums, synthetic Iron Oxides, Ivory Black (can be high), Oxide of Chromium, Raw Umber, Chromes, most Azos.

▦ Low (less than 55 per cent): Ultramarine, Manganese Blue, Flake White.

RECOMMENDED PALETTE

The following pigments are
recommended for oil painting.
For further information see the
charts on pp.18–31.

Reds
1 Cadmium Red
2 Light Red
3 Indian Red
4 Venetian Red
5 Naphthol Red
6 Permanent Red FGR
7 Quinacridone (Red)
8 Azo Condensation Red
9 Alizarin Crimson*

Yellows
10 Arylide Yellow G
11 Arylide Yellow 10G
12 Arylide Yellow GX
13 Diarylide Yellow
14 Azo Condensation Yellow 128
15 Nickel Titanate Yellow
16 Isoindolinone Yellow
17 Cadmium Yellow
18 Yellow Ochre
19 Raw Sienna
20 Transparent Gold Ochre
21 Mars Yellow
22 Naples Yellow
23 Cobalt Yellow*

Blues
24 Phthalocyanine Blue
25 Cobalt Blue
26 Ultramarine Blue
27 Manganese Blue
28 Cerulean Blue
29 Indanthrone Blue

Violets
30 Quinacridone (Violet)
31 Cobalt Violet
32 Mars Violet
33 Dioxazine Violet

Greens
34 Phthalocyanine Green
35 Oxide of Chromium
36 Viridian
37 Cobalt Green
38 Terre Verte

Browns
39 Raw Umber
40 Burnt Umber
41 Burnt Sienna
42 Mars Brown

Whites
43 Flake White
44 Cremnitz White
45 Titanium White
46 Zinc White

Blacks
47 Lamp Black
48 Ivory Black

*Refer to Pigment Charts
regarding lightfastness.

Lightfastness and toxicity

Alizarin Crimson and Cobalt Yellow are asterisked on the *Recommended pigments* list as they do not match the lightfastness of the other pigments. Alizarin Crimson is generally used full strength for glazing; it has poor lightfastness in tints (mixtures with white). Cobalt Yellow is not heat-stable and is decomposed by acids and alkalis. Its soluble cobalt content can be chronically toxic if ingested. However, it is almost the only transparent "glazing" yellow available. Chrome, Zinc and Barium Yellows are too toxic to be included.

The lead content of Flake White, Cremnitz White and Naples Yellow means they should be handled with care. Ingesting Manganese Blue could cause barium poisoning and the other Cobalt colors can cause allergic skin reactions. All the other pigments listed are relatively harmless.

Nomenclature of tube oil colors The names of tube colors often bear little relation to the pigments they contain, and you cannot rely on specialized pigment knowledge from the retailer. With artist's quality tube colors called "Cobalt Blue" or "Burnt Sienna" for instance, you should be able to rely on the manufacturers using the pigments identified by the name, but this is not always the case. What appears to be a pure pigment color may in fact be a blend. Some blends are reliable, but others may incorporate unstable colors.

Fortunately, reputable manufacturers are starting to identify pigments on the tube. Failing this, they usually publish a list of the composition of pigments, to help you check exactly what you are buying.

TRANSPARENT PIGMENTS

The Quinacridone and Phthalo-cyanine pigments are especially useful in glazing since they are so "clean" and transparent. They provide pure colors which may be mixed to almost any hue. The Azo Condensation Pigment Yellow 128 is similarly effective. Burnt Sienna is a particularly useful orange/brown, while Raw Sienna or Transparent Gold Ochre provides a more low-key glazing yellow. Their high tinting strength also makes these colors well suited to opaque painting methods when used in tints with white or other opaque colors.

TRANSPARENT COLORS SUITABLE FOR GLAZING
■ Reds: Quinacridone (Red)*, Alizarin Crimson
■ Yellows: Azo Condensation yellow*, Raw Sienna*, Transparent Gold Ochre*, Cobalt Yellow
■ Blues: Phthalocyanine Blue*, Ultramarine**, Cobalt Blue**, Indanthrone Blue.
■ Violets: Quinacridone Violet*
■ Greens: Phthalocyanine Green*, Viridian, Terre Verte
■ Browns: Burnt Umber, Burnt Sienna*
■ Blacks: Ivory Black.
*especially recommended
**semi-transparent

MAKING YOUR OWN OIL COLORS

Making oil colors is fairly easy. It involves grinding pigments (see *Appendix* p.334) and preparing the colors as described for tempera painting (see p.172). A drying oil (usually linseed) is used instead of distilled water. Problems such as the separation of oil and pigment in a tube due to over-long storage do not arise and in general, there is no need to add the specialized ingredients used by manufacturers. It is probably best to avoid pigments like Ultramarine, which are rather difficult to grind into a workable consistency without the addition of stabilizers or thickeners. Adding a little poppy oil may produce a more acceptable consistency. In my experience, pigments which are said to be difficult to grind in oil, such as Viridian, make perfectly good oil colors if ground for a little longer than usual.

The only additional ingredient that may be added is wax (in small proportions of up to four per cent). It acts as a stabilizer to stop the color running out and increases thickness and oil absorption. Add wax to the oil in small lumps and warm the oil until it melts.

Using linseed oil

The kind of linseed oil generally recommended as a grinding medium is cold-pressed (although a good quality, alkali-refined oil may also be used). This is not chemically refined, and may just be bleached with Fuller's Earth. Although claimed to be superior to the hot-pressed oils, it is uncertain whether or not chemical changes caused by the heat of the refining process are beneficial to the resulting oil film. Oils of high acid value are usually recommended for home pigment grinding since they give maximum wettability and dispersion (see p.32).

Using other oils

Poppy oil (see also p.185), which is slow-drying, may be ground with the fast-drying pigments to achieve a more uniform drying time through the range, but its most important role is in the grinding of white pigments, since it is pale-colored and less yellowing than linseed oil. Poppy oil colors are recommended for direct or *alla prima* styles of painting which do not involve underpainting. They allow plenty of time for painting wet-into-wet. Nut (walnut) oil (see also p.185) is a good alternative to linseed, but loses its freshness rather rapidly.

·Vehicles, mediums and diluents·

The "vehicle" is the binding medium (usually linseed oil) which holds the pigment in suspension and attaches it to the support. A "medium" is either the same, or an additional mixture which may incorporate oil, turpentine and resin varnish, for instance. You may add this to tube or home-ground color before painting, or you may simply use a diluent, such as turpentine, oil of spike lavender or mineral spirit.

OILS AS OIL PAINTING VEHICLES

The oil vehicle is generally either linseed oil, nut (walnut) oil, poppy oil or safflower oil (see also p.33 and p.182). Both walnut and linseed oils were used extensively from the fifteenth century, the linseed oil (with its superior drying properties) gradually proving the more popular. Poppy oil became popular in the nineteenth-century French school.

Linseed oil
This widely-used drying oil acts both as a vehicle for grinding pigments and as an ingredient in oil painting mediums It has been claimed that the "suede effect" (where brushstrokes made in one direction appear different in tone from those made in the opposite direction) is removed by the use of cold-pressed oil. In fact the effect is not related to the oil but to stabilizers used in the color.

Other forms of linseed oil, such as stand oil, sun-thickened or sun-bleached oil, are used as painting or glaze mediums on their own, or in conjunction with other materials. They are more reliable on their own where they can be diluted to a workable consistency with an essential oil such as turpentine or, for slower drying, with oil of spike lavender. Stand oil is somewhat slower-drying than sun-thickened or sun-bleached oil, but is recommended for its non-yellowing characteristics and the fact that it retains a certain flexibility on aging.

Nut oil
Made from walnuts, this is paler than linseed oil and recommended for use with the paler pigments. In the seventeenth century, Henry Peachum recommended it for use in whites for ruffs and linens. "Grind all your colours in Lindseed oyle, save when you grind your white for ruffes and Linnen: then use the oyle of walnuts, for lindseed oyle will turn yallowish."

Poppy oil
This is a slow-drying medium, suitable for direct wet-into-wet painting methods, but should not be used when painting in layers.

Safflower oil
This is used particularly for grinding white pigments. The same care should be taken regarding overpainting as with poppy oil. A paint film with safflower white underpainting and overlaid colors in linseed oil could be unsound.

Cooked oils
Although cooked oils were popular in the past, they are now considered unreliable and too yellow and are no longer widely used in painting.

OIL-PAINTING MEDIUMS

There are many recipes for oil painting mediums which have been popular at different times. All have different qualities, but the safest method of oil painting remains that of using the tube color as it comes, or simply diluted with turpentine, mineral spirit or oil of spike lavender.

Oil varnishes
Cooked oil/resin varnishes were popular in the past. Preparation involved heating a hard fossil resin (like Baltic amber, copal, or the softer sandarac resin), with the drying oil, in a proportion of around three to one, which allowed the two to be incorporated into a thick varnish, like clear honey. The varnish had good film-forming characteristics and was strong, durable and glossy. The *vernice liquida*, as it was called, was a very dark reddish brown color. Cooked oil/resin varnishes are now obsolete for oil painting purposes because of their dark color.

Other types of oil varnish incorporated soft resins like mastic or pine resin in nut oil to produce a paler varnish (*vernice chiara*) which could be used with colors like green and blue that would be adversely affected by the reddish tone of the *vernice liquida*. These varnishes still displayed a tendency to darken.

Solvent varnishes and oleo-resins Soft resin varnishes, made by dissolving a spirit-soluble resin such as mastic and, later, damar, in turpentine distillate, became widely used in the seventeenth century. These varnishes were often mixed with drying oils to produce a faster-drying painting medium than could be had with drying oil alone. The balsams or oleoresins such as Venice turpentine, Strasburg turpentine or copaiba balsam were also extensively used in mixtures with drying oils or resin/oil mediums. The resinous ingredients helped to impart a lustrousness and depth to the appearance of the painting through their highly refractive transparency, and to facilitate the handling characteristics of the oil paint for effects such as glazing.

THE PROBLEMS OF USING RESINS

With the more widespread use of resinous ingredients from the seventeenth to the nineteenth centuries came problems with the darkening, embrittlement and resolubility of the paint film which have plagued museum conservation departments ever since. Paintings from these periods, where resins are more likely to have been used extensively, have not yet been exposed to the rigorous scientific analysis which might clarify the use of resinous materials in relation to technique and permanence.

The oxidation of resins can cause a severe progressive darkening, which is not generally so pronounced in drying oils. (A few resins – mostly dammars – do not darken.)

The brittleness of a dried resin film is another reason for avoiding the excessive use of resins. An additional problem is the vulnerability of soft resins to cleaning solvents. On a painting made using just a drying oil as a medium, varnished when dry with a soft resin varnish, the varnish can be removed when it becomes dirty without affecting the paint film. But if a medium containing a high level of soft resin is used, there is a strong possibility of the colors being disturbed, even removed, by cleaning.

These problems have still not been fully resolved. Some artists insist that their techniques and effects cannot be achieved without resinous materials. Others maintain that they may be had by safer means. In my opinion it is a question of degree. Very small quantities of resins can improve handling, enhance colors, and speed drying without causing the problems outlined above.

PREPARING DAMAR VARNISH

The damar resin generally available to artists comes from Singapore, in the form of small, transparent straw-colored lumps, usually coated with white, powdery crushed resin.

To prepare damar (or mastic) varnish, place the resin in an old stocking or a muslin bag and suspend it for several hours in turpentine. The resin gradually dissolves and any impurities remain in the bag. Strain the varnish again through a clean piece of cotton or muslin; it is ready for use. The proportion should be around 200–300gm damar per 500ml (8–12oz per 24fl oz) turpentine.

MEDIUMS CONTAINING RESINS AND BALSAMS

Many formulas incorporate resin varnishes and/or a balsam (oleoresin), a drying oil and turpentine in various proportions. The amount of turpentine is only important in relation to the working properties of the medium. The more that is added, the less viscous the medium and the thinner it can be spread.

The choice of drying oil is based on resistance to yellowing, flexibility on aging and drying speed. For the first two points, stand oil is preferable; for the latter, sun-thickened is best. Both can be thinned with turpentine.

The choice of resin is now mostly limited to soft resins such as damar or mastic, the former showing better all-round properties. Most oil mediums in the past have been based on copal, but hard resins are dark and grow darker and brittle with time, so are not recommended.

Among oleoresins, Venice turpentine is the most often used (Canada balsam is a possible substitute). Copaiba balsam was used extensively in the past, but is particularly dark and prone to cracking (as are all the balsams).

Combining a resin varnish and a drying oil Recommendations for fast-drying oil painting mediums include damar varnish or Venice turpentine, mixed with turpentine. But these formulas lay themselves open to all the problems outlined above. It is better to mix the resin varnish with a drying oil. Proportions vary but, in my opinion, the ratio of resin varnish to drying oil should be no greater than 1:1 (preferably much less). The resulting mix can then be thinned to a workable consistency with between one and five parts of turpentine.

ALKYD RESIN MEDIUMS

Several manufacturers make painting mediums based on synthetic alkyd resins. These are said to be as good, if not better, than those made with natural resins. Although they have been available for 30 years, there appear to have been no long-term investigations with regard to their durability.

The alkyd resin film dries harder than that produced by a drying oil. It withstands movement, though whether it is more flexible than the oil film is a moot point. The drying process of alkyd-based color is much faster than that of oil-based color, and after six months it is as brittle as an oil film will be after five years. There is some reason to think that it does not embrittle further after that time. As far as yellowing is concerned, the alkyd is itself darker than a refined oil, and the inevitable addition of driers by manufacturers does tend to discolor the film. It does not, however, appear to undergo the progressive darkening of natural resins.

These mediums should be used in a consistent way, and according to the "fat over lean" rule which determines that each layer of paint should contain a little more medium than the one beneath. It would be inviting problems if you were to combine the use of traditional mediums with synthetic ones within the various layers of the painting. Alkyd-based mediums, particularly the "jelly" type, should never be applied on a high-gloss oil surface; they will not adhere.

·Rigid supports and grounds·

Although canvas is the most popular support for oil painting today, rigid supports are in general far more permanent and allow a wider choice of materials. With the right priming, supports like wood panels or honeycomb aluminum provide a far more permanent base than a flexible fabric. However, most artists, including myself, ignore this sensible advice and continue to paint in oils on canvas.

USING A GESSO GROUND

Gesso (see p.63) is the traditional plaster of Paris/glue size ground used over wood panels for oil or tempera painting. Its smoothness and dazzling whiteness can be used to advantage when working thinly in oil paint, or in oil glaze over tempera underpainting (see p.171). Whether you are working on smooth or textured gesso, you must seal it before applying any oil paint. The standard chalk gesso ground is particularly absorbent. Unless it is partially sealed, too much oil from the paint is taken up by the chalk, leaving the paint too lean and causing the chalk ground to yellow. The sealer should not totally shut out the oil paint from the ground, but should permit a degree of absorbency.

Sealers for gesso grounds
Several different sealers may be used over gesso (see also p.65). Proprietary plaster sealers are available, but the simplest choice is a coat of the glue size used to seal the panel and to make the gesso. Dilute this with water to around half its strength; one coat is usually sufficient. There is a marked difference between applying oil color to this treated ground and applying it to an untreated one. On sealed gesso, the strokes are fluent and the paint is manipulable.

A thin coat of shellac can also act as a sealer. If this, or the alcohol necessary to dilute it, is hard to obtain, use a high-quality French polish (flake shellac in a spirit base) instead. Its orange-brown color may serve as a colored imprimatura. Bleached shellac is available, but since all shellac is said to discolor on aging, it should only be used with opaque painting methods.

A spirit-soluble resin varnish like damar may also be used. The diluent used with the oil paint picks up the damar film as it works over the top. This makes the paint readily manipulable in a unique way. But beware of the continuing resolubility of a film which includes resinous components and of the fact that resins yellow with age.

A sealer which can only be used on a rigid support (its film is more flexible than that of oil paint) is proprietary acrylic medium thinned with water. Take care to water it down enough for it not to leave a glossy, glassy film over the gesso.

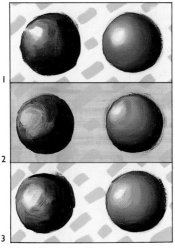

The effect of sealers on gesso
In each case the left-hand sphere is painted transparently in Phthalocyanine Green and the right-hand one opaquely, with Titanium White added to the green. Notice that on shellac, the opaque sphere works better than the transparent one.
1 glue size
2 shellac
3 thinned acrylic gloss medium

MODIFYING A GESSO GROUND

A thick-textured white ground for oil paint can be created by stirring well-washed sand into gesso before applying it to the panel. Use thick, lathered strokes of a wide bristle brush. The texture allows you to paint economically as it makes the color look more richly worked than on a smooth ground.

Gesso ground with sand for texture Left: sand-textured gesso ground, sealed with glue size. Right: oil paint applied over this ground.

Incising a gesso ground
Carving into a thick bed of wet gesso with a painting knife and applying oil paint on top, creates a textured pattern in heavy relief. Used in this way, the gesso has a very positive role in the painting. Brushstrokes made in different directions trap pigment on "crags" of gesso, causing complex color effects where different colors retain their purity, but work together optically to produce mixtures.

Oil paint on incised gesso ground Left: gesso ground incised with a painting knife. Right: Raw and Burnt Sienna covered with a blue/green glaze. The wet glaze was dabbed with a clean cotton rag to form variegated color.

Drawing on gesso with gesso

Liquid gesso poured on to a smooth gesso panel creates a relief outline image. The gesso is ready for pouring a few minutes before it starts to "gel". If it is too liquid, it does not have the body to form lines. For color effects, add pigment to the liquid. Seal the gesso before painting on it.

PRIMINGS FOR RIGID SUPPORTS

Other more straightforward grounds for oil painting on rigid supports include primers such as the proprietary Titanium White pigmented, oil-modified, alkyd resin primer (see p.66). In some ways it is superior to the older White Lead in linseed oil priming, which can yellow and has to be left for some time before painting. The so-called acrylic gesso primers (which are not gesso at all, but pigmented acrylic emulsions) may be used as a ground for oil paint.

USING UNPRIMED RIGID SUPPORTS

Several painters have worked in oils on rigid supports without applying a conventional priming, incorporating the color of the panel itself as a kind of toned ground. The oil paint may be applied in touches, leaving parts of the colored ground visible. On a ground like this, an opaque technique must be used if the true color of the paint is to be retained. And to ensure the permanence of the painting, unprimed panels should be sealed. The amount of sealer needed depends on the degree of absorbency of the panel – a medium-density fiberboard, being particularly absorbent, will require a great deal more than a piece of standard plywood, for instance. Glue size, gelatine, shellac or acrylic medium may all be used (see p.189).

UNCONVENTIONAL RIGID SUPPORTS

Apart from the common rigid supports for oil painting, artists have worked on all kinds of materials, from café table tops to corrugated iron, to the increasingly popular honeycomb aluminum panels.

Oil painting on glass

Glass is one of the most stable of all supports. Provided it is properly handled, an oil painting on glass is more permanent than one on canvas. The best glass to paint on is sandblasted on one side to create a slightly matt surface which is perfect for painting on and provides a good key for oil paint. Sandblasting does not affect the transparency of the glass.

Although glass can be used like any other support, a procedure unique to glass is back-painting – a reverse of the normal method, beginning with the highlights and working back through glazes and underpainting to the priming, which is the last coat to be applied. As in a normal painting, the primer acts as the light-reflecting backdrop for the colors, and the painting is viewed through the glass from the unpainted side.

Use thickish glass 4mm–6mm ($\frac{1}{8}$–$\frac{1}{4}$in) as it is less likely to break. Clean and degrease it with denatured alcohol before painting. You can use bristle or soft-hair brushes on sandblasted glass. For a multi-layered approach, allow sufficient drying time between coats, before overpainting. (Some artists use driers in their paint, to speed up the process.) Remember that opaque color applied to the glass will effectively obliterate any further strokes you may make over it. To avoid drawing on the painting surface (back of the glass), draw the image on a piece of paper and place it under the glass while you paint. Or draw on the "spectator's" side of the glass in all-purpose pencil, which can be rubbed off when the painting is completed.

Direct painting on glass
The sketch from which this detail is taken was back-painted in one session. It is possible to paint *alla prima*, but effects such as impasto do not work on the back of glass.

PAINTING ON MARBLE

This eighteenth-century example from Florence is painted in oil on marble laid on slate, so as to incorporate the natural pattern of the marble into the composition of the painting. This unconventional use of a stone support is said to have been invented by Sebastiano del Piombo in 1530.

The Adoration of the Shepherds (detail, c.1700), artist unknown.

——·Flexible supports and grounds·——

Canvas is the traditional flexible support for oil painting, although artists have experimented with many other fabrics — both primed and unprimed. Canvas is discussed in *Supports*, p.56–8. Choice of weave is important, and has a considerable effect on the appearance of a painting. The range of weaves available in linen canvas for artists' use is considerably wider than those in cotton — you can choose from fine or textured surfaces, depending on the painting. However, with polyester, which is more permanent than linen and cotton, you are restricted to an even more uniform texture.

USING UNPRIMED FLEXIBLE SUPPORTS

If you wish to paint on unprimed canvas you should at least protect the fibers from the oil paint by sizing. A weak solution of glue size or gelatine (applied hot) provides the traditional barrier between oil and fibers. Another possibility is a solution of carboxy methyl cellulose, (used for sizing in the textile industry), which does not appear to suffer the expansion and contraction problems of animal glue. Shellac is too brittle and acrylic medium too flexible to be used on flexible supports.

Many flexible materials have been used unprimed, including velvet, tarpaulin and drape fabric. Their strength and permanence depends on the fiber from which the fabric is made. Polyester sail-cloth does not have to be sized, but it is translucent, and absorbs oil and diluent

PAINTING ON UNPRIMED CANVAS

There are many modern examples of work on unprimed canvas. In this oil painting on jute canvas, the color and rough texture of the jute span the gap between black and white, providing a rich matrix.

W I (In Memoriam) (1938), by Paul Klee.

rapidly. Although the paint moves around easily and can be blended well, it should be used thinly, otherwise a dry pigment deposit will be left on the absorbent surface.

PRIMINGS FOR FLEXIBLE SUPPORTS

The priming of flexible supports is discussed on pp.60–2. For oil painting, the priming needs to be flexible enough to withstand the movement of the canvas, but no more flexible than the oil paint film or this may crack. An oil priming should be protected from the canvas fibers by a weak solution of glue size.

Although it is impractical to use a traditional gesso ground on canvas, it is possible to scrape or brush a very thin gesso priming into the interstices of sized canvas. This is sufficient to coat the fabric and, on linen, to give an almost white ground. It is still a good deal more absorbent than oil priming.

Nowadays, oil priming is generally a Titanium White-pigmented, oil-modified alkyd resin primer which dries in around 24 hours. Two thin coats should give a uniformly white surface. The more traditional White Lead in linseed oil takes longer to dry.

Some painters use household paint for priming, the oil-based or oil-modified alkyd-resin white undercoats for gloss paint providing the most suitable semi-absorbent grounds. However, none of the household products has been specially formulated for artist's use, and they are probably best avoided unless the nature and permanence of their ingredients can be verified (see also p.67).

Primers on flexible supports
1 Thin gesso layer on fine linen.
2 Oil priming on fine linen (left: two coats; right: one coat).
3 Oil priming on coarse linen.
4 Oil priming on cotton duck.
5 Oil priming on polyester fabric (left: uncoated; right: two coats).

1 2 3 4 5

·Imprimaturas and toned grounds·

Surprisingly, white grounds for oil painting only really came back into favor with Impressionism. From around the early seventeenth century, artists had more commonly utilized a ground that was itself colored, or tinted with color prior to painting.

For our purpose, I have defined "toned ground" as one which incorporates colored pigments in the priming materials – an opaque colored ground. I have used the term "imprimatura" to define a similarly colored ground, but consisting of a thin, transparent film of paint laid over a white priming so that the luminous, reflecting quality of the white is retained.

TONED GROUNDS

Nowadays, making a toned ground involves mixing a little oil color with the white (oil) priming. If your prepared canvas already has a white priming, mix the color with a white oil color and paint a thin coat over the priming. Dilute the paint with turpentine or mineral spirit and not with additional oil or painting medium. Let it dry before painting over it.

IMPRIMATURAS

There are three safe ways to apply an imprimatura:
■ Mix the chosen oil color with turpentine, paint it over the support, and after a few minutes, rub it off with a clean cotton rag. The result is a transparent stain of color over the primer. This occurs even with an opaque color like Yellow Ochre, since it is spread so thinly. It dries quickly and is generally ready for painting on the next day.
■ Use a very thin acrylic wash. This can be applied with a sponge. Although painting in oils over acrylics is not to be recommended, the quantity in the imprimatura is so negligible as to make its use quite safe from the point of view of flexibility and of adhesion.
■ Apply a thin watercolor stain. This has no adverse effects. Like the acrylic, it dries rapidly, so the oil painting may be started immediately.

Other suggested vehicles for imprimaturas include colored gelatine or glue size, highly diluted shellac, egg/water, a soft resin varnish or a glazing medium. I do not see any great advantage in these; they introduce resinous ingredients or needless complexity.

Why use a toned ground or imprimatura? The point of these grounds is to provide an overall matrix for superimposed colors and to give a light-to-mid-tone base over which lighter tones, highlights and mid-to-dark tones can be worked up. Painters trained to use a white ground are invariably surprised at the economy of method that such a ground brings to their painting.

Opaque toned grounds are mostly used with opaque painting methods, where the reflecting qualities of the white ground are not so important. An imprimatura is more suitable when the transparency of some of the paints is an important factor.

EFFECTS OF VARIOUS GROUNDS

The tone and color of a ground can have a considerable effect on the appearance of a painting. In these examples, the same jug was sketched on canvas on white, Yellow Ochre imprimatura and Yellow Ochre toned grounds.

Tonal modeling on different grounds The mid-to-dark tones were modeled with a Burnt Sienna/Phthalocyanine Blue mix. The lighter tones were sketched in with well-thinned Titanium White. Where the toned ground color came into play, the image had a great deal more body and dimensionality than on the white ground, even at the sketch stage.

The effect was reinforced where the area round the jug was painted with white. The background color became a local one, associated with just the jug itself.

Preliminary sketch on white ground

Preliminary sketch on imprimatura

Preliminary sketch on toned ground

Final sketch, white ground

Final sketch, imprimatura

Final sketch, toned ground

PAINTING ON WHITE GROUNDS

A white ground shows the purity of individual touches of oil color, especially if they are applied thinly. For the artist, there is also a sense of having to cover the whole of the ground, which often leads to a more consistent overall look than painting on mid-to-dark toned grounds. This accounts for the Divisionist or Pointillist style (see p.198), where the whole surface is covered in a series of short brushstrokes.

Traditionally, the white ground has been used to illuminate thin layers of transparent oil color laid over it. With the inevitable increase in transparency over the years of even opaque oil color, painters are well advised to incorporate the underlying whiteness of the ground in their work. There are innumerable variations on glazing techniques which incorporate the white ground in some way. They range from working entirely in

thin, transparent or semi-transparent colour directly on to the ground to glazing over various kinds of underpainting. Other techniques include

USING COLOR ON A WHITE GROUND

The positive use of a white ground is exemplified in some of the paintings of Pierre Bonnard, whose fluffy, smudged and subtle brushwork is consistent over the whole of the white surface of a large canvas. Considerably more actual painting is involved than there would be on a colored ground, where the artist can afford to leave larger gaps between individual touches of pigment. Bonnard exploits to great advantage the juxtaposition of colors such as lilac and pale green, blue and pink, which can be seen in their purity on the white ground. The brushstrokes are all quite tentative,

Landscape Near St Tropez, (c.1928), by Pierre Bonnard.

but strong shapes arise out of them, giving the paintings great form.

working with transparent colors into a wet White Lead in oil ground (see p.203), or leaving one part of the ground white and tinting the rest (see p.193).

PAINTING ON MID-TO-LIGHT-TONED GROUNDS

Although painting on a mid-to-light-toned ground may result in a slight lowering of tone compared to what might be had on a white ground, the advantages related to fast and accurate modeling of form and to the judgement of tone and color,

outweigh such minor effects. And with an imprimatura which is simply a veil of transparent color, the luminous effect of the white ground may still be used to great advantage.

The positive effects of an imprimatura can be seen in the work on panel of Rubens (see box, below) where it facilitates the fluency and economy of his

painting. He often used a thin yellow-brown imprimatura, made from an earth pigment, possibly bound with a drying oil. This was boldly applied with a flat bristle brush which gave it a striated look. It is not necessary to have a completely smooth, uniform tone if most of it is to be concealed beneath superimposed paint layers.

USING A MID-TONED IMPRIMATURA

Rubens' vigorous application of his imprimatura parallels the fluent vigor of the preliminary brushstrokes which are applied in a thin brown color. The imprimatura comes into its own when the light tones are heightened with white. Immediately, and with very little actual painting, the image is pulled into three dimensions. From this economical underpainting, the body of the painting can readily be built up.

A Lion Hunt (c.1615), by Rubens.

PAINTING ON MID-TO-DARK-TONED GROUNDS

Traditionally, these are used for *chiaroscuro* effects, where the contrast between brightly or partially lit objects and dark backgrounds is emphasized. The best painting method is to work with light-toned, opaque pigment out of a dark ground. Keep the dark background color as thin as possible and avoid excessive oil or resinous components. The increasing transparency of oil colors with age means that colors applied over these grounds should be opaque and painted reasonably thickly.

Small, crisp touches of opaque white have often been used on a dark ground, such as for the effects of lace-work on costumes or ruffs. A special thick, quick-drying, non-cracking white is available. Alternatively see *Appendix*, p.336 for recipes.

LIGHT OIL COLOR ON A DARK GROUND

This small painting well illustrates the use of light-toned pigments on a dark ground. It demonstrates a facility and yet an economy of execution that captures the surprise and immediacy of the moment. It is the work of an elderly artist who needs only to capture the essentials of the drama, but manages to do so with subtlety and assurance.

Susanna and the Elders (1585), by Jacopo Bassano.

PAINTING ON COLORED GROUNDS

The possibilities opened up by the use of colored grounds are so great that it is surprising that so few artists use them. Although the most traditional colors have been ochre or umber in the dull yellow to brown range, or red bole or Burnt Sienna in the dull red to orange brown area (with dull greens used to complement warm flesh-tones in portraits), there are no color or tone restrictions.

In general, a cool green or blue ground has an overall cooling effect on the painting, whereas an orange/yellow or red warms it up. Such positive colors inevitably have a strong impact on a painting, which is why more neutral colors are often chosen. These do not dictate decisions about color too forcibly at an early stage.

Colored grounds may be chosen from a wide tonal range. If you wish to use very light tones or transparent pigments, however, a light ground such as a pale ochre, mushroom or gray, is best. It allows transparent pigments to be used thinly while retaining their individual color characteristics; at the same time it allows white to be used for heightening and for adding dimension.

James II when Duke of York, by Sir Peter Lely.

PORTRAIT ON A RED GROUND

From the sixteenth to the nineteenth century, the use of colored grounds of different tones was almost universal in Europe. The favored ground color varied from painter to painter. This unfinished study shows the head and part of the hair painted on an opaque dull orange/red ground, where variations on pale fleshtones can be worked up more readily. On such an opaque ground, a painter relies heavily on the opacity of superimposed pigments for the lighter tones.

TRANSPARENT AND OPAQUE COLORS ON COLORED GROUNDS

Here the same image was over-painted on to several colored grounds, both transparently and opaquely. The examples represent only a fraction of what is possible, but they show how changes in ground color cause shifts in temperature and mood.

I mostly limited the colors in the overpainting to red, yellow, blue and green, as it is easier to perceive their relationship to the ground color. To see this, cut a window out of a piece of card to the size of one retangle, and hold it over one at a time.

Where the image was modeled in white then glazed, the ground color was used quite positively in the shadow areas. The opaquely painted versions of the image had to rely on the opaque pigments to obliterate the ground color if they were to retain their brightness. Yet, even here, the ground was called into play as a passage between two areas of color or, where the opaque color was "dry brushed" over the canvas, to provide broken color shadows.

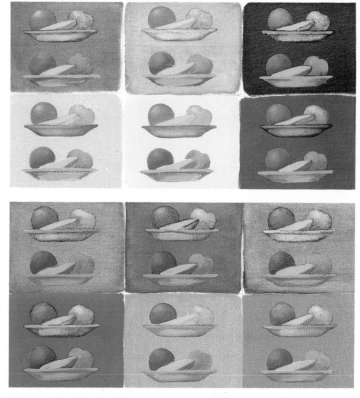

Warm and cool colored grounds
The grounds are divided into warm (top) and cool (bottom). The top row in each category is on a transparent colored ground (imprimatura). Immediately below, the same color is mixed with white to give an opaque toned ground. Each of the twelve colors is further sub-divided: in the top half, the image is modeled in white then glazed. Beneath, it is painted opaquely.

TONING PARTS OF THE GROUND

It is a short step from the toned ground which covers the canvas to identifying certain areas of a painting that can be underpainted in particular colors.

The Rokeby Venus is an outstanding example. After the painting had been slashed by a suffragette, it was found that the white lead priming had been covered with a layer of deep red paint, except under the figure of the Venus, where it had been left white. This gives the figure a notable and luminous presence and dictates a different painting method for figure and ground. The latter is painted with thin glazing colors over mono-chromatic underpainting, while the figure of Venus is richly painted in opaque colors.

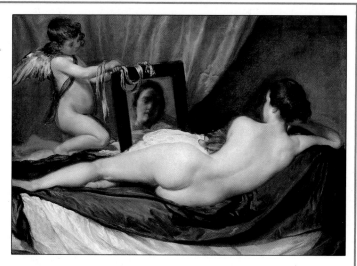

The Toilet of Venus ("The Rokeby Venus", 1648 or 1649–51), by Diego Velasquez.

·Brushes and brushwork·

Oil paints are perhaps the most manipulable of the painting media. For this reason, they can show an enormous variety of effects – from smoothly blended, enamel-like surfaces to thickly impasted ridges of striated color. These effects rely to a large extent on brushwork. Real or synthetic soft-hair and bristle brushes may be used in oil painting to create effects with one, or several colors. Brushwork is like handwriting; it reveals a great deal of the character of its author. The examples of brushwork in the paintings in this section show the diversity of possible effects and of the characters that inspired them.

CHOOSING BRUSHES FOR OIL PAINTING

The type of brush used depends, broadly speaking, on:
▓ viscosity of the paint
▓ nature of the support
▓ degree of finish required
▓ scale of the work
▓ style of painting
For a discussion of the main types of brushes for painting, see pp.131–4.

Bristle brushes
With stiff, viscous paints used direct from the tube (for *alla-prima* work, for example), bristle brushes should be used to move it around on the support. These can be handled vigorously – for "ladling" on and scrubbing in thick paint, for "push-pull"

effects, or for applying dabs of thick color. They are also useful for brushing in large areas of color, where you wish to create a smooth, thin, overall tone. They are also suitable for working in broad tonal areas such as in thin underpainting. Here, a diluent can be used in conjunction with the bristle brush to alter the tones of an applied color, to bring shape and dimension to the emerging image (see p.205). On large-scale work they allow you to work with a speed that would be impossible with soft-hair brushes.

Soft-hair brushes
These are not so well suited to applying paint thickly. They work best with a more liquid mix which can be stroked, rather

than scrubbed, on to the support. They are used for small-scale work – in particular where you want a smooth finish and perhaps a degree of detailed modeling. On a small scale, the points of fine, round sables may be "chiseled" between the fingers and stroked down a join between two colors for fine blending effects. However, soft-hair brushes, especially sables, are not without a certain resilience, and brushes such as red sable filberts can be used to push paint around, albeit on a small scale, with a fair degree of elastic strength.

Larger round soft-hair brushes are often used to apply glazes (see p.202). There are also a number of brushes that are used simply to modify the appearance of paint already on the canvas.

BLENDING TECHNIQUES

While many oil paint effects rely on strong brushwork, it is also true that one of the medium's characteristic aspects is that it allows the brushstroke to be made "invisible" by blending, or "sweetening". Just as the marks of the chisel may be erased from a sculpture, so the ridges of paint may be flattened, and adjacent tones and colors merged, allowing an image to express itself entirely independently of the brushwork.

Smooth gradations of tone or color are more easily achieved with oil paint than with any other painting medium. This is because the paint stays wet long enough for a large number of tones and colors to be put down before being manipulated.

Blending adjacent colors
The technique of blending two colors or tones involves taking a clean, dry bristle brush (usually a filbert or flat) and stroking it down the join between the colors to blend the paint on each side. Keep wiping paint off

the brush on a dry, absorbent rag.

After the initial blending with the bristle brush, the marks of the original strokes may be even further effaced by continuing the process with soft-hair brushes (flat filberts are particularly useful for this).

Blending with a bristle brush
With a clean, dry bristle brush such as a filbert, stroke along the line of the join between two tones or colors, wiping the brush off occasionally as it accumulates paint.

Blending with a soft-hair brush
Taking the blending further, an even softer effect can be had – on a portrait for instance – with a sable brush by working very lightly over the paint surface along the join.

Keeping the paint clean

It is essential to wipe the brush clean after each manipulation so that it does not contaminate the paint on the canvas. In the past, artists kept a stack of clean, dry brushes for this reason. This is important in portraiture, where the colors of a face can be easily soiled by a dirty brush.

William Gandy's "Notes on Painting" 1673–1699, contains an account of the portrait painter, Sir Peter Lely, ensuring the purity of his colors by blending in this way: "He puts in the patches of colouring very beautiful & distinct, then he takes a clean fich pencil [brush] & sweetin the edges of 2 or 4 patches of colouring together, then he lays by that pencil, & takes another clean pencil & sweetens with that, lays that by, so he takes a clean pencil stil till he has sweeted ye whole face".

Blending for smooth gradations
Left: Two rows of vertical, parallel, adjacent brushstrokes made in a number of tones of white through gray to black and yellow through orange to red.
Right: Similar rows of marks, but here the strokes were smoothly blended or fused where the adjoining tones abut.

SOFTENING A CONTOUR OR OUTLINE

With oil paints, the shape of an image may be retained and yet softened slightly by blending with an adjacent color. Even the effect of minimal blending in this way is dramatic (see below). This technique is widely used in oil painting, where profiles of objects and figures set against contrasting tones, for instance, may need softening slightly.

Modifying the degree of softening of an outline The amount of blending carried on between two colors can have a great impact on the appearance of a work. This is shown by the yellow shape with a violet shadow against a gray ground.

The degree of softening required dictates the type of brush you should use. For a minimal amount of modification, a small round, pointed sable may be used. Its tip should be very lightly moistened with turpentine or mineral spirit, just sufficient to enable the hairs to be chiseled between thumb and forefinger. This is then stroked along the join between two colors to be blended. A flat soft-hair filbert with its curved tip is useful for softening edges on a slightly larger scale. (Its edge can also be used for smaller scale work.) On a larger scale still, a bristle brush can be used; again the filbert is useful.

Softening outlines
These red circles were painted on a gray background. One was left with a crisp edge, while the edge of the other was blended with the surrounding gray.

Using different degrees of blending Above: gray, violet and yellow areas. Right: the same, with fusing. The yellow shape's outline was slightly softened. The violet shape was blended much more.

BLENDING ON A THREE-DIMENSIONAL OBJECT

Even in comparatively crude, diagrammatic images, the blending or softening technique imparts a degree of smoothness and finish. It also takes away from an image the immediacy and presence of the straight brushstroke, replacing it with something more bland and overall. This is shown by the two cylinders (below), where the softened version shows how blending generally reduces tonal contrasts. A variety of brushes, from a small pointed sable to a bristle filbert, was used. Although in this case, the image was left alone after softening, it is usual to bring up the darkest and lightest tones with repainting at a later stage.

Softening for three-dimensional images The top image shows all the main areas of tone blocked in. Below is an identically painted image, but with adjoining tones blended using a variety of brushes.

USING A FAN BLENDER

The soft-hair sable fan blender (see p.34), also known as a duster, is used to smooth or blend the surface of a painting. It is handled with a light "dusting" action to complete blending and to smooth out ridges in brush-work. It can be used to initiate blending by being stroked down the join between abutting colors, in which case it will soften and blend the join, but will keep the colors separate, rather than producing an imperceptible transition between them across a wider gap. It acts rather as a finishing or polishing tool, whereas the bristle fan blender can be used for more vigorous blending, which should be worked along the line of a join, rather than across it.

Sable blender used down the join.

Bristle blender used across the join (incorrect).

Bristle blender used down the join (correct).

IMPASTO TECHNIQUES

Impasto is the technique of applying paint thickly, so that the brushstrokes are plainly visible and create a textured effect. The examples (right), made with a flat bristle brush, show, in different ways, the expressive power of the brushstroke in thickly mixed oil color.

Mixing colors on the brush
The difference between mixing colors completely on the palette then applying the brushstroke, and mixing two or three colors loosely on the end of the brush, is shown by 1 and 2 (right). Where the colors were mixed on the palette, an entirely uniform color was produced, despite the thickness of the stroke. Where they were only loosely mixed, they work both separately and together in the stroke, giving a lively appear-

EXPRESSIVE IMPASTED BRUSHWORK

This painting illustrates all three impasto techniques. Here, color loosely mixed on the palette gives varied striations of color through the stroke. The dark "defining" lines are painted with extra-ordinary resolve. Painting wet-into-wet like this is not only difficult technically, but the stroke magnifies and accentuates any uncertainty that occurs during its making. This can be used to advantage, as in the line of the mouth, for instance, which has a touch of hesitancy.

In the background to the left of the painting, zigzag strokes have been made into the wet paint with a bristle brush. They have their own expressive impact. Finally, the painting demonstrates the stipple effect, seen along the bottom edge of the painting.

JYM.1.1981 by Frank Auerbach.

ance. The striated colors echo the lines of the bristles.

Working wet-into-wet

When applying oil color thickly into wet color, the bristle brush must be well charged with paint. To ensure an unmuddied color, paint should be heaped on the toe of the brush which is then stroked firmly and smoothly, at a shallow angle to the canvas, into the wet paint. Alternatively, the wet color can be partially mixed with the wet color beneath to create further striated color effects.

Stipple (push-pull) effect

A bristle brush and thick viscous oil paint can create a "stipple" texture. Push the brush into thick paint (or push thick paint into the canvas), then pull it away. In 4, a loose mixture of two colors was applied using the push-pull technique.

Impasted brushstrokes
1 Phthalocyanine Green and Cadmium Yellow Pale loaded on to brush and pulled across the support.
2 Stroke made with the same two colors, mixed first on the palette.
3 Azo Yellow and Phthalocyanine Green, applied separately to the brush and pulled across the support.
4 Burnt Sienna and Titanium White, loosely mixed, applied with stipple.

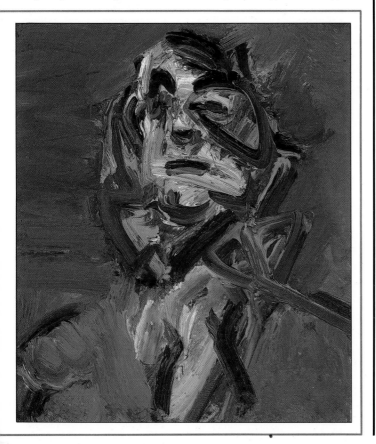

OTHER KINDS OF BRUSHSTROKES

The fluency, deftness or vigor of individual brushstrokes within a painting can give it a particular freshness or immediacy. Brushwork can operate at extremes of wetness or dryness which each give a characteristic look to an image. From the curl of wet enamel from a vertically held brush over the horizontal painting, to the dry touches of stiff pigment stroked over the ridges of a very grainy canvas, the range of possible manipulations is very wide.

One approach is represented by short, chunky strokes of paint, laid down with no blending or further manipulations; each stroke makes its statement as it is placed. Such strokes seem just of a length to deposit the amount of thick paint that the charged brush holds; they are direct and abrupt. This type of stroke characterizes much of the work of Van Gogh.

The impression of movement associated with the direction and vigor of the brushstroke can be exploited for particular effects. Vigorous, strapping brushstrokes can be used in a form of hatching. A series of strong, diagonal strokes may arise out of the natural movement of the arm which pivots at the elbow.

A less vigorous approach can be seen when small, separate touches of color are used; they combine optically (see *Pointillism*, below). The small, flat bright bristle brushes are said to have been invented for these short dabs of color. These strokes are seen in the late works of Seurat, for example.

Pointillism

The pointillist, or divisionist, method of painting relies for its effects on the juxtaposition of small dabs of relatively pure color. Theoretically, only primary colors need to be used, since mixtures of these produce secondary and tertiary colors.

But most of the neo-Impressionist painters who used the technique were more pragmatic in their choice of colors. Such colors combine optically when perceived from a distance, creating fine gradations of tone and color that serve to define the image (*see Color Mixing*, p.200).

The technique is not limited to oils, but it was with oil color that the celebrated pointillist painters, Seurat and Signac, created their effects. The technique uses opaque color for the most part; any transparent pigments are generally used as tints with white. Other artists, such as Van Gogh in his later work, were influenced by the highly repetitive mark-making that characterizes pointillist painting, but opened it up into a freer, chunkier style of painting.

COMPLEMENTARY COLOR IN POINTILLISM

This is a characteristic example of the build-up of small dabs of color over the whole painting. From a distance, the work can be seen broadly to operate within a middle range of tones. It has a shallow dimensionality.

The painting exploits one basic complementary color contrast throughout; that is, between blue and orange-red.

In the darkest areas, such as in the bodice by the arm, the colors are used full-strength. In the lighter areas, they are mixed with white. Tonal variation in the bodice, for instance, is achieved with around three tones of blue and three of orange-red. The flesh color is also broken with pale blue.

A Young Woman Powdering Herself (1889–90), by Georges-Pierre Seurat.

S'GRAFFITO EFFECTS

"S'graffito", the technique of scratching into a wet oil film, can be done with the wrong end of a paintbrush, a sharpened twig, painting knife, or other scraping device. It is effective in defining outlines or details for expressive effects. If there is a contrast in tone or color between the wet paint film and the color beneath, the outline will be distinct. It is excellent for drawing into a wet ground and avoiding the sullying effect of pencil or charcoal.

USING S'GRAFFITO

The scratching method is used in two different ways in this portrait. The white shawl is painted comparatively thinly over the black dress, and all the details are scratched out with the end of a paintbrush, or similar tool. In the bottom right-hand corner, a scratched outline image of a cat with a ball of wool can also be seen.

Portrait of Mme Derain in a White Shawl (c.1919–20), by André Derain.

·Using a painting knife·

Painting knives are useful for laying patches of oil color into the wet surface of a painting without sullying the overlaid color. They give a particular shape to the paint laid in, according to the shape of the blade and the method of application. Complete paintings may be made using painting-knife techniques; they generally have a scraped and impasted appearance with a rather "geometric" look to the strokes, due to the flat edge of most blades. The flexible steel blade can also be used with some precision at the tip, to lay in small dots of color for details, highlights or texture effects.

TYPES OF PAINTING KNIFE

Like brushes, painting knives come in a range of sizes, for use according to the scale of the painting and the nature of the mark required. The most common blades are pear, trowel or diamond-shaped, but other knives are available with squared-off or serrated ends (see p.137).

Painting knives should not be confused with palette knives, which are used principally for moving and mixing paint on the palette. Palette knives are occasionally used for laying in large areas of wet color on canvas, but painting knives are designed for more subtle manipulations. Their cranked shaft keeps your fingers away from the wet paint while the blade is doing its work.

HOLDING AND USING THE PAINTING KNIFE

Grip for bold effects
There are a number of ways of holding a painting knife. Grip the knife handle as you would a trowel for vigorous manipulations.

Grip for sensitive effects
Hold the knife like the bow of a violin. If rested on the springy part of the blade, the index finger can push the very tip of it into the paint.

Regular grip
Between these two extremes, a common method is to grip the wooden handle with the index finger pushing against the steel shaft.

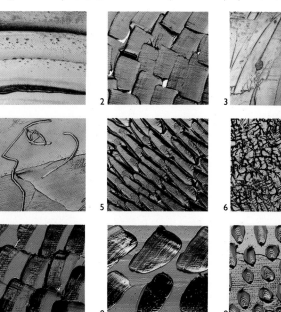

Painting knife manipulations
1 Horizontal strokes in thick paint, using a long, trowel-shaped knife.
2 Short, diagonal strokes with a short, pear-shaped knife.
3 Thick-to-thin paint in diagonal strokes with a short, trowel-shaped knife.
4 Paint applied with a palette knife then scratched into with the tip of a short, trowel-shaped knife.
5 Paint applied as 4, then textured with diagonal strokes of the short, pear-shaped knife.
6 Paint applied as 4, and "stipple" textured by applying the short, pear-shaped knife flat, then lifting it.
7 Two separate adjacent colors laid on the blade then applied in short, diagonal down-strokes.
8 Patches of dark green laid into a bed of blue oil color with the short pear-shaped knife.
9 Touches of blue laid into a bed of wet dark green with the long, trowel-shaped knife.

·Color mixing in oils·

There are three basic methods of mixing colors in oil painting. The first involves physically mixing two or more colors together on the palette to produce a third, which is applied to the support. The second method is optical mixing, where adjacent touches of two or more colors appear to combine visually to create a third. Lastly, glazing is a technique in which a transparent glaze or film of color is laid over another color to produce a new color.

The different appearance of the similar-toned oranges produced by physical mixing, optical mixing, glazing and scumbling (see p.201) is marked. In the examples below, a bright secondary color (orange) was produced, but when two colors of similar hue or low tone are combined, or where a dark natural color is overlaid with a strong transparent glaze or a semi-opaque scumble, some very subtle effects can be achieved.

PHYSICAL COLOR MIXING

Two opaque colors can be mixed to produce a third. If one of the colors is lighter, it is important to mix the colors by adding touches of the darker color to the lighter one, rather than the other way around. An opaque and a transparent color combine to produce an opaque color, and two transparent colors mixed together produce a third transparent color. Note that the physical mixing of colors in this way involves an inevitable lowering of tone and purity. So an orange produced by mixing red and yellow will appear slightly duller than a natural orange pigment. The more colors involved in the mix, the greater is this effect.

Physical mixtures
I Cadmium Red mixed with Cadmium Yellow Pale makes opaque orange.
2 Quinacridone (Rose) mixed with Cadmium Yellow Pale makes a similar opaque orange.
3 Pigment Yellow 128 mixed with Quinacridone (Rose) makes transparent orange.

OPTICAL COLOR MIXING

Touches of two or more colors of similar hue placed close together appear to combine in the eye of the viewer to produce a new color. Shown right are three orange effects and one violet effect, created with different optical mixtures of oil colors:
▦ opaque combination
▦ opaque/transparent combination
▦ transparent combination.
The second and third rely on the white ground to a greater extent than the first, due to the transparency of the pigments. Unless the individual touches of pigment are very small, the area

of color produced will not present as a pure field of the third color (particularly viewed from close-to), but will remain a lively patchwork of juxtaposed pure colors.

Broken color effects
The effect produced when a superimposed color only partially obscures the color beneath, is a form of optical color mixing. If, for example, a yellow imprimatura were laid over a roughly textured ground, and opaque red paint stroked over the ridges, the combined color effect would be similar to that obtained with juxtaposed touches.

Optical color mixtures
I Cadmium Red and Cadmium Yellow Pale (opaque)
2 Quinacridone (Rose) and Cadmium Yellow Pale (transparent/opaque)
3 Quinacridone (Rose) and Pigment Yellow 128 (transparent)
4 Quinacridone (Rose) and Phthalo-cyanine Blue (transparent)

GLAZING

In glazing, a third color is produced by superimposing a transparent film of color over another color. The orange produced by glazing transparent red over yellow has quite a different appearance to that produced by the physical and optical mixtures.

Because the artist relies on the transparency of the glaze to allow the color beneath to combine with it, the effect of the tone of the underlying color on the glaze is important. A transparent red glaze is shown (right) applied over eight tones ranging from white to black.

This has a dramatic effect on the color — a factor which you can manipulate and exploit in the creation of color effects. As with all truly transparent pigments, the Quinacridone (Rose) is relatively imperceptible when overlaid on black.

Glazing examples
Quinacridone (Rose) glaze over a uniform tone of Cadmium Yellow Pale (above).
Quinacridone (Rose) glaze over eight tones of white through black (right).

SCUMBLING

Related to glazing is the technique of scumbling — loosely brushing a thin film of opaque or semi-opaque color over a second color, which may actually show through in places, but which retains an important influence on the surface appearance of the paint.

The examples below show several different scumbling effects. A semi-opaque mix of White Lead in oil scumbled over uniform tones of red, yellow, green and blue transformed the color beneath. The resulting pale colors could not be obtained by physical mixtures.

Next, part of the scumble was glazed with a transparent veil of the same (or similar) color as that beneath. Glazing over semi-opaque scumbling has a characteristic and unique appearance.

Many artists use it repeatedly in multi-layered paintings.

In other areas, a lighter tone of the color beneath was scumbled over the surface. The opacity of the color lightens the overall tone, but the gaps in the brushwork which allow glimpses of the color beneath produce a lively surface. Next to these areas a complementary color was similarly applied. This makes the color beneath glow.

Scumbling examples
Similar scumbling manipulations carried out over areas of pure red, yellow, green and blue.
Pure saturated colors
1 Cadmium Red
2 Azo Yellow
3 Phthalocyanine Green
4 Phthalocyanine Blue
Thin white scumble
5, 6, 7, 8 White Lead in oil thin mix scumbled over 1, 2, 3 and 4
Glaze applied over scumble
9, 10, 11, 12 Transparent glaze of the original color over 5, 6, 7 and 8
Broken color scumbles
13, 14, 15, 16 Lighter tone of the original color scumbled over it
17, 18, 19, 20 Complementary color to original color scumbled over it.

GLAZING TECHNIQUES

Applying transparent oil glazes is straightforward, so long as you remember that glazes are not simply brushed on like varnish and left. They usually need further manipulation on the support in order to give the right degree of color saturation and uniformity of tone.

To make it manipulable, the paint is mixed with a painting or glazing medium, such as stand oil or sun-thickened linseed oil, diluted with turpentine. (Some artists add a little damar varnish.) Proprietary fast-drying glazing mediums based on synthetic alkyd resins are also available (see p.186). Use plenty of color in the mixture; do not simply tint the medium, thinking that too much color will obliterate the underpainting. The density of the color is actually controlled by subsequent manipulation, which can reduce a thick glaze to a mere stain.

The underpainting must be dry before any glazing is done over the top. Remember to apply the "fat-over-lean" rule (see p.205). Different colored glazes may be applied in adjacent areas, smoothed as below and fused where they join by blending. Apply the glaze as shown below. For very small areas, use small round or flat soft-hair filberts.

Any uneven tones or ridges can be evened out by subsequent manipulation of the glaze.

Manipulating a glaze

After application, leave the glaze for a few minutes to allow some evaporation of solvent. Then it can be smoothed to the required finish by dabbing with clean, dry brushes. The badger blender, with its round, flat base, is ideal. A shaving brush or any thick, bushy bristle is a good alternative. A pad of clean, tightly bound cotton or a wad of fabric kitchen paper can also be used. On smaller areas, the dabbing may be done with any bristle brush; filberts work best.

Dab the glaze with the blender as shown below. If any paint builds up on the ends of the hairs, dab the brush on to a piece of absorbent tissue to remove it. The manipulation will not succeed if the brush becomes wet with paint; if this happens, replace it with a clean, dry one. If areas of uniform glaze require further modification, such as lightening for highlights, continue working over the area with smaller brushes (see below). If part of a glaze is to be completely removed, such as for a highlight, use the corner of a rag or tissue, very slightly moistened with turpentine or mineral spirit if necessary.

see p.186

GLAZING OVER OPAQUE AND SEMI-OPAQUE LAYERS

Although this detail of a small painting is unfinished, it shows the stages of painting in opaque, semi-opaque and glazing layers. The ground is a dark, transparent warm brown over white.

The unfinished figure shows clearly the use of semi-opaque scumbles and transparent glazes. The figure of the child is very loosely painted over the dark ground with color that is increasingly opaque and impasted for the lights, compared to the more semi-opaque scumbles over other areas (where it is deeper in tone). The Virgin's robe (a portion of which can be seen in the bottom right of the detail) is characterized by semi-opaque modeling in white or pink which, even at this interim stage of painting, has a crimson glaze painted over it. The darkest shadows incorporate transparent dark red/browns, while the slightly lighter ones incorporate browns containing a touch of opaque white.

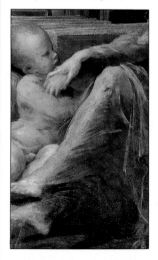

Virgin and Child (detail) (c.1424–7), by Parmigianino.

Mixing and applying a glaze

1 Mix the paint with the glaze medium to a soft, mushy consistency. Do not simply tint the medium.
2 Brush the glaze on to the dry underpainting with a large soft-hair or bristle brush.
3 After a few minutes, begin dabbing the glaze with short strokes of a clean, dry blender, held vertically.
4 If lightening or highlights are required in particular areas, continue dabbing and wiping off, with small brushes.

PRE-RAPHAELITE WET-INTO-WET METHOD

A method of painting devised by the pre-Raphaelite painters Holman Hunt and Millais, involves painting in transparent and semi-transparent colors on a coat of wet Lead White. The image is drawn on a primed canvas, then a coat of White Lead in oil scraped thinly with a palette knife over the part of the painting to be completed during the day's work. The drawing beneath is still visible. Before application, excess oil is removed from the priming with absorbent paper and a drop of resin and varnish added. The colors are laid "tenderly" on to the wet ground with soft-hair brushes echoing the *buon fresco* method of painting.

HIGH KEY AND LOW KEY COLOR

The terms "high key" and "low key" generally refer to the brightness and saturation of colors. In paintings character-ized by low key color, color is used in unsaturated form in tints and shades. Low key painting may be subdued rather than bright, but it can also be extremely delicate and subtle. Paintings which exhibit high key color are characterized by the use of bright, saturated colors.

The colors in a high key painting are invariably applied unmixed, in pure primary or secondary tones, and produce a light, fresh, vibrant quality. This can be enhanced by such effects as complementary color juxtapositions. From the mid-nineteenth century, after the color theories of Chevreul began to be assimilated, the incorpora-tion of these kinds of color contrasts became a conscious aspect of picture-making (see *Color*, p.289). Such effects are especially appropriate to oil painting which imparts rich and lustrous luminosity to the colors.

High key painting
This small painting has a lively surface made up of touches of barely fusing, partially mixed rich colors.

USING LOW KEY COLOR

Among artists whose strength of purpose is revealed in work which also reflects their retiring nature, is Gwen John. Her low key portraits are made with a quiet care based on penetrating observation. The meditative nature of the work is intensified by a subdued palette. Its overall "neutrality" gives the restrained colors an extraordinary strength.

Girl in a Mulberry Dress by Gwen John.

·*Alla prima* painting·

This direct painting method is technically very sound. The reason is that all the paint in any area of the painting is applied in one session, or at least while paint on the surface is still wet. This means that there are no problems with different amounts of oil or resin, or different drying speeds between paint layers, since there is effectively only one layer. The method came into favor with the Impressionists who, in order to continue working wet-into-wet as long as possible, often used the "semi-drying" poppy oil as a vehicle, although it is, of course, possible to paint directly in colors ground in any of the standard drying oils.

THE PRINCIPLES OF *ALLA PRIMA* PAINTING

In many ways, *alla prima* painting is the most difficult method of working in oils, since it relies so much on every brushstroke being successful, not only in its own expressive terms, but also in the choice of color and tone of the paint that it deposits, and in relation to the color, tone and form of the brushstrokes next to it. It is, of course, possible to scrape an unsuccessful area off the painting while it is still wet and rework it. Many artists do this, so that what appears as

completely fresh and fluent, may represent the sixth or seventh attempt. As long as you get it right eventually, this is perfectly acceptable.

The ability to observe an image and transcribe it directly in paint on canvas is usually the result of a great deal of practice, usually in more systematic methods of painting. This practice helps you to build up a personal "language" in the use of paint which can be brought to bear on any subject. Achieving fluency in the "language" involves an intuitive ability to judge and prepare on the palette precisely the right tone and color mix for any area, and then to select the right brush and the right painting method. It also involves the ability to make decisions and take risks.

In many ways, *alla prima* painting is best suited to small-scale works which can be completed in one session. It is a good method of producing oil sketches which may later be transcribed into larger "studio" works.

"Systematic" *alla prima* painting Not all *alla prima* painting is made with an expressive flourish. Some artists paint directly, but work slowly and methodically across the blank canvas until the whole surface is covered, possibly over a carefully drawn preliminary image in pencil. With this approach, the essence of *alla prima* is somewhat lost. However, whatever the working method or style adopted, paintings that are worked up directly with no overpainting share an intimacy and a fresh "surface" quality which the spectator may respond to with equal directness.

ALLA PRIMA AS AN EXPRESSIVE TECHNIQUE

This dramatic painting is full of lively brushwork. The whole surface is handled in the same expressive way, with paint stirred thickly into each area. For all the vigor of the strokes, the colors retain their purity. This is no naive painting; it has all the directness of an *alla prima* work but is carefully considered in all its aspects.

Meeting on the Beach (1921), by Emil Nolde.

ALLA PRIMA TO MULTI-LAYERED TECHNIQUES

There are no definitive boundaries between *alla prima* and multi-layered painting. A rough underpainting can form the basis for an essentially *alla prima* work. Here, the broad areas of a landscape might be roughly underpainted in various tones and colors appropriate to particular areas, then painted directly with superimposed touches of local colors. The underpainting would have an important unifying effect, but the painting would retain an essential *alla prima* character.

Or, a more finished underpainting might provide the formal basis for work which is overpainted in a direct way with free, spontaneous brushwork and use of color.

TIPS FOR SUCCESSFUL *ALLA PRIMA* PAINTING
■ Keep to a limited palette of around eight colors. Too many are difficult to coordinate, and most of the tones and colors required can be mixed from a limited palette.
■ Avoid muddying colors – use several brushes. Keep a brush or brushes for similar tones or colors repeated in the work. Preserve some for pale tints and white; others for the dark tones.
■ Charge the brush well with color. This helps to keep the paint which is laid into wet color clean. Hold the brush at a shallow angle to the canvas.
■ Avoid complicated mediums – just use color from the tube or thinned with turpentine. This evaporates faster if you are painting out of doors, so keep it in a screw-top dipper.

·Oil painting in layers·

The oil medium may be used to great effect in systematic methods of painting in which transparent, semi-opaque and opaque colors are overlaid in various combinations to provide paint films of great subtlety and depth. These techniques may be straightforward – such as a simple monochromatic under-painting, colored, in particular areas with a single colored glaze – or they may be complex, where many layers of glazes and scumbles are interleaved in a paint film of great complexity. In every case, certain basic rules should be observed to ensure the permanence of the paint film.

OVERPAINTING TECHNIQUES

The underlaying paint layer must be either completely dry or still wet when it is overpainted. If just a drying oil is used as the medium, this means waiting for up to a few days for the under-painting to dry before applying new paint layers. This explains why artists like Titian are described as working on many paintings at the same time. (The alternative – using an excess of resin and/or dryers – is inadvisable, see p.186.)

The "fat-over-lean" rule
Superimposed paint layers should be as, and preferably slightly more, flexible than the layer beneath. Make sure that there is a little more oil in the paint mixture with each succeeding layer. In general, fast-drying, high-oil-content colors should not be used on their own in solid layers for underpainting.

TIPS FOR SUCCESSFUL OVERPAINTING
■ Carry out overpainting when the paint layer beneath is still wet or completely dry.
■ Observe the "fat-over-lean" rule.
■ Use any resins or balsams as sparingly as possible.
■ Make sure that the surface is not too glossy, and has not become dirty before overpainting. If necessary, clean the underpainting with fresh bread, or cotton wool moistened with saliva.
■ Use paint fresh from the tube.
■ Avoid laying continuous films of very thick paint.

UNDERPAINTING TECHNIQUES

The choice of a method of underpainting depends on the nature of the subject, the method of overpainting and on the tone and color of the ground.

Monochromatic underpainting A traditional method is to paint the subject in tones of one color, on a white ground. This allows you to concentrate on the form and tonal values of the subject before having to take any color decisions. This is sometimes called grisaille painting, which, strictly means underpainting in tones of gray, although artists have used a variety of other colors including browns (common), blues and reds.

Broadly speaking, there are two methods of monochromatic underpainting on a white ground. The first is a form of transparent painting, where, for the half-tones, the color is simply diluted more thinly. The second way is to paint opaquely and to render the half-tones by mixing the color with white. In terms of surface appearance, the transparent method produces a less "meaty" appearance than the opaque method, and is not so suitable for direct glazing with transparent colors.

Transparent monochromatic underpainting This underpainting was thinly applied on a white ground, in tones ranging from very dark to light to allow for semi-opaque overpainting. The image is only roughly modeled at this stage.

Adding warm, semi-opaque flesh color A thin, warm mixture of Flake White with a touch of Cadmium Red and Cadmium Yellow was painted in a uniform tone over the area of the face, softening the rough brushwork of the underpainting and pulling the image together. The next stage would be to begin reworking the features in appropriate tones and colors.

Opaque monochromatic underpainting This type of underpainting lends itself extremely well to the immediate application of transparent glazes. The tones of the underpainting may be worked up to full strength or kept within a mid-to-light range. If the tones are kept fairly light, the true depth of tone can be established by the application of colored glazes or scumbles. This allows the overpainted color (especially if it is transparent) to work more successfully on its own terms than it can over deep tones.

If the tones of the underpainting are painted up to full strength, or indeed darker than they appear in the subject, a common method of overpainting is to apply an overall opaque color relatively thinly, so that it has a semi-opaque appearance which allows the underpainting to show through, but reduces the depth of the tones. This is an excellent and quick method of bringing an image like a portrait to a fully modeled state before the application of local color, deep shadows and highlights.

Opaque underpainting in tones of gray This image was painted with bristle brushes using opaque mixtures of black and white in a wide range of tones from white to deep gray. The depth of the darkest tones was later reinforced with the colored glazes, so darker grays or black were not used at this stage. But the image is fully modeled with fused tones and some detailing.

Glazing over the underpainting Over a similar underpainting, the water was given an overall glaze of Burnt Sienna mixed with a little stand oil in turpentine. This was painted up to the edge of the duck and around the leaves with a No.5 filbert and a large, round bristle brush. The glaze was worked over with a badger blender to make it a uniform tone (see p.202).

Adding final glazes and highlights Care was taken not to smudge the brown glaze over the edges of the white areas, and it was allowed to dry. The leaves and the duck were glazed in appropriate colors using the same technique, but on a smaller scale. Finally, the highlights on the body of the duck were picked out in white.

UNDERPAINTING IN COLOR

The functions of a monochromatic underpainting have been shown, but paintings may also be underpainted in various ways, depending on the desired effect.

Underpainting in light tones of the overpainting Deep, saturated color effects can be obtained by underpainting with lighter-toned versions of the colors to be painted on top. For instance, a blue drapery may be underpainted in a pale blue pigment, and then glazed with another deep, transparent or semi-transparent blue. This exact effect has been noted in pigment analysis of paint samples from the fifteenth century. The technique gives a brilliance and depth to colors that could not be had by any other means.

Creating a third color with underpainting The underpainting may serve to enhance the purity and depth of a particular color. It may also be used to create a more subtle third color if it is sufficiently different from the color superimposed to be able to modify its hue but still remain within a similar color area. A Viridian or Phthalocyanine Green glaze, for instance, might be applied over an opaque mid-tone blue and white mix with a touch of green in it. The resulting color will be a dark, but subtly muted green.

Modifying and darkening the underpainting A complementary colored glaze may be used to break the purity of the color if the underpainting even more dramatically. If a fairly strong Viridian or Phthalo-cyanine Green glaze were painted over an opaque Cadmium Red underpainting, the resulting color would appear almost black — so strong is the darkening effect of superimposing glazes in colors complementary to those beneath. The dark tone produced in this way has a depth and a lustrous quality that a single mix could not match.

The particular tone of the underpainting and glaze are very important, for a very pale glaze will not kill the color beneath, but will only subtly modify and darken it. Such effects used with very pale, colored underpainting and with pale glazes superimposed, can give a range of colors of great subtlety, similar to those created by pale, superimposed watercolor washes (see *Subtle colors from optical mixes*, p.159) but with even greater depth and luminosity.

COLORED UNDER-PAINTING WITH GLAZES

The chart below shows some of the effects that can be created by glazing transparent colors over an opaque, colored underpainting. (The opacity of the underpainting is such as to allow the white of the ground to have a positive effect on the appearance of the color). The overpainted areas show the brilliance and depth of tone that can be achieved with glazes. The box (bottom) examines the effects of laying a transparent colored glaze over textured white.

Creating a range of subtle tones Below is a range of deep tones, created by glazing a group of browns with the same transparent blue. The resulting shades are markedly different, and show the subtlety of hue that may be created in even the darkest shadows.

Underpainting
1, 2 Manganese Blue plus Flake White
3, 4 Phthalocyanine Blue plus Flake White
5, 6, 7, 8 Phthalocyanine Blue, Phthalocyanine Green and Flake White
9, 10, 11, 12 Cadmium Yellow Pale plus Flake White (two tones)
13, 14, 15, 16 Cadmium Red plus Flake White (two tones)

Glazes
1 Phthalocyanine Blue
2 Pigment Yellow 128
3 Phthalocyanine Blue
4 Quinacridone (Rose); Quinacridone (Rose) plus Pigment Yellow 128
5 Pigment Yellow 128
6 Phthalocyanine Green
7 Quinacridone (Rose); Phthalocyanine Blue
8 Burnt Umber
9 Pigment Yellow 128
10 Quinacridone (Rose); Phthalocyanine Blue
11 Pigment Yellow 128
12 Permanent Rose plus Phthalocyanine Blue
13 Quinacridone (Rose)
14 Phthalocyanine Blue; Phthlocyanine Green
15 Pigment Yellow 128; Quinacridone (Rose)
16 Burnt Umber

Range of browns with blue glaze
The underpainting was done in a range of orange/browns through red/browns to dark blue/browns. (On the right are lighter-toned versions.) An overall Phthalocyanine Blue glaze was applied.

COLORED GLAZES OVER IMPASTED WHITE

The examples show impasted white oil paint overpainted with colored glazes, modified by wiping along the ridges of the brushstrokes with a paper tissue so as to emphasize the impasted effect. By glazing the strokes with a uniform tone, they can appear as if painted in the glaze color.

Pigment Yellow 128

Winsor Green plus Pigment Yellow 128

Pigment Yellow 128 plus Permanent Rose

Winsor Blue

ACRYLICS

The acrylic medium, which has been developed and refined since the 1950s, represents a significant new addition to the repertoire of permanent painting media. It could be said to have as much significance for painting technique as did the more gradual move from egg tempera to oil painting during the fifteenth century.

The most important aspects of the acrylic medium are its versatility – it can be used in very pale washes or glazes or thickly impasted with rich textural effects, coupled with its permanence – the modern acrylic emulsions are not liable to the continuing chemical changes which an oil film undergoes. The best acrylic emulsions neither yellow nor harden with age. No special techniques are required in the overlaying of colors to ensure that the dried film remains sound and free from cracking and from this point of view the medium is far simpler to use than oil color.

Since the paint dries quickly, colors can be overlaid more rapidly than in oil painting. On the other hand, there is less time for the manipulation of the color on the support and in this respect, oil paints remain somewhat more manipulable than acrylics. It is also true that, comparing similarly impasted oil and acrylic painting, the former shows a little more crispness and resonance of color than the latter. But acrylic paint is sturdy and flexible; in addition to the more traditional transparent, opaque and combined painting techniques, it can be scraped, squeezed, piped, thrown, sprayed, mixed with fillers for texture effects, even woven.

The possibilites of acrylics One of the first artists in America to exploit the possibilities of acrylic paint was Morris Louis. He used "Magna" colors. These early acrylics were soluble in mineral spirit rather than water, and Louis used a special paint formulation which allowed the color to run and stain the canvas in a controlled way. This is a fine example of his mature painting. *Beta Lamda* (1960), by Morris Louis.

—·Acrylic and other resin-based paints·—

ACRYLIC COLORS

The most common forms of artists' acrylic color are based on the polyacrylates and polymethacrylates. These are used in dispersion as the vehicle with which the pigments are mixed. The acrylic polymer emulsion is water-soluble when wet and provides a flexible, waterproof, non-yellowing film when dry. By itself it gives a rather soft film, though the addition of pigments makes it somewhat harder.

1
2
3
4
5
6
7
8
9
10
11
12
13
14
15.
16
17
18

Pigments in acrylics

The range of pigments available in manufactured artist's acrylic color is not so extensive as in watercolor or oil paint. Manufacturers tend to incorporate the newer synthetic or inorganic pigments and to exclude some of the more traditional ones. The result of this is that the acrylic medium does not exhibit the particle characteristics of the pigments in the same way as watercolors in thin washes (see *Transparent acrylic techniques*, p.212). The newer pigments mean that there is generally a high degree of permanence across the range of artists' acrylic colors.

A note on the quinacridones used in acrylics There is a wide range of permanent quinacridone pigments (see p.17). In the acrylic ranges, manufacturers often use a red such as PR 207 or PR 209, which is yellower than the α form of PV 19 used to make Quinacridone (Rose) in oil paint. For a quinacridone violet, PR 122 is sometimes used in acrylics, rather than the β form of PV 19 used to make Quinacridone (Magenta) in oil color (see *Pigment Charts*, pp.18–31).

Permanent pigments in common use in acrylic painting

 1 Cadmium Red
 2 Quinacridone Red
 3 Naphthol Crimson
 4 Red Iron Oxide
 5 Azo Yellow
 6 Cadmium Yellow
 7 Yellow Ochre
 8 Raw Sienna
 9 Burnt Sienna
10 Raw Umber
11 Burnt Umber
12 Phthalocyanine Blue
13 Ultramarine Blue
14 Dioxazine Purple
15 Phthalocyanine Green
16 Chromium Oxide Green
17 Titanium White
18 Ivory Black

PVA COLORS

PVA colors based on polyvinyl acetate resins are generally to be found in the cheaper ranges of polymer paints. Most of the PVAs used by artists' material manufacturers are the more straightforward resins which tend to be at the poor end of an ever-improving market where vinylidene chloride co-polymers or ethylene vinyl co-polymers would provide a far superior vehicle on a par with the acrylic resins. The reason for the use of these lower grade polymers is that a market has been built up for PVA colors as a low-cost alternative to acrylics, rather than as a serious competitor, so that, until there is a demand from the consumer for "artists' quality" PVA colors, they will remain the "poor relations".

Most PVAs are lightfast and although there may be some yellowing, it is not as drastic as that of the drying oil in oil painting systems. Most generally require the addition of a plasticizer to add flexibility to the dried film. The plasticizer can migrate in time, leaving the film rather brittle. A four-year old painting on canvas in my studio which had a thick PVA coating was accidentally hit from behind by a hard rubber ball, causing a shatter pattern to form. None of the film flaked off however, and other paintings with a similarly thick paint film (and without such violent treatment) have survived without mishap. Nevertheless, it is probably advisable to use a rigid support for PVA paints.

The lower quality PVA mediums should not be used for external work where paints can exhibit chalking tendencies (where the pigment begins to "powder off" the surface owing to ultra-violet degradation of the paint film). In addition, pigment permanence should be checked.

ACRYLIC MEDIUMS

Several mediums are sold for use with acrylic colors to produce different effects such as impasto and glazes. Most of these mediums are versions of the same emulsion which is used to make acrylic paint. It is therefore normally quite safe to intermix them freely with the paint.

Gloss medium
In its simplest form, this is the acrylic polymer emulsion on which the colors are based. For optimum results, it should contain all the additives necessary for good film formation (see pp.44–5). The acrylic polymer emulsion itself is usually internally plasticized to give greatest flexibility and this introduces a softness to the film which may lead to tackiness and dirt retention. In the pigmented color, the pigment itself reduces this and no further modification is necessary. In the medium, however, which may contain very little pigment in transparent glazes, it is necessary to incorporate a harder resin. The term "gloss" is relative, since acrylic gloss mediums will never impart the level of gloss found in oil mediums.

Matt medium
If small amounts of acrylic color are added to matt medium for transparent glazes for instance, the mattness of the color is retained. Matt medium is basically the gloss medium to which a matting agent has been added. This may take the form of a wax emulsion or an inorganic matting agent such as silica. For optimum results, both may be added. The presence of matting agents makes matt mediums thicker than gloss mediums.

Gel medium
This is a gloss medium which has been thickened by cellulosic or polyacrylic thickeners. This allows the color to be extended or made more transparent without loss to the structure.

Flow improver (water-tension breaker)
These products are simply concentrated solutions of wetting agents. They aid the thinning of acrylic colors for glazes without reducing the color strength by addition of excessive amounts of water. Because acrylics are gelled, they do not thin readily with water alone without losing strength. The addition of the wetting agent helps to break the gel structure.

Retarder
Retarders are used to slow the drying time of the paint. These are usually made from propylene glycol and are available in a gel form or as a liquid. The former is the most useful because its structure holds more water, which keeps the acrylic film open longer. The use of a retarder increases the "wet-edge time" and makes blending easier (see p.216).

No retarder (especially the liquid form) should be used in excessive amounts, as it tends to produce a surface skin with soft color below. This can take days to dry completely due to glycol trapped below the surface of the paint film.

Mediums for acrylic painting
1 Gloss medium
2 Matt medium
3 Gel medium

TINTING AN ACRYLIC MEDIUM
It is often necessary to tint an acrylic medium for manipulations such as glazing or transparent impasto effects. Add the color to the medium rather than the other way round.

1 Add a tiny amount of color to the medium using a brush.

2 Stir the mixture thoroughly to achieve a consistency of tone.

Supports and grounds for acrylic painting

Most surfaces are suitable for acrylic painting provided they are clean, non-oily, dust-free and provide an adequate "key". On canvas, the permanence of the acrylic paint film is further reinforced by the fact that, unlike oil painting, no potentially problematical layer of glue size (see pp.63–4) is required. Indeed, if the same types of paint are used throughout, the vehicle will be identical from primer to final coat, creating a unified, "welded" film quite unlike the "sandwiched" layers of oil paint which have to follow the "fat-over-lean" rule. Supports are dealt with in detail in the sections on flexible and rigid supports (see pp.46–62).

PRIMERS FOR ACRYLIC PAINTS

With transparent painting techniques on canvas or board, where the white of the ground is all-important, acrylic primer should be used. This is often called "acrylic gesso primer" by manufacturers, though it does not provide a gesso ground in the conventional sense. Basically, these primers are mixtures of the same acrylic polymer emulsion used as a vehicle for the paints themselves, with titanium dioxide for the whiteness and a coarse extender, such as barytes with magnesium calcium carbonate, to give the primer a degree of tooth. The ratio of pigment to extender is generally about 1:1.

It is not essential to use a primer on canvas if the paint is to be used opaquely, and provided a continuous film is established over the whole area. There are, in fact, examples of work on canvas in which a dark acrylic color has been scraped over the bare canvas to provide the ground for an opaque painting technique (see *Applying a dark toned ground*, right).

Priming an upright canvas

1 Fill a large decorators' bristle brush with primer and apply it in a short, thick horizontal stroke.

Priming a canvas

When working on canvas, the primer can be brushed on using one or two coats. Another method, particularly useful with very large canvases, is to scrape the primer over the surface. This can be done by temporarily stretching the canvas using masking tape or staples, either flat on the studio floor, or upright on to the studio wall.

With a flat canvas, pour on the primer then scrape it thinly over the surface using a scraping device such as a window cleaner's squeegee (avoid those incorporating soft black rubber which may mark the canvas). I use a 30cm (12in) clear plastic ruler with a smoothly bevelled edge, screwed into the squeegee handle in place of the rubber strip. It provides a firm, flat scraping device which forces the primer into the textured surface of the canvas, giving a smooth, uniformly primed ground.

Applying the rather liquid primer to an upright canvas attached to a wall can be more difficult (see below), but is still far quicker than laboriously brushing the primer on to the support.

2 Scrape the primer into the canvas with the squeegee or improvised scraper.

APPLYING A DARK TONED GROUND

If dark acrylic paint is being applied to a bare canvas as a ground for an opaque painting technique, the paint itself is considerably more viscous than a primer and easier to apply to an upright canvas. This may be done with a thin, flexible plastic scraper, like an old credit card.

Priming rigid supports

With rigid supports the primer can be brushed on. Generally, two coats are used, depending on absorbency. The first coat can be slightly thinned with water if necessary. For large areas, a very smooth finish can be obtained by spraying the primer on with a spray gun and compressor system.

Priming very absorbent surfaces

On a very absorbent ground, such as a compressed wood-fiber board, a coat of acrylic gloss medium thinned with water and applied before the primer, will reduce the absorbency of the support to an acceptable level. If primer is applied to an extremely absorbent surface which has not been sealed in this way, the binder could sink in, leaving a powdery surface. Subsequent coats of acrylic paint would be unable to adhere to this.

·Transparent acrylic techniques·

Acrylic paint is particularly suited to those transparent techniques normally associated with watercolor. Its great advantage is that any number of thin washes can be superimposed without fear of muddying the color beneath, since once each wash has dried it is insoluble in water. The disadvantage, however, is that by the same token it cannot be modified by sponging or scrubbing, as can watercolor. Acrylic paints dry rapidly and unless the edges of the shapes have been softened with a clean, damp brush or the ground around a shape dampened before it is painted on, they will dry with a crisp, sharp line that is often difficult to soften with water and can only be disguised by being worked over with opaque color.

WATERCOLOR EFFECTS WITH ACRYLICS

As in watercolor, superimposing two transparent washes of different pure colors produces a third, quite different color. This new color will have more resonance than if the two colors had been mixed on a palette. Soft-edged, blended effects are possible, so long as you carry out one of the softening techniques described below. Similar effects can be had with an airbrush (see p.220), which can be used either with transparent or opaque color.

It is quite possible to paint wet-into-wet with acrylics. To increase the "flow" of acrylic color and help it act more like watercolor, the paint can be mixed with a solution of water-tension breaker, or it can be painted on to a surface already washed with this solution.

Painting wet-into-wet
To increase the flow of acrylic color, it can be mixed with a solution of water-tension breaker, or painted on to a surface already washed with this.

Creating new colors
By superimposing two transparent washes of different pure colors a third color can be produced with more depth than a color mixed on a palette.

Overlaying transparent washes
Superimposed washes of Phthalo-cyanine Blue, Quinacridone (Red) and Azo Yellow show the rich color effects that can be created.

Wet-into-wet effects
Here, the colors were laid in rapidly, superimposed while still wet, and left to run freely (left). The spontaneous effect is much the same as that of wet-into-wet watercolor painting.

Soft-edged blending
The same colors (above) as were used in the wet-into-wet sample, graded from dark to light and blended into the adjacent color by softening the edges (see p.213) immediately after painting.

SOFTENING EDGES

An unwanted crisp edge on a dry wash can be a problem with transparent acrylic techniques. Although softening techniques work best with watercolors, crisp edges can be avoided in two ways.

Dampening the paper

Paint a clean water line along the edge to be softened before the paint is applied. Apply just enough water to dampen the paper and make the paint diffuse into the damp area. The edge may have to be worked over with a clean sable brush to absorb excess paint or water.

Using two brushes

Alternatively, work with two brushes, one containing paint, one water. Apply the paint and soften the edge immediately by stroking along it with the clean, damp brush. A thin wash of acrylic paint dries rapidly, so any edge that needs softening has to be reworked quickly.

TRANSPARENT IMPASTO AND TEXTURE EFFECTS

The various mediums manufactured specially for use with acrylic paints can be used to create a number of effects. A very small amount of acrylic paint thoroughly mixed into acrylic gel medium will give permanent, textured and glass-like color effects which are unique to acrylic painting. If more color is added to the medium, the paint becomes somewhat less transparent.

Transparent and semi-transparent impasto effects A little color was mixed into acrylic gel medium, which retains the characteristics of the bristle brush which made the strokes (left). When more color was added to the medium (right), the transparent effect was reduced. The paint still retains a fully glossy look.

Transparent thick glazes over white textured ground This rich textural effect was produced by combining the opaque thick white of the ground with the transparent thick texture of gel medium mixed with a little color. The process can be built on by laying opaque white shapes over transparent gel medium, painting these, then re-glazing.

Rich textures can be built up in acrylics, where successive layers of paint do not need to be more flexible than those beneath (as with oil paint). Acrylic paint and mediums use the same acrylic emulsion base and "weld" together easily as one continuous film. A combination of thick, textured white acrylic paint and transparent colored glazes produces glowing color effects and an interesting paint surface which is constantly changing its appearance in different lights.

Glazing over an impasted white ground A thick coat of white was textured with a stipple brush, then allowed to dry. Thin acrylic was brushed on and, after a few minutes, rubbed in one direction with a clean rag. This made the "highlights" white. When it was dry, a second layer was applied at right angles and rubbed off in the same way.

Glazing over a variable textured ground Here the thick white acrylic ground was "combed" in several different directions. When it was dry, thin washes of acrylic color were painted on with a flat bristle brush.

TRANSPARENT TECHNIQUES ON PAPER

Effects similar to watercolor can be obtained by the purely transparent use of the acrylic medium, where the white of the paper and palest washes provide the highlights and lightest tones, and where deeper tones are obtained by overlaying a number of different color washes. The painting below demonstrates the ability of acrylics to imitate watercolor effects on water-color paper. In fact, an image like this, where a number of colors are superimposed, is rather easier to create in acrylics than it is in watercolors, where

the resolubility of the paint layers can be a problem. At the top of the painting, for example, a pure red wash was overpainted with a pure blue wash to give a purple that has more resonance than if red and blue had been mixed on the palette.

The parts of the machinery provided several small-scale exercises in acrylic painting. The crisp edge that can be a problem with transparent acrylic tech-niques was appropriate to the outlines of the various cylinders and tubes, but within these, where they were modeled to give the appearance of three-dimensionality, the edges were softened.

Building up tones on paper

When painting large areas of tone, the colors should be built up in thin, transparent washes superimposed on top of each other. A wash, once dry, cannot be easily modified, and for this reason the tones are built up gradually, using the palest of washes. Any number of washes can be superimposed to deepen the tone if necessary. This approach is demonstrated in the portrait on paper (below). Smooth transitions between the tones on the face are necessary to give a rounded form.

Portrait in thin acrylics on paper
Where broad areas of the face are concerned, colors should be built up in the palest of washes to achieve the depth of tone required.

Softened edges for modeling
The detail (above) shows how the softening of washes within the areas of the shiny machine parts helped to create the three-dimensional look. The two-brush method (see p.211) was used for most of the softening.

Imitating watercolor techni-ques This painting (right) was made in thin transparent acrylics on NOT surface watercolor paper. It employs edge-softening techniques and overlaid colors to retain the characteristic softness of watercolor.

Building up tones on a face
The detail clearly shows the tonal variation. On the mouth, a number of pale red/brown washes were superimposed to build the shape. The white of the paper provides the highlights on the bottom lip.

TRANSPARENT TECHNIQUES ON CANVAS

On primed canvas with no underpainting, transparent acrylic paints may not work as successfully as on paper as the image can look a little "thin".

Near-white, thin opaque or semi-opaque glazes can help build up the modeling of a face, for example. For a portrait, the best method is to paint in the features and the broad tonal areas using thin, transparent washes and then to introduce semi-opaque or opaque washes, alternating or combining these with transparent effects. It has to be an "all-over" technique, though the opaque or semi-opaque colors are generally concentrated in the mid-to-light and highlit areas of the face, with the transparent washes providing the darker areas. The whole image can finally be unified with an all-over glaze or wash of a very thin fleshtone. When this is dry, the highlights or the very lightest tones can be adjusted. This is a slow, systematic technique which involves a great deal of overpainting. It is therefore very appropriate to acrylic paints which dry quickly and which remain stable and permanent when painted in layers.

TRANSPARENT TECHNIQUES ON WOODEN PANELS

After the relative absorbency of paper and canvas, it can be difficult to adjust to the non-absorbency of a wooden panel. With quite viscous, opaque colors the problem is not as great, but with thin washes it can be extremely difficult to cover an area with a uniform tone, since any hint of grease on the primed surface will make the wash separate into beads of color. Even on a grease-free surface, thin paint can fail to "take" satisfactorily. To avoid this problem, use an airbrush or spray gun to lay the color on initially.

If you do use a brush, work on quite small areas at a time, working outwards with the brush. The brush should be damp, but not wet, with paint.

Thin acrylic paints on canvas
Thin, transparent washes have been combined with opaque or semi-opaque layers to give a more solid effect in this portrait.

Detail (plane)
The planes were painted in thin color washes, using a brush. Only at the final stage was an airbrush used to reinforce the deepest tones and emphasize white highlights.

Thin acrylic painting on plywood
This work was made from pieces of 12mm birch-faced plywood, each cut to the shape of a plane. The planes were painted in transparent acrylic colors.

·Opaque acrylic techniques·

In addition to transparent effects, acrylic color is equally well suited to opaque or "body color" techniques, in which the opacity of the pigment, the thickness of the paint, or the addition of white pigment provides colors which, when overlaid, effectively obliterate the color beneath. These techniques are particularly suited to working on a mid-toned colored ground where the white of the overlaid paint, (rather than the white of the ground) provides the highlights.

Compared to similar techniques in oil painting, the main advantage is that the color dries very rapidly so it can be overpainted without risk. This is particularly useful when scumbling or using dry-brush and broken color techniques. The disadvantages are that the rapid drying can leave little time for the smooth blending that is a feature of oil painting, where the paint is wet for long enough to allow the artist to lay in a number of tones before blending them on the surface of the painting. In addition, the color that is applied in oil painting is the same tone when dry as when it is applied. Acrylic paint dries darker, and this can make it difficult to match tones and colors to a dried surface, especially in portrait painting. To some extent, these disadvantages are exacerbated by relying too much on oil painting techniques.

OVERLAYING OPAQUE AND TRANSPARENT COLORS

Overlaying opaque acrylic color Here the color effects do not depend on the white of the ground (right); this is obscured by the opacity of the paint. Overpainting with body color does not produce the combined color effects that transparent overpainting does.

Transparent over opaque effects Opaque body color was painted on a white ground and, when dry, overpainted with transparent gel medium mixed with a little acrylic color (below).

Opaque over transparent effect In a reverse of the procedure in the previous example, opaque body color was partially painted over stripes of tinted transparent gel medium (above).

Opaque color over a textured ground Thick, white paint was combed to give a textured ground (left). When it was dry, opaque red and yellow were painted thinly across it. A bristle brush loaded with opaque color was pulled lightly over the surface.

BLENDING OPAQUE ACRYLIC COLORS

Acrylic color can be blended in the same way as oil color by laying down stripes and blending the join by stroking with a clean (wiped-off) bristle brush. The speed at which acrylic paint dries can be a problem with this type of manipulation. The answer is to add an acrylic retarder to the paints on the palette. This has the effect of reducing the drying time, allowing the blending to be fully worked. An airbrush gives soft edges, producing smooth transitions.

A painted surface comprising small adjacent dots of yellow and red paint can give the appearance of orange. Transitions between tones and colors can be effected using this principle. The technique is appropriate where a less slick, but more "painterly" transition is needed.

Colors blended with brushes.

Colors blended with airbrush.

Optical blending.

GOUACHE EFFECTS WITH ACRYLICS

Acrylic paints can be used in a similar way to gouache paints for body color techniques (see pp.166–9). Although they do not have the mattness or resolubility of gouache, nor do they flow out in the same way, they can imitate gouache effects very successfully.

The study below was worked in acrylics using gouache techniques. The image was drawn out in pencil and the white areas protected with masking film. A thin pink wash was applied over the whole area – the only "transparent" technique used in the study – and when it was dry and the masking film removed, the blue, gray, and ochre areas were painted in with sable brushes. These colors were mixed with a little Titanium White for extra opacity, then with water to a thick, creamy consistency which can be painted out flat. The red lines were painted in pure Cadmium Red – itself an opaque pigment; the last stage was to paint the outlines in black.

Imitating gouache with acrylics
This study, painted in flat, opaque acrylic colors, has the look of a gouache painting.

MONOCHROMATIC TECHNIQUES WITH GLAZING

An opaque, monochromatic acrylic underpainting can form a solid base for one or more transparent, colored acrylic glazes. It is important that the underpainting is dry before the glaze is applied over the top. A transparent glaze can be applied either with a spray gun (see p.220) or with a brush.

1 In this painting, a deep blue was used for the background. The figures were painted monochromatically in opaque white over the blue.

2 The figures were given a deep blue, uniform glaze. The red hood was glazed with tinted gel medium scraped over the area.

3 The tinted gel medium appears opaque white when it is applied, but dries to a clear, glossy film.

OVERALL GLAZES
There are two methods of overall glazing in acrylics. The first is to spray on the thin color using an airbrush or spray gun. The second is to apply it with a brush, one section at a time. Leave it for a minute or two, then dab it with a dry badger blender or equivalent brush to a uniform tone.

OPAQUE COLORS OVER MONOCHROMATIC UNDERPAINTING

Opaque colors can be used successfully over an opaque, mid-toned ground. A sketch may first be painted monochromatically in black and white – the white picking out any lit or highlighted areas and the black picking out shadows or silhouettes. The colors can then be painted on top.

As well as being applied over the whole of a painting, glazes can be applied more selectively to certain areas. This painting was worked monochromatically in opaque white over deep blue. Certain areas were picked out to be glazed; the figures (blue) and the hood (red). The figures were glazed with a blue wash. For the red glaze, a little Quinacridone (Red) was mixed with acrylic gel medium and scraped over the chosen area.

Brightening colors with white underpainting Red and yellow were used over white for the lights. Although opaque, they would not be as bright without the white beneath.

MONOCHROMATIC OPAQUE TECHNIQUES

One of the effects possible with opaque paint on canvas is the dry-brush technique. White acrylic paint can be used straight from the tube (undiluted) with a dry-brush technique, using the texture of the canvas to supply half-tone effects. In the example (right), painted on a blue ground, this can clearly be seen on the man's vest, where the brush has deposited the paint on the ridges of the canvas, leaving the troughs mid-blue, giving the vest a mid-to-light overall tonal value. To achieve this effect, small, flat brushes were used to maneuver the opaque pigment on the surface of the canvas. Black tones were used in the same way, at full strength for any dark areas, and used in a dragged or dry-brush technique for the half-tones in the background.

Opaque dry-brush techniques
This study from a black and white photograph shows the monochromatic use of opaque white and black paint over a blue toned ground.

Fully resolved monochromatic painting Monochromatic painting in acrylic color is not, of course, limited to dry white brushwork on mid-toned grounds. In this large painting, for instance, the imagery was drawn out on a white primed canvas using thin washes of black. It was then very carefully and gradually built up from these, using opaque mixtures of white and black. Most of the large canvas was painted using soft-hair brushes. There was a little

work at the end with an airbrush to give the effect of the mist between the stage cloths and the flats.
During the making of such a painting there is a constant reassessing of the overall tones. The last stages of a complex work of this kind are the reinforcing of the darkest tones and the white highlights to add the contrast that may have been lost while working on the grays.

THE ECONOMY OF OPAQUE ACRYLIC PAINTING

Using opaque colors over a prepared, toned ground is a method of painting which can show a quite highly resolved image after only a few simple stages. As a method of building up the underpainting for imagery, which can be further worked up — either monochromatically or in appropriate colors, it is extremely efficient.

Building up the skier study

1 First the primed canvas was painted with an opaque, mid-toned ground. The lightest tones were painted in with opaque white. The darkest and mid-to-dark tones were painted in next. This stage can be worked monochromatically or, if a particular color is appropriate, it can be added at this point.

2 The remaining colors and tones were added to complete the painting.

·Combining acrylic techniques·

Most acrylic painting is neither entirely transparent nor entirely opaque but a mixture of the two. The two areas of practice have overlapped in some of the examples discussed so far. Very complex images may be built up which incorporate a number of the different techniques. The work shown in this section is described in detail to show the many stages of its construction.

CREATING A COMPLEX PAINTING

The strange image based on a shrouded figure from a wood engraving incorporates transparent (see p.212), opaque (see p.216), scraped (see p.223) and extruded (see p.226) techniques. The ground was "scraped" on to the canvas (see p.211), using deep blue acrylic paint to provide the dark tones for the "black" lines.

Building up the painting

1 The areas of white between the black lines were first painted in Cadmium Red and only then in white, using a dragged, or dry-brush technique. The dry-brushed white paint allowed the red to show through in places, giving a solid feel to the shape. The surrounding background was also painted in white over the blue, using a wide bristle bright brush and short, dragged strokes.

2 A series of transparent glazes was applied to the background. They combined to give a mottled greenish color around the figure. The many stages of painting in opaque and transparent paint provide a rich background.

3 Strands of extruded red paint were laid over the background. Each strand was scraped back into the canvas at one end and, when dry, pulled up and knotted with a strand of different colored, dried extruded paint.

·Acrylic airbrush techniques·

Acrylic paint can be sprayed through an airbrush or spray gun to provide a wide range of effects, from uniform or graded tones over very large canvases to highlights on highly detailed illustration work.

Once it dries, acrylic paint becomes an insoluble plastic film which is very difficult to remove. So the airbrush or spray gun must be cleaned of paint immediately after every spraying (see p.222).

SPRAYING WITH OPAQUE PAINT

Any mixture of paint that has been diluted with water or medium for airbrushing should be completely free of lumps of partially mixed paint; these obstruct the nozzle and give an uneven spray.

For optimum coverage with opaque color, the thickness of thin cream is about right. The airbrush is held closer to the support than for the transparent color. There is a good degree of control over effects created and flexibility in spraying. Trigger on the air and begin spraying outside the picture area. Each pass should overlap the previous one for an even tone. Artists who do a fair amount of spraying will learn the the technique of fingering the trigger so as to increase or decrease pressure and control the amount of paint deposited. This control allows the spray to be deposited in a number of ways so that the instrument can be used as a drawing tool or paint brush.

SAFETY WHEN SPRAYING
Always wear protective clothing, goggles and a respirator when using an airbrush or spray gun as it is dangerous to accumulate acrylic or pigment deposits in the lungs. Particles can hang in the air for some time after spraying, so the protective equipment should be worn for a short time afterwards (see also p.136).

MASKING-OUT TECHNIQUES

Stencils can be made to mask out certain areas of the picture before spraying color. A stencil can be made of paper or proprietary masking film (the latter works better on paper than on canvas). Heavy-duty adhesive-backed plastic works better on canvas. Masking tape is the most efficient way of obtaining a straight edge. Latex masking fluid works very well on acrylic-primed canvas and is one of the best ways of masking out complex areas, so long as the paint is not applied too thickly.

SPRAYING WITH TRANSPARENT PAINT

It is also possible to spray with far more "watery" paint. Thin paint might be used to apply a pale, overall transparent glaze, for example. This is more difficult to apply than thicker paint and the air pressure needs to be a little lower. Do not hold the instrument too close to the painting – about 45–60cm (18–24ins) – and spray the work in stages, allowing one "mist" of paint to settle and dry on the canvas before applying another. Too much wet paint will start to run down the canvas or form wet blobs on flat canvas.

Soft-edged blending
Soft, undefined edges can be created using an airbrush or spray gun.

Similar manipulation with opaque color With opaque colors, the blended stripes look much more "solid".

BASIC AIRBRUSH TECHNIQUES

Applying a uniform tone
With opaque paint, hold the instrument about 15–25cm (6–10ins) from the support and keep it parallel for the duration of the pass.

Cutting and spraying through a mask Lay a piece of proprietary masking film over the picture area and cut out the required shape using a scalpel. Load the airbrush with color and spray evenly.

Masking out and spraying

The painting shown (below) was produced using thin sprayed colors with various areas of the image masked out at each stage. The masking-out was done using newspaper secured with masking tape. This may cause problems where the precise depth of tone of a masked-out area has to be remembered in order to key in with a surrounding color. In this case, clear polyethylene sheet can be used as a mask instead of the newspaper.

Building a painting with thin, sprayed color Here the brushwork was confined to the details on the branches and the reptile. The rest of the painting was worked up using an airbrush and a spray gun, with appropriate areas masked out during the painting process.

Spraying part of a painting

Although there is a tendency to compartmentalize brush and airbrush techniques, the fact is that the limited use of spraying within a "conventionally" worked painting may provide the only means of creating a particular effect.

For example, the problem of representing illuminated colored light bulbs is solved by painting the bulb shapes in white with a brush, then spraying white acrylic paint around each shape with an airbrush to create the diffused effect of the light. The individual colors of the bulbs can then be sprayed on.

Selected areas (the sky and light bulbs) sprayed within a brush-worked painting.

Combining transparent and opaque spray techniques

Spraying and brushwork can both be combined with transparent and opaque acrylic color to create a desired effect. In this painting (right), the opaque background color was sprayed on to the canvas and the "wallpaper" imagery painted in with a brush and transparent colors.

The paper airplane was painted opaquely with brushes; its soft shadow was applied with an airbrush.

SPRAYING ON A TEXTURED GROUND

By spraying color at a shallow angle across a textured ground, the texture can be made more apparent. To make a textured ground, apply a thick, white primer to the support. This can be stippled, combed or moulded to the desired effect. The technique can be taken further, especially on rigid supports, by adding a coarse extender to the ground coat. Pumice powder, marble dust or chips, or sand are all suitable. (Sand must be thoroughly cleaned before being stirred into the polymer emulsion).

Spraying over a stippled ground The opaque white stippled ground was sprayed with transparent acrylic yellow, and then with red, from the same direction. The resulting orange coating to the ridges emphasizes the texture of the ground even in neutral light.

Spraying over a "combed" ground The white ground was combed vertically and red was sprayed from the right so that it covered all the ridges facing that direction. Blue was then sprayed from the left. The result is a purple, produced by optical mixing.

REDUCING DEPTH OF TONE OR COLOR INTENSITY

A thin mix of semi-opaque white acrylic paint can be sprayed on to reduce tonal depth or the intensity of a color. A decision to reduce the tone of an area in a painting like this normally comes when the painting is well under way. It is likely that foreground areas will have to be masked out. In this painting (below) for instance, the background panel with sky, train and car was too deep in tone; the colors interfered with those in the foreground. So the figure, the plane and the monster were overpainted with masking fluid and the entire area was then sprayed with semi-opaque white.

To achieve an even tone over such a large area (see below right), the spray gun should be held at right angles to the surface and at an even distance, say of about 25cm (10ins). The gun should travel in even horizontal strokes, across and back, the hand making the turning movement outside the frame of the area being sprayed. This is reasonably straightforward, but it is a good idea to practise first.

Using sprayed-on white
After a semi-opaque coat of white paint was sprayed on to reduce the depth of tone on the background, the masking fluid was rubbed off the foreground figures (see box, right).

TIPS FOR USING MASKING FLUID
 The surface of the paper or canvas must be primed or have a reasonable covering of paint.
 The overlying paint should not be too thick, or the fluid becomes difficult to remove.
Remove masking fluid covered with a thin film of paint with your fingertips.
Remove masking fluid covered with thicker paint by rubbing vigorously with an eraser, against some kind of backing board.

Spraying on the white evenly
Hold the spray gun at right angles to the painting, and about 25cm (10ins) away from it. Move the gun across the painting in even, horizontal strokes.

CLEANING AN AIRBRUSH/SPRAY GUN
There are two basic steps to cleaning an airbrush.
After using an airbrush or spray gun, spray clean water through the equipment until no trace of acrylic remains. If the cleaning operation is not done thoroughly each time, ac-cumulated deposits of dried plastic paint will eventually block the instrument.
To clean paint from the needle, cover the tip with a cloth or your hand, so that air bubbles back into the reservoir, bringing with it any paint trapped in the equipment.

1 Spraying water through the airbrush.

2 Covering the tip to evacuate paint.

·Scraped color techniques·

The characteristic viscosity of acrylic paints used direct from the tube or tub makes them particularly suitable for "scraped" effects using thin card or plastic, or other spatula-like tools with a thin, flat edge. The acrylic color can be scraped to a uniform thinness over the surface.

Scraping can also be effective in multi-color ground effects, using paints direct from the tube or diluted with water or acrylic medium. Other versions of the technique include integrating the image and background color. Scraping is also often combined with "extruded" manipulations (see p.225).

S'GRAFFITO EFFECTS

Images can be formed by laying a light color over a dark ground and scraping the shapes into the wet paint with a sharp instrument (see also p.198). The unusual image below was worked by scraping through a layer of wet white paint to reveal the blue ground beneath.

S'graffito image
When the dark ground was dry, a 1–2mm coat of white acrylic paint was applied. The image was then drawn with screwdrivers.

OVERALL SCRAPED ACRYLIC EFFECTS

The s'graffito technique is a way of scraping acrylic paint in a linear way. Different, but just as effective, are paintings where the entire surface is scraped, using a tool such as the improvised scraper shown below.

All the examples shown on pp.224–5 are small-scale paintings, made using a clear plastic 30cm (12in) ruler screwed into a window cleaner's squeegee as a scraper. It is possible to apply this method on

Using the scraper
Scraper made using a ruler fixed into a squeegee handle (above). After applying paint to the edge of the picture area, pull the scraper across in one fluent movement (right).

a much larger scale, by working in turn on smaller sections along the whole length of the canvas.

On most of the small-scale images, the colors are scraped only once, and thinly, so that the white of the ground gives them their lustrousness and depth. With opaque colors, the color of the ground is not as important, allowing the technique to be repeated over areas that have not worked well at the first attempt. Tinted acrylic gel medium can be scraped over a painting to enhance colors and add depth to the surface appearance.

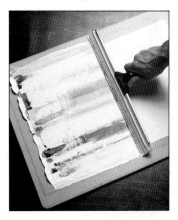

SCRAPING ON A TEXTURED GROUND

Tools like spatulas or squeegees can be used to apply a thick ground coat with a "plastering" technique. The thick layer of paint can be textured in various ways. Scrapers or rollers sold for applying textured paints to walls and ceilings can be used (see p.135). Or notches may be cut into any flat, rigid edge to create the desired pattern. The ground coat can also be stippled using

conventional stipple brushes or other suitable implements.

Such a thick paint film might be vulnerable in other media, but is acceptably permanent with the internally plasticized acrylic emulsions and, although you might be best advised to work on a rigid support, I have not encountered any problems with such thick paint films on canvas, even when rolled, provided they are not subjected to extremes of heat or cold.

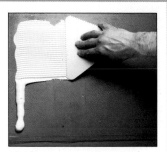

Making a textured ground
Using a spatula to create a ridged texture in thick paint.

SCRAPING TECHNIQUES FOR COLOR BLENDING

The bright, high-key color of pure pigments squeezed straight from the tube is retained in scraped images. The pulling action of the scraper has a blending effect when colors overlap, but leaves the purity of the color unspoilt in the middle of the bands. In order for the whole surface to be covered with one pull of the scraper, enough paint has to be applied at the edge. Although this means that a fair amount of paint is wasted, the wide range of possible effects may justify this.

Applying paint to the edge of the support
If a number of different colors are applied to the edge of the picture surface and scraped across it using a squeegee or plastic spatula, an immediacy of appearance results that would be hard to obtain without painstaking brushwork.

Colors can either be applied straight from the tube to create a bright, primary effect, or mixed with a little white before being applied to the edge of the picture for scraping. The second method gives a softer background, on which additional images can be superimposed using any painting technique.

Applying paint at various points on the support
Not all the colors need to be applied at the edge of the picture area. A single color can be used on its own at the edge to become the unifying overall background color out of which differently colored shapes appear. As can be seen from the clarity of the colors (right), they are not muddied by the scraping process provided the scraping is done using just one fluent, firm stroke.

Applying paint within the picture In this example, the blobs of Phthalocyanine Green and Arylide Yellow were applied at various points within the picture area.

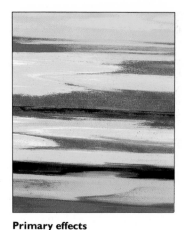

Primary effects
Scraping paint applied straight from the tube results in a bright, well-defined image.

Muted effects
Mixing colors with a little white acrylic before scraping gives a soft, blended result.

SCRAPING TECHNIQUES FOR IMAGERY

The possibilities of scraping can be extended into representational painting if the colors of the image are applied reasonably thickly, before the "background" color is scraped over the support.

The sequence of numbers below was made in this way. For the "2" and the "4", white paint was applied with a painting knife. (It could also have been squeezed direct from the tube.) The red for the "4" shape and the blue for the "2" were added next to the white. While the first colors were still wet, deep purple for the "2" and black for the "4" were applied thickly at the top edge and scraped over the whole image. The areas where the color was first applied remain bright and visible but become part of an overall film of paint which clings closely to the support.

The "3" was made in a similar way, but with several different

STENCIL AND MASK TECHNIQUES

There are various ways of making masks or stencils to create shapes with thick, scraped acrylic paint. Simple shapes can be cut out of fairly stiff card or thin plastic sheet. For more complicated shapes which are to be scraped over a large area, you can use masking tape cut to shape.

Scraping through a mask
Place the prepared mask or stencil over the area of the painting where you want the shape to appear and, if necessary, secure it with masking tape. Apply acrylic paint directly from the tube to the edge of the mask and scrape it across with a flexible spatula. Lift the card carefully at one corner and remove it, leaving the image embossed in thick paint on the surface of the ground.

Numerals paintings
These small images on white, acid-free cotton paper with a NOT surface show the various different effects possible with scraping.

colors in the background. These create a strong pattern of their own but remain distinct from the number itself by contrasting in color or by being considerably darker in tone than the number.

Using diluted paint for a scraped background Another example of the same process

shows the image of fish against a watery background. The fish were drawn first in undiluted black acrylic paint applied through a nozzle (see p.226). Yellow, also in undiluted acrylic, was added immediately afterwards. Then, the background, which is a "slurry" of blue and green acrylic, partially mixed with water, was scraped across very quickly after being poured (separately) on to the edge of the paper. This gave a streaky effect which contrasted with the solid color of the fish.

Using diluted paint
The paint and water were only partially mixed to create the multi-toned striations of blue and green in the background area.

Using a cardboard mask
The fish shapes were superimposed on to the painting by scraping paint through a cardboard stencil.

Defining shapes
The outlines were defined using a stencil. Strings of extruded green paint gave further definition.

A stencil can only be used for a limited time before paint begins to seep beyond the area to be scraped. When this happens, clean it off and leave it to dry thoroughly before using it again.

Using masking tape
Masking tape may be used for more complex scraped images and can be combined in the same image with other masking techniques. The proprietary masking film that comes in wide rolls is designed for graphics and illustration use and does not have sufficient adhesion for canvas, as does masking tape.

An image drawn out in pencil is usually visible through the masking tape, which can then be cut to shape with a scalpel. Be careful to cut through the tape only and not through the support. Smooth the cut tape down firmly with your thumb or fingernail to prevent seepage.

Masking tape used to create solid edges The curved red and blue lines, which contrast with the other, looser marks made with brushes or extruded paint, were made by masking out appropriate areas with tape.

·Extruded paint techniques·

Acrylic paint possesses remarkable plastic qualities which enable it to be used in ways that other, more traditional paints cannot. In particular, it can be extruded (squeezed) through the nozzle of the tube into "ropes" that can be pulled off the canvas when dry and knotted, plaited or otherwise manipulated in quite unconventional ways.

The paint can simply be extruded through a nozzle on to the canvas as a form of direct painting, or it may be further manipulated whilst wet, by being sprayed with water for instance, or by being extruded on to a wet or textured ground. It can be extruded with the nozzle touching the canvas, with the nozzle in a horizontal or vertical position, or from above, using various movements to control the curl or twist of the paint. These techniques can be combined with others, such as scraping or spraying. When dry, the ridges of paint formed by extrusion can be overpainted and abraded using a sander or sliced back to reveal touches of pure, bright color.

DRAWING WITH A NOZZLE

A wide, stainless steel cake-icing nozzle attached to a tube of paint is the best method of drawing directly on to the surface of a canvas. There is an art to working in this way which involves being able to control precisely the amount of paint being extruded, while retaining a fluency about the work.

Make sure there are no air-bubbles trapped in the paint, otherwise the line will "pop" When ladling paint into the opened end of the tube before the nozzle is attached, knock the tube on the workbench to allow any trapped air to rise to the surface. If you are using an icing bag instead of a tube, adopt the same procedure. Icing bags have the advantage of being able to hold more paint and of allowing you to squeeze them at a more consistent pressure than a plastic tube. Cake-icing syringes are not as good. They are generally too small and not very well sealed.

Using an icing nozzle
Hold the icing bag firmly and squeeze it evenly while pushing the paint towards the nozzle.

A random background
This work shows curls of paint over a scraped ground. The loosely textured background contrasts with the geometry of the camouflage.

Drawing with extruded paint
Here a white chalk grid drawn on the matt black ground allowed the original child's drawing to be copied in extruded red paint.

STENCILING WITH EXTRUDED PAINT

A stencil can be used to isolate the shapes of an area where you want to apply extruded paint. While the paint is still wet, the stencil should be pulled up carefully to reveal the shapes. If a skin has begun to form on the surface of the paint the stencil will not come away cleanly.

The figure in the painting below was painted through a masking film stencil, then overlaid with strings of paint extruded through a thin nozzle. The tube was squeezed while being moved from side to side which gives an easy, parallel diagonal movement to the paint.

Using a stencil
After laying down the stencil and applying extruded paint in the desired areas, remove the stencil carefully while the paint is wet.

USING A WET SUPPORT

Paint can be extruded through a nozzle on to a support wetted with clean water. This is a very immediate style of working, where every mark made remains an important component of the scheme. The wet paper allows the paint to run freely in various configurations while the solidity of the extruded paint retains the shape of the drawn image.

Self portrait
Using a mirror placed upright behind wetted paper, I copied my reflection in extruded black paint. The wetness of the paper caused the paint to run into interesting shapes.

KNOTTING AND WEAVING

An extruded strand of acrylic paint can be laid down on canvas, left to dry, and then pulled up and knotted or plaited like a piece of flexible plastic. If it is scraped down into the canvas at one end, it will adhere and support the free-hanging end, which can then be knotted.

Weaving is also possible with short, adjacent parallel "ropes" scraped down at both ends. When dry, the middle part of each "rope" is pulled up from the support and a separate dried strand woven through. There are numerous variations on these techniques. Different colors can be overlaid when wet to create multi-colored strands, or different colored paints can be placed in a tube or icing bag and extruded in a partially mixed state. The paint can be manipulated whilst still quite wet for particularly "sticky" effects.

"Woven" sock image
Strands of paint were extruded through a fluted cake icing nozzle on to a separate canvas and pulled off when dry. These were then woven through other strands which had been laid into the actual painting and while still wet, scraped back into the canvas to define the sock shape.

Plaiting extruded paint
Phthalocyanine Blue, Quinacridone (Red) and Azo Yellow squeezed straight from the tube, allowed to dry then plaited.

SPATTERING ACRYLIC PAINT

A spontaneous effect of spattered paint, which is thick and viscous in parts and thinly dissolving in others, can be made by spraying extruded strands of wet paint from close range with clean water in a a a high-pressure spray gun. The force of the spray dislodges and spatters the surface of the ridge of paint, driving it across the support where it sticks in thin, dynamic curls of color, or dissolves as pale washes in the water.

Although the effects are largely spontaneous, you do have a measure of control by adjusting the distance between the spray gun and the paint, the speed of the water and the angle of the canvas. It is not advisable to drench the surface of the painting in water; this would eventually dislodge the paint, causing it to run off the canvas.

Spattering
This small painting (top) in extruded black acrylic was sprayed with water to give a random effect (see detail, above).

ENCAUSTIC

Encaustic painting involves stirring pigments into molten beeswax and then applying them hot to the surface of the support. Encaustic is among the most permanent of all painting media, provided permanent pigments are used and paintings are not subjected to the very high temperatures that would melt the hardened surface of the wax.

The advantages of the medium are that it is unaffected by normal atmospheric changes and does not expand or shrink. The wax has no adverse chemical reactions with the pigments or the ground. It has good refractive properties and displays an attractive sheen after being buffed with a cloth. Encaustic is capable of a wide variety of effects and may be worked on intermittently and at any time without risk of damage to the paint film. The surface of an encaustic painting should be protected from scuffing.

·The history of wax painting·

The history of encaustic stretches back at least as far as Ancient Greece, though no examples of work from that time survive. Most of the surviving examples of early encaustic painting are the Romano–Egyptian panels known as the Faiyum Portraits, discovered at Hawara (see example, below). These small mummy portraits are painted on wood panels primed with distemper. They are, almost without exception, extraordinarily compelling images, characterized by an immediacy that relates directly to the encaustic painting technique.

Encaustic painting continued up to the Middle Ages. It was then used only intermittently until its revival in Germany in the latter part of the nineteenth century. The German revival continued in the early part of this century, when a range of specially designed encaustic equipment and materials was made, including electrically heated palettes on stands with integral dippers, special heaters to warm the surface while working and fuse the finished work, and heated spatulas, fed by low-voltage current from a transformer. Unfortunately, these special pieces of equipment are no longer easy to obtain, so a degree of improvisation is necessary.

ROMANO-EGYPTIAN MUMMY PORTRAIT

The bearded young man in this portrait from a wrapped mummy gazes at the spectator with the vividness that is a feature of such work.

The fleshtones are built up to a solid and impasted surface. The dark shadows are characteristically a dull brown-red and the lighter fleshtones are variously pink, orange or brown tints. There is a hint of green towards the temples, but such cool colors in the face appear largely to have been avoided. The painters of this period probably adjusted and blended the color with a metal tool known as a cauterium, which was a long-handled spatula with a small spoon-shaped end. This was warmed over hot charcoal before being used to modify the surface of the wax. In this portrait, the top of the moustache may well have been blended into the fleshtones by this means.

The clear desire to impart a naturalistic appearance to the image can be seen in the care which has been taken in the modeling. Beneath each curl of hair on the forehead is a carefully painted shadow. The encaustic technique is perfectly suited to this bold, yet careful method of painting.

Mummy portrait of a young man, detail of face, (end of second/ beginning of third century A.D.).

·Equipment for encaustic painting·

The nature of wax painting means you need certain special tools and pieces of equipment. To keep wax paints hot so that they can be applied with brushes, they are mixed and kept ready on a hot-plate or palette. As soon as the brush has made its mark on the cold support, the molten wax solidifies. It can be overpainted immediately.

Although the paint is most often applied hot to a support at room temperature, the support can be kept hot during the application of the paint, so that the wax remains liquid and can continue to be worked on the surface of the painting. The solidified wax coating can be reworked at a later stage by manipulation with heated metal tools, or by passing a heat source (such as a heating lamp or hair-drier) over the surface to melt and fuse the colors. In addition, the cooled wax surface can be scraped with blades or incised in other ways to create further effects.

KEEPING THE PAINTS HOT

Although in the past, special heated palettes have been commercially available for encaustic painting, they are no longer common. However, it is quite straightforward to improvise a home-made alternative, by laying a solid 6mm ($\frac{1}{4}$in) thick rectangular iron or steel plate over a double-element portable gas burner (camping type), or over a flat double-ring electric heater. The metal plate should be supported an inch or two above the heat source which is kept on a low setting.

A more expensive hot-plate can be bought from commercial catering suppliers. This is known as a "griddle" and is used as an evenly heated flat cooking surface. Since the device should be used on a fairly low heat setting for encaustic painting, it is important to buy a model which has a sensitive, easily adjusted thermostat.

Mixing trays

Encaustic colors can be mixed in individual aluminum trays such as those used for baking small cakes. It is important that the flat base of each tray should be in contact with the hot metal plate. A large single tray with the indented sections incorporated is not suitable because the heat from the plate tends to warp it, so that the central section lifts and is no longer in contact with the plate.

HEATED TOOLS FOR PAINT MANIPULATION

Other kinds of electrical equipment for encaustic painting can be used in the subsequent manipulation of the encaustic paint surface. An electric spatula, of the kind whose tip can be replaced with various pieces of shaped metal for smoothing or blending the paint, and whose temperature can be controlled, is

useful. If such a temperature-adjustable instrument is unobtainable, a standard electric soldering iron may be heated up, then allowed to cool to a point where it does not "fry" the wax. Various kinds of heating lamp – in particular infra-red types – may be used for the final softening and blending of the paint film. Alternatively, use a hair-drier.

Both bristle and soft-hair brushes may be used to apply the paint to the support. With soft-hair, the cheaper nylon brushes may "melt"; take care not to rest them in mixing trays for too long. (The wax has to be kept hot enough so as not to "drag" when applied to the support.)

Equipment for encaustic painting
Heat is needed for applying and manipulating the paint so useful tools include an electric soldering iron, a hair-dryer and a gas burner. Also shown are beeswax, Carnauba wax and pigment powder in individual trays.

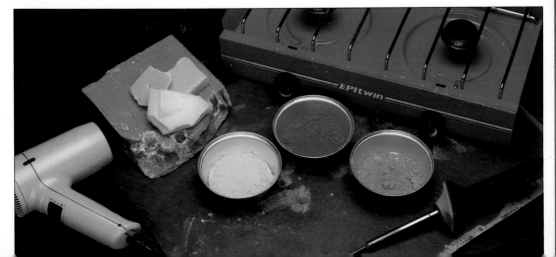

PREPARING ENCAUSTIC PAINTS

To make encaustic paints, a reasonable quantity of suitable wax is melted, then pigment powder is mixed with the wax in small containers.

Opinions vary on the best type of beeswax to use. I recommend natural, unbleached lump beeswax, which has very little coloring effect on the pale pigments, even white. However, if you want the surface of the painting to be harder than that produced by beeswax alone, add about ten per cent of the darker Carnauba wax. The paint film produced is considerably more durable than that made solely with beeswax.

There are no hard and fast rules about proportions in the paint mixture, as long as there is enough wax to coat the pigment particles. Individual artists will establish their own preferences. The amount of pigment you use depends on the required opacity of the mix. It is possible, by adding very little color, to create a paint which is something

akin to a transparent glaze – particularly with pigments which are themselves transparent (see box, p.233). If you add too much pigment powder, the paint will be much less manipulable; in fact it will probably solidify on the brush on the way from the palette to the painting. Pigments vary in their ability to disperse into the wax, but generally the two combine fairly quickly and easily.

Handling the paints

A range of seven or eight colors can be chosen for a painting, and a few containers left empty for special color mixes. In addition, a small, flat tray on one side of the hot-plate enables you to mix even smaller amounts of particular colors. Pigments tend to settle in the bottom of the mixing trays if they are left unused on the hot-plate for some time; if this happens, simply stir them again before use.

The paint can be applied to a warm or cold support. On a cold support, it solidifies instantly, on a heated one, it can be blended into adjacent colors.

Making encaustic colors

1 Melt the beeswax initially in a double boiler, so that the wax does not burn. Add the Carnauba wax. This has a higher melting point and takes a little longer to liquefy.

2 Pour some molten wax into each container on the hot-plate and stir in the pigment powder.

·Encaustic painting techniques·

Applying hot colors to a cold support is the most common way of working in encaustic. The paint is usually applied in short strokes. The nature of the medium precludes long, fluent strokes, unless a very long-haired brush is held vertically and worked rapidly. Works like the portrait below are characterized by an intensive, all-over treatment, with no single stroke any more important than the next.

The completed portrait
After the whole surface was fused, the head was modeled more fully and particular areas fused with the tip of a soldering iron (left). The detail (above) shows how the brushstrokes and circular marks of the tool, suggest the curly hair.

PORTRAIT STUDY

This copy of an Egyptian mummy portrait from around the second or third century A.D. was made on hardboard, primed with white acrylic primer stained with Yellow Ochre. A range of long-haired, pointed, flat nylon brushes was used. A relatively limited range of colors appropriate to the image and roughly the same as those in the original painting was mixed and kept hot on a heated metal plate.

The cumulative effect of the short, direct brushstrokes which solidly chart their way around the form is to produce an extremely frank and engaging image. The head gazes at the spectator with an immediacy and honesty which characterizes most of the encaustic tomb paintings of the Romano–Egyptian period (see also p.230).

Building up the portrait

The features were drawn in and the whole head roughly modeled before being heated with a hair-drier to fuse the colors. Use a hair-drier with care as the colors can suddenly melt in just one area and start to run.

Green and blue paints were used in the shadows. Similar mummy portraits sometimes contain a hint of green in the shadows, but these are more commonly designated with a dull red or brown color.

TREE STUDY

This study was made with hot colors applied to a cold plywood support which was given a thin mid-toned acrylic ground – although applying the colors directly to the wood itself would have been just as easy and as permanent.

Building up the study

The mid-to-dark tones were applied in short dabs of color, followed by the highlights. Next, some areas of foliage were melted with a hair-drier, creating a looser effect (see below).

The contrast between the white highlights and dark shadows was too marked, so the encaustic equivalent of glazes were applied (see box, below) to localize the colors of the leaves in particular areas – pale yellow, orange and green. Some scraping back with a blade was done in places. The next stage was to redefine the darkest tones, after which the whole surface was heated again. More attention was paid to the local color, and dabs of oranges, reds, blues and greens were added. On the ground, dull dark green and blue were introduced to complement the purple/reds and oranges.

Small areas of wax were scraped away over highlights to bring these forward. Lastly, uniform heat was applied in a final "burning in".

GLAZING IN ENCAUSTIC

To create translucent glaze effects in encaustic, stir a few grains of the chosen pigment into melted beeswax – just sufficient to tint it. An encaustic "glaze" is, in fact, almost as thick a layer of paint as in any other part of the painting. It cannot, of course, be modified on the surface in the conventional way like oil glazes, but it can be scraped back with a flat blade, held vertically.

Painting the foliage
The leaves were expressed in a "Pointillist" style, with dabs of thick color.

Fusing the foliage
Certain areas were melted quite fiercely with a hair-drier, so that the colors ran.

The finished study
The detail shows how a final "burning in" with the hair-drier gave a uniform quality.

—·Multi-layered encaustic techniques·—

The encaustic medium lends itself to the super-imposition of layers of color. Opaque and transparent pigments can be juxtaposed and superimposed in various combinations to produce films of great translucency and depth. Surfaces of apparent complexity can be built up by very simple means.

UNDERWATER STUDY

This fish study shows how a seemingly complicated paint surface can be created quickly and simply with encaustic. The entire painting process was extremely rapid, not merely because this was only a sketch, but because the paint solidifies almost instantly, and can be reworked immediately.

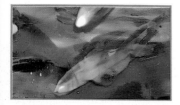

Building up the study

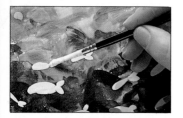

1 The background was painted in mid-to-deep tones of blues, browns, reds and ochres on the left-hand side and bottom of the sketch. A pale blue/green was used in the top right area.

2 The colors were applied loosely and randomly with long-hair, flat nylon brushes, until the whole surface was covered. The work was heated so that the liquefied colors flowed together.

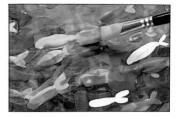

3 When dry, the entire surface was gently scraped with the flat edge of a razor.

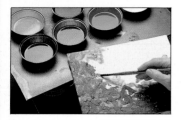

4 The first fish images were painted on to the surface using Titanium White applied with a pointed flat nylon brush. The white was overpainted with "glazes" of yellow and with some red.

5 The surface was coated with beeswax tinted with a few grains of Phthalocyanine Blue and Green pigment. When it was dry (after a minute), the surface was scraped again to adjust tonal depth.

6 Steps 4 and 5 were repeated twice more with interim "burning in" sessions, where the surface was heated to make the colors fuse (but not run).

·Other encaustic techniques·

The unique nature of the hot wax medium will suggest various technical possibilities to individual artists. It is possible, for instance, to use a painting method in which an image is drawn and built up by allowing the hot wax color to run through a small aperture in the base of a small-scale filter funnel normally used for batik work. The wax must be kept very hot and each manipulation made rapidly before it cools in the reservoir. Artists like Jasper Johns have incorporated encaustic with oil and collage techniques, using materials such as newspaper embedded in the protective and impasted wax surface.

CREATING SUBTLE LINEAR EFFECTS

It is possible to create an encaustic surface in which a linear work like a drawing is embedded within the paint film. This is done by coating a panel with a relatively thick layer of colored wax (it does not have to be particularly smooth). The image is drawn into this with any kind of scraping device. Then hot wax of a different color and tone is painted rapidly over the drawn lines and left to cool. It is very important to lay on the color in single strokes, without overpainting or scrubbing in, otherwise the wax beneath may melt and the image be destroyed.

The cooled surface is scraped down with the flat edge of a razor blade to reveal the original scratched marks filled with a second color as a drawing within the overall film of wax.

Building up the townscape study

1 A pale yellow bed of wax was laid on to a hardboard support.

2 The sketch was made by scraping into the solid wax coating.

3 Hot wax pigmented with Phthalocyanine Blue was painted on rapidly.

4 When the layer of blue was thoroughly dry, it was carefully scraped away.

5 In the final image, the sketch was given a further orange-brown "glaze" which was partially scraped back for a mottled effect.

DRAWING WITH SOLID WAX COLORS

As soon as the heat source is removed from the encaustic paints, and the metal plate has cooled, the colors solidify in their individual "dippers". They can then be tapped out of the containers and used as "wax crayons". In fact, with their pure pigment and beeswax/Carnauba wax formulation, they are considerably more permanent than the low-value wax crayons commercially available.

To make crayons like this, the wax should be reasonably well pigmented. Stir the wax color just before it is allowed to set.

It is possible to make a drawing with the crayons and then expose the work to heat which will melt and fuse the colors. Alternatively, the support (wood, canvas or paper) can be warmed while the drawing is applied. This makes the crayons melt into "paint" on contact with the surface.

Profile portrait study
The image inscribed in yellow was overpainted with blue then scraped.

BUON FRESCO

The *buon fresco* technique was practised by early civilizations such as those of the late Minoan period, the Etruscans, and the Romans – who used the technique extensively and to great effect, as evidenced by the celebrated Pompeiian wall paintings of the mid first century A.D.

But the most celebrated period of *buon fresco* mural painting in the history of art was from the late thirteenth to the mid-sixteenth centuries in Italy, when most of the great artists of the time – from Cimabue to Michelangelo – exploited the technique in an incomparable series of works. Notable examples are the Scrovegni Chapel frescoes by Giotto in Padua, the Florentine masterpieces of Masaccio, such as *The Trinity* in Santa Maria Novella and the decorations for the Brancacci Chapel in Santa Maria del Carmine, the extraordinarily beautiful and spiritual frescoes of Fra Angelico in the cells of the convent of San Marco, and many other equally inspiring works by great Italian artists like Ambrogio Lorenzetti, Uccello, Piero della Francesca, Mantegna, Ghirlandaio, Botticelli and Raphael.

——·Traditional *buon fresco* methods·——

The *buon fresco* method of wall painting involves the application of pigments ground in water or lime water to a freshly plastered wall. The pigments used should be light-proof, durable and alkali-proof. They are absorbed by the thin layer of fresh, wet lime-plaster and fuse with it into a permanent, hard, solid state as the lime carbonates. The fact that they do not rely on adhesion to the ground as do most other methods of painting, but become an integral part of it, makes *buon fresco* one of the most durable mural techniques.

THE WALL

Before plastering, the wall should be completely free of damp, grease and dust. Any previous coatings should be washed off, any crumbling mortar raked out, and any projecting or uneven elements chipped back to the level surface. The surface can be hacked to give a key to the plaster but this is not usually necessary. Any surface which has shown signs of mould or algae can be treated with a proprietary fungicidal wash which should be left for the recommended period then washed off.

The mortar

Traditionally, slaked lime is mixed with sand and/or marble dust of varying particle size, depending on which of the three layers is being applied. The sand should be dry and free of efflorescent salts or other impurities. The sand is an inert filler; the chemical change in the drying of the wall being the transformation of the plaster from calcium hydrate plus carbon dioxide to calcium carbonate and water.

THE PLASTERING

There are three basic stages of plastering a wall for buon fresco:
- *trullisatio*
- *arriccio*
- *intonaco*

The *trullisatio*

The wall is thoroughly wetted and the first render – known as the rough cast coat, scratch coat, or *trullisatio* – is applied. This mortar is a mixture of lime putty and coarse sand/gravel in the ratio of about 1:3. (Suggested

Preparation of wall for *buon fresco*

1 *Trullisatio* Lime putty and coarse sand/gravel in proportions of about 1:3 (around 3mm/$\frac{1}{8}$in thick)

2 *Arriccio* Lime putty and coarse/fine mix sand in proportions of about 1:2 or 1:2$\frac{1}{2}$ (average 1.8cm/$\frac{3}{4}$in thick)

3 *Intonaco* Lime putty and sand incorporating marble grit or dust in proportions of 1:1 (average 1.5–3mm/$\frac{1}{16}$–$\frac{1}{8}$in thick)

proportions of sand to gravel are in the ratio of about 1:5.)

For interior work on wooden lath or, more commonly nowadays, on an expanded metal screen, there is less sand or gravel in the mix. The application of the first coat is vigorous, with the mortar not smoothed, but slapped firmly on to the wall.

The *arriccio*

The second coat – known as the equalizing coat, brown coat or *arriccio* – is less coarse than the rough cast but not as fine as the final coat. The ratio of lime to sand is about 1:2 or 1:2½, and the sand element can contain a mixture of coarse and fine particles (with the coarse particles predominating). The *arriccio* is also applied vigorously to the thoroughly wetted rough cast and smoothed only to the extent that it will be capable of receiving a painted or drawn outline of the design of the mural. This preliminary outline was known as the "sinopia" after the town on the Black Sea (Sinope) from which the red ochre originally used to make the drawing was obtained.

The *intonaco*

The final painting coat, or *intonaco*, is a mixture of lime putty and sand in the ratio 1:1, the sand element often containing some marble grit or dust to add sparkle to the surface of the wall. The plastering of the *intonaco* calls for flowing strokes and floating techniques which bring the surface to the smoothness required for painting. However, it should not be made so smooth that it "closes up" the porosity of the surface. The *intonaco* is applied consecutively to areas of the wall that can be painted in the few hours between the first stages of drying, when the plaster becomes firm but remains wet, and the second stage, when the actual process of carbonation begins and the pigments are no longer absorbed by the wall. Any *intonaco* that

remains unpainted because it has become too dry, or because the painter has finished for the day, is hacked off so that it can be replaced with fresh plaster on the following working day.

TRANSFERRING THE DESIGN TO THE WALL

The design for the whole mural should be drawn out on the second coat, or *arriccio*. It is essential to have at least the main outlines of the whole image on the penultimate coat of plaster since it would otherwise be extremely difficult to work out what should go on each small section of the *intonaco*.

The drawing may be done freehand, – with brushes taped to canes, for instance – but it is

more likely to have to be transferred from a careful preliminary drawing called a "cartoon", prepared on a roll of thin, hard paper such as detail paper. The cartoon is made the same size as the mural itself, though it is generally drawn in fairly large separate sections. The drawing of the cartoon will have been scaled up using the grid system (see below and p.331) from a smaller original. It is particularly important that the horizontal and vertical lines should be accurately registered, on both cartoon and wall, so that the result is not lopsided.

Use metal spikes to anchor each end of a length of thin nylon cord. Rub chalk or charcoal along the line and "snap" the taut thread against the wall to leave a marked line.

METHODS OF TRANSFERRING FRESCO DESIGNS

The grid system
Transfer the scaled-up grid to the wall using vertical plumb lines and horizontal snaplines. Copy the design square for square, freehand or by pouncing, indenting or projection.

Pouncing
Lay the cartoon over the damp plaster. Hold the dry powdered pigment in a small muslin bag and dab it along the perforated outlines in the paper so it marks the wall.

Indenting
Lay the cartoon over the damp plaster and draw over the lines with a sharp wooden or metal spike – a nail will do – in order to indent the outlines into the plaster beneath.

Projection
Photograph the image and project it on to the wall to the desired size. This must be done at night for an exterior wall and in subdued light for an interior wall.

Dusting or "pouncing"

A traditional method of trans-
ferring the image from cartoon
to wall is dusting or "pouncing"
(*spolvero*) powdered pigment or
charcoal through holes pricked
along the lines of the cartoon.
Special perforated wheels may be
bought for the purpose. When
the paper pattern is removed,
small pin-pricks of pigment
combine to form outlines on the
wall. This technique may be used
on the *arriccio* and later on each
section of the *intonaco*, where the
image will be clearer.

Indenting the outline

An alternative, and cleaner,
method of transferring the
relevant part of the design to the
intonaco is to scratch the outline
of the design through the cartoon
paper into the damp plaster with
a sharp implement.

Drawing freehand within the grid

Another method of
applying a less precise, broad
design to the *arriccio* is to lay a
grid on the wall, using plumb
lines and snap lines, and work
freehand from square to square,
reserving the marking of more
detailed outlines for the *intonaco*.

Projecting the image

Nowadays, it is possible to avoid
the more time-consuming meth-
ods by projecting a transparency
of the design, or of relevant sec-
tions of it, on to the wall itself.

If the wall is so large that the
design has to be photographed in
sections, the grid superimposed
over the drawing must be
reproduced precisely to scale on
the wall itself. In addition, the
same camera lens should be used
for each slide, with the camera
absolutely parallel to the picture
plane and centered on each
section of the image. When the
slides are projected, the same
lens must be kept on the
projector, which should remain
on a line exactly parallel to the
wall and centered on each section
of the image, even though this
may mean using a scaffold tower.

MEXICAN *BUON FRESCO* MURAL

This fresco by the great
Mexican muralist Diego Rivera
was commissioned by the
Ministry of Education in
Mexico City. Painted on his
return from the Soviet Union
where he was a Mexican
delegate to the Soviet
Communist Party Congress of
1927, it is part of a series of
28 panels illustrating verses to
two poems by José Guttierez
on the theme of the Revo-
lution. This panel attacks the
plutocracy of Mexican society
and has a companion panel,
Night of the Poor. Rivera was an
outstanding twentieth-century
master of *buon fresco*, turning
the directness and simplicity
of the medium to powerful
artistic and political use.

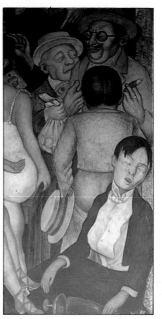

Night of the Rich (1927–8) by
Diego Rivera.

PIGMENTS AND PAINTING METHODS

Only the most permanent
pigments may be used in *buon
fresco* painting, especially for
exterior work. Not only do they
have to be lightfast but, since
lime is so alkaline, they must be
fast to alkali. They should also be
resistant to acids and other
pollutants in the atmosphere. No
pigments that contain soluble
salts may be used, since these
may cause a white efflorescence
on the surface of the wall (see
p.239).

The artificial iron oxide
colors (the Mars colors) –
which include red, violet, yellow
and black – are excellent
pigments for *buon fresco* painting.
The blue and green cobalts are
equally permanent, as are
Cerulean Blue and Manganese
Blue. Among the greens, Oxide
of Chromium and its hydrated
form, Viridian, are recommen-
ded. The slaked lime itself is
generally used for white.

The pigments should be
ground as finely as possible in
water and applied directly to the
wet plaster with no further
binding medium added. Distilled
water may be used as a pre-
caution against possible adulter-
ants in the tap water. Lime water
may also be used to grind
pigments, but this can increase
their opacity. Indeed, if an
opaque, but slightly lighter-toned
effect is required, all the
pigments can be ground in a mix
of slaked lime and water.

Painting technique

The taking-up of the pigment by
the wet wall is similar in a way
to that of the absorbent gesso
ground in egg tempera painting.
There is the same finality about
each brushstroke since, once
made, it cannot be erased –
unless a patch of plaster is
physically removed and replaced.
In both techniques, layers of
paint can be superimposed and a
depth of tone and color built
up. In the *buon fresco* method,
there is perhaps even more
clarity in the strokes or washes,
which stay precisely where they
are placed without running.

"DRY" WALL TECHNIQUES

Unlike *buon fresco*, dry wall methods are used on a wall which has dried. The most traditional form is *fresco secco*, which is carried out on a lime plaster wall, which is thoroughly soaked with lime water the day before painting starts, and again on the morning of painting. A binding medium such as casein, glue size or egg is generally added to the paint, although this may be omitted for internal use. *Fresco secco* has fallen out of use due to the fact that modern plastering materials tend not to accommodate the old techniques, which used slaked lime. Other more modern systems have superseded it.

·External mural painting·

The main problems associated with external mural work are damp, dust and the resulting lack of adhesion of the paint, the effects of the weather and of acids and pollutants in the atmosphere. Any non-permanent pigments soon fade.

An external wall can be painted in a number of ways, but the most permanent method is probably mineral (potassium silicate) painting (see p.239). This is a technique where permanent, lightfast mineral pigments ground in distilled water are applied to a calcined-flint rendered wall which is subsequently sprayed with a fixative. The pigments become chemically bonded with the wall in a way that parallels the carbonation in the *buon fresco* method.

PAINTS FOR EXTERIOR WORK

An external surface such as brick, render or concrete may be painted using exterior-quality, water-based vinyl-resin or acrylic-resin based paints, since these have a permeable paint film which, to some extent, allows the free passage of water vapor. If a solvent-based paint system is used, water vapor can build up within the wall, causing the less permeable oil film to flake off the support. A painting made with acrylic-based paints on an external wall will still have a relatively limited life, depending on the type of wall, the quality of the paint, and the weather. Some exterior murals painted on the west coast of America in "Polytec" acrylic paint have survived well for over two decades.

For *fresco secco* painting, pigments are ground in lime casein — a liquid made by grinding fresh curd (cottage cheese) with slaked lime in proportions of about 5:1.

RENDERING A BRICK WALL

In order to give a brick wall a uniform surface for painting, it is generally rendered in sand and cement. The brick wall must be free of crumbling mortar and dust, so this is generally brushed out with a wire brush followed by a stiff yard brush. Any algae is treated with a proprietary fungicidal wash which is left for twenty-four hours before being washed off and the wall allowed to dry.

The use of a bonding agent like "Unibond" or similar PVA-based materials can improve the adhesion of the render. The day before rendering, the wall is painted with a dilute coat. The proportion of PVA to water should be 1:5 or 1:6. Another coat is applied just prior to plastering, so that the wall is tacky when it is plastered. Washed pit sand is mixed with the cement; this is far less likely to cause efflorescence than sea sand. "Sharp" or coarse sand is used for the first coat, in the proportion four or five parts sand to one of Portland cement. It may be mixed with diluted PVA instead of simply with water, but this is not entirely necessary.

The first coat

This is a light coat which eliminates the unevenness in the wall and gives even suction to

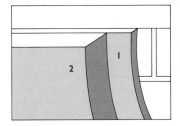

Preparation of brick wall with sand and cement for "dry" wall mural painting
1 Sand and cement render in proportions of 4 or 5:1 (3–6mm/⅛–¼in thick)
2 Sand and cement render in proportions of 3½ or 4:1 (1.5–1.8cm/⅝–¾in thick)
On an internal wall, an optional finishing coat of plaster (1–2mm) may be applied.

the second coat. The first coat is scratched to give a key to the second coat which is applied the following day. The strength of a coat of render is in the aggregate rather than in the cement, which is merely the setting agent.

The second coat

The next coat of plaster uses a finer mixture of sand, but it is usually still a medium to coarse mix. The proportion of sand to cement is around $3\frac{1}{2}$ or $4:1$. Fine sand which is used for brick-laying mortar does not have the body for plastering. The second coat is floated and rubbed up to the required finish. As with all finishing for subsequent painting, the surface should not be too smooth. Before being painted, the wall should be left to dry out thoroughly and this may take several weeks.

Efflorescence

Efflorescence is the appearance of soluble salts on the surface of the wall in the form of a powdery white substance. This is generally either the result of impurities in the sand and cement mix, or a reaction between materials in the render and the brickwork itself. Most newly applied render will exhibit some form of efflores-cence, especially if the brick-work is also new. If the brick-work is old, the impurities will have come out and the salts weathered off.

Efflorescence is provoked by damp and, once the wall has dried out completely, it will become inert so that any deposits may be brushed off and the surface painted. But if the surface is painted before it is dry, efflorescence will have a damaging effect on the paint film. There is always a varying degree of moisture in the dry wall and it is for this reason that the paint film should have some degree of porosity.

Rendering a sooty wall

In areas where a brick wall has been blackened by soot,

thorough washing and subsequent coating with PVA will not prevent the soot from staining the render. The only solution is to make a slurry with fresh cow dung and water. Apply one coat with a brush, let it dry and apply another coat. When this is dry, the plastering can proceed as above and the resulting render will show no staining. This may sound medieval, but it works well in practice.

A note on wetting the wall before plastering If a more traditional method of plastering is employed (without the use of PVA), a porous common brick or insulation block wall should be merely flicked with water. It should not be wet, but just slightly damp. No water should be used for engineering brick or a marble block otherwise what is put on will slide off as the wall repels the water.

RENDERING OTHER SURFACES

A smooth concrete or ceramic tile surface will have been "keyed" in the past with a slurry made from neat cement and coarse sand chippings which would have been dashed on with a brush, left for twenty-four hours and rendered as above. Nowadays, the proprietary PVA adhesives are used instead to establish a bond between the render and the wall.

PAINTING THE WALL

However the wall is painted, it should be stressed that — especially for lighter colors — at least two coats of paint will be required to obliterate the tiny dark points on the raised parts of the render.

Form concrete can be painted in a similar way to sand and cement render, though it provides less of a key to the paint. The problem of adhesion is

compounded if the concrete is at all "green" – it must be thoroughly dry before painting. Another problem is that, when the concrete has been cast, the mould-release agents based on silicone wax and oil with which the shuttering has been coated, will probably still contaminate the surface of the concrete. So this has to be washed down thoroughly with a detergent, then rinsed with clean water and allowed to dry before painting can begin.

Using commercial vinyl- or acrylic-based paints Most high-quality, exterior-grade commercial masonry paints are based on vinyl or acrylic co-polymers or ter-polymers. That is, they incorporate up to three different polymers in the emulsion to provide a paint medium with all the character-istics of durability, strength, flexibility and porosity required for a reasonable exterior life-span. They are water-thinned and incorporate inert fillers, such as quartz aggregate to provide body and strength, and lightfast, alkali-proof pigments.

The problem with these paints is that they are generally only available in white and very pale color tints so, unless you are prepared to work within an extremely limited tonal range, the depth of pigmentation has to be greatly increased. Adding large amounts of aqueous dispersions of pure pigment to the proprietary paint mix inevitably reduces the strength of the paint film and may break it down altogether. The commer-cial paints are mainly pigmented with Titanium White and they rely on its opacity to cover blemishes or stains in the wall. This means that, even if you add more pigment, you are limited to opaque or body color techni-ques. One possibility for working in thin, transparent techniques might be painting the wall with two coats of white exterior masonry paint and then working

over that with a thin, staining film of high-tinting-strength permanent transparent pigment from the acrylic range of the artists' materials manufacturers. The paint could be diluted with a mixture of water and a harder acrylic emulsion than that normally used to bind the paint.

Using oil-based paints

Oil-based paints are not recommended for masonry surfaces. The reason is that the wall needs to breathe – to allow the free passage of water vapor with adjustments in relative humidity and in the moisture content of the wall. An oil film is largely non-permeable and the build-up of mortar behind it can cause it to flake off. In addition, such walls are generally highly alkaline, a fact which suits the alkalinity of acrylic paints but is antipathetic to the oil film, which is more acid.

PERMANENT PAINTING WITH "KEIM" MINERAL PAINTS

The "Keim" mineral paint system is distinct from other paint systems, apart from the *buon fresco* method, in that it is non-pellicular (film-forming). It was invented in 1877 by Adolph Keim, who decided that a paint system for plaster walls would only be permanent if it was chemically compatible with the wall itself. The major constituent element of the sand, stone and rocks which provide the plaster was silica and so the system devised was to apply pure, finely-ground alkali-fast mineral pigments in distilled water to a highly silicious render and then to fix them by spraying on an aqueous solution of potassium silicate. This hardened with the evaporation of the water to form a hard and permanent bond with the plaster, but it left the plaster porous so that water vapor could continue to pass freely through the render. This is the basis of a system which is

commercially available from its German manufacturer as the Type "A" Keim paint system.

The Keim method in practice

A normal sand and cement float render is applied to the wall to be painted, then a "calcined flint" finishing coat is applied. The calcined flint render is more open to the penetration of the paint than an equivalent sand and cement render would be, though the latter – especially if wood-floated, and with a more open surface, could be used provided no waterproofing elements such as PVA were in the mix. The "open" surface of the plaster is a crucially important aspect of the Keim system. The proportions of the finishing coat are five parts calcined flint, two to three parts white cement and one part white lime.

Next the wall is coated with a proprietary Keim silicate primer which gives a uniform white painting surface. This is not strictly necessary as the system would work just as well directly on the calcined flint render. The plaster is then etched by being given two coats of a proprietary etching fluid diluted with water, which is then washed off. The effect of the etch is to expose mineral particles on the surface

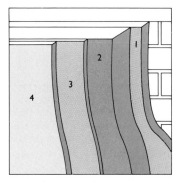

Preparation of wall for "Keim" method mural painting
1 Sand and cement float render
2 Calcined flint render finishing coat (5 parts calcined flint, 2–3 parts white cement, one part white lime)
3 Keim silicate primer
4 Two coats proprietary etching fluid

of the render and so ensure a good bond with the fixative.

The wall is wetted with distilled water before painting. The finely ground mineral pigments dispersed in distilled water are supplied by the manufacturer. They are painted directly on to the wet wall in thin, transparent layers. They may be mixed with white and applied opaquely, but the paint layer should not be too thick, otherwise it will not be penetrated by the fixative and anchored to the render. The pigment is so finely ground that it performs like a soluble dye, staining the render wherever it is applied.

Mixing colors

If two pigments are physically mixed to produce a third color, an almost inevitable separation will occur due to the different weights of the pigments, and because they are not bound in a viscous medium. It is better to create third colors by the separate application of transparent layers of two colors, as in the watercolor color-mixing techniques shown on pp.158–9.

Fixing the paint

The silicate fixative supplied by the manufacturers should never be used in its concentrated form. If it were, it would merely "sit" on the surface of the wall. Instead, it is diluted with distilled water in the proportion one part fixative to three or four parts water. The diluted fixative is sprayed over the area which has been painted at the end of a day's work.

Use just enough fixative to stabilize the work, but not so much that the wall is oversaturated. The best method is to use a wad of tissue or absorbent cloth to dab the wall after spraying – it should not be left to dry on the surface. Artists who wear spectacles with glass lenses should not wear them while spraying; the fixative may stick to them, solidify

and ruin them.

Several increasingly concentrated coats of fixative can be applied, but take care that there is still suction to the wall as a painting can be overfixed. Gauging the precise amount is partly a matter of experience.

The effect of the fixative is to transform the mineral pigment into hard silicate. It chemically binds the silicate paint to the silicate of the wall. It leaves the wall highly alkaline with a pH of around 12, so that – to some extent – it is self-protected from attack by acids in the atmosphere. It also leaves the wall porous, preventing the loss of paint due to water vapor.

Sections of concrete painted with ordinary and Keim paints
The ordinary oil, emulsion or polymer paint (left) rests on the surface, forming an impermeable skin. The Keim paint (right) penetrates the surface and anchors itself well inside, leaving the surface permeable to water vapor pressure.

Details of Keim-painted mural
This mural was painted in Keim silicate paint on calcined flint render. *The Construction Workers* (1976–7), by Desmond Rochfort.

·Internal wall painting·

There is a great deal more flexibility in the choice of painting medium for internal mural painting, since most of the established media can be used. Acrylic paints are probably the best choice for work on plaster (see p.241), though it is possible to work in oils if a plaster sealer is used. Size paints, cellulose paints, egg tempera and encaustic may all be used, though the two former may be best suited to temporary decoration such as scenery, and the two latter, which take longer to build up, to small-scale works.

SUPPORTS

Many artists prefer the slightly gritty tooth of a sand and cement render to that of plaster as a support for interior wall painting. Sand and cement render can be applied to expanded metal supports.

Sand and cement render
This usually includes a PVA bonding agent and, as for exterior work, it should not be floated too smoothly. With an expanded metal support, a light first coat is applied, followed by a floating coat and a finishing coat. White cement and a white sand, such as a Derbyshire white spar, can be used for the finishing coat if a white finish is required.

Otherwise, when the render is completely dry, it can be given two coats of a proprietary white acrylic primer.

Gypsum plaster
The modern methods of plastering internal walls, as opposed to the old sand and lime mixes, use one set hemi-hydrates – such as the gypsum/vermiculite mixes (sold in the form of a bonding and a finishing coat). The vermiculite, a lightweight mica aggregate which takes the place of sand and is considerably lighter and more reliable, swells when water is added. It is coarser in the bonding than in the finishing coat. There are two different varieties for different types of substrate. If applied to expanded metal, a tight coat about 1–2mm thick is applied to skim the metal. Just before it goes off (sets), it is scratched, and another coat of the same material (same thickness) ruled in then leveled out. This goes off in one and a half to two hours and is scratched ready for a fine finishing coat.

A similar product made for walls with suction such as brickwork can be applied directly up to 1cm ($\frac{1}{2}$in) thick, then given a 1–2mm finishing coat. On concrete, or non-porous surfaces, another version of the same plaster should be applied in a tight 1–2mm first coat and then in a 3–4mm floating coat. This is then given a 1–2mm finishing coat.

Other plasters include the one-coat finish plasters which can be applied direct to the sub-strate, ruled in, leveled out and troweled off in one operation.

Plaster is a suitable support for interior mural work, but there are two factors which must be considered. First, the plaster must be completely dry – a process which may take several weeks. This can be tested with a moisture meter. If there is any moisture in the substrate or in the plaster and a solvent paint system is used, the moisture will be trapped and the paint will come off.

Second, the plaster must not be over-troweled (have a very smooth surface), otherwise there will be poor adhesion between paint and plaster and the paint will fall off.

PREPARATION OF INTERIOR WALLS WITH GYPSUM/ VERMICULITE-TYPE PLASTER

Concrete non-porous substrate
1 Sand and cement render – tight first coat (1–2mm thick)
2 Sand and cement render – floating coat (3–4mm thick)
3 Sand and cement render – finishing coat (1–2mm thick)

Substrate with suction (eg brick)
1 Sand and cement render – up to 12mm($\frac{1}{2}$in) thick
2 Sand and cement render finishing coat (1–2mm thick)

Expanded metal substrate
1 Sand and cement tight coat (1–2mm)
2 Sand and cement floating coat (1–2mm)
3 Sand and cement finishing coat (1–2mm)

Suiting the paint to the support Acrylic- or vinyl-based paints work best on sand and cement render or gypsum plaster. The alkalinity of these surfaces is compatible with that of acrylic paints, but not with the more acidic oil-based ones. It is possible to paint on plaster with oil-based paints, but an alkali-resistant primer needs to be used. In addition, the oil film or oil-modified alkyd-resin film is far too impermeable to be safely laid on to a porous substrate which requires the unobstructed passage of water vapor. The micro-porous acrylic film is far more appropriate in this respect than an oil film.

PAINTING ON A LARGE SCALE

Most of the painting techniques described in the earlier chapters of this book may be adapted to large-scale mural work, using larger brushes and tools. Clearly, only hard bristle brushes are suitable for a fairly abrasive surface such as a sand and cement render, and even these wear down rapidly.

Artists who work on a large scale are aware of the difference in the feel of an image when scaled up from how it looks in a a small-scale study. For this reason, the grid method of transposition from study to wall, which allows little modification of the image, is often dispensed with nowadays in favor of projection systems (see p.235).

These can change the size, position and angle of the intended image rapidly, allowing a greater degree of flexibility and experimentation. On a large wall, for instance, an image may be viewed from a number of optimum viewpoints relating to the architecture and the space. It is possible to create multi-plane images in which part of the image, for example, when seen from the front may appear as an amorphous, distorted shape, but resolves itself into a normally perceived representation when viewed from a particular angle (see *Anamorphism*, p.305). The effectiveness of such ideas can easily be tested by projection methods and these can help the artist to ensure that every aspect of such a work is appropriate to the space. For the mural shown below, the position of the imagery was arrived at by the use of projectors, so various images of differing scale were tried out in various positions until the most appropriate scheme was found. The combination of the ''apocalyptic'' imagery with the pin-ball machines and computer games created a lively interior.

Mural based on a child's drawings In this mural for a university games room, images were scaled up and painted in acrylic paint on the acrylic-painted plastered surfaces of walls and ceiling.

LAMINATE PAINTING

The use of laminates for wall decoration has been extensive since the mid-1930s, and architects have been able to specify colors and textures for cladding walls and working surfaces from a wide range of "off-the-shelf" products currently available from manufacturers. The advantages of the laminate surface are that it is tough, permanent and washable, which makes it particularly suited to busy public areas. A number of surface finishes are available, ranging from glossy through matt to a rough, uniformly indented texture. In the past, commercially available laminates have usually been plain colors or imitations of wood grain or material textures. But, more recently, manufacturers have created "designer" ranges which take the medium further, including more interesting and creative designs.

Many people are unaware, however, that artists can create their own original works in laminates by painting in acrylic paint on the melamine-resin-impregnated paper normally used to give a color or design to the laminate surface — this is done before the hot-press bonding process which transforms the sheets of resin-impregnated paper into the laminate sheet (see description below).

·The laminate process·

A cross-section of a sheet of laminate shows a brown core with a thin white or colored facing top and bottom. The facing paper on top displays the color, design or painted surface of the laminate. A similar facing on the back prevents warping of the sheet. The top and bottom sheets are of absorbent paper impregnated with melamine resin. The middle section, or core, comprises sheets of brown paper impregnated with phenolic resin.

Once the paper has been impregnated with resin and dried, a "sandwich" is made, comprising a protective transparent overlay, the face paper, as many sheets of brown paper as are required for a particular thickness of laminate (up to 12mm/$\frac{1}{2}$in) and the backing paper. These sheets are placed between press metal plates, the surface of the top plate determining the nature of the surface (matt or glossy) the laminate will have. The plates are pressed together in a hot press at a temperature of 150°C. The thermosetting resins melt and fuse and, when cool, form the rigid laminate sheet. The edges are trimmed and the laminate is ready for use.

Laminate is normally bonded to chipboard for use as an internal wall cladding, but it can be glued directly as 3mm ($\frac{1}{8}$in) sheet to a smooth plaster or wooden wall using proprietary glue and pad methods. It can also be bonded to aluminum and other metals, plastic foams, gypsum and cement. It is, broadly speaking, permanent in external use.

HAND-PAINTED LAMINATES

Producing your own laminates involves the use of industrial facilities. You can obtain 3 × 1.25m (10 × 4ft) sheets of melamine-resin-impregnated paper from the laminate factory. When your hand-painted design is completed, the paper is sent through the factory along the same production line as the thousands of sheets of plain or decorative papers that make up its main output. So there is a certain risk attached to this method of painting although, in my experience, manufacturers are sensitive to this aspect of hand-painted laminates, especially if you establish a personal contact with the factory.

Supply and delivery of resin-impregnated paper You can paint on any color of paper, subject only to what the factory can supply. However, the paper is extremely brittle, especially when it is cold, and must be handled with great care. You should always wear gloves when handling it, as dirty fingerprints can easily soil the surface and are almost impossible to remove.

I have had a flat packing case constructed for the supply and delivery of the paper. This is rather bulky, and an equally satisfactory method is to have sheets sent from the factory (or

Preparing a laminate panel in the factory

1 Two sections from a mural painting made on several sheets of paper are prepared for lamination

2 A sheet of transparent protective overlay is carefully unrolled over the surface of the painting.

3 The brown paper core is laid out prior to the painting and transparent overlay being placed on top.

4 The sandwich of different layers for lamination is laid between two metal sheets and placed in the hot press.

5 The laminated panel is lifted out of the press and the surplus paper at the edges carefully trimmed.

6 When all the panels which make up the mural are laminated, they are assembled and checked for fit.

The finished mural in situ
The mural was specially commissioned for a school, where the four laminated panels which make up the design were attached to the wall separately using strong adhesive fixers.

The tough, permanent surface of the painting is ideally suited to withstand the wear and tear resulting from its situation – on a busy stairway landing in the school.

to collect them) rolled on a plastic tube with a diameter of at least 20cm (8ins) – preferably larger. The sheets should be interleaved with thin newsprint and the width of the roll should generously exceed the width of the paper. The roll should be well protected during transit with polyethylene bubble-wrap or corrugated cardboard and the paper stored flat in the studio.

Size and format of resin-impregnated paper
Always work on the complete 3×1.25m (10×4ft) sheet of paper as supplied by the factory. Before starting to draw or paint, attach the sheet to a smooth, flat wall or to the floor of the studio with

masking tape. To allow for trimming after bonding, the paper is larger all round than the standard laminated panel size, so the edge is useful – not only for attaching to the studio wall, but also for trying out color combinations before using them.

Working on a large scale
If the area of the painting comes within the 3×1.25m (10×4ft) format, there are no problems with any adjoining edges. For a larger format, two panels can be abutted and painted up to each other. When you send the paper to the factory, stress that only three edges of the facing paper are to be trimmed on each sheet. In this way, the two halves of the

image will join perfectly when the work is assembled.

For an even larger mural painting, a grid system of working square to square as accurately as possible is the only means of ensuring a continuous image through several separate panels. If you know where the joins will come, you can conceive the work so as to ensure, for instance, that half a face does not appear on one panel with the other half on another. This is an important point, since the dimensional stability of the paper can be a problem, with as much as a 3mm ($\frac{1}{8}$in) distortion over the 1200mm (48in) width as the paper is run through the drier before bonding.

——·Drawing and painting techniques·——

The resin-impregnated paper takes pencil, pastel and charcoal, and retains them after bonding. Pastel and charcoal can be fixed by spraying with an unpigmented acrylic emulsion. The best all-round paint is acrylic, which can be used in a number of ways (see *Acrylics*, pp.208–27). The paper has one particular feature which distinguishes it from other supports – its absorbency. So, when working with thin washes of acrylic color, for instance, a mark made by the brush is almost immediately absorbed into the paper, allowing no time for softening of edges or blending (as is possible on normal, sized paper). This feature may be exploited by the artist (see below). The absorbency of the paper seems to vary according to its color and is particularly marked on white, for which some manufacturers use a slightly thicker paper.

PAINTING IN THIN COLOR WASHES

When acrylic paint is thinned to a "watercolor" consistency, each brushstroke leaves its mark on the absorbent paper. The effect of overlaying colors is to create a variegated texture.

The study of Roman portrait heads (below) demonstrates the use of thin acrylic color on white paper.

In the fish study detail (below right), the shapes of the fish were first protected with masking fluid (see p.245), applied fairly thickly and allowed to dry. Then, with the panel horizontal, thin Phthalocyanine Blue and Phthalocyanine Green paint was dripped on to the paper, which quickly absorbed the drops of liquid paint. These spread into soft circular shapes. The overall green background color was sprayed on and the work allowed to dry. Finally, the masking fluid was rubbed off to reveal the intact white paper, and the red and black added on the fish shapes to complete the study.

PAINTING WITH THICK ACRYLIC PAINT

Paint can equally well be used thickly on resin-impregnated paper. For example, the scraping technique described for acrylic paints (see pp.223–5) lends itself well to lamination. "S'graffito" techniques, where lines are scraped out of thick paint, may also form part of a design. Where paint is applied very thickly, the effect of the heat-pressing process may well be more noticeable.

Scraped paint technique
Here, paint was scraped with a plastic straight-edge over the surface of the paper to a depth of about 1mm. The heat of the bonding process has had no noticeable effect.

Painting made in thin acrylics
Where the heads are in shadow, deeper tones were made by over-laying more thin washes and drying them with a hair-drier. Three colors were used in the background – Phthalocyanine Blue, Quinacridone (Red) and Burnt Sienna (see detail).

Using the natural absorbency of the support (detail) Here the inherent absorbency of the paper was exploited using a drip technique.

Thicker scraped paint
Here thicker paint (2–3mm in depth) was scraped through a stencil. The hot press had the effect of "melting" the paint; this is clearly visible in the bleeding around the edges of the fish.

THICK AND THIN PAINTING TECHNIQUES

As in normal painting, it is quite possible to combine thick and thin paint techniques in a laminate painting. This painting of a medieval figure includes scraping, s'graffito, masking fluid, spraying, stippling, sanding and glazing. The painting was made on black resin-impregnated paper. Before work was begun, the edge of the painted area was protected with masking tape to keep it crisp. White acrylic paint was scraped over the whole area and the image drawn on by incising through to the black paper with screwdrivers. Brown and yellow paint was sprayed from different directions to produce the mottled background.

The painting was gently worked over with an orbital sander fitted with fine sandpaper. Opaque paint in the face and areas of the figure was partly rubbed off while it was still wet. Some of the black incised lines were painted in to add definition, the paint wiped into the crevices with a tissue and allowed to dry. Finally, the whole image was glazed with transparent blue paint and gently sanded again.

USING MASKING FLUID

The absorbency of the resin-impregnated paper tends to make masking fluid soak into the surface. It is subsequently difficult to rub off. This "partial effectiveness" can be exploited to produce a mottled effect. If the shape to be masked out needs to be precise, two or three coats of masking fluid should be used, or it should be used over dry paint already on the surface of the paper.

The effect of masking fluid on laminate paper The fish shapes were masked out with masking fluid which was partly absorbed by the paper, giving them a mottled look.

PAINTINGS FOR PUBLIC AREAS

Public areas are particularly suited to showing original laminate paintings, since the surface is so robust and easy to clean. The fish mural painting was made for a busy public area in the accident and emergency department of a major hospital. Here, the laminate was bonded to 15mm ($\frac{5}{8}$in) chipboard at the factory before being secured to the wall. The painting was made on a full sheet of white impregnated paper. Several layers of fish were built up using the masking fluid techniques outlined above – hand-painting the fish and spraying the background with a spray gun.

In the second example from the same hospital, 3mm ($\frac{1}{8}$in) hand-painted laminate was bonded directly to the wall. Here, the design repeats from one panel to the next and yet does not rely on completely accurate positioning to read as an overall pattern.

Combined techniques
This painting on black resin-impregnated paper was made using a combination of thick and thin acrylic paint.

Masking fluid and spray technique This fish-tank painting (above) used the technique of masking out fish shapes and spraying the background.

Mural on blue resin-impregnated paper (left) The brightness of the colors was accentuated by white underpainting.

STAINED GLASS

Images can be created on glass by painting or "staining" with pigments or by etching with acid. Glass itself is made by heating silica (in the form of siliceous sand, quartz crystals or flint pebbles) with a flux (such as soda ash) to aid the fusion process, and a stabilizer (lime) until it is dissolved. The molten glass mixture is then shaped and cooled.

·Glass painting·

When painting on glass, the contours of the image are usually defined by strips of lead. These enclose separate pieces of the glass which are painted to define the features and three-dimensional form of the image. Traditionally, the features are defined with opaque black lines and the half-tones and shadows by "matting" (see below). The painted glass is "fired" in a kiln, causing the paint to melt with the glass.

THE GLASS

The best glass for stained glass work is known as antique, or "soft", glass and is made by hand. It is made from a bubble of molten glass which is blown into a long, sausage-shaped balloon. The molten glass may be colored by the addition of metal such as manganese, cobalt, copper or iron oxides. The two ends of the cylinder are cut off and the shape cut along its length. It is cooled at a regulated temperature and flattens out to form a sheet.

GLASS PAINT

The powdered paints which are used for painting on glass are generally a mixture of glass dust and iron oxide with a flux incorporated. They are used in a semi-opaque form, since the full-strength colors would show black on the glass against the light. Modern "Cathedral" colors, which come in a range of blacks and browns, are finely ground and generally only need to be worked with a spatula and distilled water on a slab for a few minutes before they are ready to use.

Transparent enamel colors

These are the same as the ceramic on-glaze enamels used for painting on tiles (see p.252). They are available in a wide range of all the main colors, with the blues and greens being particularly good. They are applied in the same way as the glass paint described above, but they are fired at a lower temperature (around $550°C$). Enamel colors tend to look as though they have been painted on to the surface of the glass rather than being an integral part of it. If fired at higher temperatures, a more "fused" effect is created, but the colors become rather lighter in tone and may even change color. If mixed with gum arabic and water, they may be screen-printed on to the surface of the glass (see p.281).

Using transparent enamels
Abstract effects can be achieved simply by flooding different transparent enamel paints on to a piece of glass which is then fired.

BINDING MEDIUMS

The binding medium used for glass painting is burned off in the heat of the kiln. It serves merely to hold the paint together and to give it some temporary adhesion to the glass. To a certain extent, it can inhibit resolubility and allow for further manipulation of the paint on the unfired glass.

Gum arabic

The most common binding medium for glass paint is gum arabic. In its powdered form or in solution, it can be mixed in with the pigment powder and distilled water with a spatula. The pigment powder may also be ground in oil if a more viscous mixture is required for manipulations which involve working the paint for longer than the gum mixture allows.

Acetic acid

Acetic acid is also used in a 40 per cent solution added to the paint mix. If this is unavailable, vinegar – which is a rather weaker version – may be used. Its function is to harden the paint layer, so that subsequent layers may be applied before firing without disturbing the layer beneath.

GLASS PAINTING TECHNIQUES

The basic design of the image is first outlined on a pattern called a "cut line", where all the shapes are drawn to size prior to any painting, staining, enameling or etching. The cut line shows each piece of glass within the overall design, with a gap between them of the same thickness as the core of the lead which is used to join the pieces together. Each piece of glass is cut well within the line of the pattern. If it were cut over it, the whole design could move out of shape, which would be disastrous when working within the dimensions of a specific window frame. If the glass is cut accurately, the leading will be accurate too. The paint is applied with the glass laid on the surface of a large electric lightbox.

Painting opaque lines

The best brush to use for painting simple, solid lines is a round long-haired brush such as the rigger or striper (see p.132). The paint should be quite liquid but rich in pigment, like liquid poster paint. The brush should be well filled and a "river" of paint pushed along the glass. If the stroke is made too quickly, it will become too light and, when fired, lose even more opacity.

Matting

The method of achieving a half-tone or a graded tone effect is known as "matting", where a thinner overall tone of paint (the matt) is applied.

If glass is to have both line and tone on it, the line work is generally painted first, in which case acetic acid may be used to harden it. After this, the matt is applied. Practically any brush can be used to apply this very liquid paint. For large areas, a bristle brush is preferable to a soft-hair one, as the paint can be moved around more effectively.

However carefully it is applied, the paint will look uneven because the glass has no porosity or texture to hold the pigment particles in place. If a graded tone is required, more pigment can be laid into the deeper toned areas. For the even-toned effect, the paint has to be modified after application, in much the same way that oil glazes are blended or adjusted with dry brushes (see p.202).

So, the next stage is to "whip" or "flog" the matt, using a dry badger brush in a light sweeping movement across the glass. The brush hardly touches the surface at all, but it creates a beatifully smooth gradation or even tone across it.

Stippling

Within the warm atmosphere of the studio, the water in the paint soon evaporates and the paint film dries out. If the tone still has inconsistencies in it, or if a different kind of tonal effect is required, the badger brush may be used vertically in light dabbing strokes to produce a stipple effect.

S'graffito

The matting technique described above may be adapted with a slightly thicker paint mix to produce an evenly opaque layer of paint on the surface of the glass into which imagery may be scratched or scraped. Any tool may be used, including needles, nails, screwdrivers, steel combs, brushes, wire wool and finger nails. The finger tips can also be used to gently rub away the applied color. While the paint layer is wet, various textured materials may be pressed into it so that an impression is formed in the glass.

Spray-painting glass

The glass painting pigments are ground finely enough to allow them to be sprayed through conventional spraying equipment. It is possible to use an airbrush, though more consistent effects can be achieved with a larger gravity-feed spray gun, which allows both uniform and graded matts to be achieved to almost any depth of tone.

Staining glass

The only true glass stain, as opposed to glass paint, is silver nitrate. This actually permeates the glass in a way that glass paints do not. It is yellow in color and stains in when fired at $620\,^{\circ}$C. The higher it is fired, the more orange and red it becomes. It is available in powder form, and is mixed with water.

Sandblasting

Sandblasting is a quick and relatively safe method of permanently frosting or matting areas of glass using a special machine.

One type of sandblasting machine is much like a vacuum cleaner, with an inner nozzle which blows out grit and an outer nozzle which sucks it up at the same time. Around the head of the nozzle is a skirt in the form of a stiff brush. The nozzle is held close to the glass in the area to be sandblasted, or passed over the surface of the glass in smooth horizontal movements for larger areas. A fine abrasive, such as emery powder, is generally used on glass. Suitable masking-out materials for sandblasting are "Fablon" and heavy-duty adhesive tape.

If both sides of the glass are sandblasted in partially overlapping areas, the combination of two tones produces darker color where the overlap occurs.

Using a grid
This piece of glass was painted with transparent enamel colors and then sandblasted through a grid to give a latticework effect.

FIRING GLASS

The pieces of glass to be fired are placed on metal trays containing a 1cm ($\frac{1}{2}$in) even layer of dry plaster powder. This allows the glass to move slightly in the kiln without risk.

The trays are pre-heated in the warming chamber of the kiln at a temperature of not less than 620°C. If a number of trays are to be fired at the same time, they should be transferred to the kiln as rapidly, but as carefully, as possible.

Once the kiln has reached the desired temperature, the firing itself only takes a few minutes. If the temperature is raised to over 700°C, the glass may begin to melt at the edges and the opacity of the paint may be fired away, but the paint will really begin to look like part of the glass itself.

After firing, the trays are transferred to the annealing (cooling) chamber as quickly as possible. The glass should be allowed to cool for as long as possible, preferably overnight. If it is cooled too rapidly, the thermal shock will cause the glass to crack.

LEADING UP

The pieces of fired glass are pieced together with strips of lead in a process called "leading up".

The cut line is taped to a wooden work bench and a right-angle of wood nailed to the bench at one corner of the design. The lead is cut into strips of appropriate length using a curved-blade lead cutter, and fitted to the edges of the pieces of glass. The corner-piece of the design is packed firmly into the right-angle of wood on the bench. Other pieces of glass are leaded up and the design built up from that corner.

Soldering and cementing

After leading up, the glass must be secured by soldering together the individual strips of lead and cementing them firmly in place. The lead should be cleaned with a wire brush or wire wool before soldering with a gas or thermo-statically controlled electric soldering iron. A tallow flux is generally used with blowpipe solder — ordinary plumbing solder will not do.

When one side of the panel is soldered, it is turned over and the other side is done. It may then be cemented. The cement mix is made from whiting, a little plaster and linseed oil. Mineral spirit can be added if the cement needs to be a little more liquid.

Leading up and soldering
The strips of lead are shaped like an "H" when seen in cross-section. Different sizes are made to accommodate various widths of glass (left). The joints between the strips of lead are soldered together (right).

Securing the leaded glass
The mixture should be pushed right around each strip of lead with a scrubbing brush so the whole panel will be solid (top). The excess cement is wiped off, scraped and cleaned when dry (above).

·Acid etching glass·

As well as painting on glass, images can be created by etching the surface of glass with acid. A hand-made form of glass known as "flash" or "flashed" glass is often used for this technique. This is white or colored glass which has a coating of a different color on one or both of its sides. It is made by dipping a bubble of molten glass into a crucible containing molten glass of another color. The glass is etched in a solution of hydrofluoric acid to remove partially or wholly the colored surface layer.

THE ACID

A solution of between 33 and 47 per cent hydrofluoric acid in distilled water is generally used in etching glass (the acid is added to the water, not the other way round). With flashed glass, the formation of a colored scum on the surface shows that the acid is biting. The glass can be taken out of the acid, rinsed off and checked periodically. At the end of the etch, it should be very thoroughly washed.

Sensible precautions must be taken when working with acid:
■ Always use an extractor unit to dispel the noxious fumes given off by the acid. If this is unavailable, the process should take place outside.
■ Use tongs to place the glass into the acid.
■ Wear gloves and goggles to protect the hands and face.

ACID RESISTS

In order to define the etched image, areas of the glass must be covered with an acid resist, or "stopping-out medium", a substance which will not be affected by the action of the acid and will leave the glass beneath unmarked. There are two main kinds of resist and these may be used to create a variety of etching effects.

Stencils

Sheets of adhesive-backed plastic sheet (the heavy type) can be used to make stencils for use on flashed glass. The plastic can be stuck on to the glass which is itself placed over a design drawn in black ink on white paper. This can easily be read through the glass and the plastic can be cut and removed with a scalpel. Adhesive-backed plastic sticks well to degreased glass and the acid tends not to creep into the design. However, the artist is limited to "hard-edge" shapes.

Different levels of etching
The amount of color removed from the glass depends on the length of time for which the plastic resist is left in place. A whole range of shades can be achieved.

Stopping-out varnish

Proprietary stopping-out varnishes can be used on degreased glass to create a wider range of tonal effects than are possible with plastic.

A single stroke made with a stiff bristle brush can be used to make a striated line in the glass which will etch in the areas where the stopping out varnish has "missed". It is also possible to stipple on the varnish to produce a more controlled tonal image.

A stopping-out mixture of one-third beeswax, one-third tallow, and one-third paraffin wax is said to respond well to techniques including fine line work, textures and stippling. The liquid latex paste masking fluids may also be used, but they are not generally so reliable, especially for etches that take a long time to complete.

COMBINING TECHNIQUES

This modern piece of stained glass demonstrates several of the techniques described above.

Stained glass design
The designs at the top were painted on acid-etched blue flash glass. The yellow shading is silver nitrate stain. The water area was masked then etched to leave the fishes (see detail). Glass paint applied in the blue area was rubbed and scratched for varied tones.

Silk-screen etching
Another method of using the resist is to put a half-tone (dot) screen on to a silk-screen and squeegee the stop-out through the mesh on to the glass (see page 287).

ACID ETCHING TECHNIQUES

The standard method of acid etching is to use an acid resist to retain defined areas of colored glass, as described above. Variations on this technique include using hydrofluoric acid on white glass to produce a subtle etch. If a "frosted" effect is required in the etched areas, then white (ammonia) acid can be used. More straightforward, though, is the sandblasting technique described on p.247.

It is also possible to achieve a wash-like gradation of tone from one area of the glass to another by having the acid bath at a slight angle, so that there is more acid at one end, placing the glass plate in the acid with the tongs and rocking it gently so that acid washes up it intermittently. This should be done through a glass-sided extractor unit, so that only the gloved arm holding the tongs is actually in the cabinet.

CERAMIC TILES

Ceramic tiles can be painted, printed, impressed and inlaid in a great many ways and at various stages in the production process. It is possible to create extremely complex images requiring many firings, or more direct, single-process images. Whatever techniques are used, the finished work will have the unique quality of the tile medium and also an extremely high degree of permanence that is difficult to achieve in any other medium.

·The manufacture of tiles·

Ceramic tiles can be hand-made – usually from red or white earthenware clays. Commercially-made tiles are manufactured in a number of ways: by extruding plastic clay through dies; by casting from slip (clay and water mixture) in plaster of Paris moulds; and, most commonly, by dust-pressing. This last method allows great control over the consistency of the tiles, which is why it is the method used for most domestic wall tiles. They are dust-pressed from a mixture of ball clay, china clay, calcined flint and feldspar. Lubricants and binders are then added for the pressing process. Dust-pressed tiles have a white body when fired. Unglazed fired tiles are known as "biscuit tiles".

MAKING YOUR OWN TILES

Clay is bought in solid blocks, sealed in polyethylene to retain around 25 per cent moisture. Whatever method you use for making the tiles, the block of clay must first be "wedged". This process involves kneading the clay like dough to remove any air bubbles, which would otherwise explode in the kiln. The method of rolling and cutting a tile is shown, right.

A spring-loaded tile cutter can be used to stamp out the shape, though cutting against a simple straight-edge or round a metal template usually gives the best finish. For a large panel, a large slab of clay can be rolled out using the same method then cut into tiles round a template.

Tiles can also be made in a hand tile press which can be found in most art colleges. This gives consistent results and any air remaining in the clay is expelled by the pressure.

Rolling and cutting a tile

1 Roll out the clay with a rolling pin on a piece of hessian (or similar backing fabric) to prevent sticking, between parallel wooden guides nailed to the bench. Coarse sand is sometimes used instead of hessian.

2 Cut the clay into square tiles using a knife and a template or straight-edge. Allow the clay to dry, turning it often to ensure it dries evenly. When it is "leather hard" – after two to ten days – it is ready to fire.

IMPRESSING RELIEF DESIGNS

This is done during manufacture by pressing the tiles into dies which can be cut or cast to the required shape from wooden blocks or resin. In a hand press a die is made to fit precisely into the bottom of the press. The clay is packed in and the machine then operated. To release the tile, the bottom section of the mould is pushed up by means of a foot pedal and the clay and die can be removed.

Even without a press, any object can be pushed into the clay to make a relief design. For example, a relief image from a linocut or a woodcut can be made by passing the clay and the block through a wringer.

The impressing of designs into the clay is usually combined with other techniques which use slips and glazes to produce a finished image. (See, for instance, *Encaustic tiles*, p.252.)

SHRINKAGE

When making tiles from plastic clay, it is important to allow for the shrinkage that occurs during firing. A rule of thumb is to allow for a ten per cent shrinkage overall (see p.251 for shrinkage guide). The amount of shrinkage can be reduced slightly by adding "grog" to the clay.

SHRINKAGE

temperature °C	shrinkage %
Smooth red earthenware	
1000	8
1050	10
1100	12
1150	13
Grogged red earthenware	
1000	6
1050	9
1100	10
1150	10

This is a filler – usually a pre-fired, pulverized clay. It may be the same material as the tiles and is usually added to the wet clay during the wedging.

COLORING TILES

One way of adding color to ceramic tiles is to color the clay itself before it is made into a tile. This is done with body stains, which are refined oxides and are normally used for coloring mixtures of clay and water called "clay slips" or "engobes". If the whole of the tile requires even staining, dry powdered unfired clay is mixed with the body stain powder in a percentage ratio, then reconstituted into wet clay with water.

Alternatively, you can douse the body stain with water, then sieve and mix it with clay slip using an electric mixer. This mixture is then sieved again, before being applied to the surface of the tile. The use of a white or colored slip, or engobe, over the surface of the tile is common in a number of decorative techniques such as using stencils, s'graffito techniques and encaustic tiles.

·Decorative ceramic techniques·

There are a wide range of methods for decorating ceramics. S'graffito techniques (scratching the design) enable you to draw directly into a layer of slip or glaze on the surface of the tile. You can also apply slip with a nozzle or through stencils. Decorative technique can create designs which are flush with the tile or in relief, and colors can be painted or printed either under, in or over the glaze.

S'GRAFFITO TECHNIQUE ON SLIP-COATED TILES

This method involves drawing directly into a white or colored slip applied uniformly over the surface on the tile. The slip may be brushed on in a thin film or sprayed on using a spray gun with a suitable nozzle. With a spray gun, it is important to sieve the slip well before application. Apply the slip when the unfired clay has dried to the "leather-hard" stage, when it will have lost much of its moisture but not become too hard.

The slip looks glossy when it is applied. At this stage it is still too wet to draw through. As the water content either evaporates or is taken up by the clay beneath, it becomes more matt in appearance and an image may then be drawn into it.

Any suitable instrument, such as the sharpened end of an old paint brush, may be used to cut through the slip to reveal the clay beneath. Once the slip has dried more thoroughly, you can scratch in more accurate details.

A white slip over a terracotta tile would give a dark red or

Applying slip through a stencil
The shape is cut out of paper with a sharp knife. The stencil is placed on the tile and dampened so that it sticks. Slip is applied over the top. When the gloss has begun to fade from the surface of the slip, the paper stencil is carefully peeled off.

brown "line drawing" through the white. But any combination is possible – the slip could be dark blue or black over a white tile for instance, so that a "scraperboard" effect could be made.

USING STENCILS

Slip can be applied in flat, solid areas of color through paper stencils. Newsprint is particularly good for this purpose. Slip can also be stippled through card stencils, or screen-printed through a coarse mesh. It has a tendency to spread slightly, so it is advisable to limit the technique to non-intricate shapes.

USING SLIP TRAILERS

Slip can be applied to tiles through a thin nozzle attached to a rubber, slip-filled bulb. The bulb is squeezed between finger and thumb and the slip extruded in a thin line. This is a fluid method of drawing directly on to the tile. It works best when used over a number of tiles laid together as a group.

"Tube lining" is a similar

technique in which a thin trail of slip is laid over the outline of an image. The various sections of the image are bounded by these raised outlines and can be filled in separately with different underglaze colors or oxides.

ENCAUSTIC TILES

This technique – which is completely unrelated to the encaustic method of painting – involves tiles that incorporate an inlay, made by pouring a white slip into an indented image or design in a tile made from clay of a different color. The celebrated decorative medieval floor-tiles used this technique. Traditionally, the design is made in white or a red terracotta tile, but there is no reason not to use any other color combination. If you wish, you can also continue working on the finished tile with underglaze and/or glaze colors (see below and right).

Once a die has been made for the preliminary indentation, the encaustic tile is then made by hand. If a die fits the base of a hand-operated tile press (described above), the tile can be pressed and removed before being inlaid. If such a press is not available, you can make a square open-mould, whose base forms

the die for the inlay. In this case, a thin layer of casting slip is poured over the base of the die and left to dry to a leather-hard state. Plastic clay of similar type is pressed into the mould by hand and cut level. The tile is then removed from the mould and the different colored slip applied as described below.

APPLYING UNDERGLAZE COLORS

Underglaze colors are special powdered paints which, when mixed with a binding medium, can be applied to unfired (green) clay or to porous, biscuit (fired, but not glazed) tiles. They contain clay, which allows them to adhere to the tile. If onglaze colors (see p.253) were applied to an unglazed tile and fired, they would just flake off, since they do not contain enough fluxing or glass-making elements to make them stick. Underglaze colors may be sprayed or printed directly on to the tile (see *Printing on tiles*, p.254).

To paint the underglaze colors on to the biscuit tile, they are ground or mixed (depending on their coarseness) with a binding medium. The most common medium is a solution of gum arabic and water,

which allows you to manipulate and thin the color as if it were paint, on the surface of the tile. The powdered underglaze colors can also be ground in linseed oil thinned with turpentine. The color can then be used in much the same way as oil paint. The binding medium is not permanent and must, like any other organic material, be driven off by firing in a ventilated kiln at between 600–650°C before the tile is glazed.

The underglaze color should not be applied too thickly, or it will weaken the bond between the subsequent glaze layer and the surface of the tile.

GLAZING

A glaze is a glass-like covering layer, which enhances the appearance of the tile, and reduces its porosity, by sealing the surface of the tile. The glaze may be transparent (clear or colored) or opaque (white or colored). Transparent glazes used over underglaze painting or printing or slip manipulations will create richly varied effects. The glaze is applied by spraying, pouring, or by dipping the tile in the glaze. It can also be applied to selected areas of the tile only.

PAINTING ON UNFIRED GLAZES

This technique, also known as "majolica", was developed in Spain. An opaque, warm, white glaze is laid over the biscuit tile. When it is dry, the image is painted on to the unfired glaze, using the basic oxides from which ceramic colors are made. (Cobalt oxide produces the characteristic blue on white tiles, and was frequently used in the past because it was reliable and readily available.) The color is mixed with water and applied with a soft brush to the powdery surface of the unfired glaze.

The refinement of the

MAKING AN ENCAUSTIC TILE

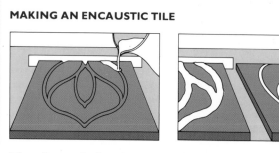

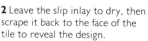

I Pour slip over the face of the tile, so that if fills and overflows the indentation. Take care to seal off any parts of the design open to the edges of the tile with a piece of damp newsprint or tape to prevent the slip running out at the sides.

2 Leave the slip inlay to dry, then scrape it back to the face of the tile to reveal the design.

brushwork is limited with this technique, but it is nevertheless an excellent way of working directly with a brush on a large tile panel. Once fired, there is a satisfying fusion of image and ground which can be lacking in the "onglaze" technique (see right).

The unfired glaze can be given a harder surface, more suitable for painting, by mixing a little gum arabic into the glaze solution, or by spraying some lightly over the top. This will hold the glaze and make it less powdery.

Applying a uniform color to an unfired glaze Use a wide bristle flat brush the same width as the tile to apply a uniform layer of color.

Using several colors on the unfired glaze The "dancers" were painted using filbert sable brushes and a range of ceramic colors. The technique was to apply small touches of a uniform tone, superimposing these to produce deeper tones.

BASIC COLORING OXIDES USED IN CERAMICS

The coloring oxides are mixed with water, gum arabic or oil to form a workable painting consistency, and are then applied to unfired, biscuit or glazed majolica ware.

The raw oxides provide the strongest colors while the carbonates offer a paler range. The main oxides or raw natural pigments used for coloring purposes in ceramic work are as follows:

Linear "portrait" tile A line drawing was made from life into the unfired glaze on the tile using a blunt steel needle. A thin cobalt oxide wash was laid over the tile with a wide, flat soft-hair brush so that it ran into the lines drawn in the glaze.

"Scraperboard" image The trees are based on an oil pastel drawing (see p.91). A transparency of the original was projected on to the panel of tiles which had previously been given two deep cobalt oxide washes on the unfired glaze. The white areas were scraped back to the blue to reveal the image of the trees. The tiles were then fired.

■ Cobalt oxide gives a range of blues.
■ Copper oxide gives greens in thin applications, and black when used thickly. It can also give a green/blue or a copper/red in certain alkaline or reducing conditions.
■ Chromium oxide gives a positive basic green color, but can be used to create reds, yellows, browns and pinks in particular combinations with lead, zinc or tin.
■ Iron oxides give colors from yellow to dark brown.
■ Manganese dioxide gives a range from pink to brown, with purple being produced in alkaline or tin glazes.

APPLYING ONGLAZE COLORS

Onglaze colors are applied to a fired, glazed tile. When the tile is re-fired, the pigments and the glaze fuse. Onglaze enamels, as they are known, are available in fine powder form. They are mixed with a suitable binding medium – gum arabic, resin or oil-based mediums are the most common – and then applied with a painting implement to the surface of the tile. A wide range of colors is obtainable because the enamels within particular ranges can be mixed.

If onglaze color is brushed on, the smooth, glossy surface of the tile will hold and show the brushmark exactly as applied, with all its ridges and striations. Artists used to painting on absorbent or semi-absorbent surfaces may find the surface somewhat resistant at first.

Onglaze color may also be sprayed on to the tile through stencils, or dusted through a fine-mesh sieve on to a tile which has been coated with ground-laying oil. (A cardboard tube with gauze over one end makes a good improvised sieve.) The color will adhere wherever there is oil. It may also be printed through a silk screen (see p.254).

PRINTING ON TILES

There are two main methods of printing on tiles: the direct method, and the indirect (or transfer) method. You can print on to the unfired clay or the fired biscuit tile (underglaze printing), or on to the glazed tile (onglaze printing). In the latter case, a further glaze may be applied, in which case the original printing is "in-glaze".

With both methods of transfer printing, the medium must be drawn off in a slow preliminary firing in a ventilated kiln.

Direct printing

Screen printing is the standard method of direct printing (see *Printmaking*, pp.282–9). For best results, a screen with a relatively coarse mesh should be used. You can use any of the binding mediums mentioned above, with the slip, underglaze or onglaze colors, to enable them to be squeegeed through the screen. Grind or sieve them with the medium to a uniform consistency. You can overprint several colors before firing, so long as you use a quick-drying medium which leaves the color relatively hard.

Most of the methods of stencil-making may be used (see pp.283–4), but if a design is too intricate, a transfer method is more suitable.

When direct printing on a commercially made, curved-edge tile, the design should be kept within the flat area of the tile.

Indirect transfer printing

In the indirect method of printing, also known as "water slide transfer", which is best suited to onglaze work, an image is printed on special coated transfer paper. The coating is a water-resistant membrane on to which the image is printed – usually using a screen-print method, though other printing techniques can also be used.

For one-off tiles a monotype can be made using the ceramic colors on laminate or glass as you would for printing ink or oil color. A print is then taken on to the transfer paper. When the image on the transfer paper is dry, coat it with a proprietary sealer, by silk-screening it on through a blank screen. Leave this to dry. Float the sheet of transfer paper in a tray of warm water. The paper will absorb the water and sink to the bottom of the tray, leaving the transfer floating on its membrane. Pick it up carefully by the top two corners, place it on the (glazed) surface of the tile and slide it into position. Use a rubber kidney to expel any air or water, working outwards from the center. Up to three transfers may be overlaid on the same tile. For both methods of transfer printing, the medium should be drawn off in a slow preliminary firing.

Underglaze transfer printing

For underglaze work, it is more satisfactory to transfer a print made on tissue paper by etching or lithography. In etching, the plate is inked up with oxides ground in fat oil. The tissue paper is dampened, then printed in the usual way. The resulting print is laid on to the biscuit tile, and wetted and dabbed with soapy water. The printed image transfers to the tile and the tissue paper is peeled off.

FIRING

Most firings begin slowly to allow the work to dry and get rid of any chemically held water. The slow firing is carried out at up to 600°C with plenty of ventilation. From this point it rises rapidly to the maturing temperature. There should be no sudden draughts or changes of temperature and the same amount of time should be allowed for the kiln to cool down as it took to heat up.

Remember that the various layers of the tile – from the body itself, through colored slip, to underglaze colors, glazes, onglaze colors and lustres (metallic salts which give a metallic finish to a tile) – will require firing at different, progressively lower temperatures. The clay tile itself needs firing at up to about 1200°C, down through the layers to lustres (about 720–730°C). With skilful firing, you can build up a rich and complex structure, because no layer which has been fired will be affected by the heat of subsequent firings (which will be at a lower temperature).

MAKING A REPEAT TILE DESIGN

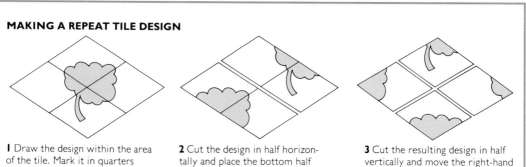

1 Draw the design within the area of the tile. Mark it in quarters with horizontal and vertical lines.

2 Cut the design in half horizontally and place the bottom half above the top half.

3 Cut the resulting design in half vertically and move the right-hand portion to the left side.

VITREOUS ENAMELING

Vitreous enameling is a method for creating painted or printed images on metal plate. The plate is fired – often several times with different colors – and the resulting image becomes fused to the metal. The enameled panel is permanent and weather-fast, so it can be used for external murals. Vitreous enameled panels have become extremely popular in decorative schemes for busy public areas where a high degree of toughness and resilience is necessary.

Small-scale enameling can be done in the artist's studio using kilns similar to those used for firing tiles (see p.257). Large-scale enameling is usually done in conjunction with an enameling factory, which will have special industrial kilns big enough for large sections of plate.

—·Enameling equipment and materials·—

THE METAL PLATE

The most common metal for vitreous enameling is carbon-free steel which can be bought in specified vitreous enameling grades. The steel must be carbon-free, because the presence of carbon during firing would cause the enamel to blister and flake.

It is also possible to enamel on copper. This is often used in conjunction with jewelry enamels, which allow the metal to sparkle through. These effects are also possible with stainless steel and the precious metals.

Aluminum can be used and is very popular in America. It is conveniently light, but has a low melting temperature, which means that low-firing enamels have to be used on it. This makes aluminum most suited to artworks intended for indoors.

The preparation of the metal plate If a large-scale artwork is being prepared – for a public site, for example – you will probably be using enameling steel, and the initial preparation, including the grip coat (see below), will be carried out by the factory. The steel should be at least 18-gauge in thickness.

The size will depend on what the factory kiln can hold. The largest size available is usually about 2400 × 1800mm (8 × 6ft), but more usual for easy handling is 1600 × 900mm (5 × 3ft).

Panels which are to be wall-mounted are constructed with a flange all the way round. Holes can be drilled through the flange and the panel fixed to a metal shoe attached to the wall. A flanged panel needs only a backing grip coat (see below), whereas a flat panel needs the same amount of enamel on the back as on the front to prevent warping. All structural work or welding is done before the metal is prepared for the enameling.

For a fine art or decorative panel, the factory should use the traditional preparation method. First the steel panel is put into the furnace to burn out any grease or accumulated dirt. Then it is placed in a 10 per cent solution hydrochloric acid bath for about 15 minutes. This etches the plate to provide a key for the grip coat. Then the panel is rinsed and neutralized, by being dipped for 30 seconds in soda ash water. Finally, it is rinsed for 30 seconds in borax, to prevent it going rusty, and then left to drip-dry in warm air.

The grip coat

Once it is dry, the metal panel is ready for the grip coat. This is the enamel ground coat, which is applied directly to the bare metal, in a spray booth. It is usually dark blue, brown, gray or black after firing, depending on the particular formulation employed by the factory. The composition of the grip coat can vary greatly, but it generally includes such ingredients as feldspar, silica, quartz, enameling grades of clay, bentonite and other mill additions. These minimize straining and maximize adhesion in the enamel. The clay makes it stick to the metal.

The prepared plate is loaded into the furnace and fired at around 860°C (see p.256). It is now ready for the cover coat.

The cover coat

The term "cover coat" applies to any enameling applied over the grip coat – for example, a coat of white (or any other color suitable for a ground). For an opaque white, a frit (see *Glossary*, p.340) is prepared by the factory, using titanium. For pastel colors, a less opaque white such as antimony is used in conjunction with industrial enamel colors.

Factory kiln rack loaded with painted panels prior to firing.

Tunnel kiln
The kiln door is opened (right) to allow the rack of panels to be loaded in for firing in an upright position; in a box kiln they are loaded flat.

The fired panels emerge The rack of enameled plates (far right) is slid out of the kiln.

TYPES OF ENAMEL

Enamels are bought in powder form, ground to specific "mesh" sizes. A popular size for artists is 80-mesh; the 120-mesh is more suitable for silk-screen purposes. The powder is mixed with another medium before being applied by brushing, spraying, pouring or printing. It can also be sieved in dry form on to the prepared panel.

Industrial enamels
These traditional enamels are highly resistant to heat and extremely opaque, so it is not possible to create transparent or translucent glazing effects with them. They come in a wide variety of colors and are safe to use and relatively inexpensive.

Jewelry enamels
These are lead-based and therefore potentially dangerous to work with. In factories, the law requires stringent controls over their handling. They are also extremely expensive. However, using these enamels is the only way of creating rich transparent and translucent effects on the metal panel. The glossy, glass-like surface of the fired panel makes these effects very successful in enameling.

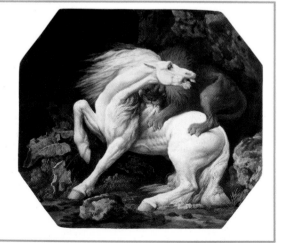

Large-scale work in jewelry enamels (detail) This mural by Amal Ghosh was worked on a factory-prepared blue-green ground. It incorporates stencil work, brushwork and sieved color.

BINDING MEDIUMS

It is essential that the medium has sufficient binding strength to hold the enamel color together, and to stick it (temporarily) to the panel. And it must allow a certain amount of overpainting if necessary. It should burn off easily in the kiln without leaving a residue, or affecting the color or structural stability of the fired enamel. There are a number of aqueous (water-based) mediums suitable for use with enamel colors.

Gums
A mixture of best grades of gum tragacanth or gum arabic, water and the enamel color itself, will have sufficient binding strength to allow for a range of artistic uses. Gum tragacanth affects the colors less after firing than gum arabic, although there is no chemical reason why this should be so. Very little gum is needed.

ENAMELING ON COPPER

This example of enameling on copper shows how complete a range of tones — from the darkest shadow to the brightest highlight — can be subtly and accurately controlled. It is a meticulous piece of work, in which each element has been detailed with precise brushstrokes. Made in the eighteenth century, it also proves the permanence of the medium. The reason for this overall stippling technique is that it is almost the only method of achieving such fine tonal gradation on the smooth non-absorbent ground on which Stubbs has painted. The ground is a white tin oxide glaze.

Horse Attacked by a Lion (1769), by George Stubbs.

Cellulose paste

A cellulose like that used in heavy-duty wallpaper paste, provides a good binding medium which will burn out well in firing and is considerably less expensive than the natural gum. It can be used for brushing on the color, but is not so suitable for spraying. Sieving dry color on to cellulose-pasted areas works very well.

Essential oils

Pine oil and clove oil (see p.34) are often used as mediums for vitreous enameling. They allow the color to be freely manipulated on the panel. However, they do not burn off very well in fast-firing kilns and are therefore more suited to slow-firing.

Acrylic mediums

Methyl-methacrylate-type acrylic resins provide excellent binding mediums for enamel colors. The color is simply stirred up in the medium. Proprietary water-based emulsions can be used, although in factory conditions, these dry too quickly to allow much manipulation.

Acrylics are beginning to be used extensively in this area because they depolymerize rapidly at about $300°C$. Once this has happened, the binder is removed, leaving clean colors with no residue. PVA mediums are not usually used as they do not have good firing properties.

Solvent-based acrylic mediums Such resins are widely used in industrial vitreous enameling. B67, an iso-butyl methacrylate which is soluble in mineral spirit with the addition of around 30 per cent of toluene, is just one example.

·Enameling techniques·

Many of the decorative techniques described in *Ceramic Tiles* (see pp.254–7) also apply to vitreous enameling. Colors can be painted on in the traditional way in opaque or transparent mediums. It is important to remember that the ground is non-absorbent.

As well as using a conventional painting method, you can paint in the design with pure binding medium, and then sieve the dry powder color on it it, so that it sticks only where there is medium. You can also apply the color through stencils, or sieve it on to the dry panel and then spray the medium into the air above it, so that it falls uniformly on to the panel. Silk-screen printing the enamel on to the panels is a common procedure and can be combined with hand painting. Trichromatic screen printing in vitreous enamel is still in its infancy, but the technique is developing rapidly. Transfer printing is an extremely popular method of working in vitreous enamel, as it is with tiles.

APPLYING ENAMEL COLORS

The enamel can be applied to the prepared metal in many different ways, provided you observe certain points. If too little color is applied, white spots can come through from the ground coat.

This is more likely to happen if the panel is fired at a high temperature. If the color is too thick, the medium may not be able to burn off through the enamel, which would cause flaking and cracking.

It is possible to print several layers on top of each other, allowing each to dry before reprinting, then giving the panel a single firing. It is best not to apply more than two or three colors at a time. Some artists prefer to fire one layer at a time. With a work which includes several panels, remember that the color will change slightly

Craft kiln for small-scale enameling A small electric kiln (left) is suitable for firing small pieces of work on metal plate and for jewelry work. These kilns can fire at temperatures of up to 1000°C and have electronic temperature control.

with each firing. So, even if the panel does not have a color which is later applied to another, it should still be refired along with the second, to ensure color consistency throughout.

FIRING

Fast-firing factory kilns are of two types: the box kiln in which the panels are fired flat, and the tunnel kiln in which panels are fired vertically. The former produces slight variations in heat at the front, center and back of the panel; whereas the latter gives a more uniform heat distribution. Results from both are equally satisfactory.

For smaller pieces of work, electric front-loading kilns are available for home or studio use, with different internal kiln sizes.

·PRINTMAKING·

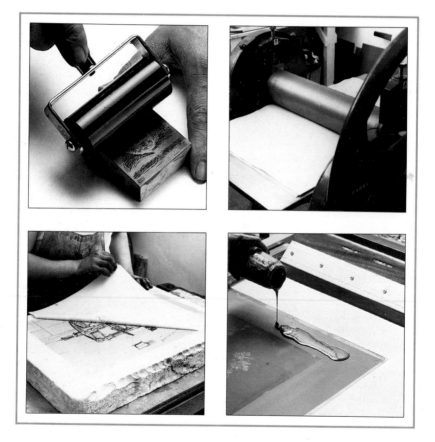

RELIEF PRINTING

Relief printing is the oldest form of print-making. The ink is applied to the raised surface and an impression is taken of the block or plate. Areas cut away by the artist, or which do not stand out in relief, will remain blank on the printed paper. An enormously wide range of materials can be used to make blocks or plates for relief print-making. These include stone, wood, lino, plastics, metal, card, potatoes, sand or cloth. The most common forms of relief printing are woodcut, linocut and wood engraving.

·Woodcut·

The ancient Egyptians, Indians and Arabs used wood-block relief printing methods to stamp or print designs on to textiles. It was not until the seventh century A.D. that woodcut printing on paper began to be adopted in China, where drawing and text were reproduced on the same block.

In Europe, the use of the woodcut in the development of printing was not properly established until the late fourteenth century, as paper was only introduced there a hundred years before. Albrecht Dürer explored and greatly developed the technique and pioneered it as an independent form of art, not merely a way of printing text. Hans Burgkmair the Elder and Hans Baldung were also involved with the development of woodcut techniques, in particular chiaroscuro, pioneered by Jost van Negker and Ugo da Carpi.

In China and Japan the art of the woodcut developed towards its great eighteenth- and nineteenth-century flowering. The Japanese *ukiyo-e* or "floating world" school progressed through the pioneering color work of Masanobu, through the technical developments of Harunobu, Sharaku and Utamaro, to the great work of Hokusai and Hiroshige. These prints greatly influenced late nineteenth-century French artists such as Gaugin. In the early part of this century, the German artists of the Die Brücke ("The Bridge") group took up the medium. Founded in Dresden in 1905, the group was enthusiastic about primitive cultures and in particular, the traditions of German art. The artists celebrated the direct, expressive power of woodcut in a series of prints that have influenced contemporary artists such as Baselitz, Penck and Immendorf.

CHOOSING WOOD FOR WOODCUT

The block for a woodcut is made from plankwood, cut along the length of the grain rather than across it (see *Wood engraving*, p.262). Plankwood suitable for woodcut can come from a number of trees – including cherry (favoured by the Japanese), pear, sycamore, apple, beech, plum, chestnut, willow and maple. It must be hard enough to enable relatively fine lines to be cut. Softer woods such as poplar, pine or lime may also be used, especially where large areas need to be cut away. These can be coated with shellac and smoothed with sandpaper before cutting.

Large blocks can be made by gluing planks together in the same way as a panel is prepared for panel painting (see p.48). Strips of wood are usually glued to the ends to prevent warping.

Some artists exploit the appearance of the natural grain by rubbing the surface vigorously with a wire brush, or by the use of acid. Normally the plankwood is smoothed before cutting. Plywood has a surface which may also be exploited (see p.261).

The woodcut block
Blocks for woodcut prints are cut from plankwood, along the grain.

TRANSFERRING THE DESIGN TO THE BLOCK
I A simple method is to make an Indian ink brush drawing directly on to the block. This method lends itself to woodcut's more direct imagery.
2 A prepared drawing may be traced through white or black carbon paper.
3 A photographic slide may be projected on to the wood.

Whichever method you use, remember the drawn and cut image will be in reverse when printed.

·Woodcut tools and techniques·

The three main tools used for woodcut are the knife, the "V" tool and the curved gouge. The knife is used for cutting outlines, and the other two are used for scooping out sections of wood. Flat chisels may also be used to remove large areas.

Apart from the conventional woodcut tools, many others may be called into service. Metal punches may be hammered into the surface of the wood to create texture effects. A variety of attachments for electric drills can be used to cut, file and bore.

USING THE KNIFE, GOUGE AND "V" TOOL

The knife is used to cut around the shape of the image. It is held at a slight angle to the cutting line so that the edge slopes outwards from the printing surface – this is to give strength to the projecting edge of the image and to avoid the inevitable accumulation of ink that would build up if the edge sloped inwards, and the printing problems that this would bring. Also, another cut may be made at an angle to the first (see below), so that a "V" section is cut around the line to be printed. This enables further wood to be cut away – with the gouge, for instance – without fear of cutting into the edge of the line and damaging it.

The gouge and "V" tool should be used following the grain of the wood. The gouge makes scooped cuts which have a quite different feel to the sharper, more aggressive cuts of the "V" tool. On a print, the gouge-marks are recognizable for the curve which is made at the beginning of each stroke as the tool enters the wood. This gives the marks a certain softness. The "V" tool enters more sharply, and the cut is narrower and deeper than that of one made by a similar-sized gouge.

HOW TO USE THE BASIC TOOLS

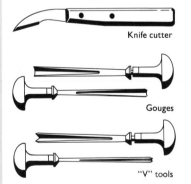

Knife cutter

Gouges

"V" tools

Using the knife
Hold the tool with the blade sloping away from the printing surface (left). A second cut, at an angle to the first (right), makes a V-shaped indentation.

Sharpening a gouge
Use a downward, rolling action, turning the gouge from side to side as you draw the edge down the oilstone.

Using the gouge
With the gouge, cut away from the body, at a shallow angle to the block. The cut has a U-shaped cross-section.

Using the "V" tool
Handle the "V" tool in the same way as the gouge. It makes a deeper, narrower cut, with a V-shaped cross-section

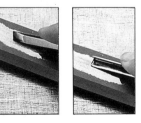

Sharpening a "V" tool
Sharpen each cutting edge separately. After sharpening, the "V" should still be symmetrical.

THE EXPRESSIVENESS OF WOODCUT

This woodcut celebrates the expressive nature of the marks made by woodcutting tools. The image is stumpy, squat and vibrant. It bears the marks of its making, in particular in the use of the gouge around the bodice and bottom of the model, on the front of the bedside table and behind the model's right foot. The marks are like white brushstrokes over black. They are functional in that they serve to provide areas of white around or within the figure, but they are deliberately left crudely visible with no "tidying up".

The image "rocks" on the two diagonal base lines as if on a rocking chair. It shows how "alive" a woodcut can be when the cuts are so evident.

At Toilette (1923), by Max Beckmann.

USING PLYWOOD

Plywood has a very different feel to any of the other genuine plankwood blocks used for woodcut. Compared to straight wood, which has a satisfying density, it is light and splintery to cut into. On the other hand, it is very responsive to the gouge and the "V" tool, both of which can be used rapidly, like sketching instruments.

The self-portrait (right) was cut directly from life, with no pre-drawing, using a sharp "V" tool and a gouge. The plywood threw up a mass of splinters, so that by the end of the "draw-ing", the surface of the panel was a mass of sharp, protruding slivers of wood which would have been impossible to ink up properly. A light sanding with an orbital sander restored the smooth surface of the panel and revealed all the incised lines.

Since the areas of wood that the tools remove will not print,

it follows that for conventional black printing on white paper, the cutting should be approached as if drawing on a dark paper with white chalk. This was the approach adopted for this economically made image.

Working back from the high-lights Just the areas of the face which catch the light were cut using both a gouge and a "V" tool. The print incorporates the natural grain of the plywood, which can be seen particularly in the black areas.

ALTERNATIVE CUTTING TOOLS

Almost any mark-making tool may be used to make indent-ations into a wood block. Metal punches may be hammered into the wood to create surface textures. And electric drills with a variety of small abrasive attachments, can also be used to incise designs.

Print cut with a soldering iron The image was slowly burned into a plum-wood block (top) with the flat "chisel" tip of an electric soldering iron to make this print (above).

·Wood engraving·

The idea of using copper engraving tools on end-grain boxwood is attributed to the eighteenth-century engraver, Thomas Bewick (see opposite).

Wood engraving became the standard method of reproducing illustrations for books. The Pre-Raphaelites produced many designs which were engraved by master craftsmen. However, commercial wood engraving was replaced at the end of the nineteenth century by photographic methods of blockmaking, and from then on wood engraving became the more specialized province of printmakers working for small private presses.

In the twentieth century the medium has been explored and extended by sculptors like Eric Gill and painters like Eric Ravilious. Specialist printmakers publish limited editions of wood engravings as original prints, in the same way as they do with etchings, lithography and screenprinting.

CHOOSING WOOD FOR WOOD ENGRAVING

Wood engraving is made on end-grain boxwood blocks (unlike woodcut, which is made on side-grain plankwood). Blocks are usually prepared by an expert blockmaker and are relatively expensive. Boxwood is hard and dense and can be smoothly cut by the sharp engraving tools without leaving the slightest burr. Other suitable woods are lemon wood, holly and maple.

The special tools used for wood engraving are known as gravers. These enable the artist to incise lines of great delicacy in the block. Wood engravings are characterized by their fine detail and careful construction, by cross-hatched or parallel-line tonal shading, and by the fact that most of the positive lines in the print are generally perceived as white out of black. They are usually made on much smaller blocks than woodcuts.

The wood engraving block
Blocks for wood engraving are cut from end-grain boxwood, across the grain of the wood.

DRAWING OUT THE IMAGE
Draw the image directly on to the block with a soft, fine-lead pencil and fix it. Darkening the block first by rubbing in black ink makes the cut image appear much as it will when printed. Alternatively, draw in white ink or trace through white carbon paper on to the block.

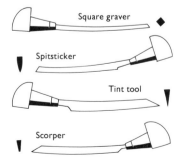

·Tools and techniques·

WOOD ENGRAVING TOOLS

Wood engraving tools are made from fine-quality tempered steel, set into a wooden mushroom-shaped handle with a flat bottom. They are very sharp.

Gravers
The basic "drawing" tool is the graver, which has the same cross section as a metal engraver's burin (see p.267). This can be square- or lozenge-shaped and is set diagonally into the handle so that one of the edges forms the base. At the cutting end, the rod is cut at an angle of between 30 and 45 degrees. The face and the two planes of the bottom "V"

section of the square meet at the cutting point. The square graver cuts a slightly wider groove than the lozenge-shaped one, which is more useful for fine work.

Spitstickers
These have a flat, curved cross-section and come in a range of sizes. The upward curve on both sides of the point means that they are extremely useful for cutting curved lines.

Tint tools
The tint tools come in a variety of sizes and have a thin, isosceles-triangle cross-section. They are used for cutting single straight lines.

Other tools
Similar to the tint tools are scorpers, which are more rectangular in section with a flat or curved cutting edge. They are used for scooping out wider lines.

Other tools include the wider chisels and the multiple cutters.

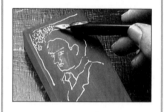

HANDLING THE TOOLS

Printmakers may devise their own methods, but the essential feature of the grip for wood engraving is that it should be firm and allow the graver to cut at a shallow angle to the block.

Press the handle into the palm of your hand. Your thumb pushes against the steel shaft on one side, counterbalanced by your index finger on the other. Tuck your little finger into the groove of the handle or lay it over the flat. When cutting, rest your thumb on the block to steady the blade at the right height.

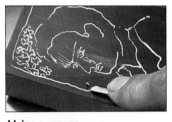

Using a graver
Push the graver forward at a shallow angle to the cutting surface.

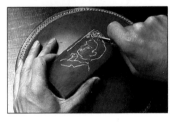

Keeping the block steady
The block is traditionally rested and turned on a circular sandbag cushion, held by the free hand during cutting. Cut curved lines by moving the block rather than the tool.

SHARPENING THE TOOLS

As with woodcut tools, gravers are sharpened on fine grade oilstones, using a drop of oil, and then polished on an Arkansas-type stone. Sharpen the flat sides of the blade in turn, leaving the point crisp and sharp. Use a circular or figure-of-eight movement over the face of the stone, to avoid wearing it down in one area.

THE WORK OF THOMAS BEWICK

Thomas Bewick used the techniques of wood engraving to great effect in his portrayal of animals, birds and country scenes. His fine line system enabled him to depict a full range of tones and minute details. This small engraving is a fine and amusing example.

He clearly delights in the lumpy shape of the camel, which is held up to view against the white ground. Within the shape, the variety of textures and movements created by the engraved line depict the shaggy coat and the play of light over its surface.

The Bactrian Camel by Thomas Bewick (1752–1828).

THE SKILL OF ERIC RAVILIOUS

The wood engravings of Eric Ravilious are characterized by an extraordinary technical skill, a charming lightness of touch and a mastery of light and shade. This small example is only a trial study, but it contains all the elements of his best work. The vertical format is cleverly used as the eye travels from the male figure resting on the bottom and right-hand corner of the print, up the steps and curls round to the wingless angel hovering above. This arcadian scene with its dreamlike atmosphere is a fine example of the kind of work that featured largely in the graphic arts of the inter-war years.

Untitled Print (1929), by Eric Ravilious.

·Linocut·

Effects similar to those of woodcut can be had using linoleum. The surface of lino is softer which makes it easier to work. But, whereas wood is dense, crisp and dry to cut, lino has a thick, almost sluggish feel. Lines cut into lino can have the clarity of those cut in wood, but lino tends to blunt tools rather rapidly. If the tools are not absolutely sharp, the edges of the cuts may crumble, producing broken lines in the print.

LINOCUT MATERIALS

To create a linocut block for printing, you need suitable lino and cutting tools. Standard lino tools are made from thin pressed steel. They come in a wide range of shapes and are pushed into a wooden handle before use. They can be sharpened on fine grade oilstones or Arkansas stones.

Linoleum for linocut

The thick, heavy-duty range of linoleums with hessian backing are the best type for linocut. Lino may be glued to a wooden block or to plywood to give it more rigidity or to bring it to the thickness necessary for machine letterpress printing. This is not absolutely necessary and a plain, unmounted sheet of linoleum can be printed perfectly well on a platen press, or even passed through an etching press if the pressure is adjusted.

Linoleum lends itself very well to multi-color printing. The slight sponginess in the surface, which is squeezed by the pressure of the press, means that flat areas of color print well.

Standard linocut tools
1 Knife-blade cutter
2 "V" tool
3 Gouge
4 Lino

PROGRESSIVE CUTTING TECHNIQUE

These two illustrations (right) show the method of clearing the lino from around an image where the perimeter has first been incised with a sharp knife. In the first, the figure barely emerges.

Clearing lino from around a cut
With a cut outline, the figure barely emerges from the mass of marks (top). More lino is removed to free the figure from the ground (bottom).

CREATING A FLUID LINE

A popular method of working among contemporary artists has been to create a line drawing in the lino in which the contours and features appear as white lines out of either black or some other color in the print. The medium lends itself particularly well to the creation of fluent lines. Matisse explored this idea earlier in the century. This print is by Mimmo Paladino, an Italian artist who has experimented with many forms of printmaking. The splash of the water and the balanced movement of the limbs gives no indication of the degree of control needed to create such effects.

Terra, Tonda, Africana (one of six, 1986), by Mimmo Paladino.

——·Other methods of relief printing·——

Relief printing can be carried out in a number of other ways using a variety of materials to make the "block".

A smooth bed of plaster can be incised, inked and printed. A plaster cast may be taken of any flattish object and a print made. Plaster or a patented wood-filler may be brushed over a wooden panel and incised for special texture effects. Always seal plaster with shellac or PVA before printing.

Rigid cell-cast acrylic sheet (Perspex, Lucite) can be used for engraving. It has a smooth,

uniform surface and is available in large sheet sizes. Acrylic paint can be applied thickly to build up relief effects for making prints. Polystyrene tiles are easy to incise and take ink well.

Cardboard can be cut into various shapes, glued to a panel, sealed with shellac or PVA, and then relief printed. The basic technique can be modified by the introduction of other relief elements such as sand (well sealed with PVA). This technique lends itself to the build-up of complex imagery and it may be intaglio printed (see p.274).

Print made from liquid plaster
Liquid plaster was brushed over a wooden block, allowed to set and incised with a woodcutter's "V" tool.

——·Printing relief work·——

PRINTING BY HAND

For small blocks with fine lines, a rubber or plastic hand-roller and a stiff ink is best. A softer roller or a runny ink tends to fill in the fine lines, and results in a bad print. For larger, bolder woodcuts or linocuts, a hard or soft roller may be used. Use a soft roller for uneven or textured surfaces. Ink can be applied with a soft leather dabber or with a brush, if a roller is not available.

The paper used for relief printing is usually thin and absorbent. Interleaving it with damp newsprint before printing ensures a deep, velvety black on the finished print, but is not strictly necessary (especially if you can rely on a strong uniform pressure from a machine press). The paper is laid over the inked block and the impression trans-ferred by "burnishing". Any smooth, round object can be used – the back of a spoon is ideal.

Making a relief print by hand
1 Roll out the ink on a slab, until it forms a thin, uniform layer.
2 Ink up the block using a roller, dabber or brush.
3 Take a sheet of paper and lay it on the block. Press the paper down with your hand. Place a protective sheet of thicker paper over the top and rub the surface with the burnisher in a regular circular motion from the center of the block outwards.
4 Peel the print away from one corner.

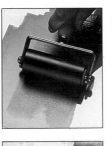
1

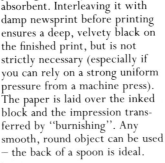
2

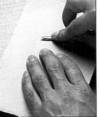
3

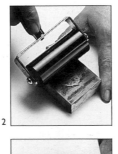
4

MACHINE PRINTING

The block is inked and the paper prepared in the same way as for hand printing (see left). For home purposes, a simple screw press may be used. The block should be packed top and bottom with thick sheets of card or solid rubber sheet (the "packing"). This ensures a uniform print and protects the block.

The hand-lever letterpress machine is one of the best methods of relief printing, the most popular being the Albion or Columbian platen press found in most art colleges. Relief printing may also be done on etching, flat-bed or cylinder presses.

Before a block is inked up, it should be placed in the press with packing over the top and the impression lever pulled to test the pressure. If the lever pulls back too easily there is not enough packing. If it does not pull back beyond a certain point there is too much. Adjusting the pressure on the block affects the quality of the print. The nature of the packing can also determine the quality of the print: harder packing gives a "flatter" print.

INTAGLIO

In intaglio printing, lines or tones are engraved or etched into the surface of a metal plate. The plate is inked and then wiped, leaving the grooves filled with ink and the surface clean. Soft, dampened paper is laid over the plate, and both paper and plate are put through the rollers of an etching press. The pressure of the rollers forces the paper into the grooves, so that it takes up the ink, leaving an indented impression of the whole plate on the paper. This impression is known as the plate mark.

The two main types of intaglio are engraving and etching. In engraving, lines and dots in the plate are cut by hand with a burin or similar tool. In etching, the lines are scratched through an acid-resist ground, then bitten into the surface of the plate by acid.

·Engraving·

Engraving can be traced back to prehistoric man, who used the technique of incising linear markings into resistant surfaces such as stone and rock. The more immediate precursors of copperplate engraving are the armorers and goldsmiths with their surface ornamentations. The silver and gold *niello* work of Italian craftsmen in the first half of the fifteenth century is an example of this.

The first dated example of a copperplate engraving is the German *The Scourging of Christ* of 1446, but one of the great engravers of the fifteenth and early sixteenth century came from Italy – Andrea Mantegna (1431–1506). His bold engravings are characterized by his system of diagonal shading. In Germany, Albrecht Dürer (1471–1528) produced engravings which were tighter in style and more deeply tonal. Copperplate engraving soon became the accepted method of reproducing paintings and drawings, but few artists acquired the skills of engraving. Notable exceptions in the eighteenth and nineteenth centuries were William Hogarth (1697–1764) and William Blake (1757–1827).

THE PLATE

Copperplate is the most commonly used surface for intaglio engraving. It is durable and reasonably soft to cut into. Other metals such as zinc (in its modern zinc alloy form) have been used, but are generally considered inferior to copper.

The standard thickness for printmaking is 16-gauge, but the slightly lighter 18-gauge can also be used. So as not to damage the blankets of the etching press or tear the paper when it is put through the press, the edges of the plate should be filed down and sanded with emery paper.

Making a preliminary drawing on the plate The technique used for the actual engraving dictates the method of drawing. Some artists prefer to draw in only the most important elements of the image, to allow for subsequent freedom in cutting. A preliminary drawing can be made on the plate in Indian ink, all-purpose pencil, felt-tip pen, or litho crayon.

Before drawing, the surface of the copper may be dulled for ease of working, by rubbing it with pumice powder and water, or with scouring powder. Remember that the print shows the reverse of the engraved image on the plate.

Preparing the plate

1 File down the sharp edges of the metal plate, then rub them down with a piece of emery paper.

2 To dull the surface of the copper plate, scour it with pumice powder and water or household scouring powder.

3 Make a preliminary drawing on the copper plate in the drawing medium of your choice (see above).

·Engraving tools and techniques·

THE BURIN

The basic engraving tool, the burin, looks exactly like the graver described on p.263, except that the mushroom-shaped handle is sometimes set at a higher angle than the main section of the steel blade. This enables the burin to be pushed along the surface of the copper at an even shallower angle than with the wood block. For copper, the blade must be perfectly sharp at all times to allow for smooth cutting. Each side of the burin is first sharpened flat, then the 45 degree facetted face is sharpened.

The burin should be held in the same position as a graver in wood engraving (see p.263). The burin is only moved forwards. To make fluent, curved lines, move the plate, which rests on a leather sand-filled cushion. If you are using your right hand to move the burin, your left hand will move the plate. A continuous and relaxed action is best, without undue force or pressure. If you hold the burin at too steep an angle, the blade will not travel through the metal. If the angle is too shallow, the blade will not cut effectively.

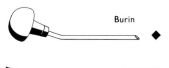

Burin

Burnisher/scraper

Line engraving with a burin

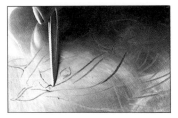

1 Hold the handle snugly in the palm of your hand with your thumb on the side of the blade, resting on the plate. Cut with a firm, smooth, forward action. Avoid pushing down.

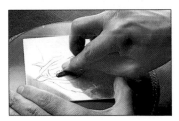

2 Cut away the spirals of metal in front of the cut with the sharp cutting edge of a scraper.

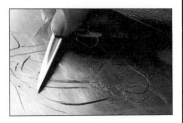

3 Use a scraper also to remove the burr thrown up on each side of the cut and smooth down the rough edges around a cut by burnishing.

OTHER TOOLS

A number of other tools identical to those used for wood engraving may be used on metal. The scorper, with a rounded or flat point, can be used for broad lines and for removing large areas. The spitsticker or the tint tools may also be used – the medium to large sizes are best for metal; small sizes may break.

Stipple engraving tools

In stipple engraving, tone is built up by a series of tiny dots, rather than with lines as in line engraving. These dots are made with the burin or with a special stippling tool. Various roulette tools may also be used. These have small steel wheels with serrated or roughened edges. Another stippling tool is the mattoir or mace-head punch, which is stamped into the plate leaving small impressed dots.

Engraving in the *crayon* manner Roulette tools and mattoirs are primarily used for engraving in the *crayon* manner, a way of reproducing the effects of a chalk or crayon drawing.

Although these techniques can be used solely for engraving, they are often also applied to plates through a hard etching ground before being etched in an acid bath (see p.273–4).

Roulette tool

Mattoir (mace-head punch)

Using a roulette tool to make a series of tiny dots on the plate.

MEZZOTINT

In mezzotint engraving, or
manière noire, the metal plate is
uniformly pitted with a series of
tiny indentations over the whole
surface which, if printed, would
produce a deep black. The print-
maker works from black to white
by scraping out and burnishing
sections of the prepared plate.
These will print as half-tones or
as white, depending on the degree
of scraping and burnishing.

Tools and techniques

The preliminary preparation of
the plate for mezzotint involves
systematically roughening it with
a rocker. This is a broad, flat
blade with a curved, chiseled
end. One side of the blade is
finely grooved, giving the end a
serrated edge. The blade is held,
or mounted on a pole at right
angles to the plate and rocked
over the whole surface in many
parallel directions to form a grid.

Once a test print has been
made, the plate is coated with

Mezzotint rocker

**Roughening the plate and
scraping out the texture** Use the
rocker to produce an overall grid
surface texture on the metal plate
(left). To scrape out areas, hold the
scraper almost parallel to the plate
so that it just shaves the surface
enough to remove the burr (right).

OTHER METHODS FOR OVERALL DEEP TONES

Mezzotint produces denser and
more subtle tones than other
techniques, but it is laborious.
Alternative methods are sand-
blasting or aquatint (see p.272).
The sand grain ground tech-
nique involves passing the plate
repeatedly through the press
with abrasive paper over a hard
ground, then etching.

black wax, or another easily
removable medium, so the
progress of the work can be
seen. The surface is then scraped
away with a scraper. To get back
to white, the pitted area must be
scraped away entirely and then
burnished and polished so that it
is unmarked. For darker tones a
certain amount of the texture
remains. Corrections may be
made by re-grounding the surface
with a roulette and rescraping.
The plate is inked using a soft
leather dabber and printed
through the etching press.

EIGHTEENTH-CENTURY MEZZOTINT

The detail is from a
mezzotint after the painter
Giordano — whose skills
included painting light out
of dark grounds. This is well
suited to mezzotint, which
directly parallels it.

The Cyclops at Their Forge
(detail, 1788), by John Murphy.

DRYPOINT

Drypoint is a form of linear
engraving in which a sharp steel
needle, diamond point or other
hard stone tool, is used to
scratch an image directly on to
the surface of the copper plate.
The line made in this way is not
as deeply engraved as a line made
with a burin. It throws up a burr
or rough edge which traps the
ink and enables the line to be
printed. If the burr were
removed, the image would not
print so distinctly.

The surface of a drypoint plate
is vulnerable to the extreme
pressure of the etching press and
the burr is quickly worn down
by printing. This means that
unless it is steel-faced by
electrolysis, only a limited
number of prints may success-
fully be taken.

Of the dry engraving tech-
niques, drypoint is the closest to
pencil sketching and is very
popular with painters. A small
sheet of copper can be worked
on with no great technical
preparation or skill, other than
that of draftsmanship.

Tools for drypoint

The diamond-point drypoint tool
produces the most fluent line. It
glides through the copper rather
than scratching through it as the
steel needle does. Additional
deeper marks or textures may be
made on the plate by using any of
the other engraving tools such as
the burin or the roulette. The
échoppe point may also be used to
incise lines which will print
thick and dark. Its round, needle-
sized point has been cut off at an
angle to create a sharp edge.

Drypoint has a spontaneous feel.
Deeper lines print the darkest.

·Etching·

The first etchings date from the beginning of the sixteenth century, with work by artists such as Albrecht Dürer (1471–1528) and Albrecht Altdorfer (1480–1538). By the seventeenth century the scope and technical possibilities of the medium had broadened considerably. It finds its mature expression in the extraordinary range of work produced by Rembrandt van Rijn (1608–1669). In the eighteenth century, Giovanni Piranesi (1720–1778) produced a powerful series of line etchings, the *Carceri d'Invenzione*. Francisco Jose de Goya y Lucientes (1746–1828) took the relatively new tonal method of etching known as aquatint to masterly heights in series such as the *Por que fue sensible*.

HOW ETCHING WORKS

In etching it is the action of acid biting into the exposed surface of a plate which creates the lines. This is unlike engraving processes, which all involve cutting lines into the plate with sharp tools.

When etching, surface areas which need to be protected from the corrosive action of the acid are covered with a thin film of resist. This is a wax-like substance which can be hard or soft depending on the type of image required and the technique. It is known as the "ground". The edges and the back of the plate are protected from the acid with varnish.

An etching needle is used to draw the image into the ground, exposing the metal in those areas. The plate is then placed in a diluted acid bath and the exposed metal is etched. The plate can be removed at any time, and the action of the acid on certain lines can be stopped by painting over them with stopping-out varnish.

Once the lines have been etched sufficiently deeply, the plate is taken out of the acid, the ground and varnish removed, and the plate inked up. An impression is then taken by passing the plate, together with overlaid dampened paper, through the etching press.

Etchings can go through a number of stages of biting, reworking and rebiting. It is usual for printmakers to take impressions (or "states") of the plate at the various stages to check the progress.

PREPARING THE PLATE

Copper and zinc are the most common metals used for etching. Zinc is coarser and softer, and a hard ground adheres to it less well than to copper. The bite can be slightly more difficult to control with zinc, but for broad work and deep biting a zinc plate may be preferable.

Copper is the best all-round metal, although iron, mild steel, brass, aluminum, and magnesium may be used. The hardness of iron and steel can be used to advantage; the surface is tough, the metal bites slowly and does not discolor inks (as zinc can do). The standard thicknesses of plate are 16-gauge and the thinner 18-gauge (commonly used in art colleges). The edges of the plate should be beveled with a file so that paper and etching press blankets are not damaged when the plate is put through the rollers.

Degreasing the plate

1 First clean the plate with metal polish, and then gently wipe or brush it with a paste made from French chalk (or whiting) and water, together with a drop of household ammonia. Denatured alcohol and whiting can also be used.

To ensure the even adhesion of a hard ground, it is very important that the plate should be thoroughly degreased before the ground is applied. In the case of a soft ground which contains grease already, this is unnecessary. Degreasing involves applying a paste made from French chalk, ammonia and water, then washing it off.

2 Rinse the plate under running water to remove all trace of the degreasing paste. The water should flow freely over the whole plate – any rivulets or drops mean that there is still grease on the surface.

HARD GROUND ETCHING

The ground is the wax-based resist laid on to the plate, through which the image is drawn. Proprietary hard grounds can be bought in solid lump or "etching ball" form, or in liquid form. The former is more widely used because it precludes the need to heat the plate, but it can be difficult to control. Liquid grounds are good for selective application and in special techniques such as sugar lift (see p.272).

The three main constituents of a hard ground are beeswax, bitumen and resin.

■ Beeswax provides the basic acid-resist coating, which is soft enough to be drawn through, and which is modified by the addition of bitumen and resin.

■ Bitumen (asphaltum) is also naturally acid-resistant. It colors the mixture and, according to the type used, makes it tough, flexible, or, in excess, brittle.

■ Resin hardens the mix and raises the melting point of the ground. Mastic, damar or colophony (rosin) may be used. Rosin is the usual choice.

Applying a hard ground

The ball or lump of hard wax ground is applied to the warm plate on an iron hot-plate. This can be improvised with a sheet of iron or steel placed over a low-burning gas ring on a

MAKING YOUR OWN HARD GROUND

Specialist etchers create the grounds that suit their own methods of working, but a standard hard ground can also be made from:
■ 2 parts beeswax
■ 2 parts bitumen
■ 1 part rosin
Grind the bitumen and rosin to a powder and mix this into the melted wax. Stir the mixture thoroughly. Pour it into suitable moulds and leave to harden, or mould it into shape in warm water.

domestic oven. The warmed copper plate melts the wax as it is applied in dabs over the surface. It is then rolled flat with a roller. Most printmakers tend to apply the wax ball directly to the surface of the plate, but, strictly speaking, it should first be wrapped in fine silk in order to trap grit or other impurities that could mark the surface. The plate should be hot enough to allow the ground to be rolled out quite thinly — but not so hot that the ground scorches. The ground will be a translucent brown.

Smoking the plate

Wax tapers are lit and held below the inverted face of the plate. This is hot, so it should be held in a hand vice. The tapers are held at such a distance that the sooty deposits from the flame blend with the still-warm wax and create a smooth black surface. This uniformly toned, dark ground contrasts well with the marks of the etching needle.

Drawing into the ground

The method is also known as "needling", because a steel needle is used to inscribe the lines on to the plate through the wax. The needle (household darning needles may be used) should have a slightly rounded tip and should clear the wax ground from the plate, so that the metal shows through clean and shiny. The surface of the plate itself should not be scored; this can result in inconsistent biting or a "foul bite". Do not rest your hand on the plate; its warmth could disturb the ground and the marks in it. For fine, detailed work, it is helpful to construct a small wooden bridge on which to rest your hand.

If the lines are too thick, they will print gray in the middle, so the best way to intensify the width or depth of tone of a line is by repeated or extended biting.

When shading by cross-hatching or with close parallel lines, remember that all lines

Preparing the plate for hard ground etching

1 Dab the ball or lump of hard ground all over the warmed plate so that it melts on the hot metal. Roll it out to a thin coating.

2 Hold the hot plate in a hand vice with the ground facing downwards. Hold lighted tapers under the plate so their smoke produces a black covering on the ground.

3 Draw the design on the black surface, through the hard ground, with a needle. As the needle incises the ground, blow or lightly dust the resulting shavings off the plate.

4 Apply stopping-out varnish to the back and edges of the prepared incised plate with a brush. Further applications can be made in the course of the etch as the design progresses.

will print in black, though their appearance − in shiny metal out of the dark ground − is light. If the cross-hatched lines are drawn too closely, the acid may bite across from one to the other, leaving an unsatisfactory gray area on the print.

Stopping-out varnish

This varnish has two main functions. Firstly, it stops the acid from biting further into a line that has already been etched, and protects other selected areas of the printing surface from the acid. Secondly, it coats the back and edges of the plate in order to protect them from the acid.

Liquid varnish can be bought in a variety of ready-mixed formulations or it can be prepared at home. There are two main types of varnish:

■ bitumen varnish − a solution of bitumen in an organic solvent
■ shellac varnish − a solution of shellac in alcohol (denatured alcohol).

Bitumen varnish may include some wax and rosin. It is dark brown and tends to thicken rapidly as the solution evaporates. It may be thinned for precise applications with a fine brush or pen. It is quick-drying. The shellac varnishes are also fast-drying and are transparent or tinted. They cannot be needled without producing a ragged line as they tend to splinter. In some cases, this splintering effect can be exploited in the print.

The advantage of a near-transparent stopping-out varnish is that it enables you to compare the biting in various parts of the plate. Being thinner than bitumen varnish, it has a tendency to spread, but, if left on the brush for a while, it will thicken naturally and be easier to control. A rectangle of sticky-backed plastic is an alternative way of protecting the back of a plate. (This vinyl material can also be used as a resist on the front of the panel.)

SOFT GROUND ETCHING

In soft ground etching, the effects of crayon or pencil drawing can be reproduced in an intaglio print. The hard ground recipe (see p.270) is mixed with up to 50 per cent tallow fat or grease. The ground is applied to the plate as before and allowed to cool. A sheet of paper is placed over the ground and the drawing made with a point on the paper. When the paper is removed, the ground can be seen sticking to it in the drawn areas. Where the metal on the plate has been exposed, the grainy texture of the paper is retained. The plate is bitten in acid and the textured lines print positively. A weaker mordant should be used than for hard ground etching (see p.273).

This is a very direct method of etching, with a characteristic soft appearance. It can be combined with other etching techniques to produce complex tonal images. The thickness and surface of the superimposed paper and the nature of the drawing tools can be varied, which means that an endless series of different effects can be created. Impressions of textiles, wire, hand or leaf prints − of anything in shallow relief − can be transferred to the plate, either as overall background textures or within particular areas. The soft ground can also be directly incised with a round-tipped etching needle or a sharp stick, to produce rich black lines in contrast to the tonal effects described so far.

Drawing into a soft ground
A photocopy of a drawing was placed over the plate and the lines traced through the paper with a pencil to transfer it to the ground.

THE ETCHINGS OF PIRANESI

Piranesi's *Carceri d'Invenzione* etchings demonstrate his ability to create a powerful sense of atmosphere and scale. In some of them he allowed his normally more formal style to loosen up so that the vigorous strokes of the etching point on the plate heighten the chiaroscuro and quicken the sense of drama.

In this detail, the eye winds down the print around the spiral staircase into the depths of the prison where another "winding" mechanism shows in vast scale against the arching figure to its right. The gigantic block and tackle at the top right and the solid wall with its massive stones on the left add to the sense of scale which the print inspires.

Etching from the *Carceri d'Invenzione* series (detail), by Giovanni Battista Piranesi (1720–78).

AQUATINT

The aquatint method of etching creates tones of various depths, ranging in texture from coarse to very fine. It can be used on its own or in conjunction with other intaglio techniques such as line etching. A plate is covered in a uniform layer of resin powder – usually rosin (colophony, see p.37) or bitumen – and heated from beneath. The resin melts and adheres. When the plate is etched, the acid eats into the metal around each grain, producing an ink-holding surface that gives a uniform tone when printed. By a repeated process of etching and stopping out, an image can be produced in different tones.

For the aquatint to be successful, the layer of resin dust on the plate must be finely and evenly distributed. It is best to use an aquatint box (dust box); several types are available.

When biting the plate in acid, an aquatint should be checked more frequently than a line etching. Heat is generated more quickly than usual because of the large area of plate exposed to the acid; this speeds up the bite.

Building up tones in aquatint
1 Stopping-out varnish is applied to the rosin-coated plate. The plate is etched a little.
2 More varnish is applied to enlarge the stopped-out area and the plate etched some more.
3 More varnish is applied and the plate etched again.
4 The final printed effect, showing how the area which has been etched most prints in the strongest black.

ALTERNATIVE METHOD OF APPLYING ROSIN
If a dust box is unavailable, place powdered rosin in a jam jar, cover it with gauze and shake it over the plate like a pepper pot. This should be done from a reasonable height. Any sealable container large enough to contain the plate and the miniature "dust storm" can be used as a small-scale dust box. This method does not produce the fine-grain effect of an aquatint box, but the coarser and less uniform tonal patterns are still expressive.

A DRAMATIC AQUATINT

The bold use of the medium is exemplified in Goya's *Por Que Fue Sensible* series. There is an extraordinary economy of means in these plates, where here, for instance, the contrast between just three basic tones – black, gray and white – is employed to suggest a fully resolved image. The strong chiaroscuro effect picks out the figure in a cold light against the gloomy interior, producing a powerful intensity of feeling.

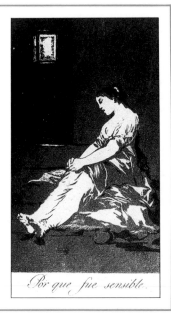

Los Caprichos, Plate 32, from the *Por Que Fue Sensible* series, by Goya.

The aquatint process

1 Agitate the powdered rosin or bitumen in the aquatint box. Allow the particles to settle. Insert the degreased metal plate so that it becomes covered with a dense and uniform layer of dust.

2 Heat the plate by moving a gas burner underneath it, until the rosin melts and the particles stick to the plate. Be careful not to overheat the plate.

3 Seal any areas with stopping-out varnish which are to be white when printed. Etch the plate in acid to eat away at the areas surrounding the grains of rosin. This produces an overall pale tone.

4 Stop out those areas which you wish to print in a pale tone and etch the plate again. Repeat the process until only those areas of the plate which need to be very dark are left exposed to the acid.

Other methods of producing grain effects if a hard ground is laid on to a plate, overlaid with sandpaper and run through the press, the texture of the sandpaper is imprinted on the ground, exposing the metal in tiny dots. The process is repeated with fresh sheets of sandpaper until an overall effect is achieved. This is then etched.

A similar effect can be produced by sprinkling salt over the hard ground. When the plate is warmed, the salt sinks into the ground. When it is cooled and placed in water, the salt dissolves, leaving pits in the ground which can be bitten.

LIFT GROUND (SUGAR AQUATINT)

This is a method of producing positive brush- or pen-line effects on a plate. The image is drawn directly on the plate using a basic mixture of $\frac{1}{2}$ Indian ink and $\frac{1}{2}$ sugar. When this is dry, a hard ground (liquid or solid) or stopping-out varnish is applied over the whole plate and allowed to dry. When the plate is immersed in warm water, the sugar melts, and the brushed or drawn areas emerge out of the ground or varnish. With thin pen-lines, the plate can be etched directly. With thicker lines or brushed areas, the plate is aquatinted as described above. These areas will then print positively (as they were drawn).

Lift ground process
1 Draw the positive image directly on to the plate with a brush or pen.
2 Apply hard ground or stopping-out varnish. In water, the sugar melts, revealing the brushed/drawn areas.

ACIDS AND BITING

In all types of etching, the metal plate is immersed in a bath of acid which "bites" unprotected parts to form the image. Trays for this process can be made of glass, porcelain or enamel. The large plastic trays made for photographic work are also suitable. The biting of the plate should be carried out under strict safety controls (see box below).

> ### SAFETY POINTS
> ▓ Make sure the trays into which the acid bath is poured are placed on a stable surface.
> ▓ Whenever possible, cover the trays with an extractor hood to draw off the poisonous fumes emitted by nitric or hydrochloric acid.
> ▓ If an extractor fan is unavailable, make sure the biting space is well ventilated. If this is not possible, carry out the maneuver outside.
> ▓ Always add the acid to the water, not the other way round.
> ▓ Always wear goggles when pouring acid or acid solutions.
> ▓ Remove the acid from the trays as soon as it is no longer in use.
> ▓ Wash off any acid that gets on to your skin immediately, and apply an alkali solution.

TYPES OF ACID

Three main types of acid are used in etching:
▓ nitric acid
▓ dutch mordant
▓ ferric chloride

Nitric acid
This is the strongest mordant. It attacks edges and undercuts the lines more than the others. For biting copper, mixtures vary from 3:1 to 1:1 water to acid.

When the fresh solution is exhausted, it turns blue. A new solution can be prevented from biting too suddenly by adding a little of the exhausted stock, or by adding copper filings. Bubbles tend to form with nitric acid and these may affect the bite, but they can be avoided by "feathering" the plate (stroking with a feather) in the acid, or by tilting the bath to remove them.

For zinc plates the acid tends to be used in weaker solution, in a range from around 12 to 6 (water):2 (acid) though even weaker solutions are not uncommon. Zinc bitten with nitric acid shows a coarser texture than copper. For iron and steel the solution is around 7 to 5 (water):1 (acid). Acid which has been used for one metal should never be used for another.

Dutch mordant
This is better than nitric acid for fine lines and delicate tonal areas. Dutch mordant may take several hours to bite deeply, whereas a strong nitric acid solution can take as little as thirty seconds. It is generally used only on copper. It bites slowly and straight down with little undercutting. The strength of the solution can be matched to the fineness of the work. A slow mix is:
▓ Hydrochloric acid 10 parts
▓ Potassium chlorate 2 parts
▓ Water 85 parts
A faster mix is:
▓ Hydrochloric acid 20 parts
▓ Potassium chlorate 3 parts
▓ Water 77 parts
Dissolve the potassium chlorate in a little of the water. Heat the mixture in a saucepan and then add it to the bath containing the rest of the water and the acid.

Ferric chloride
This can be used on copper, zinc, iron and steel. It bites evenly and slowly, without fumes. The new acid can be tempered by mixing a little of it with ammonia water in the proportion 1:1. Stir for 15 minutes, discard the liquid and pour any sediment into the bath. During biting a sediment will form in the bite. This makes it impossible to observe progress so the plate has to be removed and checked periodically.

THE BITE

The speed of a bite depends on the strength of the acid and on temperature; in winter or in a cool room the bath may need warming. There are few rules for the duration of a bite, since conditions vary so much. But it is possible at any stage to remove the plate from the bath, rinse it and check progress. A needle is a valuable tool for checking the depth of a bite. Repeated drawing and biting will require a faster bite; use nitric acid.

Open bite occurs where a line or a junction of lines is too wide to trap ink when wiped, only the edges will print black and the center will print pale gray. If you do not wish to exploit the soft effects this produces, aquatint the

area. Or it can be regrounded or varnished and needled to etch further lines into the gray areas.

Deep etch is an extreme form of open bite; the plate is heavily bitten to produce deep edges to the shapes, which then stand out like islands on the plate and print with great depth of tone. In order to keep edges sharp, several applications of stop-out may be required. Zinc is the most suitable metal.

Plates can be bitten selectively by swabbing with acid in particular areas, or a wall of plasticine or wax made to contain the acid. "Creeping bite" involves tilting the bath to clear part of the plate. Agitating the bath avoids a hard edge and creates a gradated effect. Blotting paper can be used to absorb acid

in the transitional areas.

Corrections and modifications can be made in the same way as for reprocessing old plates (see p.269). Deep areas may be scraped before burnishing and may need *repoussage* – hammering from the rear and packing with card during printing to sustain a uniform level.

Plate immersed in the nitric acid bath The reaction of the acid with the metal generates heat and there may be bubbles.

·Printing intaglio work·

At every stage of plate-making for intaglio printing, you must take a proof on prepared paper to check progress. Unsized paper needs interleaving with damp blotting paper. Heavily sized paper needs soaking in water before being sponged off and must then be stacked between sheets of glass or drawing boards.

PREPARING PAPER FOR PRINTING

Medium-weight, fine-grain, acid-free paper is the usual choice for quality intaglio printing. Deep-etch work will require heavier paper, while aquatint or fine line work may need lighter paper.

After printing, the still-damp paper can be stretched by placing it on a flat surface and sticking it down with gummed tape. This ensures that it will dry absolutely flat. However, the embossed impression of the plate itself may be lost, so it is best to stack freshly pulled prints loosely between blotting paper. This allows the paper and ink to dry thoroughly. They can be flattened later by redamping, interleaving with tissue paper over the ink and blotting paper, and stacking between drawing boards or glass plates.

INKING THE PLATE

Printing ink is made by grinding pigment in oil. Its viscosity is determined by the amount of pigment and the type of oil used, but generally it should have the consistency of thick cream.

First the plate is thoroughly cleaned of all stopping-out varnish or ground. It is then placed on the hot-plate to warm before inking. Dab ink over the plate, ensuring that all the grooves and pits are filled and ink is in the etched areas only. Wipe off the excess with tarlatan. Some of the excess ink can also be removed by scraping with a piece of stiff card or with the rounded edge of a piece of flexible plastic. This speeds up the wiping. For a line-only print, rub the side of your hand in whiting and sweep it across the plate from side to side.

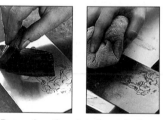

Preparing the plate for printing
Rub the plate with a bundle of scrim or tarlatan, in a circular motion.

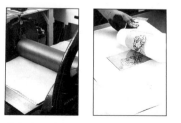

Printing the plate
Position the plate accurately on a sheet of printing paper taped to the bed of the press. Lay the printing paper on top to correspond with that on the bed.

LITHOGRAPHY

The invention and development of the art of lithography took place at the end of the eighteenth century and is credited to Aloys Senefelder (1771–1834) who founded an Institute in Munich where new techniques could be researched and promoted. He was a thorough researcher whose textbook of lithography remains as practical today as it was over 150 years ago. Senefelder was no artist himself but his invention was soon taken up by artists like Goya, Ingres and Delacroix. The immediacy of the process and its affinity to straight drawing techniques, made it popular amongst painters such as Manet, Degas, Seurat, and Toulouse-Lautrec — the latter using the technique for the memorable designs on his color posters. Lithography has an important role in printmaking today.

—·Tools and techniques of lithography·—

Lithography or planographic printing is based on the mutual antipathy between grease and water. A print is taken from a lithographic stone or plate with a flush surface, in which no area is higher or lower than another. It attracts grease, and therefore the printing ink, in the areas to be printed. In the unprinted areas, however, it attracts water and so repels printing ink.

The damp stone or plate is inked and a sheet of paper overlaid. It is then put through a press and pressure applied with a scraper — usually through a thin metal plate or tympan — across the surface of the stone. Lithography was originally practised solely on limestone slabs, though nowadays specially grained zinc and aluminum plates are also used.

THE CHEMICAL BASIS OF LITHOGRAPHY

The lithographic stone or plate is able to attract or repel grease through adsorption, which is a form of adhesion at a molecular level (see *Glossary*, p.338). Fatty acid molecules (components of the greasy lithographic drawing materials) are adsorbed on to the stone, making the area which has been drawn permanently receptive to grease.

The process is not dissimilar to the chemical action which takes place when the acidified gum arabic is used to etch the plate, except in this case the gum arabic desensitizes the undrawn areas which then become permanently resistant to fatty acids.

The adsorbed layers are so thin that they remain imperceptible and do not break up the flat, uniform surface of the lithographic stone or plate.

USING A STONE PLATE

There are a number of differences between a stone and a metal plate. The main thing to remember is that stone is more porous and feels more absorbent to work with. The effect of this when laying washes, is that they will look pale on the stone, but will print darker. It is more difficult to achieve subtly graded tones on metal plates.

It is also easier to make corrections to a stone as it can be scraped and re-etched. For this reason the stone lends itself to litho mezzotint effects, whereas the metal plate does not.

Fine Bavarian limestone of a light yellow-gray color makes the best stone for lithography. It is fine-grained and porous, and is softer than gray stone. A light gray stone will require a little more acid in the gum-etch than a yellow stone and a dark gray stone a little more still. The stones come in various sizes and thicknesses.

Lithographic stones
Two limestone lithographic stones in large and small sizes. Also shown is a levigator, used for grinding down the surface of the stones (see p.276).

Preparing the surface

The stone must be perfectly flat and grease-free. This can be achieved with a levigator, which is a heavy iron disc with a handle near the edge and holes in the center. It is used in conjunction with sand and water, to grind down the surface of the plate. The grinding sand is generally used in three grades: coarse, medium and fine.

If a somewhat grainy surface is required (such as for crayon drawing) you can use the coarse-grade sand on its own. Move the levigator round the stone in a figure of eight, using equal pressure on the sides, corners and center. When the sand is pulpy, wash it off and use a new batch. Check the flatness of the stone from time to time with the edge of a metal rule. It is important to file the edges of the stone, to ensure that the paper will not be torn when it goes through the press.

Using the levigator
With sand and water on the stone, use the levigator in a figure of eight motion. Do not neglect the edges and corners of the stone.

Checking the surface
From time to time, stop work to wash off pulpy sand and assess the flatness of the stone with the edge of a metal rule.

USING A METAL PLATE

Both zinc and aluminum plates are suitable for lithography. They have to be prepared with a grainy, grease-free surface. This is usually done with a graining machine – a large, flat, vibrating bed or tray. Place the plate on the graining machine and cover it with glass marbles. Next throw sand and water into the machine. The marbles vibrate on the sand and plate, which creates the roughened texture needed to hold the lithographic crayon and the water. You can control the roughness of the plate by changing the type of sand that you use for the graining.

A plate which has been stored for some time, and which may have accumulated grease and dust, can be chemically re-sensitized with a proprietary mixture which contains potassium alum, nitric acid and water.

TRANSFERRING AN IMAGE TO A STONE OR PLATE

The lithographic stone will print the reverse of what you draw, so if you are using an original drawing, view it in a mirror when copying directly on to the plate. If the drawing is on paper, tape it face-down on to a light-box, and view it from the back.

When printing a zinc or aluminum plate on an offset-litho machine, which can be a more reliable method of lithographic printing, it is not necessary to draw in reverse, because the ink is taken from the plate on to a roller before being transferred to the paper and is not therefore a reverse image.

You can also trace an image, using rouge (red chalk) or graphite transfer (tracing-down) paper (see below). This gives a non-greasy image. Another method is to project a slide directly on to the stone or plate.

Tracing an image with transfer paper

1 Place the transfer paper, chalk side down, on the plate. Lay the original on the transfer paper. Cover it with a thin sheet of transparent acetate for further protection if necessary.

PROTECTING WHITE AREAS

If you want a white margin around a print, or you intend a particular shape to print white, you can mask out the area with a gum or gum-etch solution applied with a soft brush. This protects it from greasy marks which can easily be made while the stone or plate is being worked.

Proprietary gum mixtures are available for working on metal plates. A gum arabic solution can be used if you are working on stone. The gum leaves a slightly darker mark on the stone or plate, so you can see where it has been applied.

Trace the contours with the sharpened end of an old paint brush or similar instrument.
2 Lift off the transfer paper to reveal the image on the stone or plate.

INKS AND CRAYONS FOR LITHOGRAPHY

Whatever color is used to ink and print the plate, the original work on it is always done in black and white. Whatever medium you use to mark the stone or plate, it must be greasy.

There are innumerable recipes for the preparation of lithographic crayons and inks (see below), but they generally all contain wax, tallow fat and soap in various proportions, as well as the black carbon pigment.

A solid ink, ground and diluted with distilled water, can be used. This usually contains some shellac as a hardener. You can also buy proprietary lithographic crayons, ranging from very soft to hard, and "tusche", the ink used for lithography. Tusche is available in slightly different formulations for use with either brush or pen. The box (right) gives recipes for lithographic ink and chalk as recommended by Senefelder, the inventor of lithography. The ingredients should be boiled up together then sieved, cooled and cut into sticks.

You can use a wide variety of other media for working on stones or plates, including shoe polish, soap, vaseline, oil pastels and all-purpose pencils. Even ordinary graphite pencils will produce a pale image.

MAKING LITHOGRAPHIC INK AND CHALK

These three basic recipes for lithographic inks and chalk are those given by Senefelder, the inventor of lithography.

Solid ink

beeswax	12 parts
ram's tallow	1 part
soap	4 parts
soot	1 part

Liquid ink

shellac	4 parts
borax	1 part
water	16 parts
soot	1 part

Chalk

beeswax	2 parts
soap	1 part
soot	1 part

Lithographic inks and resins

1 Solid stick of lithographic ink
2 Square lithographic crayons
3 Lithographic pencil
4 Lithographic ink for brush work
5 Lithographic ink for pen work

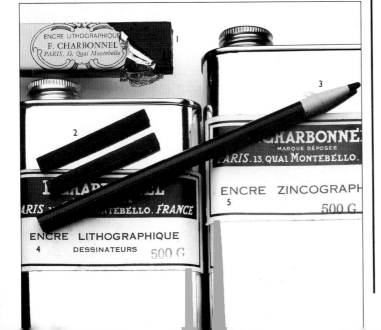

MAKING LITHOGRAPHIC LINE DRAWINGS

When doing any kind of lithographic drawing or painting, always remember that grease will print and gum will not. Any area that has been in contact with grease will leave a mark which will print unless it is physically removed.

One of the best ways of making lithographs is to do a chalk or crayon line drawing on the plate just as if it were a piece of paper. Remember that a hard crayon will produce a lighter tone than a soft one. To avoid the chalk or crayon getting warm and sticky, use a holder. This is particularly important for softer grades of crayon.

Alternatively you can make a solid black line drawing directly on the plate using tusche or lithographic drawing ink. This is made up in slightly different proprietary forms for brush or pen (zincographic ink). It produces crisp edges and solid lines.

Making a linear drawing on the stone or plate To ensure there are no smudges on the print, it is important not to let your hand touch the stone or plate.

Reinforcing the lines with lithographic ink Some of the lines are strengthened with a brush and undiluted lithographic ink. This should be dry before processing.

Direct drawing on the stone or plate Drawing with a brush or pen is particularly suited to lithography, which gives a more subtle and tonal quality to a line than can be had with screen printing, for instance.

Linear portrait lithograph
This print was made using a soft sable brush and proprietary lithographic drawing ink on a metal plate.

CREATING TONAL EFFECTS

The natural grain of the stone or plate can be used to create tonal effects: gently rub a crayon across the surface of the stone or plate. The surface texture will pick up the crayon, thus creating a grainy half-tone effect similar to that produced by the all-purpose pencil on NOT paper (see p.77–8). You can create denser areas of tone by heavier shading, or shading with a softer pencil.

You can also create half-tones by diluting tusche, or by spattering with a toothbrush through a paper stencil. Or try spraying the ink through an airbrush with a spatter cap.

Diluting the crayon

The marks of the lithographic crayon can be diluted by applying a brush dampened with distilled water or mineral spirit. Distilled water is preferable since mineral spirit can sometimes have a greasy effect. This technique enables you to create half-tone wash effects. It is a good idea first to have mastered the art of gum etching, since it is common for the half-tones to go into solid areas of black. The most important aspect of the lithographic process, is that the lithographic version of the original will generally reproduce with more tonal contrast.

Producing half-tones
Lithographic crayon can be carefully diluted using a brush dipped in distilled water or mineral spirit.

THE LITHOGRAPHS OF TOULOUSE-LAUTREC

These works have a lightness of touch, a fluency and an appropriateness to their subject matter and to the medium that makes them unique in the late 19th century. Lautrec had a gift for drawing which was allowed direct expression by the receptiveness of the lithographic stone. The softness of tone of the crayon and the bold, flat areas of the brush are retained in the stone and expressed in the print.

With Lautrec there is always the sense of an experience freshly perceived. But there is also a remarkable sense of design which controls the surface and contains the action. Here, the shape of the woman and her profile are held by the surrounding tone.

Aux Ambassadeurs (1894), by Toulouse-Lautrec.

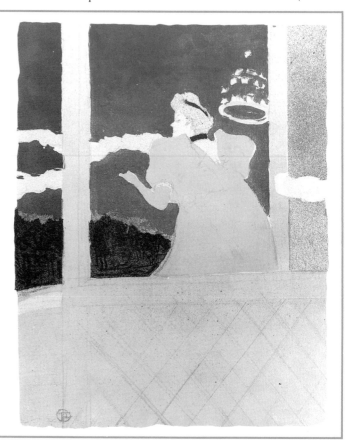

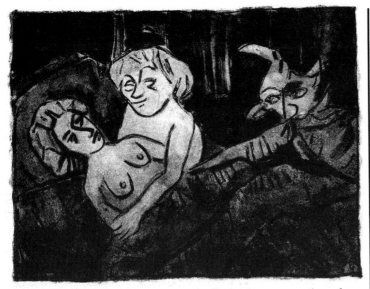

Line and tone image
This more deeply tonal print was created on a lithographic stone. The image is based on part of an old medieval woodcut. It was drawn up principally in lithographic crayon with some rich tonal effects obtained by diluting the crayon on the surface of the stone with mineral spirit (see p.278) and also by using thin liquid tusche. This was blotted in places for textural effects. Some of the crayon lines were further reinforced with brush and ink before processing.

A "MEZZOTINT" FORM OF LITHOGRAPHY

A black, greasy ground is laid over a coarsely ground stone. You can use an asphaltum solution for the ground, or lithographic ink diluted with turpentine. Scrape the image out of the dark ground using flat scrapers, wire brushes or emery paper for large areas of tone, or pointed scrapers for thin lines which you wish to print white.

Making a "mezzotint" lithograph A pointed scraping tool is used to scratch a linear drawing on to the stone through the black ground.

·Transfer lithography·

In this indirect method of lithographic printmaking, the image is drawn with greasy lithographic drawing materials on paper and transferred to the stone from which it is then printed. The paper may be of varying texture or thickness but before drawing on it, it should be coated with a weak water-based size solution or with a water-soluble glue, or gum-based white paint. This gives a key to the greasy drawing materials but also makes transfer to the stone easier, and ensures that greasy and non-greasy areas separate properly. The surface of the paper should be kept clean of greasy fingermarks which can cause smudges on a print.

Transferring the image to the stone

I Lay the paper with the drawn image face-down on the prepared lithographic stone which should be dry.

2 Lay a sheet of paper on top of the transfer paper and dampen the back of it evenly, using a sponge.

3 Pass the lithographic stone and the paper through the press to transfer the greasy image to the stone. Carefully remove the damp paper and peel the transfer paper off the stone.

4 The image will have transferred to the stone. It can now be dried using a hair-drier. Process the stone in the normal way.

Preparing and printing a stone or plate

PROCESSING A LITHOGRAPHIC STONE

When preparing the stone for printing, first make sure that the margin round the edge of the image is clean. If the margin was not protected with gum, you can clean it all the way round with a snakestone and water and then leave it to dry.

At this stage, if you wish, you can dust the stone with rosin powder to protect the greasy, drawn areas from the acidic gum etch. This is sometimes done after the first etch.

Dust the stone with talcum powder before etching. As well as protecting the greasy areas from the gum etch, the talcum powder ensures that the gum etch covers the whole surface of the stone.

The first etch

The gum etch comprises a solution of gum arabic to which some drops of nitric acid are added. Phosphoric and tannic acid may also be added to the mix. The amount of acid will depend on the drawing and the type of stone used.

After it has been etched in this way, the stone will be desensitized to grease in the non-printing areas. The adsorption,

or bonding, of the greasy areas to the stone is also speeded up by the neutralizing effect of the alkali in the soap component of the greasy areas. This "frees" the fats for bonding on to the stone.

Washing and inking the
stone The next stage is to wash the drawing in an asphaltum solution, consisting of asphaltum or bitumen, wax, tallow and turpentine. The asphaltum, which may need to be thinned with turpentine, brings up the image in brown, in a light but

even tone. The asphaltum helps the non-drying ink, which is applied next, to take to the greasy areas.

It would be possible to take a print at this stage, but the image is not yet firmly established on the stone, and so it is best to ink it up with a fatty, slow-drying ink called "press black" or "non-drying black" before "etching" it for a second time. Roll up the ink on a slab and apply it to the stone in a light, smooth rolling action. During the application of the non-drying black, keep the

ETCH TABLE
(Devised by Lynton R. Kistler, pioneer Los Angeles hand-printer)
Quantities are per 1 fl oz gum arabic

	Heavy drawing	Medium drawing	Light drawing	Delicate drawing	Very delicate drawing
Yellow stone					
drops nitric acid	15	12	6	4	0
drops phosphoric acid	5	5	4	3	0
grains tannic acid	6	6	6	5	6
Light gray stone					
drops nitric acid	18	15	10	5	0
drops phosphoric acid	5	5	4	3	0
grains tannic acid	6	6	6	5	6
Dark gray stone					
drops nitric acid	20	18	13	8	3
drops phosphoric acid	5	5	5	4	2
grains tannic acid	6	6	6	6	8

Source: *The Tamarind Book of Lithography* (Abrams, New York 1971).

Preparing a stone for lithographic printing

1 Dust the surface of the stone with sieved French chalk or talcum powder (baby powder is suitable) and rosin. Dust the powder on with cotton and dust off the surplus.

2 Apply gum etch over the entire surface of the stone. Proprietary gum arabic with nitric acid mixtures may be used. Rub the etch on with a sponge and pat it down. Leave around 12 hours.

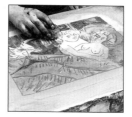

3 Wash the stone with mineral spirit to remove grease and with water to remove gum. Pour on a little asphaltum solution. Rub this on evenly, with more water.

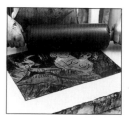

4 Now ink up the stone with press black or non-drying black, rolled up on a slab and applied to the stone with a light rolling action. Keep the stone damp with a sponge.

stone damp with a sponge. It will take some time for the image to appear in its full range of tones, particularly if it has been heavily drawn with a lot of black.

The second etch

Dry the stone with cold air from an electric fan, or a flag drier, before dusting it with rosin powder, which adheres to the non-drying black, and then with talcum powder. The stone is ready to be etched for the second time, with a gum etch or water etch solution. After etching, wash off the etch and gum the stone with gum arabic if you do not intend to make a print straight away.

PROCESSING A LITHOGRAPHIC PLATE

This method is very similar to processing a stone. The main difference is in the chemicals used for the etch.

The first etch

The plate is first dusted with talcum powder and then sponged with gum etch. This may be a proprietary solution prepared for plate only (a cellulose gum with tannic acid and a phosphate).

The amount of time the plate should be left under the gum etch varies. For lithographic crayon drawings half an hour is usually enough, but for more delicate work a considerably longer time is advisable. The action of the gum etch does not continue indefinitely, and plates left over a period of days will come to no harm. The greasy drawing is then washed out through the gum with mineral spirit, and then the gum is washed off with water. If the greasy drawing does not come off easily, wet the plate with a combination of water and turpentine. Once the drawing and the gum have been removed, the asphaltum solution is applied to the wet plate as for the stone. The non-drying ink is then rolled up on the wet plate.

The second etch

The plate is dried with the flag drier and dusted with powdered rosin and talcum powder before being given a second etch. The formula of the etch can vary greatly. Gum etch may be used, or pure gum arabic. A potassium/alum/nitric acid and water mix can be used, or a proprietary preparation of tannic acid and water. This is a strong etch and should not be applied for more than two minutes. Brush it on with a soft, bristle brush and keep it moving on the plate all the time, before washing it off. The plate is fan dried and, unless you are ready to print, gummed and stored.

MAKING A PRINT

With stones, the paper is generally dampened as for etching but for plates the paper is often used dry.

If you are using a hand-operated press, place the paper carefully over the stone or plate with some sheets of packing paper on top. A thin metal plate is lowered over the bed. A lever is pulled to lower the scraper and the movable bed is cranked through, so that an even pressure is scraped across the entire surface of the plate.

If you are using an offset litho press, lay the plate (with the image not reversed) and paper side by side. An electrically driven rubber cylinder passes over the plate, picking up the ink which it transfers to the sheet of paper.

Finishing-off

After printing, the plate or stone may need to be saved for further printing in which case the ink is removed by applying mineral spirit through water. The surface is re-inked with non-drying black, then gummed as described above.

A stone may be reground when it is no longer in use. A plate is treated with a caustic soda solution to remove all traces of grease. It can either be reground or resensitized with a proprietary solution.

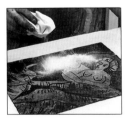

5 Dry the stone with a cold electric fan or a hair-drier. Dust it with rosin powder, then with talc. Etch the stone again with a gum etch or water etch solution.

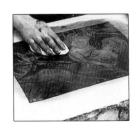

6 Wash off the etch with water and the non-drying black with mineral spirit, rubbing with rags.

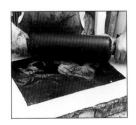

7 Keeping the stone damp, roll up the ink on a slab, then ink up the stone lightly and fan dry. Dampen a sheet of paper and place it over the stone with some packing paper on top.

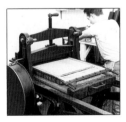

8 On a hand-operated lithographic press, lower the metal plate over the bed. Lower the scraper and crank the bed through the press.

SCREEN PRINTING

Screen printing is derived from the stencil method of painting, where parts of a design are cut out of a thin piece of card (or similar material). A flat-bottomed brush, held vertically, is used to dab paint over the card. The paint passes through to a sheet of paper or other material beneath the card in the areas that have been removed.

Early Oriental hand-cut stencils were so complex that they had to be held together on a mesh of human hairs. Screen printing or silk-screen printing, which emerged at the beginning of the twentieth century, is based on a similar idea. A fine, open-weave mesh is stretched on an open frame. The stencil is applied to the mesh and printing ink scraped through it to produce an image. Today, it incorporates sophisticated photographic methods and can produce highly complex images. At the other end of the scale, it is a simple and direct method of printing which can succeed with very little equipment.

·Equipment for screen printing·

THE SCREEN

The screen consists of an open-weave mesh stretched on a rectangular frame. The frame may be made of wood or metal, and is usually square-section. Home-made frames may be constructed from any non-warping timber. The frame must be flat and strong enough to withstand the tension of the mesh. It must lie parallel with the baseboard when printing.

The mesh

The mesh that stretches over the frame is traditionally made of silk but nowadays this has largely been replaced by synthetic fibers. The mesh should be a tough, uniform, open weave to allow the ink to pass freely on to the paper. It needs to have some flexibility but must not distort during printing. It should be easy to clean but not be affected by cleaning solvents.

One mesh that fulfills all these requirements is monofilament polyester mesh, although other synthetic fibers such as nylon may also be used, especially where a more flexible mesh is required. Coarser weaves are used for simple, bold work; fine weaves are used for work with a high degree of detail.

Stretching the mesh

Although many printmakers buy screens ready-made, the mesh can be stretched by hand. Cut the mesh fabric about 10cm (4in) larger than the frame all round, and staple it in place (see *Stretching canvas*, p.61). The warp and weft of the fabric should be parallel with the sides of the frame. To protect the mesh you can staple through thin card instead of directly on to the fabric. Cut off any excess fabric and glue the mesh along the line of the staples, using a proprietary white woodworking adhesive. When this is dry, tape the frame with heavy-duty, brown gummed paper. Apply this along the inside face of the frame all round. This protects the ink from seeping between the fabric and the frame. When the rest of the frame area is dry, seal it with shellac or polyurethane varnish.

Mechanical stretching devices

There are also mechanical methods of stretching the mesh including a roller-bar system that tightens the mesh by turning until the correct tension is reached. A frame is then placed under the mesh and glued with contact adhesive or a two-part epoxy resin. Also available are screw-grip systems and pneumatic stretching machines.

DEGREASING A SCREEN

It is very important that every screen should be thoroughly prepared by being degreased. If any trace of grease or dirt remains in the mesh, this may cause lack of adhesion of the stencil. It is best to use a proprietary degreasing paste – although household scouring powder will do.

1 Apply the degreasing paste to the wetted screen with a stiff household brush and scrub it in. **2** Wash off the paste thoroughly with a water spray. Dry the screen with a cool air dryer.

·Stencils for screen printing·

DIRECT STENCILS

It is important to distinguish between direct and indirect stencils. The former, which may be manual or photographic, are made directly on to the mesh of the screen. The latter, which may also be manual or photographic, are made away from the screen, then attached to it.

Making direct stencils

There are a variety of ways of drawing directly on to the screen. In every case, the printing relies on the fact that oil and water do not mix, so if an oil-based printing ink is used, the stencil should be drawn in a water-based medium.

A number of proprietary liquid screen-fillers are available that the artist can use to paint, scrape, spray or apply directly to the screen. Any mark made with the filler will block out the ink – so that to print a line, the areas on each side of the line would need to be "painted" with filler. This is straightforward where large shapes are involved, but would be extremely difficult for finely drawn areas. So here a "reverse" method is used, and one that is probably the most common of the direct manual stencil techniques – drawing with lithographic ink or crayon.

This method involves painting the image positively in tusche (lithographic ink), or drawing it with a lithographic (wax) crayon on the screen (see below). The whole screen is then coated with filler and the original drawing dissolved. The drawn area is thus left open to the ink when prints are taken.

Using tusche

1 Draw or paint the image directly on to the inside of the screen using tusche or a lithographic crayon.

2 Scrape a layer of blue (water-based) filler across the screen, using a piece of stiff card.

3 When the filler is dry, remove the ink or tusche drawing using rags and mineral spirit.

It is possible to draw with wax crayons or tusche directly on to the screen and then to use a water-based printing ink, but here again it is the negative area that will print, not the marks themselves.

Artists have experimented with many methods of working directly on to the screen. It is possible, for instance, to roller filler over flat "shaped" objects, those with overall texture, or items such as woodcut blocks, and thereby to take an image directly. The screen is allowed to dry and printed through.

MAKING INDIRECT STENCILS

The most common form of hand-made indirect stencil is the cut-out. This may be made with paper or with special stencil film. The best type of paper is translucent glassine paper (crystal parchment) made from heavily beaten wood cellulose fibers. Detail paper, tracing paper or newsprint may also be used.

In most cases, the ink will make the paper stencil stick to the mesh. If not, tape the edges of the paper to the frame. Or, tape the stencil (on a piece of paper larger than the frame) over a piece of glass and coat it with a turpentine-soluble varnish. Place the screen over the stencil and rub with turpentine. As the turpentine dries it will soften and stick to the mesh. At this point you can cut the edges of the stencil free of the glass.

Preparing a paper stencil

1 Cut or tear the image out of the crystal parchment paper.

2 Position the image on a sheet of printing paper on the baseboard below the screen.

3 Lower the screen and pull the ink across the screen, using a squeegee.

4 When the screen is lifted, the paper has adhered to the screen and is ready for printing.

Using proprietary stencil film A more accurate method of making hand-cut stencils is possible with the two-layer stencil film that is commercially available. This consists of the stencil plus a backing film. The film is colored but transparent, which means that it can be taped over an original design and can then be accurately cut.

With a scalpel or other sharp blade, cut into the film around the shape to be masked out, taking care not to pierce the backing film. Peel off the film in the areas to be printed, and when the stencil is ready attach it to the underside of the frame. This can be done in two ways, depending on whether the stencil film is water-based (more usual) or shellac-based.

With a water-based film, place the screen over the film, and then dab the film area with a wet rag until the color begins to come through the mesh. Continue doing this down the stencil until the whole area of film has been softened and is adhering. Remove any excess moisture with a sheet of newsprint. Leave the film to dry and then peel off the backing sheet as before.

With a shellac-based film, place the frame over the stencil and iron it from the inside through a sheet of paper, using a preheated iron. When the film is cool, peel off the backing sheet.

Using water-based stencil film

I Lay the stencil film over the image, matt-side up. Cut out the design with a scalpel, taking care not to cut the transparent film.

2 Lay the cut stencil under the screen and dab it with a damp sponge or rags until the color comes through. Then use dry rags to absorb excess water.

3 Allow the screen and stencil to dry. Carefully peel away the translucent backing film, leaving the cut-out stencil ready to print from.

·Photographic screen-printing methods·

The photographic methods of screen printing can be used to produce effects ranging from simple one-color line-positive prints, to full color photographic images. Both are based on the same technique; in the direct method, a light-sensitive emulsion is applied to the screen. A black positive image on transparent film is then placed against it, and the emulsion is exposed to ultra-violet light. This hardens the areas of the emulsion that receive the light, while those areas protected from it remain soft. When the screen is sprayed with warm water, the soft areas are washed away, leaving the mesh open to printing ink in the positive areas. The indirect method employs a light-sensitive emulsion that is available on a backing sheet. This is exposed to the light away from the screen, washed off and then transferred to it.

PRODUCING A POSITIVE IMAGE

Before the printmaker can use the light-sensitive emulsion, a positive image must be produced on a transparent or translucent film. This can be done in a number of ways. A common method is to create the image by hand (see right).

As well as black ink, any opaque rub-down lettering, textures, graphics and tones can be incorporated on the surface of the film. In addition, special red masking film, which can be cut to shape, or red tape can be used.

Drawing an image on drafting film

I Stretch a piece of thin drafting film on to the drawing board with masking tape. Draw·the image with a pen or brush and opaque black ink (or with any drawing tool in conjunction with an opaque medium).

2 Use special red masking film or red tape for any large areas that need masking out, or for straight lines. Cut out any complex shapes with a scalpel. Peel away from the backing film and stick to the artwork.

DRAWING ARTWORK FOR MULTI-COLORED PRINTS

Whatever color is used to print the final image, the artwork for each color must be drawn in an opaque medium (usually black) on transparent or translucent film. If you wish to make a hand-drawn image in several colors, first draw the artwork for the main part of the image and then superimpose a new sheet of film over the artwork when it is dry. Draw the artwork for the next area of color and repeat the process as necessary. The artwork for the second color should slightly overlap the edge of the first all the way round to ensure that in the finished print it will comfortably fill the correct area, since the main part of the image is printed last.

USING HAND-DRAWN PHOTO-STENCILS

The precision of this print echoes the stillness and the intricate play of light and shade in the garden. The weight and shape of the roof and its reflection act to hold together the delicate pattern-ing of leaves and rushes. The underlying sky/water color was cut from stencil film; the other colors were made from positives drawn directly and painstakingly in ink on drafting film.

Japanese Garden (1987), by Elizabeth Bessant.

Hand-drawn artwork for a multi-colored print

1 Black ink was used for this hand-drawn artwork. First the outlines of the angels and balloons (areas that were to print black) were drawn on a piece of translucent drafting film using a tubular pen nib and ink.
2 The artwork for the areas that were to print blue was drawn on a new piece of film. The same nib was used for outlining, and the areas filled in with a fat, round sable brush. This artwork could equally well have been cut from red masking film.
3 The artwork for the areas that were to print gray was drawn in the same way on a fresh piece of film.
4 Photo-stencils were made for each color and the final image printed in black, blue and gray.

USING LINE FILM

Different types of photographic screen print can be created using line film. For instance, if a high-contrast, black and white, continuous-tone negative is projected on to line film, all the half-tones will be reduced to solid black or transparent white. But it is still possible to retain a great deal of the image. The line positive is made to the required size and is used to create the image on the screen.

Posterization

This is one method of creating the effect of tone using line-film positives. It involves taking an original, continuous-tone (black and white) negative and making a series of line negatives in which the exposure is increased slightly every time. The resulting series of positives will range from over-exposure to under-exposure. If four stages are made, then the darkest positive will be printed in the lightest opaque color, the second darkest in a slightly darker color and so on, until the lightest positive (which contains the finest detail) is printed in the darkest color. The example below uses three line negatives. The result is a rich, tonal image that could only have been created by silk-screen printing.

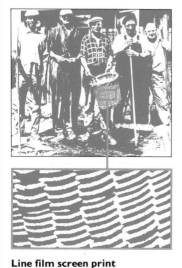

Line film screen print
A black and white photograph was converted to line film and screen printed. Areas of concentrated tonal contrast (see detail) reproduce well.

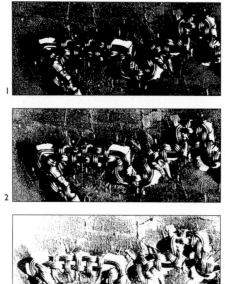

Tonal effect from a black and white photograph Here, a black and white photograph was taken of a small painting in which extruded, acrylic paint was woven into the rough, diagrammatic shape of a ship. The photograph was reproduced in line film in three stages and printed from pale gray through mid-gray to black. The result is a screen print that, in its density of tone, gives a graphic representation of the paint thickly worked on the canvas.
1 Darkest positive is printed palest.
2 Mid-tone positive is printed in a mid-tone.
3 Lightest positive is printed darkest.

PHOTOGRAPHIC HALF-TONE EFFECTS

Unlike other printing methods where the thickness of the ink determines the tonal range, in screen printing, an ink film of uniform thickness is laid on to the paper. To produce a range of half-tones, the continuous-tone image needs to be broken up into a series of small one-tone dots or lines so that the middle part of the tonal range can be read. The effect can be seen on large-scale poster hoardings or even in newspapers. To achieve this effect, the negative is projected on to the line-film through a half-tone screen that breaks up the image.

Many kinds of half-tone screen are available, all producing different kinds of tonal patterns of varying degrees of fineness. It is also possible to buy negative film with half-tone dot screen already incorporated into it. Half-tone screens are not

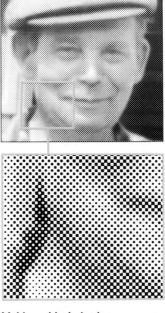

Making a black dot image
The black-dot, positive image (detail shown below) was produced by screening a photograph as described (left). The next stage is to use it to make a stencil.

necessary with this technique. The only important consideration is that the resulting image does not contain dots or tones that are too fine for the mesh.

Creating full-color, half-tone effects Full color paintings, photographs or slides can be copied on to continuous-tone black and white film, using three primary color filters – red-orange, green and blue-violet. The black and white image taken through the red-orange filter will be printed in blue (cyan); the blue-violet filter will produce yellow, and the green filter will produce red (magenta). Superimposing these three pigment primary colors will produce a full range of colors. An additional black printing from a black and white photograph of the color original, taken through a pale, straw-colored filter, will reinforce the density of the image and the darker tones.

WARHOL'S SCREEN PRINTS

Andy Warhol's portraits of Marilyn Monroe are among the most potent icons of the 1960s. They demonstrate the immediacy and force of the silk-screen medium with the clarity, freshness and direct-ness that characterizes his work of the time. But they also go beyond a mere brashness of appearance to evoke the personality that lies beneath the transformation and manipulation of surface.

Marilyn (1967), by Andy Warhol.

APPLYING AND PROCESSING PHOTOGRAPHIC STENCILS

■ For direct stencils, a photo-stencil emulsion is applied directly to the screen. This is available in a number of proprietary forms. It is generally a gelatine or PVA-based solution, which is light-sensitized by adding a bichromate just before application. This process is usually carried out in low light. Narrow coating-troughs are filled with the liquid and then scraped up the screen, which should be positioned almost vertically. Both sides of the screen should be coated twice, and an additional layer coated on to the side that will be in contact with the paper. The viscous liquid is squeegeed on to both sides of the screen, which is left to dry in a horizontal position.

■ Indirect stencils come in pre-sensitized rolls with the emulsion attached to a transparent plastic backing sheet. For indirect methods, the stencils are applied to the screen after exposure and washout.

Exposing the stencils

Translucent film is just as effective as transparent film in letting the light through when transferring the image, but it needs a longer exposure time – about 25 per cent more – than an image on a transparent acetate sheet.

With both direct and indirect stencils, the most important aspect of exposure is that the positive image on transparent or translucent film should be in direct contact with the light-sensitive film. With an indirect stencil, place the artwork film, with the emulsion side up, over the exposure light source. Place the stencil film (emulsion side up) on top and cover with a sheet of glass to achieve a good contact before exposing it to the light source from below. A similar method can be used for direct stencils, in which the whole screen is involved.

Most art colleges have special printing-down frames in which the positive and frame are placed on a large sheet of glass in an exposure unit. A flexible rubber lid is then closed and a vacuum unit switched on that shrinks the rubber over the frame. The exposure is made using ultra-violet fluorescent tubes within the unit.

Other methods of exposing the stencils include vacuum bags made from PVC, into which the screen and positive are placed and sealed. The air is pumped out to ensure a good contact, and the screen is then exposed.

Various kinds of light source may also be used: the best being the metal halogen lamps. Ultra-violet fluorescent tubes in an exposure unit are another alternative. Since the nature of the positive tends to vary, the exposure time is always tested before the sensitized screen or film is exposed.

Washing out the stencil

If you are using a direct stencil, the screen can be washed out with a fine spray of cool or warm water. This can be done in a bath tub, or in a special wash-out unit. The back of the screen is sprayed until the image appears clear and scum-free. It is then blotted and dried.

If you are using an indirect stencil, it is sometimes necessary to develop or harden the stencil in a solution before it can be washed out against a flat, laminate board. When this has been done, place the stencil on the board, lay the screen on top and blot the stencil through the mesh. Dry it with cool air and remove the backing sheet. Touch up any registration marks or flaws in the stencil with blue filler. Protect the area of the mesh outside the stencil with blue filler or, for larger areas, paper taped in place. Stick tape round the perimeter of the inside of the frame. The screen is ready for printing.

Making an indirect photo-stencil

1 Expose the photo-sensitive film to the light through the transparent or translucent artwork film. Develop or harden the film if necessary, in a bath, using weak developer.

2 Clip the film to a flat board in the wash-out unit or bath tub and wash thoroughly with a fine spray. The image appears clear out of the colored film.

3 Carefully pick up the stencil, lay it on a board and lay the screen over it. Lay newsprint on top and work over with a roller. Replace the newsprint until it is clean and dry.

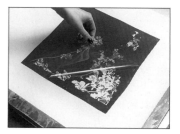

4 Dry the screen thoroughly with cool air, then peel the shiny backing off the stencil film. Touch up any flaws with blue filler.

——·Tools and techniques for printing·——

The basic printing equipment is a flat bed or base with a batten attached to it. The prepared screen is connected to this with two hinges. A movable bar on the side of the screen is used as a prop while paper is being placed on or removed from the base. Professional presses incorporate a counter-balanced system with a one-arm squeegee operation. Any size of screen can be clamped to the mechanism.

THE PRINTING PROCESS

The squeegee is used to scrape ink across the screen, so that it passes through the pores of the mesh on to the paper below. It has a wooden or metal handle, and a strip of flat-bottomed, hard, flexible plastic that acts as the blade.

Most silk-screen presses have a vacuum-pump attachment that holds the paper firmly in position on the base. This ensures that after it has been inked, it does not stick to the frame when you lift it.

Silk-screen presses may also have registration adjusters and "snap" adjusters that hold the frame off the surface of the paper so that contact is only made when the squeegee is pulled across the mesh.

USING ACETATE FOR REGISTRATION

This method is particularly suitable for detailed designs needing accurate registration.

Tape a sheet of clear acetate to the printing table and take a print on to it through the screen. Have the original artwork taped in position on a sheet of paper as shown below. Slide the paper under the acetate and align the two images exactly. Now position the pieces of registration card, as described below (see step 2).

INKS

There is a wide range of special inks for silk-screening. These have a syrupy consistency.

After a batch of prints has been made in one color, remove excess ink from the screen over sheets of clean newsprint. Rub it with solvent-filled rags, then with clean ones.

INK PROBLEMS

■ If the ink is too runny, it may "bleed" and run into areas of the screen that should be masked out.

■ If the ink is too viscous, it may not print in all the smallest areas of the stencil.

■ A too-viscous ink may also cause drying, which effectively blocks the stencil in these areas.

Simple registration and printing

1 Tape the positive or original image in the required position on a sheet of paper (the same size as that to be used for printing) on the printing table. Tape two paper "arms" to the sides of the paper if necessary so that you can move it easily. Move the paper under the frame until it exactly aligns with the stencil when the screen is lowered. Tape it temporarily in place.

2 When the paper is in position, tape three thin registration cards to the bed abutting the edge of the paper, one on the left side and two on the bottom edge. Have every sheet of paper butting up to these before printing.

3 Partially lower the screen into position and

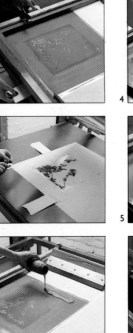

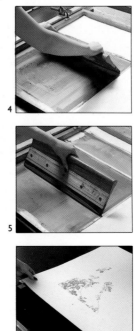

pour the ink on to it, along the masked-off area, not too close to the cut-out parts of the stencil.

4 With the screen still raised off the paper, charge it with ink by pulling the squeegee across it. Lower the screen and take a print by pulling the squeegee firmly and evenly across the stencil.

5 After each pull, charge the image with ink in the same way ready for the next print. This also helps to stop the ink drying on the screen too quickly and thereby losing parts of the image. Do this by pushing the squeegee back in the opposite direction, tilting it slightly away from you.

6 Raise the screen to reveal the finished color print. Remove the print from the bed and place in a drying rack.

COLOR AND
PERSPECTIVE

COLOR

Our perception of color is entirely determined by the action of light on the objects we perceive. In the latter part of the seventeenth century, Sir Isaac Newton demonstrated that colors were integral components of white light. He did this by allowing a beam of white light to fall on a glass prism. The light was dispersed into a band of separate colors from red through orange, yellow, green, blue and indigo to violet (the colors of a rainbow). Then, when he allowed the colored rays of light to pass through a converging lens and on through a second prism, they were reconstituted into white light.

·The constituent colors of light·

The colors which make up white light were revealed to Newton by the fact that light of different wavelengths is refracted to a greater or lesser extent when it passes from one transparent medium (air) to another dense one (glass). The rays of red-orange light pass more rapidly through the denser medium and so are bent, less than the blue or violet rays. This is why light from the sun is seen as red-orange at sunrise and sunset, when the oblique angle of the rays means they have to penetrate more of the atmosphere.

The range of wavelengths of visible light is a very tiny proportion of the electromagnetic spectrum — from around 390 nanometers for violet to 760 for red. Beyond the red are infra-red rays and beyond them radio waves. Beyond the violet are the wavelengths of ultra-violet rays, x-rays and gamma rays.

ADDITIVE COLOR MIXING

Newton's experiments showed that if the colored rays produced by dispersing white light were added together again in the manner described above, they would be reconstituted as white light. This is known as "additive" color mixing because more light is being added with each additional color.

The additive primary colors In order to produce white light from colored light, just three colors have been shown to be necessary. These are the primary colors for light. They are:
▪ blue (blue-violet) for the shorter wavelengths
▪ green for the middle wavelengths
▪ red (orange-red) for the longer wavelengths.

The additive primary colors correspond to light-sensitive substances found in the cones of the human retina where three main types have been shown to be sensitive to blue, green and red light respectively.

If three white light lamps are covered with red, green and blue filters respectively, and the lamps are directed on to a white panel so that the lit areas overlap, the area where all three overlap will be white (see p.292). Where the green and the red light are superimposed, they produce yellow light. Where the green and blue lights are superimposed, cyan blue light is produced and where blue and red are superimposed, magenta light results.

The additive secondaries
These three colors are the additive secondaries:
▪ red (magenta)
▪ blue (cyan)
▪ yellow
They are the fundamental primary colors for the painter who uses secondary and tertiary colors in the subtractive color mixing method (see right).

SUBTRACTIVE COLOR MIXING

This is largely concerned with pigments and dyes or with overlaid films of color viewed under a single light source. The principle notion is that the addition of a further color diminishes the amount of light that is reflected or transmitted to the viewer. This can be seen when, for instance, a transparent colored filter is placed over a white light. A red filter will absorb the green and blue light and will only transmit the red. Further colored filters will subtract even more light. The subtractive primaries are red (magenta), blue (cyan) and yellow.

SUBTRACTIVE COLOR MIXING FOR ARTISTS

When mixing colors for painting, each new pigment that is added will make the mix darker and the color less pure.

ADDITIVE COLOR MIXING

The additive primaries
A demonstration of the projection of the three light primaries, red (large circle) blue (smaller circle) and green (triangle) on to a white surface. The production of white light is clearly visible where all three overlap, and the cyan, magenta and yellow can also be seen where each pair of colors overlaps.

Color television screen
The color television provides an excellent example of additive color mixing. The screen comprises thousands of tiny dots arranged in threes according to the additive primaries – red, green and blue. The intensity of light which each emits allows the viewer to receive a full-color, fully tonal image.

SUBTRACTIVE COLOR MIXING

Subtractive mixing with overlaid colors
The photograph shows the subtractive effect of overlaying layers of transparent color. The image is part of a tree, mostly silhouetted against the sky, but with branches in front of the trunk brightly lit.

The "black and white" photograph has been exposed three times from a slightly different camera position through three different colored filters – the additive primary filters. The blue-violet filter has absorbed the magenta and cyan light and produced a yellow image of the tree, the green filter has absorbed the blue and yellow light but allowed the image to register in magenta on the film, and the orange-red filter has absorbed the magenta and yellow light and produced the cyan image.

Where these three primary colors overlap on each side of the trunk and at the base, a dark color appropriate to that of the trunk is produced. Where only two of them do so, as in the branches down the middle of the trunk, secondary colors such as orange-red and green are formed. Where none overlap, branches and twigs are seen in the cyan, magenta and yellow primaries.

Trichromatic printing
The principles of subtractive color mixing are the basis of all three-color (trichromatic) printing. Here, an original image is photographed separately through the three additive primary filters (**1**) on to negative black and white film (**2**). The positive plates (**3**) made from each of these three images are printed in transparent yellow, magenta and cyan inks respectively, on white paper (**4**). This combination of the yellow with the red gives the range of yellow through orange-red to magenta and the subsequent super-imposition of the cyan produces the rest of the spectrum (**5**).

For example, Cadmium Yellow, which contains a lot of orange, will give dirty gray-green mixtures with a reddish Ultra-marine Blue because they are almost complementary colors (which in subtractive mixtures produce dark gray or black). Nowadays, with the very pure colors which can be had from synthetic organic pigments such as the phthalocyanines and the azo condensation pigments (see pp.14–17), it is possible to mix secondary and tertiary colors of remarkable purity (though the subtractive principle still applies). For instance, a brighter green is had with an Azo (lemon) Yellow and a Phthalocyanine Blue.

SELECTIVE ABSORPTION

We have seen how white light can conveniently be split up into three primary colors; orange-red, green and blue-violet and that these correspond with photo-chemical sensitive substances in the cones of the retina of the eye.

Whether light is reflected from a colored surface or transmitted through it, only the colors perceived will be

Looking at a yellow object
A yellow object will absorb the blue-violet light, but the green and orange-red rays will be reflected or transmitted since the additive combination of these two colors is yellow.

Looking at an orange object
When we look at an orange object, the orange-red rays and a small proportion of the green rays are reflected or transmitted to the eye. The blue-violet rays are absorbed.

reflected or transmitted. The other colors will be absorbed by the materials. A white surface will reflect all three colors which together constitute white. A matt black surface such as carbon black pigment will absorb all these colors.

COMPLEMENTARY COLORS

From the description above, it can be seen that whatever color or colors are absorbed by the material which the rays of light strike, the remaining colors are reflected or transmitted. Thus, a yellow object absorbs the blue-violet light and reflects the green

and red. So yellow (a combination of green and red light) and blue-violet can be said to balance or complete each other since a combination of them in light (additive mixing) would produce white and in pigment (subtractive mixing) would produce black. They are known as complementary colors.

Complementary colors in art For a painter the fundamental complementary colors are:
- green and magenta
- blue-violet and yellow
- red-orange and cyan (blue)

(The designation of the precise hues of complementary colors has varied a little from one color theorist to another.)

The complementary colors are of considerable importance in painting since they are the colors of greatest mutual contrast and may be used in a variety of ways to enhance, enliven or subdue the appearance of a painting. Linked to this are the theories of simultaneous contrast, successive contrast and mixed contrast (see below).

Green Magenta

Blue-violet Yellow

Orange-red Cyan

·The theories of Chevreul·

Although the conscious use of complementary colors in European painting can be seen to good effect in early egg tempera panel paintings, for instance, where colors such as pink and green are juxtaposed in flesh-tones, it was not until the eighteenth and nineteenth centuries that theories about the nature and application of complementary colors were articulated.

Perhaps the greatest theorist, whose attention to the practical aspects of his ideas revolutionized the ideas of many painters, was Michel-Eugène Chevreul, who in 1839 published his great work on the principles of harmony and contrast of colors *De la loi du contraste simultané des couleurs*. Chevreul's ideas about color effectively transformed the nature of European painting. They did so because they expressed clearly and in practical ways some of the notions of color that artists had perhaps until then only been aware of in a vague and empirical way. Chevreul defined the three simple laws of simultaneous, successive and mixed contrast.

DEMONSTRATIONS OF SIMULTANEOUS CONTRAST

Simultaneous contrast of two tones When two separate sections of tone, one light and one dark, are viewed separately, they will not appear to be as contrasted as they will when viewed side by side, where – at the point of contact especially – the tone of the darker piece looks even darker.

Simultaneous contrast of graduated tones When a number of uniformly toned strips of increasingly greater tonal depth are juxtaposed, the maximum point of contrast along the edges gives the flat area of tone a fluted or channeled look. The importance of this to practising artists cannot be overstressed, and Chevreul points out that to avoid this effect, the edge of the adjacent darker tone must be painted in a lighter tone to give the appearance of a smooth gradation.

Simultaneous contrast of complementary colors With two adjacent complementary colors such as yellow and violet, the complementary of the first will affect the look of the second, so that the violet looks more violet and the yellow more yellow. Thus the effect of simultaneous contrast is greatly to emphasize the contrast between complementary colors.

Simultaneous contrast of similar colors With two similar colors juxtaposed, the same rule applies – that is, the complementary of each will affect the other. But, here, the effect is different: if red is placed next to orange it will be made to look a more violet red by the blue cast which the orange induces. If the same red is placed next to violet the red will look more orange due to the yellow induced by the violet. Where the area of one color is considerably smaller than the other the effect of this irradiation is greatly pronounced.

SIMULTANEOUS CONTRAST

The law of simultaneous contrast states that if different tones of the same color are placed side by side in strips or if different colors are juxtaposed in the same way, the contrast between them will appear far greater than if they are viewed separately. Chevreul identifies a tonal change at the point of contact between areas of color in addition to a color change if two separate colors are involved. "In the case where the eyes sees at the same time two continuous colors, they will appear as dissimilar as possible both in their optical composition and in the height of their tone." He demonstrates that strong color such as red will show a tendency to irradiate the surrounding space with its complementary color (green) and that this will affect the appearance of the color with which it is juxtaposed. In terms of "simultaneous" contrast, this is an effect that happens immediately the eye perceives the tonal or color juxtaposition.

SUCCESSIVE CONTRAST

The law of successive contrast is similar in many ways to that of simultaneous contrast except that, where the latter happens immediately, the former concerns itself with after-images. So that if the eye observes a color fixedly for a while and then looks away, an after-image is formed in a color that is complementary to that originally observed. Such effects are of particular interest to painters when considered in conjunction with Chevreul's third law, that of mixed contrast.

MIXED CONTRAST

This is the phenomenon of the after-image effect described above being changed in color by the influence of the color of another object in view. So that if, for example, you stare for a while at an area of orange-red and immediately afterwards at an area of yellow, the yellow will appear green since it mixes with the blue after-image of the red.

The notion of mixed contrast relates very directly to large-scale paintings or mural artworks which are viewed "successively" and in which there are generally clearly delineated areas of strong, saturated color.

CHEVREUL'S IDEAS ON COMPLEMENTARY COLOR

Chevreul's laws of contrast pay particular attention to the use of complementary color. Indeed, he pointed out that in his own "harmony of contrast" the use of complementary colors was superior to any other assortment. The three main complementary pairs are, however, quite different from each other in respect of their tone values.

"Red and Green are the complementary colors most equal in height: for Red, under its relation of brilliancy, holds a middle place between Yellow and Blue, and in Green the two are combined."

"Blue and Orange are more opposed to each other than Red and Green, because the less brilliant color, Blue, is isolated, whereas the most brilliant (Red and Yellow) are united in Orange."

"Yellow and Violet form the most distinct assortment under the relation of height of tone since the lightest or the least intense color, Yellow, is isolated from the others."

The implications are clear to painters. For instance, the fact that yellow is most pure at a high level of brightness compared to violet is a good reason for using yellow for lights and violet for shadows. The former are pushed forward on the picture plane by the latter.

COLOR NOTATION SYSTEMS

The notion that each color has its own complementary color that balances or completes it, meant that a system of color notation would enable the artist to find the complementary of a color rapidly by simply referring to what was basically a chart. This was developed from the idea of the color wheel on which the colors are arranged in complementary pairs opposite each other. The simplest color wheel is one that shows magenta opposite green, violet opposite yellow and orange-red opposite cyan. More complex wheels show many more hues.

Chevreul and Runge's systems Chevreul constructed his chromatic circle with seventy-two separate hues, obtainable from the three primaries – red, yellow and blue. In addition, each hue was represented in tints to white and shades to black in twenty-one steps from white to black. The color hemisphere which Chevreul developed was similar to the three-dimensional system devised by Runge earlier in the century in the form of a sphere and in which the three distinct qualities of a color could easily be perceived. These are:
■ Hue – the color itself (red, blue, green)
■ Saturation or chroma – the intensity of the color. The degree of saturation depends on the amount of white (tint) or black (shade) with which the color may have been mixed. In practice it might be less saturated by being applied in a very thin transparent film over a white or toned surface.
■ Value or relative lightness – the degree of lightness or darkness (usually in relation to a fixed gray tonal scale).

Other color systems
The German Ostwald and the American Munsell, both working

in the latter part of the nineteenth and early twentieth centuries, each developed a separate system of color notation in which a hue of particular saturation and value could be precisely identified and reproduced. Such a system may be of no more than academic interest to painters.

EXPLOITING COMPLEMENTARIES

One of the first things that an awareness of complementary color teaches artists, is that a color may be broken or dulled very effectively with a touch of its complementary in physical mixtures rather than by adding black, and that the high key of a glaze color, for instance, may be reduced by a very thin glaze of its complementary – a practice, it appears, that was already being used by Cima in the fifteenth century. These effects are not found on even the most complex color spheres or color trees since they can, of course, only concern themselves with a single opaque hue of a certain tone and brightness.

APPLYING CHEVREUL'S THEORIES

Chevreul was well aware that complementary colors could be used both to enhance each other's effect in situations of simultaneous contrast and also to neutralize the colors that each comprises. In the latter case, when discussing the combination of colored threads for tapestries, Chevreul warned against including complementary colors in mixtures that were intended to make brilliant colors. On the additive principle of color mixing, adjacent touches of red and green, blue and orange, or yellow and violet merely give an impression of a neutral grayish color. The important point here is the size or scale of the color

in relation to the whole. For the painter, the range is from the intimate physical mixing of pigment particles, in which neither color is distinguishable, through small adjacent dots of pure color which read as neutral from a distance, to larger areas of adjacent color which may show an aggressive contrast or a harmony and balance depending on how the color is used. The intensity or the saturation of the color also comes into play here, so that where equal amounts of red and green which are similar in tone might give a balanced effect, different amounts of yellow and violet would be required to give a similarly balanced effect, since pure yellow has a higher level of brightness than violet.

Juxtaposing similar colors

In the close juxtaposition of two separate colors to give the impression of a third, the best way of avoiding the neutralizing or graying effect is to use colors which are similar. Chevreul, for instance, when discussing the mixing of red and yellow tapestry threads to produce orange, recommends the use of a red inclining to orange and a yellow inclining to orange. One of his "rules of harmony" states that different but similar colors can be "agreeable" when juxtaposed. It may certainly be more lively in certain cases to use two separate colors to give an impression of a third, rather than physically mixing it. In the juxtaposition of similar colors, Chevreul recommends the lowering of tone of one to make the other appear more brilliant.

THE EFFECT OF COLOR ON DIFFERENT GROUNDS

Chevruel points out that "every recipe for coloring compositions intended to be applied upon a ground of another color must be modified conformably to the effect which the ground will

produce upon the color of the composition". Every painter knows that this is so – indeed Leonardo had pointed out the same thing centuries before – but Chevreul was the first to itemize these effects in relation to his theories of contrast which stated that a red shape tends to color the surrounding space green, yellow makes it violet, blue turns it orange, and vice versa. This interaction between colors relates as much to tone and shape as to the color itself.

White ground

The effect of a white ground is to make the color more brilliant or deepen its tone through its complementary being added to the white.

Black ground

On black, the combination of the complementary with the black may lighten the tone of the color unless the other is a brilliant, saturated color (see *Isolating colors with black or white*, below).

Gray ground

According to Chevreul, the proximity of gray makes all the primary colors gain in brilliance and purity. A gray image on a brightly colored ground will, of course, take on the complementary color of the ground and by doing so will intensify the ground color.

ISOLATING COLORS WITH BLACK OR WHITE

Any opaque color superimposed on another color will be affected to a greater or lesser extent by irradiation – the effect of the color's proximity. This can be avoided by isolating the color with black or white. Chevreul pointed out that stained glass windows were beautiful because they showed a simple design with well-defined parts that could be seen without confusion from a distance. But

the most important aspect for him was that, because it was surrounded by black, each color was able to be seen in all its purity and brilliance. The idea of isolating colors with black outlines is characterized in the paintings of Georges Rouault (1871–1958) and Fernand Leger (1881–1955), both of whom recognized the rich and resonant effects produced, especially with primary colors.

An alternative technique which gives a quite different effect is to use a white contour (*anticerne*). This is easily done by painting separate strokes of color on to a white ground. Both techniques are most effective with flat areas of color.

Gray shapes on different colored grounds The small gray rectangles on the blue and the yellow paper are in fact the same color and tone; they were cut from the same piece of paper. But the one on the yellow looks considerably darker in tone than that on the blue.

Colors isolated with black and white The contrast between the effect of isolating the areas of bright color with black (left) and white (right) is marked. Out of black the colors glow; against the white they appear deeper in tone.

OPTICAL COLOR MIXING

If the pure orange-red, blue-violet and green additive primary colors are painted in equal proportion on a disc which is then spun, the result is a grayish white. In other words, the colors reconstitute themselves as white light.

When the additive primaries are painted on a disc in pairs, the additive secondaries (subtractive primaries) appear when the disc is spun. In practice it is difficult to achieve the required purity of color with pigment to show this effect perfectly. But the principle is well illustrated in these photographs of a painted disc, at rest and spinning.

Optical mixing of additive primaries

1 Red and blue are paired on the perimeter, green and red on the middle ring, and green and blue in the center.

2 When the disc is spun, a blue approaching cyan can be seen in the middle, a rather brown yellow in the middle, and a rather violet magenta on the outside.

COLORED LIGHT ON COLORED SURFACES

Another of Chevreul's "harmonies" was the unifying effect of a number of different colors seen through a colored glass. He discussed at some length the effect of colored rays of light on the colors of material objects, pointing out that red rays on white made the object appear red, on black purple-black, on deep green red-black, and on light green red-gray (complementary effects). Red on red produced a considerably deeper and more brilliant red than that perceived under a white light.

Glazing techniques in art
These ideas are of particular interest to painters, not only because they demonstrate the color changes that are brought about by different colored lights, but because they also demonstrate precisely the color changes that would be brought about by superimposing a transparent glazing color of similar hue on a painting. Glazing a painting amounts to precisely the same thing as superimposing a colored gel over the white light used to illuminate it.

These illustrations by Oliver Bevan show what effect colored light, and therefore also to a large extent, similarly colored glazing pigments, have on colored material. The one difference is that glazing may change colors in a similar way but it cannot lighten tones as light can. For a description of glazing techniques in oil painting see pp.202 and 206–7.

Metamerism
Two colors which appear the same to the eye under one set of lighting conditions may appear to differ when the lighting is changed. This is due to the colors being arrived at through different mixtures of pigments, for instance or through the effect of variations in surface quality.

THE EFFECTS OF COLORED LIGHT ON COLORED OBJECTS

White light
A number of colored objects from violet through dull red to yellow, green and blue can be seen in their "true" colors under white light.

Yellow light
If a yellow glaze were applied over a painting of the objects, the transformation would be quite remarkable. The violet denatured alcohol becomes deep red. The pale blue flat cylinder on its edge becomes green, and the dark blue enamel jug becomes black.

Orange light
Under the orange light the yellow cylinder appears white, while the pale blue cylinder has now become a deep, dark green. The dull red plastic fish has now become a deep, warm red.

Red light
The large yellow cylinder in the middle has become a glowing orange, while the liquid in the bottle has become almost transparent.

Magenta (rose) light
The yellow cylinder is now a warm pink, while the grass-green bowl in front of it is now a deep red-brown. The enamel jug has changed tone completely to a deep, luminous cyan blue.

Blue light
Here the darkest tones are now concentrated in the middle of the still life. (Notice how the different colored lights can dramatically alter tones.)

Green-blue light
Under the green-blue light the liquid is now a deep blue, while the red fish is a deep, cold green.

Green light
Under the green light the yellow of the cylinder once more begins to assert itself. The fish is slightly yellower, and the enamel jug remains black.

PERSPECTIVE

Natural perspective may be considered as the way our eyes perceive the spatial relationships between the various objects we have in view. This perception is extremely complex, since when moving around – as we do most of the time – we are constantly shifting and adjusting our point of view and focus. As we move around within a space for instance, we are processing images of many different views of the same object to enable us to register a fully three-dimensional image within its three-dimensional setting. Even with our eyes fixed on a single point, we are aware of a field of vision that radiates from that point, encompassing much more of the space that we inhabit than we usually see in paintings.

—·The principles of linear perspective·—

It is worth comparing the experience of natural perspective to the more limited vision of space which arises, for instance, out of the application of artificial or linear perspective. The rules of linear perspective limit the viewpoint to that of one fixed eye. They are based on the notion that objects of similar size appear to get smaller in proportion the further away from the eye they are. At the vanishing points (which also represent infinity) the objects would be imperceptible. The image is created as if drawn on a flat sheet of window glass (the picture plane) set up between the artist and the subject.

This concept of an intangible, yet psychological, barrier introduces a notion of separateness which underlies the conventions of linear perspective, so that, for the observer there is always a sense of "looking in", rather than of being in the projected space. In addition, the geometrical constructions upon which it is based limit the representation of all horizontals and verticals parallel with the picture plane to straight lines, whereas, in reality, they are experienced with varying degrees of curvilinear distortion. Some artists have incoporated this principle in their work to great effect.

OTHER SYSTEMS OF PERSPECTIVE

It is true that linear perspective represents the most complete geometric method of representing objects in space on the two-dimensional surface of the support. This is perhaps why it gets more coverage than alternative systems in handbooks of this kind. But it is, in fact, only one form of perspective and there are equally valid alternatives which may be more interesting to some artists.

Of particular interest is the synthetic, or curvilinear system, which a number of artists had used before Leonardo da Vinci articulated it in his writings (see p.302). A number of orthographic one-plane projection methods, including isometric projection, are now commonly used by architects and are recognizable in a more primitive form in most arts from the periods before the development of linear perspective. These are not strictly perspective systems at all, since they do not set out to show objects receding into infinite space, but rather to give as much clear information about a three-dimensional object as can be projected on to a single plane. This more conceptual method of organizing space has found favor with many modern painters.

Perhaps the single most important practical advance in recent years has been the computer systems which enable artists with little knowledge of geometry or mathematics to make highly complex perspective drawings for their work using any of the systems which have been mentioned above.

Using artificial perspective
One of the first and finest examples of artificial perspective (see p.300–1). *Trinity* fresco, Santa Maria Novella (c.1425–8), by Masaccio.

—·The history and use of perspective·—

The ancient Egyptians were able to represent their world quite satisfactorily in one impacted plane without recourse to perspective. Figures varied in size according to their importance in the scheme of things. They could be seen either face-on, from the side, or in a combination of both viewpoints. This system was coherent, organized and direct. There were no problems of distortion associated with later, more complex systems. This correlation between size of image and emphasis filters through the centuries and also finds expression in Byzantine art with its flat, anti-illusionistic images.

GREEK AND ROMAN DEVELOPMENTS

The Greeks were the first to explore the notion of the recession and projection of images. According to Vitruvius, who wrote his *De Architectura* around 25 B.C., the notion of projecting radii from a fixed vanishing point in order to give the illusionistic appearance of buildings in painted stage scenery was being developed over four hundred years earlier by Democritus and Anaxagoras.
. The theoretical treatise that was to have the most significant effect on the development of linear perspective was Euclid's *Optica* of around 300 B.C., in which the laws of geometry were applied in an investigation of the process of seeing. Euclid introduced the notion of straight visual rays entering the eye at the apex of a visual cone. This work, which was gradually expanded and developed theoretically by subsequent writers, was to lead to the first practical account by Alberti in around 1435 A.D. in his treatise on painting, of its application for artists in constructing images with linear perspective.

Among the theorists who developed Euclid's work was Ptolemy, whose *Optica* of around 140 A.D. introduced the idea of the central visual ray (see p.304) and whose *Geographia*, which was not to reach the West for another 1250 years, was the first account of how perspective may be used in map-making to make a two-dimensional version of a three-dimensional (spherical) form (see above, right).

Ptolemy's representation of the globe, from the 1462 edition of the *Geographia*

In the meantime, the development of the use of perspective in practice can be seen in examples of Greek and early Roman art, where a form of axonometric projection in which the sides of an object perceived in depth are angled but do not converge, was used in conjunction with an empirical parallel perspective to give a degree of spatial realism. The "Room of the Masks" in the Palatine in Rome of around the first century B.C. is an excellent example of the attempt to create a convincing architectural setting on the two-dimensional wall. In most examples of this kind, the art of representing an illusory space seems to be seen as an art in itself, rather than as the means of making what actually happens in the scene more convincing. John White, writing on perspective, points out that the later development, leading up to the Renaissance, is no mere secular decoration as is found in Pompeii but a commitment to the convincing expression of religious history. In fact, the use of perspective died out after the Roman period for almost a thousand years. It was revived in thirteenth-century Italy and developed rapidly thereafter.

THE REVIVAL OF PERSPECTIVE

The "disappearance" of perspective in art is paralleled in the theoretical writings by a similar gap. The important Arab work on optics, *Perspectiva* by Alhazan of around 1000 A.D., which was to reach Europe in the twelfth century, brought together most of the early writings and introduced new ideas relating the passing of light rays through the eye to the curvilinear shape of the cornea.

A revival of interest in optics in the thirteenth century, especially in relation to Christianity, is expressed in the writing of Roger Bacon in his *Opus Majus*. His ideas were disseminated in the popular *Perspectiva communis* of John Pecham and a century or so later in Italy by Blasius of Parma. By the early fifteenth century, the application of linear perspective in the making of paintings, especially after the famous pioneering experiments

(now lost) in Florence in 1425 by Brunelleschi, was ready to be formalized in the treatise of Leon Battista Alberti, whose method of constructing perspective is shown below.

The treatise of Alberti

Alberti postulated a pyramid of visual rays from the object to the eye. The central visual ray – "the prince of rays" – passed to the eye through the center of the pyramid at a given distance.

What was pictured on the intersection was exactly proportional to the objects seen according to Theorem 21 of Euclid's *Optica*, which states that if a straight line intersects two sides of a triangle (at any point) and is parallel with the third, then the two triangles will be in direct proportion. Thus all shapes which are parallel with the picture plane can be accurately represented with no distortion and in perfect proportion.

ALBERTI'S PRINCIPLE

 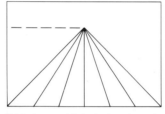 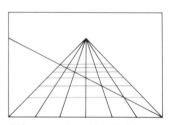

I The method of constructing perspective in a painting was to draw a rectangle for the picture area and to decide how large a figure was to be at a certain point in it. The height of a man was to be divided into three parts proportional to a *braccio* – around 57cm (23in).

2 Having established what the scale of a man, and therefore of a *braccio*, was to be on the painting, the base of the painting rectangle was marked off with this distance all along its edge. A central vanishing point was established in the center at the height of a man's head (three *braccio* up, to scale) and lines (orthogonals) were drawn to this point from the points on the subdivided base line.

3 Transversals could easily be established by marking a point three *braccio* high on one of the sides of the rectangle, drawing a diagonal to the opposite bottom corner, and at the points of intersection of the orthogonals, drawing lines parallel with the base line.

TOWARDS A CENTRAL VANISHING POINT

In art itself, the move towards a single vanishing point, central-linear perspective system was gradual. Giotto, (1266–1337), was one of the first artists to bring a sense of spatial unity to his compositions in a way that was recognised by his contemporaries as being completely innovatory. At around the time of his death, other works began to show a developing sense of perspective, especially in their treatment of architecture.

At around this time, the development of vanishing axis perspective, in which separate vanishing points were used to

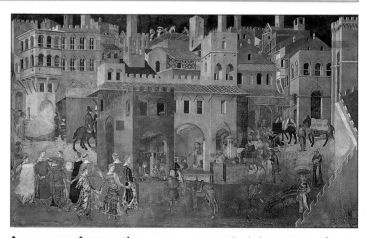

A new sense of perspective
This townscape section from a fresco from the Sala del Nove in the Palazzo Pubblico in Siena shows a profound empirical, if not scientific, sense of perspective in its treatment of architecture.
Allegory of Good Government in the Town (detail, 1337–9), by Ambrogio Lorenzetti.

create a symmetrical arrangement of parallel edges linking on a central vertical or horizontal, allowed the "interior" rectangular space represented in a painting to be slightly flattened, or opened out so that more of the sides, top and bottom could be seen.

Brunelleschi's experiments with central perspective
It was not until 1425 that Filippo Brunelleschi demonstrated a central perspective system in which all the orthogonals converged to a central vanishing point which depended on the fixed viewpoint of the spectator. His panels which depicted the Baptistry and the Palazzo Vecchio in Florence were designed to be seen in a mirror through a peephole in the panel corresponding to the vanishing point of the painting.

The notion of central perspective caught on rapidly amongst the painters and relief sculptors of the day, and Masaccio's *Trinity* fresco in Santa Maria Novella of around 1425–28 is one of the first and finest examples of a work whose structure is entirely planned according to artificial perspective. Here, however, the figures are not drawn in strict accordance with the perspective of an architectural structure which does conform to a single viewpoint. This is a feature of many works of the time where it was clearly much easier to establish the geometry of perspective with architecture than it was with the human figure.

The conventions of central perspective
With a single central vanishing point, the problem of the position of the viewpoint becomes critical. For a square interior space, for instance, if the scene is pictured from too close, then the width of the "walls", "ceiling" and "floor" will be too dominant. If viewed from too far, they will barely show in the painting. An average and commonly used

distance from the picture plane is around one and a half times the width of the image. The newly discovered system, articulated by Alberti a decade or so after Brunelleschi's experiments, meant that for Renaissance artists, the illusion of space could more tangibly be represented on a two-dimensional surface than ever before. Since the eye of the spectator would inevitably be drawn in by powerful orthogonals, it was possible to make this a more subtle process by intercepting it with the undistorted frontal planes which work so well in this system. These could be placed at various carefully designed stages to guide the eye around and into the depth of the painting. The vanishing point might be concealed behind an object towards the front or at the back of the image. It might be set behind the face of a figure looking directly back at the spectator, or it might simply be on the distant horizon visible through the architecture of the painting.

The conventions of central perspective were both liberating and, to some extent, restricting. Liberating because, for the first time, painters could articulate an utterly convincing illusionistic space within which the religious drama could be enacted and this gave considerably more credence to the depiction as a "real" event; but restricting because, to work effectively, the system demanded a fixed viewpoint which was often not the one from which it was, in practice, possible to view the work. In addition, as Leonardo was later to point out, there were anomalies in a system which took no account of vertical or lateral convergence.

However, if one considers the pictorial basis on which such works as the eleventh-century Saint Savin wall paintings were constructed, compared to the work being produced only three of four centuries later, it is clear that a very dramatic change had

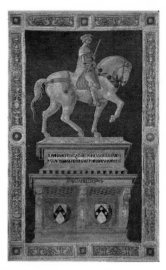

Manipulating perspective
If the horse and rider had been painted according to the perspective of the plinth, they would have looked extraordinary. Clearly Uccello found a compromise solution which allowed the perspective of the plinth to give an impression of height and grandeur to the horse and rider, which are seen from a less distorting point of view.
Sir John Hawkwood (Florence Cathedral), by Paulo Uccello.

occurred in a relatively short time. The Saint Savin paintings are constructed according to a spiritual vision which dispenses with space and material density and incorporates both heaven and hell in one impacted plane which is at once near and infinite and in which everything has its rightful size according to a strictly prescribed iconography. Perspective relates to physical vision and would no doubt have been considered as inferior as the eyes of the body compared with those of the soul. The new Renaissance system however, placed individual man at the center of a new world of objective truth. A world which could now be accurately depicted according to a simple system of measurement and proportion.

How artists approached central perspective
Most contemporary artists approached

artificial perspective with a degree of pragmatism. They incorporated it when it was useful to do so but were prepared to be flexible. John White says of Paulo Uccello for instance, that he continued to use shifting vanishing points long after he had mastered artificial perspective. It is ironic that Uccello, who, like Piero della Francesca, was much occupied with the theory of perspective, should have created works like the fresco of *Sir John Hawkwood* (see p.301) and the *Deluge* in Santa Maria Novella, which are both based on careful and accurately drawn perspective but which contain elements that are not compatible with the scheme.

LEONARDO DA VINCI'S CURVILINEAR SYSTEM

The first to point out the anomalies of the grid system of constructing a perspective (*Costruzione Legittima*, as outlined by Alberti), was Leonardo da Vinci. He drew a simple diagram of the plan of three cylindrical columns along a straight line parallel with the picture plane, and demonstrated that if lines were drawn from the edges of these to the eye, on the picture plane, the two outside columns would appear wider than that in the centre.

Leonardo went on to develop a system of perspective which attempted to take into account the fact that images received by the eye were subjected to a curvilinear distortion. His synthetic perspective system represented a departure from the tenets of artificial perspective in a number of ways. It suggested that natural perspective was more accurately represented as being curvilinear in all directions from the point nearest the eye on the plane surface. Rather than the size of objects diminishing in direct proportion to their distance from the eye, the size in fact depended on the visual angle – the wider the visual angle the greater the distortion. As with the earlier system, all orthogonals converged to the vanishing point in straight lines.

It seems that Leonardo never put his system into practice. It remains however, one of the most interesting alternatives to most of the systems which rely on straight verticals and horizontals and it conforms more accurately to the natural experience of perspective.

Implementing Leonardo's system As an experiment, try making a drawing of everything within your field of vision, even those areas at the very edge. This includes your hands and the drawing board. What generally emerges is a drawing which, in order for everything to be included, has the appearance of a photograph taken with a wide-angle or fish-eye lens, in which vertical and lateral convergence bends and distorts what we think of in the abstract as being straight lines. More than any other approach, this gives the impression of the observer being drawn in, or being part of the scene represented.

There are obvious problems in this system, the main one being that if you are working within a conventional rectangular format, it may be awkward to relate the

Curvilinear perspective
The arching figures in the composition open out the flatness of the picture plane like the opening petals of a flower. This gives the work an extraordinary sense of space and movement, unfettered by the constraints of linear perspective. *Christ's Entry into Jerusalem* (1921), by Stanley Spencer.

Leonardo's illustration of curvilinear perspective On the plan of three columns on a line parallel with the picture plane, lines drawn from the edges of the columns to the eye show that the two outer columns will look wider than the center one. But if the rays from the columns are drawn on an arc centered on the eye, each is the same width.

image to the frame. Some artists who appear, at least empirically, to have adopted a more curvilinear approach to perspective, have solved the problem with specially-shaped canvases.

In natural perspective, the curves are very gentle, so that generally, observers are only made aware of them when an unusual or unexpected image is perceived. An excellent example given by Laurence Wright, is the image of the contrails of squadrons of fighter planes, whose straight flight-paths, seen from below, gave the impression of a "domed birdcage".

MAKING PERSPECTIVE DRAWINGS

The first of many books to deal with the practical construction of perspective drawings, *De Artificiali Perspectiva*, was published in 1505, by Jean Pelerin (or Viator). He introduced the idea of both central and diagonal vanishing points, the latter being used to accurately position objects which were at an angle to the picture plane. The notion was extended in 1600 by Guido Ubaldo del Monte, who made the point that the vanishing point of any line on a plane could be determined by drawing a line parallel to it from the eye to the picture plane. Any number of vanishing points could then be used as required. Later, in 1636, Girard Desargues in his *Manière Universelle* introduced the idea of a vanishing trace or axis from which vanishing points could be determined for the different sides of a sloping surface on a single plane. So by the mid-seventeenth century, a three-point perspective system had been developed which enabled any object with a plane surface at any angle to the picture plane to be accurately depicted from a fixed viewpoint. A number of alternative methods of drawing were to be developed but, by the end of the

century, the use of perspective had become so confident that it was possible for an artist and brilliant perspectivist like Padre Andrea Pozzo to produce his quite astonishing *Glory of St. Ignatius* (see below). The task of transferring the accurate scale drawing to a barrel vault of such a size was extremely arduous. Pozzo had to construct a grid on the arched ceiling which would provide the framework into which the preliminary drawing could be made. To do this, he constructed a horizontal grid to scale on the level of the springing, using cord. He then took a line using cord from the viewpoint on the floor of the nave through the intersections of the cord grid, to a corresponding point on the ceiling. The points on the ceiling could then be joined up to provide the required grid and transfer the drawing accurately.

Using a projector
Nowadays the task of transferring an image has been greatly facilitated by the use of projectors (see also p.331). Indeed in certain cases, the use of photography has enabled artists to avoid the problem of having to draw up complex perspectives. If, for instance, a decorative scheme is being proposed for a wall on a building, it is a simple matter to take photographs of the building, enlarge them to the required scale and create perfectly acceptable line drawings on overlaid translucent drafting film.

The Glory of St Ignatius (1691–4), by Padre Andrea Pozzo.

·Constructing linear perspective·

One way of illustrating the basis of linear perspective is to imagine that a spectator is looking from a fixed position at a fixed object (such as a building) through a rectangular window.

The window-pane corresponds with the surface of the drawing or painting. Rays of light from the object converge on the eye, passing through the window at points which could be plotted. If

these points were joined up, an accurate image of the object could be obtained. The basic definitions described and illustrated below are based on this premise.

The basic principles

1 In perspective drawing, the "window-pane" is known as the picture plane.
2 The base of the picture plane – the bottom edge of the painting – is known as the ground line.
3 The ground line is the nearest edge of a plane which stretches to the horizon, known as the ground plane.
4 The furthest edge of the ground plane is the horizon line. The height of the horizon line up the picture plane coincides with the eye level, so if the spectator is looking from a high vantage point – the top of a building for instance, the horizon line will be correspondingly high up the picture.
5 The distance between the picture plane and the eye of the spectator in front of it and the objects behind it determines the size and position of the objects on the picture plane. If an object is fixed, the closer the eye moves towards the picture plane, the smaller the object will appear. If the eye is fixed, the closer the object, the larger it appears.
6 The point that marks the position of the eye on the drawing is the station point (or point of station).
7 The point on the horizon line directly opposite the station point is called the center of vision.
8 The line that joins these two points is the central visual ray. This ray is the central axis of the so-called cone of vision which describes the convergence of light rays on the eye.

1 Picture plane

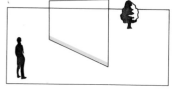

2 Ground line

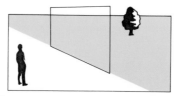

3 Ground plane

4 Horizon and horizon line

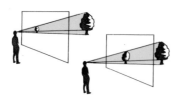

5 Distances from picture plane

6 Station point

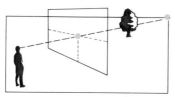

7 Center of vision

8 Central visual ray

THE RULES OF LINEAR PERSPECTIVE

The three main rules are:
◼ Any plane parallel to the picture plane retains its shape without distortion and only diminishes in size. Thus vertical lines remain vertical and horizontal lines parallel to the picture plane remain horizontal.
◼ All parallel horizontal lines converge to vanishing points on the horizon line. Those at right angles to the picture plane converge to the center of vision.
◼ A line drawn from the eye or station point parallel with any line or set of parallel lines on the subject will locate the vanishing point for that line or lines at its point of intersection with the picture plane.

VANISHING POINTS

Linear perspective relies on the simple fact that objects appear to diminish in size in direct proportion to their increasing distance from the picture plane. With a simple object like a box, which has two sides parallel with the picture plane and two sides at right angles to it, the two sides at right angles will appear

to converge at a point on the horizon known as a vanishing point. Any line which recedes in any direction and on any plane can have its vanishing point established.

A vanishing point can be used to determine the relative size of an object anywhere behind the picture plane and, in addition, to measure distances along lines which travel to a vanishing point. To establish such distances along a particular vanishing line, a measuring point can be simply marked by describing an arc by using the vanishing point as center and taking a radius to the station point (the eye). See diagram (right) for the method of measuring distances along a particular vanishing line.

Measuring distances along vanishing lines To measure accurate distances along a line running to a vanishing point, a special system is used. An arc centered on the vanishing point with a radius taken to the station point cuts the horizon line at one side of the center of vision. A line from this point to measured points on the ground line (or picture plane) will

cut the vanishing line at the appropriate places.

Where an object has planes at oblique angles to the picture plane, on ascending or descending axes, for instance, it is possible to locate their vanishing points, not on the horizon line, but on vanishing traces or axes above or below it. Lines may then be projected from these ascending or descending vanishing points.

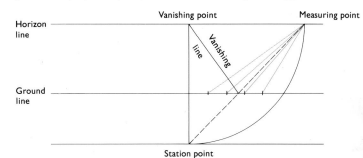

COUNTER PERSPECTIVE

Of particular interest to artists who may be commissioned to work on large vertical walls, is the notion of counter perspective. This is brought into play to counteract the fact that images painted the same size up a vertical wall will look progressively smaller, since from a fixed viewpoint, the same angle of vision will take in more of the subject as the view is directed upwards.

The most famous and often-quoted example of counter perspective applied to architecture, is the Campanile of Santa Maria del Fiore in Florence, designed by Giotto. Each section of the tower as it rises, is built taller than the section below it, so that the effect from a fixed low viewpoint is of balance and symmetry rather than of acceleration. In practice, of course, the further from the image the spectator can be, the less perspective correction would need to be applied. But from close to, the amount of correction needs to be quite dramatic. The diagrams (right) show a fairly extreme example of counter perspective.

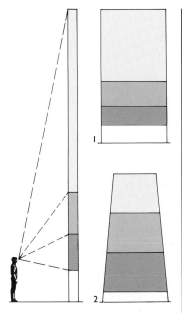

Counter perspective example
A man with an eye level of about 1.5m (5ft), standing around 2.4m (8ft) from a wall, looks at three horizontal painted bands of color, (beginning around 1.2m (4ft) from the base of the wall). The lowest band is about 1.2 m (4ft) high, the center band just under 1.5m (6ft) high, and the highest band about 6.3m (21ft) high. Each represents an angle of vision of 30 degrees and the man sees three equal bands of color.
1 The wall as actually painted.
2 How the man sees the wall.

ACCELERATED PERSPECTIVE

This is the opposite of counter perspective. It is used to increase the effect of perspective rather than diminish it – often in the theater, where an illusion of great depth needs to be sustained in a relatively shallow space. The combination of an upward-sloping stage and inward-sloping scenery, following a skilfully coordinated artificial perspective system with illusionistic painting, allows the audience to enjoy a convincing illusion.

ANAMORPHISM

An image drawn from an extreme oblique angle to the picture plane will, when viewed from a central position, have an elongated and very distorted appearance. It may only be seen correctly from the original oblique viewing angle. One of the most celebrated examples features in *The Ambassadors* by Hans Holbein the Younger, where a strange shape at the bottom of the painting only resolves itself into a skull when the spectator stands at one side of the canvas and looks across it.

CONSERVATION AND FRAMING

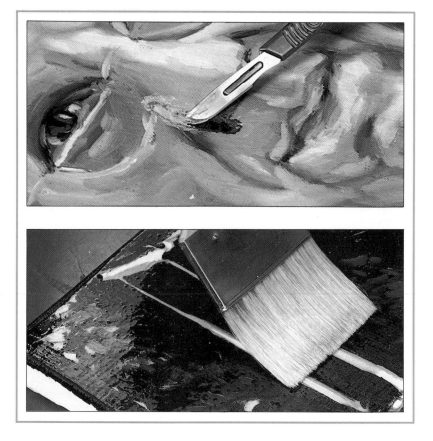

CARE AND RESTORATION

Research in the area of conservation has identified the various ways in which old paintings deteriorate and many of the reasons why this deterioration occurs. Picture restorers now have increasingly efficient methods of reducing or even eliminating many of the harmful effects brought about by the aging process. However, these findings also provide artists with a great deal of practical information about sound working methods, indicating the techniques and materials that should be employed – and those which should be avoided – if the durability of the artist's work is to be ensured.

——·Factors that affect deterioration·——

Paintings deteriorate in two main ways: First, the painting materials themselves can change – so that pigments may discolor or varnishes yellow – and, second, the structure of the painting itself may change – that is, the layers that are bonded together become weaker due to differential movements or stresses contained within the layers. Several factors are involved.

LIGHT

The most obvious cause of discoloration in pigments and varnish is the action of light. The more light to which the painting is exposed, the greater the adverse effect. In strong sunlight, the effects are greatly accelerated, because of the presence of the ultra-violet (U.V.) element. Artists are therefore encouraged to hang and store paintings in areas where the light is shaded. This is particularly important for works on paper. These are more vulnerable because the pigments are not surrounded by a protective medium and because paper itself is relatively unstable, particularly as an exposed support.

In museums, ultra-violet filters are employed to eliminate U.V. light and light levels at the picture surface are strictly controlled.

HEAT

Allied to the effect of light is that of heat. If a painting is hung in direct sunlight, it will get very hot – especially under glass, where temperatures of 40–50°C can be reached on the surface of the painting. This accelerates the oxidation reactions within the paint and varnish and also within the cellulose fibers of canvas supports, causing considerably faster physical degradation of the painting.

Therefore, the colder it is, the slower the rate of deterioration will be. In practice, though, paintings cannot be enjoyed at uncomfortably low temperatures (museums generally keep the temperatures of their galleries at around 20°C). A painting that is to spend some time in storage can be kept at a lower temperature, but sudden large fluctuations in temperature should be avoided.

HUMIDITY AND DAMP

The biggest factor contributing to changes in stress in a painting is relative humidity (RH), the percentage of moisture present in the atmosphere. The drier the conditions, the bigger the stress in the paint and ground layers (for the effect of this on the size layer, see *Supports*, p.62 and *Grounds*, p.64).

The worst conditions occur in the winter, when cold air from outside is brought in and heated up by dry forms of (central) heating. These can reduce the RH to levels as low as 30 per

ANALYZING MATERIALS AND TECHNIQUES
In recent years, modern scientific methods of chemical analysis such as gas chromatography and mass spectrometry have been used in the conservation departments of the major museums. These have led to the positive identification of the ingredients used in painting mediums, varnishes and in the sizing and priming layers of old paintings. Such work is now also revealing much technical information about methods of painting in the past which formerly could only be surmised (see *Introduction*, pp.6–9).

cent and this creates huge stresses in paintings. Time lapse photography experiments have shown the cracks on a painting surface becoming visibly wider as the RH decreases. If there is minimal stress at 70 per cent RH, there is ten to fifteen times that amount of stress when the RH falls to 40 or 30 per cent.

In museums, a constant RH of 55 per cent is adequate for the painting to remain stable. In practice, this means that artists and their patrons should use humidifiers to maintain their work in prime condition. The new and inexpensive "ultrasonic humidifiers" are very efficient and suitable for this purpose.

The problem of damp is overestimated since paintings prefer damp to dry conditions. It should not, of course, be so damp that mildew forms on the canvas. Artists who wish to store work in an area that may seem too damp should leave a piece of glue-sized canvas in the space. If this does not grow mould, then the space is probably adequate. Paintings should not be stored so that they come into contact with the ground (see p.329).

Preventing deterioration

The combined effects of the above factors put a strain on the bond between the different layers of the painting so that, in time, the layers start to separate or "cleave". If the painting has reached this state, a specialized restoration job is needed. However, the artist can take responsibility for protecting his own work from the effects of light, heat and relative humidity, as well as ensuring that paintings are kept clean and dealing with minor repairs, such as bulges or holes in the canvas.

·Cleaning·

It may be necessary to clean the surface or back of a painting which has become dirty in storage or in transit. If dust is the problem, it can be blown off with compressed air or vacuumed off with a soft clean brush on the end of a vacuum cleaner nozzle. A simple way to cut down the inevitable build-up of dirt on the unglazed surface of a painting is to incline it with the top forward of the bottom when it is hung on a wall.

If the painting has got so dirty that the dirt has to be physically removed, the judicious use of distilled water or saliva on white cotton swabs is normally the best method.

The cleaning medium should be applied with small swabs on small areas at a time, so it is possible to look at the swab and see if color as well as dirt is coming off. If this is the case, the cleaning should be stopped. Care should be taken not to put contaminated swabs in the mouth.

CLEANING ACRYLIC PAINTINGS

An acrylic paint film from acrylic dispersion paints is relatively soft, which makes it very attractive to dirt. The reason for this softness is that, when the water has evaporated off, small droplets of polymer are left which need to be soft to coalesce and enable a film to be formed. In effect, the convenience of water as a diluent is therefore balanced by the softness of the resin which attracts dirt. The best way of dealing with this is to interpose something between the painting and the source of the dust – the best method being to glaze the paintings. The problem of varnishing acrylic paintings is discussed under varnishing.

The problem of dirt on soft acrylic film can be compounded by the fact that it retains hydrophylic elements which can be affected by the water used in cleaning, resulting in the removal of surface paint. However, this problem does not usually occur with the more modern acrylics now commonly used.

CLEANING OIL PAINTINGS

For oil painting, cotton swabs dampened with saliva will remove a great deal of the accumulated dirt. Mineral spirit may also have to be used in very small quantities where the dirt is greasy, taking care not to dissolve the varnish. This can be a problem on a relatively recently completed painting, but an older work which has been coated in damar or mastic varnish will be unaffected by the mineral spirit. In any case, the swab should be only slightly dampened in mineral spirit and tried out on the perimeter of the painting first.

CLEANING EGG TEMPERA AND ENCAUSTIC PAINTINGS

An egg tempera film is very stable when it has hardened and very resistant to dirt. It is also one of the most permanent of all paint films. The encaustic paint film may be more attractive to dirt if beeswax alone – with its relatively low softening point – is used, and less susceptible if a harder wax – such as carnauba wax – has been incorporated to raise the melting point. Both egg tempera and encaustic can be rubbed with slightly damp cotton and buffed up with a piece of silk.

CONSERVATION CLEANING TECHNIQUES

The use of saliva or distilled water on cotton swabs, and of solvents to remove surface grease has already been discussed. For conservators, however, the cleaning process invariably involves removing layers of old yellow varnish. This is felt to be necessary to reveal, in their original splendor, the colors which the artist actually used and intended to be seen. In come cases, the colors have faded or changed in time, while other (more permanent) pigments on the same painting have remained relatively unchanged. Such changes are difficult to quantify, and conservators vary in their approach to the problem of varnish removal.

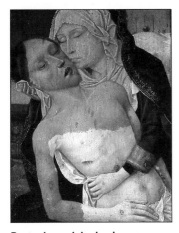

Restoring original colors
The varnish coating on this painting has yellowed badly. When half of it is removed, the extent of the discoloration becomes apparent.

"Total" cleaning
This is the removal of every trace of varnish from the whole painting. The conservators at the National Gallery in London, for example, prefer to remove all the varnish and any later acretions of paint down to the original paint film.

"Partial" cleaning
This technique leaves a thin layer of the original varnish over the whole surface of the painting. Conservators at the Louvre in Paris use a partial cleaning system.

"Selective cleaning"
Here, the amount of varnish removed in any area is adjusted according to the conservator's idea of the balance of tone and color in a work. The Metropolitan Museum in New York favors such an approach to cleaning.

In fact, the difference between the three methods may not be that great. On the one hand, it is extremely difficult to take a varnish down to a very thin layer, since the dissolving of the varnish is a process of diffusion and the solvent can soak through the varnish like water in a sugar cube. On the other, it may be difficult to get the last traces of varnish off.

USING SOLVENTS

Old yellowed varnish becomes gradually less soluble with time, so that the disparity between its own solubility and that of the paint film is reduced. The problem is to find the correct solvent or solvent mix for the so-called "solubility gap" between the two, so that the varnish can be dissolved safely without affecting the paint film beneath.

In an ideal example, a painting might have a one-hundred-year-old damar varnish which has oxidized as far as it will go. The paint will have been bound in linseed oil or nut oil with no additional resinous ingredients and the gap in solubility between varnish and the paint film will therefore be large. In such a case, a number of solvents may be used, including iso-propanol and iso-propan-2-ol, which belong to the alcohol series of solvents. This also includes methanol, ethanol and butanol. The more carbon-containing atoms there are in such solvents, the more they will begin to affect the paint film, so the conservator must establish empirically the correct solvent to use. Whichever solvent is chosen, the problem of toxicity should be taken into account. Conservators are very aware of the accumulated chronic effects of exposure to organic solvent vapors, and take sensible measures to protect themselves. Artists would be well advised to do the same (see p. 42).

OTHER CLEANING AGENTS

If the solubility gap is very small – when, for instance, there is resin in the paint film or oil in the varnish – the use of conventional solvents may not be appropriate for the reasons outlined above. One alternative is the use of chemical reagents. These cause the breaking of molecular bonds within one or other of the materials. Such reagents are generally alkaline and tend to work on the surface of the painting, reacting with the varnish. They range from mild soaps to very potent chemicals like sodium hydroxide.

Another new area of cleaning is the use of enzymes, in particular the "lipases", or oil-breaking-down enzymes, which are applied in a similar way to the chemical reagents in the form of "poultices", working over small areas of the painting at a time.

Whatever system is used, the cleaning of old paintings remains a somewhat hazardous operation. Research done in the 1950s shows that, during the cleaning process, substances known as the "leachable materials" are taken out of the dried paint film. These act as the plasticizing material in the rigid cross-linked paint film, so the paint becomes brittle and rigid if they are removed. The problem gives another reason for leaving, if possible, a very thin layer of the original varnish on the painting.

·Minor repairs·

Relatively minor damage such as bulges and even small holes in the canvas, can usually be dealt with reasonably successfully by the artist. More serious damage which results from the aging process can only be rectified by highly trained restorers using specialized equipment and techniques (see opposite).

DEALING WITH DENTS AND BULGES

It may sometimes be necessary to remove dents or bulges in a painting – for example, when a large canvas has been stacked next to a smaller one which has pushed against it.

Artists tend to slosh quantities of water on to the back of the canvas in the area affected which has the effect of shrinking it and pulling out the bulge (see p.59). However, modern canvases woven on power looms have a very tight weave and are therefore prone to shrinkage so that a great deal of water on the back of the canvas will shrink it to the point where, ultimately, the ground will begin to flake away from the painting. Such a problem is particularly apparent with a glue-sized canvas, though acrylic-primed canvases can also be affected. The answer is to use moisture as sparingly as possible. The canvas can be dabbed with a moist "squeezed-out" sponge but it should never be soaked.

If the back of a canvas has grown mould as a result of being stored in a particularly damp environment, it should be sponged with fungicide. The painting surface should be swabbed as described above.

USING A BACKBOARD

Attaching a backboard is a simple and very effective way of providing valuable additional protection to a painting on canvas (see p.62). It is a physical barrier to the blows and water spillages that canvases seem prone to, and to the accumul-ation of dirt, which greatly accelerates the degradation of the canvas. In addition, it creates a barrier in terms of moisture changes, which dramatically reduces their harmful effects on the paint film. A backboard therefore prevents the need for major repairs, as well as helping to keep the picture clean.

Protecting the paint film
Here, the relatively wide stretcher frame has had the same protective effect as a backboard. The paint film has only cracked badly where the back of the canvas is exposed.

REPAIRING HOLES IN THE CANVAS

Occasionally, a new painting might be mishandled and suffer structural damage such as a hole being torn in the canvas. Although artists would be best advised to leave such a major repair to a trained conservator, most would probably have neither the resources nor the inclination to do so and would attempt a repair themselves. In this case, the canvas should be prepared by moistening the back of the wounded area slightly and flattening it using weights. This enables the damage to be assessed more easily and any wounded areas to be brought together. Any loose threads or frayed edges of canvas should be cut off neatly.

1 Attach a patch to the back of the canvas using a wax-resin adhesive applied hot (60 gms beeswax + 40 gms crushed damar resin melted in a pan). Feather the edges of the patch itself to assist its invisibility.

2 If a hole is evident from the front, it must be filled to the level of the rest of the canvas with a proprietary fine-surface filler paste incorporating PVA, which imparts flexibility. This can be sculptured to the texture of the surrounding canvas and primed and painted by the artist to match the rest of the work (see also p.313).

·Lining·

A major part of the work of museum conservation departments is the repair of damaged painting supports and the consolidation of cracked or flaking paint films.

Paintings on canvas exhibit a tendency to structural collapse considerably more rapidly than those on panels, where problems of warpage, splitting, wood-boring insects or dry rot can normally be adequately treated without having to transfer the work to a new support. The most common treatment for a degraded and weakened canvas is for it to be lined. This involves sticking it to a new piece of stretched fabric which takes over the strain that the old canvas can no longer sustain. Re-lining is a similar process but here, an old lining is removed before a new one is attached.

TRADITIONAL LINING METHODS

Traditional methods of lining attempt to deal with three problems in the same operation:
■ the replacing of a weak support with a new one.
■ the removal of unwanted surface deformation on the painting. This may be in the form of open cracking and/or cupped paint (the depressions which may occur inside a network of cracks).
■ the general consolidation of the layers which make up the structure of the work.

There are two main traditional lining methods.

The glue/flour method

Before they are glued together, the original painting and the new lining material (traditionally, sized linen) may be stretched and the back of the painting may be given a preliminary coat of glue size (see p.62). The adhesive is then applied – often with a comb applicator – to the lining fabric and/or the back of the painting. The recipe used at the National Gallery in London is 1kg (2¼lbs) plain flour, 1½kgs (3½lbs) Croid Aero glue (animal glue) and 4½ liters (8 pints) of water. The mixture is heated in a double boiler, and the painting is then placed on the lining fabric and ironed on with warm irons.

The structure of the painting is penetrated by the warm glue. The aqueous moisture helps to relax and flatten the surface of badly cupped paintings. The total effect is the flattening and consolidation of the structure of the painting which becomes rather rigid and board-like with a uniformity of surface which can be all too obvious in some cases. There is also a danger of the canvas shrinking and the paint flaking off, because of the powerful shrinkage of the animal glue in dry conditions.

Wax/resin method

In the "hot-melt" beeswax resin method, the painting and support are suffused with 6 parts beeswax and 4 parts crushed resin. The cupping of the paint is not as much reduced as in the former method, since the aqueous component is lacking. The painting ends up being relatively flat and well consolidated, though the suffusion of the wax/resin mixture can result in darkening as the resinous component ages.

The results of stress
The stress on the canvas at the edge of the stretcher bar and on the tacks, which may also rust, results in the face of the painting detaching from the frame.

The effects of stretching The strain imposed by stretching is not limited to the tacking edge, but affects the whole canvas. The deterioration caused by years of tension can be seen in this Cézanne landscape. The puckering at the top of the picture can only be alleviated by lining the canvas.

Applying the wax/resin mixture The beeswax and resin are melted in a glue pot and applied to the back of the canvas and pressed in with hand-held warm irons. This ensures that the entire structure is cocooned in wax, correcting the bulk deformations.

MODERN LINING METHODS

More recent lining techniques do not attempt to deal with everything in one operation, but have concentrated on refining the individual aspects of the process. The problems of cleavage and cupping are, to a greater or lesser extent, dealt with before lining (see p.311). The lining itself is carried out with synthetic adhesives which will not impregnate the support but merely establish a "nap-bond" between the lining and the back of the original canvas. There are basically two modern methods:

Lining with heat-seal adhesives

The first method uses an ethylene vinyl acetate copolymer adhesive – incorporating microcrystalline waxes. A lining which uses such an adhesive requires heat and is normally applied on a flat, heated metal surface known as a hot table.

The painting is pre-stretched, as is the lining material – which may be the traditional linen, a glass fabric or polyester sailcloth (see p.58). The Beva adhesive is now available as a thin uniform film which can be peeled away from its backing sheet and placed between the back of the painting and the lining material. The hot table activates the adhesive and a vacuum pressure brings the surfaces together.

In the early years of the process, too much pressure was used, resulting in paintings with a corrugated texture. Since this was first noticed, the pressures have been reduced.

Lining with solvent-activated adhesives

Solvent-activated adhesives are applied in a thin film which is normally silk-screen printed on to the lining fabric. The film then swells as it is activated by a solvent, such as toluene, which is brushed or sprayed on. The "loomed" or pre-stretched painting is placed on the lining on a low-pressure lining table. Within two hours, the painting will be dry, though the adhesive takes a few more days to take full effect, after which the lined painting can be re-stretched.

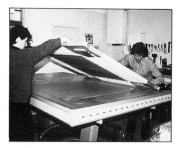

Using the low-pressure lining table This is a metal table with small regular holes drilled in it through which air is sucked, creating a low vacuum which draws the solvent away from the work.

The use of the humidity chamber

For both the modern lining techniques, the painting is first flattened and its main deformations corrected by stretching and the controlled use of moisture. This is done by putting the work in a high humidity environment – the humidity chamber – where the relative himidity is taken up to 80 per cent, and in which the painting is left for two or three days. The elevated humidity is not high enough to shrink the canvas, but the paint absorbs moisture and becomes more pliable. The method is particularly effective with areas of big dented flaking since the expansion of the structure allows them to be repaired using an aqueous adhesive such as a 10–15 per cent gelatine solution. After conditioning, the painting on canvas is put on a lower pressure table. Sheets of Mylar (a polyester film) are placed over it to sustain the vacuum and to protect its surface while the deformations are pressed down during drying. The process is repeated several times. Difficult areas may be locally misted to assist the flattening process.

A recent development in the lining and flattening process are low-pressure tables which incorporate humidity chambers. This will allow a far greater degree of control over the conditioning process.

RE-LINING

In both methods of lining described above, the front surface of the painting may be faced with tissue paper and glue to protect it. In the case of re-lining (where the old degraded lining has to be taken off the back of the canvas), this facing is essential for its cushioning protection. It also holds the paint in the correct place on the painting in the event of it de-laminating.

An old lining is removed by being pulled off by hand in narrow strips. All traces of the old glue are removed from the back of the old canvas, either by very careful washing with warm water or scraping with a scalpel.

TRANSFERRING

The transfer of paintings is a "last resort" technique which involves the complete removal and replacement of the old support and sometimes of the ground as well – a risky and very time-consuming process. It is now rare for paintings to be transferred, though many have been in the past. Among examples of recently transferred paintings is the large work on panel *The Incredulity of S. Thomas* (1504) by Cima da Congliano (National Gallery, London: No 816), which required the complete removal of the seven thick poplar planks which made up the panel down to the level of the original gesso ground. This was then reinforced with acrylic primer and smoothed, inter-

leaved with linen and bound to a rigid fiberglass-laminated honeycomb aluminum panel. In this case, as in all examples of the transfer process, the paint surface must first be faced with relatively thick facing layers of Eltoline tissue, pasted on with appropriate adhesives – such as mastic in turpentine with stand oil, wax/resin or glue/water mixtures. In the case of large paintings, such as the Cima, the front must then be reinforced with a temporary support before work can begin on the back.

Spontaneous transfer
The term "spontaneous transfer" refers to the accidental separation of the canvas from the ground which may occur in humidity chambers where the relative humidity reaches 100 per cent.

·Repairing the paint film·

Depressions in the paint surface and flaking of the paint film are known as "cupping" and "cleavage". These problems can, to a certain extent, be attended to as part of the lining process, incorporating the use of the humidity chamber (see opposite). But, before that, any loose flaking of paint must be consolidated by the introduction of weak adhesives between the paint and the ground and the use of warm spatulas to press down the flaking area.

USING ADHESIVES

The main factors to be taken into account when establishing the type and use of adhesives are:
- how easily the material will penetrate into the crack
- how much deformation needs to be corrected
- whether the surface of the paint is going to be affected by the carrier of the adhesives – some paints, for instance, are blanched by water or affected by solvents.

Broadly, the paint requires readhering and making flat without in any way changing the surface. Weak gelatine solutions have traditionally been used where an aqueous adhesive helps to flatten the paint or soften the ground. Wax has also been used because it flows well beneath the surface of the paint. Otherwise, the newer synthetic resins in solvent or the acrylic dispersion adhesives have added further possibilities.

FILLING AND RETOUCHING

Traditionally, a chalk and gelatine mixture has been used to fill gaps in the paint film and it is still used on panel paintings. Proprietary fine-surface fillers incorporating PVA are used for paintings on canvas. The filler is scraped on with a spatula and then taken down with a swab and water or saliva, and may be indented to match the weave of the canvas; it can also be sculpted when dry.

Once the painting has been cleaned, the losses exposed and the holes filled, it is given an isolating layer of varnish. The retouching of the actual paint film is always made over varnish so that it can be removed if necessary. The modern synthetic resins used by conservationists for varnishing are removable and have excellent resistance to cross-linking (see also p.314).

The approach to retouching varies from one country or institution to another. At the Courtauld Institute and the National Gallery in London, for example, deceptive or "illusionistic" retouching is practised. This is barely distinguishable from the original paint, even when examined at close quarters.

In Italy, on the other hand, a number of retouching systems are used which are not noticeable from a distance but are quite obvious when examined closely. After retouching, the painting is varnished.

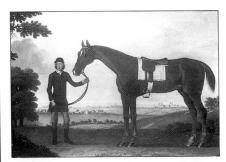

Cupping and cleavage
Although this picture appears to be in perfectly good condition when viewed in normal light (top), the deformation of the paint film can be seen clearly in raking light – when the painting is lit from the side (bottom).

VARNISHING

A varnish is a thin protective layer between the paint film and the atmosphere. It should be transparent and colorless and should form a good bond with the dried paint film but be removable without affecting the paint in any way. A varnish is a solution of resin in solvent and is applied when the paint film is thoroughly dry.

PROTECTIVE REQUIREMENTS OF A VARNISH

The varnish should protect the paint film from dust and dirt in the atmosphere and from abrasion. If a varnish is too soft (see *Varnishing acrylic paintings*, below), it will, in fact, pick up dirt. Some thermoplastic resins have low glass transition temperatures which means they can soften at relatively low temperatures and thus attract dirt.

The varnish provides some measure of protection from the effects of oxygen and moisture; this varies according to its permeability. The varnish must be sufficiently elastic to prevent cracking as the canvas expands and contracts. It must place the minimum stress on the paint layer. The addition of ultra-violet absorbers to the varnish may act as a filter, protecting the paint from the light. But, in practice, these are rarely used.

VARNISH DETERIORATION

Varnish can deteriorate both physically and chemically. The former shows itself in cracking, chalking, shrinkage and wrinkling. Chemical degradation is a result of oxidation, both of the resin and, occasionally, of the solvent. Linear polymers deteriorate by chain-breaking and cross-linking (which leads to insolubility). The deterioration of the varnish layer is one of the principle problems faced by conservators (see p.309).

VARNISH SOLVENTS

Solvent-type varnishes dry by solvent loss, or evaporation. The varnish film becomes touch-dry before all the solvent is lost. If the varnish forms a gel with considerable solvent still present, it will tend to flow into the irregularities of the paint surface. If this solvent is easily oxidized and discolors, it may lead to the discoloration and faster deterioration of the paint film. This is one of the reasons for not applying varnishes before the paint is completely dry. Solvents must be carefully and correctly balanced in a varnish formulation to achieve the right gloss and a satisfactory drying rate.

VARNISH RESINS

The type of natural or synthetic resin from which the varnish is made will affect its durability and gloss qualities (see also p.35–7).

Damar
The natural resin damar is relatively non-viscous when dissolved in turpentine, which means that it brushes easily and wets the surface well. This makes it very glossy and enables it to saturate colors, especially dark ones, giving them greater depth. The alcoholic and ketonic components in the damar cause gradual oxidation; impure resin discolors more quickly.

Mastic
Mastic is another natural resin of low viscosity which exhibits similar characteristics but which is generally regarded as being slightly inferior to damar, in its more rapid rate of oxidation. Both are natural resins which will eventually and inevitably begin to exhibit signs of yellowing.

Other natural resins have been used to make varnishes in the past, but are now generally avoided because of evidence of deterioration. Shellac, for example, darkens considerably and is liable to crack badly. Most of the natural resins have now been replaced by modern synthetic alternatives.

Synthetic resins
The synthetic alternatives in common use in proprietary artists' picture varnishes are the polycyclohexanone or ketone resins which are as non-viscous as damar and which give a similar intimate bond with the paint surface, brushing easily and wetting well. A "final varnish" resin used extensively in conservation is B67. It is soluble in mineral spirit with the addition of around 20–30 per cent of toluene. It is extremely stable and appears to incorporate a stabilizer to prevent it from cross-linking and becoming insoluble. B67 remains relatively unchanged for between eighty and one hundred years, and is available as a spray varnish in proprietary form.

Probably the most stable of the synthetic polymers is B72. This is an acrylic co-polymer which is extensively used in conservation, but is not available

on the retail artists' material market. Such polymers are "long-chain" high viscosity resins, which means that the long strands of polymer which make them up inhibit the mobility of the varnish. For this reason, they do not wet intimately the surface to which they are applied, and therefore give a lower gloss. B72 is non-yellowing and does not change its solubility as do most other resins over a long period of time.

VARNISHING OIL PAINTINGS

The chapter on oil painting has pointed out the dangers of using excessive amounts of resin varnish in the painting medium. An artist who has done so may find, for instance, that detailed work on the surface of the painting is dissolved and dispersed by brushing resin varnish on top. This is because the resin in the paint layer is redissolved by the solvent in the varnish. Such an effect may also occur many years later when the old yellow varnish comes to be removed and the solvents used to do so can disturb the original paint.

The answer is to rely on drying oils and diluents alone when manipulating the oil paint. This makes for a wide (and therefore safe) solubility gap

between the dried paint film and the varnish (see above). Any of the resin varnishes discussed above are suitable for oil painting. Damar is the traditional choice, giving high gloss. Ketone is a modern and probably less yellowing alternative. The excellent and slightly less glossy B67 is beginning to be available to artists.

VARNISHING ACRYLIC PAINTINGS

The solubility gap between paint layer and varnish can be very small indeed where acrylic paints are concerned so that problems can occur if a varnish needs to be removed. One obvious answer might be to use a solvent-based resin, but this makes the acrylic resin swell. In addition, such resins are not perfectly stable, they oxidize and become less and less soluble and would end by requiring solvents for their removal that would almost certainly dissolve the acrylic paint film. However, the B67 resin varnish described above would remain soluble in something between mineral spirit and toluene and is also very stable and non-yellowing.

The proprietary water-soluble acrylic varnishes tend to be variations of the acrylic dispersions that form the binding medium for the paint itself. The

"water liking" ingredients that enable the acrylic resin to be dispersed in water remain in the film when it is dry, often giving a milky look to the varnish. The matting agents used to reduce the natural gloss of the acrylic dispersion can also give a milky effect.

APPLYING VARNISH

Varnishing should be done in a clean, warm, dry, ventilated room. The painting should be clean, grease- and dust-free and the paint must be absolutely dry. It is normally laid flat and the first coat of varnish applied thinly with a flat, wide hog-hair brush. A varnishing brush should be kept for this purpose alone; it must, of course, be absolutely clean. More than one pass is made with the brush. In fact, with the short chain varnishes such as the ketones and damar, continued brushing can give a semi-matt appearance with the brush just breaking up the surface as the varnish begins to dry. Such effects are not so possible with the less mobile long chain polymers, but these are less glossy anyway.

The second coat can be brushed or sprayed on (it is possible to spray both coats, but brushing is generally thought to provide a better bond between varnish and paint film).

How to apply varnish

I Ensure the painting to be varnished is free of dust and grease. If absolutely necessary, clean it carefully with cotton moistened with saliva.

2 Apply the first coat with a varnishing brush. The strokes should be made in one direction, parallel with the edges of the picture.

3 When the varnish is dry, apply a second coat using either the same varnishing brush or a spray gun to give a fine, even film. Make the strokes at right angles to the first coat.

FRAMING

Once a painting or drawing is completed, it must be mounted and/or framed. It is relatively easy for the artist to frame his own work, but the way in which a finished artwork is framed has an inevitable effect on how it is viewed, so the choice and construction of frame is an important factor in the presentation of the work.

THE HISTORY OF FRAMING

The early Renaissance practice of preparing and painting on a panel with a gesso ground often incorporated the moulding and gilding of the frame as an integral part of the work as a whole. But, as the practice of making paintings on canvas developed, the frame became a separate component which was attached to the canvas after it was finished. The frame was an important and expensive decorative feature designed to display the work to advantage and, in itself, to demonstrate the skills of the wood carver and the gilder. This "dressing-up" of the painting produced some extraordinarily elaborate frames and some extremely beautiful ones, but the frame often had very little to do with what was going on in the painting.

Contemporary trends
In the late nineteenth and throughout the twentieth century, there has been a move amongst most painters to return to the earlier concept whereby the painting and frame were more integrated. Artists such as Van Gogh and Seurat, for example, often painted their frames in a style akin to the works themselves. An alternative has been to dispense with the frame altogether or simply to protect the canvas with a thin strip of plain or painted hardwood.

Among contemporary painters who have explored and furthered the notion that the frame is an absolutely integral element of the

INTEGRATING PAINTING AND FRAME

Many of Georges Seurat's works of the late nineteenth century show a marked concern with the decoration of the frame, to which small dabs of the same colors used in the painting are applied with equal care and precision. In the picture shown on p.198, for example, an "inner frame" or border painted in this way is incorporated within the actual frame.

Several of Van Gogh's pictures of the same period illustrate the same point. Here, the way in which the frame has been painted parallels the direction of the brushstrokes in and around the forms of the lemons, grapes and pears, emphasizing the horizontal and vertical planes of the frame itself. The effect of this is to underline the defining movement of the brushstrokes in the painting. The frame therefore remains separate in one sense from the subject of the painting but, in another sense, becomes completely integrated into the work as a whole.

Still life with lemons, grapes and pears (1887), by Vincent Van Gogh

painting itself are Howard Hodgkin and Mimmo Paladino; the former, in work in which the frame and painting merge almost imperceptibly (look closely at the example on p.181), and the latter in work which introduces new motifs in the painting of the frame to enrich and expand the narrative of the painting itself.

·The framing process·

The construction of a rectangular picture frame is straightforward. It simply involves cutting four lengths of moulding with accurate 45 degree angles at both ends of each piece, gluing and pinning these together (see p.319). In practice, artists who attempt to do this with no equipment other than a saw, glue, hammer and nails invariably find it practically impossible to get a perfect angle. If you envisage doing a lot of framing, it is worth investing in a few basic tools – some form of miter cutter is certainly essential.

CHOOSING THE MOULDING

Proprietary picture frame moulding is widely available in a huge range of sizes, styles and finishes. Many of these mouldings are designed for the cheaper end of the market – for the framing of supermarket prints and photographs, for example – and may not be of interest to artists. In addition, many are designed for work of a limited size – for glazed work on paper or prints, for instance – and may not be appropriate for larger paintings on canvas. However, if you do find a satisfactory moulding within the commercial range, you will save money by buying it in 30m (100ft) batches, with the moulding divided into 2.5–3m (8–10ft) lengths. For the larger-scale canvases, a limited range of mouldings are available in plain pine or ramin.

Plain wooden mouldings like these can be primed and painted or stained in any way felt to be appropriate to the painting. This may be the only satisfactory way of ensuring the permanence of a colored frame; commercial colored moulding can darken quite drastically.

Making mouldings

If a suitable moulding cannot be found, the artist can sketch the required design and have it manufactured in wood. If the proposed moulding profile is a reasonably straightforward shape, this need not be an expensive business, especially if a large amount of moulding is commissioned.

The alternative is to ask a plasterer to create a mould from which the artist can cast lengths of moulding when required. This is a relatively straightforward matter and involves the cutting of an aluminum template from which the mould can be run. The mould is given a coat of shellac to seal it. When the cast is taken, it is normally reinforced with scrim soaked in plaster, and timber. The most important thing to remember is that the timber must be soaked (preferably for two or three days) before being incorporated into the moulding, otherwise the whole thing will crack. The plaster may be sized and painted or coated with red bole and gilded according to choice. A moulding may, of course, be incised, inlaid or adapted in any way considered appropriate.

CUTTING THE MITER

Assuming the frame is rectangular, the moulding will require cutting at an angle of 45 degrees. The cheapest method of doing this with any degree of accuracy is to buy a wooden miter box made of hardwood, into which the moulding is placed. The blade of a tenon saw is placed between the guide cuts in the two vertical sides of the box and the moulding is sawn. In practice, the accuracy of the wooden miter box lasts for only a short time as the action of the saw inevitably widens the guide cuts; a metal box is better. But, for artists who are going to continue to make frames, a moderate investment in a miter cutter makes a great deal of sense. These are simple cast iron stands with a framework and saw attached, to enable cuts to be made at specified angles. The best makes are extremely long-lasting and reliable, with the only maintenance required being the occasional sharpening of the saw blade. Another, but considerably more expensive, machine is the guillotine miter cutter which most picture-frame workshops use. This comprises two sharp knives set at right angles at 45 degree to the moulding so that they can cut both corners of a miter at once. These are usually operated by compressed air or with a foot pedal. They are not generally capable of cutting mouldings whose width is in excess of 8cm (3ins). The reason that they are preferable to any of the sawn methods is that the problem of sawdust is eliminated. With sawn mouldings, the dust must be removed before gluing and pinning.

Whichever method is adopted, the lengths of the moulding will have to be accurately measured so that the painting fits. Measure the height and width of the painting and add to those measurements enough to allow a gap between the edge of the rebate and the painting itself of between $\frac{1}{8}$ and $\frac{1}{4}$ in all round, depending on the size of the canvas and of the rebate. This measurement will represent the shortest (inner) side of each piece of the frame.

GLUING AND PINNING

The established method of gluing and pinning is to put a spot of fast-drying white wood glue on the cut face of the pieces

of moulding to be joined and to position them in corner clamps. The two pieces of moulding should be pushed gently together and the clamps tightened. There should not be any excess glue visible at the join but, if there is, wipe it off with a damp cloth. The corner can now be side-pinned using a small hammer and panel pins. A nail punch should finally be used to hammer the heads of the pins into the timber so that the holes can later be filled and made good. The corner comprising two sides of the frame should be left in the clamp to dry. Two halves are glued and pinned at a time so that, when they are dry, the other two halves may be put together in a similar way and the frame completed. When the frame is dry, the pin holes can be filled with a wood filler or with a white powder filler mixed with a little PVC glue and water. When this is dry, it can be retouched to the color of the frame.

A more professional method is to use an underpinning machine. The two pieces of moulding are given a spot of glue as above and placed on the machine. A right-angled piece of metal is fired up into the corner of the frame from underneath. This allows the underpin to hold the frame together while the glue sets. A complete frame may be made rapidly in this way and there are none of the problems associated with unsightly holes in the side of the frame.

PUTTING A PAINTING IN A FRAME

If the painting is being placed directly into a frame without mounting or glazing, it is generally held in place with cork or balsa wood slices. These allow the painting to fit snugly in the frame but also to move a little if necessary.

The inside edge of the rebate is often covered with a soft material such as velvet ribbon to protect the surface of the painting where it touches the rebate. To prevent the painting from falling out, it has been customary to nail panel pins into the back of the frame next to the canvas and then bend them over the stretcher frame. This is not a particularly sound method since it creates stress on the canvas at the point where the nail is bent over. In addition, the nail may start to rust. A better way of securing the painting is to screw proprietary nylon angle brackets or mirror plates on to the frame which lip over the back of the canvas and hold it in place.

In order to keep a stretched painting on canvas in good condition for as long as possible, the use of a hardboard, plywood or even cardboard backboard to keep out dust and dirt and to act as a buffer against atmospheric changes is strongly recommended (see pp.62 and 312). A couple of screw eyes with rings are screwed into the back of the frame and picture wire strung between them (see below).

FRAMING DRAWINGS, PRINTS AND PAINTINGS ON PAPER

Drawings, prints and paintings on paper are framed in the same way, but have to be protected by glass. In turn, their own surface must be protected from abrasion with the glass itself, so they are generally "window mounted" in cardboard, or a fillet is intro-duced between the glass and the mounting board. In addition, there is a backing board to protect the back of the work. There may also be an imperme-able sheet of inert plastic film between the backing board and the back of the mount.

The glass
Picture glass is generally as thin as the size of the frame will allow. This is to enable the image to be seen as clearly as possible and without risk of distortion or any latent color in the glass affecting it. Glass is simply cut with any steel or diamond wheel glass cutter. It should be cut right to the rebate to prevent risk of dust or dirt getting in from the front. The cut is made smoothly and in one go against a wooden or metal rule held against the glass as a guide. To snap a piece off, put the rule under the glass along the line of the cut and push down on one side while holding the other steady. The glass should be cleaned and degreased with a small amount of proprietary cleaner or denatured alcohol. It should be polished with a lint-free duster.

The mounting board
Since the original has been made, one imagines, on the best acid-free paper or board, it would make no sense to use a highly acidic wood pulp mount since it would soon contaminate the artwork. The best and most expensive mounting board is known as museum board or conservation board and it comes in an extremely limited range of white and off-white colors, but it is acid-free and therefore reliable.

The most primitive method of cutting a window mount is with a cheap craft knife, such as a Stanley knife, against the bevel edge of a heavy metal rule. Holding the angle of the bevel along the length of the cut is extremely difficult, so most artists opt for a relatively inexpensive hand-held mount cutter. This holds the blade at the required angle while it is drawn across the board against the edge of a metal rule. On a professional mount-cutter, the length of the cut can be pre-set so that complete accuracy is maintained.

Fixing the work to the mount A work on paper is traditionally fixed to a window mount with a pair of hinges made from thin Japanese paper and

stuck with a flour and water or cellulose paste. The use of adhesive tape or drafting film is not recommended as these can discolor the artwork. The window mount itself may be hinged in a similar way to a piece of the same museum board so that the artwork is securely held as the "filling" in the sandwich. For a work on handmade paper, for instance, in which it is necessary to see the whole of the sheet – including the deckled edges – a window mount is inappropriate, but a system of paper hinges can still be used, one on each corner of the paper and pasted to the conservation board beneath. In this case, the frame will have to incorporate a fillet to ensure a space between the paper and the underside of the glass.

The backing board
A loose sheet of Mylar or equivalent inert plastic may be placed between the mounting board and wooden (hardboard or plywood) backing board to ensure the mounting board is not contaminated by acidic elements in the backing board. This is not generally considered necessary, however. The backing board should be cut tight to the frame and is generally secured with a point driver or glazing gun which fires diamond-shaped flat points into the edge of the frame to ensure that dirt does not penetrate the gap between backing board and frame.

Strong brown gummed tape is secured around the back of the frame as an added precaution against dirt. Finally, a pair of screw eyes with rings are screwed firmly into the frame between two-thirds and three-quarters of the way up on each side and picture wire or nylon cord strung across. This ensures the painting leans forward slightly from the wall. The framed picture is now ready for hanging; if it is very large, it may be better to screw it to the wall (see right).

HANGING A VERY LARGE PAINTING
A very large painting may be too heavy or cumbersome to hang from normal picture wire. A secure method of hanging such a painting is to attach one or two mirror plates to the back of the frame on each vertical edge so that they protrude when seen from the front. These can then be screwed from the front into the wall.

Disguising the fixture
When the picture has been attached to the wall, the visible part of the mirror plate can be made less obtrusive by painting it to blend in with the wall.

How to frame a picture

1 Measure and cut the required length of moulding with 45 degree angles at each end, using a miter cutter or miter box. Do the same for all four sides of the frame.

2 Spread a thin layer of glue over the cut surfaces, then secure them in a corner clamp or vice and pin them together. When the frame is dry, the holes can be filled and painted over.

3 For drawings, prints and paintings on paper, measure the window mount and cut it out using a mount cutter to give a beveled edge and a steel rule to ensure a straight cut.

4 Attach the work to the mount with paper "hinges" or stick masking tape along the edge of the picture and lower the mount into the correct position.

5 Cut a piece of glass and place it in the frame rebate, followed by the mount, the picture and the backing. Insert the hardboard and secure it by driving pins into the frame.

6 Tape round the edges of the frame with brown gummed tape to keep out dirt. Insert two screw rings into the back of the frame and attach picture wire or nylon cord.

·APPENDICES·

PHOTOGRAPHY

For some artists, photography has assumed a primary importance as the medium with which to give their art visual expression. For others, it has a secondary, but still crucial, importance in providing reference material for painted or printed artworks. For most artists, it is a valuable means of documenting work in slide or print form.

·Photography as art·

The emergence of photography as a medium for those who call themselves "artists" rather than "photographers" is a relatively recent development, but one which has resulted in creative work of great originality and variety. There is some overlap between photography and art, but the artists who use photography can perhaps be differentiated by their emphasis on the concept which underpins and informs the way in which the image is obtained, rather than on the "purity" of the straight photographic image itself.

STYLES AND SUBJECTS

The actual appearance of photographic works is, of course, as diverse as the styles in any more traditional medium.

They include multi-print assemblages, action sequences, large-scale photoworks, portrait transformations, strange conceits and documentation works. The latter point to a trend in art which photography may be said to have encouraged; that is, it allows artists to work freely in less conventional areas and medi.. – for example, directly in the landscape or in "performance" related disciplines. The photo-graphic documentation of such activities is as close a substitute for the action or the piece of work itself as may be represented and sold in an art gallery.

Many artists who use photography in this way also incorporate text in their work. In many cases, the work is presented in the form of a book.

TECHNIQUES

The photographic techniques adopted for work of this kind are hugely varied. For a number of artists, the instant-picture cameras provide images for immediate use. Some prefer to use a straightforward 35mm SLR camera with a standard lens for all their photographic pieces, while others adopt large-format cameras in studio situations and a range of advanced manipulative techniques including montage and masking effects, multiple printing and image distortion.

If a photographic image is sold as a work of art, the aspect of permanence assumes some degree of importance. The image – particularly if in color – should be hung in a relatively shaded spot and certainly should never be exposed to the direct rays of the sun.

CONSTRUCTING A PHOTO MONTAGE

This work comprises a series of free-standing triangular photographic cut-outs which have been mounted on to board. Photographs taken from various heights in fields of stubble give higher or lower vanishing points to the lines of stubble as they recede. When taken out of context in this way, the images take on the appearance of snow-capped mountains (with the lightening of tone towards the peaks).

Adapting familiar images
Here, a composite picture has been made by cutting out images from different photographs, arranging them to form an image with different associations and re-photographing it.

CHALLENGING VISUAL PERCEPTION

Photography can use very simple means to make work which explores the paradoxes of visual perception. This work itself usually has a clarity of appearance which is belied by its often enigmatic atmosphere. Here, for instance, the positive/negative aspect of the image is immediately clear, but what the image actually represents is somehow obscured by the fact that it seems to provoke other associations. The piece has an astronomical look, as if the reflected phases of the twin moons of some planet poised in space are being subjected to a scientific investigation. On the left, the sphere floats in a kind of liquid space whereas, on the right, the dark tone of the quadrilateral itself lifts it away from the background. Here we are looking up as the perspective lines of the "floor" recede to a low vanishing point and the quadrilateral looms. On the left we are looking across, and the vanishing point is above the piece so the effect is to make the top sphere itself loom large. What provokes these speculations of course, is simply the photograph of a sphere on a mirror on the floor.

Gravitation (1979) by Tim Head
Here, the artist has juxtaposed positive and negative versions of the same image. The different aspects of each side of the work are somehow reinforced by the fact that the negative side has been inverted, so that the position of light and shade on both pairs of spheres is constant.

PHOTOGRAPHIC TABLEAUX

All good art prompts the viewer to look again at everyday objects and events with a new focus and a new perception. Here, for example, it is as if the chance discovery of a roll of soft, gray rubber-backed carpet underlay, with a surface so ripe for scratching off and texturing, has made the artist make a mental connection with elephant skin and this perception has formed the basis for the whole work.

The tableau, itself so carefully set up and photographed, upturns the conventions of commercial studio photography. There is no concealing the apparatus from which the legs are suspended – the human figure is miniaturized and made more of a victim by their scale.

Untitled (1982) by Boyd Webb
The elephant legs, figure and stool are held in a motionless pose in crisp focus. The blurred background frieze adds a strong sense of horizontal motion and gives a real sense of the world going by.

·Photography as reference·

For many artists, the camera is an invaluable adjunct to the sketch book in the accumulation of reference material with which to prepare the finished work. The camera cannot replace the sketch book, because it is a quite different tool. The photographic image requires a further stage of processing through the artist's chosen medium, and retains a sense of separateness. A sketch, even if it is only a few rapidly drawn lines, has a vitality and an immediacy based on an intensive act of observation and on an active mechanical response.

THE ADVANTAGES OF THE REFERENCE PHOTOGRAPH

Although the sketch is still a vital source of reference, using a camera can greatly extend the range of subjects which it is possible to record.

"Instant" referencing
The reference photograph is the only means of swiftly recording elements which might later be usefully incorporated in a painting. An image seen from a train or a plane window, for instance, is not easily sketched but it is readily photographed. Similarly, a particular cloud configuration or a chance arrangement of figures in a crowd can be recorded before the scene changes.

Recording movement
The camera's potential to freeze a split second of action enables the artist to work with a degree of representational accuracy which was not possible before the advent of sophisticated fast-shutter-speed cameras. A bird in flight or a running, jumping, or diving figure, for instance, are images which can now be perceived in detail.

Demonstrating alternative ideas
In more conventional work, the camera may be used to give an indication of the possibilities for a painting in terms of composition, setting and light. In a portrait, for instance, various poses in a number of settings and with varied lighting can be tried out with the camera before you decide on a scheme for the painting. In addition, you may choose to work from life for the figure itself but from photographs for the background. In short, the camera gives you more freedom to construct a painting out of a number of different elements.

Compiling a reference library
Many twentieth-century artists have incorporated popular imagery from a variety of ephemeral sources in their work. A good method of filing such visual information is to photograph it and keep a record in slide form. You should be aware of the copyright laws in this respect but, for an image on poor-quality newsprint for instance, which is going to disintegrate rapidly, it makes sense to photograph it at an early stage.

"Two-dimensional" source material is not confined to the printed page and it is possible to record imagery from the television screen or video monitor. Such imagery further extends the range of source material available to the painter.

WORKING FROM PHOTOGRAPHIC REFERENCE

Photographic reference material can be used selectively. A drawing or painting may be based on all or part of a photographic image which may also be inverted, reversed or otherwise modified in a number of ways.

Freezing action
This "splash" image demonstrated quite effectively how the camera can freeze a split second of action to enable you to see precisely what is happening and, if necessary, to re-create it in a chosen medium. This would clearly be impossible with any other form of referencing. There was, of course, no way of knowing when the pictures were taken how the splash would come out. The transformation from black and white photograph to soft pencil drawing, together with the modifications made to the inside of the circle and the exclusion of external detail such as the posts and shadows, effects a complete re-creation of the original image.

"Splash" colored pencil drawing For this image, a complete 36-exposure roll of black and white film was shot as large stones were pitched into a river. The picture used was by far the most appropriate image with its encircling crown of projected water.

Combining photographs and life This formal portrait is an example of a painting worked partly from life and partly from photographs. The painting of the figure was made from life over a period of several days, during which most of the time was spent on the head. The background was taken from a separate room in the house from that in which the portrait was painted and although some hours were spent working on it from life when the light was appropriate, most of the background was worked up from a photograph. Unless a lack of uniformity is a positive aim, it is necessary in work which incorporates painting from life as well as from photographs to achieve the sense of a completely integrated image.

Portrait using photographic reference Each element in this painting has been carefully organized to produce an image which works as a whole, so that there is no apparent discontinuity between the parts painted from life and those from photographs.

DOCUMENTATION AND PRESENTATION

Almost every situation in which an artist may be professionally involved will require some kind of photographic documentation of his work. The more well-known the artist, the more frequent are the requests for images of work to be reproduced in books and magazines, so it is essential for a professional artist to have good-quality color slides and black and white prints of his or her work.

A good set of slides may be enough to persuade the director of a gallery to pay a studio visit. It is certainly essential in any application to a regional arts association or to the jury in the first stages of an open compe-

PRESENTING IDEAS
Reference photography plays an important part in the preparation of proposals for public artworks or for exhibitions (see also pp.332–3). A common technique is to photograph the site (or the gallery space), to photograph the

Preparation for a sculpture In my proposal for a large-scale flat cut-out sculpture to be attached to the steel collar on a chimney stack, I constructed a photo-montage of the site with the figure superimposed to scale. This gave the client a good idea of what was proposed.

tition for a public artwork, for instance, that they should be able to see the work in as presentable a form as possible. If the artist is chosen to be represented in an important solo or group show, it is invaluable for the exhibition organizers to have accessible material that they can show or send out to members of the press, the major art bodies or museums.

Invariably, if the material is not available immediately, there may be too little time to have work photographed; it is far less time consuming if work is photographed and filed accurately as soon as it is completed. Photographing paintings need not be a complex or expensive process (see opposite).

drawing/painting/maquette and to superimpose the latter on to the former in a photo-montage which may then be rephotographed so that it can be presented to the commissioning committee as a hypothetical view of the installed work.

Detail of the sculpture This pen and ink study of the actual sculpture is juxtaposed with the photo-montage to show the detail of the work.

·Equipment and techniques·

BASIC EQUIPMENT

A range of basic photographic equipment is usually all that is needed for referencing and documenting artists' work.

Cameras

The camera most commonly used by artists is a 35mm single lens reflex (SLR). This is extremely versatile and can be used for original work, reference and documentation. The film size is large enough to be able to produce images on fine-grain film which, when greatly enlarged, retain a reasonable crispness. Most of the standard lenses available on such cameras produce sharp-focus images, and the focus can be accurately adjusted by looking directly through the viewfinder. Many SLRs have automatic settings which will either take the picture at the correct shutter speed when the aperture has been pre-set or at the right aperture when the shutter speed has been set.

Lenses

The standard 50mm lens is quite adequate for most reference photographs and pictures of paintings (in the case of details or of miniature work, one or two close-up lenses can be screwed to the standard one). However, if you wish to photograph the whole of a large subject, such as a building, it may then be difficult to get far enough away to encompass it with the standard lens. In this case, a "wide-angle" lens is needed. On the other hand, objects in the far distance may provide ideal reference but appear as a tiny dot in the frame through a standard lens. Here, a "telephoto" lens is called for.

Nowadays, it is possible to buy good-quality "zoom" lenses which cover a wide range of focal lengths. You might then travel with the camera body and two zoom lenses: a 28–80mm lens which covers the wide-angle problem, the standard lens and beyond, and an 80–260/300mm telephoto lens to bring the distant images closer.

With a wide-angle lens, the depth of field – the depth of the image in focus – is very great, whereas with a telephoto lens and a short depth of field, focusing has to be very accurate to obtain a sharp image, so a tripod is commonly used. An additional problem with zoom lenses is that their aperture tends not to open to more than about f3.5, so a relatively fast film must be used in order to cover most natural lighting situations.

Films

Any of the standard 35mm films may be used for slides, color prints or black and white prints, depending on your personal choice. Generally, the slower the speed of the film which can be used at a reasonable shutter speed, the better the quality. For color slides, low-speed Kodachrome or Fujichrome is perhaps preferable to Ekta-chrome with its somewhat bluish cast, though these have to be sent to the manufacturers' laboratories for processing, which inevitably involves a period of delay.

A relatively new kind of film which has proved popular for reference work with artists and (perhaps more especially) illustrators, is the Polaroid instant-slide film which is available as low-speed color slide film, medium-speed, continuous tone, black and white reversal film and black and white line film. The films are supplied with a small processing pack so that they can be developed in a moderately priced processor, and viewed immediately or, in the case of slide film, projected in less than two minutes.

PHOTOGRAPHING PAINTINGS AND DRAWINGS

A perfectly reasonable and uniformly lit photograph of a painting or drawing can be taken as follows:

■ Position the camera on a tripod. Mount the painting on the wall, or on an easel – absolutely vertical and parallel with the camera's picture plane.

■ Place a telescopic stand on each side of the camera, at 45 degrees to the picture plane.

■ Fit a flash unit on each stand, facing away from the artwork. The units should incorporate sensors (facing the artwork) to assess the amount of light needed for a perfect exposure. Connect the units to the mains via a transformer.

■ Attach an umbrella reflector to the stand so that the flash will bounce off it on to the artwork.

■ Connect an extension sensor from one of the flash units to the hot shoe of the camera and attach a photo cell to the other flash unit so that, when the first flash goes off, it triggers the second simultaneously.

■ Set the camera shutter speed for electronic flash, normally 1/125 of a second, and estimate the aperture from the guide on the side of the flash unit. Once a correct aperture has been assessed for a particular make of film, it will be constant.

For large paintings, the lighting stands should be comparatively further from the image. If they are too close, the edges of the painting will show lighter in the photograph. If the image to be photographed is glazed, a piece of black card with a hole through which the camera lens can point should be held in position to avoid reflections. It is best to bracket the shots, so that a photograph is taken with an aperture rating on each side of the estimated correct exposure.

COMPUTERS

Artists have been using computers as a creative medium since the 1960s, writing software programs that instruct them to perform certain tasks or to interact with spectators in particular ways. Harold Cohen, for instance, has spent many years "teaching" his computer how to make a mark or construct an image according to his own particular expert system. Other artists have programmed computers to respond to the movement or sound of spectators and to react in particular ways. In 1969, for instance, Edward Ihnatowicz created a sculpture in which a giant robotic arm, jointed like a lobster's claw and with microphones attached, turned in the direction of any sound created by spectators in a gallery.

Nowadays, new kinds of projection technology are being developed which use lasers to create three-dimensional images. New technology such as this opens up a whole new field of practice for creative artists.

The use of the computer as an artistic tool has been made possible by the widespread availability of new technology at greatly reduced prices. The new wave of interest among artists also relates directly to the graphics software packages developed for major commercial users such as the industrial design and advertising agencies.

HOW COMPUTERS ARE USED

At the basic level, computer software can be used to speed up the process of moving around imagery and typography. This enables designers and artists to experiment with various ideas without the time-consuming process of committing them to paper. With the new transputer chips now replacing the older central processing units, not only is the speed of work being increased, but ever more complex visual effects can be represented and explored.

Drawing in an image
The artist can work − with no special computer knowledge − by picking up tools from the edge of the screen and applying them in a suitable way for the project in hand. He or she can draw directly on to a digitized tablet and the image will appear on the screen, or an original drawing may be laid on to the digitized tablet and its outlines traced through. Alternatively, an image may be fed in by being scanned directly by a video camera.

Modifying the image
Once the image has been drawn and "loaded" into the computer, it can be squashed, stretched, enlarged, reduced or modified in any number of ways and in almost any color required. Some systems, for example, are capable of reproducing millions of colors (though only a handful of those can be on screen at any one time).

The kinds of modifications or adjustments which may be made

Sketching by computer This simple portrait was drawn directly on to a digitized tablet, using a combination of two colors. It shows how the computer can be used to recreate perfectly conventional drawing effects, in much the same way as a pencil and paper.

are limited to what the computer has been told to do, and it is up to artists to suggest appropriate effects. Such software is command-orientated and, unless it has been taught how to create an effect, it will not be able to make it. The range of possible manipulations is increasing all the time; painting software with "smudge", "smear" and "wash" commands is now available, for example, enabling subtle effects to be reproduced.

Experimenting with the image Here, the colors have been changed and the features portrayed in solid blocks of a single color, to create a more abstract effect.

Potential improvements in computer technology In this respect it is worth considering how far computerized music has advanced in comparison to the visual arts. Modern keyboard instruments are now touch-sensitive and can respond to and encode the slightest pressure of the fingers. When artists decide that they want to deal with subtle differences of pressure on the digitizing pad or the different characteristic brushwork of a soft hair or a bristle brush it will be quite possible to instruct the computer accordingly.

COMPUTERS AS AN AID TO CONVENTIONAL ARTISTS

"Imaging" techniques like those described above allow the "conventional" painter to digitize a painting, so that it appears on the screen, and then to modify it in various ways. Different tones, colors and shapes can then be tried until the desired effect is reached, at which point the painting itself can be reworked. This is a time- and material-saving method of decision making. Such a technique can also be helpful in deciding on the color of a mount or a frame, for instance.

Computer study
Nowadays, increasingly sophisticated software means that computers can recreate the effects of pens, brushes, airbrushes, pencils or pastels, subject to the restrictions of the screen. Drawings can either be reproduced or original artwork created in its own right. This student's sketch has an easy fluency and a sense of movement which shows a relaxed use of the computer and a delight in the various textures that can be explored.

THE QUALITY OF THE COMPUTERIZED IMAGE

The creation of imagery with computer "paint box"-type software relies to a great extent on the output device for the quality of the imagery to be sustained. Any device capable of following a digital signal is capable of recreating the image. Such devices include printers, plotters and screens.

The cathode ray tube is probably the weakest component of the image-creating system. A 512×512 screen, giving half a million dots towards the resolution of the image, is considered good, but a 2500×2500 screen will give a very sweet curve to a line which, on a normal screen, would look like building bricks. The so-called anti-aliasing devices incorporated in software are designed to deceive the eye into reading those stepped lines as smooth and un-jagged but the fact that they are necessary demonstrates how

the artist is at the mercy of a technology that, in some respects at least, is still in its infancy.

However, in an industry where developments of four years ago are now considered obsolete and where – given the current state of the technology – the power of existing equipment will soon be greatly increased, no doubt the quality of repro-duction will also be enhanced.

The limitations of the screen
Curves can only be reproduced as a series of straight lines, so their quality depends on the number of dots which make up the screen.

COMPUTERS IN ARCHITECTURE
Computer systems can provide invaluable help to artists who work in the public sector. Where new buildings are concerned, for instance, it is more than likely that the plans will exist on a datafile which enables the artist to show the effect of a proposal in its potential site and with the sun at any relevant angle!

Showing the effect of perspective The perspective systems currently available make it possible to avoid time-consuming mechanical perspective drawing for artwork proposals, since the computer can do it so much more rapidly.

THE STUDIO

The ideal artist's studio would be large, warm and suffused with north light from a high window. A high light source prevents unwanted shadows and the northern orientation prevents direct sunlight from beaming awkwardly across a painting. Large paintings can be moved in and out with ease and stored in a separate area.

In practice, most artists have to work in far from perfect conditions. Even so, certain criteria must always be considered when choosing and furnishing a studio.

LIGHT

The type of light in which a painting is viewed has a great influence on its appearance, so this must be considered when the picture is being made. Natural light allows the colors to be perceived with clarity in their true value but – when the painting comes to be sold – it may well be displayed in artificial light, which would transform its appearance.

Unfortunately, there is usually no way of knowing in what conditions a finished work is likely to be displayed. Ultimately, you must decide the type of light by which you prefer to work, though this may, in part, be dictated by imposed factors. The many artists who like to work on into the night have no choice but to rely on artificial light.

Daylight
If a studio lets in shafts of sunlight, the best method of diffusing it is to install thin, white, translucent roller blinds which can be pulled down easily when necessary. A less expensive alternative is to tape translucent drafting film over the window panes. Tracing paper or tissue paper could also be used in this way. Net curtains will only partially diffuse the light.

Artificial light
For a constant and uniform studio light, the best kind of artificial lighting is probably the standard fluorescent tube. The "color temperature", measured in degrees Kelvin (K), designates the warmth or coolness of the color. "Artificial daylight" lamps are available with a color temperature of 6500 K that corresponds to that of natural light. In practice, however, these lamps give a rather cold, gray atmosphere to a studio and indeed to a museum, where conservators have opted instead for a lamp of intermediate color temperature, between daylight and tungsten light, of around 4000 K.

The new tri-phosphor or multi-phosphor lamps are particularly efficient. The amount of light these give out at various wavelengths stays stable for around 6000 hours. Furthermore, the amount of light they supply per watt of electricity (lumens/watt) is particularly high, which means they are very economical.

The tri-phosphor and multi-phosphor lamps are particularly suited to studios in which the artist is making large-scale works and requires a constant overall light level. There are, of course, artists who work on a very small scale – making wood engravings or painting miniatures, for instance. Here, a small spotlight on an adjustable bracket will give a pool of light within which the piece can be worked. Indeed, such a set-up can greatly assist concentration if the rest of the studio is kept in relative darkness.

HEAT

It is very difficult to work in cold conditions but a large, badly insulated space can be expensive to heat and it is often better to concentrate the heating close to the actual working area. Portable kerosene and electric heaters provide a good localized source of heat and enable a check to be kept on the amount of fuel consumed.

For studios with large ceilings, towards which the heat escapes, a small fan set at the top of a cylinder of polyethylene suspended from the ceiling and reaching almost to the floor, will recirculate the heat quite substantially. Of course, any insulation that is installed will also have a positive effect.

VENTILATION

Any artist who works with organic solvents such as turpentine or mineral spirit should be aware of the health risks which arise from their misuse and always observe sensible safety precautions (see also p.42). Apart from using only very small quantities at any time, and keeping containers sealed as much as possible, the room in which they are being used should always be kept well ventilated, to allow any accumulated solvent vapor to disperse. An extractor fan set in a window may be sufficient, but certainly, in warm weather, all the windows should be left open.

WALLS

Most artists prefer to paint all the studio walls in a neutral color, such as white or gray, which does not unduly affect the appearance of the color on the canvas.

Artists who work on very large canvases often prefer to stretch the canvas on a wall in the studio and to paint it there rather than stretching it directly on a wooden frame. Most studios have a "painting wall" on or against which most of the work is made. A false wooden wall may be made by fixing a horizontal/vertical framework of timber to the wall and screwing sheets of 12mm plywood to this. This gives a uniformly flat surface to which canvas may be stapled. With a plastered wall, a stretched canvas has to be attached with masking tape, which is not so effective.

FLOOR

The floor should be kept swept if the studio is being used for painting, since dust will stick to wet paint and varnish films. Flat wooden floorboards provide an excellent backing for stretching canvas on the floor.

STORAGE

Ideally, the storage area should be separate from the painting area which should in turn be separate from the framing and stretcher-making area and so on. Dividing up the studio in this way increases the efficiency of the space and makes clearing up much easier.

Storing materials and equipment If at all possible, every piece of equipment should be allocated a particular space on a wall, shelf, bench or in a cupboard. The best method of protecting the hairs of brushes is to store them upright in jam jars or brush vases. Painting mediums, and especially organic solvents, should be kept in a high cupboard and well away from the reach of children. All bottles should be kept tightly stoppered at all times.

Storing paintings, prints and drawings A separate area of the studio or a separate room may be designated as a storage space. Large paintings should be protected from dust by being wrapped with polyethylene – not just over the paint surface but over the back as well. The corners should be protected with corrugated card or proprietary corner protectors. These enable three or four similar-sized paintings to be stacked against each other.

STORAGE SYSTEMS

A relatively simple wooden structure can be built to stack large paintings. This comprises a series of upright pieces of timber from floor to ceiling around 75cm (2ft 6ins) apart, against which a small number of paintings rests. Another series of uprights another 75cm (2ft 6ins) in front of these can provide another stacking area.

Between the two sets of uprights along the floor, some pieces of 5 × 5cm (2 × 2ins) timber are bolted to ensure that the bases of the paintings are held off the floor. This assists ventilation and helps avoid damp. If the ceiling is high, cross-timbers can be installed to provide further racking space for smaller paintings above the larger ones.

For paintings, drawings and prints on paper, a plan chest with large, shallow drawers is ideal. Each drawing can be protected from the one above by being interleaved with an acid-free tissue paper. Alternatively, a simple structure can be made with loose pieces of timber constructed in a similar way to pallets and stacked on top of each other.

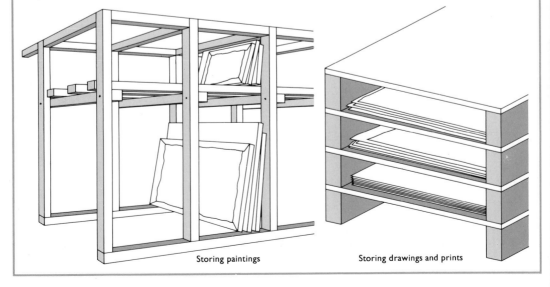

Storing paintings

Storing drawings and prints

EASELS

An easel is an essential piece of basic equipment, as it provides a secure platform for the canvas while the artist is working on it. Easels are available in two main types: studio easels and sketching easels. The former are large and heavy and designed to support large canvases. The latter are light and fold into compact, transportable pieces of equipment. They are designed to take smaller canvases and drawing boards and can be used when painting or sketching out of doors.

Between the two main types are the radial easels, used extensively in art colleges, which are strong enough to support relatively large canvases but which do not take up too much space and can be easily packed away.

Studio easels

The best studio easels are constructed in beech, oak or mahogany, on a solid H-frame base with two firm uprights at each side. The base should have four castors attached so the easel can be easily moved to any part of the studio. Between the uprights, a central post has adjustable height settings and can be tilted forward to prevent glare and backwards for certain paint manipulations. The shallow tray on which the painting rests and on which a small palette, painting materials or brushes may also be rested, can be moved up or down by a winding mechanism.

Sketching easels

Portable sketching easels are usually designed in a tripod system with extendible legs. They are generally made from beechwood or aluminum. The best of them allow a drawing board to be securely held horizontally so that watercolor painting may be made. Sketching easels tend to be extremely light, which is good for transportation but not so good when used outdoors in windy conditions. In such cases, the easel may be secured by suspending a weight – such as a rock or a large stone – from the apex of the tripod, or by tying the legs to pegs pushed firmly into the ground.

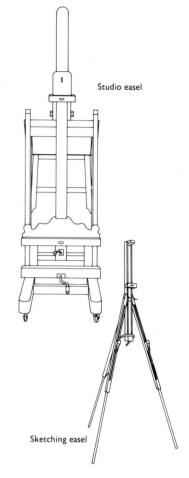

Studio easel

Sketching easel

·Painting and drawing aids·

FRAMING DEVICES

Many inventions have been designed to help the artist depict his or her subject accurately.

Cardboard viewer and finder

The simplest method of locating a subject within the rectangular frame of the canvas or paper is to cut a similar shape to that of the canvas out of the middle of a small piece of card or stiff paper. This is then held at an appropriate distance from one eye and a composition established. The proportions of the subject can be gauged along one edge of the viewer or "finder" and transferred to the edges of the painting. Such small devices are easy to make and have, in the past, been commercially available as "sight measures", with one moveable edge to establish the correct proportion of the canvas or paper before it is held up in front of the subject.

Portable grids

The portable grid, or "screen frame" is an open frame on which a grid latticework of thin black wire has been stretched. The frame is set up on a couple of strong vertical poles pushed into the ground. The artist works on a support which has the same proportions as the frame and with an identical grid of vertical, horizontal and (two) diagonal lines drawn on to it.

The subject is viewed through the frame and its features can be drawn into the corresponding areas on the grid on the drawing surface.

Tracing frame

In a variation of the apparatus described above, a pane of glass is set up in front of the subject. By keeping to the same, fixed, one-eye viewpoint, the artist is able to draw the image directly on to the glass screen. This should be done using a waxy or fatty material, such as all-purpose pencil, that will stick to the glass.

COPYING

Copying an image from an existing drawing or painting can be made much easier by using one of two simple techniques. If an image from a drawing needs to be transferred to a canvas of the same size, it can simply be traced. If the original drawing has a fragile surface (if it is in chalk or charcoal, for instance), a sheet of acetate can be placed over it before the tracing paper is laid on top.

Matt drafting film is dimensionally more stable than tracing paper, but more expensive. A harder pencil can be used on drafting film than on tracing paper, because it is so receptive to the graphite lead.

In order for it to appear the right way round, the image will have to be redrawn on the back of the tracing paper before being traced on to the canvas. If the original image is on thin paper, this can be avoided by using a lightbox (see right).

Using a grid

This is the method by which squared grids are drawn both on the original drawing or reference image and on the support on which the copy is to be made. The grids are identical, but one may be considerably larger or smaller if the size of the study needs to be increased or diminished. The artist refers to the grid on the original sketch or reference image and plots the outlines of the original, square by square, on the new support. To facilitate the drawing, the squares may be lettered down one edge and numbered along another in the same way on both the original and on the new support.

Tracing on a lightbox
One way of saving time is to place the original image face-down on a lightbox. This enables it to be traced in reverse, so it will be the correct way round when rubbed down.

DRAWING FROM PROJECTED IMAGES

There are various methods of projecting images which enable the artist to trace them directly on to the paper or canvas. The use of these is long established. Devices such as the camera obscura, the camera lucida and the graphic telescope were very popular with nineteenth-century artists, although they were often rather clumsy and difficult to use. Nowadays, electrical forms of projection, such as episcopes and slide projectors, are most commonly used.

Episcope or Epidiascope

This modern device is designed to allow flat artwork to be placed under a glass and projected up to any size, depending on the distance of the projector from the canvas (the instruments usually have fixed-focus lenses). Like the camera obscuras, which they resemble, they do not have very good illumination and have to be operated in a darkened room for the image to be seen at

all. In addition, even the best machines only allow a small original image to be seen at once, so that even a medium-sized drawing on A3 paper, for instance, would generally have to be projected a quarter at a time.

Slide projector

A solidly constructed slide projector of the type which is designed to be left running for a considerable time, is the most efficient and versatile device for projecting a transparency or an original study for a painting on to the canvas itself. The variable focal length zoom lenses which allow an image to be enlarged or reduced with the projector in the same spot are extremely useful. In a cramped space where a large image is required, a wide-angle lens may also be used. The projector will allow the image to be reasonably clearly seen in a shaded room without the necessity for blackout facilities. It should be kept on a solid base to avoid losing the correct position of the image. If the image moves, it is difficult to

return it to the right position. The canvas, too, should be rigidly supported. When drawing out an image in this way, the artist should stand to the right or left of the image so as not to obscure it.

Drawing from a projected image
A slide projector is useful for scaling up an image accurately. Here, a slide taken of the sketch featured on p. 77 was projected to cover the whole wall.

EXHIBITING WORK

However many times an artist's work is exhibited, the experience of seeing it properly presented, within the clear and ordered space of a gallery, is always exciting for the artist as it enables the limitations and strengths of the work to be seen with great clarity, perhaps for the first time. Most exhibitions are in galleries, but public art commissions provide new opportunities of getting work seen by a wide audience.

GALLERY EXHIBITIONS

It is a major achievement for a would-be professional painter to have a solo exhibition in a reputable gallery. Indeed, once an artist's work has been shown, further exhibitions become more likely. This is because the art world is relatively small and news of what is considered to be exciting new work travels rapidly around the circuit, so other galleries become keen to show the work too. Gallery directors each have their own methods of deciding which artists to show.

How work is chosen
Current enthusiasms in the art world play a large part in determining which painters are in demand. In addition, gallery directors are often guided by the recommendations of colleagues and other artists, or – much more rarely – they will decide to exhibit on the basis of a set of slides sent to them unsolicited by an artist. Galleries do occasionally get in touch with artists and request a set of slides, so it is vital that a good photographic record of all work is kept (see p.324). Then, if they are interested, they will probably suggest a studio visit. If this is successful, an exhibition may be forthcoming.

One method of getting work seen is to submit examples to the more important national open submission exhibitions. Although, statistically, there is only a small chance of being selected, good-quality work will always stand out. Such shows are seen by large audiences, they are reviewed and they often go on tour, so an application is well worth considering.

Types of gallery
Some artists become attached to small commercial galleries who act as their agents. Such galleries may take a large proportion of the sale price of a work in commission, but they manage all aspects of the business side, including transportation, framing and storage of artworks, publicity and exhibition costs, negotiations with prospective clients, invoicing and accounts. They are professional dealers who understand the market, who know the collectors, and for whom the promotion of an artist's work is also in their own financial interest. Such an arrangement is ideal for many artists, enabling them to concentrate on their work without external pressures, but others prefer to have more control over their business.

Showing in museums or other state– or regional arts association-funded galleries is a different matter. The gallery may take a (considerably lower) percentage of the sale price and will generally take care of transportation, insurance and publicity. It has responsibility towards the exhibition, and may organize a tour of other galleries, but the contract between artist and gallery ends with the return of the work.

Planning the exhibition
If the exhibition is a group show, the hanging of individual pieces of work will generally be left to the selectors or organizers. For a one-person show, the artist usually decides on the distribution of the paintings within the available space. One-person exhibitions are generally planned well in advance – at least a year and often considerably longer – so that the artist has a chance to get to know the space and decide on which works to include and where to put them. In many cases, the artist will create a work or a series of works exclusively for a particular gallery.

In both cases it is customary for the artist to be given a ground plan of the gallery, drawn to scale. There may also be sets of elevations of the gallery walls. Such plans enable the artist to mark out existing or projected work to scale within the space. This can be particularly useful in giving an idea of the likely appearance of the show and of how the works will be perceived. Hence, the nature of the pictures is often determined, to some extent at least, by the features of the gallery in which they will be displayed. Some artists go to the trouble of making a small-scale model of the gallery into which miniature versions of their artworks, also to scale, can be tried out. This demonstrates the importance that artists attach to the influence of a particular space on their work.

·Public art commissions·

The developing interest in the sponsorship of artworks in public places means there are now many new opportunities for artists to present their work to the public in ways other than via the gallery circuit. A number of development bodies have been set up to liaise between industrial or municipal clients and artists and to organize schemes for the location of art in public places. Potential locations for such works include schools and colleges, hospitals and community centers.

THE COMMISSIONING PROCESS

Potential public art sponsors include local community groups, local government agencies and large industrial companies. The sponsors will have identified a possible site – they may be the developers themselves. An independent selection committee is then generally appointed, comprising professional art advisers and representatives from interested bodies associated with the site and the surrounding area.

How the works are chosen
Artists are commissioned in one of two ways:
■ by direct selection – this may involve looking at slides of artists' works or inviting selected artists to introduce their work to the panel.
■ as the result of some kind of competition; this may be open or limited to a small number of pre-selected artists.

If a limited competition is organized, the selected artists are paid to produce proposals for the site in question and a final choice is made from these. This may involve some kind of local community ballot. An outline budget will normally have been drawn up before the selection process and this may have to be modified according to the nature of the proposals.

Throughout the commissioning process, the sponsors will usually co-ordinate a fund-raising and information campaign to keep the community involved. This may include radio and television coverage, as well as articles and pictures in the local newspapers.

PRESENTING IDEAS

The differences between being accepted for a public art commission and being a runner-up are not only enormous in financial terms, but mean that the artist cannot actually realize the work. This is particularly frustrating, especially at a stage where all aspects of the actual fabrication of the work will have been researched and planned. It therefore follows that the presentation of the preliminary sketch or model (the "maquette") is of crucial importance.

It goes without saying that the quality of the artwork itself is the first priority, but the way it is presented to a selection committee will undoubtedly affect its choice. For a three-dimensional work, a clear, well-made model of the site, however diagrammatic, will enable the work to be seen to scale within its proposed setting. See box (below) and *Presenting Ideas*, p.324.

THE TERMS OF THE COMMISSION

A written contract with the artist establishes the amount of the commission, identifies the responsibilities for all aspects of the work, including maintenance, and establishes the time of payments. Some artists like to work for a fee, keeping all other costs – such as materials, fabrication, transportation, installation and personal expenses – entirely separate. This makes a great deal of sense, especially on a large project where costs may escalate.

The payment of the fee is generally in stages, such as a third of the total for the preliminary presentation, a third on go-ahead and a further third on completion. Alternatively, payment for a maquette stage may be entirely separate from the fee for the whole work and, where a major work is undertaken, there may well be more payment stages spread over a period of time.

PROPOSAL FOR A LOW-RELIEF SCULPTURE
Even a relief work or a mural painting is best presented within a model of the part of the building where it is to be placed. In the case of relief works, the model should be three-dimensional. Such submissions should be accompanied by a description of the exact materials and colors to be used, its dimensions, the ideas behind its design and precise information as to how it should be mounted. A thorough approach such as this demonstrates a degree of professionalism to which the selection committee may respond.

Scale model of the proposal
For my proposal for a low-relief sculpture to be mounted on the wall of a community center, a fully detailed portable model was made.

PREPARING MATERIALS

For some artists there seems little point in preparing one's own art materials when there is such a wide commercial choice. But it is extremely straightforward to prepare your own oil paints (see p.184), pastels, gouache and encaustic paints, mediums for tempera painting and other basic materials. You can use completely reliable ingredients and can thus ensure a high standard of product. In addition, it is far less expensive to buy the raw materials than to buy ready-made products and, in general, no special equipment is required for home manufacture. It is not particularly time-consuming and there is a positive pleasure to be had from working with materials you have prepared yourself.

PASTELS

To make home-made pastel colors, you need:
- a binding solution
- pigment powder
- precipitated chalk
- a preservative (if necessary)

The traditional binding material is gum tragacanth which is mixed with cold water in a weak solution. Mayer recommends 30gms (1oz) of gum tragacanth to 1500ml (50fl. oz) of water for the strongest solution with additional amounts of water for weaker solutions. Different pigments require binding solutions of slightly different strengths for pastels to feel consistent through a range of colors. This is due to the varying absorption of the binding medium by different pigments. Gum tragacanth is rather expensive nowadays and an excellent alternative binding material is refined sodium carboxymethylcellulose (see p.64). I use a relatively low-viscosity grade in an approximately eight per cent solution with cold water. Since CMC solution is more resistant to microbiological attack than most other water-soluble gums, it is not absolutely necessary to add a preservative if the pastels are going to be used relatively quickly.

In order to make a wide range of colors of different tones, it is necessary to mix the pigment powder with precipitated chalk in varying proportions – a pale color has a lot of chalk and a little pigment. Pastelists who work to strict tonal values establish the precise tone of a color by working to controlled methods of halving and quartering known amounts of ingredients before mixing. Others prefer to achieve the right tone by eye. The chalk and pigment powder can be separately bound and then mixed (the strict method) or dry mixed on a glass slab before adding binding medium. For a light-toned pastel, always add the colored pigment powder to the chalk and in small amounts at a time.

Method

1 Mix precipitated chalk with the binding solution to a uniform stiff but malleable consistency. This can be done with a spatula on a glass slab.
2 Do the same with the powdered pigment.
3 Mix the correct proportions of chalk mix and pigment mix to obtain a color of the required tone. Alternatively, the chalk and pigment can be combined in dry powder form and then mixed with the binding medium.
4 Flatten out the mixture a little on the glass slab and cut a small section with the spatula or a palette knife. Mould this into a rough cylinder with the fingers.
5 Place the roughly cylindrical shape on to a sheet of newsprint or similar paper and roll gently using the inside length of the index finger with the pastel parallel to it. Let this dry in a warm atmosphere. It is ready to use when completely dry.

GRINDING PIGMENTS

The best and most economical equipment for pigment grinding is a ground glass slab and a glass muller with a ground base, although mullers and slabs made from hard stone such as porphyry or marble are often used. The abrasive "tooth" of ground glass wears smooth after a certain amount of grinding (depending on the nature and amount of pigments ground, but generally after 20–30 grinding operations). When this happens, resurface the glass by wet-grinding an abrasive powder over the surface. Wash this off before recommencing pigment grinding.

There is an art to using a muller, which you can quickly learn by experience. The key is to achieve a continuous, smooth, circular action which soon brings the paste to the creamy consistency that characterizes a well-dispersed pigment. As you grind, pigment builds up around the sides of the muller and round the edge of the grinding area. Take this up with a spatula and replace it in the middle of the slab.

GOUACHE PAINTS

To make your own gouache paints, you need:
■ pigment powder
■ binder – 30 per cent gum arabic solution. A number of gouache manufacturers use dextrin instead of gum arabic as a binder. This is an acceptable alternative, but more dextrin will be required than gum to make a paint of similar consistency.
■ precipitated chalk – to determine the strength of color and the opacity
■ glycerine – around five per cent by weight of the total weight of the formulation – to act as a plasticizer and humectant
■ a drop or two of preservative (any of those recommended in the materials section)
■ a drop or two of a wetting agent (oxgall or any of the synthetic wetting agents recommended in the materials

section). This is only required if the quality of the wash produced by the paint needs to be improved.

There is no rigid formula for the ratio of binder to pigment or pigment to precipitated chalk. The former depends on the gum absorption of the pigment, which varies in each case. You should add only enough binder to allow the paint to flow; if too much is added, the paint will be transparent. Distilled water can be used to thin the mixture. The amount of precipitated chalk will depend on the color strength of the pigment, so that a great deal more chalk generally needs to be added to a phthalocyanine pigment, which has a high tinting strength, than a cadmium yellow, for instance. The best artists' materials manufacturers obtain opacity by very high pigment loading – for which special dispersing equipment is required – rather than by incorporating

precipitated chalk, but a home-made product will perform well with chalk incorporated, provided the latter is of good quality. Precipitated chalks vary greatly from relatively transparent to opaque. For gouache paints, a clean, bright white chalk with good opacity is required.

Method
1 Grind the pigment powder with the gum arabic solution (see *Grinding Pigments*, opposite). If necessary, add distilled water to facilitate grinding.
2 Add sufficient precipitated chalk to give the required strength of color. Mix and grind well.
3 Add the glycerine and mix well. Then, add a few drops of wetting agent if necessary, followed by a few drops of preservative.
4 Store the paint in a screw-top tube or jar ready for use.

TEMPERA EMULSIONS

A number of recipes are given here. The basic recipe, generally speaking, is:

1 part egg
1 part oil
2 parts water

If resin is also introduced into the mix, it generally takes half the oil's share:

2 parts egg
1 part oil
1 part resin
4 parts water

The keen tempera painter may wish to experiment on this basic formula. Linseed oil provides the oily ingredient, the heavy-bodied stand oil being favoured for its non-yellowing properties, with damar varnish generally used as the resinous component.

The following are variations on the basic egg/oil mixture. Recipes 1–7 are water soluble and 8–9 are soluble in turpentine.

Recipe 1 (Tudor Hart)
1 part yolk of egg
1 part sun-bleached linseed oil
2 parts water
10 drops spike-lavender oil (per egg yolk used)

Recipe 2 (Ralph Mayer)
2 parts whole egg
1 part stand linseed oil
1 part damar resin varnish
4 parts water

Recipe 3 (Ralph Mayer)
6 parts yolk of egg
2 parts stand linseed oil
2 parts damar resin varnish
1 part water

Recipe 4 (Kurt Wehlte)
2 parts yolk of egg
1 part boiled linseed oil
1 part damar resin varnish
2–4 parts water

Recipe 5 (Arthur Laurie)
2 parts whole egg
1 part stand linseed oil
3 parts water

Recipe 6 (Arthur Laurie)
2 parts yolk of egg
1 part linseed oil
3 parts water

Recipe 7 (Maria Bazzi)
2 parts yolk of egg
1 part stand linseed oil
1 part damar resin varnish
4 parts water

Recipe 8 (Arthur Laurie)
1 part yolk of egg
1 part stand linseed oil
a little turpentine

Recipe 9 (Arthur Laurie)
1 part yolk of egg
1 part linseed oil
1 part Venice turpentine

In a comparison between emulsions made to the basic formula with and without resin, the former appeared to have more satisfactory working qualities. In addition, the emulsion stayed fresh for considerably longer than the one with just egg, stand oil and

water, though no preservatives were added. This may have been due to some residual alcohol in the damar varnish.

It should be said that the individual brush stroke in an egg/oil/resin tempera is not "taken up" by the gesso panel in quite the same smooth way as a straight egg yolk one. It can have a tendency to sit on the surface — a reason for its being used in impasto effects.

Method

The standard method is to first mix the aqueous ingredients — the egg and the water — and to add the oil or oil and resin mix drop by drop with continuous agitation. In my view, as with making mayonnaise, an electric blender provides the most reliable method of emulsification, with the egg and the water being beaten while a thin stream of oil is poured in. This works best when stand oil and damar varnish have been mixed together beforehand to give a thick stream of oil. Stand oil on its own is too thick to pour easily into a blender or mixer and, although the blobs of oil which fall into the mix tend to become well dispersed into an acceptable emulsion, it may be easier — especially for small amounts — to emulsify the egg and oil with a muller on a slab. This technique is the only possible one where very viscous emulsions are to be made.

Gum tempera

Gum arabic solution can be purchased ready-mixed or made up in the ratio 60gms (2oz) powdered gum per 150ml (5fl.oz) hot water.

Recipe 1 (Ralph Mayer)
5 parts gum arabic solution
1 part stand oil
1 part damar varnish
¾ part glycerine (optional)

Recipe 2 (Kurt Wehlte)
3–4 parts gum arabic solution
1 part boiled linseed oil

Recipe 3 (Gum/egg yolk tempera) (Fontanesi)
1 part gum arabic solution
1 part yolk of egg

Casein tempera

Casein tempera is quick-drying and completely insoluble when dry. Dry casein is added to water and left to stand, as descibed in *Casein glues* (see right).

Recipe 1 (Kurt Wehlte)
300ml (10fl.oz) hydrolized casein
30ml (1fl.oz) boiled linseed oil
30ml (1fl.oz) Venice turpentine
a few drops of cobalt drier

Mix the oily ingredients before "mayonnaising" into the water-based part (see left). Add the drier last.

Recipe 2 (Ralph Mayer)
45gms (1.5oz) casein or ammonium caseinate
300ml (10fl.oz) water
¼ teaspoon sodium orthophenyl phenate (preservative)
45ml (1.5fl.oz) damar varnish (prepared in the ratio 300gms (10oz) resin to 300ml (10fl.oz) turpentine)

Stir the casein into the water, and add the sodium orthophenyl phenate. Pour in the damar varnish and emulsify the mixture by stirring or with an electric mixer. A little glycerine can be added to improve brushing.

Recipe 3 (Ralph Mayer)
Saponified beeswax can also be mixed with casein solution and most water-based binders, to produce impasto effects.

30gms (1oz) white beeswax
150ml (5fl.oz) water
15gms (0.5oz) ammonium carbonate
 (or)
1 teaspoon ammonia water

Boil the beeswax in the water. Mix the ammonium carbonate with a little water and, when the wax has melted, pour it (or the ammonia water) into the wax solution. Continue heating until the ammonia gas is driven off and allow the mixture to cool; re-warm prior to use.

OPAQUE OIL WHITES

These are used as fast-drying, crisp whites in tempera and oil painting.

Recipe 1 (George Warner Allen)
1 part stand oil
1 part turpentine
2 parts yolk of egg
2 parts water

Grind these ingredients with Flake White oil color (see *Grinding pigments*, p.334) which is first placed on blotting paper to absorb most of the oil. This is a very quick-drying mix.

Recipe 2 (Arthur Laurie)
1 part yolk of egg
1 part stand oil

Add a little turpentine to the above ingredients and grind white lead into the mixture. I have found this recipe to be rather more slow-drying.

Recipe 3 (Ralph Mayer)
1 Grind Flake White or better, Titanium White, with whole egg until the mixture is the same consistency as tube Flake White color.
2 Mix with an equal proportion of tube Flake White or a mixture of three parts tube white to one part egg white.

CASEIN GLUES

The following proportions will give water-soluble glues of a similar consistency:

Recipe 1
100 parts casein
300 parts water
8 parts sodium hydroxide (NaOH)

Recipe 2
100 parts casein
300 parts water
4 parts sodium hydroxide

Recipe 3
100 parts casein
600 parts water
13 parts sodium hydroxide

Add the water to the casein and allow it to stand for five to ten minutes. Some commentators say that the casein should be left in the water for several hours before the alkali is added. Add the alkali (NaOH) slowly while stirring the mixture.

Recipe 4 (Wehlte)
To reduce the risk of residual alkali, Wehlte suggests using a wet-mix borax casein:

15gms (0.5oz) crystalline borax
150ml (5fl.oz) hot water
45gms (1.5oz) powdered lactic acid casein
150ml (5fl.oz) cold water

Add the powdered lactic acid casein to the cold water, cover with a thick wet cloth and leave it to stand for twelve hours. Dissolve the borax in the hot water and add to the casein mixture. Leave for a few hours before use.

If the medium is not going to be used immediately, add a couple of drops of disinfectant to the mixture while hot. Casein is very prone to decomposition and preservatives such as sodium orthophenyl phenate or para chloro meta xylenol may be used to prevent this.

Water-resistant glues
The calcium caseinates are particularly useful for their water resistance. Formerly, this was achieved by the addition of formaldehyde, either sprayed in dilute form on to the finished coating or mixed very slowly in with the binder in the ratio of 50ml (2fl.oz) of formalin per 250ml (10fl.oz) water per 500gms (1lb) of casein.

The addition of calcium hydroxide to the sodium hydroxide glue in the following proportions is now more commonly used to enhance water resistance:

10 parts casein
25 parts water
1 part sodium hydroxide (NaOH)
2 parts calcium hydroxide (CaOH₂)

STARCH PASTE

A simple binding medium made from starch and water is very quick to prepare. The following recipe is the one recommended by Arthur Church.

45gms (1.5oz) powdered starch (from rice, wheat, corn, potatoes or arrowroot)
360ml (12fl.oz) distilled water

Mix the powdered starch vigorously with a little cold water to a creamy consistency and pour this into the boiling distilled water (you can vary the quantity of water to get the desired consistency).

On aging, aqueous solutions undergo a process called retrogradation by which the starch becomes less soluble. This can be reduced or prevented by modifications such as dextrinization (see p.40). The process is accelerated at lower temperature and increased concentrations. The presence of calcium sulfate in a formulation can accelerate the precipitation but wetting agents such as anionic aryl-alkyl sulfonate types inhibit the process. The effect in a paint film is to reduce gloss and impart a chalky appearance.

SCRAPERBOARD GROUND

Kurt Wehlte's recipe makes a white ground to which the black ink which is used in scraperboard readily adheres.

5 parts dry glue size
100 parts water
a little alum
Blanc Fixe pigment
a little glycerine

Mix the glue size, water and alum, and add the blanc fixe and glycerine. Mix to a brushable consistency and apply in four coats to ensure an opaque ground. Allow each coat to dry thoroughly and smooth on the final layer with a spatula. When this is completely dry, coat it with black ink.

A NOTE ON THE USE OF TURPENTINE AND MINERAL SPIRIT IN OIL PAINTING
Turpentine and mineral spirit can be used as diluents for drying oils and may also be used as an ingredient of oil painting mediums. Both substances have merits and drawbacks. If turpentine is allowed to oxidize, a non-volatile residue forms. This residue yellows considerably. The use of partially oxidized turpentine can ruin a painting, leaving it sticky and non-drying. Turpentine should therefore be carefully stored away from heat, light and air. Artists' materials manufacturers supply a redistilled turpentine which should reduce this problem to a minimum. There is some evidence that certain resins retain turpentine for a long time, i.e. it does not evaporate immediately. Any such turpentine trapped in the film could oxidize and cause yellowing. This is another reason for avoiding the use of resins in painting mediums and for using turpentine merely as a diluent for the drying oil. Mineral spirit can be used as a substitute in some cases but is not as good a solvent. It may also cause turbidity in some varnishes.

Toxicity
Turpentine is generally more toxic than mineral spirit though different grades of each vary in composition and aromatic content (the harmful component). The toxicity of volatile solvents is gauged by its threshold limit value (TLV). This is a measurement of the maximum strength of the solvent vapors which can be safely tolerated over an eight-hour working period. The TLV of turpentine and mineral spirit is the same. The effects of turpentine may be worse but, under certain conditions – such as a poorly ventilated environment – both could be fatal. Painters who are concerned about their level of exposure to organic solvent vapor should wear an appropriate respirator (see p.42).

GLOSSARY

Absorption (light) All substances absorb incident light at different wavelengths. Their color depends on the wavelengths reflected.

Acid A substance which liberates positive ions characteristic of the solvent. In aqueous solution this would be the hydrogen ion H^+.

Acrylic Synthetic resin commonly used in an emulsion for preparing acrylic colors or in a solvent-based system for varnishes and in restoration.

Additive mixture The superimposition of colored lights to produce a third (lighter) color. The mixture of orange-red and blue-violet light will produce magenta. This is the principle of the color television screen.

Adsorption A molecular or electrostatic attraction between the surface of two molecules.

Aerial perspective Deals with the effect of the atmosphere on objects, lightening them in tone and cooling them in color as they recede towards the horizon.

Aggregate Groups of pigment particles held together by attractive forces.

Airbrush A miniature spray gun in pen-like form for use in small-scale painting or for fine detail work.

Aliphatic Organic compounds that do not contain a benzene ring structure.

Alkali An aqueous base, see *base*.

Alla prima painting Also known as "direct painting", this is a one-layer painting technique in which the painting – usually painted from life – is completed in one sitting or while the paint remains wet.

Alum Generic term for a group of double salts typified by potash alum $K_2SO_4.Al(SO_4)_3.24H_2O$

Amorphous Non-crystalline.

Anhydrous Without water of crystallization.

Anisotropic Substances, like most crystals, for instance, whose optical properties in particular differ according to their orientation.

Aqueous Water-based.

Aromatic Organic compounds containing a benzene ring structure.

Arriccio In *buon fresco*, the second coat of plaster on which the preliminary outline drawing is made.

Autoxidation Slow oxidation by oxygen in the atmosphere. Of cellulosic material such as paper, autoxidation is the degradation brought about by long-term exposure to light and air. It describes the initial stages in the drying process of vegetable oils.

Backboard A sheet of wood or plastic to protect the back of a (framed) painting or drawing.

Base (i) A substance which liberates negative ions – characteristic of the solvent. In aqueous solutions this would be the hydroxyl ion OH^-.
(ii) An inert pigment on which a lake is formed.

Binder The substance that holds the pigment particles together in a paint formulation and which attaches them to the support, e.g. linseed oil, egg yolk, acrylic resin emulsion.

Bistre Rarely-used impermanent yellow/brown pigment made from the soot of beechwood. The term is commonly used to designate the color of a crayon made from more permanent pigments.

Bitumen (or Asphaltum) A tarry compound soluble in oil or mineral spirit. It is no longer used as a painting pigment but continues to be widely used in the processing of lithographic stones or plates.

Blanching The whitening of an emulsion film after drying due to the absorption of moisture. Also the discoloration of a dried paint film or varnish after a solvent is applied.

Bleeding Migration of a dye or pigment dyestuff through a superimposed paint layer in which it is slightly soluble.

Blending The physical fusion of adjacent colors on a painting to give a smooth, often tonally graded transition between areas of color.

Bloom Cloudiness in a varnish which takes place after it is apparently dry – usually due to atmospheric contamination.

Blue Wool Scale An internationally recognized measure of lightfastness, expressed upwards from 1–8. Each successive figure represents double the lightfastness of the last.

Blush Clouding of a varnish during drying due to the condensation of atmospheric moisture which may precipitate components of the varnish.

Body color (i) Opaque watercolor paint (i.e., gouache). The opacity may arise from mixing white with a colored pigment.
(ii) More generally, any painting technique which uses opaque rather than transparent color.

Boiling point The temperature at which a liquid boils (i.e. its vapor pressure equals that of the atmospheric pressure). This is a unique point for many substances and can thus characterize them. Mixtures, such as mineral.spirit, have a boiling range, not a specific boiling point.

Broken color Color that has been dulled by mixing with another color or affected optically by the juxtaposition or superimposition of another color.

Buon Fresco A technique of permanent wall painting involving the application of pigment to the still wet surface of a thin layer of lime plaster (the *intonaco*). The pigment is absorbed by the plaster and bonds with it as it hardens.

Burin Tool (also known as a "graver") used for metal and wood engraving, the cutting point being the apex of a long thin inverted triangle of tempered steel.

Burnisher Tool used for smoothing the surface of a metal plate or for taking hand prints from a block.

Burr The spiral of metal thrown up by the burin.

Calligraphy The fine art of lettering with a pen or brush.

Carbohydrate Naturally occurring organic chemicals containing carbon, hydrogen and oxygen (e.g. sugar, cellulose, starch).

Casein A glue or binding medium prepared from skimmed milk.

Cellulose Basic structural constituent of plant material, found almost pure in fibers such as cotton.

Chalking Powdering of the paint surface due to breakdown of the binder usually caused by ultra-violet radiation.

Charcoal Drawing material made by charring twigs of willow or vine.

Chemical compound Substance containing two or more elements (e.g. sodium chloride NaCl).

Chemical element Chemical which cannot be divided into a simpler chemical (e.g. sodium, chlorine).

Chiaroscuro Technique used in painting to explore the often dramatic tonal contrasts between light and shade.
A chiaroscuro woodcut is a technique in which a number of blocks are made for a single print to imitate the effect of overlaid tonal washes in a drawing.

Chroma The degree of saturation or intensity in a color.

Chromatic pigments Colored, as opposed to white, gray or black (achromatic) pigments.

Chromophore A group of atoms within a molecule which gives it its characteristic color (e.g. azo group $N=N$).

Cissing The break-up of a wet film on a surface due to poor wetting or lack of adhesion.

Cockling The deformation of a sheet of paper when wetted.

Collage Artwork created by assembling, juxtaposing or overlaying diverse materials which are usually glued to the support.

Colloid Dispersion of minute particles of one substance (the inner phase) in another (the outer phase).

Color temperature The measurement of color in degrees Kelvin emitted from a light source. Tungsten light with a color temperature of around 2700 degrees K appears yellower than daylight with a color temperature of around 6500 degrees K.

Complementary color The color which gives black or gray when mixed with another color. The complementary of a primary color, for instance, is the combination of the two remaining primary colors. Thus, in subtractive color mixing, the complementary of blue (cyan) is orange-red – a mixture of red (magenta) and yellow. Every color has its complementary or opposite color, i.e. the color of greatest contrast. It can also be said to complete or balance its partner.

Condensation (i) Deposition of moisture from the atmosphere. (ii) A reaction between two chemicals which involves the elimination or removal of a third, often water.

Consistency A subjective term describing the "feel" or "texture" of a color.

Conté crayon Proprietary drawing stick of varying hardness in a traditional range of black, white and red colors.

Continuous tone In photographic film, an image which shows a complete range of tones without having had to be converted into dots or lines by a half-tone screen.

Covering power A measure of the amount of color or medium needed to cover a given area.

C.P. (chemically pure) Term used to describe a pure pigment such as Cadmium Sulfide (CdS) to distinguish it from an extended one such as Cadmium Lithopone (CdS BaSO$_4$).

Cross-hatching A drawing and painting technique in which tonal effects are built up by the superimposition at various angles of rows of thin parallel lines.

Cross-linking Molecules linked in a network structure to form a polymer.

Cutting Dissolving a resin in solvent.

Deckle The irregular edge of a sheet of hand-made paper.

Dextrin Substance obtained by heating dry starch. A cheap alternative to gum arabic, sometimes used as a binder in watercolors.

Dichroism The phenomenon of a colored pigmented film appearing differently colored when viewed in different circumstances; e.g. the top tone of a color can appear to be quite different from its undertone.

Diffraction The scattering of light – usually by an aperture or the edge of a solid – producing a series of dark and light bands or a spectrum.

Diluent Liquid used to thin the consistency of a prepared color, e.g. mineral spirit for oil paint, water for watercolor and acrylic.

Dipper Shallow receptacle attached to a palette and normally containing a painting medium or diluent.

Direct painting (see *Alla prima* painting)

Disperse To produce a homogenous suspension of solid in liquid.

Double bond Joining of two atoms by sharing two pairs of electrons.

Drier A chemical substance, usually a metallic salt, which accelerates the drying process of a paint film by absorption of oxygen.

Dry-brush technique A method of painting in which paint of a dry or stiff consistency is stroked across the canvas. It is picked up on the ridges of the (rough) weave of the canvas or by the texture of paint on the surface, leaving some of the color already on the canvas still visible. This produces a broken color effect.

Efflorescence Crystalline deposit on the surface of paint produced by the migration of soluble compounds.

Empirical formula The simplest formula which represents the ratio of atoms present in a compound.

Emulsifying agent A surfactant which assists in stabilizing an emulsion by holding the particles in suspension by electrostatic forces.

Emulsion A stable mixture of normally non-miscible components such as oil and water. Egg yolk is a naturally occurring emulsion.

Enamel (i) Term to describe a high-gloss coating.
(ii) Colors that are painted or printed on to steel plates, ceramics or glass and subsequently fired.

Encaustic (i) A painting technique involving the application of pigments bound in hot wax.
(ii) In ceramics, a form of inlay tile decoration involving clays of different color.

Engraving A technique in print-making in which the lines or tones of an image are cut directly into the surface of a wooden (end-grain) block or metal plate.

Enzyme A protein which acts as a catalyst for a specific chemical reaction.

Epoxy resin Powerful synthetic resin used in the preparation of two-part adhesives and paints which set by chemical reaction rather than by evaporation of solvent.

Essential oils Partially volatile oily liquids which give plants their characteristic odor, e.g. oil of cloves, cedarwood oil, turpentine oil.

Ester The organic equivalent of a salt formed by replacing the hydrogen of an acid by an alkyl or aryl group, e.g. $CH_3COOC_2H_5$ ethyl acetate.

Esterification The formation of an ester.

Etching A method of printmaking in which the lines or tones of an image are drawn into a prepared ground on the surface of a metal plate and then bitten in acid before being printed.

Extender A pigment which has a limited effect on a color. It may be added to control the properties of a paint or to reduce the cost. Examples are chalk and China clay.

Fat Containing a large amount of oil.

Fat-over-lean The rule that applies to oil painting in layers. Each superimposed layer of paint should have a little more oil in the medium than the one beneath. This enables the superimposed layers to be slightly more flexible and ensures a greater degree of permanence for the dried oil film with less risk of cracking or flaking.

Ferrule The metal tube from which the hairs of a brush protrude.

Filler (see *extender*)

Film Layer of surface coating or paint.

Firing Baking of clay, glass etc. in a kiln.

Fixative A surface coating which prevents the dusting of pastel, chalk etc.

Flash point Temperature at which the vapor above a liquid will ignite if a source of ignition is applied.

Flocculation The aggregation of pigment particles in suspension.

Fluorescence Light re-emitted while an object is exposed to radiation (especially ultra-violet radiation).

Flux A substance incorporated with the raw materials of glass, clay bodies and glazes to facilitate fusion.

Formalin An aqueous solution of formaldehyde.

Fresco secco Painting on a thoroughly wetted but previously dried lime-plaster wall with pigments mixed in lime water or bound in casein or egg.

Frits Mixtures of lead or other metal compounds with silica and other materials which have been melted at high temperatures, cooled in water and ground to provide a basic component of glazes for use in ceramics and vitreous enameling.

Frottage Taking an impression of an image in relief by rubbing with a (wax) crayon on to thin paper laid over the relief work.

Fugitive (pigment) Impermanent, of poor lightfastness.

Fungicide Chemical which prevents mould growth.

Gel A viscous colloidal solution.

Gesso Painting ground for rigid supports, commonly made from chalk and glue size.

Glaze Film of transparent color laid over a dried underpainting. Glossy, impermeable surface coating for fired clay.

Glyceride An ester of glycerol.

Gouache Opaque watercolor (body color).

Grain The texture of canvas (e.g. fine grain), or of wood.

Granulation Granular effects of paint on the support which may be caused by flocculation or by differences of specific gravity in pigment mixtures.

Grisaille Monochromatic painting in various tones of gray. A finished work can be executed in grisaille or the technique may be used as the underpainting before the subsequent addition of local color and depth by means of opaque, semi-opaque or transparent colors.

Ground The surface on which color is applied. This is usually the coating rather than the support.

Gum Water-soluble secretion from certain trees, e.g. acacia.

Half-tone In printing, a method of giving the appearance of lighter and darker tones when painting in a single tone (e.g. black) by converting the original image into a series of small dots or lines.

Hatching Method of tonal shading using criss-cross lines.

Hiding power The ability of a coating to obliterate the underpainting – a measure of opacity.

Highlight The lightest tone in a painting (usually white).

HP (hot pressed) Artists' quality paper with a smooth surface.

Hue (i) Spectral color.
(ii) Often used by artists' materials manufacturers to indicate the use of a substitute pigment (e.g. Cadmium Yellow Hue).

Humectant Hygroscopic additive (e.g. glycerine) to watercolor paints, to keep them moist.

Hydrocarbons Compounds of hydrogen and carbon.

Hydrolysis A chemical reaction involving decomposition by the addition of water, usually in the presence of an acid or base. Oils are split by hydrolysis into glycerol and fatty acids.

Hydrophilic Having an affinity for water.

Hydrophobic Having an aversion to water.

Hygroscopic Absorbing moisture from the air.

Impasto Painting technique with thick paint – often applied with a painting knife or bristle brush – in which paint is heaped up in ridges to create a heavily textured surface.

Imprimatura A very thin transparent stain (or "veil") of color laid over the white ground before the painting itself is begun. The reflective qualities of the ground are hardly affected but it provides a useful background color and makes it easier to move between the lights and darks when painting.

Inert pigment (see *extender*)

Infra-red Thermal radiation beyond the red end of the visible spectrum.

Inorganic Chemical not derived from living matter (i.e. non-organic).

Intaglio A method of printing in which ink is held in grooves or channels which are engraved or etched into the surface of the plate from which the print is made.

Intensity Strength of color.

Interface The boundary between two surfaces.

Interfacial tension A more accurate term for surface tension, since the interface between a gas and a liquid is involved.

Internal sizing Method of reducing the absorbency of paper by sizing at the pulp stage rather than "surface sizing" after the paper has been formed.

Intimate mixture A completely homogenous mixture, as in a thoroughly wetted and dispersed mixture of pigments, for instance.

Intonaco In *buon fresco* painting, the smooth final layer of wet plaster on to which the painting is made.

Iodine value A measure of the saturation of an oil.

Ion A charged atom produced by dissociation in solution (e.g. H^+, OH^-).

Ionization Dissociation into ions, usually in gases.

Isotropic Having the same properties in all directions – liquids are isotropic.

Key A painting is said to be "high key" when the colors and tones are bright and "low key" when they are dark or sombre.
Also used to describe a surface to which paint will adhere readily.

Laid Type of paper made by lifting pulp against a characteristic horizontal and vertical mesh of "laid" lines and "chain" lines.

Lake A pigment formed by the precipitation of a dye on to a white base.

Laminated Layered structure (e.g. plywood).

Levigate To grind into a powder with water. Separation of pigment by particle size, usually by sedimentation in water.

Lightfastness The performance of a pigment when exposed to light.

Lignin A complex aromatic substance obtained from wood. Its acidic components make it largely responsible for the yellowing in cheap grade wood-pulp paper.

Lithography A "planographic" form of printing which relies on the mutual antipathy of water and grease to form an image.

Local color The actual color of a subject as seen in even, diffused light, although it may look quite different in different lights.

Loomstate canvas Canvas which has had no "finishing" treatment.

Mahlstick A long stick with a soft pad at the end, used to steady the painting hand and hold it off the (wet) surface of a painting.

Maquette Preliminary model (of sculpture etc.).

Marouflage A method of attaching a painted canvas to a wall or other rigid support. Modern methods make use of synthetic resin adhesives. Rubber rollers are used to ensure even contact with the support and to remove air bubbles.

Masking (or "masking out") The protection of areas of the support from the applied paint. A common method with watercolor and acrylic paints is to use a rubber masking solution. Other methods involve using paper stencils and masking tape.

Medium An additive used to control the application properties of a color. Also the vehicle in which the pigment is dispersed.

Melting point Temperature at which a solid melts and becomes liquid. Chemicals have characteristic melting points.

Metamerism The phenomenon in which two color matches may appear to differ under changed illumination. This is due to the different composition of each color.

Micelle Aggregation of molecules in a colloidal solution.

Micron Unit of measurement used to gauge size of pigment particles (one micron = one-thousandth of a millimeter).

Micro-organism Microscopic living matter, e.g., bacteria, mould.

Mildew Fungal growth due to damp conditions.

Mineral Naturally occurring inorganic compound.

Mineral acid Inorganic acid such as hydrochloric acid.

Miscibility Measure of mixing capability.

Modeling In painting technique, indicating the three-dimensional shape of an object by the appropriate distribution of different tones.

Molecule The smallest entity into which a compound can be divided without losing its chemical identity.

Molecular weight Mass of one molecule of a substance relative to that of carbon 12.

Monochromatic underpainting Preliminary painting in tones of one color. This may subsequently be overpainted in color using glazes, semi-opaque or opaque painting techniques.

Monochrome painting (see *grisaille*)

Monomer Single chemical compound, the unit of a polymer.

Montage Sticking additional material on to a painting or photograph to create juxtaposition effects.

Mould Fungal growth.

Mould-made paper Artists' quality paper made on a cylinder mould machine.

Niello An early form of engraving in which incised lines in silver and gold were filled with a black compound to show the design.

Not (not hot pressed/cold pressed) Artists' paper with intermediate texture between smooth (hot pressed/HP) and rough.

Oil paint Paint prepared by grinding pigment powder with a drying oil.

Oleoresin (or balsam) Mixture of essential oil and resin exuded from coniferous trees.

Opaque painting The opposite of transparent painting. Here, lighter tones are not produced by thinning the paint, but by white.

Optical mixing The perception as a single color of two or more different colors in juxtaposition.

Organic Relating to living compounds.

Organic acid An acidic material of organic origin, e.g. acetic acid CH_3COOH

Oxidation Addition of oxygen.

Palette (i) Portable surface for mixing colors.
(ii) The range of colors an artist chooses to work with.

Particle size The diameter of a pigment particle, usually described as a particle size distribution since pigments are of variable diameter.

Paste A viscous material intermediate between solid and liquid – usually a solid dispersed in liquid.

Pastel Weakly-bound pigment in stick form.

Perspective Prescribed method of representing the three-dimensional world on the two-dimensional surface of the support.

pH A measure of acidity related to the hydrogen ion concentration in aqueous solution.
pH 8–14 alkaline
pH 7 neutral
pH 1–6 acidic

Pigment Solid colored material in the form of small discrete particles.

Plasticizer An additive which imparts flexibility to a binder.

Polymer A chemical produced by combination of monomer units.

Polymerization A reaction by which a polymer is formed.

Porosity The degree of absorbency of a substance.

Precipitate A solid produced from solution by chemical reaction.

Precipitated chalk High-grade artificially-made chalk.

Preservative Substance added to painting materials to inhibit microbiological growth.

Primary color Light: red-orange, blue-violet and green.
Pigments: red (magenta), blue (cyan) and yellow.

Primer Substance which provides a suitable prepared surface for painting in terms of adhesion and color and

isolates the paint film from the support. Usually white pigment and extender in a binding medium. This may be applied directly to a support (acrylic painting) or over a layer of glue size (oil painting).

Protein A basic component of living matter whose structure is based on a polymer of amino acids.

Rectification Purification of a solvent.

Reduction (of color) Mixture with white.

Refraction The bending of light by a surface.

Refractive Index A measure of the degree of refraction.

Relative Humidity (RH) The amount of water vapor present in the atmosphere.

Relief printing (or letterpress printing) A form of printing in which the ink is applied to the raised surface of the block or plate.

Resin A hard, non-crystalline substance with an amorphous structure. Either naturally obtained from the secretions of trees or synthetically produced. Widely used in varnishes and (in the synthetic forms) in the binding mediums for paints such as acrylics.

Resist A protective layer applied to a painting, screen or metal plate in printmaking to define an image by preventing paint, ink or acid from affecting certain areas.

Rough The most heavily textured grade of artists' paper.

Roulette A tool with a serrated or dotted edge which is used to indent tonal effects into metal plates in engraving.

Salt A compound formed by the reaction of an acid and a base.

Sanguine Red crayon.

Saponification The formation of soap by reacting an oil or fat with an alkali.

Saturation (i) The intensity of a color.
(ii) The presence of only single bonds in a molecule.

Scorper Wood-engraving tool used for scraping out relatively wide lines or clearing areas around a shape.

Scraper Tool used in metal engraving to take rough texture off the surface of the plate.

Scraperboard Smooth chalk board with black or white surface which can be incised to create an image.

Scumbling A painting technique in which semi-opaque or thin opaque colors are loosely brushed over an underpainted area so that patches of the color beneath show through.

Secondary colors Light: red (magenta), blue (cyan) and yellow. Pigments: green, orange-red, blue-violet.

Sepia Originally, coloring matter from the ink sac of the squid or cuttlefish. Now it designates a particular yellow/brown color.

S'graffito A method of drawing or painting in various materials by scratching through a layer of one color or tone to reveal a second.

Shade Color mixed with black.

Siccative (see drier) Also traditionally a rapid-drying varnish-based medium used to accelerate drying.

Silk-screen A method of printmaking in which ink is forced through a stretched mesh on to the paper.

Silverpoint Method of drawing with a pen-like instrument with a silver tip. Nowadays a clutch pencil with silver wire is used.

Single bond The sharing of two electrons or saturated molecule as in CH_4

Size Material such as glue or gelatine used to prepare canvas prior to priming or to reduce the absorbency of paper. It can be used as a binding medium for painting.

Slake To combine chemically with water.

Slip A liquid clay.

Solution A liquid containing a dissolved solid as distinct from a suspension or a colloid.

Solvent Any liquid in which a solid can be dispersed to form a solution. A resin varnish dissolved in an organic solvent like turpentine will harden after being applied as the solvent evaporates. Used widely as thinners or diluents.

Spattering A method of flicking paint off the stiff hairs of a bristle brush or toothbrush to create a mass

of irregular spots of paint. The effect can also be created with an airbrush or spray gun.

Spitsticker Wood-engraving tool used to cut curving lines.

Spraying A technique of applying paint with a spray gun, airbrush or aerosol can which facilitates smooth gradations of tone or soft edges.

Squaring (or "squaring up") A method of transferring the contours of an image to the canvas. A grid of squares is superimposed over the original study. A similar but larger-scale grid is fixed to the canvas or wall and the image drawn in, square by square.

Starch Substance synthesized in plant cells from carbon dioxide and water during photosynthesis. It is used as an adhesive and as a binding material.

Stencil A masking device to prevent paint or ink from filling in certain areas of the painting or print.

Stippling A method of painting which involves applying small dots of paint to the canvas – it gives greater control than spattering.

Stretcher frame The (usually wooden) frame on which the canvas is stretched.

Structural formula A formula which indicates the spatial arrangement of atoms in the molecule.

Stump Tightly rolled paper or leather cylinder used to smooth charcoal and pastel on a drawing.

Substrate The material on which the painting ground is supported.

Support The structure (wood, paper, metal etc.) on which the painting is made.

Surface film Layer at the surface of a paint film.

Surface sizing A method of decreasing the absorbency of a material like paper by coating the surface with size.

Surface tension The intermolecular forces which reduce the surface area of a boundary. The effect can be seen in droplet formation, in a soap bubble or the curved meniscus on a liquid in a tube.

Surfactant (or water tension breaker) Substance which increases the flow of a paint over a surface, e.g. oxgall.

Tackiness The stickiness of an incompletely dried film.

Tacking edge The edge of the stretcher bar to which the canvas is attached by tacks or staples. Nowadays artists tend to staple to the back of the stretcher bar rather than the oustide edge.

Tempera Tempera painting generally incorporates a water-soluble emulsion which dries to a hard film. Egg tempera painting, incorporating egg, egg and oil or egg, oil and resin emulsions is the most commonly known, but other forms include gum and glue tempera.

Thermoplastic Softening under heat.

Thickener Additive employed to increase viscosity.

Thinner (see *diluent*)

Tincture Color or the addition of color. A color intended to be used for tinting.

Tint Color mixed with white.

Tinting strength A measure of the ability of a pigment to tint a white.

Tint tool Wood-engraving tool used for cutting single straight lines.

Tone The degree of lightness or darkness of a color.

Toned ground An opaque imprimatura in which the color is mixed with white to give a uniform opaque ground. The priming itself may be tinted to give a similar effect.

Toner Organic pigment based on a metallic salt.

Tooth The slightly rough surface of a priming or paint film which allows a subsequent layer of paint to grip and bond successfully.

Top tone (mass tone) The color of an undiluted pigment.

Tortillon Small paper stump used to manipulate a drawn surface.

Traction Movement of one paint layer over another, usually giving rise to cracking.

Transparent painting Uses transparent colors and relies for its effects on the whiteness of the ground or on the various tones of the underpainting.

Trompe l'oeil Illusionistic painting that deceives the observer into thinking that the objects depicted are real.

Ultra-violet Radiation beyond the violet end of the visible spectrum.

Underpainting Preliminary painting, over which other colors are applied.

Undertone The color of a pigment as it appears in thin transparent films – this may appear quite different from the top tone.

Value The extent to which a color reflects or transmits light.

Varnish Protective surface film imparting a glossy or matt surface appearance to a painting.

Vehicle The binder, or medium in which pigment is ground.

Verdaccio Greenish underpainting.

Viscosity A measure of the flow characteristic of a color or medium (e.g. stand oil is more viscous than alkali-refined linseed oil).

Vitreous enameling Method of decorating prepared metal panels by applying enamel colors and firing at high temperature.

Volatile Capable of evaporating from solution.

Warp The taut parallel threads on the loom through which the weft is woven.

Wash A thin transparent layer of paint (especially watercolor).

Watercolor Paint made by binding pigment in a water-soluble gum.

Water of crystallization Combined water in crystalline materials, e.g. $CuSO_4.7H_2O$

Weft (see *warp*).

Wet edge time The time for a film to become unworkable – often equal to the time taken for a solvent to evaporate – particularly in viscous films.

Wet-into-wet Method of painting in which wet color is applied into or on top of wet color already on the support.

Wetting agent An additive which aids the wetting of a pigment by a binder or the surface of the substrate by the medium.

Wove Paper that is made against a "woven" metal mesh, giving it something of the appearance of canvas – as opposed to "laid" paper.

BIBLIOGRAPHY

Abbott, W: *The Theory and Practice of Perspective* Blackie and Sons (1950)

Adhémar, J: *Toulouse Lautrec: His complete lithographs and drypoints* Thames and Hudson (1963)

Albers, J: *Interaction of Colour* Yale (1963)

Alberti L B: *On Painting* translated by John R. Spencer, Yale (1956)

Antreasian, G and Adams, C: *The Tamarind Book of Lithography* Abrams (1971)

Armfield, M: *Manual of Tempera Painting* George Allen and Unwin (1930)

Arnheim, Rudolf: *Art and Visual Perception* University of California (1954, 1974)

Ayres, J: *The Artist's Craft* Phaidon (1985)

Baldry, A L: *The Practice of Watercolour Painting* Macmillan and Fine Art Society (1911)

Bazin, G: *Baroque and Rococo* Thames and Hudson (1964)

Bazzi, M: *The Artist's Methods and Materials* John Murray (1960)

Borsook, E: *The Mural Painters of Tuscany* Phaidon (1960)

Beardsley, J: *Art in Public Places* Partners for Livable Places (1981)

Bewick, T: *A General History of Quadrupeds (1790)* Ward Lock reprints (1970)

Bomford, D: *Conservation and Storage: easel paintings* from *Manual of Curatorship* edited by Jon Thompson, Butterworth (1984)

Borradaile V and R: *Practical Tempera Painting* Crosby, Lockwood, Staples (1949)

Borradaile V and R (translators): *The Strasburg Manuscript* Tiranti Ltd (1966)

Buckland-Wright, J: *Etching and Engraving* The Studio Limited (1953)

Cennini, Cennino d'Andrea: *Il Libro dell'Arte*, The Craftsman's Handbook, translated by Daniel V Thompson, Jr, Yale (1933) Dover Publications Inc (1954)

Chamberlain, W: *The Thames and Hudson Manual of Etching and Engraving*, (1972)

Chamberlain, W: *The Thames and Hudson Manual of Wood Engraving*, (1978)

Chamberlain, W: *The Thames and Hudson Manual of Woodcut Printing and Related Techniques*, (1978)

Chevreul, M E: *The Principles of Harmony and Contrast of Colours*, Introduction and notes by Faber Birren, Reinhold Publishing Corporation (1967)

Church, A H: *The Chemistry of Paints and Painting*, Seely, Service & Co, (1915)

Completing the Picture, Tate Gallery (1982)

Demus, O, Hirmer, M: *Romanesque Mural Painting*, Abrams (1970)

Doerner, Max: *The Materials of the Artist*, Translated by Eugen Neuhaus, Hart-Davis (1949)

Dubery, F, Willats, J: *Perspective and Other Drawing Systems*, The Herbert Press, (1983)

Dupin, J: *Miro*, Abrams (1962)

Eastlake, Sir C: *Materials for a History of Oil Painting*, (1847), Reprinted as *Methods and Materials of the Great School and Masters* (two vols), Dover Publications Inc (1960)

Edgerton, Samuel Y Jr: *The Renaissance Rediscovery of Linear Perspective*, Basic Books (1975)

Findlay, W P K: *Timber, Properties and Uses*, The Dolphin Press (1975)

Ford, J E (Editor): *Handbook of Fibre Data Summaries*, Shirley Institute, (1966)

Friedlander, W & Blunt, A: *The Drawings of Nicholas Poussin*, The Warburg Institute, University of London, (1963)

Gettens, R J & Stout, G L: *Painting Materials: A Short Encyclopaedia*, Van Nostrand (1942) Dover Publications, Inc., (1966)

Gettings, F: *Polymer Printing Manual*, Studio Vista, (1971)

Gilbert & George, 1968–1890, Eindhoven, (1980)

Gilbert & George, the Charcoal on Paper Sculptures, 1970–1974, Musée d'Art Contemporain de Bordeaux, (1986)

Gilmour, P: *Understanding Prints: a Contemporary Guide*, Waddington Galleries (1979)

Goethe: *Theory of Colours*, translated by C H Eastlake, John Murray, London (1840)

Gregory, R: *The Intelligent Eye*, Weidenfeld & Nicholson (1970)

Gross, A: *Etching, Engraving and Intaglio Printing*, Oxford University Press (1970)

Haak, R: *Rembrandt's Drawings*, Thames and Hudson, (1976)

Hamilton, D: *The Thames and Hudson Manual of Architectural Ceramics*, (1978)

Hardie, M: *Cotman's Watercolours: The Technical Aspect*, Burlington Magazine, July 1942

Hardie, M: *Watercolour Painting in Britain (Vol I: The Eighteenth Century)*, Batsford, (1966)

Harley, R D: *Artists' Pigments 1600–1835*, Butterworth (1970)

Hayter, S W: *New Ways of Gravure*, Routlege & Kegan Paul (1949)

Hedgecoe, J: *The Photographer's Handbook*, Ebury Press, (1977)

Hedley, G: *On Humanism, Aesthetics and the Cleaning of Paintings*, reprint from a lecture series at the Canadian Conservation Institute, (1985)

Hedley, G & Villers, C: *Polyester Sailcloth Fabric: a high-stiffness lining support (Science and Technology in the Service of Conservation*, Edited by Brommell & Thomson), International Institute for Conservation of Historic and Artistic Works, (1982)

Herbert, K: *The Complete Book of Artists' Techniques*, Thames and Hudson, (1958)

Hiler, H: *Notes on the Technique of Painting*, Faber (1934), Second Edition (1957)

Hilliard, N: *A treatise concerning the arte of Limning*, ed Thornton R K R and Cain T G S, Mid-Northumberland Arts Group with Carcanet New Press, (1981)

Hind, A M: *Giovanni Battista Piranesi*, (1922), Holland Press (1967)

Hind, A M: *A Catalogue of Rembrandt's Etchings*, Da Capo (1967)

Hind, A M: *A History of Engraving and Etching*, Houghton Mifflin Co, (1923)

Holmes, Sir C J: *Notes on the Science of Picture Making*, Chatto & Windus, (1927)

Jane, F W: *The Structure of Wood*, (1970), London, International Institute for Conservation of Historic and Artistic Works, New York Conference, vol 2: Conservation of Wooden Objects, (1970)

Joachimedes, C M, Rosenthal, N, Schmied, W (editors): *German Art in the 20th Century, Painting and Sculpture 1905–1985*, Royal Academy, London

Kirk, Othner: *Encyclopaedia of Chemical Technology* Vol 15, John Wiley & Sons Inc., (1968)

Knappe, K A: *Durer: The Complete Engravings, Etchings and Woodcuts*, Thames and Hudson (1965)

Langford, M: *The Darkroom Handbook*, Ebury Press, (1981)

Latilla, E: *A Treatise on Fresco, Encaustic & Tempera Painting*, Chapman and Hall (1842)

Laurie, A P: *The Painter's Methods and Materials*, Dover Publications Inc (1967)

Laurie, A P: *Greek and Roman Methods of Painting*, Cambridge University Press (1910)

Laurie, A P: *The Technique of the Great Painters*, Carroll & Nicholson Ltd (1949)

Leonardo da Vinci: *Notebooks*, edited by Edward MacCurdy, Jonathan Cape (1938)

Lightbown, R: *Mantegna*, Phaidon, Christie's, Oxford, (1986)

Lochnan: *The Etchings of James McNeill Whistler*, Yale, (1984)

Male, E: *The Gothic Image*, Collins, (1961)

Malins, F: *Drawing Ideas of the Masters*, Phaidon, (1981)

Mann, Sargy: *Drawings by Bonnard*, Arts Council of Great Britain, (1984)

Mara, T: *The Thames and Hudson Manual of Screen Printing*, (1979)

Martineau, J & Hope, C (editors): *The Genius of Venice 1500–1600*, Royal Academy of Arts, Weidenfeld and Nicolson (1983)

Mayer, R: *A Dictionary of Art Terms and Techniques*, A & C Black, (1969)

Mayer, R: *The Artist's Handbook of Materials and Techniques*, 4th ed Faber & Faber (1982)

Meiss, M: *The Great Age of Fresco*, Phaidon, (1970)

Merrifield, M P: *Original Treatises on the Arts of Painting*, 2 vols, Dover Publications Inc (1967)

Mills, J S & White, R: *Conservation and Restoration of Pictorial Art* (page 74, table 9.1), Edited by Brommelle and Smith, Butterworths (1976)

Murray, P & L: *The Penguin Dictionary of Art and Artists*, Penguin Books (1959)

Narazaki, M: *The Japanese Print: Its Evolution and Essence*, Kodansha International Ltd, (1966)

National Gallery Technical Bulletins 1–10 from 1977 to 1986, National Gallery

Osborne, Roy: *Lights and Pigments*, John Murray, London (1980) *Paint & Painting*, Tate Gallery (1982)

Paladino, Mimmo: *Etchings, Woodcuts and Linocuts, 1983–86*, Waddington Galleries (1986)

Pansu, E: *Ingres Dessins*, Chene, (1977)

Pirenne, M H: *Optics, Painting and Photography*, Cambridge University Press, (1970)

Pope-Henessy, J: *Fra Angelico*, Phaidon (1952)

Pupin, J: *Miro*, Abrams, New York

Reyntiens, P: *The Technique of Stained Glass*, Batsford (1977)

Richard Long, Van Abbemuseum Eindhoven (1979)

Rood, O: *Modern Chromatics*, Van Nostrand Reinhold Company (1973)

Rose, Bernice: *Jackson Pollock, Works on Paper*, Museum of Modern Art, New York (1969)

Ruhemann, H: *The Cleaning of Paintings*, Faber (1968) (contains an excellent and useful bibliography)

Ryder, N: *Acidity on Canvas Painting Supports: De-acidification of Two 20th Century Paintings*, The Conservator, No 10 (1986)

Seddon, R: *Artist's Studio Handbook*, Muller (1985)

Senefelder, A: *A Complete Course in Lithography*, London 1819, Da Capo (1977)

Sepeshy, Z: *Tempera Painting*, American Studio Books (1946)

Sol le Witt, Wall Drawings 1968–1984, Stedelijk Museum, Amsterdam (1984)

Stainton, L: *British Landscape Watercolours 1600–1860*, British Museum Publications (1985)

Stout, G L: *The Care of Paintings*, Columbia University Press (1948)

Talley, M K: *Portrait Painting in England: Studies in the Technical Literature before 1700*, Paul Mellon Centre for Studies in British Art (1981)

Taylor, C J A & Marks, S (Editors-in-chief): *Paint Technology Manuals* (6 parts), Chapman and Hall (1969)

Textile Finishing Manual, BASF

Theophilus: *De Diversis Artibus*, translated by C R Dodwell, Thomas Nelson & Sons (1961)

Thiem, Gunther: *German Woodcut in the 20th Century*, Institute for Foreign Cultural Relations (1984)

Thompson, D V: *The Materials and Techniques of Medieval Painting*, Dover Publications, Inc (1956)

Thompson, D V Jr: *The Practice of Tempera Painting*, Yale 1936, Dover Publications, Inc (1962)

Timber Research and Development Association (TRADA), *Wood Information Sheet 10*, (1985)

Uitert, E Van: *Van Gogh Drawings*, Thames and Hudson (1979)

Vasari, G: *Vasari on Technique*, translated by Louisa S Maclehose, Dover Publications Inc. (1960)

Viator: *De Artificiali Perspectiva* (Toul, 1505 & 1509), reprinted in *On the Rationalization of Sight* by William M Irvins Jr, Metropolitain Museum of Art, New York (1938)

Vibert, J G: *The Science of Painting*, Percy Young (1982)

Vickrey & Cochrane: *New Techniques in Egg Tempera*, (1960)

Vytlacil, V & Turnbull, R D: *Egg Tempera Painting*, 1935, Papers of the Society of Painters in Tempera, Vol I, IV

Wehlte, Kurt: *The Materials and Techniques of Painting*, Van Nostrand Reinhold Company (1975)

White, G: *Perspective (A Guide for Artists, Architects and Designers)*, Batsford (1968)

White, J: *The Birth and Rebirth of Pictorial Space*, Faber, 2nd edition (1967)

Wind, E: *Pagan Mysteries in the Renaissance*, Faber & Faber (1958)

Wright, L: *Perspective in Perspective*, Routledge & Kegan Paul (1983)

Yee, C: *Chinese Calligraphy*, Methuen (1938)

INDEX

ACKNOWLEDGEMENTS

Author's acknowledgements
I am most grateful to the following for sharing their expertise and giving so much helpful advice during the preparation of this book. Also, to some for allowing pictures to be reproduced or for sitting for them: Roger Ackling, Hugh Adams, Simeon Adams, Dr. Helena Albuquerque, George Warner Allen, Sr. Francisco d' Almeida, T.E. Anderson (Hercules Ltd.), Philip Bale (Hercules Ltd.), John Beardsley, Maria-Clara Pinto Beça (Aleluia), B.T. Bellis (The Leys School), Oliver Bevan, Ian Biggs (Conté U.K. Ltd.), Professor Lewis R. Binford, Constance Boggis-Rolfe, Robert Boyd (Russell and Chapple), Geoffrey Burnham (Burnham Ltd.), Les Caird, Dr. Colin Campbell (Ciba Geigy), David Carter (Blythe Colours Ltd.), Peter Chadwick, Michael Chaitow, P.H. Coate & Sons, L. Cornelissen & Son, Dr. John H. Coy (Ciba Geigy), John Dale, Jake Davies, Richard Dixon-Wright (St Cuthbert's Mill), Mike Dodd (Pittard Group plc), Simon Draper, Brenda Drayton, Geoff Eley, Brenda Fawcett (Perstorp Warerite), R.R. Franck (International Linen), Amal Ghosh, Mike Goodall (Southampton City Art Gallery), Mary Greaney, Simon B. Green (Barcham Green & Co.), A. Greenwood (Pecket Well Mill), Dr. E. Hartley (ICI), Richard Hayward & Co., Tim Head, Gerry Hedley (Courtauld Institute), Martin Hill (Thorn EMI), Sarah Hocombe, Chris Hollings (D. & J. Simons & Sons Ltd.), Dave Holt (Silvermans), Lisa Hughes, F. Hugh Howarth, Derek James (Chelsea Art School), Jason Jefferies (Faber Castell), Richard Jobson, Stephen Johnson (Norsk Hydro), John Keel (Rowney Artists' Brushes Ltd.), Ken Kellaway, Dr. Peter Laight (Pittard Group plc), Mark Lancaster, Bill Latham (Deancraft Fahey Ltd.), Dominic Lawson, Claude Libeert (Libeco S.A.), The Lisson Gallery, Richard Long, Henry Lydiate, Dr. J. McAllister (Ciba Geigy), Jane McAusland, Alan McWilliam (Chelsea Art School), Medite of Europe, Steve Meredith (Hoechst (UK) Ltd.), Louis P. Miles (International Institute for Cotton), John Mills (National Gallery, London), R. Murray (Blythe Colours Ltd.), David Nash, Sr. Eduardo Nono, John van Oosterom (Falkiner Fine Papers), Alan Oswald (Ciba Geigy Bonded Structures Division), Philip Preston, Dr. M. Pidgely, The Public Art Development Trust, Helen Reid (Rexel Ltd), Professor and Doctor A.C. Renfrew and family, Robert Ritson (Chelsea Art School computer department), Sr. J. Rocha e Melo (Aleluia), Desmond Rochfort, Ashok Roy (National Gallery, London), Kirsten Salén, Richard Shone, Camilla Smith, Henry Smith, Dr. Peter Smith, Dr. Umberto Sozzi, Marianna Stamp, Sundeala Ltd, Richard Sweetman, David Tee (Rexel Ltd.), Steve Thorpe, Mr. Varkey (K.T. Textiles), M. Vickey (Rowney Artists' Brushes Ltd.), Caroline Villers (Courtauld Institute), Boyd Webb, Bernice Weston, Raymond White (National Gallery, London), Roger Whitney, Ron Wright (Perstorp Warerite).
 Special thanks to Alun Foster, my scientific adviser, who provided a

great deal of information for the "materials" section and the glossary and who checked the manuscript. Also, to Jonathan Leslie for assistance with research.

I should like to thank Barbara Thomas, my typist, for so patiently, accurately and promptly transcribing so much handwritten text.

Finally, my thanks to the Directors of Dorling Kindersley and to the editorial and design team, Caroline Ollard, Mark Richards, Tim Hammond and Joanna Martin, who worked so hard on this project.

Dorling Kindersley would like to thank the following:

Neville Graham and David Nixon for design assistance; Rebecca Abrams and Sophie Mitchell for editorial assistance; Richard and Hilary Bird for the index; Henrietta Winthrop for production services; Margaret Little for typing.

Elizabeth Bessant
Claire Carré (Design and Artists' Copyright Society Ltd.)
Mary Ann Chew
L. Cornelissen and Son
Prudence Cuming Associates Limited
Robert Douwma Prints and Maps Ltd
Paul Fahey and Bill Latham
(Deancraft Fahey Ltd)
B.T. Galloway (National Gallery)
Chris Hough (Falkiner Fine Papers)
Alun Jones
T.N. Lawrence and Son Ltd
London Graphic Centre
Rexel Cumberland
Mr. Rushworth (Windmaster International)
Mike Taylor (Paupers Press)
Wheatsheaf Graphics Warehouse
Winsor & Newton

Line illustrations
Meridian Design Associates

Photographic credits

T = top, **C** = Centre, **B** = bottom, **R** = right, **L** = Left

48 (B) Reproduced by Courtesy of the Trustees, The National Gallery, London; **69 (R)** John Judkyn Memorial, Bath; **73 (TL)** Musée Ingres, Montauban; **75 (BR)** Reproduced by kind permission of Virgin Records Limited; **76 (B)** © David Nash 1987. All rights reserved DACS; **83 (T)** Arts Council of Great Britain; **83 (B)** Southampton City Art Gallery; **87** Reproduced by Courtesy of the Trustees, The National Gallery, London; **95** Sterling and

Francine Clark Art Institute, Williamstown, Massachusetts; **98 (B)** Bildarchiv Preussicher Kulturbesitz, West Berlin; **103** The Baltimore Museum of Art: The Cone Collection, formed by Dr Claribel Cone and Miss Etta Cone of Baltimore, Maryland. © DACS 1987; **122 (T)** Fitzwilliam Museum, Cambridge; **122 (B)** Reproduced by Courtesy of the Trustees of the British Museum; **124 (T)** Collection, the Museum of Modern Art, New York. The Joan and Lester Avent Collection; **125 (B)** Collection of the Earl of Leicester, Holkam Hall; **126** White crayon, black walls, first drawn by: David Connearn, Jo Watanabe. First installation Six Geometric Figures: Lisson Gallery, London, England. May, 1980 First Installation Cross and X: The Tate Gallery, London. April 1981 Collection, The Tate Gallery, London. Detail reproduced courtesy of The Lisson Gallery, London and by kind permission of Sol le Witt and The Tate Gallery, London; **127 (T)** Reproduced by kind permission of Gilbert & George, **127 (C)** Reproduced by kind permission of Roger Ackling; **127 (B)**, **128 (T)** Reproduced by kind permission of Richard Long; **129 (T, C, L, BR)** © David Nash 1987. All rights reserved DACS; **131**, **138** Reproduced by Courtesy of the Trustees of the British Museum; **138–9** Courtauld Institute Galleries, London (Spooner Collection S.32); **150** Reproduced by kind permission of the Nolde Museum, Seebull, **154 (T)** Reproduced by Courtesy of the Trustees of the British Museum, **154 (BR)** Norfolk Museums Service, Norwich Castle Museum; **166** Southampton City Art Gallery; **167** Reproduced courtesy of Waddington Galleries, London. © ADAGP 1987; **169 (T)** by Courtesy of the Board of Trustees of the Victoria and Albert Museum; **170** Reproduced by Courtesy of the Trustees, The National Gallery, London; **176** Ashmolean Museum, Oxford; **180 (L)**, **180–1** Reproduced by Courtesy of the Trustees, The National Gallery, London; **181 (R)** Reproduced by kind permission of Howard Hodgkin; **188 (B)** by Courtesy of the Board of Trustees of the Victoria and Albert Museum; **189** Galerie Beyeler, Basle, © ADAGP, Paris & COSMOPRESS, Geneva 1987; **191 (T)** Private Collection, Southampton City Art Gallery, © ADAGP 1987; **191 (B)** Reproduced by Courtesy of the Trustees, The National Gallery, London; **192 (T)** Musee d'Art et d'

Histoire, Nîmes; **192 (B)** National Portrait Gallery, London; **193 (B)** Reproduced by Courtesy of the Trustees, The National Gallery, London; **197 (B)** Southampton City Art Gallery; **198 (L)** Courtauld Institute, Princes Gate Collection; **198 (R)** Tate Gallery, London © ADAGP 1987; **202** Courtauld Institute Galleries, London; **203** Southampton City Art Gallery, © Estate of Gwen John 1987; **204** Reproduced by kind permission of the Nolde Museum, Seebull; **208** Collection, The Museum of Modern Art, New York. Gift of Mrs Abner Brenner; **221 (CL)** Manchester City Art Galleries; **228** Fitzwilliam Museum, Cambridge; **236**, **240** Reproduced by courtesy of Desmond Rochfort; **246–9** Chelsea School of Art; **247 (T)** design by Sarah Hocombe, Chelsea School of Art; **256 (B)** Tate Gallery, London; **261 (T)** © DACS 1987; **263 (T)** Dover Publications, Inc, New York; **263 (B)** © Estate of Eric Ravilious 1987. All rights reserved DACS; **246 (BR)** Reproduced Courtesy of Waddington Galleries Ltd, London; **268 (BC)** Reproduced Courtesy of Robert Douuma Prints and Maps Ltd; **267 (BL)**, **271 (L)**, **272** Reproduced by Courtesy of the Trustees of the British Museum; **278 (B)** Sotheby's London; **285** Elizabeth Bessant; **287 (B)** Tate Gallery, London. © DACS 1987; **291** Mansell Collection; **292 (TL)**, **296 (TL, TR, BR)**, **297** Oliver Bevan, © Chelsea Art School; **298** Mansell Collection; **299** Reproduced by Courtesy of the Trustees of the British Museum; **300**, **301** © Scala Florence; **302** Witt Library/Leeds City Art Gallery. Reproduced by permission of the Stanley Spencer Estate; **303** Mansell Collection; **309**, **310**, **311** Conservation pictures by Courtesy Courtauld Institute Technology Department; **313** Conservation pictures by courtesy Tate Gallery, London; **316** Vincent van Gogh Foundation/National Museum Vincent van Gogh, Amsterdam; **322 (T)** Reproduced by courtesy of Tim Head; **322 (B)** Reproduced by courtesy of Boyd Webb; **327 (BL)** Chelsea Art School, **327 (B)** Reproduced by courtesy of Robert Ritson.
All other photography by Peter Chadwick.

Typeset by MS Filmsetting Limited, Frome, Somerset
Reproduction by Colourscan, Singapore